Also by Annie Cohen-Solal

Sartre: A Life

Painting American

Painting American

The Rise of American Artists, Paris 1867–New York 1948

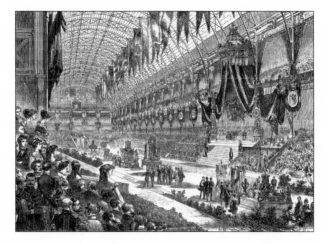

Annie Cohen-Solal

Translated from the French with Laurie Hurwitz-Attias

Alfred A. Knopf New York 2001

THIS IS A BORZOI BOOK
PUBLISHED BY ALFRED A. KNOPF

www.aaknopf.com

Originally published in France as *"Un jour, ils auront des peintres"*:
L'avènement des peintres américains Paris 1867–New York 1948 by Editions
Gallimard, Paris, in 2000. Copyright © 2000 by Editions Gallimard.

Cet ouvrage, publié dans le cadre du programme d'aide à la publication,
bénéficie du soutien du Ministère des Affaires Etrangères et des Services
Culturels de l'Ambassade de France aux Etats-Unis.

This work, published as part of the program of aid for publication,
received support from the French Ministry of Foreign Affairs and the
Cultural Service of the French Embassy in the United States.

Library of Congress Cataloging-in-Publication Data
Cohen-Solal, Annie, [date]
[Un jour, ils auront des peintres. English]
Painting American : the rise of American artists, Paris 1867–New York
1948 / Annie Cohen-Solal.—1st American ed.
p. cm.
Includes bibliographical references and index.
ISBN 0-679-45093-9 (alk. paper)
1. Painting, American—19th century. 2. Painting, American—
20th century. 3. Painting, French—Influence. I. Title.
ND210 .C6613 2001
759.13'09'034—dc21
2001032669

Manufactured in the United States of America
First American Edition

for Archibald
and in gratitude to Leo

Contents

Contents

Part III

From Notre Dame de Paris to the Brooklyn Bridge
1913–1948

Painting American

Ouverture

Paris, 1867

Bumpkins in a Ballroom

"HIS FEZ TOPPED with a white egret plume, the sultan seemed to gaze attentively at the dazzling sight of animated crowds and the flutter of fans spread out before him. . . . Coachmen in head-to-toe livery led horses covered in gold armor. The hundred guards in white-tasseled helmets paraded like knights arriving for a medieval tournament. Carriage followed carriage, and the bands played, and the drums beat, and the numberless throng cheered loudly as they passed."[1]

Paris, July 1, 1867, two o'clock in the afternoon. In a torrid heat, beneath the glass panels of the Palais de l'Industrie, several thousand of the elegant and select had assembled to observe the awards ceremony of the Olympiade des Arts et de l'Industrie. Only a monarchy seems to know the secret of creating such a lavish festivity, this one presided over by Prince Napoléon, cousin of Emperor Napoléon III and head of the organizing committee.

The Exposition Universelle d'Art et d'Industrie had been inaugurated by the emperor and empress on April 1st. Now, three months later, it was culminating in an event that would capture worldwide attention as a glorious and gilded high point for Paris under the Second Empire. But the spectacle was as absurd as it was solemn and grandiose. The hymn that Gioacchino Rossini had composed for the occasion, though intended to celebrate peace and prosperity, vibrated with martial platitudes that spoke of "rumbling cannons" and "heroes of combat." And the emperor's pompous, self-congratulatory speech boasted that "representatives of science, the arts, and industry had raced from every corner of the earth," to admire France "as it truly is, grand, prosperous, and free."[2]

Perhaps there was some cause for Gallic self-satisfaction. The French Empire, buttressed by its colonies—particularly Algeria, "that jewel whose facets were as yet uncut"[3]—had taken its shining place alongside the Ottoman, the Russian, and the Austrian empires, as well as the kingdoms of Prussia, Italy,

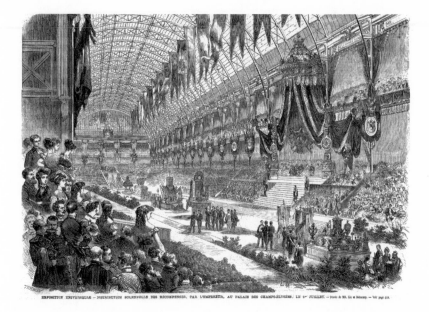

EXPOSITION UNIVERSELLE — DISTRIBUTION SOLENNELLE DES RÉCOMPENSES, PAR L'EMPEREUR, AU PALAIS DES CHAMPS-ÉLYSÉES, LE 1er JUILLET. — Dessin de M. [...] et Deberny. — Voir page 416.

Paris, July 1, 1867, Palais des Champs-Elysées. The Emperor's awards ceremony at the Exposition Universelle was grandiose and solemn. During the Second Empire, genre painting triumphed over history painting. Everywhere, French culture predominated.

and Württemberg, France's rivals in glory and prestige. Meanwhile, on the official list, the United States of America found itself oddly squeezed between the principality of Liu-Kiu and the Empire of Brazil.

The privileged audience had been held captive for hours in the afternoon heat before the moment for awarding the medals to the artists finally arrived. As one journalist reported: "The first group, consisting of members of the Beaux Arts, advanced to the podium, led by its president, Count de Nieuwerkerke. This glorious legion of artists included Cabanel of the magic brush; Gérôme the richly imaginative; Meissonier the grand artist; Théodore Rousseau, landscapist without rival; the Prussian [Ludwig] Knaus, to whom the Flemish masters had confided their secrets; the Belgians [Henri] Leys and [Florent] Willems, whose portraits of women even Meissonier himself admired; and [Alfred] Stevens, whose women were their rivals."[4]

History painting was enjoying its last hurrah under the Second Empire, and the Exposition Universelle provided an opportunity to exhibit some of the finest examples of the day: Meissonier stood out with his impressive *Portrait of His Majesty the Emperor at Solferino*. Isidore Pils commemorated other Napoleonic victories, such as *The Battle of Alma, 20 September 1854;* some con-

tinued to depict the recent Crimean War. Among them, Adolphe Yvon presented a painting (number 618) entitled *The Capture of the Malakoff Tower, September 8, 1855, Crimea,* alongside which was hung a two-page explanatory gloss reproducing a dispatch sent by General MacMahon to the Traktir camp. Painting number 619, entitled *September 8, 1855,* was accompanied by a didactic extract from the first volume of Baron de Bazancourt's exhaustive *Crimean Expedition.* In the ethnographic manner, Jean-Léon Gérôme presented *Ave Caesar, Morituri Te Salutant;* and Cabanel, with his mythological scenes, thrilled critics with his *Birth of Venus* and *Paradise Lost.*

As it bade farewell to history painting, the year 1867 would see, above all, the forceful arrival of genre painting. Théodore Rousseau showed *Farm on the Banks of the Oise River;* Jean-François Millet presented *The Harvesters.* Other French landscape artists, such as Eugène Lepoittevin, Emmanuel Lansyer, Jules-Adolphe Breton, and Adolphe Leleux (a student of Paul Delaroche), had all entered traditional scenes such as *The Beach at Etretat, Morning in Brittany, Washing Place at Low Tide, Burial in Brittany, Breton Peasant,* and *Blessing of the Wheat in Artois.* Picturing rural settings in Calvados, Berry, Sologne, the Landes, Picardy, and Artois, as well as in the forests of Fontainebleau and Compiègne, their canvases featured reapers, sowers, goose girls, sheep, shepherdesses, and livestock. One could almost hear the Angelus calling the faithful to worship. In short, viewed through the lens of its genre artists, France came to be equated with its own landscape: cultivated, domesticated, sentimentalized, and populated by plain country folk in reassuringly quaint native garb. History painters, however, continued to offer an image of the nation that remained emphatically stiff and intractable.

The American delegation seemed oblivious to its second-class position on that stage. In 1867, shaking off the lethargy that had gripped it in 1855 before the previous Exposition Universelle, members of the National Academy of Design appointed two prominent landscape painters—Jasper Cropsey and Frederic Church—to propose to the United States Congress that they send a contingent of Americans and their works to Paris for the latest Exposition.[5] While a scant ten American painters had shown thirty-nine works at the Exposition Universelle of 1855, in 1867 forty-one Americans showed eighty-two—a large and varied group of paintings that, judged by American standards, seemed top-notch. Still, it was too little and too late to give any strong creative impetus to the American presence, and the original funds barely covered half of the expenses involved.[6] Convinced of the superiority of its landscape artists, the United States selection committee determined that they should be heavily represented. Among the artists they sent to Paris were Albert Bierstadt, Sanford

R. Gifford, George Inness, Asher B. Durand, John Frederick Kensett, Jervis McEntee, Frederic E. Church, and Worthington Whittredge (later known collectively as the Hudson River School, the first truly "American" school of painting).[7] And fittingly, the works shipped to Paris illustrated some of the most celebrated landscapes in the country: *Autumn in the Ashokan Woods, View of the Adirondacks Near Mount Manofield, The Sources of the Susquehanna, Autumn on the Conegaugh, Pennsylvania, Twilight on Mount Hunter, Lake George in Autumn,* and *Morning on the Coast of Massachusetts.* The United States had sent its best to France. Whittredge (who later became president of the National Academy of Design) had submitted *The Old Hunting Grounds,* which had been unanimously acclaimed by critics at home and had even begun to assume iconic status in American landscape painting.[8] Church's *Niagara* was also considered a masterpiece. An enormous canvas, it depicted the falls at their most majestic, "with only the roar left out,"[9] as an admiring journalist wrote. One enthusiastic British critic, astonished that such a talented painter was American, asked, "But how long has he lived in England?" In 1867, the Americans arrived in Paris, glowing with confidence. But they were headed for a fall.

"Infantile arrogance"; "Childish ignorance"; "The American school is trailing painfully behind the English"[10]—these were some of the snickering remarks that greeted their arrival in Paris. As far as the French were concerned, the landscapes of Massachusetts, Kentucky, and Lake George provided neither reassuring familiarity nor seductive exoticism. At a time when Jules-Adolphe Breton's *Blessing of the Wheat, Artois* and Gérôme's *Door of the El-Assaneyn Mosque in Cairo, Showing the Heads of the Beys Immolated by Salek Kachef* were on exhibit, American depictions of Niagara Falls, the Adirondacks, or the Susquehanna—enormous, empty, silent, frozen—seemed bland and old-fashioned to the French. Even some American critics echoed the sentiment: "There can never be serious dispute of the proposition that figure painting is the highest effort of art. . . . Precisely in this, American art is most deficient."[11] In the United States, landscapes accounted for nearly half of the works produced; in France, they represented a much smaller proportion.

The medals to be awarded by the jury had recently been the subject of a heated debate; jury members wished to reduce their number and value, and also to exclude themselves from receiving such honors. Instead, the Imperial Commission rejected their proposal and increased the number of medals sixfold. The French rewarded themselves thirty-two times! There was little left for the Americans. Only Church's *Niagara* seemed worthy of a silver medal. And only the president of the American delegation, William J. Valentine, was named, if only for reasons of protocol, to the rank of officer in the Legion of

Honor. Though intended to flatter his guests, State Minister Eugène Rouher's speech could not avoid an air of condescension. "The United States of America," he declared, "kept away in 1862 from peaceful competition by a great war, has in this Exposition of 'Sixty-seven reclaimed its rightful place among countries of political and industrial importance, and held most nobly to their ranks."[12] Such official bombast aside, the Americans had indeed, despite the turmoil of the Civil War, found their way back to Europe. Their return to the "ranks" had been awaited with high expectations.[13]

Who was to blame for the American failure at the 1867 Exposition Universelle? The American artists themselves, for failing to realize that American landscape would not win over the French judges? The French critics, for expressing chauvinism and cruelty? The United States Congress, for dragging its feet? The selection committee, for sending such an inappropriate choice? Unlike the French custom, the committee consisted *not* of artists (they had recused themselves, believing it unethical to judge their peers), but of fifteen dealers and collectors. They had followed the advice of the initial recommendation of three expert painters: the American school had furnished "particularly fine landscapes," and therefore "a preference should be given to paintings of this class."[14]

American journalists fired the first rebuke to their compatriots' showing. In *Harper's* magazine, M. D. Conway pronounced the American pavilion "a failure" because of its dullness: "The dead pink walls of the American section would seem to have been committed for decoration to an intensely economical Committee of Quakers, and closely contrasted with the magnificence of several Oriental departments adjacent, are simply contemptible. It would seem that our display has been ordered not to appear in a 'Court Costume.'"[15] And the renowned critic James Jackson Jarves remarked: "We most failed in our lauded landscapists. Bierstadt's 'Rocky Mountains' . . . looked cold and untruthful. Its interest was confined to a tableau-like inventory of an extensive view, while its effect on the mind was similar to sounding phrases of little meaning. . . . Church's 'Niagara' with no more sentiment, a cold hard atmosphere and metallic flow of water . . . was a literal transcript of the scene [and] taught us a salutary lesson in placing the average American sculpture and painting in direct comparison with the European, thereby proving our actual mediocrity."[16]

Throughout the exhibition, dedicated as much to industry as the arts, the Americans successfully preserved their reputation for technical and mechanical innovation. The French admired their machines for peeling apples, sweeping carpets, cutting buttonholes, and rinsing glasses; they gaped at the Steinway pianos, the McCormick steam engine, Comstock's rotating plough, Samuel-

son's horse-drawn wheat harvester, Herring's harvester "which works over a field, turning over the hay with long hooks," and Baker's model bakery "in which Boston's famous cookies are kneaded, rolled, cooked, and sold by means of steam,"[17] among many other marvels of progress.

Other observers, however, regretted the American pavilion's austerity. One French journalist, A. Malespine, wrote, "Among all the splendors offered up to view in the Exposition park—the Egyptian palace, the Chinese houses, Hindu pagodas—the public passes with near indifference in front of two unfinished constructions whose simple architecture does not dazzle the eyes. . . . These are simple cabins, whose grandeur is doubtless moral. . . . One houses the American delegation . . . and the other is a school."[18] Malespine's next article ends bluntly: "Such as it is, this exposition would be considered a thing of some accomplishment were it to come from Costa Rica or Nicaragua. It is unworthy of the sons of Washington."[19]

In his various articles, Malespine constantly gripes about the American pavilion's negative aspects. "Sad is the impression a visitor gets as he makes his way across the pavilion of the United States," he wrote. "He crosses the narrow space allotted to the New World with an astonishment and stupor that is all the greater when he realizes that several minutes will suffice to observe all the objects sent in by this eminently progressive country. . . . He seeks in vain to find a catalogue; there are few indications, and most of them were not translated, badly translated, or not available; the employees . . . seem not to know as much as they should. It is true that this is nearly as true in other parts of the Exposition, but it seems inappropriate that America with its reputation would have made these vulgar miscalculations."[20]

For his part, Eugène Rimmel offered in his memoirs a more exacting analysis. He grudgingly allows that the "American school of painting was clearly the daughter of the English," while arguing that the time when Americans bought "paintings by the square meter and statues by the pound" had passed. Though "very tiny," the exhibition appeared "most remarkable," thanks to Kensett and McEntee. But finally, the true "grandeur" of the Americans, one that they "could not exhibit," he admitted, drawing on firsthand experience from his travels in the United States, lay in their "nine hundred million hectares of territory, their twenty thousand kilometers of coast, and their two-thousand-league rivers [sic]."[21] "All in all, the American presence is not commensurate with their present importance and certainly not with their brilliant future," Rimmel concluded. "Immature and crude, their presence, in the context of our old civilizations, suggests a giant bumpkin stumbling around a ballroom."[22]

American painters who longed for recognition in the Mecca of the art

world understood immediately that they had no other choice but to bend to French taste—for French taste ruled the world. Their humiliation at the Exposition Universelle spawned a new determination. The "sons of Washington" would accept the challenge. Suppose, after their unworthy showing, they found ways to narrow the gap? Suppose the "bumpkins" not only learned the steps but in the end managed to call the tune and make the ballroom their own?

Part I

The Argonauts and the Golden Fleece

1855–1900

One

"O, That We Had Cathedrals in America"

A ROUND 1867, American painters rose slowly from a silent past. Their status in the United States had hardly begun to change, and indifference had for many years been their daily bread. Their careers, like that of Thomas Worthington Whittredge, had until then developed within the narrow world that was America. Born in 1820 into a farm family, near Springfield, Ohio, Worthington Whittredge was a gifted child, clever at drawing. To avoid the wrath of his father, who considered all artists "lost souls," he chose to learn the craft of lettering and poster design. He produced for local artisans and tradesmen signs on doors and storefronts that read "Smith Carpenter" or "Thompson Grocery Store."

This very limited trade soon bored him. In Indianapolis, a photographer introduced him to the technique of daguerreotype, in which he naturally progressed to portraiture. A few months later, benefiting from the dynamism of Cincinnati and its blossoming art school, Whittredge took some classes before opening his own portrait studio in Charleston, Virginia. Thanks to quick mastery of the technique, he made a decent living. But before long he began to paint; he produced landscapes, showing three works at the Cincinnati Academy of Fine Arts and about ten others at the National Academy of Design in New York. In 1849, honored with commissions and letters of credit from Joseph Longworth and William Scarborough, two Cincinnati patrons who had secured work for him, he was drawn into a current that would carry most painters of his time and struck out for Europe.

With the help of fellow Americans already abroad, Whittredge toured the main European academies. In the autumn of 1849, he spent a few days in the Barbizon artist colony, in the Fontainebleau forest near Paris. He was remembered by local painters as being "on his way to Düsseldorf." His memoirs note that while at Barbizon in the company of Jean-François Millet, he met a group of French artists who impressed him as genuine iconoclasts. Although he

appreciated their spirit, their painting left him cold.[1] With Emanuel Leutze, he spent five years in and around the Düsseldorf Academy, made friends with the painter Karl Friedrich Lessing,[2] and worked studiously on his landscape technique. After that, he traveled to Italy, where—with his friends Buchanan, Haseltine, Gifford, and Bierstadt—he sketched innumerable landscapes around Naples before repairing to Paris, Brussels, and London.

In 1859, back in the United States after ten years in Europe, Whittredge settled with other landscape artists in New York City, at 15 West Tenth Street, a magic address in the history of American art; this handsome building of studios was to become the center of the New York art world in the coming years.[3] Suddenly feeling himself at the heart of everything, the boy from Springfield, Ohio, had trouble getting his bearings. "This was the most crucial period of my life," he wrote. "It was impossible for me to shut out from my eyes the works of the great landscape painters which I had so recently seen in Europe, while I knew well enough that if I was to succeed, I must produce something new and which might claim to be inspired by my home surroundings. I was in agony."[4]

His European experience had been a culture shock, a total upheaval, a bout of vertigo. He needed five full working years to get back on his feet. Then, supported by the fraternity of John W. Casilear, John Frederick Kensett, Sanford R. Gifford, and Jervis McEntee, he traveled as much as he could, absorbing his own country, from the Mississippi River to the deserts of New Mexico, from the Catskills to the Rocky Mountains, from the Rio Grande to the Shawangunks. Managing at last to "shut out from his eyes" the memories of his master, the painter Claude Lorrain, he was able to develop a very personal sensitivity to the American landscape. In 1864 came his first post-European success, *The Old Hunting Grounds.* The painting depicted a stand of somber birch trees, with a splash of light at its center; in front, a riverbank and an abandoned old Indian canoe. This canvas, shown at the National Academy of Design, was promptly acquired by the collector James W. Pinchot and, three years later, was exhibited at the Paris Exposition Universelle. American critics wrote that by including the Indian canoe, the painter had made an important political and historical comment. For many years, they considered this work an icon.[5]

In 1860, Worthington Whittredge was elected to the National Academy of Design. At age forty, this tall, striking man appeared strangely grave, an eccentric with a colossal forehead, a gigantic black beard, and somber, protruding eyes under immense eyebrows. In fact, his face tempted many a portraitist, such as his friend Leutze, who dressed him in an old uniform as the father of the American nation for *Washington Crossing the Delaware,* his most famous canvas. Whittredge was well-liked, generous, hard-working, studious, and con-

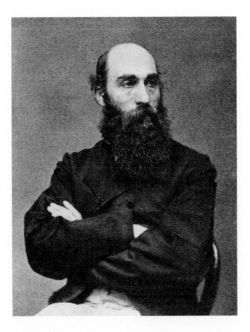

Worthington Whittredge, one of the American landscape painters, served as president of the National Academy of Design from 1875 to 1877. When he came back to the United States after ten years in Europe, Whittredge had trouble getting his bearings. "It was impossible for me," he wrote, "to shut out from my eyes the works of the great landscape painters I had seen in Europe. . . . I was in agony."

siderate toward his peers; in 1874 they elected him president of the National Academy of Design, a position he held until 1877.

Concentrating on the panoramas of his homeland, he steadfastly pursued a career as a landscapist. Carrying his gun, stool, umbrella, and paint box, he set out on often dangerous expeditions to discover new subjects. He worked particularly hard on a canvas called *Crossing the Ford,* struggling especially with one obsessive detail: a stand of cottonwood trees. Determined to get it right, he consulted guides of the region, traveled back to Colorado, and, between Denver and Loveland Pass, searched for several months for a particular group of trees he had discovered four years earlier along the banks of the Cache la Poudre River. He finally found the place and worked desperately, producing sketch after sketch, to render an accurate version of this singular group of trees. Only after two years' effort could he assure himself that he had succeeded.

At the 1876 Centennial Exposition in Philadelphia, a critic hailed *Crossing the Ford* as a "model of excellence." Two years later, another one described it as "the archetype of American landscapes." No wonder, therefore, that it was acquired by the greatest collector of Whittredge's work, Othniel C. March, a

paleontologist at Yale and director of the university's Peabody Museum. As a scientist, March passionately admired Whittredge's work both for his topographical precision and his feeling for local atmosphere. In 1901, Whittredge received a silver medal at the Pan-American Exposition in Buffalo, New York, before showing one hundred and twenty-five landscapes at the Century Association in New York City.

A dedicated and hard-working craftsman, Whittredge won national acclaim and recognition—through numerous sales and honors—long before his death in 1910. His rise from a dutiful midwestern farm boy hinged on his success in merging the techniques he had acquired in Europe with the natural realities of his native land, producing abundant and popular works in which he developed a distinctive pictorial vision. In effect, his was the classic trajectory, flat and unadorned—the archetypal career for an American painter of his time.

With rare exceptions, those who came of age during America's colonial period could not hope for a career even remotely like Whittredge's. Their efforts were regarded as "no more valuable than any other useful trade . . . like that of the carpenter, tailor or shoemaker, not as one of the most noble arts in the world."[6] Artists committed themselves above all to documenting reality, depicting a scene, a face, a place as accurately as their skills permitted. They mastered a technique, using it as a tool. "The democratic nations," Tocqueville wrote, "will cultivate those arts which are likely to render their life comfortable, rather than those whose aim will be to render it more beautiful; they give the edge to the useful over the beautiful and want the beautiful to be useful."[7]

As early as 1766, the great American portrait painter John Singleton Copley was complaining about working "among people entirely destitute of all just Ideas of the Arts."[8] "I think myself peculiarly unlucky in living in a place into which there has not been one portrait brought that is worthy to be called a Picture within my memory," he wrote to his colleague Benjamin West.[9] The nineteenth-century American critic John Neal described what he regarded as his own true moment of "artistic initiation," which occurred during a visit to the local shoemaker when he was a child living in a small town in Maine: "I saw pasted on the wall, over the shoemaker's bench, a pen-and-ink head, which delighted me beyond measure . . . this little affair, though unfinished, I looked upon as a marvel. I went up to the garret, and there, seating myself on an old leather trunk, near a little window, covered with dust and cobwebs, went to work and made copy after copy, some of which were traced . . . until I had every scratch of the pen daguerreotyped upon my memory. This, I believe, was the beginning of my experience in art."[10]

Certainly, exceptional cases existed, such as Copley himself, who had great success attracting wealthy patrons; and Benjamin West, who, thanks to the

support of his Philadelphia patron, traveled to Italy as early as 1760, before being appointed History Painter to the court of George III in England in 1772, and twenty years later, president of the British Royal Academy. As the first celebrated American expatriate artist, West welcomed generations of young American painters in London, eager to work on large historical canvases.[11]

The American Revolution spurred history painting, then the most prestigious of all genres in the world. "I could not be happy unless I am pursuing the intellectual branch of the art," wrote Samuel Morse to his parents from London in May 1814. "Portraits have none of it; landscape has some of it; but history has it wholly."[12] In 1826, he became a founder and the first president of the National Academy of Design in New York, but ten years later, when Morse completed his vast *Salon du Louvre,* he was unable to sell it. Disheartened, he abandoned his career as a painter and decided to go back to science, since he was also an "engineer of considerable talent."

American paintings of the antebellum years fell into three categories: portraits, landscapes, and history. Portrait craftsmen were usually itinerant artists who, like James Guild or William Dunlap, did portraits on demand. For years, from Portland to Boston, from Boston to Newport, then to Utica, Saratoga, New York, or Philadelphia, Dunlap set up his easel and sold his works, before becoming a founder of the National Academy of Design. Recognizing that the areas of production and consumption did not coincide, certain portrait artists of the North established themselves in Southern cities such as Baltimore, Charleston, Norfolk, or New Orleans, meeting other painters and seeking new clients. Similarly, Southern portraitists migrated north to centers such as Philadelphia, New York, or Newport to seek out the wealthy collectors.

In 1803, under Thomas Jefferson's presidency, the United States doubled its territory through the Louisiana Purchase, negotiated with France, thus extending its western frontier to the Pacific. An image of American democracy—its ethical principles, its history, its territory—began to emerge, drawing on a new conception of Nature, all-powerful and pure, the antidote to European corruption. In 1804, Jefferson dispatched Meriwether Lewis and William Clark up the Missouri River, with the objective of finding the route through the Northwest Territory that would join the Atlantic and Pacific Oceans. The project, lived as a national adventure, aroused the imagination of the American people and made them aware of the immensity, beauty, and abundance of their country. "The eyes of your countrymen are turned toward you," wrote Jefferson to the leaders of the expedition. During the voyage, Clark noted excitedly in his diary: "I don't believe that in the whole universe there could be landscapes comparable in sumptuousness with these which we are seeing at the moment."[13] In this very young democracy, with scarcely any historical tradition, a veritable

cult of the national geography took root: among the marvels of America was the land itself. A prejudice against the artifice of European landscapes, transformed by the human hand, echoed the criticism of the continent's corrupt monarchies: America's Nature became a metaphor for democracy.

The painter Thomas Cole developed a metaphysical concept of the American landscape, this "oasis that yet remains to us, and thus preserves the germs of a future and purer system." The natural majesty of the Hudson River struck him as more impressive than that of the Rhine, for "its shores are not besprinkled with venerated ruins or the palaces of the princes," and the Connecticut River, whose surroundings remained "trackless wilderness."[14] Cole went further, pointing out to his fellow painters that landscape, the only domain in which they could excel, remained the very solution to religion's dilemma, since the affinity between the painter and Nature was identical to the relationship the Puritans had posited between Man and God. Nature painters such as John James Audubon and George Catlin continued to depict bison hunting, Indian rituals, and the astonishing range of rare American flora and fauna in a precisely detailed style. All in all, landscape artists remained the lucky ones. During the Civil War, American history painting enjoyed a last, brief vogue: battle scenes allowed painters or illustrators to work while expressing support for whatever political cause they believed in, until the newly invented medium of photography brutally drove them out of business.

Not incorrectly, local artists identified their pathetic status in America—and its sharp contrast to that of their brethren in Europe—with their country's religious past. "The religion practiced by the first emigrants and the one that they are bequeathing to their descendants," wrote Tocqueville, "simple, austere, nearly primitive in its principles, is an enemy to outward signs of pomp and ceremony, and generally little favorable toward the fine arts."[15] Since the seventeenth century, when America was a territory of scattered farming communities, religious leaders wielded enormous influence over their flocks. In sermons, they would recount the stories of the first Pilgrims, these men "of small account at home. . . . If you will follow them back to their homes, you will now and then find a mansion, never a castle, but almost always a yeoman's house or a laborer's hovel," the minister Henry Ward Beecher recalled during the commemoration of the 240th anniversary of the landing at Plymouth Rock. "It is hardly possible to make barrenness more bare of all appliances for the senses than was New England," he added. "Yet there arose in the popular mind a vast and stately system of truth."[16]

The most eloquent preachers of the antebellum years had crafted a forceful vision of the American democracy built by its zealous pioneers. Freeing themselves from European tyranny, the first settlers created a world devoid of

superficiality, pleasures, and amusements—poisonous weeds to be rooted out—building upon solid democratic principles, such as equality and a well-developed educational system. When these pioneers decided to abandon Europe, they pointedly rejected the corruption and hierarchies of its opulent monarchies, the pleasures that the kings threw carelessly to the crowds. "The Venetian school, illustrious and marvellous, has left in art a few signs of liberty, and yet where might we expect some recognition of the simple dignity of human life, if not in that Republic? No: her rich men had artists, her priests had artists, her common people had none,"[17] cried the Reverend Beecher in one of his frequent sermons attacking the Venetian Republic. In mythologizing the founding of America, it further became the fashion among nineteenth-century pastors to forcefully denounce Catholic cultures, especially the Italian system fouled by the arrogance of its wealth and its lack of democratic ideals.

The Gothic cathedral became the most detested product of Latin cultures, a symbol of the Catholic Church, which for centuries as the dominant art patron in Europe had used its fabulous riches and power to commission countless works to beguile ordinary folk. Beecher declaimed, "What despot would not be glad to furnish amusements, if, for such an equivalent, the people would be content under all his oppressions? Today, he . . . would let his people dance if they would consent not to vote. He would pay for pipe and lute, if they would leave him throne and scepter. . . . The Puritan lived in an age when the priest, the aristocrat, the king, had long and long been served by Art. . . . It had brought nothing to the common people and much to their oppressors."[18] Beecher and other ministers strongly contrasted American democracy with European regimes, but, in their hostility toward corrupt monarchies and lavish papism, they sometimes slipped into a caricatural and dogmatic definition of art, equating it with nothing but sensuality and sloth.

Toward the end of the 1830s, a subversive movement transformed the spiritual climate of New England: in their sermons, certain ministers relinquished traditional dogma for literalism, referring to the texts of the Old Testament through modernized allegories or metaphysical tales. Their imaginative style, colored by poetic imagery, soon earned these ministers enormous popularity. A powerful irruption of European ideas contributed to this metamorphosis. These clergymen had read Voltaire and the philosophers of the Enlightenment and admired the Romantics. Well-traveled, cultured, familiar with the great theatrical repertoire, they had visited the museums of the Old World and journeyed widely in their own land, frequently and passionately expounding on their experiences. They formed the ideal evangelical corps of the new gospel: they became the apostles of Beauty.

The battle for the recognition of American painting broke out around 1850 and began to be won around 1860. With the evolution of great industrial centers, the country's urbanization, and the emergence of a merchant-patron class—lawyers, bankers, politicians, journalists—the clergy, to preserve their intellectual authority, felt compelled to modernize their thinking. In their sermons, lectures, and writings, they contemplated the possibility of "building Cathedrals" and applauded the reconciliation between Art and Religion.[19]

"O, that we had Cathedrals in America," Nathaniel Hawthorne had sighed before St. Paul's in London, "if only for their luxury, their sensuality."[20] His wish would soon be granted: in the following years, an alliance would develop between art and religion, between artist and preacher. Then, the unthinkable happened: priests started commissioning artworks for their churches, and even some ministers' sons became artists. Religion and Art, long inimical, began speaking the same language. Championed by the more liberal clergy—Congregationalists, Unitarians, Presbyterians—that new enlightened view of art spread rapidly. The Reverend Samuel Osgood insisted that "the Arts play a major role in the education of the People. Only he who has enjoyed the influence of Art can appreciate Nature. All forms of Art develop and refine the esthetic sense." Furthermore, as though referring to some sort of preliminary redemption, he spoke of Nature as a means of reconciling Art and Religion. "Art is the mouthpiece of Nature," he concluded. "Nature is the mouthpiece of God."[21]

Among the Transcendentalist and Unitarian Mysticals of New England, the pastor of the Second Unitarian Church of Boston, Ralph Waldo Emerson, emerged as a radical incarnation of this intellectual revolution.[22] He had abandoned his pulpit to become a minister-poet and then a philosopher. His talents as a speaker were legendary, and for more than forty years his sermons and essays exerted enormous influence. During a dinner honoring the poet William Cullen Bryant at the New York Century Association, Worthington Whittredge admiringly described Emerson as "at his best. I was singularly struck with the frequent haltings of his speech, amounting almost to a painful waiting, while he was twisting his lips and hunting for a word, but when the word came, it always seemed the only word in the dictionary that fitted the place."[23]

In his comments on American democracy, Emerson emphasized the primacy of ethical principles over traditions, of soul over mind, of the laws of nature over the laws of man. In his essay "Self-Reliance" he asked, "What have I to do with the sacredness of traditions, if I live wholly from within?"[24] And in "Nature" he wrote, "He who knows the most, he who knows what sweets and virtues are in the ground, the waters, the plants, the heavens, and how to come at these enchantments, is the rich and loyal man. . . . These bribe and invite not kings, not palaces, not men, not women, but these tender and poetic stars,

eloquent of secret promises."[25] In a masterful use of paradox, Emerson described the construction of American democracy by reversing images of rich and poor, of plain and fair: to desert the city, the village, politics, and palaces in order to rediscover Nature was to renounce Europe and its corruptions. "Nature is loved by what is best in us," he declared. "It is loved as the city of God, although, or rather because, there is no citizen."[26]

Following Emerson's example, Henry David Thoreau espoused more radically this philosophy of total destitution, of a return to nature at its most primitive. The idea provided him an "indescribable innocence and beneficence . . . ; such health, such cheer, they afford forever!"[27] As the critic of *The Illustrated Magazine of Art* wrote in 1854, "Landscape-painting, the only department in which we hope to form a school, has been cultivated with true devotion. Here we may gain a proud eminence among the nations, and here alone. The character of our civilization is too earnest and practical to foster imaginative tastes: the nearness of our past denies to the artist the deep perspective of distance. But the hills rock-ribbed, the course of noble rivers, the repose of lakes, and a climate peculiarly our own, these things, as they appear in the Catskills and Adirondacks, the Hudson, Lake George, and especially in our autumn loveliness, furnish rich materials for landscape composition."[28]

It was Hawthorne who, during his trips to France and Italy, most cogently compared these new American creations with the traditions of the Old World. Hawthorne found the Avenue of the Champs-Elysées disappointing, imagining that it "must be somewhat dry and artificial at whatever season, the trees being slender and scraggy. The soil is not genial to them." Amazed, he recalled seeing not "one blade of grass in all the Elysian fields, nothing but hard clay, now covered with white dust. It gives the whole scene the air of being a contrivance of man, in which Nature has either not been invited to take any part, or has declined to do so."[29] The Tuileries Gardens inspired in him a similar feeling of alienation, where the trees "need renewing every few years. The same is true of the human race, families becoming extinct after a generation or two of residence in Paris. Nothing really thrives here; man and vegetables have but an artificial life, like flowers stuck in a little mould, but never taking root. I am quite tired of Paris," he added.[30]

In this new American climate, where spirituality and nature mingled with art, other possibilities emerged. Thomas Cole had always been one to make his own luck, but his career suddenly took a turn that even he could not have foreseen when three of his landscapes of upstate New York appeared in the window of William Colman's bookstore in New York City. Immediately snapped up by artists such as Asher B. Durand and William Dunlap, the works soon went on display at the National Academy of Design, where two prominent New York

art patrons, Philip Hone and William Gracie, saw them and decided to commission paintings from him. This good fortune ushered in a new vogue for American landscapes which would last for several years. Soon, landscapes by Cole and others would be in demand from new patrons such as Luman Reed, Jonathan Sturges, Marshall O. Roberts, George Whitney, Samuel P. Avery, Nicholas Longworth, and Ogden Haggerty. In four decades, a tremendous number of paintings emerged, coherent in style and theme, which later formed the Hudson River School (the actual term was not coined until 1874). The careers of its members often followed very similar paths. Most came from rural families. Asher B. Durand was the son of a clockmaker and blacksmith; Bierstadt, the son of a cooper; Alexander H. Wyant, that of a cabinetmaker; and Whittredge, that of a farmer. Many had started off as craftsmen or engravers, or, as in the case of Wyant, had been leather-workers, makers of saddles and harnesses. With the help of a patron, each of them completed his education in one of the great European academies. They idolized Claude Lorrain, Millet, Rousseau, Turner, and Constable.

Inspired by the increasing demand for landscapes, American painters followed in the footsteps of Meriwether Lewis and William Clark, exploring the country's new territories. Durand undertook several long expeditions to the Adirondacks; Bierstadt explored Kansas, Nebraska, Colorado, and Wyoming; George Inness concentrated on Connecticut, Massachusetts, Virginia, California, and Florida; John Frederick Kensett navigated the Mississippi River; Whittredge crossed Colorado and New Mexico several times; Sanford R. Gifford covered Wyoming and the coastline from Alaska to California; William Trost Richards roamed through the Adirondacks, the Catskills, and the entire Hudson River Valley; Wyant chose Ohio, West Virginia, New Hampshire, Arizona, and New Mexico; John William Casilear grew attached to the Catskills, the White Mountains, and the Genesee River Valley in western New York State; and Alfred Thompson Bricher roamed New England, especially Maine, from Mount Desert Island to Casco Bay. Landscapes such as Bierstadt's *A Storm in the Rocky Mountains* fetched enormous prices, most between five and nine thousand dollars.

American art critics rejoiced in the proliferation of landscape exhibitions. Writing for *The Crayon,* one noted that "landscape seems to be, for our time, the principal outlet for artistic capacity."[31] "Landscape-painting," wrote a journalist in *The Knickerbocker,* "has acquired in our country a dignity and character from the works of its professors, which cannot be claimed for any other branch of the fine arts."[32] Durand was praised for the "individuality of his trees, true patriarchs of the woods." His paintings, "entirely American," stood for the "models" for "existing and future artists . . . to build up a distinctive

school of American art in painting, a school whose fame is to be co-extensive with that of [the American] industry. We have artists capable of this great work."[33] Whittredge hailed America as "the greatest country in the world for scenery."[34] When interviewed by a journalist, George Inness attacked "European artists whose very names are a detestation to any lover of truth. The skindeep beauties of Bouguereau and others of whom he is a type are a loathing to those who hate the idolatry which worships waxen images. . . . The highest art is where has been most perfectly breathed the sentiment of humanity. Rivers, streams, the rippling brook, the hillside, the sky, clouds, 'all things we see' can convey that sentiment if we are in the love of God and the desire of truth. Some persons suppose that landscape has no power of communicating human sentiment. But this is a great mistake."[35]

Of all the Hudson River School painters, none achieved greater fame than Frederic E. Church. His work *Niagara* had been given an exhibition all its own in 1857, an arrangement the artist himself devised. Indeed, Church stagemanaged his reputation with enormous canniness, overseeing the promotion and publicity of all his works. Two years after *Niagara*'s grand success, he received even greater acclaim for *The Heart of the Andes,* which he exhibited with meticulously orchestrated dramatic flair. The painting, in an enormous, ornate frame, was hung close to the floor in a darkened room, draped in black cloth. Church was inviting the spectator into a panoramic landscape grandiose, dazzling, and majestic, yet also wild and unspoiled. The eye could discern the tiniest detail in his monumental canvas—a ladybug poised on a water droplet hanging from a fern leaf. Viewers brought along opera glasses, and at the entrance to the gallery, for twenty-five cents, received a substantial pamphlet written by Theodore Winthrop. Church was called the "Van Eyck of the plant world," with Darwin as his model, and von Humboldt his most devoted admirer. When *The Heart of the Andes* sold for ten thousand dollars, Church became the most financially successful American artist in the world.[36]

The Civil War had isolated America from the Old World. Then, patrons of the arts focused their interest on local works and American artists managed to free themselves from English, German, and French artistic influence, as Whittredge had liberated himself from that of Claude Lorrain. Such experience inspired the bravado of the Americans who blithely attended the Exposition Universelle of 1867. As a unified group, confident about the quality of their works, they offered a genuine Emersonian representation of nature. But their brash claims, roundly rejected by French critics, would backfire at home; no wonder some collectors, such as William J. Hoppin, John T. Johnson, William Blodgett, Robert L. Stuart, William T. Walters, and William Wilstach, began to sell their American landscapes and to buy French paintings.[37]

Two

A Generation of Pioneers

"CHARLES C. INGRAM, portrait painter, Studio no. 284, Fourth Street."

"J. F. Kensett, landscape painter, Studio, Waverley House, no. 697, Broadway."

"A. B. Durand, landscape painter, Studio no. 91, Amity Street."

"George Fuller, portrait painter, Studio no. 159, Atlantic Street, Brooklyn."[1]

In the second half of the nineteenth century, artists offered their services in art magazines such as *The Crayon*. Direct contacts with buyers through magazines, or sales at auctions, provided the only access to markets in the late nineteenth century. And since the taste for landscapes that had created the first true market for local artists was languishing, most painters searched for new ways to attract commissions. Jervis McEntee, one of Worthington Whittredge's painting companions on his frequent trips to the West, complained that "people have the greatest hesitancy about coming to artists' studios for fear of interrupting them. The more I think of it the more I am convinced of the necessity of some business management for the sake of our pictures. The whole thing is changing. No one comes to the studio now."[2]

"The fact is simply this, that there are not enough good painters in this city to furnish forth even one annual exhibition."[3] While critics blamed the artists, artists in turn deplored the indifference of collectors who tended, after the 1867 Exposition Universelle, to prefer European painters: during the following ten years, imports of European art to the United States increased tenfold.[4] Thus, the second great battle being fought by Americans on their own soil was that fought by painters against their direct competitors in Europe. Paradoxically, American artists found themselves snared in the same trap as their predecessors who fled Europe to evade its monarchical corruption: in order to survive, they had to attract the favor of the rich and rely on their goodwill. Although artists did rise in status, not much had been gained in the process at this point; despite the end of the Civil War at Appomattox in 1865, the postbellum nation remained divided. Its cultural life emerged in haphazard, empirical ways,

according to the personal efforts of one or another artist, or one or another patron, in one or another city, and at the mercy of chance, luck or caprice, a situation that produced immense inequities throughout the land.

Philadelphia, known as "the American Athens" and long the nation's most cultured city, bore, in its institutions and traditions, the mark of its founder, William Penn. That English aristocrat, a friend of the French Encyclopedists, broke with his family in the cause of the radical ideals of the Quakers and, in response to their persecution, eventually crossed the ocean to found, on fresh soil, a world of tolerance and equality. In Pennsylvania, which he conceived as a multidenominational and multicultural refuge, he mixed with the Indians and promoted universal schooling for girls and boys, rich and poor. His was a religion of humility, with considerable mistrust for the Puritans of Boston— proud and sectarian, with the arrogance to put their names on the books they wrote. The Quakers established a culture of austerity, where simple silhouettes cut from black paper served as the only acceptable family portraits. Their faith was exemplified by the moral strength of martyrs such as Mary Dyer, hanged near Rhode Island simply for preaching a religion based on direct contact with God. From this specifically Quaker culture emerged the self-taught painter Benjamin West, born to a modest Quaker farming household in Chester County near Philadelphia. The backing of William Smith, the dean of a nearby college, and of John Morgan and William Allen, two Philadelphia art patrons, enabled West to work in London, where he became the founding father of American painting, teaching three successive generations of artists there on visits from his native land.

In 1794, one of West's students, Charles Willson Peale—painter, naturalist, political activist—founded, after returning from Europe, the Columbianum, a school for the fine arts in Philadelphia, after having created in 1782 the nation's first art gallery, which housed his personal collection. This bizarre combination of art gallery and natural history museum—where could be seen at random, as in a "cabinet of curiosities," the bones of a mammoth, paintings by Copley, and suits of armor—gave rise, soon after, to the country's first art school, the Pennsylvania Academy of the Fine Arts. Local artists soon formed a Society of Artists of the United States sponsoring the country's first exhibition. Organized by a Council of Academics, and run by one of the city's art patrons, the Academy admitted girls to its classes after 1860: they studied the works of John Ruskin, and drew from nature in small groups overseen by grown-ups.[5] As the country's foremost art school throughout the nineteenth century, the Academy also sponsored exhibits of European masters that attracted an average of thirteen thousand visitors per year. Among them were the *American Exhibition of British Art* of 1858 that introduced viewers to the Pre-Raphaelites and, in

years thereafter, exhibitions of French art that featured, among others (and on several occasions), one of Jean-Leon Gérôme's greatest historical paintings, *Egyptian Soldiers Crossing the Desert*. Visitors went to the Academy to admire the collection of the painter and inventor Robert Fulton, which included a series of European masterpieces as well as several handsome paintings by Benjamin West, or to find the city's guiding artistic lights, such as the portrait painters Thomas Sully and John Wesley Jarvis, who received clients in their studios and exhibition rooms.

At the start of the nineteenth century, New York's cultural life ranked far behind Philadelphia's. In 1805, a visitor eager to see paintings could choose between "Curiosities from art and nature" at the Savage Museum, a collection of engravings and pictures at the Shakespeare Gallery, and "rarities" from nature at Delacoste's Cabinet. Yankees and Knickerbockers, the city's founders, had always been more inclined to commerce than to culture. When Samuel Morse returned from Europe in 1823, he was unsure whether to set up residence in Philadelphia, New York, or Baltimore. Initially, he found New York disappointing: "This city is given wholly to commerce. . . . Every man is driving at one object, the making of money, not the spending of it." Two years later, Philip Hone commissioned Morse to undertake a portrait of Lafayette for New York's City Hall; other requests followed. By 1831, Morse, delighted by his ultimate choice of New York, called the city the "capital of our country." "Here artists should have their rallying point," he cried.[6]

Whereas in Philadelphia it was primarily local artists who initiated the creation of museums, schools, and academies, in New York it was businessmen and politicians who founded the cultural institutions, most of which started as joint-stock companies. The American Academy of Fine Arts, the New-York Historical Society, and the Century Association all rose according to that principle. Some leaders pushed for greater municipal aid to New York's cultural institutions with the simple purpose of improving the reputation of the city, which "had been too long stigmatized as phlegmatic, money-making, and plodding."[7] In 1824, the city government determined to create an Atheneum, a municipal cultural center somewhat similar to those in Philadelphia and Boston.

Samuel Morse and other artists, finding the atmosphere of the American Academy of Fine Arts stifling, started the New York Drawing Association, which became the National Academy of Design, in 1826. Its annual exhibitions would long remain New York's—even America's—most prestigious shows, but they never provided much of a forum for young artists. Little wonder that New York artists, like their predecessors in Philadelphia, tried to take matters into their own hands by creating organizations such as the American Art-

Union in 1838 (first calling itself the Apollo Gallery, then the Apollo Associa-
tion, and finally, in 1844, the American Art-Union). In fifteen years, the Art-
Union grew to a membership of 18,900, representing people from every state
in the country. It published a monthly *Bulletin* and opened a gallery on Broad-
way to display works that were then distributed among its members through an
annual lottery. "The gallery is no longer a superfluity," wrote one journalist in
1848, "it has become a necessity. It is part of the public property as much as the
fountains, the parks, or the City Hall. The retired merchant from Fifth
Avenue, the scholar from the University, the poor workman, the newsboy, the
beau and the belle, the clerk with his bundle, all frequent the Art-Union."[8]

The Art-Union was succeeded in 1858 by the Artists' Reception, a painters'
organization presenting exhibitions at the Dodworth Building on Fifth Avenue
and offering musical evenings for "a large and animated company, consisting of
the elite of the city, and many distinguished guests."[9] The hard work and ded-
ication paid off: at last, in New York, artists were gaining attention for their
work. Soon other associations followed their example: the Salmagundi Sketch
Club, the Watercolor Society, and the Decorative Arts Society. New Yorkers
had reason to be pleased, for between 1840 and 1850, thanks to the generosity
and activism of the city's art patrons, New York eclipsed Philadelphia as a cul-
tural center. The city, as Hone noted, "would become as celebrated for taste
and refinement, as it already was for Enterprise and public spirit."[10]

The situation was far different in Boston, home to intellectuals and Puri-
tans, as well as the site of Harvard, the country's oldest college. The Boston
Atheneum represented the center of cultural life, and Bostonians, unlike
Philadelphians, seemed a bookish lot. As a result, the first art exhibition there
took place only in 1827 and the Museum of Fine Arts didn't open its doors
until 1876. The Boston Artists Association, founded in 1842, was led by Wash-
ington Allston, the city's premier painter and the Transcendentalists' darling.
When the painter William Morris Hunt returned from Paris twenty years later,
he founded the Allston Club, which in one show devoted to "modern French
art from the collections of artists and patrons in the Boston area" converged
around *The Kill,* the work of a French genius, Gustave Courbet, who had been
rejected by the conformists in his own country.[11]

In 1852, Hunt bought Jean-François Millet's *Le Semeur* (*The Sower*) for
three hundred francs (then roughly $60), the first Barbizon School painting
purchased by an American.[12] Hunt advised his Harvard friends Thomas Gold
Appleton, Thomas Wentworth Higginson, and Quincy Adams Shaw, who
energetically supported the new French art.[13] They were joined in their passion
by the critics Martin Brimmer and Edward Wheelwright, then by the engineer
George Lucas, whose enthusiasm in turn infected William T. Walters, the rail-

road magnate from Baltimore. This excitement for the Barbizon School and French Realists rankled the American artistic tradition, influenced almost exclusively by English aesthetics. Heretofore, Nature was idealized and associated with lofty notions of the Sublime, the Beautiful, and the Picturesque, in accordance with British eighteenth-century ideals, in contrast with the gritty, earthy, even realistic manner favored by the French painters.

Buying works by Jean-Baptiste-Camille Corot and Millet and displaying on the walls of one's sitting room images of plows, beggars, animals, and farmers from the regions around Paris provided certain American collectors not only an aesthetic but also a political statement. Higginson was a militant activist for the rights of women and blacks, and a devoted reader of the works of Thoreau and Emerson; Hunt attacked whenever possible anyone (and there were many) opposed to the "morbid style so popular in France."[14] "It is not worthwhile to be alarmed about the influence of French art," wrote Hunt. "It would hardly be mortifying if a Millet or a Delacroix should be developed in Boston. It is not our fault if we inherit ignorance in art; but we are not obliged to advertise it."[15] Hunt also influenced American painters such as J. Foxcroft Cole and Thomas H. Robinson, who were carrying the Realist torch in America. Cole and Robinson had studied at Barbizon, and depicted oxen pulling plows or pastoral Normandy landscapes. They joined Seth M. Vose, a dealer from Providence, Rhode Island, whose gallery channeled works by Corot, Courbet, Dupré, Daubigny, Millet, and Rousseau into private collections throughout New England.

In the period following the Civil War, the United States was bursting with riches: the agrarian nation of Jefferson, with its free-trade, anti-urban ideology, rushed into the industrial age. Under the Homestead Act of 1862, the Federal government had freely distributed parcels of land west of the Mississippi River, precipitating an important transfer of capital from the East. Under President Andrew Johnson, the United States became the bastion of an aggressive capitalism reinforced by strong protectionist barriers. In the North and the Midwest, enormous industrial and financial empires rose from the exploitation of raw materials, such as steel, oil, iron, sugar, tobacco, and cotton—and new industries took off: railroads, steel, textiles, telegraph, and, later, telephone. At the same time, the conquest of the West accelerated. Cities like Pittsburgh, Detroit, Cleveland, and Columbus grew with staggering speed into enormous urban centers, offering the opportunity for uncontrolled urban development.

Taking full advantage of the geographical immensity of the North American continent, and energetically expanding their business activities, great leaders of industry—Carnegie, Vanderbilt, Frick, Rockefeller, Havemeyer, Bliss, Whitney, Stewart, Morgan, Aldrich, Gould, Crocker, and many others—

amassed fortunes greater than those of the European monarchs. This was the heyday of the great industrialists. Driven by money and unrestrained ambition, they imposed on the nation their ideas, their principles, and their new patterns of consumption unknown even to Europeans. Not everyone was invited to the party, of course. The wives of the plutocrats, still relegated to silence and submission, felt the very first stirrings of suffragism. The country's black population, in spite of the recent abolition of slavery, remained shackled by a brutal and entrenched system of segregation. Native Americans, "bothersome" obstacles to westward expansion, at times still suffered violent repression.

America's tastemakers were these barons of finance, kings of sugar, princes of steel, and monarchs of the railways. Symptoms of a world where federal support of culture was nonexistent, they exercised absolute power through private patronage, creating museums, financing art education, energizing collections, and setting aesthetic standards. Dutifully endorsed by a fawning press, their choices dictated local tastes and inspired other collections. If Cornelius Vanderbilt bought French paintings, hordes of collectors followed suit; if Henry Clay Frick bought Italian, so did everyone else. These were the men American artists needed to please, at all costs.

Other parts of the country followed a similar pattern of cultural evolution, particularly around Chicago (which was emerging as a huge industrial center), Pittsburgh, Columbus, Cleveland, Detroit, and Buffalo. Private collections were growing and museums were being founded. Devastated by the Civil War, the South was slower to develop, and the West was only starting to take shape. It was difficult to find any sense of continuity among these scattered art centers; America retained pockets of artistic darkness that proved stubbornly resistant to enlightenment. Thomas Hart Benton, the twentieth-century painter, recalled in his autobiography what it was like to grow up in the Midwest during that period: "There was, throughout the great valley of the Mississippi, from the eighteen-eighties up to the Great War, the most complete denial of aesthetic sensibility, that has probably ever been known. . . . Dad was profoundly prejudiced against artists, and with some reason. The only ones he had ever come across were the mincing, bootlicking portrait painters of Washington who hung around the skirts of women at receptions and lisped a silly jargon about grace and beauty."[16]

Benton recalls that his father, a general, then a United States senator, remained obsessed with pushing the country forward, armed with manly values rigorously closed to any form of aesthetics. He was deeply suspicious of intellectuals and artists, and regarded them as "pimps." "The attitude," wrote Benton, "could be attributed to the exigencies of pioneer needs, where the

mind was supposedly grooved to action alone. The claim is generally made that the hardships of pioneer life made the cultivation of aesthetics impossible."[17]

In 1873, the artist Jervis McEntee bemoaned the vagaries of taste afflicting his generation: "A reputation in England is valuable while here it is worth nothing. Our people having no deep-seated love of Art are fickle and take up and abandon their favorites in mere caprice. We who are living and working today are the pioneers and I hope and believe that those who come after us, who are strong and original men, will have a better time."[18] How could this generation of pioneers assert itself in a country seeming to have eyes only for Europe's, whereas people outside its artistic centers appeared hopelessly and utterly indifferent?

Indeed, art critics had always been the principal ally of painters in the effort to wrest the power of taste from the elite. John Neal, the first truly American critic, had fought hard for a more enlightened understanding of the painter's profession in America, launching an appeal on their behalf as early as 1829. "If we consider the disadvantages under which they have labored, with no models, no casts, no academy figures, and little or no opportunity for them ever to see the old masters gathered together, . . . we could say that . . . at this moment there are more distinguished American painters than are to be found in any one of what are called the modern schools of Europe."[19] Many years later, Ralph Waldo Emerson, in "The American Scholar," his celebrated address to the Harvard chapter of Phi Beta Kappa, warned his audience that "we have listened too long to the courtly muses of Europe. The spirit of the American free-man is already suspected to be timid, imitative, tame." Emerson supplied the remedy: "We will walk on our own feet; we will work with our own hands; we will speak our own minds. . . . Our day of dependence, our long apprenticeship to the learning of other lands, draws to a close. The millions that around us are rushing into life, cannot always be fed on the mere remains of foreign harvests."[20] Elsewhere, admitting that in America "the arts . . . do not flourish," Emerson noted that "beauty, truth, and goodness, are as indigenous in Massachusetts as in Tuscany, or the Isles of Greece."[21] And, in *Walden,* Henry David Thoreau observed that "the head monkey in Paris puts on a traveler's cap, and all the monkeys in America do the same."[22]

Such opinions concealed a profound insecurity. Four decades later, a different sort of appeal could be heard, one more certain of America's capacity for full participation in the art world. Gone was the rigid denial of European ascendancy over America in matters of culture, replaced by an undeniable enthusiasm for an attitude of openness and eclecticism. "Let us even compete with other nations, in inviting to our shores the best art of the world," wrote James Jackson Jarves in 1864. "Titian was not a Venetian by birth, but his name

now stands for the highest excellence of that school, as Raphael does for that of Rome, and Leonardo for the Milanese. . . . Least of all should America be behind in this sound policy, for no country stands in sorer need of artistic aid."[23]

All in all, any argument about American artists or American art remained strongly bound to the European model. Consecration in European capitals indeed endowed American painters with an aura of success in their own country, just as it had for Benjamin West, John Singleton Copley, Rembrandt Peale, John Vanderlyn, Washington Allston, Thomas Sully, Samuel F. B. Morse, and Charles R. Leslie. After the Civil War, beginning with the generation of Winslow Homer and Albert Pinkham Ryder, whose canvases elicited the interest of their European colleagues, American painters at home could begin to lift their heads. In Europe during the final years of the eighteenth century, the age of Romanticism had been launched with poets such as Hölderlin, Novalis, Shelley, and others. Their revolt against conformism and philistinism reshaped attitudes toward the artist in society. Painters, sculptors, and writers linked arms in anti-institutional solidarity, producing ever more innovative and provocative works. In France, Delacroix and Hugo, followed later in the century by Courbet, Baudelaire, Manet, and Zola, actively stirred the crowds. American artists would soon enough hear their muffled echoes from abroad.

Three

"The Magnificent Ghosts of Genius"

B EING A PAINTER in Paris was another story. Americans traveling there in the years following the Civil War discovered social institutions, structures, and an art world that were all radically different from what they had known at home. Artists in the United States dealt with a system of free enterprise governed by wealth and patronage; an enormously varied archipelago of art centers scattered across a creative wilderness; and barons of taste who spent or withheld money according to the fluctuations of their fortunes, their generosity, and their whims. In France, however, artists had to contend with the State's dominant presence, sustained by many years of tradition; a homogeneous culture with aesthetic uniformity; and enormous power concentrated among a few mandarins elected for life to the Royal Academy of Painting and Sculpture.

The social status of the artist in the two countries similarly reflected this dramatic contrast. "We were constantly haunted by the magnificent ghosts of Genius,"[1] declared one American artist in Paris. They knew they were witnessing a historic moment. Everything seemed to glitter, inspiring excitement, even transcendence; it was a time when writers celebrated painters unabashedly as "geniuses," and painters fought heroically in the political struggles of their country.

Since the Middle Ages, the relationship between artists and the State had been profoundly transformed, following political and social upheaval. During the seventeenth century, the royal academies supplanted France's medieval system of trade guilds. Under the Ancien Régime, the king surrounded himself with artists, and he and the aristocrats, as sole patrons, would look on the court painter and the court writer as employees, dependants. These royal academies gave birth to a new conception of the artist as "a man of learning who taught the great principles of beauty and taste." In pre-revolutionary France, therefore, the artist acquired a privileged position, his individual status depending

on this orbit of king and court. Landing in mid-nineteenth-century bourgeois France, young American painters found the world of visual arts profoundly dominated by tradition, centralization, and ambition. The prestigious institutions at the system's core—the Académie des Beaux-Arts, the Musée du Louvre, and the Musée du Luxembourg—though created during the French Revolution, nevertheless carried the imprint of the Ancien Régime.

A good example was the Institut de France, established during the Revolution, under the Convention on Brumaire 3 in the Year Four (October 25, 1795), to replace five royal academies. "We have borrowed from Talleyrand and from Condorcet the model for a national institute," declared Pierre Daunou, a historian and a co-organizer of the Institut. "Such an idea is grand and majestic, and the execution of it must exceed in splendor all royal academies, just as the accomplishments of the French Republic soon outshone the most brilliant epochs of French monarchy."[2] This magnificent gesture, while intended as a radical break with the past and its monarchical legacy, actually perpetuated the previous elitist system. Forty academicians, elected for life at the Institut, who presided over the destiny of the arts in France, each wielded considerable power for many years. Thus Ingres, who broke all records for longevity by remaining a member for over forty-two years, was long able to frustrate his enemy Delacroix's hopes for admission. Later, Ingres would recall his months as rector of the Ecole des Beaux-Arts with typical hauteur: "I taught them how to see and to copy nature, based on the classics and Raphael: the hall was always filled; I spoke eloquently and [after I left] I was deeply missed."[3]

The Ecole des Beaux-Arts—the French national school of fine arts, founded in 1648, as the Académie Royale de Peinture et Sculpture, and merged with the Académie Royale d'Architecture in 1793—drew its professors exclusively from the "closed shop" of Academicians. To enhance his personal prestige, Napoléon I rechristened it as the Imperial and Special School. Inspired by the practices of the late 1800s, the teachings of the Ecole des Beaux-Arts concentrated on preparing art and architecture students for the Grand Prix de Rome. The lucky winner would spend four prestigious years at the French Academy in Rome, that holy see of classicism.

The Louvre, a palace begun in 1546 by Francis I next to the river Seine—on the site of a twelfth-century fortress built by Philippe-Auguste, renovated by Charles V as a residence in the fourteenth century—was expanded in stages by every French monarch up to Napoléon III. The museum itself grew similarly, developing out of the royal art collection started by Francis I and expanded by his successors, even after the building was opened to the public in 1793. Conceived from the first as a repository for "the great riches of the nation in drawings, paintings, sculptures and other monuments of art," its aim was to

"attract foreigners and command their attention." Thus France would spread "her glory over all ages and nations. The national Museum would serve as the cornerstone of the finest erudition and be admired by the entire universe."[4] Napoléon I filled it with the spoils of his Italian campaign; and in due course, its name was also changed from the People's Museum to Musée Napoléon. "Greatness alone is Beautiful," declared the emperor succinctly. His convictions were not unfounded. "Vastness and boundless ambition can overcome many deficiencies."[5] It was the time of great colonial conquests. France, England, and Germany, heirs of the great Western cultures, inheritors of Greece and Rome, competed in amassing their fortunes and then reinforced their position in the world by using the spoils of their kings or emperors for political gain. From Pergamon, Germany's emperor William II had brought Priam's treasure and the Temple of Zeus back to Berlin; from Athens, Lord Elgin brought the Parthenon's marbles to London. For his part, Nathaniel Hawthorne, unimpressed by the "golden scepter and the magnificent sword and other gorgeous relics of Charlemagne . . . the suits-of-armor and weapons that had been worn and handled by a great many of the French kings; a religious book that belonged to St. Louis; a dressing glass . . . which formerly stood on the toilet-table of Catherine de' Medici. . . . and thousands of other treasures," found the Louvre "disappointing" and concluded harshly: "The French seem to like to keep memorials of whatever they do, or whatever their forefathers have done, even if it be ever little to their credit."[6]

The key word, in those glorious days from the seventeenth to the nineteenth century, was the word "Salon." This was a "public Exhibition of the works of living artists" held twice annually since 1667 (and annually after the Revolution), which derived its name from the Salon Carré du Louvre and took place in the Palais de l'Industrie. One went there to admire the masterpieces produced the preceding year by the "stars" of contemporary art. It was an event traditionally honored with the attendance of the state's highest authority: first the king, then the emperor (when he was not at loggerheads with the Institut), and later the president of the Republic (when he could spare the time). A two-step process of selection operated in the Salon: first, gaining admission; second, achieving the distinction of a first- or second-class medal. "Accepted" or "Refused"—these words fell like an axe that could make or break an artist's career. Paris housed the period's uncontested prime art market. "Hundreds of people were waiting next morning before the massive doors of the Louvre," American painter Frederick Champney would later report on the opening of his first Salon in 1844. "The crowd was composed mostly of artists and their friends, all anxious for the fate of their pictures. I was almost carried off my feet and up the grand staircase by the impetuosity of the rush."[7]

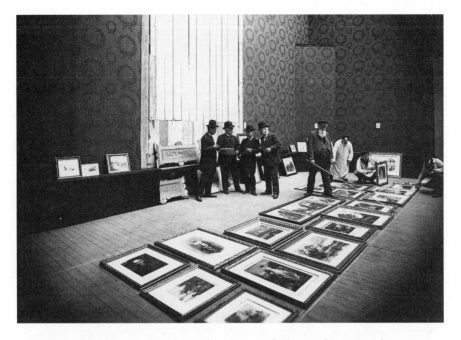

American painters came in droves to study in France. The key word in Paris at that moment was "Salon." A two-step process of selection operated in the Salon: first, gaining admission; second, receiving the distinction of a first- or second-class medal. "Accepted" or "rejected"—these words fell like an axe that could make or break an artist's career.

Young foreign artists came to understand the power of the "Salonniers"—critics, literary luminaries, sometimes well-known writers who, in commenting upon the paintings developed their aesthetic criticism as an art in itself; one spoke of "writing a Salon." In the grand tradition of early Salonniers, Denis Diderot (who covered the Salons from 1759 to 1781) produced passionate panegyrics and pamphlets full of venom and irony: texts through which contemporary tastes found their expression. A century before the invention of photography, the Salonniers gave their readers minute descriptions of the exhibited works, attempting to render visible what they had seen.[8]

Later, during the course of the nineteenth century, Charles Baudelaire became a master of the technique. Using his commentaries to excoriate his most conformist colleagues, he branded "the criticism of the newspapers, often silly, often violent, never independent, with its lies and shameless cronyism."[9] He would also take aim at official painters: "Mr. Horace Vernet is a soldier who paints. I hate this art improvised to the beating of drums, these canvases daubed at a gallop. . . . I hate him because he was born with a silver spoon in his mouth . . . the absolute antithesis of the artist."[10] Baudelaire had incensed

"the heirs of Leonardo da Vinci, Raphael, Michelangelo"[11] and rejected Jacques-Louis David as a "cold fish,"[12] but he was never more impassioned than in categoric defense of that man who would become his absolute idol, Eugène Delacroix: "Never was an artist more attacked, more maligned, more ridiculed. But what do we care about . . . the outcries of a few bourgeois salons, the venemous dissertations of a few coffeehouse-academies, the pedantry of domino-players? The question is forever answered, the result is there, visible, immense, inflamed with life."[13]

Over the course of the eighteenth and nineteenth centuries, links would be forged between writers and painters, a marriage of necessity: they admired, detested, supported, attacked, visited, stimulated, and quoted each other non-stop. After visiting the 1812 Salon, the great David himself took up his pen to celebrate the arrival of a newcomer: "One would be hard-pressed to find such bold brushwork. . . . Where does it come from? It would be difficult to start out with more fanfare. . . . I do not recognize this touch."[14] He had just discovered Théodore Géricault, through Le Chasseur de la Garde. Seven years later, Géricault caused another sensation at the Salon with Radeau de la Méduse (Raft of the Medusa). "Here is France herself, here is our whole society embarking on this raft," wrote the historian Jules Michelet, prophet of the 1848 Revolution.[15] And Baudelaire exulted, "This is pure Delacroix—a painting genius has arisen in front of our eyes!"[16]

Such was the official French system, in all its academic pomp and smug pretension to universality, that confronted the American painters. The Louvre and the Ecole des Beaux-Arts formed the active branches of this official government imposing its values on the entire art world. The Institut de France was its parliament. The Academy functioned as a monopoly, maintaining its members in a closed and stratified organization. Once inducted into its caste system, the Academy member prevailed for life: as member of the Institut, professor at the Ecole des Beaux-Arts, jury member at the Salon, medal-winner by the decision of that same jury, state-commissioned-painter—nothing was withheld from the elect.[17] This system perpetuated itself inflexibly with absolute arrogance, ignoring all events that occurred outside of its frame, especially the rise of the Impressionists, an independent group of painters with their own art, their own critics, their own market. Thus, while the academic system seemed to flourish, it was actually starting to collapse.[18]

While the government would remain the chief patron of art, a new kind of player soon arrived on the scene. Riding the wave of economic expansion during the 1850s caused by France's rapid industrialization, these entrepreneur-collectors from the new upper-middle class, wielding a great deal of power, penetrated the art world. For example, in 1855 several industrialists, including

Eugène Schneider, Emile Péreire, and Jean Dollfus, were appointed by Prince Napoléon to the Imperial Commission charged with organizing the first Exposition Universelle. Bankers such as Benjamin Delessert, Jacques Laffitte, and the Rothschilds, as well as textile manufacturers, railroad and steel magnates, or department-store owners, all actively collected seventeenth-century Dutch and eighteenth-century French masters. But this new "entrepreneur-amateur," who admired and bought representations of the material world in the style of the Dutch masters, energically contributed to the rise of nineteenth-century realism. Though traditional in their aesthetic tastes, they also favored some new artistic forms; they moved into the newly designed apartment buildings of Baron Georges Haussmann's urban-renewal project in the middle of Paris, which provided new spaces for the new art.[19] The paintings that went into these prestigious apartments of the haute bourgeoisie had to be smaller in size to fit a more intimate scale—quite different from the palaces, mansions, churches, and State buildings that until then had been the usual destination for paintings in France.

Eugène Schneider, owner of the Creusot foundries, acquired both extraordinary political power and unusual social clout, building a sort of semi-official dynasty within a decade. In 1851, he became minister of agriculture and commerce; a year later, vice-president of the legislature; soon the deputy of the region, then the mayor of Le Creusot. At the same time, he continued to pursue his industrial activities aggressively, constructing steel railways, waterworks, locomotives, railway stations, boats, marine motors, torpedo boats, and such bridges as the Pont Alexandre III. The Schneider Pavilion at the 1855 Exposition Universelle was a monument to his success. His family business became the leading commercial enterprise in France, if not the world.[20] Also among these new collectors were the brothers Péreire, bankers and railroad pioneers, who had founded the Crédit Mobilier; Jean Dollfus, who headed the Dollfus-Mieg Textile works; railroad magnate Adolphe Thibaudeau; and, later, bankers James de Rothschild and Isaac de Camondo. Some of them commissioned young painters to decorate their town houses. This new group of collectors, by creating an alternative to the traditional patronage of the State, transformed the relationship between collector and artist and gradually began to play an active role in the upcoming changes in French art and society.[21] At the 1867 Exposition Universelle, the success of genre painting at the expense of the big history paintings bore witness to this social upheaval.

Europe—especially France—had become the crucible of new artistic directions, and long maintained its status as the paragon for American painters. Through its economic domination, its numerous and excellent schools, its diverse traditions, its opulent institutions, its rich museums and monuments,

Europe reigned supreme. All through the nineteenth century, American painters retained an ambivalent attitude toward the European model, an attitude informed by admiration as well as covetousness and sometimes envy. Astounded that they didn't have to pay to get into the Ecole des Beaux-Arts, they joined the studios according to their specialties: Philadelphians, often portraitists, attended classes with Jean-Léon Gérôme; Bostonians, usually landscape artists, congregated in the studio of Thomas Couture.

Four

"Greeks of Our Time"

PARIS IS the "best school in the world," exulted one. "The best in modern art," proclaimed another. Paris has "the greatest museums," rejoiced a third. "I am falling head-over-heels in love with Paris," a fourth chimed in.[1] American painters freshly arrived in the French capital bubbled over with excitement and enthusiasm. Among Europe's institutions, the museums, schools, and studios of Paris enjoyed the greatest prestige, led of course by the Louvre and the Ecole des Beaux-Arts. "I just finished my first day. It is marvellous! I feel that I am really becoming an artist."[2] "To become an artist"—that goal represented the Holy Grail for generations of American painters, who regarded the experience of Paris as essential to this goal, the indispensable rite of passage. Paris alone could confer the stamp of legitimacy.

The wave of American painters arriving in Paris between the Civil War and World War I has few equivalents in the annals of art history, in terms of quantity, intensity, and impact. Frustrated by the cold indifference of their compatriots, bored with working from plaster molds, besieged by self-doubt as they waited for potential clients to come to their Broadway or Brooklyn studios, hordes of young artists struck out for Paris, hungry to create masterpieces and to find legitimacy, recognition, and a bohemian lifestyle. "I want no more of America," Kenyon Cox wrote to his parents, "where there is no chance to do good work and where people would prefer that you should paint badly rather than try to do as well as circumstances will permit."[3]

For Kenyon Cox, being a professional artist justified any sacrifice, any self-denial, any cost. Expatriation, rupture, upheaval—none of it mattered when glory was within reach. Moreover, this magnetic gravitation toward a unique urban pole had been a training ritual throughout the history of Western tradition. "It is by the standards of French schooling," wrote James Jackson Jarves, "that our own rapidly-developing New York school system is being judged. In a way it could be said that New York is but an outgrowth of Paris . . . that the French are the Greeks of Our Time."[4]

Since the Renaissance, the ritual of artistic pilgrimage had remained a mainstay of European painters, who took off for years on their "grand tour." Giorgio Vasari, in his *Lives of the Artists,* published in Florence in 1550, wrote that Pietro "often used to ask of those he knew had traveled the world, where were the best masters. Excited by the advice given by his teacher, and convinced by the insistence of many other friends, he arrived in Florence with the ambition of achieving excellence there." Perugino had started work as an errand boy to a painter in Perugia, where he was born, and his struggle to achieve fame and fortune through painting was fired by tales of illustrious painters told by his master, and he nursed "the ambition to become one of them, if chance were on his side."

Why Florence in 1470? Because the city's very air enlivened those "free spirits" who refused to content themselves with accomplishing mediocre work, because it called forth individuals of talent, self-reliant and quick-witted, artists eager to earn a living under the most competitive and stimulating conditions, and, finally, because Florence offered glory and honor to those who could play according to its rules. "It is very true that when a man has learned all that he needs to, and he wants to do more than live from day to day like an animal but desires to make himself rich," wrote Vasari, "then he needs to leave the city and cash in abroad on the excellence of his own work and the reputation of Florence."[5] Around 1860, for painters from all over the world, Paris began to play the role that Florence had played four centuries earlier for the painters of Europe.

From Rome to Florence, from Siena to Bologna, from Venice to Ferrara, from Naples to Padua, from Antwerp to Amsterdam, from Madrid to London, from Munich to Düsseldorf, European painters traveled from studio to studio seeking the counsel of the greatest masters. They built their careers by a series of geographic migrations, in an environment unconcerned with cultural differences or linguistic obstacles. In the seventeenth century, any self-respecting painter had to travel to Rome: "Italy! Italy! Such is the vow of any artist who begins to sense beauty in his work and becomes possessed by the dynamism of his talent," wrote Pierre-Henri de Valenciennes in his *Traité de Paysage,* the "bible of all the young painters of the Corot period."[6] This great period of classicism hailed a return to antiquity in line with Winckelmann's teachings.[7] During the eighteenth century, Paris became the world's salon and the European academy of the intellect, fostering "the fever that had gripped the finest brains in Europe and pulled them in like a magnet." And for this cosmopolitan passion that survived for several decades, much is owed to the Romantics.[8]

During the first third of the nineteenth century, the Düsseldorf Academy held the reputation of being the best art school in Europe. The Boston painter

William Morris Hunt went there for artistic training, but detested the German schooling; his teacher there, Wilhelm von Kaulbach, followed what Hunt described as a "grinding" method: "Nothing here to stimulate or develop the perceptions; and everything to suppress instincts and enthusiasm. One learned neither to see nor to feel, everything was a task, a parrot's training."[9] Disheartened by his German years, Hunt decided to try Paris, enrolling in Thomas Couture's studio. At the 1852 Salon, Hunt had admired the work of Jean-François Millet and even acquired one of his canvases, *Le Semeur* (*The Sower*). Then he visited Barbizon, the artist colony near the Fontainebleau forest—a landscape that James Fenimore Cooper had admired for its "extraordinary rocks," the giant oaks and elegant birches, describing them as "exceeding in savage variety anything he had seen in America."[10] The son of a wealthy Vermont congressman, Hunt remained in Barbizon two full years, becoming a very close friend and disciple of Jean-François Millet. Rousseau, followed by Millet, Corot, Narcisse Diaz de la Peña, Jules Dupré, and Charles-François Daubigny, had taken up residence there, initiating a system of direct, open-air painting that represented a radical break from traditional studio work. Their canvases at the 1867 Exposition Universelle—filled with scenes of rural life, farmers ploughing their fields, laborers, women tending children, beggars, and old folks—signaled the emergence of genre painting and the eclipse of history painting. Their message, taken up in various ways by such European writers as Zola, Hugo, and Dostoyevsky, also reflected some of the American tradition, as expressed by thinkers like Cooper, Thoreau, and Emerson.

What made William Morris Hunt, a Harvard graduate, decide to set up his easel in the woods, dressed as a local peasant? What precisely was the attraction of this locale for dozens of young Americans? Was it an attraction for the raw beauty of the Fontainebleau forest? A nostalgia for the picturesque folklore of rural traditions, for a rustic style unknown to Americans? Or was it condescension among painters in the colony, working under a venerated master? At Barbizon, Hunt was joined by Will Low, then by Wyatt Eaton, J. Alden Weir, the Lowell brothers, Birge and Alexander Harrison, Robert Vonnoh, and much later by Edward Wilbur, Dean Hamilton, and Edward Potthast. Several hotels sprang up near the hostelry of Père Ganne to accommodate painters and art lovers. After Millet, another French master, Jules Bastien-Lepage, settled there, attracting even more foreign artists. This painter from Verdun had spent his life painstakingly illustrating the daily chores of the poor. From this time onward, Hunt became increasingly active as a solid mediator between the Barbizon artists and American collectors.[11]

Count de Nieuwerkerke, superintendent of fine arts from 1863 to 1870 under Napoléon III as well the director of France's museums, and therefore the

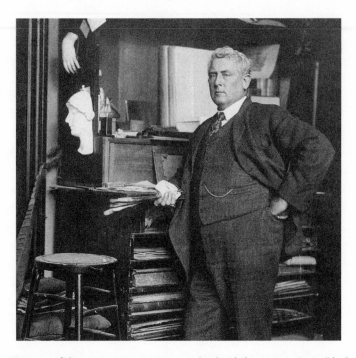

J. Alden Weir, one of the many young Americans who decided to train in Paris, "the best place in the world for a young man to study art. We are going to fertilize the soil of the United States," Weir wrote to his brother on his return to the United States, where he in turn became a member of The Ten in New York.

highest French authority in cultural matters, rejected Realism and the aesthetic ideas promulgated by the Barbizon painters. "It is the painting of democrats," he said. "People who do not change their underwear and look down upon the world around them. Their art displeases and disgusts me."[12] In 1868, only after many years of solitude and a cold shoulder from the cultural authorities in their own country, and virtually on their deathbeds, would Théodore Rousseau and Jean-François Millet receive the Légion d'Honneur. And thanks to William Morris Hunt, certain American collectors with "democratic" ideas had developed a fierce enthusiasm for the Barbizon painters. *L'Angelus* by Millet, priced at five hundred dollars in the early 1860s, sold ten years later for twenty thousand. Even his pastels would fetch close to five thousand dollars apiece.[13] These French painters, rejected by the conformist taste that governed State patronage in their own country, could not have survived as artists had they not come to the attention of men such as Cornelius Vanderbilt, John Astor, and William Aspinwall and gained their support.

For some Americans, reports from Paris or Barbizon inspired distrust and suspicion, perhaps because of suggestions that sacred Victorian values were

being corrupted there. Certainly, France had aided the United States in its War of Independence; but Europe was Europe, and the ways of some French painters, including those of the Barbizon School, and of novelists such as Emile Zola, implied just the sort of decadence they loathed. "No Victorian mother wanted her daughter alone with a man who could visualize scenes even faintly resembling Titian's, let alone Manet's," Mary Cassatt would later write.[14] But what worried mothers was what made Paris, over several decades, an artist's paradise for American painters, beginning with the Romantics and continuing with the Impressionists and the Symbolists.

In the case of the Weirs, the pilgrimage to Paris was a family affair. J. Alden Weir's father, Robert Weir, himself a painter and professor of fine arts at West Point, taught Whistler there; Julian's half-brother, John Ferguson Weir, was the first director of the first professional art school in an American university, the Yale School of the Fine Arts. Julian (now known as J. Alden Weir) was the last of sixteen children, almost all artists. His own adventures in Paris, from 1873 to 1877, were almost a collective experience for the Weirs. Financed by a rich family friend, Mrs. Bradford R. Alden, the young student regularly sent her his expense statements. Meanwhile, the senior Weir, counseling his youngest son on the use of the paintbrush, compared Titian's palette with that of Veronese, and Van der Helst's with that of Frans Hals, and consistently offered fatherly, common-sense wisdom such as "Always carry paper and pencil in case you find yourself with nothing to do."

It was drummed into Alden that he was living "the most glorious period of his life." "You have my very best wishes with respect to your attachment, old boy. But be a painter first—that will carry off all the rest in triumph," his brother John wrote.[15] The entire Weir clan—whether in New Haven, West Point, or New York—felt Alden was their emissary to the Old World, the chosen one whose fame would outstrip that of the other family members. They participated from afar in his adventure, which seemed to mirror their hopes and dreams. After arriving in Paris, he assured them he was studying with "the greatest masters of his time," working his way through the world's best museums, visiting the "great men of the future," and most important, adopting his father's expression, "observing the sabbath and resisting the temptations of Paris society."[16]

From Montmartre to Montparnasse, from bar to café, from museum to studio, painters in Paris in those days lived round-the-clock, finding the city and society open to them. Far from the bourgeois constraints at home, they leaped into the role of transgressors, sometimes consorting freely with the high and low. "We spent an evening at Constant's on the rue de la Gaîté, in the company of thieves and pimps," one of them wrote, "and the evening before with a

duchess or a princess on the Champs-Elysées."[17] The Hotel de la Haute Loire at 203, Boulevard Raspail, the first choice of all the Americans—modest, well situated, hub of all their encounters—served as a central meeting spot. Communities gathered around Montparnasse, on the rue Campagne-Première, rue Notre-Dame-des-Champs, rue Boissonnade, rue Delambre, and rue Vavin, depending on the housing available in those locations. Other favored neighborhoods were Saint-Germain-des-Prés, Clichy, and the Ternes district. For thirty to forty francs (six or seven dollars) a day, they could share a hotel room or rent a maid's room. Things could occasionally get difficult, as Harry Siddons Mowbray recalled. "The studio next door was even smaller than mine and rented by three newly arrived Americans, Lorado Taft, George Brewster, both sculptors, and the painter Robert Vonnoh. It is clear they are living with very reduced means and look at me as an 'artist arrivé.' Pride keeps me from revealing that I am as broke as they are and that even the cheap little restaurants are beyond my means."[18]

If Americans were not living high, they were at least partaking of the phenomenal cultural wealth: masterpieces in countless museums, architectural monuments everywhere. In the Galerie du Luxembourg, recounted the American orator and preacher Henry Ward Beecher, "I found myself absolutely intoxicated, trembling and laughing and weeping . . . almost hysterical." "I have lived for two days in fairyland," he wrote.[19] Later, standing in front of Kenilworth Castle in England, Beecher had been overcome with emotion; never had he seen a building as old. "Surely, if we could bring home but one thing from Europe," wrote painter George S. Hillard, "that one thing should be a cathedral."[20]

Cultural education was a matter of daily immersion. Discovering that the museums and palaces were free and open to the public on Sundays, Walter Channing noted that people from all social classes and walks of life could surround themselves with beautiful things. "During the Revolution, the French may have killed their king, but they spared the Louvre."[21] Kenyon Cox had barely arrived in France when he wrote his parents from Rouen: "There is so much artistic material here that one might almost be content to stay here and paint for years. One can't drive down a crooked street or turn a sharp corner without finding more to paint than he could by hunting months of subject in America. . . . If Paris is at all like this it must indeed be a paradise for artists."[22]

A paradise it seemed, theirs for the taking. "A few days ago I got some more fine photographs—three large ones of Michel Angelo [sic], two of which I have hung over my table. My wall is covered with red paper and hung with sketches and here and there pieces of drapery. . . . I am very much pleased with it, and when I get my stove going and my carpet down I will be ready for work. From

my window I can see the Tower of St. Jacques, the beautiful spire of Sainte-Chapelle, and the two large towers of Notre Dame. I am only one block from the river and in a street that is remarkably quiet, Rue du Pont de Lodi."[23] With Notre Dame and Sainte-Chapelle framed in the window of his freezing room, J. Alden Weir had symbolically appropriated his mythic surroundings. This was his first step toward "becoming an artist."

Five

An American Colony: Pont-Aven

AT THE VERY MOMENT when American painters headed back to
Europe after the Civil War, artist colonies began springing up in France,
particularly in Normandy, Brittany, and in Paris's rural outskirts. Their popu-
larity would crest over the next several years. "Life here is cheap and we can
find a better place to paint because models are readily available and willing to
pose for a few pennies," wrote Frederick Bridgman in 1870, emphasizing the
economic argument for his family back home in Alabama.[1] Over and above the
financial advantage, Brittany also offered models for genre painting, which was
all the rage at the Salon.

"The Salon is over," wrote Howard Russell Butler to his sister. "The
medals have been given. . . . Paris has no longer any attraction for the artist—
in a week's time they will nearly all be gone."[2] Like other Americans, Butler had
begun to abide by the rhythms of Old World artistic life. When the academies
closed for three months at the beginning of July, students from the Ecole des
Beaux-Arts and other schools deserted Paris for the artist colonies. In pursuit
of instruction from an accredited master, many American painters were drawn
to these colonies. They left their deepest mark in the Breton town of Pont-
Aven.

"This small port . . . is perched on the rocks, at the foot of two imposing
cliffs scattered with enormous rounded boulders of granite; they seem about to
come crashing down on you at any moment," wrote local historian Jacques
Cambry describing Pont-Aven's charms, several years before the first American
painters discovered it. "They enclose the cottages and make up the garden
walls. The river roils over the rocks that have tumbled off the mountain. Mills
built along the banks, connected by wood bridges, use the boulders to keep
their wheel axle in place. Covered with trees of exceptional variety, the sur-
rounding hills are an extraordinary sight. The noise of the water, the cascading
sound of twenty waterfalls, deafens the visitor like the windmills in Don
Quixote."[3]

Pont-Aven is squeezed between granite and water. The pure waters of the

Aven River gush down from the mountains, cascading into the sea; the ocean's salt water slowly rises and gently ebbs in the estuary, turning the Aven between tides into a navigable river known as a *mascaret*.[4] Granite boulders are piled everywhere: sitting in the middle of the current, they resemble enormous cracked eggs, as in the so-called "Chaos of the Aven"; others have been worn over time into long, smooth surfaces, like the "Rocher du Diable" ("Devil's Rock") or the "Roche Gargantua" ("Gargantuan Rock").

Trapped upstream in the Aven estuary, between earth and water, the town had made a virtue of necessity; it consisted of "fourteen mills, fifteen houses," as the French proverb went, and these thrived in rare harmony. Rows of mills, mainly for paper and flour, sat perched one above the other between the water and the rocks: moulin de Kermentec, moulin de Kerniguès, moulin de Penan-ros, moulin de Poulhouas, moulin Barnabé, moulin de la Porte Neuve, moulin du Grand-Poulguen, moulin du Petit Poulguen, moulin du Ty-Meur, moulin Neuf, moulin Du Plessis, moulin David—these formed the magic story of Pont-Aven.

An absolute antithesis of the virgin American landscape undifferentiated by history, this region had a past that could be read in its monuments: from the Neolithic period (the New Stone Age), dolmens of Kerguillotou-Bihan, Ker-marc, Coat-Luzuen, Kergoadic-Bihan or the menhir of Kerangosquer; from the late Middle Ages, the enigmatic, crude Nizon calvary—a thin piece of granite erected to ward off the plague—where, around the statues of the Christ and the Virgin, fifteen figures had been sculpted from one single block of raw stone; the bare wooden Christ in the Trémalo chapel, or the simple granite country churches such as Saint André or Saint Sylvestre, low and irregular, with wildly disproportionate bell towers.

Thanks to the industriousness of its merchants, sailors, and millers, Pont-Aven had rid itself early on of the rural clergy's influence and achieved a mea-sure of religious autonomy from the local church. Nearly half a century before the French Revolution, liberated from the economic and political domination of the neighboring cities of Nizon and Riec, the town developed rather along the lines of an independent state, open and tolerant. After the Revolution, it turned into a small republican territory with its active port, markets, sweet shops, fairs, and inns; Breton was spoken, of course, but—in another sign of openness—so was French. The houses of royal officers and local millers along the Place Royale gave the town an air both prosperous and picturesque. Through its streets and squares—the tiny street of La Petite-Tourte, the rue Neuve-de-Quimperlé, the Chemin du Bas-Bourgneuf, the Place du Beurre—passed spinners, lace-makers, lavender dealers, vegetable farmers, as well as local women in their dark skirts, white-lace collars, high white-lace headdresses

and wooden shoes. A plain granite bridge spanned the Aven, leading visitors to the town's main square and its three famous inns—the Gloanec, the Lion d'Or, and the Hôtel des Voyageurs—and, farther down, the Café des Arts. However, in 1860, with the expansion of the French railway system into Brittany, Pont-Aven started to benefit from a connection to the outside world.[5]

This was the village that twenty-five-year-old Robert Wylie discovered upon arriving in July 1864. Born on the Isle of Man in the Irish Sea, but orphaned at a young age, Wylie was raised in Philadelphia by his uncle, a respected Presbyterian minister. He had begun as a craftsman, sculpting ivory, then started taking night classes at the Pennsylvania Academy. His charisma and political acumen made him a natural leader; at nineteen, his colleagues elected him to head the committee that ran the live-model class at the academy; a few years later, to improve the teaching of drawing, he initiated a system of peer criticism among the students and founded the Philadelphia Sketch Club. The secrets of Wylie's success, it was said, were his modesty and discipline. "A quiet gentlemanly man and a strict Presbyterian, a man of excellent principles and a strict observer of Sunday" is how J. Alden Weir described him in a letter home.[6] Wylie also won over the people of Pont-Aven. As his friend Benjamin Champney put it, "He understood their ways, and was unfailingly polite with them. . . . Thus . . . he earned their confidence more than did any other outsider."

Wylie's fortuitous discovery of Pont-Aven followed three frustrating experiences in Paris. Having originally applied to the Ecole des Beaux-Arts, he was "encouraged" to try the Académie Suisse but found it second-rate. By the time he was able to try a second time to enroll at the Beaux-Arts, he was over twenty-five, the age limit for registration. Later, when, thanks to a change in the rules regarding age, he tried a third time, he discovered that the school did not admit foreign students (it would remain closed to foreigners for five more academic years). His friend Charles Way, a young man from Boston, introduced him to Henry Bacon, who, sensing that Wylie was near the end of his rope, suggested a jaunt to Pont-Aven. There, Bacon promised, they could enjoy "a joyful, productive, Bohemian life amongst the primitive peasants and fishermen."[7] On their first trip, in 1864, they were accompanied by two artists from Philadelphia, Earl Shinn and Howard Roberts; two Boston painters, Benjamin Champney and Moses Wight; and a young bank-note engraver from Tuskegee, Alabama, named Frederick Bridgman. They settled there, and gamely dubbed themselves "The Seven Original Sinners"; except for brief trips to Paris, Wylie remained there until his death. Others joined the group, and by 1866 they numbered a dozen in all. An "artist dormitory" was born, a colony created by and almost exclusively for Americans. That same year, Thomas Eakins, a strong

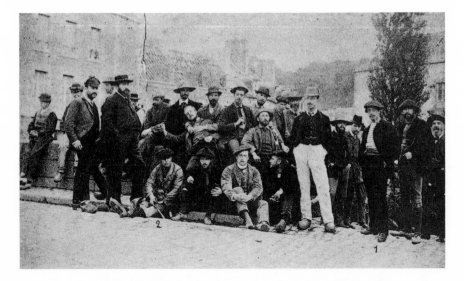

In the artists' colonies at Barbizon, Giverny, or, as shown here at Pont-Aven, the American painters found ideal working conditions amidst the local people. "Living is cheap," one of them wrote, "and models are available and pose for a few pennies."

advocate of the Realist tradition, came to Paris from Philadelphia at the age of twenty-two to study with Jean-Léon Gérôme at the Ecole des Beaux-Arts. He eventually became the "guardian angel" of Frederick Bridgman, Roberts, and Shinn when he forced open the doors of the Beaux-Arts by convincing Count de Nieuwerkerke to admit them as students.

Word of Pont-Aven spread quickly, and American painters soon began to arrive in waves. They came from everywhere: not only the larger Eastern cities such as Philadelphia, Boston, New York, and Baltimore, but from smaller towns as well—Warrenton, Virginia; Gloucester, Massachusetts; Providence, Rhode Island; Portland, Maine—and even from heartland states such as Ohio, Utah, Kansas, and Wyoming. They all took the train from Paris to Quimper, where they climbed aboard a four-horse postal carriage that rattled its way through Quimperlé, Baye, and Riec. After frequent windings uphill and down, the carriage traced the Toullifo coastline, descended into the town and across the Pont-Aven bridge. The whole trip took twenty-four hours.

With the second wave of American artists, in the 1870s, came William Lamb Picknell, J. Alden Weir, William H. Lippincott, Thomas Hovenden, H. Bolton Jones, and Henry Mosler. But it was the third wave, in the 1880s and '90s, that would usher in a new era. Pont-Aven drew new arrivals from Boston and Philadelphia, including Charles Fromuth, Henry Ossawa Tanner, Robert Henri, and Edward Redfield, who had studied at the Pennsylvania Academy of

the Fine Arts in the 1880s with Eakins or Thomas Anshutz. Some came from
farther off: Wilder Darling from Ohio, Burr H. Nicholls from Buffalo, John
Noble (known as "Whiskey Bill") from Wichita. Women arrived as well,
among them Helen Corson and Cecilia Beaux, hoping to share in the great
adventure. In ten years, the colony boasted fifty painters; in twenty years, a
hundred. The last Americans remained in Pont-Aven until the beginning of
World War II.

The place saw the coming and passing of generations. Frederick Ramsey,
for example, the son of Milne and Ethel Ramsey, was born in 1875 at the Hôtel
des Voyageurs, attended by a veterinarian. Several pairs of brothers came to
Pont-Aven: Frank and Bolton Jones; Frederick and Charles Bridgman; Alex-
ander, Birge, and Butler Harrison. Courtships played out: Helen Corson
attracted Edwin Blashfield to the town before marrying Thomas Hovenden in
1881. Others spent their final days there—notably, the colony's founding father,
Robert Wylie, who died tragically one night in 1877 and was buried in the fam-
ily crypt of Julia Guillou, the colony's godmother. Charles Fromuth and Fran-
cis C. Penfold died up the coast at Concarneau in 1937 and 1941, respectively.

Two distinct types of artist found a home at Pont-Aven. The Bostonians
were landscape painters trained by Hudson River School artists such as George
Inness or at the Academy of Düsseldorf; those who went to Düsseldorf
included Picknell, Samuel Swift, Robert Henry Logan, Walter Griffin, and
Childe Hassam. Then there were the Philadelphians, portrait and genre
painters trained in realism by Thomas Eakins and Thomas Anshutz between
the mid-1870s and the mid-1880s; among these were Wylie, Alexander Harri-
son, Fromuth, Clifford Prevost Grayson, Lippincott, Henri, Redfield, and Tan-
ner. Within a few years, in the Salons and French museums, the public
discovered many of the austere and realistic prize-winning paintings from these
years of intense activity.

What special magnetism can account for this strange love affair between a
group of American painters and a small village in Brittany? Americans, like
other foreigners, were being treated as probable spies in Paris during the
Franco-Prussian War of 1870–71. Pont-Aven offered them an agreeable and
cheap refuge. The town had indeed managed to keep running during the war
years, as well as during the Paris Commune. And aside from the strict Presby-
terians who would not work on Sundays (such as Wylie, Butler, and Arthur
Wesley Dow), or Mormons such as Harwood, they seemed to thrive under the
local rhythm: work from 7 a.m. to noon and from 2 to 6 p.m.; merry meals
eaten at long communal tables set with enormous slabs of Breton butter and
pitchers of cider, to accompany the crêpes and flaming omelets that the young
painters greeted with cheers. But none of this cross-cultural camaraderie would

have come about had it not been for several exceptional members of both communities—American and Breton—who reached accross the divide.

Julien-François Tanguy—they called him "Le Père Tanguy—was Pont-Aven's notary public and had given the first Americans the keys to the Manoir de Lezaven, which they transformed into several spacious studios. Young Francine found them models. During the day, the artists painted; in the evening, they repaired to the Café des Arts, where they showed off their works and commented on each other's progress. Julia Guillou stood out among the locals as most responsible for the colony's success. She took over the Hôtel des Voyageurs, which had gone downhill dramatically after the suicide of its previous owner, Madame Feutray. Guillou, the daughter of a crêpe vendor, had a genius for organization, publicity, business, and artistic patronage, and became known as *la mère des artistes*. When Picknell started working on *The Road from Concarneau,* she supported him and provided for the materials; the painting won a medal in the 1892 Salon.

In Pont-Aven, painting became religion. Whether walking the beach at Doëlan, contemplating the Kermeur-Bihan dolmen, or observing local rituals like the "Procession for Forgiveness" (which sometimes lasted four days), the Americans found themselves immersed in a mix of Catholicism and ancient Celtic legends—a culture at once authentic, primitive, and savage that provided access to a past they could now begin to appropriate for themselves. In Brittany, the culture of the Druids had survived Christianity, and the Americans were fascinated by everything they saw, from the bagpipes and "bombardes" to the dancing of the Pont-Aven gavotte.

"I painted in secret, just like the first Christians prayed," the French artist Charles Filiger would later say.[8] Passion, austerity, purity, and even mysticism—all colored a routine pushed to the absolute limit. In this small, timeless town, the Americans came to know the romantic saga of an oppressed people who fought to preserve their identity and their customs. They could well identify with the irrepressible Celtic spirit of freedom, and for many it was as though they had managed to locate their own ancient roots. Pont-Aven became a journey into the past, into a forgotten world of primitive beliefs, even the most absurd and incomprehensible of which seemed natural. As absorbing as the culture was, the enterprise appeared far from merely romantic. A veritable American network grew up, efficiently channeling the talents and complementary interests of those involved. Robert Wylie and William Lamb Picknell, as part of the first generation, naturally became its elder statesmen. "Wylie invited me to his studio and showed me his works," Weir recalled. "He [also] told me about John's [John Smith Lewis] picture from the Universal Exposition. The French liked it very much. He hoped that John would send another

one."[9] As a group leader, Wylie felt responsible for them all. Similarly motivated, the artist Alexander Harrison trained Picknell, Dow, and Cecilia Beaux; in 1889, he opened a studio to help his compatriots prepare for the Exposition Universelle. Henry Mosler had become a professor at Quimperlé and organized drawing classes throughout Brittany. Later, in 1902, Frank Penfold would become a professor at the Académie Julia (named for Julia Guillou). Among the French teachers, Jules Bastien-Lepage at Concarneau had an influence so profound that his death in 1884 stirred even greater emotion than Wylie's had in 1877.

Arthur Wesley Dow helped his compatriots by supplying them with suitcases, tickets, passports, housing—and complained that he had "all the work of conducting a tourist agency without any of the profits."[10] Others started spreading the word to America about French painting. Earl Shinn wrote for the *Philadelphia Evening Bulletin,* signing his columns "Enfant Perdu" ("Lost child") or "Rash Steps"; Mrs. Hillard reported in the *Boston Transcript;* Penfold praised Pont-Aven to his students in Philadelphia. The colony's most fervent supporters in the United States included Cecilia Beaux, portrait painter and first female professor at the Pennsylvania Academy of the Fine Arts; Childe Hassam, one of the founders of the Cos Cob colony; Alexander Harrison, one of the first Woodstock, New York, artists; and William Lippincott, who started the Ogunquit colony in Maine.

"I'm leaving Paris on Friday evening and going to paint in a real backwater," Paul Gauguin wrote to Félix Bracquemond in June 1886. "I like Brittany. When my wooden shoes clump along the granite surface, I can hear the muted, flat, powerful tones I'm trying to achieve in my painting."[11] How did that social landscape strike him? "Barely one Frenchman," Gauguin wrote his wife. "Every one a foreigner, a Dane, two Danish women . . . and an abundance of Americans. My work has sparked plenty of discussion and I must admit that it was favorably received by the Americans." At the end of July 1886, he offered a glimpse of deeper connections: "I work hard here and I work well. I'm treated like the best painter of Pont-Aven, not that it earns me one penny more than anyone else. But it has given me respectability, and everyone here (Americans, English, Swedes, French) fights for the advice I've been stupid enough to offer, because in the end we're all taken advantage of without receiving the recognition due to us. . . . Perhaps someday my art will dazzle the world, and some appreciative soul will haul me up out of the gutter."[12]

Little more is known about relations between Gauguin and the American painters in Pont-Aven. They worked side by side but practically never met. At the very same time, however, in the late 1880s, an extraordinary group of painters—Paul Sérusier, Maurice Denis, Edouard Vuillard, Emile Bernard, and

Charles Filiger, among others—came together under Gauguin's spell. The Nabis, as they called themselves, with their vibrant color and simplification of form, expressed what Denis called a "passionate equivalent of a powerful sensation"[13] in such masterpieces as *Le Talisman* and *Taches de soleil sur la terrasse*.

Only much later would the Americans be confronted forcefully with the esthetic experiments taking place in France. In 1891, while passing through Pont-Aven, Paul Signac provided an unenthusiastic description of the village: "It is an absurd place, with its little nooks and waterfalls, made for English watercolorists. Strange little hotbed of pictoral symbolism. . . . Around it, drunk and boisterous, wheel painters wearing corduroy. The tobacco dealer's sign is an artist's palette reading 'Artists's Materials.' The maids at the inn wear arty ribbons on their headdresses and must be poxy."[14] American artists had gone far in Pont-Aven, but little did they know that it was not the center of everything they had sought to conquer. They still had some way to go before becoming "legitimate" artists. Upon their return from the colonies, they finally plunged into the heart of the Parisian art world—right at the moment when that world was being profoundly transformed and breaking up into factions.

Brouhaha, Hue and Cry, and Fisticuffs

"AMAZING AND IDYLLIC": the American painters who returned to Paris from the artist colonies scarcely had words enough to praise the French schools and museums under the Second Empire. Yet it was during those years that the French art world underwent one of its gravest crises: political power, represented by the emperor, collided violently with the Académie des Beaux-Arts. And in 1861, students of the Ecole des Beaux-Arts gathered to protest the school's traditional methods. They rented space on rue Notre-Dame-des-Champs and invited Courbet to teach there.[1] "I cannot teach my art," responded the master from Ornans. "I reject the teaching of art. . . . No period can be pictured except by its own artists. . . . I reject History painting as it looks to the past . . . Beauty is in Nature . . . you'll find it all around you all the time . . . I don't believe in schools, only in painters. . . . I could only collaborate with artists who would be my peers, not my students . . . who would remain in complete control of their individuality and self-expression."[2] Courbet's attack on official art education amounted to a call to insurrection. Rejecting academic study and training by imitation, he celebrated nature and the real world, respecting above all the individuality and autonomy of every artist, in a new and progressive concept of the teacher-student relationship.

It was no accident that the students flocked to him for everything: his work reflected the shake-ups in the art of his day. In 1855, weary of rejection and ostracism at the hands of the official juries, he opened his own exhibition space, the Pavilion of Realism, on the periphery of the grounds of the Exposition Universelle, and showed forty of his own paintings, weakening the official jury's legitimacy and its stranglehold on art. Courbet, a free spirit, rebel, and outsider, with the support of a private patron, Alfred Bruyas, had begun to destabilize the sacred structure of official art.

Earlier that same year, Courbet had finished *The Painter's Studio: A Real Allegory Summing Up Seven Years of My Life as an Artist,* an immense canvas at

the center of which he depicted himself surrounded by allegorical figures from French society. The work, which he described as a "realistic allegory showing a seven-year period of [his] artistic life," represented a whimsical and ambitious declaration of faith in his art. "There are thirty-three people in it, all large as life," he wrote. "I had sworn I would do it and it's done. . . . I've put myself in the center, painting. On the right is the art world . . . On the left, the rest of the world. . . . These are the people who come to be painted in my studio."[3] Innumerable experts have tried to decipher the puzzle of this painting and to interpret Courbet's place in the world of art.[4] Had he found a way out of the academic monopoly into an artistic independence open to the newly emerging public? Perhaps in this "allegory of the incomplete"[5] he was pointing toward the limits of imposing coherent meaning on art. At the very least, he subverted certain aesthetic rules, undermining many of the established givens of his time.

During the winter of 1861–62, Courbet organized a studio at 82, rue Notre-Dame-des-Champs, which, although it lasted only a few months, felt like a breath of fresh air.[6] "For some time . . . all of modern painting converged in my studio," he wrote his father. "In the end, I won."[7] This experience confirmed the need for a change and launched a new era. Other private and independent ateliers soon followed the example of Courbet's. The most faithful to his model was run by Horace Lecoq de Boisbaudran on the quai des Grands-Augustins. Lecoq de Boisbaudran respected the "innate talent" of each individual and forbade his students to draw inspiration from his own works or anyone else's. He hoped to develop what he called the "education of the picturesque memory."[8]

Several months earlier, Napoléon III, angered by the scornful manner of the Beaux-Arts academicians, attempted to limit their prerogatives. Painters had long criticized the emperor for his indifference; and Napoléon III never passed up an opportunity to give tit for tat. But in April 1863, when the artists rejected by the Salon jury turned to him seeking justice, he followed the advice of his entourage and acted swiftly. Had the jury really proved any more rigid than in years past? Had the proportion of works refused—three-fifths of those presented—actually risen? Whatever the case, the emperor licensed an alternative salon, without medals and without jury: the "Salon des Refusés."[9] And deciding to support a parallel exhibition, by publicly disavowing the judgment of the "wise men" who ruled over French art, the emperor signaled quite plainly that their days were numbered.

In a decree dated November 13, 1863, Napoléon III formally undertook the reform of the Ecole des Beaux-Arts. While official instruction had been firmly controlled by the academicians, the Académie and the Ecole des Beaux-Arts had been turned into reflections of each other, like veritable Siamese twins.

That connection was severed by the emperor's decree, written by Eugène Viollet-le-Duc—an architect known more for his theories than his iconoclasm—and Prosper Mérimée, the author of *Carmen,* on which Bizet's now-famous opera was based. Philippe de Chennevières, the assistant curator of the Imperial Museums, captured the atmosphere in Paris at the time: "At this point anyone—doctors, lawyers, journalists, and amateurs—who thought he had something to say on artistic matters launched into the quarrel with unbelievable passion and vehemence." "Never, I repeat never," he added, "had the art world seen such a shake-up, such brouhaha, hue and cry, and fisticuffs."[10]

Some who backed the reforms, like Viollet-le-Duc, didn't shy away from denouncing the entire official art world. "A young artist enrolls at the Ecole and wins some medals . . . but at what cost?" he asked. "At the cost of following to the letter every rule established by the professorial staff, and of entertaining no ideas that weren't advanced by the faculty, and most especially of never having the pretension of an idea of his own."[11] Viollet-le-Duc attacked the "state of patronage under which students live, even more stifling than the former patronage of corporations."[12] Delacroix himself, long refused entry into the Académie, complained that teachers at the Ecole "taught Beauty the way you teach algebra."[13] Lecoq de Boisbaudran bemoaned the obsession with competition and imitation, and criticized the effects of such a system, in which students were "more worried about a diploma than about real knowledge." Sounding a warning, he asked, "After several years devoted to such exercises, what will remain of their most valuable qualities? What happens to innocence, sincerity, naturalness? The exhibitions of the Ecole des Beaux-Arts speak volumes about what happens."[14]

The Académie, led by the recalcitrant Ingres, viewed the emperor's decree as the affront it was intended to be. Report, decree, response, counterresponse, appeal to the Conseil d'Etat: for more than eight years a state of war opposed the emperor and the Académie. "Between Ingres and Delacroix, what is your position?" someone asked American artist John La Farge the day he came to Paris in 1856.[15] How did these events strike the young American painters just arriving? What did they think of the emperor's intervention on the side of the artists against the all-powerful academicians? In no way could they understand the Colbertist tradition lying behind this appeal to the ruling prince, a legacy as old as the feudal system.

Provincial French artists began to arrive in Paris with letters of introduction to "Gustave Courbet, of Ornans," among them Claude Monet from Le Havre, Frédéric Bazille from Montpellier, Camille Pissarro from Saint Thomas in the West Indies, and Paul Cézanne from Aix-en-Provence. Bazille, who pursued both medical and art studies for three years in Montpellier and then for a

year and a half more in Paris, hated the instruction he received at Charles Gleyre's studio on the rue de Vaugirard in Paris: "What Monsieur Gleyre teaches me, the craft, can be learned as easily everywhere. I hope that if I ever amount to anything, at least I'll have the credit of not copying anyone."[16] From the start, the official art scene struck him with its cynicism and its mediocrity. "There are very few living painters truly in love with their art," he wrote to his father. "Most of them just want to make money by catering to public tastes, which are usually mistaken."[17] Each year's visit to the Salon only strengthened his convictions: "Saw extremely few beautiful things at the Salon," he wrote to his mother in May 1864. "Cabanel did a mighty awful portrait of the emperor, which did not prevent him from getting the Grand Medal of Honor."[18]

Bazille even rejoiced at being a victim of the jury: "My two paintings were not accepted by the Salon. Far from being discouraged, I share the experience with all that was good this year at the Salon. . . . In any case, what happened this year will never happen again, as I will never submit anything else to the jury."[19] Later, when tensions mounted, he wrote: "Everything at the Salon shows deplorable weakness. Courbet's paintings, weak ones for him, seem like masterpieces in the middle of such universal mediocrity."[20] Gradually, inspired by his admiration for Courbet and Manet, and encouraged by his friends, "a dozen talented young men," including Monet, Renoir, and Sisley, whom he had met in Gleyre's atelier, he decided that he was indeed part of the new group of painters. "The jury laid waste to everything," he wrote his father. "What pleases me most is that there is real animosity toward us. Monsieur Gérôme did most of the damage. He called us a bunch of lunatics and declared it his duty to do everything to prevent our paintings from being shown."[21]

The activism roiling the studios also invaded the Salons. Although art historians have traced the chronology of events in this period with enormous care,[22] a precise date assigned to the unraveling of the old order, much less to the birth of Impressionism, remains elusive. Did it happen with the Exposition Universelle of 1855, or Courbet's Pavilion of Realism that same year? Or the Salon of 1859? Or in 1863 with Manet's *Déjeuner sur l'herbe,* and the death of Delacroix? Or in 1865 with Manet's *Olympia?* In the space of four to eight years, signs of change had multiplied: the development of new techniques such as photography; the increased power of new players such as art critics; the change in public tastes due to increasing outside influences such as orientalism; the role of new patrons from the industrial bourgeoisie. Between the 1855 Exposition Universelle and the Salon of 1869, a chain of events unfolded that finally shackled the all-powerful Salon.[23]

"What need is there to go back into History? What need to take refuge in myth? . . . Beauty is right before us, not in our brains; it is in the present, not

in the past; it is in the truth, not in dream; it is in life, not in death. The universe in front of us is what the painter must translate."[24] Jules-Antoine Castagnary's remarks about the annointed works of the 1869 Salon read as unambiguous and unequivocal. "Few are remarkable," he wrote. There are "major generals in uniform, judges in robes, and clergy in ecclesiastical gowns. I searched among these men decked out in their medals and crosses for some representative of our wealthy bourgeoisie, . . . and cannot find a single one."[25]

Tensions had been mounting for some time. The rigidity and strict monopoly of the State's system had provoked many a rebellion from the more independent painters. In 1855, when Courbet exhibited outside of the official space with his private patron's support, the public understood this step as a first warning. Not long after, in 1863, more artists, all rejected by the official jury, managed to get the authorization for opening the "Salon des Refusés." In May 1867, Courbet and Manet, resolutely continuing their long battle with official-dom, each constructed a special exhibition space to show a large group of his own works, just a few streets from the grounds of the new Exposition Uni-verselle, where neither artist—nor any of their friends—were represented in the officially sanctioned exhibition. For Castagnary and for many others, how-ever, the 1869 Salon, with its multiplicity of tendencies, unequivocally heralded the arrival of what we would come to call Impressionism. From that point on, Official Art and the New Painting split definitively.

The political unrest that shook France in 1871 due to the Franco-Prussian War and the battles of the Paris Commune affected the art world as well. The 1871 Salon was canceled. Most artists left Paris: Pissarro and Monet went to London; Corot, Renoir, Manet, and Cézanne moved to the provinces. Frédéric Bazille, who might have become better known and achieved greater success, was killed in Beaune-la-Rollande on November 28, 1870, while fighting against the Prussians. During the suppression of the 1871 Commune uprisings, "Citi-zen Courbet"—representing concerned artists—expressed the "wish that the government . . . would see fit to authorize razing the Vendôme column, or that it would undertake the project itself." Elected to the Council of the Com-mune, and named a delegate of Public Instruction as well as president of the Federation of Artists, Courbet called for the "free expansion of art, released from all governmental oversight and all constraints."[26] He was acting squarely in the French tradition: the man of letters or the artist, challenging political power, whether that power is embodied by king, emperor, or president of the Republic. These would be Courbet's final acts: imprisoned, condemned, finan-cially ruined, he paid dearly for his convictions. In his last paintings, all of them marked in red with the name "Sainte-Pélagie"—the jail where he ended his life—whether representing rotten pears, a branch of blossoming apple tree,

or a just-captured trout below which he added "*In vinculis faciebat*" ("painted in chains"), he never stopped expressing either his need for freedom of expression or his dedication to reality. Aesthetically, the road to Realism that he had opened would never stop developing. And neither Courbet's death nor any political upheaval could halt the progress of the "New Painting."

Seven

Masters and Disciples:
"Rembrandt, Rubens, Gérôme"

WHATEVER RESENTMENTS and disaffections may have been welling up in the hearts of French artists during the years leading up to the 1869 Salon, American painters flocked to the Salons and exhibitions and signed up at the Académie as willing apprentices to the official masters.[1] The rigid studio hierarchy—in which an artist worked for years under his master before going off on his own—had been rooted in France for centuries. The young painter absorbed a culture, an entire social universe, starting with a whole new vocabulary—"drawing an academy"—that referred to obligatory drawing from a nude model. "The true events of school life are the schooling and the advance," wrote Earl Shinn, "not the describable things, not the holidays and junketings, not the diversions and recreations I have attempted to portray. What is really the week's affair of the Beaux-Arts man is his academy."[2]

The Ecole des Beaux-Arts was still the most prestigious art school in the Western world. Three new painting studios had recently been established by proclamation of the emperor. For the young American artists, Jean-Léon Gérôme and Alexandre Cabanel stood out as by far the most influential professors. Gérôme taught drawing from live models with authority, precision, and rigor. By the time Thomas Eakins arrived at the school, he had admired Gérôme for several years, since first viewing the exotic *Egyptian Soldiers Crossing the Desert*. But during his first five months at the Ecole des Beaux-Arts, to his great surprise, the young American was forbidden to paint. Gérôme decided he was not ready and forced Eakins to work exclusively on drawing. Only after Gérôme was finally convinced that Eakins had mastered the technique did he allow his charge to pick up a paintbrush. It was March 21, 1867.

Far from lamenting the frustrating months spent drawing, or even questioning the reasons for his predicament, Eakins continued to praise Gérôme as a "model of method" and tirelessly asserted that, of all contemporary painters, Thomas Couture and Gérôme stood "at the head of all art."[3] George deForest

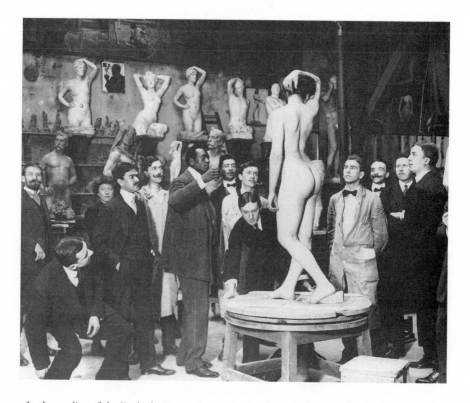

In the studios of the Ecole des Beaux-Arts or the Académie Julian (seen here), the Americans worked under the French masters, whom they venerated as veritable gurus.

Brush echoed Eakins's conviction: "No pupil left the studio for his life work without learning to draw the human figure accurately. No poor proportions, crude outlines, or vague shadows were permitted under Gérôme's vigilant eye."[4] J. Alden Weir also expressed his enthusiasm for Paris—"the best place in the whole world for a young man to study art"—and in particular for Gérôme: "He teaches [art] in such a healthy way. He will not dodge about for effect, glaze or attempt any tricks as he terms it, but he must try to study the value of color and paint solidly. First he says unless one has the action and character, it is nothing and I feel he is justly right."[5] The Americans, who had come to work with the descendants of their Renaissance heroes, rhapsodized over their French masters and proclaimed their allegiance to the sacred triumvirate "Rembrandt, Rubens, Gérôme."[6] The unwitting anticlimax, now obvious, was then not in the least apparent.

Cabanel, Gérôme, and Couture were their masters and gurus—loved, admired, venerated. "For no man could suit my case better than Gérôme,"

wrote Weir. "He is a very superior instructor and one whom everyone honors and respects." As evidence of the seriousness of his master's work, Weir recounted Gérôme's trip to Rome, where the French artist had paid three thousand dollars for the cast of an antique armor breastplate. "People think that these men paint pictures at pleasure and not cost them anything [*sic*]. . . . So one sees how very expensive it is for such great artists as these."[7] An entourage of students grew up around such teachers, gleaning tidbits and anecdotes and repeating what gossip they heard. Devoted though Weir was, he was astonished to meet one student who had stayed thirteen years with Gérôme—an extreme case of the student-teacher connection, which everyone knew was indispensable: "Weir, student of Gérôme" was admitted to the Salon, "Becker of the Couture Studio" received a medal.

They all sent letters home full of lovingly detailed descriptions of their cherished master. "Gérôme has made a picture of Dante," wrote Thomas Eakins. "No one else could have done it. . . . Some painters paint beautiful skins, some find happy bits of color . . . but who can paint men like my dear master, the living thinking acting men, whose faces tell their life long story? . . . Gérôme has raised himself above his fellow men by his brain as man himself is raised above the swine. He has made himself a judge of men and insofar as a painter is a creator he creates new men or brings back those you want to see to like."[8]

Official art was their religion and its practitioners their high priests. Nothing could distract them from the deadly serious goal of total absorption in their art, as if they were swept up in a mystical experience, in relation to which they showed little critical distance, and less irony. Something of the cult that had grown up around Gérôme can be gathered from a story recounting one of the master's regular Saturday studio tours. On that day, Weir showed two works: a drawing and a portrait. "I looked forward to pleasing him," Weir wrote. Gérôme "said nothing at all about [my] drawing, but gave me a most savage talking to about the value of color and got up as if mad and went in to the small antique room." When the master returned, he demanded that Weir wait until he had reviewed a more senior student's work; it dealt an excruciating blow to the confidence of a young man who, as the new student and a foreigner, also had to perform menial tasks, according to the studio tradition. But then "Gérôme turned suddenly . . . to my portrait, then turned about and asked who did it. I answered in a rather sheepish manner, expecting to be blown up much worse than before, but he said 'Ce n'est pas mal du tout, mal du tout!' ['This is really not bad, not bad at all!'] Then put on his coat and went out. . . . I received all kinds of congratulations from old students who said that he seldom ever praised one any more than this. He has also told me to paint

from the life model this week, so that I now feel like taking hold with a new vigor."[9]

No doubt some of the French master's allure had something to do with introducing his American charges to two experiences unknown to them at home: classical art and nude models. "You wanted to know the Romans?" Eakins asked regarding antiquity. "There they are real. Gérôme knows them. He knows all men. . . . Maybe he will be a gladiator some day. How proud it would make him. . . . Gérôme has given us the people, the grand old people of the Bible and the Arabian nights."[10] Moreover, in France, the nude was the first essential step in artistic apprenticeship. "Observe how your muscles are inlaid one against another," Gérôme told his students. "They are carpentered. Yes, there's something in your drawing, but it is not the vivacity of flesh. Go next Sunday to the Louvre and study the drawings of Raphael. He doesn't work as hard as you in drawing, yet one feels the elasticity of flesh built of flexible fibers, articulated around the bone, and wrapped in satin. You tell me you'll express that texture afterward. I tell you that Raphael expressed if from the first stroke."[11]

For those accustomed to copying from molds and plaster casts as in the United States, the difference was quite startling: in France, attention to the body was direct, crude, exacting, physical; in America, it was bowdlerized, glancing, timid, a half-view of a camouflaged figure. Eakins defended his teacher's use of live models, arguing that "the sensual people are better than the fools."[12] Weir advised his father—who was also an art teacher—to find the funds to supply his students with a live model at least four hours daily. "It would advance your school more rapidly than in any other way," he pointed out.[13]

"He investigates like an antiquarian," Eugene Benson recalled of Gérôme: "He is severe like the classicists; he is daring like the romanticists; he is more realistic than any other painter of his time and he carries the elaboration of surfaces and the science of design further than his contemporaries. Like the modern mind, he travels, he investigates, and he tries to exhaust his theme. He labors to leave nothing unsaid, to cover the whole of his subject."[14] Gérôme's American students, subjugated by the rigors of his discipline, thrilled to his tyrannical demands. And to these disciples he revealed his secrets, such as the key to painting historical scenes, which is to show, according to his own training in David's studio, not the action itself, but the instant that follows it.[15] As usual, he taught by his own example, as in his 1867 work, *The Death of Caesar*.

A tall, thin man, very much at home in the studied elegance of his age, Jean-Léon Gérôme wore his mane of white hair brushed back, his moustache trimmed pencil thin, and always sported a well-cut three-piece suit and an

impeccable top hat. In 1848, at the age of just twenty-four, he received his first official commission from the French government. Soon after, Prince Napoléon bought a painting from him, *Greek Interior*. At thirty-nine, he became a "head of a studio" at the Ecole des Beaux-Arts, and the following year was elected to the Académie. Gérôme would dominate the world of official painting for four decades, teaching nearly three generations of history and genre painters.

A pompous thoroughbred of the system he had come to control, Gérôme shrewdly promoted his interests and guarded his privileges. In addition to being a professor and a member of the Académie, he held a seat on the Salon jury and regularly exhibited his own work there. Not surprisingly, his paintings, academic in style, sold extremely well. The dealer and engraver Adolphe Goupil, his father-in-law, had invented a technique called "héliogravure" and used it to reproduce Gérôme's work, which helped spread the French painter's fame among American artists and collectors. Two of his American students, Earl Shinn and Fanny Field Hering, had published monographs about his work in the United States, including engravings. Others—including Frederick Bridgman, Kenyon Cox, Harry Moore, William Lamb Picknell, Abbott Handerson Thayer, Theodore Robinson, Edward Butler, and Dennis Miller Bunker,[16]—all carried their admiration for their teacher's genius back home. John Ferguson Weir, J. Alden's brother, organized an exhibition of his works at Yale. "Gérôme's *Death of Caesar* from J. T. Johnson's collection," he wrote, "will be the central interest . . . I have had it in my room for about two weeks. . . . It is certainly one of the greatest works of modern Art." Perhaps carried away by youthful enthusiasm, Weir cheekily adds: "Gérôme may think it a strange fact that one of his greatest masterpieces should find its way into so out of the way a place!"[17]

Like other masters of his time, Gérôme dispensed sublime precepts; he maintained his hold over his students by inviting them to his private studio, where he advised them about the Salon, the right museums to see, the proper works of art to study, the best countries to visit. Above all, he warned against "the Realists," starting with Edouard Manet and Gustave Caillebotte. "My friend," he would tell one, "here we are swimming in pig slop," and, furthermore, insisted that "the impressionist style is the result of the stupidities that some intriguers have put before you."[18] Gérôme would not age gracefully, ending up a crank who continued to violently denounce the new directions of French art.

Thomas Couture—"the Inescapable Couture," as Lewis Mumford dubbed him—presented an altogether opposite perspective. Declaring indifference to the Classicist-Romanticist debate, Couture styled himself as an eclectic[19] and ranted indiscriminately against the Academy, official authority, and the Prix de

Rome. He reigned over his own studio and his "disciples," pursued his own whims, and promulgated his favorite precepts and techniques in a book called *Causeries de l'atelier* (*Studio Chats*). Couture had concluded that he alone could point French art in the right direction, by avoiding two pitfalls, "false classicism" and "commercial romanticism." According to the logic of his own cult, art should be considered the ultimate endeavor, and the artist superior to the philosopher.[20] His American students, who took naturally to his undogmatic pragmatism, were only too pleased to concur. "Couture is the greatest artist of the age," wrote Elizabeth Gardner. "He's a genius. . . . He inspires hope and courage."[21] Couture's reputation, however, did not outlive his living breathing presence in the artistic life of his time. The Beaux-Arts, though, was not without its barbaric aspects. There was hazing, for example, cruel rituals intended to initiate new students. The teaching methods practiced by the studio heads remained based on endless repetition and mindless imitation of the one model to admire slavishly: classical antiquity. The teacher's job was to correct attempts to stray outside the rules.

Such artists as James Whistler, Frédéric Bazille, Claude Monet, Auguste Renoir, and Alfred Sisley studied with Charles Gleyre. Though more liberal than the others, Gleyre shared the same values as the French masters: studio work, drawing from the nude, antic inspiration. "Remember, young man," he once said to Monet, "when you draw you must think of antiquity. Nature may be well and good as a subject for a study, but it offers nothing of interest. There is only style." Gleyre also railed against "this damned color," his peculiar bête noire, for fear that it would "get the students mad."[22] A Swiss citizen, unclassifiable, neither naturalist nor idealist, neither academician nor Beaux-Arts professor, he taught at the Académie Suisse, where he influenced such great artists as Renoir, Bazille, and Monet. "Only paint from your *own* inspiration. Do not follow your master's example blindly. What has been done, definitely belongs to the past."[23]

Alexandre Cabanel, the favorite court painter of Emperor Napoléon III, who had won more official honors and prizes than any other nineteenth-century French painter, was considered the most amiable of all the teachers at the Beaux-Arts. Much more flexible and gentle than Jean-Léon Gérôme, he would offer freedom to students who admired his highly classical *Birth of Venus*. One young foreign painter, George Moore, for example, greatly influenced by his compatriots' praise, admitted bluntly, "My plans, so far as I had any, were to study painting in Cabanel's studio."[24] Jules Bastien-Lepage was more critical. Remembering his years with his master, he wrote: "At the Ecole des Beaux-Arts I certainly learned my trade [but not] my art."[25]

L'Académie Julian, Rodolphe Julian's studio, sprang from the Ecole des

Beaux-Arts. His first students, excluded elsewhere, headed there by necessity; later, others came by choice. A carnival wrestler before becoming a painter, Rodolphe Julian was described by George Moore as "a Southern type, with dark eyes, rosy, prudent, seductive in his manners and sensuality."[26] The colorful warmth of Julian's personality played an important part in his success as a teacher. "As soon as he appeared," remembered his student Georges Rochegrosse, "there was silence. Each one quickly took up his pencil or his brush and resumed the tireless search for truth according to nature, so greatly was Julian both feared and loved."[27]

A self-taught and eccentric provincial with good business sense, Julian successfully exploited the limitations and flaws of the Ecole des Beaux-Arts. He opened his first studio in 1868; within a few years it came to function as a safety valve, a welcome alternative to the system. The Beaux-Arts required foreigners to take an exam in French; Julian waived the requirement. The Beaux-Arts was closed to women; Julian built studios expressly to welcome them. The Beaux-Arts forced its students into rigid dependency, under the scrutiny of one master; Julian allowed them to study freely with several different teachers of their own choosing, and even to form separate groups within the studio (as the Nabis would later do). The Beaux-Arts required its students to follow an annual program strictly designed to prepare them for the prestigious Prix de Rome; Julian's could come and go as they pleased, staying a year, a month, or just a few days. And with a staff culled from the Beaux-Arts itself—free-lancers engaged on a part-time basis—Julian could offer instruction substantively similar to the Beaux-Arts' but with far greater flexibility. At the same time, his students sacrificed none of the back-scratching benefits of the official system. The teachers, who were members of the Salon jury, "served Julian students' admission; in exchange, the students reelected their teachers to the jury each year by an overwhelming majority."[28] In fact, the only drawback at the Académie Julian was that students had to pay for their instruction—and usually in advance.

Foreigners accounted for half of Académie Julian's matriculants. Between 1868 and 1939, Julian would build a network of former students across five continents, among them a considerable number of Americans, especially Impressionists and Post-Impressionists.[29] One even wrote that "their education would be incomplete had they not been to Julian's."[30] His empire anticipated and charted the directions French art would take in the future. And although Julian offered little in the way of aesthetic innovation, by integrating the emerging artists—and all those who toiled on the margins—and creating an open space where diverse subgroups could coexist freely, unimpeded by dogma, he suc-

ceeded: the Académie Julian prefigured the transformation of traditional French teaching and pointed the way toward the twentieth century.

Still, most Americans remained only too eager to harness themselves to the official system with all its feudal bridles, if only officialdom would have them. Not infrequently, allegiance assumed parodic proportions. Frederick A. Bridgman, aping his master, Jean-Léon Gérôme, filled his studio with weapons, suits of armor, and sundry exotica; his technique, his style, and his works likewise betrayed a sometimes slavish imitation. When he prepared himself to paint *The Mummy's Funeral*—which he exhibited in the 1877 Salon—Bridgman and his friend Charles Sprague Pearce went as far to follow Gérôme's footsteps, traveling to the Middle East to observe local customs. "When translated into American, Gérôme means Frederick A. Bridgman,"[31] another American artist cynically noted.

J. Alden Weir, though close to Gérôme, understood the dangers of the master–apprentice system. "Many of the students have told me repeatedly to leave Gérôme, as he would spoil my good color," he wrote. A friend of Bastien-Lepage, with close ties to the Barbizon group and an admirer of Corot and Millet, Weir shuttled between Paris, Pont-Aven, and Fontainebleau. Nonetheless, he would not be persuaded to abandon his teacher. "I feel as he says," he wrote in a letter home, "that drawing is the thing to be learned, and when one can draw he can do as he pleases with color." Alarmed by his son's unprogressive observations, Weir's father expressed concern: "Now if study abroad leads to an adopted manner, following in the footsteps of others, I think it certainly very pernicious. Don't lose your individuality."[32]

Few Americans dared to criticize the official system. Kenyon Cox, however, remained an exception. Though thoroughly enthusiastic upon his arrival in Paris, he began expressing disappointment after studying with Carolus-Duran. Then, in 1878, after being admitted to Cabanel's studio at the Ecole des Beaux-Arts, he swiftly transferred to the more flexible Académie Julian. A year later, he would return to the tradition of the Ecole des Beaux-Arts to work with Gérôme. Cox's varied and unusual training helped him develop an opinion— informed and detached—of the French system. Gérôme, he wrote to his parents, was "rigid," Cabanel "pompous," and Carolus-Duran a "snob."[33] Back in the United States, Cox became an academician, resisting all modern movements as rigidly as the French masters he had himself formerly criticized.

Eight

"The Art Sensation of the Year"

F OLLOWING FRANCE'S 1870 defeat in the Franco-Prussian War, the
Third Republic replaced the Second Empire. Napoléon III was out, and
the new bourgeois Republic came to power. With this political shift, brand-
new political personalities arrived on the scene. The civil servants in charge of
visual arts were assigned new titles: "Directeur des Beaux-Arts" for Charles
Blanc, Philippe de Chennevières, Eugène Guillaume, and Henry Roujon;
"Sous-Secrétaire d'état aux Beaux-Arts" for Albert Desjardins and Jean
Casimir-Périer; "Ministre des Beaux-Arts," for Antonin Proust.[1] These new
characters, all of them steeped in the ideology of the Republic, had learned to
respect democratic values.

They shifted the official taste toward the Realists, celebrating the very
painters that Count de Nieuwerkerke had banished.[2] The new French premier,
Léon-Michel Gambetta, a thirty-two-year-old liberal lawyer, supported the
Republican idea against those who, in the name of moral order, had hoped for
a return to the monarchy. After Gambetta appointed Antonin Proust—a close
friend of Manet's—to the position of Ministre des Beaux-Arts, Manet's and
Courbet's works found their way into the Musée du Luxembourg, the only
museum in Paris that displayed work by contemporary artists. Granted, com-
mittees and commissions multiplied and aesthetic judgment remained in the
hands of bureaucrats, but new players and alliances meant new choices—the
same game, perhaps, but with different results.[3]

During this political transition, the new government showed itself clumsy
and ambivalent, consolidating its power in fits and starts. As for the visual arts,
the incoming personalities would have to manage an explosive situation, that
of the Salon's inevitable transformation. Since 1855, when Courbet, with the
support of his private patron Alfred Bruyas, built his own Pavilion of Realism,
artists had started challenging the State's powerful hegemony over the art
world. Other manifestations of their discontent would follow, from the 1863
Salon des Refusés to Manet's and Courbet's own exhibition rooms at the 1867
Exposition Universelle. During those chaotic years, the State seemed com-

pletely unable to recover its traditional footing with respect to the arts, and the slow demise of the Salon only reflected the deep crisis that had pervaded the art world for years. In 1872, Charles Blanc, Beaux-Arts director, rigidly refused to reconsider the composition of the Salon jury. In 1882, in a manner utterly inconsistent with Blanc's attitude, undersecretary of state for the Beaux-Arts Edouard Turquet responded to the artists' rebellion by decreeing that the Salon should "be managed exclusively by the artists," and adding that the government "should stay out of it."

Passing into the artists' hands, this institution, marred by artistic centralism, proved a disappointing and mediocre affair.[4] Two years later, when the Salon des Indépendants was established, things got even worse: with the explosion of the single Salon into a fragmented series of unrelated exhibitions, the situation became hectic and unmanageable, permitting such an excessive number of works to be shown that it would be impossible to view all of them. The hegemony of the Salon—the exhibition venue most coveted by living artists, the once unrivaled herald of the new talents, the new directions, the new tendencies—had undoubtedly come to an end. Hereafter, art would emerge in lesser and often airless events and venues.[5]

Profound change had also been under way in the art-education system. Courbet, Charles Gleyre, Paul Lecoq de Boisbaudran, and others had long offered alternative training in their private studios, showing the need for a more flexible curriculum, responsive to the changing aesthetics. The attempted reform of the Ecole des Beaux-Arts, after a lukewarm reception, led to merely superficial changes and eventually failed. In 1862, Viollet-le-Duc, who had been among the first to denounce publicly the institutional inertia and the weight of traditions that hampered the dynamism of artistic creation, had ably articulated the exasperating reality: "We must admit that if we French are among the boldest when it comes to conceiving new ideas, we become the shyest people when it's time to actualize them. In our imagination, we revolutionize institutions with youthful ease; but habits, personal interest, and petty rivalries block us the moment we try 'to change the world [sic].' Ten times over we've heard about reform projects in the French Beaux-Arts instruction system, and each time these programs dissolved after a few guys assured us that 'everything's fine.' A single speech, and it was all over."[6]

By 1876, the critic Edmond Duranty had joined the increasingly open condemnation of the attitudes still prevailing in France. Sensing that he was living in an age "smothered by the innumerable creations of past centuries," Duranty thrilled to the "sudden burst of new ideas," admired the "fresh new branch" that was "growing however tentatively on the tree of art." "But," he wondered, "would that branch produce leaves, flowers, or fruits?"[7]

The ever-growing ranks of artists in France and the increasing influence of innovative painters provided a catalyst for change. French artists had started to meet and to organize themselves in "cooperatives" or business associations by 1869. Four years later, a newspaper called *L'Avenir National* (*The National Future*) announced that a "corporation of artists" was then just being formed; their aim was "to counter the Salon system." A new milieu was born of these artists, along with the critics, dealers, and patrons who supported their work; together, they formed a network outside the official system, mirroring the natural evolution of the modern art world. In 1873, a certain Claude Monet wrote to *L'Avenir National* that "a group of painters gathered in [my] home has read your article with pleasure. We are happy to know that you defend our ideas and we hope that . . . *L'Avenir National* will support us when our new group is fully constituted."

Indeed, several months later, in a space provided by the photographer Nadar in his studios at 35, Boulevard des Capucines, near the church of the Madeleine in Paris, the group that Monet helped organize opened its first exhibition to the public. The members of the "Private Association of Painters, Sculptors, and Engravers" had by now produced a charter and, under the leadership of Edgar Degas—who, like Monet, was by then an early "protégé" of Paul Durand-Ruel—resolved to submit nothing to the Salon jury. Instead, they would exhibit their works "two weeks before the opening of the official Salon, in a free and open space" far from the one where the Salon des Refusés was showing, to which they had formerly been consigned. Within twelve years, this "artists' cooperative" organized eight group shows. Unable to define these artists precisely, critics referred to them by strange names; even the most neutral were intended pejoratively: "Independents," "Impressionists" (the one that would finally stick by 1874),[8] "Intransigents," "Phalangists," "Lunatics," "Radicals," "Maniacs," and "Actualists." But however difficult it was to find an appropriate name for these new painters—who were bound more by common purpose to exhibit their work than by any universally shared aesthetics—the critics sensed an emerging rhetoric of independence and foresaw the arrival of a new order.[9]

Rejected by the experts, scorned by the general public, the future "stars" of the 1874 show would have to wait years before winning critical validation, and even longer before gaining popular interest. But a loyal handful of writers, art lovers, and dealers coalesced around them. The most modest of this intrepid few were Père Martin, a second-hand goods dealer born on a farm in the Jura region; Père Tanguy, the son of Breton craftspeople, and a pigment-grinder and paint-merchant; and lastly Père Petit.[10] These small-time dealers eased the burdens of painters whose work was all but unsalable, managing finances that

One figure emerged among the bigger art dealers: Paul Durand-Ruel. A keen businessman, he shrewdly applied market economics to art and found a market for French Impressionists in the United States in the 1880s.

very often teetered on bankruptcy; in so doing, they ran the constant risk of falling into penury themselves. They listened to their charges' complaints, offered advice, extended them credit, absorbed their debts, and accepted paintings in exchange for furniture, thus buffering the hard realities faced by the painters and allowing them to pursue their work.

Among the bigger art dealers, one figure emerged who would radically transform the traditional way of doing business in the arts, a true entrepreneur. His name was Paul Durand-Ruel. At the 1855 Exposition Universelle, when everyone had been raving about the work of Horace Vernet—a popular military painter—Durand-Ruel celebrated Delacroix, the fierce Romantic, and the works of what he referred to as the School of 1830. He was a man with his own ideas and tastes. In 1869, he created a monthly journal, the *International Review of Art and Curiosity,* followed by a weekly, *Art in the Two Worlds,* in which he introduced the new painters. Occasionally, he could be combative: when the Salon of 1874 snubbed Corot, yet again giving the Medal of Honor to Jean-Léon Gérôme, Durand-Ruel commissioned his own medal from the sculptor Geoffroy Dechaume and presented it to Corot in his gallery. When in 1878 the official selection committee of the Exposition Universelle excluded Manet,

Delacroix, and Millet, Durand-Ruel mounted an exhibition at his Rue Laffitte gallery, *Authentic French Painters, 1830 to 1870,* including no fewer than eighty works by Corot, thirty-two by Delacroix, and thirty by Courbet.[11] Durand-Ruel, leading the "Republic of New Artists" and running his gallery as an artistic democracy, would spare no expense, miss no opportunity to strike back at the Académie. As a consequence, he was scorned and marginalized by French arts-administration officials, who regarded him without sympathy or seriousness. "They would like me to pay for the crime of fostering the Impressionists to the detriment of artists who, supported by the State and by unenlightened public taste, have been designated the true masters of the age," he wrote accusingly.[12]

A keen businessman, Durand-Ruel took a freewheeling approach to countering the monopolies of the Salon; he sought out new markets, took chances on younger artists, and by shrewdly applying traditional market economics to art, he established a nearly absolute monopoly over the Impressionists and the School of 1830. In 1866, visiting Théodore Rousseau's studio, he bought seventy paintings on the spot. In 1871, at Manet's atelier, he "looked to get everything that Manet had in his home," according to his memoirs, "or in other words, twenty-three canvases for thirty-five thousand francs. . . . Several days after that [he] went back to visit Manet, who by then had gotten back a certain number of his works that had been spread out among his friends, and [he] bought a second group for a total of sixteen thousand francs."[13] Durand-Ruel went on similar sprees chez Degas, Monet, Pissarro, Sisley, Renoir, and Cézanne, betting without restraint on their future. In 1884, he admitted that his debts had mounted to a million francs.[14] Even then, his artists knew they could usually count on him. That same year, Degas, being "threatened with seizure of goods," dispatched his maid to Durand-Ruel to "get a little money." "The government . . . tells me . . . that fifty francs will do. But if you can give her a hundred, she will keep a little something for herself. . . . Oh! How I am going to cram your gallery with my works this winter and you will stuff me with money. It is simply too tedious and humiliating to have to go running after a hundred-sou coin."[15]

Progressively, with one show after another show, Durand-Ruel went "global." Following his French success, he opened a gallery in London (1870–75) and organized exhibitions in Brussels, too. Then, he plunged into the American market. On March 13, 1886, accompanied by his sons Joseph, Georges, and Charles, he left for New York, where he stayed four months. His absence from France was felt. "My dear Durand," Monet wrote him in despair, "it's been a month and a half since you left . . . for America . . . and no word from you, not one cent from your son. . . . It's becoming unbearable: if you

succeed over there, what'll happen here in Paris if I'm forced to slash my prices? I'll be desperate . . . I wish you every success but alas my heart is no longer in it."[16] Durand-Ruel evidently responded. Two months later, Monet wrote again: "I am so very grateful for the five hundred francs you sent me. I'm going to use it right away and it will quickly disappear." He also warned his absentee dealer about the wages of neglecting the home market: "You only have eyes for America," he added, "and you're being forgotten here: as soon as you have new paintings, they're gone."[17]

Durand-Ruel's first exhibition in the United States, *Works in Oil and Pastel by the Impressionists of Paris,* included more than three hundred pieces, collectively valued at some eighty thousand dollars. It opened on April 10 at the American Art Association, on Madison Square. In galleries designated A, B, C, and D, the public could find works by Pissarro, Monet, Degas, Manet, Caillebotte, Seurat, Sisley, Signac, and Renoir, among others, whose excellence was celebrated in the catalogue introduction by Théodore Duret. The *Home Journal* got it right, if understatedly, when it reported that the exhibition represented "very fairly the rebellion against academical traditions which has been going on in Paris during the last quarter of [a] century."[18] American journalists agreed that Durand-Ruel had presented a "rare lot of masterpieces," as *The Nation* put it.[19] "It is seldom," chimed in a writer for the *Critic,* "that what is virtually an entire school of art is transported bodily from one country to another."[20] The sheer breadth and power of the show overwhelmed the American public. "It will be the art sensation of the year . . . these bizarre and original works will be of great educational importance," wrote a writer for the *New York Mail and Express.*[21] Others, like the critic for the *Telegram,* were completely bowled over by what they found in Madison Square: "No exhibit of like interest or instructive value has ever been had there," he wrote.[22] The only discordant note was struck by the militant weekly *The Churchman.* The works in Durand-Ruel's exhibition, it claimed, were "simply expositions of the social and moral culture of Zola of sensualism and voluptuousness, or sheer atheism. . . . Degas is nothing but a Peeping Tom . . . not one of these men approaches women without a covert insult or defamation."[23]

One could have rightly thought, even then, that Durand-Ruel's show had not merely been a seasonal sensation but had left a lasting impression. "One thing is sure," declared a critic in the *Home Journal* a month later, "a person who once gets these intensities in his eye will not get them out. He will be surprised some fine morning to find himself calling for more."[24] Another critic, in *The Sun,* wrote "One can clearly sense that these painters have worked with well-defined goals, and if they have ignored convention, it is because they have surpassed it; and if they have ignored secondary truths, it is for the purpose of

displaying greater truths better."[25] Most New York critics displayed a receptive-ness to the new rare in Paris at that time. "New York has never witnessed an exhibit as interesting as this," added the journalist for the *Critic*.[26] Individually, Monet received the greatest attention, as "the most representative, the most brilliant of the group";[27] Manet's *Absinthe Drinker* also attracted notice, as did works by Renoir, Degas, and Courbet. However, not all the American critics were favorably impressed. One critic, reviewing the show in the *New York Times,* wrote that even "helpless American painters" from the Hudson River School "might blush, if they could not model human figures better than Seu-rat's number 170 *Bathing.*"[28]

Durand-Ruel himself was nearly as much celebrated as the painters and their works. The critics described him as "strange," "passionate," "other-worldly," and hailed him an as "apostolic figure,"[29] a "friend of the new painters," who went into debt, investing a considerable fortune, backing up his aesthetic choices, "a dealer with a religion for art." Few journalists remained unimpressed by his enterprise. "We admire unspeakably the enthusiasm, sin-cerity, energy of this man, this champion of a cause for which he accepts so many sacrifices."[30] "Its very singularity," reported the *New York Mail and Express,* "emphasizes the fact of its being a work of love, a crusade, a missionary undertaking."[31] Indeed, more than a few critics employed religious metaphors in expressing their estimation of the French paintings and of the man who brought them to the United States. If Durand-Ruel was a kind of prophet, then his art was no longer a sin; if his mission was "religious," his exhibition should be approached with reverence.

On May 25, Durand-Ruel moved the show to the nearby National Acad-emy of Design, and augmented it with twenty-three paintings lent by such American collectors as Harry Havemeyer, Alexander Cassatt, and Erwin Davis. Most notable among these was Manet's *Boy with a Sword* (which Davis donated to the Metropolitan Museum three years later). When the show reopened at the Academy, the critics immediately focused on these additional paintings, particularly those by Berthe Morisot and Monet, and celebrated the local American collectors for their daring choices. "The exhibition was a huge suc-cess, due to the public's curiosity," Durand-Ruel would later admit modestly, "and unlike in Paris, it occasioned neither head-knocking nor stupid remarks and caused no protest. The press unanimously praised the show, and numerous favorable articles appeared in the New York press and in other large cities in the United States. . . . This was not about my fortune, so much as a real success that promised a wonderful future."[32] Durand-Ruel's success was not merely a *succès d'estime.* He sold Manet's *The Salmon* to Harry Havemeyer and found new admirers among the country's industrialist elite, such as Albert Spencer,

Cyrus Lawrence, A. W. Kingman, and W. K. Fuller. J. Alden Weir, who by this point had returned to New York, wrote his brother that Durand-Ruel's show "was the most extraordinary exhibition for an artist to see that [the American people] yet had."[33]

In autumn of the following year, 1888, Durand-Ruel returned to New York and rented gallery space at 297 Fifth Avenue. But while he could still show works, he now found himself prohibited to sell them: American art dealers, incensed by his shrewd business sense as well as by his monopoly over paintings by the French Impressionists, had, in the interim, demanded that the government apply the "33 Tax"—a 33.3 percent duty on works of art imported from abroad. However, this trade barrier couldn't alter one simple fact: after thirty years of profitless toil, the French Impressionists had finally found a market. Within a few years, American collectors would chase madly after them. "Do not think that the Americans are savages," Durand-Ruel wrote to Fantin-Latour. "On the contrary, they are less ignorant, less close-minded than our French collectors."[34]

Meanwhile, back home in France, a new order with new economic configurations was taking shape, guided by private interests and the market. The time-honored celebration of individual masterpieces, a product of the Academy system that for centuries favored official patronage, had run its course. Instead, artists were now to be celebrated for the totality of their oeuvre. But freedom from tradition had its down side. Market value came to be identified with aesthetic value. This was precisely what Théodore Duret had perceived when he noted that, in the face of centuries of patronage, "the public openly mocks Impressionist works, stunned that the thing actually sells! Not enough to allow them to do something idiotic, but the bottom line remained that they sell."[35] The Industrial Revolution had turned the middle class into the new arbitrators of France's cultural life; preferring the here and now to historical heroes, they ushered in scenes of contemporary life—train stations, city streets, urban and industrial development—that would replace history painting entirely.[36] And by the end of the nineteenth century, the French government's absolute control over artists and the art world would recede into the past.

During this period of transition, and of intense conflict between artists and the State, French painters united not only among themselves but with writers as well, supporting each other, quoting each other, touting each other's achievements. In the lower right-hand corner of Courbet's *The Painter's Studio,* one finds Baudelaire reading, and, further in the background, Champfleury and Proudhon. In several group portraits by Fantin-Latour—*Homage to Delacroix,* the *Studio in the Batignolles,* and *The Corner Table*—his friends and

teachers included not only Delacroix, Manet, Renoir, Monet, Zacharie Astruc, Edmond Duranty, and Whistler, but also Baudelaire and Zola. Manet asked Astruc, Zola, Berthe Morisot, and Mallarmé to serve as his models for various paintings. Cézanne painted Père Chocquet, the small-time dealer who supported struggling artists, and Gustave Geoffroy, a critic-friend. Pissarro celebrated Courbet, Baudelaire, and Cézanne. In the same vein, Edmond Duranty—who in 1876 published *The New Painting,* a sort of manifesto for their movement—was commemorated at his library desk, amidst piles of manuscripts, in two paintings by Degas. Degas, though, was most inspired by the figure of Manet, devoting numerous drawings, etchings, and oil portraits to his friend, as though he was a sort of talisman. With his handsome countenance and the elegance of a detached dandy, Manet indeed became the face of Impressionism: in addition to Degas's depictions of Manet in the 1860s and '70s, there are several by Léon Lhermite and Fantin-Latour. Manet in turn portrayed Degas, Monet, and Baudelaire. These works—signs of faith, acts of revenge upon the old system—declared not only solidarity but also an allegiance to the New Painting. Winking to each other, braving public outcry and chilly reactions from official artists, these New Painters continued marching to the forefront of French art.

They rarely chose foreigners or outsiders as the subjects of their homages. But there were three notable exceptions: three American artists, each privileged, cosmopolitan, and cultivated, each wielding great influence in his or her various ways: James Abbott McNeill Whistler, Mary Stevenson Cassatt, and John Singer Sargent. All three deeply immersed themselves in French artistic life, playing dynamic roles in its most inner circles. And, as William Morris Hunt had done several years earlier, they created what would prove to be enduring connections between France and the United States.

Nine

With or Without His Sting: Whistler the Butterfly

S TANDING, ARMS CROSSED, in his black frock coat, an ironic gleam in his eye, Whistler seems to challenge the observer. By his side, in a white artist's smock sits Fantin-Latour at work, palette in hand. Next to them, the beloved—or accursed—artistic elders: Baudelaire, Manet, Champfleury; behind them, the new generation: Bracquemond, Balleroy, Duranty, Cordier, and Legros. And behind them all, on the wall in a gold frame, a faded yet time-less portrait of Eugène Delacroix.

Fantin-Latour's *Homage to Delacroix* was submitted to the 1864 Paris Salon, one year after Delacroix's death, as a way of redressing a wrong.[1] Some critics saw the painting as the "Manifesto of the New School," for in it one could recognize, according to the artist himself, not only the American "Whistler, creator of *The White Girl* [*Symphony in White, No. 1*], which had received such attention in the 1863 Salon des Refusés, but also the undeniably talented Manet who had the gift of displeasing the dull and conventional, Bracquemond . . . , Legros . . . and so forth." These men, in their shared strug-gles, formed in the words of Duranty, a brotherhood of "controversial artists paying homage to the memory of one of the most controversial artists of the time."[2] But, among them, one stood out: the twenty-nine-year-old American, James Whistler. When his image was seen by the general public in this painting by his friend Fantin-Latour, Whistler's name was already known in the Parisian art world, his paintings having caught the eye of Courbet, Manet, Degas,[3] Baudelaire, and Théodore Duret.

Born into an eminent military family, James Abbott McNeill Whistler was not a typical American painter. His father, George Washington Whistler, a mil-itary engineer, had been sent to Russia to help build the first railway line con-necting Moscow and Saint Petersburg, using techniques of which Americans in that age were the undisputed masters. Whistler thus spent a fair amount of his adolescence in Russia, where he would complete the cultural education he had

In this painting by Henri Fantin-Latour, *Homage to Delacroix,* the portrait of Delacroix
is surrounded by the critics and painters who championed the New Painting.
From left to right: Louis Cordier, Edmond Duranty, Alphonse Legros, Fantin-Latour
(in white shirt), Whistler. In the group at right: Champfleury, Edouard Manet,
Charles Baudelaire, Félix Bracquemond, and Albert de Balleroy. Standing, arms crossed,
an ironic gleam in his eye, Whistler seems to challenge the observer.

received in London museums as a child. By the age of fifteen he already knew
he wanted to paint. In 1849 he wrote from London, "I hope, dear Father, you
will not object to my choice, viz.: a painter, for I wish to be one so *very* much
and I do not see why I should not, many others have done before. I hope you
will say 'Yes' in your next [letter?] and that dear mother will not object to it."[4]
Although he and his family were unencumbered by financial constraints, in
1851 he entered the United States Military Academy at West Point, then the
Coast and Geodetic Survey, where he learned etching. The experience proved a
total disappointment.

　　When Whistler arrived in Paris in 1855, he was just twenty-one. It was the
year of the French Exposition Universelle, and well before the biggest wave of
American artists came to the capital. With family support, he rented a studio
on the rue Campagne Première in Montparnasse, and in 1856 occasionally
attended Charles Gleyre's atelier. Henry Murger's *Scenes from Bohemian Life*
(1845–49)—which was later adapted for the libretto of Puccini's opera *La
Bohème*—offered the inspiration from which he fashioned his own image of

the artist's life during his four years in Paris. A dandy who hung around young working-class women and generally spurned anything bourgeois, he went about sneering at the popularity of historical paintings, working instead with engravers. "Very recently," Baudelaire wrote in 1862, "the Martinet Gallery exhibited a collection of subtle etchings depicting the banks of the River Thames, by a young American artist, Mr. Whistler. They are fresh with improvisation and inspiration, forming a wonderful jumble of fishing tackle, boatyards, ropes; a confusion of fog, furnaces and swirling wisps of smoke; the complex and profound poetry of a capital city."[5] The notice was no accident. Whistler, the talented young printmaker, also displayed good business sense. In 1858, with his friends Legros and Fantin-Latour, he had already founded the "Society of Three," aimed at promoting and selling their works of art.

Official rejection of Whistler's work inevitably forged his association with the controversial outsiders of the day. His painting *At the Piano,* declined by the jury of the 1859 Paris Salon, found a space at François Bonvin's "Atelier Fla-mand" (Flemish Studio) and won the enthusiastic approval of Courbet;[6] a year later, though, it was accepted by London's Royal Academy. In 1862 the *Young Girl in White* (later called *White Lady* at the 1867 French Exposition Universelle and, subsequently, *Symphony in White, No. 1* and *The White Girl*), was turned down twice by the Royal Academy in London before receiving the same treat-ment from the Paris Salon jury a year later: " *The White Girl* was refused at the Academy!" an exultant Whistler proclaimed in a letter to Fantin-Latour in 1862. In another to George Lucas, he stated, "I am now exhibiting the *White Child* at another gallery, where she is proudly on show to the whole of Lon-don! . . . She looks very distinguished in her frame and is creating real excite-ment here, which either the Royal Academy could not prevent or did not count on. . . . In the catalog it is printed 'Rejected by the Academy.' What do you think of that?"[7] "You're famous," Fantin-Latour wrote to him enthusiastically in 1863 when the Salon des Refusés opened. "Your painting is very well situated where everyone can see it. . . . Courbet called it an apparition. Baudelaire found it charming, absolutely charming. . . . 'Exquisite delicacy,' he says."[8] Stimulated by the kind of publicity his work was generating, Whistler tacked between the Parisian and British aesthetic movements, exhibiting at both the Salon des Refusés in Paris and the Royal Academy in London. (His paintings were shown at the Royal Academy every year from 1859 to 1870, except 1866.)

At a time when portraitists typically depicted women in elaborate chig-nons and crinoline dresses, Whistler's life-size portrait *The White Girl* showed a vulnerable-looking young woman with long, flowing hair. In a long white dress of fluid cambric, with a white lily in her hand, she looks mysterious and inti-mate. The painting shocked and outraged some observers but delighted others.

"This portrait is alive. It is a remarkable painting," exclaimed Fernand Desnoyers.[9] *The White Girl* also won the approval of Duranty, Zola, and Castagnary; the latter noted the Pre-Raphaelite influence on Whistler's style and composition and compared the subject to Titian's virgins, interpreting it as "the bride on the morning after."[10] "Indeed, its rejection by the 1863 Paris Salon," noted Ernest Chesneau, "brought instant celebrity to Mr. Whistler."[11]

Whistler's popularity and fame steadily grew, both in Paris—where he became friends with some of the New Painters, such as Manet and Degas, as well as the new writers and musicians—and in London, where he had bought a house in 1859 and settled in 1863. Whistler established a place for himself in London's cultural scene as well. He organized "Sunday breakfasts" and built up a network of collectors that included his half-brother George Whistler; Thomas de Kay Winans, a colleague of his father; Luke and Alexander Ionides, scions of a Greek family of arms manufacturers; and the British industrialist Frederick R. Leyland, popularly known as the "Medici of Liverpool," and Whistler's brother-in-law, the surgeon Francis Seymour Haden. Sensing that London's art market was ripe for cultivation, Whistler encouraged his friend and fellow artist Legros to join him. Before long, he reported to Fantin-Latour: "Legros has made enormous progress and has produced a great number of beautiful works. He has earned a great deal of money and so will you when you come over to London. The three of us need to be here, but no others, so as not to flood the market! You must come over and set up here during the exhibition—you will be rolling in guineas! In the meantime, here is another commission for you—you must paint two more flower bouquets the same size as the ones you did for Mr. Ionides. You'll get paid 150 francs for each, so paint them at once and you will have the money right away. . . . Do not pass by your growing business opportunities."[12]

Whistler's nose for business as well as self-promotion never wavered. When Fantin-Latour asked him to pose for his homage to Delacroix, Whistler agreed at once. "Of course, Legros and I will come to Paris to pose two weeks before the Paris Salon. So save us two good places," he replied, adding a bit of reciprocal flattery: "Fantin, your painting is going to be so beautiful. . . . I am sure it will draw attention to make you famous."[13] Later, Whistler organized a retrospective of his work in London, inspired by the Courbet Pavilion at the 1855 Exposition Universelle and the 1867 Manet Pavilion. He would exhibit not just one painting at a time as was formerly the practice, but a whole collection. He also went much further than his predecessors: laboring over the presentation of his works, demanding that they be hung in neutral-colored frames, insisting on subdued lighting, supervising the writing of the catalogue, designing the invitations himself, thus orchestrating the entire event. His many talents enabled

him to bypass deftly and completely the tangle of customs that had been the trend during the academic era.

Despite his many talents, the artist, emblematic of a new age, would encounter several setbacks in his career: a very public falling-out with his patron Leyland,[14] and a suit against John Ruskin.[15] Whistler went into bankruptcy and had to accept a commission from the Fine Art Society. Flirtation with the brush would prove invigorating. In just a few months, he produced hundreds of drawings, studies, engravings, and paintings of Venice, giving new impetus to his art, developing what he referred to as a "complete perfection in the art of finish," which was for him "the great characteristic of Whistler shows."[16] He also developed a new signature: a logo in the form of a butterfly, to which he sometimes added, when the mood struck him, a scorpion's stinger.

On February 20, 1885, Whistler gave a memorable "Ten O'Clock Lecture" at the Prince's Hall in London, about his theories on art: "The auditorium was full of artists, critics, and men of letters," recounted Théodore Duret, who went to London especially for the occasion. "The dogmatic part was listened to with surprise by most people, who having so long endured Whistler's alleged eccentricities, could not imagine the genuine and earnest ideas that nurtured his artwork. . . . All the targets of his vitriol were in attendance: critics, journalists, aesthetes. When Whistler alluded to them, the audience recognized exactly to whom he was referring yet they showed their pleasure by laughing loudly. His oratorical skills drew long-lasting applause."[17] Whistler's charm was enough to disarm even his fiercest critics, whom he chided as "Preachers," "Evangelists," and "Dilettantes." In a somewhat elitist manner, he elaborated his new aesthetic suppositions, now similar to those of the Symbolists. "Through . . . the brain of the artist, like through an alembic, is distilled the very pure essence of this [school of] thought. It was started by the gods and they then allowed him to realize it."[18]

The journalists on hand were more interested in the scene than in the substance of Whistler's discourse. By their reports, the audience comprised nearly eight hundred prominent and fashionable figures, including the Countess of Lonsdale, Lady Randolph Churchill, Lady Archibald Campbell, Sir Arthur Sullivan, Lord Wharncliffe, and Lord Rowton—all of whom arrived at ten in the evening, following dinner. "Diamonds flashed, satins gleamed,"[19] wrote one reporter as Whistler displayed "the eccentric genius of an artist,"[20] fluctuating between "paradoxical and cynical comments." Speaking for over an hour with "quite exceptional eloquence," Whistler delivered himself of "an earnest protest against mediocrity and vulgarity,"[21] as his "brilliant arrows of scorn and satire" found their targets among those seated before him. But not everyone writing in the press expressed pleasure with the event, most notably Oscar

Wilde, "in complete disagreement with Mr. Whistler," insisting that "an artist is not an isolated fact; he is the result of a certain milieu and a certain entourage."[22] Relations between the two degenerated after that point. Whistler, who had once greatly admired Wilde, expressed his new disdain in a letter to a newspaper in 1886: "What has Oscar in common with art? except that he dines at our tables and picks from our platters the plums for the pudding he peddles in the provinces. Oscar—the amiable, irresponsible, esurient Oscar."[23]

In 1888, after Monet took Whistler out to lunch in Paris with French Symbolist poet Stéphane Mallarmé—who was impressed by Whistler's ideas about form and color existing on their own in painting, and by his analogies between art and music—Mallarmé translated the "Ten O'Clock Lecture" into French. That same year, Whistler and Mallarmé began corresponding regularly, and they met frequently when Whistler was living in Paris between 1892 and 1895. Mallarmé became his greatest friend and supporter during what would be nearly the last years of Whistler's life (Mallarmé died in 1898, and Whistler in 1903). "From the outset, Mallarmé fell under his spell," wrote Henri de Régnier, "and as if someone had waved a magic wand, by the ebony switch with which this great dandy of painting played so elegantly. Everything about Whistler aroused curiosity and interest in Mallarmé; his mysterious and yet reasoned art, full of nuances and complicated ingredients . . . his wit and ready ability for scorching retorts and cruel replies, which were his weapons of attack and defense."[24] Mallarmé introduced Whistler at the Tuesday night gatherings of the ultra-refined circle of Parisian Symbolist writers: Joris-Karl Huysmans, Octave Mirbeau, Robert de Montesquiou, and Henri de Régnier. "As soon as Whistler starts to speak," Mallarmé wrote, "I no longer dare open my mouth."

After 1880, having "conquered Parisian celebrityhood"[25] and taken London by storm, Whistler set out to conquer the American market. Two of his works were highly praised in the United States: first, *The White Girl,* which became "one of the most celebrated paintings of the age," inspiring an "epidemic of imitations," including those by J. Alden Weir, William Merritt Chase, Cecilia Beaux, Dennis Miller Bunker, Thomas Eakins, and George W. Maynard; and the second, *Arrangement in Grey and Black, No. 1: Portrait of the Painter's Mother,* 1871–72, depicting a peacefully seated elderly woman, shown in profile holding a handkerchief. The latter epitomized Quaker simplicity and was wildly praised; some hailed it as "the American Mona Lisa." Whistler never agreed to visit the United States, not even in the fall of 1883, to escort an exhibition of his works in Baltimore, Philadelphia, Boston, Chicago, and Detroit. Nevertheless a critic spoke of a "contagion," declaring that there was "an entire tribe of Americans singing the praises of Mr. Whistler."[26]

Nevertheless, within two years, relations between Whistler and some of the more conservative American critics would begin to sour. When William Merritt Chase executed a full-length portrait of him with his famous lock of white hair, holding a cane and wearing his signature frock coat, Whistler condemned the result, offended that the painting made him look like a "mannered dandy." Whether Chase intended it to be unflattering or not, Whistler's churlishness emboldened other detractors. He became the object of a particularly unpleasant smear campaign; some mocked him as the "prophet Whistler," an "American by birth," who had "acquired the reputation of an artist who was stubborn, extravagant, subtle, and dynamic."[27] Others condescendingly opined that he was "a reflection of Manet when he paints seriously and relapses from his habitual addiction to tomfoolery, humtongery [sic] and quackery of all kinds."[28] Whistler immediately retorted: "In the American newspapers, which naturally I do not read, I get an impression of unpleasant aggressiveness toward me."[29] Nearly ten years later, he wrote that "American journalists have made it their pleasure, and even their duty, to be as scandalously impertinent, insulting, and unfair as possible toward me."[30] Later, believing art to be universal, he challenged the right of journalists even to refer to an American art. The end of his honeymoon with American critics did not prevent Whistler's work from being steadfastly supported by some of the most progressive American art collectors of the time, whose tastes were unaffected by judgments in the press. They included Isabella Stewart Gardner, Richard Canfield, Charles Lang Freer,[31] Henry Clay Frick, George Vanderbilt, John G. Johnson, and Louisine and Harry Havemeyer.

Paris, London, Venice, Amsterdam, London, Paris, London; Realist, Impressionist, Symbolist; the Royal Academy, the Salon des Refusés, the official Paris Salon, private galleries. Whistler's aesthetic evolution had faithfully followed Parisian artistic currents. In the tradition of Delacroix and Courbet, he choose the "Dutch Route" along with Degas and Manet; then, influenced by the wave of *japonisme*, he refined his painting style, deciding to look for the Beautiful only in nature, through a simple artistic "craving for form and color."[32] Whistler gave his paintings titles such as "Nocturne," "Symphony," and "Harmony," seeking to unite the pictorial aesthetics with that of music, in accordance with Baudelaire's ideas about nature and Mallarmé's quest to create a synesthesia of words, sounds, and colors. In 1894 the French composer Claude Debussy, who greatly admired Whistler's paintings, wrote to a friend while in the midst of composing his *Nocturnes* for orchestra, referring to Whistler's own *Nocturnes* as the inspiration: "They are essentially an experiment in the different combinations that can be achieved with one color—for example, what a study in gray would be in painting."[33]

By the time Whistler reached his mid-fifties, he expressed his frustration at the lukewarm reception the French government had given his work. In 1891 (when he was fifty-seven), the Glasgow Art Gallery in Scotland bought his *Arrangement in Grey and Black, No. 2: Portrait of Thomas Carlyle* for £1,000. It marked the first time one of his works had entered a public institution, but Whistler remained unsatisfied. He dearly wanted the French State to acquire *Portrait of the Artist's Mother*. Mallarmé resolved to come to his aid and, together with art critic Théodore Duret, Montesquiou, and the radical deputy Georges Clémenceau, sought support from their political and social connections to persuade Henri Roujon, the French minister of fine arts, to act. The painting was transported from London to Paris and exhibited at the gallery Boussod, Valadon & Company. As Whistler impatiently awaited a decision, he considered setting up a fund to have the painting bought by a private group of art lovers. Then came encouraging news. "I am for the moment seated at this café with Mallarmé," he wrote to his wife. "The Luxembourg is I believe not so far off . . . for a close friend of Mallarmé holds the post of Ministre des Beaux-Arts."[34]

Finally the news arrived: "The Minister will come on Friday." Indeed, Minister Roujon, accompanied by Clémenceau, visited Boussod, Valadon & Company to see the painting. A few days later, Montesquiou was able to inform Whistler that "the Minister made [him] the object of an operation that involved an exceptional fortune, of the most flattering sort. . . . Everything ended well and your reply to the Minister was perfect."[35] That very same day, Théodore Duret received a letter from Roger Marx: "The minister will sign a waiver in the amount of four thousand francs to purchase *Portrait of My Mother* for the Musée du Luxembourg; I was given formal assurance and also was told that a new letter would be written to Whistler that would satisfy his understandable pride in the matter."[36]

The French press announced the news on their front pages. *Le Figaro* rather clumsily congratulated the museum for having acquired a specimen of that "curious contemporary English school." *Le Gaulois* reported that Whistler had with "infinite graciousness and selflessness sold—one might even say given—his painting to the French State."[37] Indeed, Whistler couldn't have cared less that what he got from the sale was a quarter of what the Glasgow Art Gallery had paid him for his *Portrait of Thomas Carlyle*, which he considered a lesser work. What counted for him was that the French government had bought it; he was happy.[38] The following year, Whistler was named a Chevalier of the Legion of Honor, after an exceptionally short period of consideration, thanks to the help of Montesquiou. "I'll scarcely be able to give you an idea of the importance it has here," he exulted to his wife. "In England they don't have

the slightest idea." Quoting a friend, he added: "Here it is a very great honor, especially in the field of Art, for it opens all the doors, 'assuring your future,' to money and that means a fortune!"[39] In a letter to an English friend, he could barely contain his satisfaction or his sense of humor, which had returned in full bloom: "How nice to have been insulted in England only to be covered with honors in France! Fancy! had it been t'other way about!!! What a fool's Paradise one would have lived in."[40]

When his painting was hung in the Musée du Luxembourg, Whistler refused to be classified among the "foreign artists." At the same time, though, Pissarro was celebrating him as "the only artist that America can boast about with any justification."[41] "For ages now," Whistler had declared in 1862, "art has not had a nationality."[42] Indeed, Whistler's name was never associated with the landscape painters of the Hudson River School, among whose works he had exhibited in the United States pavilion at the Exposition Universelle of 1867. "There is no such thing as English art," Whistler wrote to his friend Henry Labouchère. "Art is art and mathematics is mathematics. What you call English art, is not art at all, but produced of . . . an excellent army of mediocrity . . . they are not commercial travelers of Art."[43]

Whistler was no ordinary American painter. The man who at twenty-nine gazed back defiantly in Fantin-Latour's *Homage to Delacroix* never lost his drive or his biting edge. He was the first American painter to enter the circle of new French artists—and he stood out among them. Resolutely independent, he never allowed himself to be defined by institutions or by aesthetic movements, going even further than Courbet and Manet in declaring his distance from the world of officialdom. He achieved his success by dint of his gifts as a painter, engraver, and theorist, to be sure, but no less so through his talents for business and self-promotion, turning his career into a work of art and making his presence felt on the French, English, and American art markets. He was the modernist artist par excellence, the first to dare negotiate the breach between the academic system and the private dealer.[44]

Two "Cosmopolitan and Cultivated" Americans

A MONG THE AMERICAN PAINTERS living in Paris, one group remained resolutely immune to the seductions of official French art, refusing to be taken in by the system: these were the women. Female artists accounted for a quarter of all American artists in Paris—a higher proportion than was the case among their French counterparts—and included Emily Sartain, Eliza Haldeman, Alice Kellogg, Mary Cassatt, Sarah Chapin, Cecilia Beaux, Elisabeth Adams, Lyle Durgin, Mabel Blake, Ada Philbrook, Katherine Cohen, Lucy Lee-Robbins, Elizabeth Gardner, Louise Bachmann, Lila Cabot Perry, Ida Burgess, Elizabeth Nourse, Amanda Brewster, Mary MacMonnies, Adeline Albright, and Kate Augusta Carl. In France, women artists were not admitted to the Ecole des Beaux-Arts,[1] whereas, thanks to the feminist movement in the United States, they enjoyed equal footing with men in their access to education. At the Pennsylvania Academy of the Fine Arts, all classes were open to women artists; and by 1860 they could attend the same studios as their male colleagues, except for classes employing nude models. For that, they would have to wait another eight years.

Despite the inequality of opportunity in France, those women were no less aware than the men who went abroad that Paris was the center of the artistic universe, an indispensable stop in serious art training. Most came from wealthy families in Philadelphia, New York, or Boston, and wanted to be full-time professional artists.[2] Their fathers were typically influential in their communities: Mary Cassatt's father, Robert Simpson Cassatt, was a banker; Eliza Haldeman's, a professor; and Emily Sartain's, a prominent journalist. Their mothers had generally been raised in accordance with Victorian ideals. In France, they found that women painters seemed to owe whatever status they enjoyed to the fame of their teacher—for example, Eva Gonzalès to Edouard Manet, and Berthe Morisot to Corot.[3] The Americans were taken aback by the antifeminist

attitudes prevalent in Paris. A recurring complaint could be heard about the vulgarity of their male colleagues. "One evening," Alice Kellogg wrote to her parents, "Ida, Page, Carie, Adele, etc., were touring the studios with Monsieur Colarossi. This was not pleasant, I can assure you. I would not nor could not advise any woman from whatever good family to come here. If you do not know a word of French, that might be acceptable, but these French men are not decent."⁴

Even far more insidious than bad manners, however, was the prevailing view in France that women painters were merely engaging in a frivolous diversion, a sophisticated pastime for the leisured rich.⁵ As a consequence, they were forced to pay higher fees: if a man could study at the Académie Colarossi for sixteen francs for instance, it cost a woman twenty. For the same access to Carolus-Duran's studio, men paid thirty francs, while women paid one hundred. "We have to recognize right from the start," wrote one American woman, "that living in Paris costs more for a woman than for a man. In some studios, the fees are double what the men pay."⁶

Against the fervent wishes of her father, Mary Cassatt left her family home in Philadelphia for Paris soon after the American Civil War ended. "I would rather see you dead," he had told her. After a year of private lessons in Paris at Gérôme's and Chaplin's studios, and some months spent with her friend Eliza Haldeman in artist colonies near Fontainebleau and Barbizon, choosing the path of independence, Cassatt began systematically to study the paintings of the masters in the museums throughout Europe. Without benefit of any patronage whatsoever, she managed on seven occasions to get her work—genre scenes popular at the time, and portraits—accepted into the Salon and often exhibited "à hauteur de cimaise"—in the choicest locations. Amazingly, less than two years after her arrival in Europe, Cassatt exhibited *The Mandolin Player;* four years after that, *During the Carnival;* and, in the years that followed, *Spanish Scene* and *Portrait of Madame C.* Despite her success during this period, Cassatt signed her works "Mary Stevenson," using her middle name, for fear of bringing shame to her family.

Cassatt viewed her return to Philadelphia in 1870–71 as an "American exile." So much was lacking; her native city had no collections of masterworks, no good models, no provocative art scene. Accompanied by her friend Emily Sartain, she went back to Europe, determined to visit all its museums systematically, and to copy the works of her favorite painters: Velázquez, Murillo, Goya, Rubens, Hals, Parmigianino, Correggio. "Painting doesn't teach itself," she once said. "One doesn't need to take lessons from a master. What the museums have to teach will suffice."⁷ Armed with a commission from the Bishop of

Pittsburgh to paint copies of two Correggio paintings in Parma for Pittsburgh's cathedral, Cassatt traveled to Parma at the beginning of 1872. Although Parma was a second-rate city in the realm of the arts, the absence of other foreigners allowed them to take an active role in the local life. "Emily will miss a dinner with Verdi," Mary wrote on April 1, 1872. "The best thing for me is to stay in Parma for a while."[8]

In October, Cassatt went to Seville and lived in the Casa de Pilatos, the palace belonging to the dukes of Medinaceli built in 1520, with its brightly colored tiles and splendid gardens. "If you leave Paris in January," she wrote Emily, "it will be like coming to Paradise."[9] In Seville, she found herself in the company of contemporary Realist painters such as Raimondo di Madrazo and Mariano Fortuny, and copied works by the great Spanish masters, such as Velázquez, Murillo, and Goya. Cassatt preferred their directness and bold colors to the "washy, unfleshlike, and grey" paintings by French artists such as Cabanel and Bonnat.[10] After Seville came stays in Antwerp, Amsterdam, Bruges, and finally Rome—"a beautiful place, [which] stinks, is dirty, melancholy, but still fascinating."[11]

Were her originality and dynamism a direct result of her refusal to compromise, a defiance against prescribed Victorian gender roles, a sheer consequence, in other words, of her energetic determination? "There is someone who feels as I do," Degas told his friend Léon Tourny as they stood before a work of hers at the Salon of 1874.[12] Three years later, Tourny introduced Cassatt to Degas, who invited her to join his group of promising young painters, advising her to follow his more "orthodox" model of independence. "Degas told me not to send any more work to the Salon and to exhibit with his friends in the Impressionist group," she recalled much later. "I joyfully accepted the offer. Finally, to be able to work in absolute independence and without worrying about what the jury's opinion will be, I had already recognized which would be my true masters. I admired Manet, Courbet, and Degas. I hated conventional art. I was beginning to live."[13] Cassatt helped organize the fourth Impressionist exhibition of 1879, when the French press began to celebrate her work. "There is not one painting or pastel by Mademoiselle Mary Cassatt that is not an exquisite symphony of colors," wrote one critic. "There is nothing more graciously honest and aristocratic than her portraits of young women."[14] "Monsieur Degas and Mademoiselle Cassatt are perhaps the only artists to distinguish themselves among this group of 'dependent' independents," wrote another. "Both have a lively sense of the scattered light in Parisian apartments and use original color nuances to render the skin tones of women wearied by long nights."[15] Cassatt continued to collaborate with Degas, work-

ing with him on the journal *Le Jour et la Nuit* (Day and Night), which was never published.

Cassatt's family provided more than material support. Her father, mother, and sister joined her in Paris in 1877, and were initially quite suspicious of the local "American colony" and its "petty scandals."[16] Everybody pitched in to further Mary's career—father, mother, sister, brother, sister-in-law, nephews, niece. They posed as models, kept themselves informed about the local artistic life by reading *Le Figaro,* went to the opera, visited art exhibitions, critiqued paintings, corresponded with people around the world, solicited help from family friends in the United States, and sold her works (as well as those by her friends Degas, Monet, and Morisot). In fact, for all the excellence of her own work, Cassatt's greatest legacy to the world of art may in fact be her persuasive championing of French Impressionism, which inspired and catalyzed not only her own family but innumerable American collectors.

"I was sixteen years old when I first heard of Degas, of course through Mary Cassatt," Louisine Havemeyer, née Elder, wrote in her *Memoirs.* "She took me to see one of his pastels and advised me to buy it. . . . The drawing of the picture was as firm as a primitive . . . the beauty of the colors was simply entrancing. It was so new and strange to me! . . . Miss Cassatt left me with no doubt as to the desirability of the purchase and I bought it upon her advice."[17] It was in June 1874, soon after the first Impressionist exhibition, that Cassatt met the determined, curious, passionate, and altogether unconventional Louisine Waldron Elder, then nearly nineteen years old, through Emily Sartain. Elder started collecting right after their first encounter. She liked a Degas pastel, *Ballet Rehearsal,* which cost five hundred francs, and, borrowing the money from her two sisters, she quickly made her first purchase. Next, she bought Monet's *Drawbridge in Amsterdam* for three hundred francs, and then *Young Women Peasants in Normandy,* a fan painting by Pissarro. A little later, she was dazzled by Courbet's work displayed in the lobby of the Théâtre de la Gaîeté. "Mary praised Courbet so highly," Louisine later wrote, "that I immediately felt tremendously curious to see all of his paintings."[18]

In London that summer, at an exhibition at the Grosvenor Gallery, Louisine found herself strangely drawn to a painting by an artist named Whistler. She wrote to the painter, who extended an invitation to his home. He was, she recalled, "restless, excitable, with a burning intelligence concentrated in his piercing black eyes."[19] He searched through a portfolio and pulled out five pastels that he had done in Venice. "Do you like the black paper as a background?" he asked her. "It has a value, hasn't it? But it sets the critics by the ears, you know they think I'm mad. . . . I call that *Nocturne.* Do you like the

name? . . . Do you know the critics hate me so they are using themselves up trying to get back at me?"[20]

Besides Louisine Elder, Cassatt advised her own brother Alexander Cassatt about what art to buy, and was often asked by the Durand-Ruel family—who were already representing her work—for counsel regarding American clients. On May 24, 1897, "a certain Mr. Beatty, director of the Carnegie Museum," in the process of appointing three painting juries, arrived at the Durand-Ruel gallery. "Do you know him and can you influence his choice?" the art dealer wrote to Cassatt. "I do not know him," she replied, "but I'll go with you to see him. I would be happy to, and if I can do something to advance art in the city of Pittsburgh, I'll do it."[21] On July 20, 1899, Joseph Durand-Ruel, one of the dealer's three sons, wrote to her again: "One of my clients, Mr. Milliken of New York, saw a Velázquez at Bourgeois's, *The Infante d'Espagne,* showing a nurse and a dwarf. You went to Bourgeois's last year with Miss Hallowell. Is this the same painting? Is it the same theme? Is it worth recommending? My father is not here at the present and so I thought I'd ask you." Cassatt replied by return mail: "The Bourgeois Velázquez [was] a simple joke; if I thought it had the slightest value, I would have immediately recommended it to Mr. Have-meyer."[22]

During this same period, J. Alden Weir kept up his Parisian chronicle by writing to his family. "Sargent is one of the most talented fellows I have ever come across," he wrote on one occasion. "His drawings are like old Masters and his color is equally fine. He was born abroad and has not yet seen his country. He speaks as well in French, German, Italian, as he does in English, and has a fine ear for music. . . . Such men wake one up and, as his principles are equal to his talents, I hope to have his friendship."[23]

As Weir demonstrates in these few lines, John Singer Sargent's arrival in Paris did not go unnoticed. Indeed, one would have thought the prodigal son had returned. The Sargent family letters, the private diaries of the artist's friends, and various other eyewitness accounts all virtually memorialize the event—the circumstances and date of his arrival, his age, his choice of a studio—and allow us to follow in close detail the effect that Sargent's coming played on the Parisian art world. He whom Rodin would later call "the Van Dyck of our times,"[24] and who would become the official portrait painter of the White House, had perhaps the most exceptional trajectory among all the American painters of that time.

Sargent's success as a worldly portrait painter drew principally on two main assets: his talent and his family. The son of American emigrés, he received his early artistic training in Florence, where he was born, and then in Dresden. Inevitably, the Sargents made their way to Paris.[25] Getting their son into a

proper studio seemed to be a family mission. "Everyone says that Paris will be the best place to find such advantages as we would like to give him," Fitzwilliam Sargent wrote to a lawyer friend in Boston in April 1874, "and consequently we propose to . . . remain there as long as the weather and other circumstances permit. And perhaps we may even venture on a winter there. If you can get him into the Atelier of some first rate painter we flatter ourselves (perhaps it is a parental delusion) that he will make something out of himself more than common."[26] Sargent himself, sounding slightly more blasé, explained to an acquaintance in Florence, "We hear that the French artists, undoubtedly the best nowadays, are willing to take pupils in their studios."[27]

In the first week of May 1874, the Sargents left Florence, arriving in Paris on the sixteenth. A mere four days later, thanks to a chance encounter with Walter Launt Palmer, an American friend of John's, the vitally important search for the right studio and the right teacher was accomplished.[28] Palmer was studying with Carolus-Duran, a teacher he praised as genuinely interested in his students' work; for Palmer, like his friend a fellow of quality, it did not hurt that Carolus-Duran's studio was more elegant than others. Still, though late for registration, Sargent dithered over his choice: should he follow the trend and, like so many other American painters, flock to Jean-Léon Gérôme? "I admired Duran's pictures immensely in the salon," he wrote a friend, "and he is considered one of the greatest French artists. With Gérôme's pictures, I was rather disappointed, they are so smoothly painted, with such softened edges and such a downy appearance as to look as if they were painted on ivory or china. Their coloring is not very fine either."[29] Carolus-Duran was more independent, everybody admitted; in Sargent's mind, that settled the matter.

The Sargents spent the rest of their first week in Paris looking for an apartment and visiting the museums. On May 26, the artist and his father went to visit Carolus-Duran's studio. It was no ordinary first day, according to Will Hicok Low, who was already enrolled there: "He made his appearance at the Atelier of Carolus-Duran almost bashfully, bringing a great roll of canvases and papers, which unrolled displayed to the eyes of Carolus and his pupils gathered around him: sketches and studies in various mediums, seeming the work of many years; (and John was only seventeen) . . . an amazement to the class. . . . The master studied these many examples of adolescent work with keenest scrutiny, then said quietly: 'You desire to enter the atelier as a pupil of mine? I shall be very glad to have you do so.' And within days he had joined the class."[30]

Carolus-Duran was himself only thirty-six. But perhaps because he was known to be suspicious of the official system, the majority of French students, hungry for academic validation, unlike their English and American counter-

parts—avoided his studio. His new student Sargent, for his part, was not too young or cautious to recognize the benefit of tutelage under "a young and rising artist . . . with a very broad, powerful and realistic style,"[31] and already one of the most promising portrait artists of the Third Republic. Under his influence, Sargent began painting directly on canvas and playing with aesthetic techniques in a manner that was not merely flexible, but nearly avant-garde. "Velázquez, Velázquez, Velázquez, never stop studying Velázquez," Carolus-Duran told his students. It was a fine balance of rigor and freedom. As Low recalled, "we were all, no matter what . . . , given a model, a palette and brushes, and told to render what we saw."[32]

The following years confirmed for Sargent how fortuitous his choice of teacher had been. He had managed to bypass the deadening duties, abuses, and rituals of the Ecole des Beaux-Arts, and found a private studio infinitely more democratic. "Our revolutionary atelier was, in point of fact, one of the quietest places of study in Paris," Low wrote in his memoirs.[33] Carolus-Duran worked with his students twice each week, devoting time to each one. "He generally paints a newcomer's first study, as a lesson," wrote Sargent, "and as my first head had rather too sinister a charm, suggesting immoderate use of ivory black, he entirely repainted the face, and in about five minutes made a fine thing out of it, and I keep it as such."[34]

Sargent remained with Carolus-Duran four years, garnering medals, prizes, and fame. Everything came easily to him. Every new American to arrive in Paris soon heard about "a wonderful fellow pupil, a Boston boy named Sargent, a painter who was the envy of the whole studio and perhaps a bit the envy of Carolus, himself," recalled Edwin Blashfield. "There was not any story of his painting as did Da Vinci for Verrocchio in the latter's picture [sic], nor was he as yet a Michelangelo so overtopping his master Ghirlandaio, but all the same we watched his growth and wondered whether Carolus were teaching him or he were stimulating Carolus."[35] Sargent also joined the drawing class of Adolphe Yvon at the Ecole des Beaux-Arts, in order to work on his drawing technique. A year later, his work was chosen from among that of three hundred candidates for second prize and the silver medal. "It was," wrote his proud father, "the first time that any American has passed so high."[36]

Almost twenty years after Whistler and ten after Cassatt, a third American to the manor born was making a glittering entrance on the Paris scene. When Whistler and Cassatt had arrived, the French art world was racked by tensions and upheavals, and they struggled from the margins among other controversial artists rejected by the Salon, participating in decidedly new aesthetic experiments—Whistler by default, Cassatt by choice. Arriving in 1874, the year of

the first Impressionist exhibition, Sargent strategically decided to take a more conventional road, the official one, by now no longer the only one, and therefore of easier access. After winning his medal at Ecole des Beaux-Arts, he made his first submission to the Salon jury: *Miss Frances Sherborne Ridley Watts,* a likeness of a wealthy American woman clothed in red and black, in the fashion of the Italian Renaissance; followed in 1878 by *The Oyster Gatherers of Cancale,* a genre painting of a Brittany beach—both works in perfect harmony with French tastes of the time. Recognizing the popularity of genre painting, as well as of landscapes and portraiture, Sargent had assimilated with lightning speed the vocabulary, grammar, and rhetoric of the Salons.

Sargent's bravura performance remains his portrait of Carolus-Duran, which he submitted to the Salon of 1879. In this ironic and energetic painting, Sargent captures all the creative dynamism of his teacher, even while presenting him in elegant, one might say dandyish, attire. Dedicated "A mon cher maître M. Carolus-Duran," it is signed "his affectionate student John S. Sargent. 1879." The painting," wrote Blashfield, "took us all by storm."[37] Sargent's father, as involved in and attentive to his son's career as ever, also marveled at the canvas: "There was always a little crowd around it, and one heard constantly remarks in favor of its excellence."[38]

Portraits of artists were then all the rage in Paris, but never before had a student had the audacity to turn his master into his model, or a teacher consented to pose for one of his students. It was a risky gesture, but Sargent pulled it off triumphantly, at the age of twenty-three. The painting earned him an honorable mention at the Salon and was reproduced on the cover of the magazine *L'Illustration.* Some mischievous American critics, such as a writer for *The Art Amateur,* used the occasion to throw darts at the French. "John S. Sargent is, or was, the favorite pupil of Carolus-Duran. The accomplished Frenchman used to be very proud of him. But if our Sargent continues, as he is doing, to win from the critics abundant praise, while his master receives nothing but blame—well, I'm afraid he'll get himself disliked."[39] Other more serious commentators, however, perceived, in the role reversal represented in the portrait, a sign of America's coming of age, and of a revolutionary change about to occur. A number of American critics rejoiced at the idea that one of their own had gone so far as to "eclipse his master."[40]

Every year for the next five years, Sargent sent one or more of his works to the Salon, mostly portraits, but also genre paintings based on trips to Spain, Italy, Brittany, and North Africa. One painting, *El Jaleo: Dance of the Gypsies,* exhibited in the Salon of 1882, depicted a vibrant, sensual gypsy dancing in a Madrid café. A few critics felt Sargent had done Manet one better, and even

John Singer Sargent, the prodigy of American art, eclipsed his master, Charles Carolus-Duran.
But his *Portrait of Madame X* (*Madame Pierre Gautreau*), 1884, shown here in his studio,
provoked a scandal that forced him to leave Paris.

that the work was worthy of the Spanish master Goya. With that effort, according to an English critic, Sargent became "the most talked about painter in Paris."[41] Beyond his talent and masterly technique, it was Sargent's surprising audacity that the public most admired. Inexorably, year after year, achieving triumph after triumph, the young prodigy continued his seemingly unstoppable Parisian career. In 1884, however, his *Madame Pierre Gautreau* (*Madame X*), exhibited at the 1884 Salon, received devastating notices. Sargent had enjoyed the game by testing the limits of French taste again and again, surprising viewers, intriguing and shocking them. It proved a dangerous game of escalating stakes.

"Detestable! Boring! Curious! Monstrous!"[42] For the young genius who had "eclipsed his master," "equaled Goya," and "surpassed Manet," for this "new Michelangelo or nearly so," these were painful words. The subject of the portrait, Virginie Avegno Gautreau, was presented in profile, her shoulders bare, her pose distinctly artificial and provocative. Born in New Orleans, Gautreau was a dolled-up demimondaine who had married a French banker. She, too, thrived on shocking society. For both artist and model, two singular

individuals, the encounter inevitably ignited sparks. In "homage to her beauty," he wanted very badly to paint her. She took him a little too far.

Louis de Fourcaud recognized in Sargent's portrait another critique of Parisian society, but he felt that this time the painter hadn't pulled it off. To paint this "demi-mondaine à la mode," this "parvenue," Sargent had "tried to look beneath the artificial trappings and find the natural, tried to have the woman's true personality emerge from beneath the various disguises." That, Fourcaud added, "made everyone crazy. There are very few portrait artists who could have succeeded at doing that, and in their effort to please their clients, most of them would have ended using a formula."[43] Indeed, Sargent's *Madame X* was the exact antithesis of Whistler's *Young Girl in White*—the artificial woman in contrast to the natural one. "Is Mr. Sargent in every fact an American painter?" Henry James asked.[44] "Was he an Impressionist? A Realist? A great artist?"[45] Such questions were posed then, and are still being posed today by critics and art historians. One of them wrote that he had chosen his own path, which lay someplace "between modernity and tradition."[46]

In 1886, after extended visits to England in 1884 and 1885, Sargent left his studio on the rue Notre-Dame-des-Champs and, following in Whistler's footsteps twenty-five years later, moved to London. Having taken the best possible education from Paris, he claimed that London would serve better as a place to meet with American clients. He returned to Paris only occasionally, stopping there, for example, in 1885–86 on the way to visiting Monet in Giverny. Swiftly, Sargent attracted in London the rich clientele he was indeed looking for. "John Singer Sargent, An Educated Cosmopolitan,"[47] *The Art Amateur* magazine dubbed him a few months after his arrival in a flattering profile. Strangely enough, unlike Whistler and Cassatt, Sargent was never chided for abandoning his homeland for Europe. Perhaps his "more classical" aesthetic inoculated him?

Whistler, Cassatt, and Sargent: these Europeanized members of the American "aristocracy" seem to us like characters that spring directly from the pages of Henry James's novels. "We can deal freely with forms of civilization not our own, . . . and in short . . . claim our property whenever we find it," James wrote. Although they were not contemporaries, Whistler, Cassatt, and Sargent prefigured painters of a new type. In their mobility and cosmopolitanism, they represented the freedom of the twentieth-century artist, gliding comfortably from one culture to another, one language to another, one continent to another. Decorated and celebrated, they carried throughout their lives both an affection for Europe and an elitist condescension for America.

Naturally enough, relations among them were not immune to jealousies, tensions, or rivalries, with Sargent usually the object of resentment. Imagine

Whistler as the French government was arranging to acquire Sargent's *La Car-mencita* for the Musée du Luxembourg at the very moment it was being cajoled to take his own *Portrait of the Artist's Mother,* painted almost twenty years earlier. The thought may have clouded Whistler's judgment during his visit to the Salon of 1891; seeing Sargent's *Portrait of a Boy,* which was "supposed to be a masterpiece," Whistler wrote to his wife that it was simply "horrible!"[48] In 1903, four years after becoming president of the Pennsylvania Railroad, Alexander Cassatt commissioned Sargent to do his official portrait. But several years later, when he approached Sargent to paint a portrait of his wife, Lois Buchanan Cassatt (niece of James Buchanan, the fifteenth president of the United States), he found that Sargent had become the official portraitist of American celebrities—presidents, Rockefellers, and Vanderbilts—with his efforts priced accordingly. Alexander Cassatt could no longer afford Sargent, so he turned to Whistler. The portrait was delivered two years later.

Eleven

Getting In: Legions of Honor, Honorable Mentions, and Third-Class Medals

"MY FATHER'S CHECKS have been coming in longer intervals, and I'm pulling the devil by the tail. Such a situation is too normal in my circle to pay any attention to it. . . . I've seen young French students stay in the studio at dinner and eat the bread crusts we were using as erasers. I have never heard them complain. Their absorption in their work and the promising future makes these matters insignificant. Besides, in the world of students, like in the Orient, poverty doesn't turn you into a pariah."[1]

Like most other young American painters in Paris, Harry Siddons Mowbray had no private fortune to draw upon. Daily life could be miserable. A benefactor was required to finance their trips and cover the cost of their studies, as an alternative to family support. The majority of them came from working families, and going to Paris entailed great sacrifice, huge economic risks, and, for most families, an untenable burden, and was considered a hazardous detour from professional life. The immediate goals of these artists remained elemental: to find a painting master and gain admission to the Salon.

Even as late as the 1870s, with the pillars of officialdom shaken by Viollet-le-Duc and others, the Beaux-Arts teachers, arts administrators, and academic painters embodied prestige and legitimacy and justified the sacrifices for most young Americans and their parents. The "independent" artists and the new aesthetic movements were regarded with great suspicion, and even seemed to some a menace. "We cannot in fact understand the purpose of the new school," one local American newspaper complained in 1879. "It is founded neither on the laws of Nature nor the dictates of common sense. We can see in it only the uneasy striving after notoriety of a restless vanity, that prefers celebrity for doing ill rather than an unnoted persistence in the paths of Art."[2]

As always, students who managed to get into the Ecole des Beaux-Arts and to become the disciples of Gérôme, Cabanel, or Bouguereau set their sights exclusively on having their work accepted into the Salon. Striving for that singular goal, they kowtowed incessantly to their teachers, in slavish imitation, and focused their energies on conforming rather than inventing. Captives of their ambition, with no margin for error, they toed the official line, wrapping their work in its rhetoric. To criticize it was to enter dangerous waters; to embrace the New Painting was to run one's ship aground. Most were pretty well programmed to express contempt. "I went across the river [and saw] a new school [of artists who] call themselves Impressionalists," J. Alden Weir wrote his parents on April 15, 1877. "I never in my life saw more horrible things. They don't observe drawing nor form. . . . Worse than the chamber of horrors. . . . I stayed fifteen minutes, I paid one franc for the entrée. . . . I was mad for two or three days not only for having paid money, but also for the most demoralizing effect."[3]

It was the "unlucky ones," the majority of Americans rejected by the Ecole des Beaux-Arts, who would be forced to cultivate flexibility and independence, whether in the studios of the more liberal Rodolphe Julian or Thomas Couture, or in the artist colonies of the Fontainebleau forest or in Moret-sur-Loing, Marlotte, Barbizon, Grez-sur-Loing, or Milly-la-Forêt. Such was the experience of William Morris Hunt, Robert Vonnoh, William Hicok Low, Edward Wilbur, Dean Hamilton, Edward Henry Potthast, and others in the 1850s and 1860s. During the 1870s, a third generation of Americans worked around Jules Bastien-Lepage, influenced by his Realist approach. When Bastien-Lepage spotted Alexander Harrison's *Castles in Spain* at the 1882 Salon, he immediately recognized in it a shared "idiosyncratic loyalty" to nature.[4] By this time, even the officially anointed could be won over. Harrison began working with Bastien-Lepage, whom until then he had considered his master. Later in the late 1880s, a colony of American painters would gather in Giverny and work near Monet.

By the mid-1870s, whether working inside or outside the official system, the Americans in Paris were experiencing something quite different from their humiliation at the 1867 Exposition Universelle. Diligently directed and motivated, most of them progressed rapidly. The very academic traditions so harshly attacked by Viollet-le-Duc had become a "how-to" for most of them. If slavish imitation of French masters was the narrow path to artistic success, then slavishness it would be. They patiently adopted the inviolable commandments of French art training at the very moment these principles were beginning their inevitable decline. Canny, pragmatic, they rose to the challenge,

strategically producing twice as many genre paintings as landscapes in the ten years since the drubbing of the Hudson River School landscapists.

The number of American painters in Paris grew from several hundred during the Second Empire to several thousand by the beginning of the Third Republic. During the course of the last three decades of the nineteenth century, more than a thousand American artists exhibited nearly 4,500 works of art in the Salons, thus proving their desire to be legitimized by the official authorities.[5] They were by far the largest foreign contingent to exhibit at the Salon of 1885, and starting in the 1890s they accounted for a fourth of all foreign painters living in Paris.[6] Some, like the portraitist George Healy, would show at the Salon for nearly fifty years; Daniel Ridgway Knight would remain in Paris for nearly twenty-seven years, Frederick Bridgman for twenty-four, Alexander Harrison for twenty, Frank Boggs for nineteen, and John Singer Sargent for eleven.

American artists traveled, inquired, and came to understand exactly what the Salon juries were looking for. They threw themselves into genre painting, although the subjects they undertook were the furthest imaginable from their own cultural experience, resulting in more than a few amusing incongruities. The following list represents a selection of their efforts. Lewis J. Shonborn (born in Nemora, Iowa): *Stables Interior; Clearing the Mists; The Mower; Tunis Prison Door* and *Arab Encampment*. John Smith-Lewis (born in Burlington, Alabama): *Harvesting Kelp; After the Shower: The Shipwreck in the Bay at Saint-Malo;* and *On a Pilgrimmage to Méné*. Elizabeth Nourse (born in Cincinnati): *In the Barbizon Sheepfold* and *Arab Interior at Biskra*. Eanger Irving Couse (born in East Saginaw, Michigan): *Woman Watching the Herd* and *Unloading the Boats*. Louis Paul Dessar (born in Indianapolis): *Menders of Fishing Net; Fishermen's Return;* and *Sunday in Etaples*. Anna Elizabeth Klumpke (born in San Francisco): *Cowshed Interior at Jaccournassy* and *Marguerite at Spinning Wheel*. Albert Humphreys (born in Cincinnati): *Breton Interior*. Frank Boggs (born in Manhattan): *Unloading the Crab Boat at Dieppe; The Djama-Kibir Mosque; March Downpour;* and *On Paris' Quai Henry IV*. Clement Swift (born in Acushnet): *Ocean Plunderers*. Burt Nicholls (born in Buffalo, New York): *Pont-Aven (Finistère) Cabbage Seller*. Charles Courtney Curran (born in Sandusky, Ohio): *Leaving for a Promenade*. Frank W. Stokes (born in Nashville, Tennessee): *Etaples Interior*.

French farmers became their favorite subjects. Americans had an eye for French peasantry since the 1850s, when works by the Barbizon painters first became popular. In the Realist vein, Robert Wylie and Henry Mosler painted French laborers and their desperate working conditions in the 1860s and 1870s.

Wylie's *The Fortune-Teller in Brittany* (also called *The Breton Witch*) is a dark work in which the style of the Flemish Realists is used to depict one of the country's ancient and mysterious rites. Equally harsh and unadorned is Mosler's *The Return*, a heartrending scene of a runaway child reunited with his family.

A few, including Daniel Ridgway Knight, present a more idyllic view, picturing Brittany as an idealized world, superficial and prettified, designed for the tourist gaze. *The Washerwoman, Dinner During the Rainy Season, The Harvest, The Gossipers, The Shepherd's Friends, The Lazy Girl, The Shepherdess of Rolleboise* all present peasant life as simple rustic enjoyment. "These peasants are as happy as any in the world. Of course they work hard," Knight said, "but they're not the only ones who do."[7]

By 1889, the number of American landscapes had diminished considerably, accounting for no more than a fourth of the paintings that Americans produced in Paris (and landscapes of their native land, a mere 10 percent). Harrison, Picknell, Vonnoh, and Walter Gay, influenced by new trends—particularly Impressionism—were hailed by some French critics favorable to this new movement. They had begun to introduce into their works such technical innovations as the visible brushstroke, which was transforming the texture of the painting's surface. One critic wrote of the "brilliant audacity" of Picknell's *The Road to Concarneau,* another of its "dazzling aesthetic," which while it did not dilute color in the manner of the Impressionists, nonetheless offered a new direction.[8] What is particularly intriguing about their critical success was that it drew upon a convention of American landscape painting, emphasizing other-worldly, atmospheric realism over the starkly pictorial, and using straight-line techniques of the earliest American painter-engravers. The originality of Alexander Harrison's formal approach in *The Wave* and *Solitude* likewise impressed the French critics. Of all the American painters exhibiting at the Paris Salons—Sargent and Whistler included—Harrison was the most acclaimed. One began to hear somewhat surprising commentaries on both sides of the Atlantic. An American critic who saw the French painter Frédéric Montenard's *The Grand Road to Toulon* in a New York gallery perceived a connection to Picknell's *The Road to Concarneau,* which contained, he argued, the same "sunny beauty."[9]

Albert Bierstadt, an unreconstructed paragon of Yankee stubbornness, continued to ship his enormous canvases to France, still refusing to paint anything but American landscapes. *Storm in the Rocky Mountains* followed *Mount Whitney,* and then came *The Buffalo Hunt.* While others of his generation managed to incorporate elements of French taste into their work, Bierstadt would not even pretend to.[10] Not surprisingly, neither medal nor glowing

review would come his way during his time in Paris. And when the American selection committee for the 1889 Exposition Universelle decided not to include his works, it marked the end of an era. Fittingly, *The Buffalo Hunt* was the final painting by Bierstadt displayed at the Salon—the last of its breed.

The finest American portrait painters remained Sargent, Whistler, Cassatt, Cecilia Beaux, Lucy Lee-Robbins, Elizabeth Nourse, and Anna Elizabeth Klumpke, all of whom infused elements of genre works into portraiture. This was especially the case when artists painted artists, thus creating a realm in which to plot one another's relative positions in a symbolic context. In Adolphe Yvon's studio at the Beaux-Arts, Sargent did a small pencil sketch of his friend J. Carroll Beckwith. Beckwith painted William Merritt Chase, who in turn used Whistler as a model, although they were apparently quarreling at the time. William Bouguereau created a portrait of his student Elizabeth Gardner, who later became his wife. Sargent earned notoriety with his portrait of Carolus-Duran. Carolus-Duran asked one of his students to model for him, Lucy Lee-Robbins, who, though only nineteen, had displayed impressive talent and maturity. Lastly, Anna Elizabeth Klumpke decided to pay homage to French painter Rosa Bonheur with a portrait done late in Bonheur's life, before also writing a biography of her. "In France," wrote Klumpke, "he who makes great art occupies an important relation to the state as well as society. A country whose monuments are the record of its history, France fosters art because it recognizes in its growth, a means of education and refinement. She throws around it the same laws, which protects all other commercial interest, and socially opens to her artists the same doors which swing back at the touch of her scholars, soldiers, literati, and statesmen."[11]

Paintings of classical subjects pervaded the Salons—owing to the influence of Léon Bonnat and Jean-Léon Gérôme—and attracted the attention of Edwin Howland Blashfield, Frederick Bridgman, and Sarah Paxton Ball Dodson, who all launched into depictions of Greek goddesses, Roman emperors, and armed gladiators. Likewise, historical scenes with Middle Eastern themes still offered an easy avenue to acceptance. *The Nubian Storyteller in the Harem; Cleopatra on the Terraces at Philae; Entertainment for an Assyrian King; Abraham's Sacrifice:* these are titles of works by Edwin Lord Weeks, Charles Sprague Pearce, and Bridgman. Students of Carolus-Duran (who never got his fill of Velázquez), Gérôme, and Bonnat fed the vogue for Spanish subjects. Among their offerings were Thomas Eakins's *Street Scene in Seville* in 1870 and Sargent's *El Jaleo: Dance of the Gypsies* in 1882 and *La Carmencita* in 1890. Drawing on her memory of her trips to Spain, Mary Cassatt painted scenes such as *The Mandolin Player* in 1868 and *Young Lady Offering the Panal to the Toreador* in 1873; William Turner Dannat had enormous success with *The Smuggler from*

Aragon at the 1883 Salon, then with *Spanish Quartet* at the 1889 Exposition Universelle.

Few Americans referred to American history in their work, but there were exceptions: Henry Bacon's *Boston Boys,* shown at the 1875 Salon, depicted Boston children in the 1770s complaining to General Thomas Gage over their treatment at the hands of the redcoats; and William P. W. Dana's *Naval Combat* evoked an episode from the War of 1812;[12] Birge Harrison painted *The Departure of the Mayflower, 1620;*[13] and Frederick Du Mond went further back into the country's collective memory to produce *Christopher Columbus, Presenting his Plans for the Discovery of America, Is Treated Like a Fool by the Counsel of Salamanca.*[14]

Unfortunately for its industrious and now enlightened participants, the Salon in 1880 proved once again a chaotic affair. Visitors came away overwhelmed. Who could remember anything from an exhibition of seven thousand works of art? Furthermore, its organizers had established new rules segregating the works of foreign artists from those of French artists—blatant discrimination that galled the Americans. After all, exhibiting side by side with French artists and being judged by French masters had been the primary motivation for their Paris pilgrimage. Then there was the jury's chauvinism in awarding the Grand Prix and First Class medals, a bias very much against the Protestant ethic of fair rewards for best work. For all the inroads that savvy Americans had made, the Salon that year left them bitter though undeterred.

After their schooling and the Salon, the career-minded young American painters in the Parisian art world strove to win awards. Receiving an award vastly increased the chances of attracting a dealer, which led to renown and the opportunity to earn a living from one's art. When Robert Wylie received the Second Class medal at the 1872 Salon, Adolphe Goupil immediately became his dealer, giving him a monthly stipend and the chance to stay on in France indefinitely. Wylie's award, after so many meager years, became—as fellow American Frederick Champney related—an "occasion for pride" not only for Wylie himself but "all his fellow Americans." Suddenly, the dream of an American art seemed around the corner. In 1880, Picknell received an "honorable mention" for *The Road to Concarneau,* thus becoming the first American landscape painter to win that distinction in France. In fact, by the late 1870s, awards to Americans had begun to pile up: Bridgman in 1877; Sargent in 1878, 1879, and 1881; Penfold in 1878; Picknell in 1880; Chase in 1881; Weir in 1882; Whistler in 1883; Vail and the two Butler brothers in 1886; Alexander Harrison in 1885 and 1889. And the list goes on.

Then to the fourth and final stage: official recognition from the French government. To have a work purchased by the State or to be awarded a Legion

of Honor was the Holy Grail of these Parisian years, the ultimate sign of artistic legitimacy. Mosler became the first American to be so honored when *The Return,* exhibited at the 1879 Salon, was purchased by the government. The description of it in the Musée du Luxembourg's catalogue makes plain what the government admired about the painting: "To the left, in a Breton bed made of turned wood, in the form of an armoire, between two candle-sticks, lies the body of an old woman. Kneeling beside her is a young man, his bare feet soiled by a long walk, his head hidden in his hands. To the right, near the bed, stands a priest, looking pious and reflective. Near the bed, a wooden bucket, a bundle of firewood, and before it, the hat, the staff, and the slender satchel of the traveler."[15] Mosler's consecration by the French seven years after Wylie's medal owes much to his meticulous mimetism, his ability to assimilate and capture—down to the most mundane detail—the essential pathos of French genre painting at the time. His violent interior of a rural Breton dwelling indeed tapped into the fashionable vein for images steeped in high emotion and drama.

In 1880, one New York critic described the "very French manner" of the museum system as follows: "The desire of [an artist's] soul is to have an important canvas bought for the Luxembourg, though the price paid is a small one. . . . Possession of a medal enables them to dispose of their pictures to the State . . . ; if they miss the Luxembourg, they still have a hope of having it hung by the State in some provincial town, for every large town in France has its picture gallery."[16] The French government's acquisition process involved a complex power dynamic: the director of the Académie des Beaux-Arts and some twenty advisers would visit the Salon and deliberate on the spot over possible choices, then vote in front of each painting in competition.[17] Later, as desperate artists began virtually to lay siege to the administration, or lobby a particular senator or deputy for a recommendation, matters could become more sordid.

From the 1883 Salon, the French government purchased Dannat's *The Smuggler from Aragon* and Weir's *Portrait of a Woman;* then, Eugene Vail's *Fishing Port in Concarneau,* was acquired in 1884, Harrison's *In Arcadia* in 1886, and Walter Gay's *Benediction* in 1888. By 1900, the French public began to discover their country anew through images by American painters. The Luxembourg had acquired some thirty of their works; and the Legion of Honor had by then been awarded to Bridgman, Vail, Cassatt, Tanner, Browne, Armstrong, Dannat, Harrison, Mosler, Sargent, Whistler, and Gay. Picknell recalled that in 1878, when Bridgman, at the age of thirty-one, won a medal at the Salon and a Legion of Honor, he was so proud, rumor had it, that he had them "sewn into his undergarments."[18]

Paris was witnessing the birth of a distinct and honorable group of talented painters who, using traditional techniques and working in fashionable

French genres, could finally be called an "American school," according to French critics. Its "stars" were Whistler and Sargent; its academic practitioners, Bridgman, Knight, and Dannat; its token Impressionist, Mary Cassatt; its experimentalists Harrison, Mosler, and Picknell. Together, they represented the same broad range of styles as French art of the period. American critics for their part began to discern the rise of a school of "Parisian painting," distinct from "French painting": it had among its members very few native French, its ranks drawn primarily from the most talented of the foreign-born. "Parisian art is not the outcome of the French minority, nor the fruitage of any French school or fashion. . . . It does not comprise people like Gérôme or Cabanel . . . but rather the young artists who have been formed by them . . . [who] have left the track of the fashion which these men represent . . . and who are forming fashion of their own."[19] While covering the French scene for an American newspaper, Henry Bacon noticed that "Americans were well represented in the annual exhibitions, and a number recognized as holding rank amongst the Parisians."[20]

A strong sense of group identity became integral to the success of the expatriate Americans in finally breaking into the French art scene. As societies, associations, and mutual support groups multiplied, a small democracy emerged. Wylie, Mosler, Harrison, Penfold, Sargent, Whistler, and MacMonnies acted as mentors to Picknell, Dow, Beaux, Wilder Darling, Ralph Wormley Curtis, and Thomas Wilmer Dewing. An individual success became a victory for the entire group. Wylie's gold medal at the 1872 Salon was experienced as an "occasion of pride" for Champney and the others. Bridgman's Legion of Honor provided an "incentive" for Picknell, who proceeded to work like a madman. When, three years later, his own "honorable mention" finally came, it shone for the whole United States.

Finally, those expatriates possessed one quintessentially American asset: a deeply rooted and unshakable optimism. "Perhaps we are called to inherit the French tradition in large part," wrote Will Low in 1872.[21] Some years later, Cassatt passed the torch to Weir, when he was on his way back to the United States. "I always have a hope," she told him, "that at some future time I shall see New York the artist's ground. I think you shall create an American school."[22]

Twelve

Success: A New School "Nurtured by Us"

T HE YEAR 1883 proved a particularly chaotic year for French art. Exhibitions at galleries such as Paul Durand-Ruel's and Georges Petit's had shown the most original works of the year. In contrast, the Salon, controlled by the artists themselves, had shocked the world by its smallness and mediocrity. After Manet died at the age of fifty on April 30, 1883, Petit and Durand-Ruel supervised the auction of his works. Although most collectors of the artist—including Faure, Rouart, and Duret—attended the auction, the results were modest and many of the larger works didn't sell,[1] recalling the worst setbacks Manet had experienced during his lifetime. "Faire vrai, laisser dire" ("Create truth and let it speak") had been his motto all along. At the time of the 1876 Salon, he had organized a two-week "open house" in his own studio. "The cleanest and best organized studio you'll ever find," wrote the critic for *L'Univers Illustré*. "It doesn't smell the least bit like revolution."[2]

Attacked by artists, lamented by the public, ignored by critics, the 1883 Salon further broadened the gulf between artists and the State.[3] The ranks of French painters, divided up into coteries, seemed rife with conflict. Traditional critics expressed pessimism: "Most of the important artists from the last two Salons are missing," wrote one of them. "Only an Exposition Universelle that included every faction could now save national art."[4] Was French art so imperiled as to need to be "saved"? Those who used the word "faction" as nothing more than a euphemism for every element of the New Painters arrayed against the Académie believed so, and ultimately expected full vindication for their view. "All things considered, our proud masters, Cabanel, Bouguereau, Baudry, . . . Yvon, whom the factions try to annihilate, will be avenged by posterity. Sure, we can still take pride in our rugged pioneers, who explore new territory and bring to France the glory of its most shining achievement: superiority in great art."[5]

Thrown into turmoil by the new shows and recent events, official art

seemed in mortal danger. In the *Revue des Deux Mondes,* Henry Houssaye ful-minated against the "mediocre" Salon, "so inferior to the previous one." "One is baffled," he wrote, "by the multitude of paintings and almost blinded by the sharpness of their effect: the confusion of a kaleidoscope. We see nothing clearly and we stare uncomfortably at the bad works in huge numbers, with their gaudy colors, their bizarre or ridiculous compositions. . . . No doubt the encroachment of Impressionism and Naturalism into serious painting has drastically contributed to the weakness of the young school."[6]

In the same vein, some critics defensively reasserted their unshakable con-viction in the superiority of French art. Thus, Ernest Chesneau, celebrating the Salon's newest discoveries—painters Henri Grevex, Alfred Philippe Roll, Félix de Vuillefroy, Georges Antoine Rochegrosse—reinforced the notion that "tal-ent is the currency of French art."[7] Houssaye declared likewise his faith in "French art," by which "we mean modern art, because France will, no matter what, maintain for a long time its uncontestable rank of excellence."[8] The Tri-ennale—the only show still under government control—was held between September 15 and October 31, its offerings chosen by a state-appointed jury composed primarily of Académie members. Ironically, though organized by the most conservative members of the official establishment, it displayed more original and more modern works than were on view at the Salon earlier that year.[9]

At the same time they were condemning their own nation's contribution, French critics writing about the Salon of 1883 acknowledged the "American school." Boggs's *Port of Isigny* (*Calvados*) was a "good painting";[10] one critic admired the work of Pearce, a "student of Bonnat," because he expressed "much feeling" and offered a "very sympathetic picture of a young girl carrying water";[11] Penfold was a name to remember because of *The First Step,* a "very sophisticated" work; J. Alden Weir's *Portrait of an Old Man* was judged to be "very good, well posed, well modeled, with freedom, and the hands done with great care," and "the ensemble has real character."[12] Another critic, Eugène Véron, extolled the "qualities of white in Julius L. Stewart's *Portrait of Madame X,* done "after the manner of Jacquet," and Bridgman's *The Ciccada* which gives the "sign of a painter who is an archaeologist and searcher for the pictur-esque." "We do not understand," he went on, "why this erudite painter and fantasist-poet should not from now on be regarded as being among those 'without rival.' "[13] Henry Mosler's *The Spinner,* Véron wrote, showed "true observation of this majestic clarity of nothingness; a pretty story that cannot be better put with greater enthusiasm."[14] Sargent, of course, did not go unno-ticed. "We can revisit with interest," one reviewer stated, "the Velázquez-like portraits of children which had been admired earlier at Georges Petit's

gallery."[15] Praise for Whistler, too, was a given: "much expression," they wrote, in his "*Portrait of an Old English Women* [sic]," referring to the artist's portrait of his mother.

The increased visibility of painters such as Whistler, Sargent, Cassatt, Harrison, Mosler, Weir, Nourse, Beaux, Dannat, and Bridgman, and the general acknowledgment of their talent, heralded the birth of a school of expatriate American painters. Members of this school could be found on both sides of the Atlantic, as Edward Strahan noted in his article "Art in America" in the Salon catalogue, in which he pointed out their newfound popularity among American collectors, who until then had only had eyes for the European masters. "The production of good paintings," he wrote, "has continued its slow and steady progress and the art lovers have shown themselves less blind to American talent than was generally believed. Indeed, the appearance of a work such as Monsieur Sargent's *Woman with a Rose* is the best proof that American art is neither dead nor slumbering."[16]

From then on, American painters stopped being perceived as mediocre, out-of-touch, exotic, or ridiculous. They inspired respect, both in France and in the United States and from every quarter of the art world, including teachers, colleagues, and critics. The French government had bought their works, and even in America they were beginning to find a market—an ultimate sign of arrival. With this notable recognition of expatriate American painters on their own soil, both aesthetically and financially, the gap between American art and French art began to diminish, a shift that inevitably caused a wide range of repercussions in the United States.

For the first show he held in New York, Paul Durand-Ruel had benefited from a privilege "normally reserved for museums"—that of exhibiting paintings without duty "on the condition of clearing all rights on the sales" and "sending back to Europe any work that had not found a buyer."[17] In 1887, New York dealers lobbied the government to rescind Durand-Ruel's privilege and enforce the standard 33.3 percent tax on the importation of all works not created in America. They were expressing the same kind of ferocious protectionism advocated by conservative historian and economist Emil Schalk, who had argued that "without protection, society and civilization cannot exist. . . . Protection is the slow-working agency which gradually lifts man to higher planes of civilization."[18]

The tax on imported products had been raised from 10 percent to 33.3 percent in 1883. After he became president in 1885, Grover Cleveland, a Democrat, unsuccessfully tried to reduce the rate, in an attempt to mollify the populist wing of his own party, which increasingly manifested signs of labor unrest. But in the end he could not persuade either the Republicans (who controlled the

Senate) or the Democrats (who controlled the House of Representatives) to act. Equally ineffective was the data collected by the Union League Club of New York from scores of artists and art professionals, who wanted the tariff abolished. Charles B. Curtiss, a prominent lawyer who presented the data before Congress, argued that while raising import taxes was justified in the case of manufactured products, a work of art was *not* a manufactured product in the commercial sense, but rather an educational tool to elevate the spirit of the people. "The United States," he wrote in his report would be "the only nation in the civilized world that levied heavy duties to keep works of art outside its borders."[19] In this connection, Curtiss was concerned that the measure would antagonize the French, but that was already the case.

The wrangling spawned fierce debate over the status of a work of art: was it a perishable commodity, like a food product, a manufactured product, or was it a cultural object with no connection with the world of commerce?[20] The Democratic-controlled House of Representatives perceived political advantage in promoting the view that a work of art was like any other commodity, and as such it could be subject to a specific tax that would be shouldered mainly by the wealthy. They pointed to one French painter, Ernest Meissonier, the price of whose work *Friedland* had risen steadily from sixty to eighty thousand dollars, amounts such as no one except a very few individuals—in this case, A. J. Stewart, the department-store magnate—could possibly afford. If there was a salt tax for the poor, the Democrats argued, there should be an art tax for the rich.[21]

Mindful of American anxieties over perceived cultural inferiorities, Congress had justified the tax as necessary for the protection of local painters. Everybody got into the act: politicians, dealers, critics, and artists. In a message to Congress before the tax measure was passed, Chester Arthur, Cleveland's Republican predecessor, had expressed his own worries about the tax. What was involved, he proclaimed solemnly, was "the practical exclusion of our painters and sculptors from the rich fields for observation, study, and labor which they have hitherto enjoyed."[22] An American critic who had visited the 1889 Paris Salon was embarrassed to note that in a country without protectionist barriers, "Americans are very well represented . . . a striking commentary on our tariff legislation." Whistler, whose relations with American journalists were far from cordial, used the opportunity to reiterate his misgivings about his own country's politics: "I shall only come back to America," he declared, "when the customs laws on works of art are withdrawn."[23] Even old Frederic Church, the only American to have won a medal in 1867, admitted that he felt ashamed about the American tax and decided that if his nation insisted upon it, it would then have to live with the consequences. He announced that he would not par-

ticipate in the Exposition Universelle of 1889 in Paris. "Any nation that put a 30 percent duty on foreign works of art and refused to pass an international copyright law," he stated, "had better take a back seat in the manner of foreign exhibitions."[24]

In 1887, Jean-Léon Gérôme wrote a lengthy, withering letter of protest: "In the huge budget of the United States, the sum arising from duties on pictures is but a drop of water in the ocean. But there is a moral aspect to this question. Was it not in . . . France that your young painters have been taught? . . . Is it just to treat the works of these foreign artists, these educators, with such severity? . . . People will one day say: 'It was at the close of the nineteenth century, in the full flush of civilization, that the strange idea emerged of likening the products of the mind to sardines in oil and smoked ham. All over the world works of art were duty free. In one country alone were they saddled with an excessive tax and that country was the youngest, the greatest and the wealthiest of nations.' "[25]

In retaliation for the art tax, the French government decided to tax American pork at the same rate of 33.3 percent. And so the war of "pork tax versus artistic tax" began. Whitelaw Reid, the American ambassador in Paris under President William Henry Harrison (Cleveland's successor in 1889), made the issue his absolute priority, pleading for bilateral negotiations that took into consideration the amount of pork the United States exported to France versus the number of paintings the French exported to the United States—an improbable balance-of-trade calculus connecting American pig farmers and French painters. Reid complained that in nine years the French imports of American pork had fallen in total worth from four million to one hundred thousand dollars per year. "If we could approach the [French] Government," he advised President Harrison in a private letter, "with a suggestion that the best way to avoid the threatened action of Congress [to increase the duties on importing French wines] would be to show a rational spirit on the subject of pork, and if we could add that prompt and friendly action on this subject might lead to a law admitting French pictures free, there might be a better chance for reaching a satisfactory result than at present."[26] On December 5, 1891, Reid finally succeeded in getting the French import duties on American pork lifted; but another four years would pass before the United States lifted its foreign import duties.

The French counter-protectionist sentiment had spread among some French students of the Ecole des Beaux-Arts as well. Jealous over the number of awards given to foreign students, they demanded that admissions of outsiders to the school be tightened. In the journal *La République Française,* one student wrote: "Because of the lack of slots, it would be fair to limit the num-

ber of places given to English and American students, who are crowding the
studios. The number of foreigners has risen to such a degree that in certain
painting studios the Americans and the English are in the majority . . . making
themselves a place in the sun."[27] Another Beaux-Arts student, in a studio
speech, demanded that the "number of foreigners admitted be limited; that
prizes no longer be awarded to foreigners." "Our hospitality is becoming a
joke," he added. "What are we getting in return? The Americans, who came by
the thousands to train in our schools, are starting—now that they have a few
decent painters and sculptors—to slap prohibitive import duties on our works
of art."

Meanwhile, reorganization of the Salon continued. By 1884, its monopoly
was broken by the increasing number of private shows and alternative associa-
tions in Paris. The Society of Artists held its first exhibition, then came a show
at the National Society of the Beaux-Arts, and many more afterward. Paris no
longer had one Salon but rather two or three different major shows a year; by
1890, they all attracted foreign journalists. Nonetheless, while the sheer num-
ber of venues and of works exhibited had grown, the quality had not kept pace.
France's unquestioned domination of contemporary art was beginning to
crumble. "Among the creating nations, France fell from a hegemonic position
to a peripheral one; the development of a true art market with its network of
dealers and galleries only created a proportional increase in the gap between art
and the State."[28]

In these halcyon years of the expatriate American painters, their most glo-
rious hour undoubtedly came with the 1889 Exposition Universelle in Paris.
Sargent and Melchers each won a Grand Prix; gold medals went to Alexander
Harrison, George Hitchcock, Vail, and Whistler; and other Americans won
fourteen silver medals,[29] thirty-two bronze medals,[30] and twenty-three honor-
able mentions.[31] The harvest of awards, seventy-five in all, was most impres-
sive. To top it all, the French government honored Dannat, Harrison, Knight,
Mosler, Sargent, and Whistler as Chevaliers of the Legion of Honor.

One by one, French critics expressed their surprise: "Twenty years ago,"
wrote François Thiébault-Sisson, "no American school of painting existed;
today, one is exploding with life and vitality. . . . Three hundred and thirty-six
paintings by more than two hundred artists, some of which are already true
masters."[32] Another critic, Henry Havard, also tipped his hat to the Americans:
"Without going back further than ten years," he wrote, "no one would have
dared predict that the United States would assemble at the Champ de Mars
nearly two hundred works, all of them of unquestioned interest."[33] The critic
for the *Revue des Deux Mondes,* stunned by the American pavilion, went even
further: "It was an unexpected revelation. The New World appeared, rich in

works and overflowing with promise, in a grandiose setting of exotic palaces. The future belongs to them."[34] The future indeed seemed to be theirs; critics in their own country, recalling the "dark and rightfully deserted" space of the American pavilion at the previous Exposition Universelle held in Paris, now swelled with pride: "Since 1878, American artists have carved for themselves a large and glorious place in Europe. America boasts an elite artists [*sic*], such as Abbey, Whistler, Dannat, Sargent."[35]

French journalists fell all over themselves trying to comprehend the turn of events and assign credit for the American success, making sure it went to the right places. "To whom should go the credit for this?" asked Thiébault-Sisson. "To a twofold and fecund influence," he replied. "On the one hand, to our French artists—Bastien Lepage, Bonnat, Cabanel, Boulanger, Lefebre, Carolus-Duran; and on the other hand, to a powerful and original master, born American and English by choice: the name of this master is Whistler."[36] "When we consider these events with a certain concern," added Havard, "we cannot keep ourselves from feeling a certain pride. For these new schools have been nurtured by us; they are a part of us."[37] Indeed, the American success gave France cause for celebrating itself as an international cradle for talent, the mother bountiful brooding over all these artists, to be forever admired for its "benevolent influence."[38] "[T]heir art, like their genius, is the antithesis of art. . . . It derives from ours," declared Havard.[39]

Accustomed to commenting arrogantly from a position of absolute hegemony, these writers clearly felt a profound disquiet; the rapid rise of American painters had belied their assumptions of America's chronic cultural inferiority, and the best they could do was to salvage at least some credit in France. But even in spinning the unbearable truth, they desperately clung to their original frame of reference. "Their talent does us too much honor," wrote Varigny, "that we should complain about it."[40] No wonder: if the Americans had turned into artists, it was because they were good imitators: "In the American gallery," Varigny observed, "one would imagine himself in a French gallery. . . . They have become so French that we can hardly distinguish which is which."[41] One of his colleagues took things further: "One might believe one was still in France, so close was the resemblance between imitation and reality. One can see," he added, "that our masters, dead or alive, continue to forcefully dominate the foreign schools."[42]

The future, so it now appeared clear, belonged to foreigners, and, grudgingly or not, everyone would go on celebrating the "glory of the American artists." Some writers proved visionary: "It would go against ordinary laws of artistic evolution," read an article in a major magazine, "if a particular movement of art did not emerge from this brilliant virtuosity, once transplanted

onto native territory."[43] The greatest misery amidst all this success was felt particularly by the non-expatriate American painters, saddled with the rather sad label of "home artists," their work exhibited in a separate pavilion, in a much darker and smaller space. Covered in glory and medals, bound for all sorts of riches, those who had attempted the transatlantic adventure had triumphed. No label could do them justice, although many were applied: "Paris Americans," "American expatriates," "Paris-based artists," "Franco-Americans," "European-influenced artists."

The American network in Paris consolidated itself after the triumph of the Exposition Universelle of 1889. The American Art Association was created in 1890, as was the Paris Society of American Artists. A year after that, the American Women's Art Association was founded. Above all, the Salon du Champ-de-Mars, established in 1890—with Edward May as a founding member and Alexander Harrison as the first painting juror—ordained the Americans as fixtures on the new French art scene, which was thenceforth open to new ideas and to foreigners. Undeniably, Americans had accomplished the impossible, and it mattered little whether or not French masters had influenced their work. Could anyone succeed in Paris without copying Paris? Still, some embittered French critics could not keep from offering the once withering but now increasingly tired taunt: "Will the United States ever have an art of its own?"[44]

Part II

The Return of the Prodigal Sons

1870–1913

One

A "Secret Conspiracy"[1] Against Thomas Eakins

"THE MOST SERIOUS OBJECTION to a number of years' residence in a foreign country is that it invariably unfits a man or woman to live at home afterwards." In its brochure *The Art Student in Paris,* published in 1887, the Boston Art Students' Association included an honest assessment of the negative consequences of the European pilgrimage. Will Hicock Low felt like a stranger to life in Manhattan after his return from Paris. Dennis Bunker could not accustom himself to the New England light, which he found "painfully bright." "I prefer a solemn sky and gray world. . . . In France, sunless days are common. They are much more agreeable for painting, because they don't change and you can work in peace." [2]

After a decade in Europe, Worthington Whittredge readjusted badly to artistic life in America, experiencing several "desperate" years. "Frankly, I doubt the desirability of long foreign study," he wrote. "A flying visit across the water is not objectionable but rather to be commended. . . . But to go abroad and become so fascinated with the art life of Paris . . . as to take up permanent abode there is not everywhere believed to be the best thing for an American artist. We are looking and hoping for something distinctive in the art of our country, something . . . to enable us to pronounce without shame the oft-repeated phrase, 'American Art.' . . . A man is of no use in this world who does not have faith in the heritage of his own country."[3]

In 1870, after nearly four years in Paris, Mary Cassatt returned to Philadelphia, beginning what she referred to as her "American exile." She missed the museums, the models, the milieu. "I have given up my studio and torn up my father's portrait," she wrote her friend Emily Sartain in July 1871. Away from the French atmosphere, a part of her was missing; she felt mutilated. "I have not touched a brush for six weeks nor ever will again until I see some prospect of getting back to Europe."[4] When she moved back to Europe in early December, it was for good.

It did not matter *when* they came back. Those who came home in the 1880s and 1890s were not any happier than those who had done so ten years earlier. The metamorphosis that energized American cultural institutions in the intervening decades did nothing to alter the general melancholy. Certainly, a lot had evolved in their country: private collections, museums, artist colonies, and public interest in art; but the academies and other training grounds remained, all in all, hopelessly mired in the past.

One of the rare Americans to declare himself both thrilled by his French experience and perfectly happy to be back was Thomas Eakins.[5] Having gone to Europe with the goal of rounding out his training, he believed, after three and a half years of study, that he'd reached his objective. "I am now as strong as one of Gérôme's pupils and I have nothing to gain by remaining," he announced. "What I have learned, I could not have learned at home, for beginnings Paris is the best place."[6] For Eakins, it was plain: his French training, however valuable, was behind him; the future lay at home in Philadelphia. And although deeply influenced by French models and European taste, he never set foot in Europe again.

"I am proud to be a Philadelphian," he wrote to Emily Sartain before leaving the French capital. Arriving home on the fourth of July, 1870, at the age of twenty-six, he immediately set up a studio, threw himself back into his favorite activities—rowing, sailing, swimming in the Schuylkill River—and then got to work. By the following April, he had produced his first important canvas, *The Champion Single Sculls* (long known as *Max Schmitt in a Single Scull*). In fact, for the next three and a half years, he painted nothing but rowers. He borrowed a theme that his principal teacher in Paris, Jean-Léon Gérôme, had elaborated in 1861 in *The Prisoner*, which depicted a rower on the Nile, but set it in a contemporary American context, on the Schuylkill River. He intended to become a truly American painter, yet without losing touch with Paris. He kept up his correspondence with Gérôme and sent him a watercolor, *John Biglen in a Single Scull*, 1873–74. "My dear pupil," Gérôme wrote back, "I received the watercolor that you sent me, I accept it with pleasure and thank you for it." Then the master proceeded to offer his critique. "The individual, who is well drawn in his parts lacks on the whole . . . a sense of movement and seems immobile. . . . There are two moments to choose from for painters of our sort, the two extreme phases of action, either when the rower is leaning forward, the oars back, or when he has pushed back, with the oars ahead; you have taken an intermediate point, which is the reason for the immobility in the work."[7]

Eakins literally went back to the drawing board: he made numerous drawings, watercolors, photographs, and studies in oil, worked on perspective, and

even dug up his old Paris sketchbooks. Before going to Paris, as part of his drawing lessons, he had taken the anatomy class of Dr. Joseph Pancoast, a celebrated surgeon at Jefferson Medical College, and even worked with the medical students until he judged his own understanding "as great as that of most physicians, and considerably greater than that of most artists."[8] In response to Gérôme, Eakins sent *The Rower,* a new watercolor. "I have received your pictures and I find great progress," Gérôme wrote in the spring of 1874. "I send my compliments and urge you to pursue your development in this serious vein, which will guarantee your future as a man of talent." With a fair amount of self-satisfaction, he added: "Your watercolor is good from every point of view. I am truly content to have in the New World a student such as you who does me so much honor. Your devoted master, M. Gérôme."[9]

Gérôme's approval notwithstanding, *Max Schmitt in a Single Scull* was rejected by the National Academy of Design. Eakins could not understand why; he was bewildered by the hostility his work elicited in his own country. "My picture is rejected," he wrote to fellow painter Earl Shinn. "It is a much better figure picture than any one in New York can paint. I conclude that those who judged it were incapable of judging or jealous of my work, or that there was no judgment at all on the merit. . . . If you hear why I was refused, tell me."[10] That same year, two of his canvases, including *A Hunt in the United States,* were accepted for the 1875 Paris Salon and other works of his were shown at Goupil's in London.[11]

Eakins was caught in a peculiar limbo: his brand of Realism now seemed out of sync with both the French and the Americans—too technical for the former, too violent for the latter. He was applying Gérôme's methods while at the same time embracing contemporary American themes. "His landscapes are easily as interesting as his men and their wondrously ugly muscles,"[12] the New York *Tribune* critic sniped; and in Paris, a journalist in *La Revue des Deux Mondes,* upset by his last Salon paintings, noted that they "look like photographic proofs covered with a light watercolor tint; we wonder if they're not specimens of an unknown industrial process, maliciously sent to Paris to . . . unhinge the French school." Could he reconcile his work with the taste of one country or the other? Rather than try, Eakins held fast: he was not one for concessions. His only support in the United States remained his friend Earl Shinn, another former student of Gérôme's, who'd become a critic for *The Nation.* "We learn that Eakins is a realist, an anatomist, and a mathematician, that his perspective, even of waves and ripples, is practiced according to strict science,"[13] Shinn wrote in praise of *Max Schmitt in a Single Scull.*

Recognized in Paris, rejected in New York: the paradox haunted Eakins for years. Still, he forged ahead following his own logic, and, encouraged by Gérôme, he pursued themes that stimulated him and practiced different techniques. He also obsessively studied the movement of animals; photographed nude males in the open air in order to master human anatomy; navigated among watercolor, drawing, oil painting, and sculpture; studied the theories of the British philosopher Herbert Spencer on the role of science in art; and produced figures never seen before in American museum collections: rowers, bathers, swimmers, boxers, sculptors, surgeons, musicians, every manner of professional and popular character of the day—all of them native to his American environment but utterly alien to the exhibitions of the National Academy of Design.

In Europe, Eakins had been deeply influenced by the interest in Spanish subjects, which were in vogue among the students of Carolus-Duran, Gérôme, and Bonnat. A visit to Spain confirmed his passion for Velázquez, and in particular for *The Fable of Arachne* (1644–48), popularly known as *Las Hilanderas* (*The Tapestry Weavers*), "the most beautiful piece of work that I had ever seen in my life," he noted in his journal.[14] In 1875, Eakins painted one of his major works, a monumental canvas called *The Gross Clinic.* In the manner of Rembrandt's *Anatomy Lesson,* and with the same fervor for detail, Eakins produced a mesmerizing surgical scene. The great majority of American critics, one after another, vilified the painting. "The scene is so real," wrote one, "that viewers might as well go to a dissecting room and have done with it . . . a picture even strong men find difficult to look at long."[15] "To sensitive and instinctively artistic natures," noted another, "such a treatment as this one, of such a subject, must be felt as a degradation of Art."[16] "The horribleness taught nothing, reached no aim," wrote a reviewer for *Scribner's Monthly.*[17] What Eakins showed the viewer, according to another, was "revolting to the last degree," and "ought never to have left the dissecting room."[18]

The American rejection of European Realism—Spanish, Flemish, and French—had a second angle: a militant protectionist battle to safeguard American taste from foreign influence. "As to the propriety of introducing into our art a class of subjects hitherto confined to a few of the more brutal artists and races of the world," declared critic S. G. W. Benjamin, "the question may well be left to the decision of the American public. . . . If the innate delicacy of our people continues to assert itself, there is no fear that it can be injured by an occasional display of the horrible in art, or that our painters will create many such works."[19] Eakins's canvas is "painted in the modern French manner, with great mountains of paint . . . [of] color there is none."[20] Fearful that through Eakins's brush an epidemic from the Old World—Europe in general and

France in particular—would spread to the New World, the American critics, through their strident warnings, aimed to quarantine him. Eakins's brand of Realism had made him famous but was scuttling his career. Already viewed with increasing suspicion in Philadelphia, he soon understood that New York would have to be his next stage.[21]

Gradually, beginning in the 1880s, his works began to be shown, but only in exhibition spaces open to newcomers. The gallery of the Pennsylvania Academy of the Fine Arts was closed for a seven-year renovation; and the National Academy of Design remained stubbornly hostile to him. Practically the only two options remaining to him were both in New York: the Society of American Artists—and more open to younger artists—and the American Society of Painters in Water Color (later renamed the American Water Color Society). Generally, critics praised his "technical abilities" or the "power of his realist vision," but also lamented what they deemed to be a lack of poetry and beauty in his art. Not surprisingly, he sold very little. "I have many pictures and painted studies unsold, and many frames," Eakins noted bitterly on January 1, 1883, when he was doing an inventory of his studio.[22] His New York dealer Charles Haseltine exasperated him with his silences.

In 1886, after ten years in Philadelphia, a storm erupted. At the eye of it was not so much Eakins's work as a painter but as a teacher. In 1876, Eakins had begun teaching the life class at the Pennsylvania Academy of the Fine Arts, where he had once studied. Three years later, as newly appointed director of the school, he rapidly transformed the curriculum in accordance with his convictions: the training would now require study of anatomy, mathematics, and perspective, including required courses in drawing from live nude models and the dissection of human corpses. This program offered, he felt, the only hope of understanding nature. "The course of study is believed to be more thorough than that of any other existing school. Its basis is the nude human figure," announced the school's brochure, which Eakins himself wrote.[23] Rigorous and exhaustive, the new curriculum was aimed at producing serious portrait painters. Modeled on that of the Ecole des Beaux-Arts in Paris, Eakins's program offered students the most progressive, innovative, and dynamic art training in the United States. Over the seven years it lasted, enrollment tripled. "The school is full," Eakins told the board of directors, "its pupils are becoming known, its reputation is wide, and its standard of work is very high."[24]

But soon, "right-thinking" people took notice. Anonymous letters began to arrive, accusing the painter of corrupting young girls of good families through exposure to the indecent spectacle of immoral women and naked men. One girl's mother wrote the president of the Academy: "For the culture of high Art, she has entered a class where both male and female figures stood

before her in their horrid nakedness. . . . Nothing can be beautiful that is not pure and holy, that so elevates humanity that it becomes better fit to enjoy that purity and holiness, that belongs to immortality. Now I appeal to you as a Christian gentleman, educated amidst the pure and holy teaching of our beloved Church, and where the exhortations to purity of mind and body were amongst your earliest home teachings. . . . Does it pay, for a young lady of godly household to be urged as the only way of obtaining a knowledge of pure Art, to enter a class where every feeling of maidenly delicacy is violated?"[25]

Rumors led to scandal. Eakins, it was said, ordered his students to photograph one another or even to pose naked. One day, gossip had it, he had even asked a female student to pose nude, sitting in for a sick model. What's more, he did not hesitate to get undressed himself, or worse. The crucial question was simple: should the penis of the male model be exposed in the life-drawing class taken by male and female students together, or should it be camouflaged by some means? "The smaller bag tied with tapes or thongs," used at the Art Students League in New York, as Eakins would later write, "seems to me extremely indecent, and more than one has been at the root of embarrassment and unspeakable wounds."[26] On February 8, 1886, the education committee, shaken by the rising number of accusations against Eakins, informed the board of directors that it had taken "under serious consideration for some time a change in the management of the schools, and had finally concluded that it would be well to ask for the resignation of the present Director."[27] The head of the board asked Eakins to step down. "In accordance to your request just received," Eakins wrote the next day, "I tender you my resignation as director of the schools of the Pennsylvania Academy of the Fine Arts."[28]

The letter was oddly short and bland for someone who had steered the school for more than seven years. But in fact, Eakins would fight back aggressively. "The thing is a nightmare," he wrote to Edward Hornor Coates, the board's president, one week later. "It seems to me that no one should work in a life class who thinks it wrong to undress if needful."[29] He argued his good intentions, defended his moral standards, and proclaimed his innocence; it was simply a matter of technical questions, he added, as to what was best for American art, and the training of his students. "It is not a rare ambition in a painter to want to make good pupils. . . . My dear master Gérôme, who loved me and had the same ambition, helped me always and has to this day interested himself in all I am doing."[30] In attempting to vindicate himself, Eakins referred again and again to the French system as the supreme model: French training, French masters, everything French—that seemed for him the magic word in devising his own program, which was a direct copy of the Ecole des Beaux-Arts' curriculum.

Two irreconcilable camps confronted each other in Philadelphia. What could Eakins hope to achieve by wrapping himself in the banner of Gérôme? And what logic could he use to answer his enemies? Convinced of the excellence of the Beaux-Arts training in Paris, he had dedicated himself to rescuing American art by the strict implementation of the French model back home in his native city. He would try to explain his position rationally, emphasizing the quality of his methods, and, paradoxically, pointing out that he was the "only artist in the city habitually using the nude model." He would even undertake a futile campaign to convince Victorian mothers of the beauty of the human body. "I see not impropriety in looking at the most beautiful of Nature's works, the naked figure . . . or is it a question of sex? Should men make only the statues of men to be looked at by men, while the statues of women should be made by women to be looked at by women only? . . . Such indignities anger me. Cannot anyone see into what contemptible inconsistencies such follies all lead? and how dangerous they are? . . . [M]y life has been full of care and thought and governed by good moral principles, and it is very wicked and unjust to misfit my doing to motives which a very little consideration would show do not govern them."[31]

From all across the city, students came to demonstrate their support under the painter's windows. Gérôme sent a letter of support. Walt Whitman also weighed in, writing, "Eakins is not a painter, he is a force. . . . I never knew but one artist, and that's Tom Eakins, who could resist the temptation to see what they thought ought to be rather than what is."[32] Friends in Paris, such as H. C. Cresson, who had been a fellow student in Gérôme's studio, likewise came to his defense. In an open letter to the publisher of the *Philadelphia Evening Item,* Cresson argued that "any French professor would scoff at the idea of anyone attending a life model class if the 'points' so necessary in gaining the correct movement, proportion and swing of the figure, were covered."[33] The prevalent injustice of the "whole conspiracy," he declared—a "secret conspiracy"—was that it turned Eakins into a pariah.[34] Enemies lurked in all ranks: students, parents, colleagues, and journalists. Even members of his own family, such as his embittered brother-in-law, and jealous former students such as Thomas Anshutz, conspired against him.

But Eakins fought on fiercely. "Was there ever so much smoke for so little fire?" he wrote to Edward Hornor Coates. "I never in my life seduced a girl, nor tried to, but what else can people think of all this rage and insanity?"[35] Sordid rumors and calumny mounted daily; any story was grist for the mill. A month after his resignation from the Pennsylvania Academy, the Sketch Club—where he had given free courses for years—dismissed him. "We hereby charge Mr. Thomas Eakins with conduct unworthy of a gentleman and discreditable to

this organization and ask for his expulsion from the Club."[36] In March 1886, drained and exhausted, Eakins admitted in a letter to Emily Sartain that, after throwing him "out of the Academy, the Philadelphia Sketch Club, and the Academy Art Club," they were determined "to drive me out of the city."[37] It was just about sixteen years since he had returned so enthusiastically to his hometown.

Two

"We Will Help Fertilize
the Art Soil of America"

"I FEAR MY GOING HOME," wrote J. Alden Weir on May 1, 1877. "My future looks dark. It scares me when I think of returning."[1] In the weeks before coming back to New York, Weir sent his family desperate messages. After nearly four years in Paris, the prospect of life in the United States filled him with trepidation. Was he was afraid that he hadn't learned his French lessons well enough? Did he dread the hopeless mediocrity of the art world in his native land. "New York is not such a bad place to live in after you get acquainted," Weir's friend Wyatt Eaton teased him. "There are a great many instructive and interesting things in the Metropolitan Museum—a splendid Franz Hals, a fine Rubens and in the Historical Society Rooms there is a really fine collection of Old Masters. . . . I believe there is no reason why we should not go on progressively here as well as abroad; Swain, Gifford, Thompson, Homer Martin, Winslow Homer, Tiffany, Inness and some others are going ahead splendidly. I have met some people of splendid taste and in fully sympathy with art; and you will be received by them as I have been, with open arms."[2]

Little by little, with the encouragement of his correspondents, Weir came around. "To grow fast and learn to float, it [*sic*] must have the right soil and atmosphere as well as good instruction," he wrote.[3] Two months later, in a letter to his brother, he exuded optimism. "We will help fertilize the art soil of America, but history shows us that no great geniuses have been produced and flourished until the ideas of the country were in a ripe state. Although it is impossible to transplant the full grown tree, still there is a slight possibility of grafting, although for many years there may be no gathering of fruit."[4] Determined to fight for "the cause of American art," Weir, like Thomas Eakins, developed his own declaration of faith. But unlike Eakins, he strove to negotiate shrewdly within the American context. Where Eakins had tried to "trans-

plant the full grown tree" and been rejected, J. Alden Weir and others, by choosing to "fertilize the art soil of America," hoped to succeed.

In fact, J. Alden Weir returned at the right moment, precisely when others were already at work undermining the dominance of the National Academy of Design and the iron grip of the Hudson River School generation. The Academy's annual exhibition in the spring of 1877 presented primarily works by young European-trained artists such as Frank Duveneck, Will Hicock Low, Abbott H. Thayer, and William Merritt Chase. With five paintings accepted, J. Alden Weir felt particularly favored. Critics who, a year ago, had complained about "the great lack of invention and imagination evinced by our painters," warmly welcomed these newcomers, praising "the novelty and fresh character of the collection. . . . This season it is as if some magician's wand had been waved over the scene, causing a sudden transformation . . . of conventional caution into audacious daring."[5]

A new age seemed to be dawning in New York's art world. But while exhibition committee members lent their support to young painters, the more conservative Academicians of the old guard watched and complained of the "excessive visibility" accorded to the "expatriates," invoking the customary "rule of eight feet," by which every Academician had the right to that much wall space, and not one inch less. The press caught wind of the conflict and took the side of the young painters. "It will be generally understood," wrote a critic from the *New York Times,* "that outsiders have no chance at the exhibitions of the Academy . . . because a body of worthy old painters are in a huff over the result of exertions on the part of a Hanging Committee of three elected by themselves. . . . But the act of the Academicians at once acknowledges several things. One that their work cannot stand the competition of outside painters even before a tribunal appointed by themselves; another that young painters must look elsewhere for encouragement and appreciation."[6]

Several weeks later, in reaction to the Academicians' intransigence, a group of young painters returning from Europe founded the Society of American Artists. Weir was elected to the Society and became an active member of its exhibition committee, working to organize visits to studios and to set up selection committees throughout the country and abroad, particularly Paris. It seemed that the day had come for a new attitude of open-mindedness and equity toward younger artists. The Society organized its first show in March 1878 with works by Chase, Duveneck, Eakins, Sargent, Thayer, and John H. Twachtman. "This exhibition means revolution," prophesied Clarence Cook, the powerful critic for the *New York Tribune.* "Here in this modest room Art in America . . . shuts the door behind her and . . . sets out in earnest to climb the heights."[7] The following year, which would prove crucial, Weir became secre-

tary of the Society. Almost twenty-seven years old, a muscular man of great elegance, warmhearted and good-natured, he exuded solidity and confidence. But though effective as a cultural activist on behalf of others—a role he was to play for a great many years—Weir would have trouble impressing himself on the New York scene as an artist in his own right.

Weir visited France regularly. "Never was man more delighted than I was to return again to sunny France," he wrote in June 1878.[8] He adored being "feted like a king" among his friends Jules Bastien-Lepage, Pascal Dagnan-Bouveret, and Gustave Courtois—who had been fellow students in Gérôme's class at the Beaux-Arts and were always on his side and still painting "wonders."[9] He knew he got privileged treatment, especially when he visited Durand-Ruel's apartment: "I had a rare treat in the hotel Durand-Ruel, where were collected together the works of Rousseau, Corot, Daubigny, Miller, Courbet, Diaz, and others of worth," he wrote. "To see these works one is really inspired to go to work immediately. The simplicity and truth of these men makes one love art and want to get to work."[10] But at the same time, despite the optimism he clearly felt when in Paris, Weir expressed a surprising patriotism, as if suddenly realizing the need to support his own country. "One thing I am glad of is that I am an American," he wrote in a letter to his brother, "and think more of my country than ever before."[11]

Fertilization or transplant? By his botanical metaphor, Weir had shrewdly formulated the issue. The artists returning from France were faced with carving a narrow path between the conservative Academicians, who controlled the schools and exhibitions, and contemporary European artists, who dominated the art market. Weir returned to an extravagantly prosperous country, where the nouveaux riches, disdainful of local artists, acquired exclusively European art; apparently, only paintings by Gérôme, Bouguereau, and Cabanel were considered worthy of being hung in Newport palaces. Weir often complained about the situation to his brother: "We have in New York and Boston a few men who paint portraits in a style that wins admiration, even in Paris where are painted the best portraits; yet these men are so stingily employed that it must be hard for them to live. In France such men as Duveneck, Alden Weir [i.e., Julian himself], W. M. Chase, Wyatt Eaton, . . . Thayer, and Vinton would find themselves in full employment, but here, if our Museum of Art wants a portrait of its president, it gets painted by Bonnat."[12]

Faced with indifference and hostility, he often felt tempted to give up this "dogged battle." "I have not a commission nor have I sold anything," he wrote his friend Twachtman in a moment of despondency. "[N]othing seems to be going on . . . everyone has the blues."[13] Slowly, portrait commissions began to come in. Weir earned a modest living, teaching at Cooper Union, at the Art

Students League, and giving private lessons. In 1880, when he exhibited a portrait of his friend the sculptor Olin Warner in the new galleries of the Metropolitan Museum of Art and in the Salon of the Society of American Artists in New York, the painting attracted critical attention. One critic remarked that the portrait revealed "so much veracity and force as to make [*sic*] almost an era in our portrait painting."[14] During these difficult years, Weir was encouraged by his closest friends, Olin Warner, Wyatt Eaton, and Albert Pinkham Ryder. They lived in studios near Washington Square and would often meet for a glass of wine or beer in the cafés on Fourteenth Street or Sixth Avenue. At the Tile Club, modeled on a French salon, Weir, Edwin Abbey, William Merritt Chase, Elihu Vedder, John Twachtman, the architect Stanford White, the artist and critic Earl Shinn, and other painters, architects, sculptors, writers, and musicians met once a week. Weir and his friends organized memorable excursions to view the "picturesque." They once rented a barge for three weeks, decorated it, and floated it to Albany, where they invited people on board and encouraged them to buy their paintings. "I miss the strong, earnest bodies of live men, working together and using each other's experience," Abbey lamented after leaving New York. "I never worked so easily and surely. Now I feel greatly the lack of congenial companionship." Our group will become a "strong power and influence for good," he added.[15] But by 1882, despite the warmth of his new ties with fellow artists and colleagues, Weir lost heart again. He missed France more than ever; the American art scene remained generally depressing, and he foresaw little chance of it improving.

Even after he was elected an Associate of the National Academy in 1885, and a full-fledged Academician the following year, Weir confronted a nonstop struggle. "It is a dogged battle I have been fighting . . . the drubbing up and worrying. . . . Up to the present time I exist, and have some prospects of getting a portrait; but pictures can't be painted without models, which requires money. I hope to get two things in show windows this week and by next week to have two children's heads to place somewhere else."[16] Yet he continued to champion, as the only adequate remedy, the education of the American public. When the Federal government imposed a tax on the importation of foreign art, Weir vehemently condemned this protectionist measure. The tax, he felt, was "unprecedented in the annals of any civilization" and, indeed, "most unwise and shortsighted."[17]

By the mid-1880s, the movement born eight years earlier was losing steam. The Society of American Artists lost their own exhibition space and were forced to rent rooms from the National Academy—in effect, to seek shelter in the enemy camp. "It seems to me that we are driven to the wall and the

only reason we take it, is because there is nothing else to get," a downhearted and defeated Weir wrote Twachtman. "The United States is a country of fifty millions of people and in all the broad land there is not even one gallery to exhibit in. The annual county fairs, where hams are hung along side of Corots . . . can hardly be considered good art exhibitions. . . . Why not acknowledge that society in NY has no interest in the SAA and not hold any more shows? . . . The art critics . . . [have] told us that some of these men promise good [sic]. They have been promising for a long time."[18]

Escorting Mrs. Alden in the summer of 1878, traveling with Erwin Davis two years later, scouting in London for Henry Marquand—Weir increasingly stepped into a new role as an adviser in French art to wealthy patrons. He would guide them through the Paris art world, lead them to the artists' studios, take them into the galleries and select the works they should buy. At the same time, he could also fulfill his mission of shaping collections in the United States. His country needed to possess not only the works of great French painters such as Manet and Courbet but also those of Bastien-Lepage, Dagnan-Bouveret, and other younger artists.[19] Weir believed that these new painters, by combining academic tradition and pictorial experimentation, working between portraiture and landscape both in the studios and outdoors, had something valuable to teach their American counterparts. Through his interventions, they found an American market.

At the third Impressionist exhibition in Paris, in April 1877, J. Alden Weir had strongly rejected the New Painting, bowing to his teacher Gérôme's harsh criticism of those who "respected neither design nor form."[20] Later, through his friendships in the Barbizon group and the influence of Bastien-Lepage, Weir began to question Gérôme's rejection of "la belle couleur," and by the mid-1880s he had embraced Impressionism. Durand-Ruel's 1886 exhibition in New York struck him then as the "most dazzling thing ever shown to an artist."[21] He reached the last step in his conversion to the new French aesthetics on the unforgettable occasion of meeting Edouard Manet.

One day, strolling through Paris with William Merritt Chase in 1881, Weir was struck by two paintings by Manet, *Boy with Sword* and *Young Girl with a Parrot*, in a gallery window. He bought them for an American collector, Erwin Davis. "I have never met Manet and was anxious to know so fine a painter," Weir wrote. "He was at home when I called, painting from a very beautiful model in a Watteau costume. He insisted on my coming in and that he was about to stop work. I told him about the two fine canvases I had purchased. . . . He invited me to dine with him the next night. He was very sore that his work had been acknowledged by so few. . . . My impression was that he

was a man whose disappointments had eaten into his life."[22] By the time he returned home, Weir had metamorphosed into an expert on the New Painting and applied his talents and powers to placing it in new collections.

Again acting on behalf of Davis, Weir bought Bastien-Lepage's enormous *Joan of Arc* for four thousand dollars. When exhibited for the first time in New York, it was an immediate sensation: "Its presence in America will doubtless not be without good effect upon the large and earnest body of youthful artists and art students," wrote a journalist in *Scribner's Monthly*.[23] Edward Abbey pronounced the painting the greatest modern work he had ever seen. "I never had anything so stir me up in my life," he recalled.[24] Over the years, Weir went on to write a number of articles about Bastien-Lepage,[25] and that French painter, in turn, did his part to help his American colleagues. In an interview with the *Boston Herald,* for example, Bastien-Lepage predicted the genesis of an American school of painting that would be "original and unconventional," the triumph of artists not "fettered by tradition."[26] During these years in New York, Weir never lost touch with Paris; his friends kept him up-to-date on everything happening there. "Bastien has been decorated, and his success at the last Salon (the portrait of Sarah Bernhardt and his potato gatherer) has put him in the first rank of contemporary masters. All Europe talks of him," Albert Edelfelt wrote Weir at one point.[27]

A few weeks after Bastien-Lepage died, on December 10, 1884, Twachtman meticulously described the Parisian reaction in a letter to Weir: "His death was felt by the whole artistic community. At his funeral everyone seemed to be present. I stood opposite his house from which he was taken forever and I thought of you and wished that I might cull a few flowers and send them to you. The hearse was covered with them. . . . He was a wonderful force in art and will no doubt live as long as his canvas will last."[28] With Bastien-Lepage's death, Weir had lost the closest friend of his Paris years. The following spring, when Bastien-Lepage's brother began raising money to erect a statue in his brother's honor in his native town of Damvillers, Weir solicited contributions from his American friends. The check he sent for 1,200 francs was an early act of transatlantic solidarity between French and American painters.

Three years after his first purchases for Davis, Weir set off for London, prowling for exceptional works on behalf of Henry Marquand, and made his most extraordinary purchase to date. For the sum of twenty-five thousand dollars he acquired a portrait he described as "finer than any at the National Gallery," Rembrandt's *Portrait of a Man.* "Now we will have a very remarkable picture, of which the country will be proud, a gem of the first water."[29]

By 1887 it was clear to Weir and others that European art had made tremendous inroads in the American market. In May, New York dealer Roland

Knoedler auctioned off the William Hood Stewart collection. Stewart had been a great collector of European works and, as photographs of his collection attest, had adopted the European habit of hanging his paintings close together. The real prize of the sale—which drew every major collector of the period— was an enormous painting by French artist Rosa Bonheur that Stewart had acquired sixteen years before from William P. Wright for fifty thousand dollars. When, thirteen years earlier, Wright had bought it from the dealer Gambart, he had paid only thirty thousand dollars. The painting, a gigantic canvas called *The Horse Fair,* 1852–55, and its creator were well known to critics and the general public; for nearly thirty years, newspapers such as the *New York Times* had celebrated Bonheur's independence, flamboyance, and Bohemian lifestyle. A lesbian and an iconoclast, she had made frequent visits to the American West to observe Native Americans, for whom she felt "true passion," deploring their treatment by the "white usurpers."[30] Depicting excited beasts rearing and stamping, Bonheur's *The Horse Fair* had been hailed as an incongruous and provocative tour de force.

A dealer named Rockwell bid for Thomas B. Clark; Samuel Avery represented Cornelius Vanderbilt. In the end, Vanderbilt got the Bonheur painting for $53,500 (only $3,500 more than Stewart had paid sixteen years earlier). In the thirty years since she had painted it, the market value of the work had nearly doubled, and the cult of Rosa Bonheur launched. Magazines fought to publish everything they could learn about her, and the public scrambled to acquire anything she painted. Measuring eight by sixteen feet, *The Horse Fair* was so enormous that even Vanderbilt didn't have a wall big enough for it. He donated it to the Metropolitan Museum, where it attracted huge crowds of admirers.

Shuttling between France and America, Weir continued his influential work. He introduced French painter Pierre Puvis de Chavannes to architect Stanford White, who invited the artist to create frescoes for the main stairway of Boston's new public library, a monumental Italianate building that McKim, Mead & White had just completed in 1892.[31] Weir urged curators at the Metropolitan Museum to exhibit Whistler's work, and devised strategies for buying a broad range of European paintings for young American artists to study. He contributed to a profound transformation at every level of artistic life: forging a group identity, building collections, founding artist colonies.

When the American painters had begun returning from Europe and found their efforts thwarted by the conservative academies that still controlled the urban art scene, many took refuge in European-style artist colonies that were being started outside the big cities. Around 1880, William Lamb Picknell and thirty other veterans of Pont-Aven, among them Frank and Bolton Jones,

Arthur Wesley Dow, and John Kenyon, set up shop in Annisquam, north of Cape Ann, near Boston. They wore clogs and berets trying to recreate the atmosphere of their beloved Breton village. Weir was among those who took part in the exodus and, joined by Twachtman, Childe Hassam, and Robinson, started a summer course for artists in Cos Cob, Connecticut, near Greenwich in 1890;[32] then, with Chase, Harrison, and Hassam, he moved to East Hampton, Long Island. Another center, the Art Students League Summer School in Woodstock, New York, was founded in 1906 and became one of the country's liveliest art centers, which it remains to this day. Several years later, William Morris Hunt, a Barbizon alumnus, created Massachusetts' first artist colony in the fishing town of Magnolia. At Shinnecock Hills, in eastern Long Island near Southampton, William Merritt Chase founded a school for the study of painting from nature, modeled on the French *plein-air* method. Another Barbizon painter, Henry Ward Ranger, created a colony in Old Lyme, Connecticut. Up and down the East Coast, art colonies sprang up that to greater or lesser degrees resembled those at Pont-Aven, Concarneau, Grez-sur-Loing, and Giverny.

"Your idea is the right one," J. Alden Weir had written to his brother enthusiastically in 1877, during his first years back in America. "Schools must be founded and the country manured and not grafted. Plant the good seed; we are the manure which will do it, although the 19th century will not see the effect. I feel that we are, however, bound to be a great art nation and hurray! for America. . . . You are sound, the fertilizers are what we want, so when the seed is turned up by the storm there will be a chance of its taking root. Nature and art are founded on the same principles."[33]

Art historian Ernst Gombrich, talking about the Protestant Reformation, analyzed the respective cultural importance of the cities of Antwerp, London, and Brussels before arriving at the following conclusion: "In biology the word 'ecology' refers to a species of animal or vegetable that survives only in a certain climate and in a certain environment. Naturally I am employing this word metaphorically. Many interrelated factors bring about the flowering of a particular style. And when they are gone, art can die."[34] What kind of art would be born of the new ecology being sown by American artists returning home from Europe?

Three

Between Pale Lilac and Yellow: The "Monet Gang"[1]

IN 1887, J. Alden Weir and his friends in the Society of American Artists were in trouble: their movement had been losing ground and in peril of being absorbed into the National Academy of Design. That same year, in Giverny, a tiny village only two hours from Paris, a group of American painters began to thrive. There, drawn by the presence of a reclusive master, Claude Monet, they would establish the most American colony in France. "Giverny is really far superior to Barbizon from every point of view," Canadian painter William Blair Bruce wrote his family.[2] Monet had settled there in April 1883, attracted by the luxurious gardens, the proximity of Paris, and the exceptional light mirrored in the meandering waters of the Epte River. Throughout the 1880s, the market value of his works had fluctuated enormously because of a crisis in the French art market; now, however, in addition to Durand-Ruel, he was represented by Boussod and Valadon, and by Georges Petit. In 1889, when Theo van Gogh managed to sell a Monet painting for the unimaginable sum of 10,350 francs, Monet was even able to buy a house. For the artist, it ended three decades of financial turmoil and inaugurated his most dazzling years.

"The more I work, the more I see how much work I still have to do, in order to capture what I'm seeking: the 'impact of the instant,' and especially the uniform envelope of light. . . . In short, I am more and more driven by the need to capture my own sensations," Monet wrote to his friend Gustave Geoffroy in October 1890. "As a pure landscape, a landscape never merely exists, since its aspect changes every moment; it draws life from the continuous variations of air and light."[3] In the 1890s, attempting to capture light in its "ephemeral effects" and "most fleeting moments" at the different hours of the day and different seasons of the year, Monet embarked on his "series" period: *Poplars, Haystacks* (more than thirty oil versions), and *Cathedrals* (more than twenty). That effort launched his most fertile years, and immediately achieved immense commercial success. In May 1891, all fifteen of the *Haystacks* canvases exhibited in the Paris

Durand-Ruel Gallery sold in four days. "Everything Monet paints flees to the U.S., at prices of four, five and six thousand francs. Everyone wants a haystack in the sunset!!!!" Pissarro wrote to his son Lucien.[4] At Giverny, setting up their easels in the fields, a group of American painters imitated the French painter's new project: Theodore Robinson with his *Wheat Field* series and John Leslie Breck with his *Studies of an Autumn Day,* among others—all poor replicas of Monet's masterworks.

"Don't fail to see some of his last winter's work, at Durand-Ruel's and elsewhere," Robinson advised a friend in June 1891, referring to Monet's *Haystacks.* "It is colossal, something of the same grave, almost religious feeling there is often in Millet."[5] But *what* was it about these simple variations on light that so beguiled the Americans? Was it that he positioned himself, on the one hand in the role of a landscapist—the traditional genre of American expertise—while at the same time stepping out of it, into another dimension which the American critics soon referred to as "religious"? In a pamphlet published in 1891 in New York, the collector William H. Fuller offered a clue: "Among innumerable truths which nature is constantly revealing, some few may have escaped our knowledge, which a more attentive student has discovered and recorded upon his canvas."[6] Monet's dialogues with nature, twisting, searching, exploring, fascinated the Americans. While French critics admired Monet's "remarkable work" (Octave Mirbeau on the *Poplars* series), his "superb unity" (Pissarro on the *Cathedral* series), his "eye" ("Monet's eye, precursor, [that] guides us, . . . and renders our perception of the universe more penetrating and more subtle," wrote Georges Clémenceau on the *Cathedral* series),[7] Americans detected in Monet's art something more essential, almost metaphysical, calling it nothing less than "true representation of Nature itself."[8]

Theodore Butler, Theodore Wendel, Robinson, and Willard Leroy Metcalf, who had blazed that American trail to Giverny, convinced Lucien Baudy and his wife to give up their café–grocery store and build a hotel. Opened in 1887, the Hôtel Baudy generated a virtual American onslaught on the village: John Singer Sargent and J. Carroll Beckwith spent four successive summers there; Lilla Cabot Perry, probably the only one to really get close to Monet, came from Boston with her whole family;[9] Frederick MacMonnies and his wife, Mary Fairchild MacMonnies, arrived soon after.[10] When they returned home, the American painters who had been staying near Monet at Giverny turned into his greatest promoters, raving about his work in Boston, New York, and elsewhere. During the summer of 1887, Sargent painted *Claude Monet Painting at the Edge of a Wood,* a portrait in profile, and acquired Monet's *Waves at the Manneporte* for his own collection. "It is with great difficulty that I tear myself away from your ravishing picture for which 'you do not share my admi-

ration' (what nonsense!), in order to tell you once more how much I admire it," Sargent wrote Monet in elegiac tones. "I could remain in front of it for hours on end in a state of voluptuous stupor, or of enchantment, if you prefer. I am delighted to possess such a source of pleasure."[11] Back in Boston that summer, Sargent threw the full weight of his prestige behind a passionate promotion of Monet.

"I saw Monet yesterday and a dozen or so canvases he did at Rouen last winter," Theodore Robinson wrote his friend J. Alden Weir in May 1892. "They are the *Cathedral,* mostly the façade, filling up all the canvas, and they are simply colossal. Never, I believe, has architecture been painted [like this] before, the most astonishing impression of the thing, a feeling of size, grandeur and decay. . . . He is not satisfied himself, will return next winter—said he tried to paint them as he would paint anything, 'all together' and not a 'line' anywhere—yet there is a wonderful sense of construction and solidity. Isn't it curious, a man taking such material and making such magnificent use of it? . . . Monet was cordiality itself. It's very pleasant to think that I have a place in his affection."[12]

Soon after returning home, Robinson who had kept a diary in Giverny, wrote an article about Monet for *The Century Magazine,* illustrated with a portrait of Monet as a patriarch, with beard, cane, and fisherman's jacket. "Monet," he wrote, "is the most aggressive, forceful painter, the one whose work has influenced his epoch the most. . . . There is always a wonderful sense of movement, vibration and life."[13] J. Alden Weir shared Robinson's passion, and bought from Robinson a drawing by Monet, *The Manneport, Etretat.* Without question, though, the most enthusiastic Monet admirer among the group of Americans who visited Giverny was Lilla Cabot Perry. At a conference for art students at the Boston Museum of Fine Arts, she confided some of Monet's "secrets"—for example, that his painting was always based on the same simple palette, "bright yellow, blue, green, and one or two different lakes and sometimes a little vermilion. He can sit down with his nose to the canvas, and can see almost how his paintings are going to look."[14] She later published a long article about her memories of the French master.[15]

Soon, American Impressionist painters began to appear on the scene. Among the first true converts, John Leslie Breck, a Monet disciple, received an honorable mention at the 1889 Exposition Universelle in Paris, and then began receiving quite a bit of attention in the United States. Three of Breck's paintings, *Field of Yellow Irises at Giverny, Yellow Fleur de Lys* [*Lily*], and *Garden at Giverny,* which Lilla Cabot Perry had brought to Boston in the fall of 1889, dazzled a critic there, Hamlin Garland. "A blinding group of paintings, an explosion of colors, by an individual named Breck . . . introducing 'Impres-

sionism,' the latest thing from Paris."[16] That same autumn, a painter named Thomas Buford Meteyard alerted his family, "If you hear about the works of someone named Breck this summer in New York or Boston, you must go and see them. . . . He's an Impressionist from the Monet school and a friend of the artist. I admire his work very much."[17] A New York critic declared in 1891 that, among the "Boston Impressionists," Theodore Wendel "succeeds in copying Monet's style to best effect."[18]

Theodore Robinson—the "first American Impressionist," in the words of local critics—took New York by storm with his painting *The Cowgirl*, shown in the 1889 Paris Salon before it appeared at the Society of American Artists. He followed it with *View from a Hilltop at Giverny, Winter Landscape, Flowering Trees in Giverny, Trognon and His Daughter on the Bridge*, and *Wheat Field in Giverny*, pious celebrations of the region and its light. "I have become very much an Impressionist," Phillip Leslie Hale, the creator of the most original American works in the same vein, told his family. When William Merritt Chase—who had never been to Giverny—exhibited at the Boston Art Club in 1886, some critics took him for the first American artist to "incorporate Impressionism" into his work. Chase had studied in Munich before going to Holland, and knew and admired the Impressionists but only from a distance. "I want all the light I can get," he wrote. "[It is] the only way rightly to inter-pret nature."[19] First in Boston, then in New York, critics judged his show to be the best mounted by an American since William Morris Hunt,[20] perhaps because both in his work and in his classes at the New York School of Art he appropriated such dictums of Monet as "Nature rarely repeats itself."

Little by little, the American public was discovering, almost at the same time, Monet and his American followers. But just what were they—a "studio"? a "school"? In the end, they were quite simply a very small group of experi-mentally inclined American painters who had assembled at Giverny and sent paintings, letters, and news back home. Two things bound them together: first, a common attraction to the aesthetic margins, derived from their training in Paris's more liberal studios—the Académie Julian (in the case of Breck, Wen-del, Ritter, Metcalf, Butler, Hale, Perry, and Mary Fairchild MacMonnies) or the studio of Carolus-Duran (where Sargent, Beckwith, and Butler had trained); and second, their shared Boston or Cincinnati roots. One after the other, John Twachtman, Frederick MacMonnies, Alice Jones MacMonnies, Will H. Low, William De Leftwich Dodge, Alexander Harrison, and Louis Ritter all passed through the small village of Giverny. In their eyes, it became the new mecca of artistic innovation.

This little group by no means represented a majority of the Americans studying in France. Most who attended the Ecole des Beaux-Arts and toiled

away in the studios of the more conventional teachers, remained—sometimes irremediably—slaves to the taste of their French masters. Frederick Bridgman, who'd been called an "exact copy of Gérôme," published a passionate diatribe against Impressionism, *Anarchy in Art:* "Most of the horrors from the point of view of subject, color, and form, which are being hung on the walls of our recent expositions, are the products of brain diseases, of envious men thirsty for fame, of new art and seeming uniquely to preoccupy oneself with the desire to give an illusion of the vibration of light." Then, carried away by his own argument, he added: "The Impressionists' paintings are the result of theories by Manet, a clumsy and uneducated painter. . . . *Olympia* is a chubby young woman poorly drawn and vulgarly painted. . . . The Salon des Refusés was started to ease inflamed egos and to satisfy their passion for publicity . . . the great part of this fashion is due to the army of critics who follow after the leaders like sheep . . . this class of critic should be whipped."[21] Envious artists, docile critics, decadent masters—endorsing the prejudice of the official art world, Bridgman was parroting Jean-Léon Gérôme's venomous attacks against Impressionism, and perhaps earning his rich name.

J. Alden Weir came gradually to Impressionism. Under the rigid tutelage of Gérôme, he had expressed the requisite absolute rejection of the "Impressionalists." Later, as he developed into a French art expert and scout for wealthy American patrons, he began to appreciate the New Painting, acquiring—on behalf of Erwin Davis—the first two Manets for the Metropolitan Museum. And by the time he met Whistler and Manet and visited the 1889 Exhibition Universelle, Weir had completed his conversion. Adopting a pastel palette and visible-brushstroke technique, he turned from portraits to landscapes before falling under the spell of Japanese prints.

In 1891, when Weir showed at the Blakeslee Galleries and at the Society of American Artists—his first solo exhibitions—everyone acknowledged the transformation in his art. But not everyone welcomed the change. His brother John, in particular, was shocked: "You have thrown up your reputation, success, all that professionally most people strive for, for a conviction within your own breast, the immediate effect of which brings down upon you ridicule and harsh criticism."[22] His patron, Percy Alden, criticized his "peculiar style" and admonished him: "Now, I take it that you want to sell—nay, must, for you are a skilled workman and should always command your own price, if, *bien entendu,* you do work that your customers (excuse the word) like and want."[23] Most critics also resisted Weir's new style. This "New-Impressionistic handiwork" is decidedly "out of place" in a portrait, declared a critic in the *New York Times,* while the *New York Herald* dismissed the "spinach-like texture" of the figures and the *Sun* castigated the "mist of green that suggests miasma."[24] Weir

and Twachtman were invited to show in May 1893 with Monet and another French painter, Albert Besnard, at the American Art Galleries. "Monet is the King of the Impressionists," announced a critic for *The World*, "the first real painter of landscape who has ever lived."[25] Popular opinion was divided between the merits of the "decorative power" of the Americans against the "wild splendid color" of the French.

Despite all the criticism, Weir continued to follow his inclinations. "I have exhibited these things because I recognize in them a truth which I have never before felt," he wrote his brother John in January 1891, in a letter discussing the changes his art had undergone: "[P]ainting has a greater charm to me than ever before and I feel that I can enjoy studying any phase of nature, which before I had restricted to preconceived notions of what it ought to be. . . . My art is my life and who ever said a truth that was believed at first? Traditions are good things and interesting, but . . . I was trying to see through the eyes of greater men, so that I was hampered by trying to render the things I did not see and unable to get at the things that really existed."[26]

Monet's influence, undeniably, led some American painters to free themselves from the tyranny of the academies. But why was Impressionism the first French movement to have this effect? Did it penetrate the Americans' art more easily, because of the landscape tradition in their country?[27] The Hudson River School painter, a humble intermediary who eliminated all personal references from his work, depicted nature as savage, virgin, infinite, its sanctity captured in immutable light.[28] Monet's art, conversely, allowed the artist's personality to pervade the canvas. He fragmented and dissected the forms under an omnipotent light, overwhelming the viewer with his presence and spontaneity. Rarely had the Americans in the artist colonies been touched by concurrent aesthetic developments in French painting. At Pont-Aven, quite certainly, those who rubbed shoulders with Paul Gauguin and the Nabis never adopted their aesthetic. And even Picknell, who greatly surprised most French critics by finding a new language in *The Road to Concarneau,* had simply returned to the fixed light of the Luminists, in an old American style.[29] At Grez-sur-Loing, Low, Robinson, and Robert Vonnoh, imitating Bastien-Lepage's Naturalism, combined academic drawing with *plein-air* painting, similarly producing a uniform, gray, shadowless light, likewise hearkening back to their own tradition.

At Giverny, something different happened. As if playing variations on Impressionism, each American painter produced his own personal version of it. Alexander Harrison's was exemplified by his *In Arcadia,* which represented a nude woman dancing in a garden. Weir's aesthetic evolution—influenced

successively by Gérôme, Bastien-Lepage, and Monet, and shifting from genre to portrait, then to *plein-air* painting—epitomized the American artist's struggle to free himself from the shackles of a sterile tradition. Traditionalists such as Bridgman refused to budge. But a few, including Whistler and Cassatt, recognizing the value of innovation, cast their lot with the most experimental painters. And those who followed them—Weir, Robinson, Chase, and Twachtman—assimilated the new tendencies, recognizing change as inevitable if there was ever to be an autonomous American art. Childe Hassam grasped the essence of Impressionism, and criticized the error by which historical painting had "been considered the highest branch of art," explaining, "after all, see what a misnomer it was. The painter was always depicting the manners, customs, dress and life of an epoch of which he knew nothing. A true historical painter, it seems to me, is one who paints the life he sees about him and who makes a record of his own epoch."[30] This of course echoed precisely the view that Duranty had expressed twenty years earlier.

While enthusiasm for French Impressionist painters continued to grow wildly in the United States, where the price of their works hit unprecedented levels, in France the market for the New Painting (with certain exceptions) was not as strong, and support was especially weak within official circles. The situation was similar regarding other French art as well. Government support could not even be mustered when a popular Realist work painted in the 1850s, Millet's *Angelus*—a depiction of French rural life—was offered for sale at the auction of the Secrétan collection in 1889 and word spread that an American was going to buy it. Armand Fallières, the minister of public instruction, who intended to get the painting for the French public collections, had asked the Chamber of Deputies to allocate additional funds, but the deputies declined his request. The painting went to the United States, purchased for 600,000 francs by a dealer representing the American Art Association.[31] French critics arrogantly denounced the Americans' buying frenzy: "The artistic education of Americans still lingers in a rudimentary stage," one of them wrote. "And, even though they cover Millet's *Angelus* with gold, they'll admit it openly."[32] Two years earlier, another had already noted the phenomenon and French reaction against it: "The Parisian columnists have fulminated against the American 'grabbing-mania'—almost legal robbery—of our most precious masterworks. But since average taste remains obviously much higher in France than in America, what better way for Americans to improve theirs than to buy masterpieces of French painting, at tremendous cost?"[33] It was perhaps comforting to analyze the situation in that light, since there were really no other lessons to be drawn from this hemorrhage of French art, which was only just beginning.

The same "American menace" jolted Monet into action by July 1889 when he learned that Manet's widow was about to sell *Olympia* to an American collector.[34] Fearing another humiliating loss like that of Millet's *Angelus,* and mindful of the striking indifference evinced by the French officialdom at the sale of Manet's studio a few months earlier, Monet promptly launched an "*Olympia* rescue mission." His campaign succeeded in buying *Olympia* through private contributions for the price Manet himself had set, 20,000 francs, and donating it to the Musée du Luxembourg.[35] Never before had such an initiative been necessary in France, where art had always had one primary patron—first the king, then the State.

"Monsieur Minister," Monet wrote to Armand Fallières in his official letter, "On behalf of a group of subscribers, I have the privilege of offering to the State Edouard Manet's *Olympia.* . . . We need only recall artists decried and rejected during their lifetimes whose fame today is undeniable—such as Delacroix, Corot, Courbet, and Millet, to cite only a few names—the isolation of their beginnings and their incontestable posthumous glory." Monet pursued a persuasive line of argument: "We have all watched with concern the incessant changes in the art market, the competition for artworks posed by America, and the easily predictable departure to another continent of so many works of art that are the joy and the glory of France. . . . We are placing *Olympia* into your hands, Monsieur Minister."[36] While Monet and his friends were forcing *Olympia* through the doors of France's museums,[37] three years had already passed since Weir had presented *Young Girl with a Parrot,* 1866, and *Boy with Sword* to the Metropolitan Museum of Art in New York.[38]

The narrow-minded official French attitude manifested itself again after Gustave Caillebotte's death in 1894. The painter and collector bequeathed his collection of sixty-seven works by his Impressionist friends to the Musée du Luxembourg. His will also stipulated his hope that the collection would remain intact. But owing to violent opposition by defenders of traditional taste, only thirty-eight of the works were accepted into the official collection of the French State, and those not until almost two years later, and considering the climate, that seemed like a lot.[39]

As *plein-air* painting inspired more and more enthusiasm with the American public, Durand-Ruel met the demand: in both New York and Paris, he showed a selection of paintings and sculptures by American artists, among whom figured most of the Giverny group: Hassam, Edmund Charles Tarbell, Vonnoh, Twachtman, Beckwith, Charles Courtney Curran, Robinson, and Hale.[40] At the same time, however, tensions developing since 1890 within the Society of American Artists were now mounting. According to one conservative critic, they were caused by a "crowd of new radicals . . . the Monet gang

back from Europe [who] want anything pale lilac and yellow."[41] It was indeed this "Monet gang" who would quit the Society, just as, twenty years earlier, its founders had walked out of the overly conformist National Academy of Design. And from Giverny, the temple of light, had come the "new truth" that would illuminate American painting from then on.

Four

Chicago, 1893

D URING THE FOUR DECADES following the Civil War, American cultural institutions flourished, and American painters returning from Europe regarded with wonder the spectacular changes the country had undergone in their absence. Later, these years would be eulogized—or reviled, depending on the commentator—as America's "Gilded Age."[1] In 1876, at the Centennial Exposition in Philadelphia, which marked the hundredth anniversary of the United States' Declaration of Independence, more than ten million visitors witnessed a tremendous display of artworks seen, for the first time, alongside the usual technical and industrial demonstrations. The Exposition bubbled with optimism and, according to the *New York Tribune,* curious crowds wandered among the displays as if "attending not a fair, but a school."[2] "We are still considered a resourceful but ignorant people, blessed with enormous energy and remarkable ingenuity but behind Europe in matters of refinement."[3] The Centennial Exposition had a notable effect on the economy, inasmuch as, according to one expert, "the setting in motion of millions of people, each with money to spend, has had an effect in breaking the lethargy that stifled enterprise in the business world."[4]

Soon, such fairs blossomed throughout the country, with expositions in New Orleans in 1885 and 1904, Chicago in 1893, Nashville in 1897, Omaha in 1898, Buffalo in 1901, Saint Louis in 1904, Seattle in 1910, and San Francisco and San Diego in 1915. Mounted by a growing and varied range of experts— industrialists, politicians, and academics—they seemed to epitomize the glorious achievements of the United States of America, allowing them to be enjoyed as mass entertainment while promoting a political agenda. Although organizers of Philadelphia's 1876 Exposition had been guided by a rather conventional vision of popular culture, the Chicago fair's organizers seventeen years later would dedicate themselves to restoring the people's confidence, confirming the country's international preeminence, and shaping the tastes of the general public.

During these same decades, new museums sprang up rapidly, one after the

other, beginning with the Metropolitan Museum of Art in New York and the Museum of Fine Arts in Boston, both founded in 1870; and the Art Institute of Chicago (founded in 1879) vastly expanded its holdings in 1887. Other public and private collections opened to the public, including one at Yale University in New Haven, Connecticut, and in cities such as Cincinnati, San Francisco, Kansas City, Pittsburgh, Columbus, Cleveland, Detroit, and Buffalo. In contrast to its European counterparts, the American museum emerged as a cultural institution created by the will and resources of a handful of businessmen, and managed by a board of directors as a private but nonprofit enterprise. This first wave of new museums (the second wave would follow in the 1930s) gave rise to a spurt of neoclassical buildings housing collections consisting of mainly European masters. The American museum would play for culture the role that churches and meeting halls had played for religion; it would perform a pedagogical function and—as the mayor of Boston proclaimed at the founding of the city's new museum—it would be "the crown of our educational system."[5]

Certainly, academies in the major cities remained stultifyingly conformist. But during these decades, American painters and collectors entered into a symbiotic relationship with Europe, and with France in particular, ushering in an "unaccustomed" moment of "coherence and intimacy."[6] The period was one of a flourishing "transatlantic civilization"—international, cosmopolitan, pluralist.[7] Cities such as Chicago, Cleveland, San Francisco, Des Moines, Philadelphia, and Washington, D.C., were, under the aegis of the City Beautiful movement, dazzlingly transformed in accordance with a monumental classical aesthetic. The Boston Public Library, with its elegant white marble, its bronze doors, and its audacious proportions, was designed by McKim, Mead & White to rival the great Florentine palaces of the Renaissance, and even featured frescoes commissioned from John Singer Sargent, Edwin Austin Abbey, and Pierre Puvis de Chavannes. The Library of Congress in Washington, sometimes venerated as "the country's supreme monument," was yet more ambitious, with frescoes created by Elihu Vedder, Edwin Blashfield, and Kenyon Cox, among others. Thus, European-trained architects and painters collaborated with one another, applying their savoir-faire to construct the country's most prestigious buildings. The "American Renaissance" exploded from every corner, shaped in large part by the aesthetic of Second Empire and Third Republic Parisian chic—a metaphor, perhaps, for the ambition to create an authentically American culture, and to prove its supremacy over that of Europe.

But no single monument nor any single cultural event would reveal the cultural kinship between the United States and Europe as clearly as the World's Columbian Exposition in Chicago in 1893. In its architecture, its scale, and its

ideology, the Chicago fair represented the culmination of this great period of American cultural eclecticism. "When the White City was built in 1893," wrote painter Will H. Low, "art assumed a definite place in our national life." He went on to echo Abraham Lincoln: "Then, for the first time, we awoke to a realization that art of the people, by the people, for the people, had come to us. It came to this New World in the old historic wave from the seed sown in the Orient through Greece, through Italy, from Byzantium, wafted ever westward, its timid flowering from our Atlantic seaboard had been carried a thousand miles inland to find its full eclosion; not as a single growth, but as a triple flowering of architecture, painting, and sculpture."[8]

It was in this atmosphere of economic exuberance and unrestrained optimism that, on May 1, 1893, the World's Columbian Exposition in Chicago opened, with much pomp and circumstance.[9] There the United States celebrated with all grandiosity the four hundredth anniversary of Christopher Columbus's discovery of America. Under the direction of E. T. Jeffrey, American experts scrupulously studied the Exposition Universelle of 1889 in Paris, down to the slightest detail. Then, just as painstakingly, they planned their event as both a counterpoint to and an echo of the French version, offering popular entertainment at modest prices in the artificial exotic villages, complete with lighting effects and lectures by celebrities. The organizers omitted nothing and, while they borrowed shamelessly from the French, they dreamed obsessively of surpassing them. In May 1889, the *Chicago Tribune* launched a competition for its readers, inviting them to submit drawings of an Eiffel Tower–like edifice. Several months later, the newspaper announced that a tower rising more than 1,600 feet would be constructed by two Washington, D.C., architects, and that the structure would "put the Eiffel Tower in the shade." Beset by financial problems, the tower was never erected, but the rivalry persisted.

During preparations for the Chicago World's Fair (as the World's Columbian Exposition was popularly referred to), conflicting opinions arose, particularly with regard to the architectural projects. Some, obsessed by the new, by ideals of originality and purity, rejected European and neoclassical influences in a manner that was nearly xenophobic. Others believed that these same influences had already pervaded American culture, and that their assimilation signaled the country's cultural maturity. Nationalism or eclecticism? Pure "Americanism" or European-style Neo-Renaissance? In the end, the fair's constructions mingled Venetian canals, Greek temples, Renaissance castles, Roman palaces, and Gothic vaults with these new edifices known as skyscrapers, in an original and bizarre union. The Hall of Honor (the Woman's Building), which one could reach either by boat or by train, would be remembered

in particular as one of "those palaces that one would only expect to find in Paris!"[10] The 1876 Philadelphia Exposition had honored America's Founding Fathers and the American Revolution; the Chicago Fair glorified industrialist patrons of the arts, the modern-day Medicis, their tastes and their prerogatives. From this point forward, there would be no denying the existence of American culture or its power to rival Europe's. That is what American steel magnate Andrew Carnegie had intended to convey to Kaiser Wilhelm, the German emperor, when he asserted that the age of monarchies was extinct and the age of the great American industrialists had begun.

In the American wing of the Chicago World Fair's fine-arts building, the number of works displayed was four times greater than that of the Paris Exposition Universelle of 1889. Yet the selection process had been unusually contentious by any standard; jury members diverged dramatically in their aesthetic choices. The New York meetings, in particular, degenerated into choleric debate, mainly over the existence of a pro-French bias. William Merritt Chase, for example, refused to include works by the Western Realist Frederic Remington, whose paintings epitomized an authentic American art wholly unaffected by European trends. J. G. Brown and Thomas Moran rose in opposition to this exclusion. "The committee," they argued, "would accept nothing that isn't according to Modern French notions." As now constituted, they continued, the exhibition "does not in any way represent American art."[11] "Whatever Mr. Chase thinks of Mr. Remington's art," they added vehemently, "he cannot say that he is not original, popular, and a representative American. But no. Remington isn't French enough, so he cannot exhibit at Chicago."[12]

In this tense atmosphere, some saw French influence as a scourge, a veritable plague. "My idea of an exhibition of the work of American painters at the great American exposition," observed Moran, "is that it would fairly represent American art; it should show what this country has accomplished and what it is accomplishing. To do this it is necessary to show the work of all or many of the most prominent artists of the country, not to judge paintings submitted by the standard of a school."[13] "Careful study of the French and American sections of the Exposition art department," wrote an art critic, Lucy Monroe, "only serves to confirm the first impression that the latter is the stronger of the two."[14] Monroe took this as proof of nothing less than the triumph of American art over French. Meanwhile, a Parisian art critic, Jacques Henric of *La Gazette des Beaux-Arts,* expressed an altogether different view: "Here we find the triumph of French artistry in all its plenitude, and America's avowal of our unquestionable superiority."[15] In concluding its work, the American selection committee ultimately settled on a great diversity of works, which were met with an equally diverse reception: Winslow Homer and George Inness were

judged to be the most "American"; Sargent and Whistler, the most gifted. Works by Alexander Harrison, Julian Story, Gari Melchers, Thomas Eakins, Thomas Hovenden, and others received excellent notices, but in terms of overall sales the Americans were largely surpassed by the Europeans, whose works sold ten times as well.

The French jury selected nearly five hundred paintings, all along very classical lines, featuring such artists as Léon Bonnat, William Bouguereau, Jean-Léon Gérôme, Carolus-Duran, Edouard Detaille, Jules Breton, Adolphe Yvon (with his *Portrait of Monsieur Carnot, President of the French Republic*), Fleury, Laurens, Léon Germain Pelouse, Benjamin Constant, and Rosa Bonheur. Roger Ballu—the French high commissioner of fine arts and the official representative of the minister of fine arts—reported to his superior with all due chauvinism on the reception of the French in Chicago: "The welcome given to our entries evoked great patriotic emotion in every Frenchman present in Chicago. We felt as if we were in the presence of a great national success. . . . The paintings constituted an ensemble of the most interesting by their value and their variety. The portrait of Monsieur Le Président de la République occupied the center of one of two large rooms; it was framed and hung over a piece of red velvet fabric with gold embroidery, which had been ordered from the Maison Belloir in Paris."[16]

Yet a number of American observers criticized severely what they saw as dreary conventionality among the French offerings. Thomas Beer recorded the following scene: "J. P. Morgan stalked through the Palace of Fine Arts and brutally remarked of the French exhibits that they seemed to have been picked by a committee of chambermaids. Indeed, the artists were disappointed with the French exhibits and the disappointment showed in William Walton's official volume on the fair's art. "Where were the Impressionists? These Monets, Seurats, and Renoirs so cried up in the magazines weren't to be seen. . . . Instead, here was the full Academic tone and scope—military pieces, the inevitable Madeleine Lemaire, the inescapable Debat-Ponsan, the *'Wasp's Nest'* of William Bouguereau."[17]

Indeed, what Morgan and others were looking for, in the Palace of Fine Art, could be found not in the French show but in an American one, an exhibition of "one hundred and twenty-six masterpieces by Foreign artists from private American collections," assembled by the pavilion's director, a young woman named Sara Tyson Hallowell. From Boston to Saint Louis, from New York to Philadelphia, from Washington to Baltimore, from Cleveland to Chicago—for three years Hallowell had scoured the country for foreign masterpieces in private hands and persuaded collectors to lend their treasures. She had borrowed from the holdings of the Havemeyers, Alexander Cassatt, and

Potter Palmer, gathering works that included Manet's *The Dead Toreador* and *Two Sailors;* Degas's *Ballet* and *Horse Race;* and landscapes by Pissarro, Sisley, and Monet. Hallowell's pavilion was unanimously pronounced the finest art exhibit at the fair. And with the powerful support of Chicago patron Bertha Honoré Palmer, the highly talented Hallowell was soon tapped to oversee all other pavilions. But finally, sexist and conformist forces scuttled her candidacy.

It is interesting that Commissioner Ballu mentioned the "collection of paintings by French masters in private American hands" in his report to his minister. He felt compelled to admit that he shared the "marvelous impression" made by this "elite exhibit composed exclusively of masterpieces assembled with great care, set far enough apart that they don't compete, and paying the greatest possible compliment to our art in this century." Indeed, in his official speech at the French banquet hosted by the American organizers, Ballu confessed that the Americans had "added" to the French painting section "an incomparable gallery of French masters belonging to wealthy American owners," and that thanks to them, French "living masters" were able to "escort our great departed masters." "Within several years," his remarks concluded, "what will you think of us, the venerable old Europe? You will imagine, indeed, that Europe feels for you the same tenderness and admiration that a mature man feels for a handsome youth passing by, and in return you might offer your recognition, your grateful friendship . . . your respect for his glorious past." Ballu was careful to add that "Europe is not only the past, but also the present, and wants to be the future."[18] With such awkward discourse, the French civil servant revealed a certain degree of malaise. Why were the most original French painters of the last few years absent from the official French selection? Why had they been excluded by the French, only to be selected by the Americans?

Perhaps it was out of tact that Hallowell had decided to display only fourteen examples of French Impressionism, but her presentation left little doubt that these were pioneers of a revolutionary new approach to painting that had already influenced numerous artists internationally, and that these artists would endure.[19] Her intuition about their importance in the history of art would prove correct.

For six months, the Chicago World's Fair celebrated the triumph of America itself: Rockefeller's industrial state had definitively buried the rural republic over which Lincoln had presided in the 1860s.[20] But had it succeeded in outshining the Paris expositions? The Chicago Fair covered four times the surface area of the one in Paris in 1889, and the largest of the American buildings was four times larger than the greatest French monument. In the opinion of Henri

Loyrette, "One cannot state too many times, that the Columbian Exposition of 1893 was not a success."[21] What was truly on display in this grandiose project—as all the measurements and comparisons attest to—was a growing struggle for power that was already evident before the fair. In their first attempt to challenge Europe on the cultural field, American officials revealed both admiration and rivalry, the two main impulses that would henceforth enrich relations between the Old World and the New. Thus began the confrontation between these two "imperialisms of the universal."[22]

"How shall we assay this French influence, first brought into the Brown Decades by William Morris Hunt, who had sat at Millet's feet?" asked Lewis Mumford in *The Brown Decades*.[23] The time that young American painters had spent in France had clearly inculcated in them a tradition of excellence and put them in contact with the French masters. But would they remain second-rate imitators, or become creators in their own right? Our American painters "are mere imitators as clever as their masters, but imitators nevertheless," wrote one critic the day after the World's Columbian Exposition had opened.[24] Would an autonomous American art ever be invented? Amidst the radical transformations their country had undergone, American painters found themselves at once stimulated and destabilized; but the ultimate effect on them remained to be seen.

"Where is our American national art?" asked Lucy Monroe in June 1893. "If we find it at all, we must find it in the clap, clap, clap of wooden shoes. If we see it at all, we must hunt for it . . . in the taverns of the south of France, in the boulevards and attics of the French capital."[25] The question of debt and dependence with regard to France haunted many. Others, such as John La Farge, regarded the issue in a more positive light. "We are not as they are—fixed in some tradition," he wrote. "And we can go where we choose—to the greatest influences, if we wish, and still be free for our future."[26]

U.S. Senator George F. Hoar gave an address before the Senate in which he proposed the creation of a national committee for the fine arts, according to the French model. "I understand that in France all the designs of important public works of art are submitted, before the Government contracts for them, to a Commission of eminent artists who have won their spurs, and to whose judgment the public and their professional associates are willing to defer."[27] Others, however, rejected French models and, remaining obsessed with America's presumed cultural inferiority, took an extraordinarily isolationist stand. "The American who lives in Paris till he is a mongrel Frenchman can never paint a great picture," gibed one journalist. "Men can learn the technical part of their trade in foreign lands; but the wit, the fancy, the poetry, the knowledge of human nature, must come from home. Nationality can no more be changed

than can color of the skin, and the man who tries to be other than he is inevitably meets the fate of the jackdaw who is dressed in borrowed plumes."[28] Did the European model represent an ideal, or a foil? Should the art housed in the Louvre be the subject of abject admiration, or, as painter Albert Pinkham Ryder believed, of absolute indifference? These sweeping questions in relation to the European model—and to the French one in particular—inflamed extremist positions. Some sense of equilibrium was yet to be found.

Five

The Great Wave of Collections
in America

"'WHO IS THIS VERMEER?' inquired J. Pierpont Morgan of the dealer offering him one of the Dutch master's works. When the dealer told him about Vermeer's art-historical importance and the scarcity of his work, Morgan asked abruptly how much it cost. 'A hundred thousand dollars,' was the dealer's reply. 'I'll take it,' Morgan announced, unfazed by the high price. If Morgan acquired a Vermeer out of narcissism, William Vanderbilt bought a couple of Corots because, as he put it, he was 'tired of having people tell him he must.'"[1]

Dizzying industrial development, rampant banking speculation, and the rise of colossal financial dynasties: during the last decades of the nineteenth century, all of these combined to create empires that marshaled material resources and human energies in proportions heretofore unknown and at breakneck speed. "Robber barons" engaged in titanic battles, playing the country's political organizations off against each other, dodging financial panics, bouncing from crisis to boom, amassing fortunes and ruining others trying to amass their own. It was a time of unthinkable wealth and unimaginable opulence, of every possible excess and abuse—all pursued with unapologetic fanfare. This was the age of Andrew Carnegie, Vanderbilt, Morgan, George Hearn, William B. Astor, Andrew Mellon, William C. Whitney, Oliver Payne, Jay Gould, and Henry Clay Frick—oil tycoons, steel magnates, coal barons, gold kings, iron masters, copper princes. Self-admiring, fiercely competitive, arrogant, they welcomed some newcomers into their ranks and rejected others, deciding who were their peers and who were mere parvenus. All this in a highly mobile society in which status could be bought and sold at a speed matching the gyrations of the stock markets, and in which social-climbing strategies went hand in glove with financial gains—in which the reign of the "haves," it seemed, would last forever.

Drunk with conquering industries and accumulating wealth, these men built themselves extravagant homes—town houses in New York, summer palaces in Newport—and stockpiled within them marble, gold, ebony, antiques, oriental rugs, and medieval tapestries. They purchased Italian Renaissance, French Gothic, and medieval Flemish objects, reproduced Louis XIV dining-room sets, designed their gardens in the style of Versailles; they used Europe's art treasures to advertise and consolidate their fortunes and cultivate social prestige. Things European were the most desirable by far, the more expensive and impractical the better. And in the quest for upward social mobility, a private collection full of fine art trophies remained the greatest tool, the ultimate trump card of snobbery.

For four decades, an exceptional dealer dominated the art market in the United States, running his business like a veritable international corporation. At age eighteen, Joseph Duveen forced his father into debt soon after joining his father's firm, incurring great financial risk to purchase three eminent collections: first the Hainauer collection in Berlin, followed by those belonging to Rodolphe and Maurice Kann in Paris—all told, an investment of ten and a half million dollars—which he would sell during the next forty years. His art empire would prove one of the most profitable long-term investments in the history of the art market. Aiming to create a monopoly and gain expert legitimacy in the eyes of his clients, Duveen enlisted the help of several art historians, including Bernard Berenson, who authenticated works from the Middle Ages and Renaissance masters, and George McCall, who helped him compose the catalogues that accompanied each work sold. Duveen didn't just sell paintings; he built collections. And each collection he constructed, crowned with a specially commissioned brochure, conferred prestige on its purchaser. Duveen played skillfully upon the egos of wealthy men looking for art, inflaming rivalries in their quest for social standing—and made himself rich in the process.

During his four decades in business, Duveen was responsible for massive transfers of English and Italian art collections to the United States. Thanks to his empire, America's holdings in medieval and Renaissance artworks were second only to Italy's. With its strong currency reserves, the United States could well afford to swallow up the treasures of European patrimony, just as wealthy seventeenth-century Dutch merchants had acquired art from Southern Europe.[2]

The first American collectors to snap up works by the French Impressionists—the Davises, Spencers, Fullers, and Kingmans—bought their first Monet paintings at Durand-Ruel's 1886 exhibition in New York. Adding more such works to their collections became easier after Durand-Ruel opened his New

York gallery in April 1888. Another milestone passed that same year, when Albert Spencer, one of the more adventurous of the early collectors, decided to sell off his Barbizon collection and buy some of the New Painting. Nearly seventy of the Barbizon canvases were sold, for a total of $284,000; and over a period of several years, he was able to acquire some very handsome works by Monet, Degas, Boudin, and Renoir. In 1890, within a matter of a few hours, W. H. Crocker of San Francisco bought an entire collection of French paintings from Durand-Ruel for the staggering sum of $100,000.[3]

In February 1891, at the Union League Club in New York, William H. Fuller organized the first American exhibition devoted entirely to Monet, with thirty-two paintings. The following month, Durand-Ruel countered by mounting his own exhibition of Monets, Sisleys, and Pissarros at the Club, before moving it to his New York gallery at 315 Fifth Avenue, at the corner of Thirty-second Street. A year after that, in Boston, the Williams and Everett Gallery displayed works by Theodore Robinson and Theodore Wendel, both Monet disciples; only a few yards away, there was another Monet exhibition, featuring twenty-one works, at the St. Botolph Club, organized by Boston collector Desmond Fitzgerald. From then on in the United States, there was no avoiding the Impressionists.

By the end of 1892, Monet's name was firmly established in New York; his works attracted collectors even while being attacked in the press. "The modern Impressionists," wrote one critic, "the open-air enthusiasts, who, because purples and pinks have been neglected in the paintings of the immediate past, see almost nothing else by way of colors, and ask to see nothing else."[4] Another asserted, "If [Monet] sees Nature as he paints here, either his vision must be diseased or that of every other landscape painter that ever lived; if he does not, he is humbugging the public."[5] Opinions such as these dissuaded only the most timorous among the collectors.

Paul Durand-Ruel, though in competition with other dealers on the American scene, was continually praised in the local press. He and his sons, wrote one journalist, "regard art with a personal as well as commercial eye. It is not enough to sell a picture for them, but also to know and love the picture that they sell. . . . Curiously enough, with all the keen refinement of their Gallic education, that education which renders it possible for men to be the shrewdest of businessmen without ceasing to be gentlemen, they combine a thoroughly American energy, rapidity of ideas and execution, which do not occur commonly under the slower business conditions of Europe."[6] Durand-Ruel had just concluded a particularly profitable year, thanks in part to purchases made by two steel barons—Harris Whittemore of Naugatuck, Connecticut, and Alfred Atmore Pope, of Cleveland, Ohio, both advised in art matters by Mary Cassatt.

For three years, Sara Hallowell had been art advisor to a Chicago couple, the Potter Palmers, taking them to Paris in 1889 and again in 1891. She took them to galleries, museums, and artists' studios, and on the second trip they bought eleven Monet paintings, three Boudins, and one Degas. The following year, 1892, they bought eleven Renoirs, eighteen Monets, seven Pissarros, two Sisleys, and one Degas. Audacious buyers, the Potter Palmers had a taste for the latest work and a sturdy confidence that their collection would enhance their standing in Chicago society.[7] During the winter of 1893, the popularity of Impressionist works in the United States continued to grow apace. An exhibition of works from private American collections was held at the Vanderbilt Gallery of the American Fine Arts Society. During the same period, however, the sale of Henry Johnston's collection provided an indication that the dollar value of the New Painting had not yet caught up with the growing enthusiasm for it: one Monet went for merely five hundred and fifty dollars, while ten years later, each of his paintings would sell for twelve thousand.[8]

A year later, the economic boom of 1894 solidified the Impressionists' foothold in America. Durand-Ruel decided once again to move his New York gallery, setting up shop at 389 Fifth Avenue, at the corner of Thirty-sixth Street, in a building owned by Harry Havemeyer, who in 1883 had married Louisine Elder. Nine years earlier, at age eighteen, Louisine had met Mary Cassatt in Paris and begun assembling a collection of new, original, and rare works of art. Havemeyer—a millionaire after expanding his family's sugar-refining business during the late 1880s, and thus known as the "Sugar King"—was a man of traditional tastes in art, collecting mostly Dutch and Flemish masters until, under his wife's influence, he began buying more modern works as well. Paul Durand-Ruel, who had met Havemeyer for the first time in New York in 1885, sold him Manet's still life *The Salmon* in 1886, became the couple's friend and adviser at the time of the Exposition Universelle of 1889, and helped him acquire some works for his collection of Old Masters.

Within a few years, the Havemeyer Collection boasted nearly fifty works by Courbet, including some of the artist's finest pieces; sixty of Degas's graphic works and seventy of his bronzes (the second-largest collection of the artist's work anywhere in the world); twenty-five of Manet's best works (second in the world in terms of size and quality); and seventeen paintings by Mary Cassatt.[9] Nearly half of these artworks had been acquired through Durand-Ruel. Throughout the 1890s, the Havemeyers had shown exceptional taste. Through Cassatt, they met and became close to Degas—indeed, so close that the artist would agree to sell them his painting *Dancers Practicing at the Barre,* and two drawings from his own collection, with which he had previously not wished to part.[10] In September 1895, Durand-Ruel sold the Havemeyers two Degas pastels

from his own collection; they were "long and slender," and depicted two dancers. For *Dancer in Green,* showing a dancer in a strenuous pose, he obtained fifty-five hundred francs; for the other, *Dancer in Yellow*—a somewhat less interesting effort—only thirty-five hundred. Later, Paul's son Joseph Durand-Ruel showed the Havemeyers a pair of Degas pastels that had belonged to his father; and again, one of the works was more interesting than the other: the elder Durand-Ruel had held onto one pair of drawings—the less interesting duo—permitting the Havemeyers to acquire the better one.[11]

"How would you like to have a portrait of Clémenceau by Manet?" Cassatt asked the Havemeyers one day in the fall of 1896, referring to the French president. "I saw Clémenceau yesterday and he wants to sell his portrait. He says he does not like it, but I rather think he is hard up and wants some money." The Havemeyers went to Clémenceau's house outside Paris to see the work in question, which Manet had painted in 1879. "We became friendly at once," Louisine Havemeyer later wrote. " 'I sat for Manet many many times,' " Clémenceau told them, " 'but he could never make it look like me,' and he took hold of the frameless portrait and swung it around to show it to us. 'I don't care for it, and would be glad to be rid of it,' he continued. . . . 'Manet never finished it, and yet I gave him forty sittings! Just think of it, forty sittings for one portrait! . . . I shall never hang it anyway.' " The Havemeyers listened to Clémenceau and Cassatt discuss the separation of Church and State, paid ten thousand francs, and left with the portrait.[12]

Under rather different circumstances, the Havemeyers acquired some highly controversial works, including Manet's *The Masked Ball at the Opera* and *The Railway* (*Gare Saint-Lazare*). While visiting the 1883 Salon in Paris, Louisine had noted that Manet's paintings were the object of jokes and gibes by visitors. "I always regretted that I did not understand French better," she recalled. "There was always a crowd before these two pictures, there was tittering, elbow nudging and shoulder shrugging with much laughter and vociferous exclamations." The general public openly mocked Delacroix's *Monsieur Pertuiset Hunting,* but it was Manet's *Portrait of Henri Rochefort,* 1881, that was the object of most scorn. "One day I saw a young man draw his companion away saying: 'You must not go near it, don't you see his face is just about breaking out with smallpox?' "[13]

By acquiring *The Masked Ball* in 1894, Louisine Havemeyer continued to show her confidence in Manet's genius despite all the public hostility toward his work. She much admired this painting, which revealed a new sort of social commentary—one formulated in the details, in the wings, on the margins. "How the critics whistled and hissed," she remembered, "and found the masked ball (which they attended night after night) indecent and a menace to

society."[14] Finally, "to please himself," her husband bought *Gare Saint-Lazare*, recognizing that it was "one of Manet's greatest achievements." The little girl in the work "is just a natural little girl, doing just what a little girl naturally would do when she found herself beside the big Gare St. Lazare where the trains are rushing in and out she looks and looks and looks."[15] Critics reserved some of their most savage commentary for this painting; some suggested maliciously that the girl was an escaped mental patient, a prostitute, a vagabond. The Havemeyers took it with them to the United States.

It was not until 1895 that the vogue of Impressionist painting definitively touched the American shores. That same year, the Federal government finally lifted the import tax on foreign art, and Paul Durand-Ruel decided to devote an entire show in his New York gallery to Manet.[16] More and more American collectors would swap their Barbizon works for Impressionist art. Paintings by Monet, Pissarro, and Renoir—who only several years earlier had been begging Durand-Ruel to send them five hundred francs to see them through until the end of the month—were entering a boom period. Within four years, the value of a work by Monet multiplied four- or fivefold. In 1895, each of his *Cathedral* canvases sold for nine to ten thousand dollars.[17]

From then on, French Impressionist paintings became coveted trophies in the rivalry among the wealthy American collectors. Alexander Cassatt, Henry Johnston, Frank Thomson, William H. Fuller, Alden Wyman Kingman, George Vanderbilt, Albert Spencer, and Erwin Davis—all fell into this craze.[18] The painters most in demand were of course Manet, Monet, Renoir, and Degas, but also Courbet, Sisley, and Pissarro. Their dealers were Paul Durand-Ruel and his three sons; Alphonse Portier; Ambroise Vollard; Père Ganne; James Sutton; Boussod and Valadon; and Delmonico.[19]

Thus emerged a new breed of American collectors, one that inverted the traditional artist-patron relationship. If, in classical times, an artist was ennobled when an aristocrat bought his art, in late-nineteenth-century America, it was the nouveau riche who aimed to ennoble himself by buying masterpieces, as J. P. Morgan had intended to do when he acquired his first Vermeer. Some not content with the prestige of private ownership[20] built museums bearing their names—the Corcoran Gallery of Art in Washington, D.C., the Walters Art Gallery in Baltimore, the Isabella Stewart Gardner Museum in Boston, to name but a few.[21] These were part of a select few actually interested in experimental art—the way Louisine Havemeyer, when she was very young, had passionately admired the most innovative French artists.

Women were often the go-betweens, the intermediaries between the American industrialists and the French artists. Daughters of wealth and position such as Mary Cassatt, Sara Tyson Hallowell, and Lilla Cabot Perry could

rely upon the connections that were their birthright and use them to expand a network at once social, professional, and familial—gradually and patiently, with discernment and with conviction. They were true ambassadors of French Impressionism in this country, but they were not the only women furthering the cause of art in America.

For several years, philanthropic societies supported by private donors had been formed across the country, founded by women such as Candace Wheeler or Sarah Worthington King Peter. The latter, the daughter of Ohio's first governor, daughter-in-law of Senator Rufus King, wife of the ambassador to the court of St. James, second wife to the British consul in Boston—in short, a woman with impressive social connections and surrounded by intellectual luminaries—incessantly involved herself in artistic activity, developing such institutions as the Franklin Institute (a design school for women in Philadelphia), and another in Cincinnati (the Ladies' Academy of Fine Art), where she also mounted a public collection of European art.[22] In 1897, philanthropists Amelia, Sarah, and Eleanor Hewitt—granddaughters of Peter Cooper, a distinguished inventor, industrialist, and philanthropist, and daughters of New York's mayor from 1886 to 1890, Abram S. Hewitt—founded the Cooper Union Museum for the Arts of Decoration (now the Cooper-Hewitt National Design Museum) in New York, the first museum devoted to the decorative arts. The Centennial Exposition in Philadelphia had provided the occasion for launching the decorative-arts movement, through the intermediary of the Women's Pavilion. The Chicago World's Fair in 1893 provided another occasion for women to play a pivotal role in philanthropy and patronage.[23] Yet the lasting influence that women would have on the status of American painters had only begun to be felt.

In 1895, a French journalist asked Paul Durand-Ruel about French art in American collections. On March 1, the dealer answered in a long and revealing letter that reads like a virtual geographical map of art in America at that time. "Dear Sir," he wrote, "I am enclosing the names of several art collectors in New York and other large American cities. There are many others but the list would be too long. Nearly half the works by the painters of the School of 1830 can be found in America, spread out over several hundred collections. The same is true for all of our living artists. . . . Three hundred works by Monet are to be found in private galleries. Of the most remarkable collections in New York, I cite the following: Mr. H. O. Havemeyer, who has in his possession eight superb paintings by Rembrandt, two by Franz Hals, and . . . a series of modern masterpieces by artists such as Corot, Delacroix, Courbet, Manet, Géricault, Millet, Degas, and Monet. Madame Vanderbilt owns several Millets, including *The Sower*, some fine works by Rousseau, and important paintings by Troyon and

Degas. Mr. Cornelius Vanderbilt and Mr. W. K. Vanderbilt have great riches. Mr. George Vanderbilt owns an excellent collection of modern paintings by Monet, Renoir, Pissarro, and Daumier. Mrs. W. Astor and Mr. J. J. Astor have a remarkable collection of works from the French School. Mr. Charles A. Dana, the publisher of the *Sun,* owns, among other works, *The Dance of Love* by Corot and *The Turkey Shepherdess* by Millet. Mr. George Gould counts among other marvelous masterpieces several works by Corot, including *The Evening.*

"Mr. Wm. Rockefeller has works by Millet, Delacroix, and a host of other handsome French paintings. Mr. Henry G. Marquand, the president of the Metropolitan Museum, owns many French works. Mr. Erwin Davis has given the Metropolitan two paintings by Manet, *Boy with Sword* and *Woman with Cherries,* and owns remarkable works by Delacroix, Courbet, and Millet. Mr. Albert Spencer possesses a sizeable gallery, with works by Rousseau, Corot, Daubigny, Monet. Mr. Cyrus Lawrence has three very handsome Monets and Sisleys. Mr. A. W. Kingman is one of the premier collectors of Puvis de Chavannes, Monet, Renoir. Among the other notable collections, made up almost entirely of works from the French School, one can cite those of Mr. C. P. Huntington, M. K. Jesup, Chas. S. Smith, August Belmont, Alfred Corning Clark, W. H. Fuller, J. A. Garland, Henry Graves, and Benjamin Altman; Thomas Newcombe is the happy possessor of Corot's *Nemi Lake.*

"In Philadelphia, the gallery of Mr. P. A. Widener includes works by the Flemish masters and important works by Corot, Decamp, Fromentin, Rousseau, Daubigny, Manet, Monet, Pissarro, among others; Mr. Elkins has a number of handsome works of the 1830 School, as well as works by young modern painters. Mr. John G. Johnson has bought noteworthy works by older masters, and numerous works by Delacroix, Corot, Courbet, Daubigny, Millet, Manet, and Degas. In Baltimore, the galleries of Mr. W. T. Walters are renowned throughout the world, featuring Corot's *Saint Sebastian,* Rousseau's *Le Givre,* and Delacroix's *Christ on the Cross.*

"In Boston, Mrs. Frederick L. Ames owns one of the most remarkable collections, devoted exclusively to some of the most important and most beautiful 1830 paintings. Quency Shaw is the happy possessor of the most beautiful and numerous collection of works by Millet anywhere in the world: at least twenty paintings, including *Potato Harvest,* . . . and forty pastels . . . plus superb works by Rousseau, Delacroix, Dupré. Mr. Martin Brimmer possesses numerous Millets and paintings from the 1830 School. In Cleveland, Mr. H. H. Wade's gallery includes Puvis de Chavannes's marvelous *Summer.* Mr. A. A. Pope has a choice collection of works by Manet, Monet, Degas, and Whistler.

"In Chicago, one of the best-known galleries belongs to Mr. Potter Palmer,

with superb works by Delacroix, including *Lion Hunt,* and Corot's *Evening* [*sic*], and paintings by Fromentin, Rousseau, Monet, and Renoir. . . . Mr. C. Hutchinson has some truly noteworthy works by twenty masters and several paintings by younger artists. Mr. Martin Ryerson owns a collection of Perugino, Ruysdale, and a number of works by Puvis de Chavannes, Monet, and others. Mr. Yerkes, who will set himself up in New York at the end of the year, owns a very important and very remarkable collection of the greatest French masters and modern painters, with numerous works by Rembrandt, Franz Hals, Rubens, and Van Dyck, next to the finest works of Troyon, Corot, Millet, Rousseau, Daubigny, and works by the young school.

"One of the most beautiful galleries in America can be found in Saint Paul. Mr. J. J. Hill owns works of Delacroix, Corot, Millet, and Rousseau. Among the Delacroix works is *The Coast of Morocco.* . . . Among the Corots are *The Wagon* and *Setting Sun in the Great Forest.* In San Francisco, Mr. W. H. Crocker is the happy owner of Millet's *Man with a Hoe,* one of Corot's *Dance of the Nymphs,* and numerous works by Degas, Puvis de Chavannes, Monet, Renoir, Pissarro, and Sisley. In Norwich, Mr. William J. Slater owns *The Dance of the Nymphs* by Corot (Laurent Richard collection), a *Christopher Columbus* by Delacroix, and other superb works by Corot, Troyon, Millet, Rousseau, and Decamp."[24]

How would one react to such a daunting list of masterpieces? Delacroix and Corot, Manet and Courbet—all artists championed by Paul Durand-Ruel in his battle against official art in France—had been recognized by American collectors from New York to San Francisco. A new map was being drawn, one dotted with treasure spots and new museums. In the final years of the nineteenth century, the majority of the most innovative paintings created by French artists during the previous four decades had swiftly crossed the Atlantic and had been replanted in a country with artistic roots far different from the ones from which they had sprung—a unique phenomenon in art history. But where would this new map lead young American artists and the American public?

Six

From the "Blue Shadow School" to "The Ten"

"WE THE UNDERSIGNED agree to resign from the Society of American Artists upon the signatures of the whole Ten being attached. J. Alden Weir, Willard L. Metcalf, Edward Simmons, T[homas] W. Dewing, Childe Hassam, Robert Reid, Edmund Tarbell, Frank W. Benson, Joseph De Camp, J. H. Twachtman. We the undersigned agree to cooperate and consolidate for the purpose of holding an annual exhibition of work—each member pledging himself to exhibit. And we moreover agree to admit no other man to this group without a unanimous consent."

In New York on December 17, 1897, J. Alden Weir and nine of his colleagues, a group dubbed the "Monet gang" by one waggish critic, resigned from an institution that had become, to their minds, too conservative.[1] "We are not nearly so dangerous as the public is trying to make out," Robert Reid declared. "We are simply a dozen [sic] men who want and intend to give an exhibition."[2] J. Alden Weir added his denial of any "sudden impulse" behind the actions of this new group; the Society of American Artists had simply "grown so large that it has no direct purpose."[3]

According to the position of The Ten, the art world in America had evolved into an arena in which "commercial art" on one side battled "authentic art" on the other. Some members blamed the new powers within the Society for turning exhibitions into "paying business ventures." Edmund Tarbell attacked the members of the ruling body of the Society as "men of mediocre ability" compared to the "artists of merit," whose cause he joined.[4] The Ten's noble aim became nothing less than a crusade to educate the public in the subject of "true art."[5]

The secession of The Ten marked one of the defining moments in the battle for American Impressionism that had been raging for some time on the New York art scene. In 1892, the most conservative members of the National Academy of Design had rejected the candidacies of Tarbell and Benson even though

both artists had previously been subsidized by the Academy. Besides, some trustees on the governing board of the Metropolitan Museum worried that the "conservative force will go and the Museum will be run by the Impressionists," as its director Henry G. Marquand wrote.[6] The "Impressionist menace" born in France threatened to contaminate, one by one, heretofore protected American institutions.

The allergic reaction to Impressionism finally reached the more liberal Society of American Artists by 1894. The Giverny artist Theodore Robinson warned his friends that "a gang, led by [Kenyon] Cox and rather loud-mouthed was rather ill-disposed to impressionistic pictures." Nevertheless, he had managed with the help of friends to get some of "our men in" and push out "a few of our enemies."[7] But after new members were elected in the spring of 1895, the Robinson group found itself in the minority, outvoted by what he called a "solid phalanx of mossbacks" who "voted out every impressionistic [sic] aspirant."[8] Several months later, William Merritt Chase resigned after ten years as president of the Society. Chase had earned a reputation for tolerance and openmindedness, and even showed a fondness for Impressionism. With his resignation, one of the last ramparts protecting the American friends of Monet within the Society had toppled. When Robinson died on April 2, 1896, the most conservative wing of the group took back control of the Society. At the following year's exhibition, every critic noted, "the Impressionists are the losers."[9]

As soon as The Ten announced their secession, the Society's powerful members reacted sharply. "I don't think this movement is at all serious," declared George Barse, the organization's secretary, in patronizing tones. "I expect to see them all Ten back in the society sooner or later."[10] The organization's vice president, Kenyon Cox, tried to explain the secession as sour grapes and jockeying for power: "Most of them are impressionistic [sic] painters, and while impressionism continued to be looked upon as the beginning and the end of art, they, naturally, received rather more consideration than now, when people are beginning to see that there are other things." He added, "They have received most of what the Society has had to give. They have until very recently controlled the jury."[11] The Ten's departure did involve a settling of scores in the name of American art, but at the heart of it all, the debate still centered around the European art model.

Jervis McEntee, one of the most reactionary of the Society's members, criticized the work of The Ten as "foreign-looking art." Another attacked the group not for rejecting American art, but for failing to truly embody the European spirit, in which tradition and art remained inseparable. In Europe, he declared, "institutions of art command gratitude, respect, and a certain amount of self

sacrifice from their members. . . . But in America, there is yet no deep feeling of tradition."[12]

Paradoxically, American painters struggling to create an American art remained trapped in European models, the very ones that the Europeans themselves were challenging. In fact, one of The Ten took note of similar actions undertaken abroad. "It is interesting to note that this movement has its parallel in both France and Austria, and that in each case the more vital art seems to be represented by the Secessionists. In France, it is a new salon, popularly known as the Champs de Mars, which has taken precedence over the old Salon of the Champs-Elysées. In Germany, too, the Secessionists, whose society is called the Secession, seem on the whole to be exhibiting at present the best things."[13]

Despite the smug predictions by certain members of the Society of American Artists, The Ten lasted for a decade. In a group photo, they pose wearing three-piece suits, ties, and collars, and sporting pocket watches, gloves, and canes—looking far more like bankers than like artists. Not all of them were young; Weir, Twachtman, Simmons, and Dewing, at almost forty-five, were all ten years older than the others. Nevertheless, these artists continued to see themselves as "the most progressive and radical" American painters, as they had when they first returned from Europe. Transformed by the light of Giverny and the vision of Monet, they would force, in their own way, the advent of an American art, sometimes seeming to replay at home the battle of the Salon des Refusés and the first Impressionist exhibitions in Paris.

The group's first show opened on March 31, 1898, in Paul Durand-Ruel's New York gallery. Each artist selected his own paintings and oversaw their hanging within his allotted space, an arrangement that struck many as particularly democratic. It was "a rare treat," wrote one critic, "to walk through a little gallery containing nothing but good pictures."[14] The show's real success lay in its overt challenge to the "barbaric idea of large exhibitions" in the manner of the National Academy of Design. The plain frames and carefully designed catalogues underscored something new and sophisticated about the group. "Secessionists, but not revolutionists," Royal Cortissoz of the *New York Tribune* mischievously commented, although he recognized a "general atmosphere" that harked back to "old modern French impressionism."[15] On the whole, critics who went to the show expecting to discover a new kind of painting found no "battle cry" and "no particular school of ideas."[16] Sales reflected the lack of excitement: only three canvases were sold.

The following year, at the group's second show, there were fewer paintings than at their first show. This time, the gallery décor captured as much critical interest as the art. The Ten had ripped out the customary red velvet and replaced it with light gray fabric they believed would show their work to greater

advantage. "The cleverest and . . . the most artistic little exhibit that the New York art public has seen in many years," a critic from the *New York Times* wrote. "The quiet harmony of color and tone . . . is most attractive."[17] Although the group enjoyed the prestige of exhibiting at Durand-Ruel—thus putting them on a par with the best French Impressionists—sales of their work were not improving. Several lost their will to fight in the face of such commercial and personal failure. Some critics reproached them not so much for imitating Monet but for living "in some realm apart from mankind,"[18] ridiculing them as the "Sacred Ten," the "Council of Ten," and the "Vibratory."[19]

This hostility resurfaced after Theodore Robinson's death. Weir and several others had decided to donate one of his paintings, *Port Ben, Delaware, Hudson Canal,* to the Metropolitan Museum of Art. But the museum's acquisitions committee haughtily refused the gift, calling it "an example of a school it did not think wise to encourage."[20] Their response threw Weir into a rage. The museum had turned down the painting, he told the *New York Times,* because it was "a small one by an American artist, instead of by some French or German one. A foreign artist has great vogue over here, and the museum seems willing to accept any third or fourth rate painting so long as it comes from a European painter. This painting is far better than a great quantity of foreign pictures in the museum. Many of these are absolutely worthless, big canvases, without any artistic value whatever. The Museum, of which I am a patron . . . has accepted a great deal of rubbish in the past. . . . They selected for refusal a picture which was the choice of professional artists and representatives of American art. . . . The Museum Trustees have not always shown a great desire to foster American art. Some time ago they had a great opportunity to secure a fine Whistler and they let it slip. But any foreign painting which takes up a lot of room seems to be just the thing to have."[21] Was Weir right? Had the museum's trustees refused Robinson's painting because it was too European—as they implied—or because it wasn't European enough, as he claimed? Hassam's reaction to the episode was to decry the museum's "provincial snobbism," its blatant condescension toward American art.

This conflict affected J. Alden Weir profoundly, and heightened his consciousness as an American painter. "Europe palls on me," he realized in Paris during the summer of 1901. "America, the best country in the world . . . America is the place."[22] He would remain in contact with Europe only through regular correspondence with Whistler and Sargent, and with his old teacher Gérôme. But the sands had shifted; from now on, his future lay in the New World. John Weir echoed his brother J. Alden's sentiments when reporting on the Paris Salon the following spring: "No great light, no master *par excellence,* a

few quiet modest things in a wilderness of debaucheries. The old group of real masters have gone by."[23]

A few months earlier, Weir had stopped teaching to devote his spare hours to the fight for American art. After Twachtman's death in August 1902, he fought to ensure his friend's posthumous reputation. Twachtman had suffered repeated humiliations in the last years of his life. "My pictures have been sent to all the cities in the land and are returned after an absence of from three to six months," Twachtman had written to Harrison Morris (the director of the Pennsylvania Academy of the Fine Arts) in November 1900. "And you want me to continue at that sort of business?" Several months after his friend's death, Weir organized an exhibition and sale of ninety of Twachtman's works, collecting $16,600 for them, which offered some consolation.[24] Weir fought for other friends as well, including J. Appleton Brown, C. E. S. Wood, and Alfred Q. Collins.[25] Such was the fraternity of The Ten. When Willard Metcalf was laid low by a series of personal and financial crises after Twachtman's death, Childe Hassam offered friendship and support, working with him at the artist colony in Old Lyme until he got back on his feet. Along with such mutual support among artists came official recognition. By 1905, critics were slowly coming around, with increasingly positive notices. And in 1908, finally, American museums began to acquire paintings by "Monet's Gang," these artists who were, after all, the American Impressionists.

Seven

The Revenge of Thomas Eakins

W HILE IN NEW YORK, after their failed "coup" against the National Academy of Design, the American Impressionists were still sinking under the weight of commercial failure and personal setbacks, at the same time, in Philadelphia, the Realists took up their own fight against the local academy. Their fight was based on a political analysis that would, step by step, lead to much more efficient actions and, ultimately, to an upheaval against the official system. They revered Thomas Eakins, who had been ousted from the Pennsylvania Academy of the Fine Arts in 1886 just as Robert Henri was arriving. Henri, then twenty-one, was studying with Thomas Anshutz, one of Eakins's two students who had taken over as instructors of his life and anatomy classes after his dismissal. "It was an excitement to hear [Eakins's] pupils talk of him," Henri remembered. "They believed in him as a great master . . . he teaches the great masses of the body . . . the anatomical study is so much more complete than in other schools."[1]

There in Philadelphia, the scene of Eakins's undoing, the new group started to define an agenda and launched its action. Leading the charge was Henri, who attempted to mix French and American training, and undertook "a pilgrimage" to Paris on his own terms. "I have got the Paris fever badly and want to go next year," he wrote in early 1888. "Finney, Fisher, Grafly and Hefeker also intend going. . . . I have enough to think that I am about as good as any here—but that is not saying much. I can't learn much from those about me in drawing. At Paris, they have their 'atmosphere' and their great masterpieces."[2]

The following September, Henri and his colleagues Harry Finney, James Fisher, Charles Grafly, and William Hefeker made the transatlantic trip. "As we neared Paris, we thought of the long long journey we have had. It seems much longer than it has really been, less than three weeks ago we were at home— what a lot of incident and experience has been crowded in those three weeks! We got Fisher to tell us how to say 'I do not understand' and practiced the

many forms before we could master it. . . . Paris! we are here!"[3] Robert Henri and his companions moved into the fifth floor of a building at 12, avenue Richerand, just "twelve minutes by foot from the Academy Julian." "Tired as we were, we took a ramble on the streets of Paris, Fisher always in the lead, we saw the beautiful Opera House, Théâtre Français, and the exterior of that immense building the Louvre, where all the great old masters are. We were very tired, and so, as much as we would have liked to have gone on and seen all Paris at once, we returned to our lodgings and went to bed."[4] Even though they had to squeeze into two rudimentary rooms and eat on a folding table set on the balcony, their enthusiasm remained undimmed. "Ah, this is what I have so long wished for. Here we are, all at our table in our own den, comfortable and happy, with brilliant prospects ahead. . . . Who would not be an art student in Paris?"[5]

Thanks to the financial support of Emilia Cimino, Henri's trip to Paris turned into a true apprenticeship in freedom. "Paris is decidedly 'Go as you please,'" he noted in his journal that autumn. "It is nothing to see a man walking along in wooden shoes, reading a paper and carrying under his arm a yard of bread from which he is eating! Many things that in America would be the height of indecency occur about us with an innocence that is really amusing."[6] Soon after the new year began, Henri registered at the Académie Julian, in the classes of William Bouguereau and Tony-Robert Fleury. From his years with Bouguereau, Henri absorbed two elements in particular: the concept of the canvas as a whole, and the *pochade* technique—small, rapid oil sketches that have the spontaneity of a drawing from life. "'This is no study!' Bouguereau would exclaim. He gave me the deuce, jumped on the carelessness of drawing. I am working for the big impression, but he demands the careful completeness."[7] There were other, more serious disagreements between the teacher and his pupil involving the use of color: "Bouguereau is not a colorist," Henri noted, "and as for reproduction of color . . . it is always the same waxy, angel-like color—just a little insipid. So from this I am not inclined to put the same confidence in his criticism on color as in the other branches—although I continue the same respect and esteem for him as a critic and as a man."[8]

"'All those purples,'" Henri recalled Bouguereau sighing one day before one of his paintings. "[H]e said I was going the wrong way. There was nothing true in the study—'A fashion that will not endure long'—he gave it to me with force. He was very much in earnest and I respect his intentions but am not convinced; I think I am nearer right than ever before."[9] Later, following his own instincts, Henri expressed satisfaction with his work: "Painting got on well, very well with color. Trying to work as freely as possible. Couse came in

afternoon. . . . He liked the landscape better. I have concluded to send the landscape."[10] Spontaneity, self-sufficiency, independence of judgment: all qualities that Henri later demanded of his own students.

Henri made regular visits to the Louvre, whose galleries, he wrote, were "landmarks in the history of art."[11] His studious analysis of the works of Velázquez, Delacroix, and especially Rembrandt confirmed his growing inclination toward realistic painting. "Rembrandt! What a great man—he stands with the modern painters untouched, not great only for what he was—but for what he is as well!" He discovered Goya, Manet, and Frans Hals, whose somber tones and bold brushstrokes he admired. Henri was equally sure of his dislikes. "Dare I defy public opinion by saying that I see nothing in Raphael to warrant the great honor given him? I dare, and I also say that I see little feeling, ordinary color, hard finish, generally conventional or poor composition in his work . . . if it were not for the name I would pass his pictures."[12]

Eager to make his way into the French art establishment, Henri was thrilled at his acceptance to the Ecole des Beaux-Arts, though exhausted by the entrance process. "To design following the Doric order court interior presenting stables to a chateau; Damn the architecture! I don't know anything about it and I don't want to know anything about it. . . . I don't care. . . . I shall get 0 on it. . . . This Beaux-Arts exam has robbed me of a week . . . it's all a farce. . . . I'm all broken up . . . feeling very much dragged out . . . drouzy [sic], weak."[13] A month later, when he got the news that his work had been rejected by the Salon, he took it as bravely as he could: "I did not feel so bad as I thought I would. Felt pretty bad just the same."[14]

In considering what he would do at the end of the academic year when his compatriots hurried off to the artist colonies, Henri initially decided to go his own way. "I hate and I have never been contented with the idea of doing Brittany like everybody else does. I have been hungry for some original method of taking my summer recreation and outdoor sketching. . . . I do not like this old beaten road."[15] Three months later, however, he changed his mind. "Went to see Harrison in morn, at his studio, were received cordially; like him from first. Are to go have his criticisms at Concarneau in Brittany this summer."[16]

In the end, Henri did join his friends, enjoying the same solidarity Wylie and others had experienced before him. "Spent afternoon at school not working but looking at the work of the others. Hamilton gets no. 2 in the Beaux-Arts exam. Salle holds his place of no. 1. Hamilton pulled from 19 in drawing. Good for America!"[17] In another entry he wrote, "Had lunch with Tanner. He is clever in making compos; has a cleverly drawn charcoal quai subject, that he expects to paint."[18] Henri became great friends with the black painter Henry Ossawa Tanner, another Philadelphia native, who would later record how diffi-

cult it was to be both black and a painter in his own country, and why therefore he would build a life for himself in France.[19]

A bond formed between the boys from Philadelphia, a group that also included Charles Fromuth and Edward Redfield, with Henri at the center. When Henri's paintings were turned down by the Salon, Tanner suggested submitting them to the Nouveau Salon. Acting for both himself and his friend Mayers, Henri took the precaution of altering their names. "I changed the names," he wrote, "mine will be Henri Robert and [Alfred] Mayers (of whose pictures I have charge) will be Alfred Mayet. Things were very quiet at the [Nouveau] Salon. Very few people knew they could get their pictures away from the old Salon and so very few who were rejected sent them to the new. The sight of my things made me awfully blue. They are bad. Had I seen them before they were sent to the new I would not have sent them at all. Early to bed."[20]

Unlike many of his compatriots, Henri showed mature aesthetic judgment very early on. "[Frank] Thompson and I went to Independents Ex," he mentioned in his diary on March 24, 1889. "It was not as amusing as last year. The 'impressionists' (as called) are the best."[21] Two months later, at the Paris Exposition Universelle, he found his artistic sympathies were aligned with the Realists, particularly Corot, Daubigny, and Millet, who had forty, eleven, and thirteen paintings, respectively, in the Centennial Exhibition of French Art that had been organized for the exposition. He was proud of the American showing: "The American ex very good. Remarkable portrait picture of little girls by John Sargent. Could not rave over some of his other portraits. . . . Paper mills at work. . . . Edison's type setter and his phonograph . . . music and singing from New York—this made such a marked impression on me! Lively goings on in the Algerian street; no end of beautiful women."[22] Among his favorite French painters were Albert Besnard and Jules Bastien-Lepage. "I am much interested in [Besnard] . . . he is to me today the greatest master of France; has said more and has said it with wonderful complicity," he confided to his diary in March; Bastien-Lepage's *Joan of Arc* was "getting to be my favorite picture," he added in May.[23] Henri's artistic apprenticeship, unusually wide and thorough, included reading the works of Balzac, Zola, and Tolstoy, whose novels provided the closest literary equivalents to his own aesthetic tastes.

When he returned to Philadelphia in 1891, struck by the city's "desperately provincial" atmosphere, Henri sank into a depression that lasted for several months. He started teaching at the Philadelphia School of Design for Women and it wasn't until autumn 1892, when he met John Sloan at the studio of a friend, sculptor Charles Grafly, that Henri began to come out of his slump. Sloan and Henri shared a passion for the poetry of Walt Whitman, who had recently died, and in no time decided to unite their artistic efforts. Sloan was

six years Henri's junior and, at the time, was slogging through courses at the Pennsylvania Academy, spending tedious hours on charcoal sketches of plaster casts. Since February 1892, Sloan had been earning a living as an illustrator at the *Philadelphia Inquirer*, and was waiting for the day when he could get out of the newspaper business and become an authentic artist.[24] As photographs rapidly replaced drawings in newspapers, the need for illustrators was already in decline by the 1890s.

"What do you think," Sloan asked his new friend, "of launching an experimental studio that would provide the best possible training in the country?"[25] The idea appealed to Henri. In a short time, with a workspace, a model, several chairs and a few lamps, they started the Charcoal Club in March 1893. Although it only lasted six months, the club prefigured future alternatives to the official institutions. And it was a success. Two evenings a week were devoted to sketching nude models, and on Monday evenings Henri critiqued everyone's drawings. For just two dollars a month, students at the Charcoal Club were offered training which could compete in every respect with Paris: nude models, group work, and the guidance of a gifted teacher with three years of European training and a critical awareness of recent artistic trends.[26] For several months at 114 North Ninth Street in Philadelphia, apprentice painters experimented with French-style training techniques. Their numbers grew rapidly. Eventually there were thirty-eight in all, almost twice the number of students at the local Academy. Henri and Sloan had victoriously picked up where Eakins had left off.

Henri believed in spontaneity, sending his students out into the streets to sketch restaurants, boxing matches, and working-class neighborhoods. Besides John Sloan, he had other friends who worked as illustrators: William J. Glackens, George B. Luks, and Everett Shinn. Newspaper work had taught them to do fast sketches from live subjects. Henri encouraged them to apply this skill to their painting, showing them engravings by Rembrandt, Goya, Daumier, and Toulouse-Lautrec, and arguing that this too was art. He fought to break down the distinction between high art and daily work. He encouraged them to think of art as a vocation rather than a job, and involved them in the greater issue of the status of the American artist and the development of a true American art. Marked by its local roots, their art would cease to be a flaccid imitation of another continent and culture.

In his teaching, his painting, his letters, his writings, and his political battles, Henri proved himself the most fervent advocate for an authentically American art. "We want to know the ideas of youth, the freedom of creation," he wrote. "We want American painters to be able to express their age in their own country. The art that we need is art that expresses the spirit of people today."[27] Robert Henri pioneered a new concept for an American art, an idea

that grew out of deep confidence. Granted, it was important for painters in the United States to be aware of contemporary European aesthetic trends, but the benefits would not be immediate and the path to an independent American art was not yet fully apparent. The basics of French training had to be dispensed in carefully controlled doses. Anatomy lessons taught in the style of Jean-Léon Gérôme had horrified Victorian mothers in Philadelphia, much as Monet's sophisticated theories about light had puzzled American artists who hadn't experienced the transatlantic pilgrimage. Henri himself, who would exhibit four works at the Paris Salon in 1899 and sell one of them—*The Snow*—to the Musée du Luxembourg, had made a brilliant success of his Paris trip. "He showed them the Frenchmen, but he did not encourage them to imitate the Frenchman," as Forbes Watson put it.[28]

The Charcoal Club, though a short, improvised experiment, became a catalytic moment in Henri's career. The Pennsylvania Academy of Fine Arts devoted two entire exhibitions to his work in 1897 and 1902, recognizing his importance as a Realist painter. For nearly a decade in Philadelphia after his three years in Paris, he fought to establish an American system of art instruction. In 1900, on the invitation of William Merritt Chase to teach at the New York School of Art, which Chase headed, Henri moved to New York. By that time, his project had matured and had acquired a political agenda: after the Pennsylvania Academy, the National Academy of Design would be his next target, and New York his new battlefield. By early 1897, William J. Glackens, George B. Luks, and Everett Shinn had already moved to the metropolis, where they earned their living as illustrators for the *New York World*. A few years later, John Sloan and George Bellows joined them in New York for good.

Eight

"Come Take a Ride Underground"

"COME TAKE A RIDE UNDERGROUND..." "In the city where nobody cares..." In the lyrics of their popular songs, Edward Laska, Thomas W. Kelly, and Charles K. Harris distilled the dynamism and abandon of the urban culture that was exploding in the world's new great metropolis. In 1904, the first subway line was finished; that same year, ground was broken for Pennsylvania Station, initiated by Alexander Cassatt, brother of Mary Cassatt and president of the Pennsylvania Railroad Company. He had commissioned the firm of McKim, Mead & White to design a prestigious station that he hoped would rival the grandeur of Paris's Gare d'Orsay, which had been built 1898–1900. Also in those years, millions of immigrants arrived at Ellis Island, transforming New York into a gigantic hub of new arrivals, where Eastern European Jews, Italians, Irish, Chinese, and Germans settled, often cheek by jowl.

The members of the Municipal Art Commission, a group of architects, artists, and civic leaders, urged the city government to undertake a ten-year building plan. In 1892, an architectural competition was announced for a cathedral to be built on Manhattan's Morningside Heights. After the opening of the Brooklyn Bridge, arguments arose as to whether or not a bridge could be called a "monument." From that point on, the theoretical relationship between the American democratic republic and its public architecture, heretofore elaborated only in contrast to Europe's example, was entering a critical stage: it was no longer possible to reproduce old European representations without giving them a new twist.[1]

Robert Henri and his friends arrived in New York during this period of dizzying change, and armed with extraordinary originality and talent, they would write the next chapter in the story of American art. A new way of life was taking shape for the artist in New York, characterized by considerable and collective creativity. In 1901, Henri moved into the Sherwood Building, at the corner of Fifty-seventh Street and Sixth Avenue, built twenty years earlier. The Sherwood represented a new paradigm for an urban artists' community, with

apartment-studios and facilities for communal dining and socializing, where they could spend time together.[2] J. Carroll Beckwith, the "dean" of the building and grandnephew of its owner, was pleased to invite many of his friends over for some of the lively parties held there. "Have moved to the studio," Henri wrote John Sloan after his move. "[G]ot by chance one of the excellent studios Frank DuMond had. . . . Am greatly pleased."[3] Three years later, Sloan joined Henri to live in what had become a colony for artists.

None of the members of the group were native New Yorkers, but after Paris and Philadelphia, the "Sherwood experience" brought out their American creative spirit. They arrived between 1896 and 1904, just as a new bohemia of artists, journalists, writers, and critics was forming in New York, congregating in the American equivalent of the Paris bistros, where gatherings of artists had given birth to the first Impressionist exhibitions three decades earlier. William Glackens, George Luks, Everett Shinn, and Sloan absorbed the life of the city and would create the first images of a cityscape in progress.

The West Side, particularly Chelsea, attracted the most artists. Popular hangouts included Mouquin's on West Twenty-eighth Street and Sixth Avenue, Petitpas on West Twenty-ninth Street (where the painter and poet John Butler Yeats, father of the Irish poet, held court), and Café Francis on West Thirty-fifth Street. Artists from Henri's circle gathered at the Francis—and often at the café-owner's home on West Twenty-third Street—arguing with the critics Mary Fanton Roberts (who wrote for *The Craftsman*) and Charles FitzGerald (Glackens's brother-in-law and a writer for the *New York Evening Sun*). FitzGerald, an Irish Catholic who had arrived in New York several years earlier, was on friendly terms with the *Sun*'s owner, William J. Laffan, a businessman and collector who had started out as an art critic and now served as a trustee of the Metropolitan Museum of Art. Another Irishman, Frederick James Gregg, also wrote for the *Evening Sun* and shared FitzGerald's Modernist ideas.

Henri and his friends took New York's measure, depicting life in working-class neighborhoods such as the Lower East Side and Coney Island, forcing American life into American art. Theirs was not the America of open spaces, embodiments of God's grandeur, and not the world of high-society portraiture, but the lives of the immigrant masses they had first depicted in illustrations for newspapers and magazines. To them, *this* was the real and true America.

They reported the clash between the old and the new, the city by day and night, captured an urban civilization in evolution, with its construction sites, elevated trains, skyscrapers, slums, markets, excavation sites, accidents, and fires—elements of a chaotic world of intersecting realities. They painted crowds, boxing matches, and nightclubs. They described the masculine ideal,

the changing roles of women, and, above all, the immense flood of people that was fast becoming New York's most valuable resource. These were the themes they imported from periodical illustration, transforming them into art with formidable virtuosity in a variety of mediums—pencil, pastel, watercolor, gouache, charcoal—and grounding the act of painting in a new spontaneity of execution. "All are men who stand for the American idea," Henri later wrote of his comrades. "It is the fashion to say that skyscrapers are ugly. It is certain that any of the Eight will tell you: 'No, the skyscraper is beautiful. Its twenty stories swimming toward you are typical of all that America means, its every line indicative of our virile young lustiness.' "[4]

Their great models remained French artists such as Manet, Degas, and Caillebotte, who broke down traditional barriers between genres in paintings such as *The Gare St. Lazare, The Hatmaker, Woman Ironing,* and *The Floor Scrapers,* depicting the conditions of women and men working, the underbelly of urban life. In 1905–06, John Sloan undertook a series of ten etchings called "New York City Life" inspired by Balzac's *Human Comedy,* creating a record of the city's various inhabitants and walks of life. In *Coffee Line,* for instance, ragged unemployed men wait in the night for the free coffee provided by one of the city's wealthiest newspaper magnates—a raw scene of unflinching social commentary. In *Hairdresser's Window,* sullen and blank faces contrast with aggressively cheerful ads. Sloan would complain he never sold a single painting before the age of forty-nine, but decades later Andy Warhol would declare that Sloan was one of the few historical artists who had ever influenced him.[5]

All the while, Henri continued teaching. Instruction at the American academies still focused on drawing, mainly of plaster casts of classical or mythological subjects. Students began by spending months or even years "drawing the solid," the first category of classical models, before being permitted to draw from life. Conventional art teachers, relying on classical methods that had been regarded as the standards in art education for generations, were painfully conscious about introducing color, the palette, and the brush, believing—as did Jean-Léon Gérôme—that the brush in particular "should be kept put [*sic*] out of sight of the student until he mastered his proportions and can draw."[6] The debate over drawing versus color was hardly new; Ingres had demonized Delacroix's use of color in the 1850s. Now, some sixty years later, the traditionalists had to contend with a new fly in the ointment in the person of Robert Henri. No one better understood his impact and charisma than his student Guy Pène Du Bois: "The day he first walked into the classroom had been like every other . . . I shall always picture the entrance as a rock dashed, ripping and tearing, through bolts of patiently prepared lace. . . . Life certainly did that day stride into a life class."[7]

Hundreds of young artists flocked to Henri's classes at the New York School of Art, where he taught from 1902 to 1908, among them Rockwell Kent and Edward Hopper. A born teacher, Henri freely expressed his political opinions, read from his favorite books, celebrated the poetry of Walt Whitman and Ralph Waldo Emerson—his heroes—and the great European Realist painters Velázquez, Goya, Hals, and especially Manet. "He would talk about some book he'd read and what it meant about life, and how this painting and the attitude toward it were related, or not related to the book. . . . What he did was to inspire on the part of the listener to go out, to look up all his stuff and to get involved with it."[8]

On his return from Paris, Robert Henri had found a pragmatic way of exploiting the lessons of French art in an American context; his association with illustrators furnished the key. At a time when newspaper photography was still in its infancy, the sketch seemed the only way to deliver the drama of the streets. In a frenetic world far removed from the stateliness of academic painting, the newspaper artist needed a quick eye and a nimble pencil. As with the Impressionists years before, the world of the here and now attracted these artists—the city, the body, the violence of boxing, all of modern life. Illustration itself, and sketches made in illustrative style, epitomized Eakins's belief in "art for life's sake" rather than "art for art's sake."

The years that Robert Henri and his group spent exploring and interpreting New York would prove decisive for American art. Henri's reputation—built as much in Philadelphia and Paris as in New York—grew out of his brilliance as both an artist and a teacher. In April 1902, eighteen months after his arrival in New York, the Macbeth Galleries mounted an exhibition of his work. More shows followed, in New York and Philadelphia, and each time critics affirmed the "power," "energy," and "movement" in his portraits and landscapes. Charles FitzGerald called his work the model for a new American painting, contrasting Henri to "all the hands that ever niggled over a surface for the sake of explaining and polishing what from the first conception was meaningless and worthless."[9] Henri's relations with the academicians would soon prove how right FitzGerald was.

"Americans appear to be concerned with the art of every land save that of America," exclaimed Sir Caspar Clarke, who had come from his native England to become director of the Metropolitan Museum, and who was well acquainted with private art collections in New York.[10] Indeed, the aesthetic preoccupations of the Henri group remained of interest only to its members, and their work attracted the attention of few dealers. But they persisted in adhering to the spirit of Sloan's manifesto: "We should turn our eyes from Paris and Rome and fix them on our own fields." Public taste would gradually catch up to them,

and wealthy art patrons, including William T. Evans and Thomas B. Clarke, emerged to take them under their wings. In time, exhibiting work by American artists in one's home would no longer be regarded in the United States as a sign of insufficient means or vulgarity.

The growing appetite for American art was encouraged by a few intrepid dealers, such as George A. Hearn, who had stopped selling European paintings in 1879 and began focusing his efforts on American works, although his taste remained essentially classical. When he became a trustee of the Metropolitan Museum of Art in 1904, its acquisitions program changed. Two years later, he established the G. Hearn Fund, to bring contemporary American paintings into the collection, and he mounted an exhibition of his own donations to the museum; the show, though conventional, constituted a major step forward.[11]

Other dealers soon followed Hearn's example, among them J. Dudley Richards in Boston and William Macbeth in New York. Robert Henri and the others could henceforth rely on a growing network of galleries willing to exhibit their work. Macbeth's, located in a basement at the corner of Fifth Avenue and Twenty-seventh Street, had been in operation since 1892. "The work of American artists has never received the full share of attention it deserves," he had written when he opened his gallery, "and the time has come when an effort should be made to gain for it the favor of those who have hitherto purchased foreign pictures exclusively. . . . I hope to make this establishment known as the place where may be procured the very best our artists can produce."[12] Macbeth also published a quarterly circular called *Art Notes* in which he presented the work of "young artists of promise."

As one of Henri's closest friends, Everett Shinn soon benefited from the new welcome at Macbeth's gallery. Sometimes compared to Honoré Daumier for his "grim humor," Shinn was admired for his manner of telling "the tale of toil along the river front, in the suburbs where gangs of men dig ditches and cut streets through hills, or singly ply their grimy trade of rag-picking,"[13] and his commercial work, which often appeared in magazines like *Ainslee's Magazine, Harper's Weekly, Truth,* and *The Critic,* had already attracted a following. William Glackens became one of the most familiar illustrators in the city after being recruited by the *New York Herald.* George Luks's paintings first found a place in 1902 at Frederick Chapman's gallery, where FitzGerald saw them and praised the "highly moral" nature of his subjects. Two years later, when a group show of works by Henri, Sloan, Glackens, Luks, Arthur B. Davies, and Maurice Prendergast was presented at the National Arts Club, Luks was recognized as a "real newcomer" on the New York art scene, and James Gibbons Huneker of the *New York Sun* called him the "Dickens of the East Side."

However, progress was not entirely without setbacks; most critics of the

show remained circumspect. "Decidedly," wrote a journalist for the *New York Globe and Commercial Advertiser,* "they have a novel point of view, an outlook where nature is seen under her most lugubrious mood, where joyousness never enters . . . and where unhealthiness prevails to an alarming extent . . . A simple visit to the rooms will chasten the spectator"[14]—hardly approval to nourish the artistic soul. Sloan, after completely converting to urban realism by 1906, attracted warmer critical praise for his effort. As for George Bellows, the last to arrive in New York, his career took off with impressive speed from the moment of his first show. "It is real," wrote Huneker in the *New York Sun* about one of his famous boxing scenes. "It is truthfully painted. . . . You hear, you feel the dull impact of the blow."[15] "Come Take a Ride Underground"—Robert Henri and his friends had heard the song of the city. After struggling for years in New York's seedy neighborhoods, they would soon manage to bring their protest to the attention of a wider world.

Nine

Ashcan School vs. Academy

B Y ALL APPEARANCES, Robert Henri kept up cordial relations with most of the country's art institutions. He was elected to the Society of American Artists in 1903, and invited to sit on the jury for the Carnegie International exhibition in Pittsburgh in 1905, the same year he received the Chicago Art Institute Prize for his *Lady in Black*. His paintings, acknowledged by his journalist friends, kept selling; his classes at William Merritt Chase's New York School of Art, grew ever larger. And in May 1905, he was elected as a full-fledged member of the National Academy of Design.

Such accolades and honors from the establishment seem strange for a man whose mission radically opposed the tenets of official art. Not for him the lonely struggles of Thomas Eakins against the Pennsylvania Academy of the Fine Arts or The Ten's costly secession from the National Academy of Design. His fight would be grounded in realpolitik. Within a matter of years, he would construct an alternative system of education that was to become the launching point of his assault. Ever the adept politician, he readied his project quietly and patiently under cover before descending upon the Academy.

The Victorian ladies of Philadelphia had railed against Eakins's use of nude models; Jervis McEntee had dismissed the art of the American Impressionists as "under foreign influence"; Kenyon Cox attacked the "Impressionistics" for having overstayed their welcome; the Metropolitan Museum of Art refused Theodore Robinson's *Port Ben, Delaware, Hudson Canal,* demonstrating their "suspicion and condescension" toward contemporary American painters. Henri and his friends, outraged by these retrograde attitudes, would decidedly declare war. Henry Reuterdahl, an illustrator, complained about the policies of the National Academy of Design. "The Academicians," he said, feared that if "the younger men were admitted, they would soon be the dominating spirit in the juries, with the result that many of the Academicians' pictures would go unhung. An Academy exhibition now looks like an exhibition of life-insurance calendars. The pictures are all painted on the academic formula. Unless a man paints accordingly there is no place for him to exhibit in

New York. The Academy is doing everything for itself and its members and nothing for American art. If it is the guardian of American art, as it pretends to be, it ought to give the young man [*sic*] a chance."[1]

Limitations of space at the Academy's annual exhibitions inevitably caused all manner of sordid wheeling and dealing: favored paintings were placed at eye level with plenty of light; second-rank ones were positioned higher, packed close together, and were poorly lit; and third-rank works, after being accepted, were often not hung at all. But then, very few people visited these shows anyway. "I went to see the exhibition at the National Academy of Design. From eight in the morning to when the gallery was closed I saw no more than a dozen people," John Sloan wrote in a pseudonymous piece.[2] Indeed, the most pressing problem facing American artists remained the shortage of new exhibition spaces.[3]

Though initially conciliatory, by 1907 Robert Henri unleashed an out-and-out crusade against the Academicians' authority. As a newly elected member of the National Academy of Design, he was invited—along with twenty-nine other jury members—to select paintings for that year's annual show. When works by Everett Shinn, George Luks, William J. Glackens and him were refused—or, to use the Academy's term, "declassed"—he decided to remove two of his own pictures from consideration. The press reported on the situation: what first appeared to be yet another "academic squabble" turned into a huge political debate about the state of American art, and more particularly about the pernicious role played by the Academy, of which Henri and company seemed like the first victims. "Honest stupidity," Sloan fulminated in the *New York Times*. "The Academicians produced what you might call high-class American pot-boilers, they have a keen resentment for anything that is inspired by a new idea; and have an equally keen appreciation for everything that follows the old hide-bound conventions."[4]

Within days, Henri and his colleagues Luks, Sloan, Glackens, Ernest Lawson, and Arthur B. Davies met to plan a group show for the following year. Two weeks later, they declared to the press, "We've come together because we're so unlike. We don't propose to be the only American painters by any means, but we do say that our body includes men who think, who are not academic, and who believe above all that art of any kind is an expression of individual ideas of life, the seamy side. It is vulgar. Your [the academic artists'] portraits for instance, must be only of the rich, and always see to it [that] the lady is seated on a gold chair. . . . That's part of the formula."[5]

A critic for the *New York Times,* among the first to support the group, took up the baton: "Let the younger outsiders come together and form a new organization of a lively, militant sort," he wrote. Keep "the Academicians from going

to sleep by holding them to the necessity of doing their very best. That is the way to interest the public and put life into every studio."[6] Effortlessly, it seemed, Henri had gotten the press to denounce the Academy and promote his group's efforts in a series of articles. A few weeks later, when thirty-three out of the thirty-six requests for admission to the National Academy of Design were turned down, the issue violently reignited.[7] "Door Slammed on Painters," thundered the headline in the *New York Sun*.[8]

Day after day, members of the new group fed statements to the press: "We want true American art," read one, "and not bad copies of foreign artists. I think that we have in this city much that is best in American art, and the field is big enough for us all. What we have decided to do is for the best interests of the future of American art. It will give the people of this city a chance to see true American art."[9] Journalists occasionally resorted to religious imagery when framing the debate, describing Henri as the "leader of an expedition to an artistic promised land."[10] Reactionary or conservative critics, who logically should have stood behind the Academy, sometimes instead sided with the outsiders, mainly because these rejected young artists appealed to the older generation's patriotism, xenophobia, and virulent anti-Europeanism. Writing about "New York's art war," a critic at the *New York World* hailed the crusaders as "the eight rebels who have dared to paint pictures of New York (instead of Europe) and who are holding their rebellious exhibition all by themselves."[11]

Early that May, Henri and his friends, together with the dealer William Macbeth, established the financial framework of the operation. Three more artists—Maurice Prendergast, Arthur B. Davies, and Ernest Lawson—joined their ranks, after which time the group was known as The Eight. By no means Realist painters, the newcomers seemed an odd fit among the original group. Lawson painted the parks and beaches of New York in bright colors; Davies transcribed his dreams of unicorns in the Symbolist mode of artists such as Odilon Redon and Gustave Moreau; and Prendergast, who came from the United States' other art capital, Boston, remained essentially an Impressionist. Despite their aesthetic differences, they joined the anti-academy cause to counter the opposition that the art establishment was mounting to the aesthetic movements sweeping Europe and to experimentation in general. "These absentees could by themselves make a stunning exhibition," William Macbeth wrote in his *Art Notes*.[12] To this end, he rented them his gallery space, which they occupied during the first two weeks of February 1908, for the modest sum of five hundred dollars.

From the moment it opened, on February 3, The Eight's exhibition captured the attention of the public and in two weeks drew nearly seven thousand visitors—"three hundred people an hour, while a permanent line of at least

eighty-five people waited outside," according to Sloan. In the entryway hung Henri's *Laughing Child,* a painting inspired by the work of Franz Hals, followed by Glackens's *At Mouquin's,* depicting one of their favorite hangouts, then Sloan's *Movies 5 Cents* and *Hairdresser's Window, Sixth Avenue,* and finally Luks's *Macaws,* with its strange assemblage of figures.[13]

Certainly Robert Henri knew how to play the press, and naturally New York's art critics were prepared for the show long before it opened. The usual diehards were hostile, calling the group "rebels" and "apostles of ugliness,"[14] "insurgents, anarchists, socialists, all the opponents to all forms of government, to any method of discipline";[15] re-naming them "ashcan school of painting," "outlaw salon," the "black school," and so on. But The Eight's critic friends, colleagues from Café Francis, Mouquin's, and Petitpas such as James Huneker and Frederick James Gregg, proved firmly supportive, as did Guy Pène du Bois, one of Henri's students, who penned an editorial for the *New York American* on their behalf. They, too, had their names for the group: "The Eight," "The Eight Independent Painters," "The Eight Secessionists," "The Society of Eight," and "The Philadelphia Boys." Most sympathetic critics saluted the birth of a new American art that would transform the artistic sensibilities of the entire country. Mary Fanton Roberts regarded the work as "a home-grown art, out of our own soil," and published a series of perceptive pieces with titles that crystallized the issue: "Is America Selling Her Birthright in Art for a Mess of Pottage?" or "The Younger American Painters: Are They Creating a National Art?"[16] The latter she answered herself with a stirring call-to-arms for her fellow citizens: "Any one of them will tell you that just now there is no civilization in the world comparable in interest to ours; none so meteoric, so voluble, so turbulent, so unexpected, so instinct with life, so swift of change, so full of riotous contrast in light or shade. . . . [W]e are just beginning to understand our power, our beauty, and our blunders and the fact that we have just as good a right to regard ourselves as a source of inspiration as of revenue only."[17]

In *Harper's Weekly,* Samuel Swift insistently used words such as "optimism" and "virility" to define this new American art, hailing Henri as a "truly American prophet of a new, more direct and more democratic spirit in American art." In the face of such stirring critical homilies, even some of the most traditional critics showed some conciliation. "These painters . . . experiment," wrote one of them, "they are often raw, crude, harsh. But they deal in actualities. They paint their present environment—the only real historical school—and they do it with a modern technique."[18]

A new language emerged that defined American art as the resolute opposite of French art. "Take any of the Parisian chaps," one critic wrote, "beginning with Henri Matisse, who make a specialty of movements—well, their work is

ladylike in comparison with the red blood of Bellows."[19] This celebration of a
new era spawned a rhetoric of dynamism, masculinity, and potency: Luks's
work, in particular, attracted panegyrics: "*The Wrestlers,* Luks' Strong and Virile
Canvas is Center of Interest in His New Exhibition," was one newspaper's
headline.[20] Others used words like "vigor," "energy," "power, and "force" to
describe their impressions. The exhibition also proved a commercial success: six
of the paintings sold for $4,000; four of these were bought by an art patron and
artist named Gertrude Vanderbilt Whitney. After its two-week run in New
York, the show began a year-long tour that would take it to Philadelphia,
Chicago, Buffalo, Toledo, Detroit, Indianapolis, Cincinnati, Bridgeport, Pitts-
burgh, and Newark.[21]

In 1909, Henri left the New York School of Art and opened up the Henri
School. Despite his brilliance as an organizer, he was still disappointed in his
own artistic career. "I would like to be famous for my paintings as much as for
my teaching," he later wrote, "but I was very afraid that I would only be
remembered as a teacher."[22] The following year, he published *The Art Spirit,*
which he would call his "manifesto."[23] "Art is not in pictures alone. Its place is
in everything, as much in one thing as another," he emphasized, while dis-
cussing the ways of fostering the "growth of art" in America—where many of
his ideas seemed nothing less than revolutionary.[24]

"There is much talk of the 'growth of art' in America, but the proof
offered deals too often with the increase of purchases. . . . We may build many
imitation Greek temples and we may buy them full of pictures, but there is
something more—in fact the one thing more which really counts before we
can be an art nation—we must get rid of this outside feeling of looking in on
art. We must get on the inside and press out." Henri drove home his point even
more urgently when he insisted that the greatness of art in America could be
achieved only "by entering into the very life of the people, not as a thing apart,
but as the greatest essential of life to each one."[25] At stake was American society
as a whole: a society in which the artist, the public, and the collector each had
a part to play. Gone were the days when the all-powerful art patron dictated
taste and controlled the market. It was time for those directly responsible for
aesthetic production to take center stage. "To have art in America will not be to
sit like a pack-rat on a pile of collected art of the past. It will be rather to build
our own projection on the art of the past, wherever it may be, and for this con-
structiveness, the artist, the man of means and the man in the street should go
hand in hand. And to have art in America like this will mean a greater living, a
greater humanity, a finer sense of relation through all things."[26]

Henri's broadly humanistic conception of the Artist strongly clashed with
the nationalistic attitudes around him and which to some degree had furnished

him support. "We must always try to attach our small American patriotism to something far larger," he wrote. "Every great artist is a man who has freed himself of his family, his nation, his race, a man who has shown the world the path to Beauty, to true culture, who was a rebel, a 'universal citizen.' " Nor were his prophetic views on Native American culture, particularly welcome. "I do not wish to explain these people, I do not wish to preach through them, I only want to find whatever of the great spirit there is in the Southwest. . . . They have art as part of each one's life. The whole pueblo manifests itself in a piece of pottery. With us, so far, the artist works alone."[27]

Following the tide of the Russian Revolution, during the first two decades of the twentieth century New York fostered a wave of politically committed intellectuals and artists. John Reed and Emma Goldman offered romantic images of revolutionary zeal, with their calls for a just society that would transcend class and national borders and better all mankind. Henri, Bellows, and Glackens, virtual anarchists themselves, attended Goldman's lectures on workers' rights and free love. She put them in touch with the Ferrer School (which would play a major role in the history of the times), and they started teaching art classes there.

The Francisco Ferrer Association was formed on June 3, 1910, named for the great Spanish teacher who had established open and progressive "modern schools." Its textbooks were provided by the great radicals and scientists of the time, such as Pyotr A. Kropotkin and geographer Elisée Reclus. Ferrer's assassination in October 1909 had catalyzed an international uproar. Writers Upton Sinclair, Jack London, Maxim Gorky, and Anatole France protested the "superstition and bigotry of the Spanish Catholic church, . . . an enemy to civilization everywhere in the world."[28] Later, such figures as dealer Carl Zigrosser, professor Bayard Boyesen, and artist Rockwell Kent would take up Ferrer's battle cry.[29] John Sloan became a militant socialist, ran for the State Assembly in 1908, and contributed articles to periodicals such as *The Call* and *The Masses*.[30]

By undermining the authority of the Academicians, The Eight's show established a striking precedent. Most observers celebrated the event, which brought to the country a new "dynamism" and "virility." Yet only a small number of local critics were truly capable of evaluating the aesthetic impact of the paintings themselves. Among the few up to the task, James Huneker of *The Sun* indulged in a "confession": "[I] had been a frequent visitor at the Paris Autumn salons of the Independents and compared with the performances in paint [I] had witnessed there this show at Macbeth's is decidedly reactionary. The truth is that New York in the matter of art is provincial. We see sometimes, of course, the modern masterpieces. . . . It was 1885 or thereabout that

Messieurs Durand-Ruel gave an exhibition of Monet, Sisley, Pissarro and other now classic impressionists. Great was the wail that arose. . . . Any young painter recently returned from Paris would call the exhibition of the eight painters very interesting but far from revolutionary. If some of us sit up aghast, what will happen to our nerves when Cézanne, Gauguin, van Gogh appear?"[31]

There was the rub: Matisse, Rodin, and Picasso had been showing in New York for some time, though only at a tiny insider's gallery, Alfred Stieglitz's exhibition space at 291 Fifth Avenue. The aesthetic revolution sweeping Europe for almost two decades—that of the Post-Impressionists and the early Modernists—had already penetrated the United States. Were any of The Eight aware of the works of Gauguin, Seurat, van Gogh, Cézanne, Matisse, or Picasso? How did the work of the American Realists stack up to that of these new European pioneers, their exact contemporaries? Indeed, Henri and his colleagues had disrupted the rhythm of the Academy, radically improving the condition of the American artist in terms of their education, exhibitions, and sales. But by no means did their project address the development of European aesthetics. In trying to get the public to embrace an American art that was neither too new nor too outdated, what choice did they really have? Too many walls still needed to be knocked down.

During the last decade of the nineteenth century and the first decade of the twentieth, despite resistance from the country's museums and the academies, Impressionism made its way into America via private collectors and painters who had stayed in Giverny—but now their art seemed hopelessly passé, perhaps ten to fifteen years behind the times. The Realist struggle, initiated more than twenty years earlier under Thomas Eakins, achieved its major breakthrough thanks to "Henri's gang." The evolution of American art followed its own course: rather than a complete overthrow, it took the form of successive counter-coups, crashing against the gates of the American academies. These institutions were run by older men who in their youth had benefited from the European experience, but learned over the course of time the necessity of protecting themselves against the threat of the New. Worthington Whittredge, Kenyon Cox, J. Carroll Beckwith, and J. Alden Weir had fought hard against the system in their day, but eventually became the system themselves. Increasingly, the development of an American art would follow this paradigm.

After 1908, the artists from The Eight never exhibited together again. However, by then they had cleared the way for numerous groundbreaking shows to come. The most memorable of these, the Independent Exhibition, which took place in 1910 in a vacant building on West Thirty-fifth Street, strictly followed Henri's sacred principle of "No jury, no award." More than a

thousand people were packed in at the show's opening on April 1; while another 1,500 waited outside. Guy Pène du Bois considered the Independent Exhibition to be the New York version of the Salon des Refusés.[32]

At just that moment, Stieglitz's gallery was featuring *The Younger American Painters,* showing works by Marsden Hartley, Morgan Russell, Alfred Maurer, Max Weber, Arthur Dove, John Marin, and Edward Steichen. The art produced by these expatriate artists living in Paris had been strongly influenced by the great Post-Impressionist masters Cézanne, Matisse, Picasso, and Rodin, among others. Compared to them, Henri and his friends remained, in Huneker's words, "decidedly reactionary," much as New York remained, in contrast to Paris, a "very provincial" capital. There would not be long to wait: in just three years, another wave would hit America, one more radical than the one preceeding—a veritable revolution in color and form: Modernism would take Manhattan.

Ten

The Photographers Step In

"WHEN I CAME BACK from Europe it took me about three weeks to reconcile myself to New Yorkers—New York itself was as wonderful as ever. I felt the way Tannhauser must have felt when he returned from the Venusberg and lost his patience listening to his colleagues theorizing about love. There is certainly no art in America today, what is more, there is, as yet, no genuine love for it. Possibly Americans have no genuine love for anything, but I am not hopeless. In fact I am quite the contrary."[1]

Is it truly a surprise that, on returning to New York, Alfred Stieglitz would refer to Wagner to express his culture shock? "Wartburg" was America, "Venusberg" Europe. Stieglitz—like Tannhäuser in his mythical thirteenth-century kingdom—would in the first years of the twentieth century lash out against stunned New Yorkers: "Poor wretches / Who have never tasted love / Away! Hasten to the Hill of Venus!"[2] At the age of seventeen, Alfred Stieglitz and his parents—German immigrants[3]—left the United States to spend a few years in Berlin. They would end up staying for nine years. Eventually Stieglitz abandoned his coursework in mechanical engineering at the Technische Hochschule and turned to photography, studying with the chemist Hermann Vogel. When he returned to New York in 1890, twenty-six-year-old Stieglitz could no longer recognize the city. "It was not the one I loved," he wrote. "It was strange to experience such unhappiness in my homeland among my own people; to feel no point of contact with anyone or anything. The streets were filthy. . . . For months I cried every night . . . from a sense of overpowering loneliness; the spiritual emptiness of life was bewildering."[4]

Deeply influenced by his stay in Europe, Stieglitz had a hard time readjusting to New York; in contrast to Berlin, he found the city physically filthy and culturally barren. "The spiritual emptiness of life," he recalled, "was bewildering," and he wanted to return to Europe at once.[5] One night, during a blinding snowstorm, he came across a carriage driver watering his horses: a "human touch," he thought. The photographer sprang into action and began

a "series of photographs of one hundred phases of New York," with the hope that his images would turn out "as supremely well as they could be done and to record a feeling of life as I felt it."[6] *The Terminal, Winter Fifth Avenue, The Rag Picker, The Asphalt Paver, Spring Shower,* and *Reflections—Night—New York* were all produced during this early period. With his colleague Joseph T. Keiley, Stieglitz began experimenting with new developing techniques, such as the glycerine-platinum method, a way of controlling the relative strength of some parts of the photograph.[7]

Stieglitz's return to the United States differed greatly from the experiences of such painters as Hunt, Cassatt, Eakins, Weir, and Henri. He was able to carve his way into the American art world through the medium of photography, an art form that was as yet untried, unstoried, uncontested, and lacking almost entirely in institutional support. Thus, he avoided for the most part the battles against the American academy that had drained so many in the earlier generations of American painters. To be a photographer rather than a painter proved a great advantage.

What did he first discover in the photographic circles? "An amalgamation of the dying and the dead," as he referred to his fellow members in the New York Camera Club and the Society of Amateur Photographers, which together comprised the entirety of the New York photographic world.[8] Stieglitz started merging the two organizations, and founded the Camera Club of New York. Although such organizations attracted the best photographers on the East Coast—including people like the young Paul Strand—Stieglitz found them hopelessly provincial and, influenced by his European experience, decided to transform the state of American photography, making it international in scope. "Before I realized it, I was editing magazines, arranging exhibitions, discovering photographers and fighting for them, etc. etc.... In short, I was trying to establish for myself an America in which I could breathe as a free man."[9] The photography clubs were soon following his lead. "The Camera Club," he announced, is founded "to further the art and science of photography."

In 1897, Stieglitz launched a quarterly magazine called *Camera Notes,* which he intended to be as much a "battle field" as a "bugle call."[10] The idea was, as he wrote in the first issue, to tell his readers "what is going on in the photographic world at large."[11] He wanted to broaden the horizons of American photographers by introducing them to the most advanced European techniques, thereby creating a "first-class community of photographers." An elegant magazine with a small format and sophisticated design, *Camera Notes* carried all Stieglitz's hopes of introducing into the provincial sterility of his

country a "new spirit in life that went much deeper than just a fight for photography."[12] That spirit—a mixture of exactitude and insolence—was truly his own.

"Your *Camera Notes* gives me a quarterly fit of envy & discontent," wrote British photographer A. Horsley Hinton to Stieglitz from London in 1898. "Strange we cannot do this kind of thing in this country."[13] In the fall of 1900, one of the most talented American photographers, a Bostonian named F. Holland Day, mounted a show in London consisting of nearly four hundred works by American Pictorialist photographers, bluntly entitled *The New School of American Photography.*[14] "It was like a bombshell exploding in the Photographic world of London," wrote one observer.[15] Gradually, American photography became a subject of discussion in European capitals. "Photography is more than just a charming distraction, it is a true art," wrote H. P. Linel, a journalist for *Le Figaro,* with not a little condescension. "To be convinced of this all you need do is visit the sixth international salon of photography, mounted by the photo-club of Paris. Alfred Stieglitz has managed to convey the cold sadness of a snowy night lit up by brilliant shafts of light from streetlamps."[16] Despite the journal's early success abroad, Stieglitz gave up running *Camera Notes* as of the July 1902 issue, and the magazine soon folded.

That same year, during the *American Pictorial Photography* show at the National Arts Club in New York, Stieglitz coined a term based on the name of a German movement: "In Munich, the art center of Germany, the 'Secessionists,' a body of artists comprising the most advanced and gifted men of their times . . . have broken away from the narrow rules of custom and tradition."[17] Accordingly, Stieglitz came up with the name "Photo-Secession" for his work in America, thereby aligning himself with such groups as the Vienna Camera Club, who had formed in 1891; the Brotherhood of the Linked Ring, organized in London in 1892, and the Photo-Club de Paris, founded in 1894. The name linked American photography with the International Organization of Radical Photographers.

"The Secessionists of Munich," one could read in the final issue of *Camera Notes,* "gave, as the reason of their movement, the fact that they could no longer tolerate the set of convictions of the body . . . a body which exists on conventions and stereotyped formulae, that checked all spirits of originality instead of encouraging them."[18] This ringing declaration on behalf of photography was composed by another American artist—both a photographer and a painter—sixteen years younger than Stieglitz, who had been in Paris for two years already, brilliantly advancing the cause of American photography. His name was Edward Steichen.

Steichen had independently arrived in the French capital during the Expo-sition Universelle of 1900. The American pavilion, in the "Roman style, like the American capital of Washington," a French journalist observed, was "always nearly empty"; he also mocked its floor for being "covered with . . . linoleum!"[19] "In this pavilion," proudly announced the American general commissioner, Ferdinand W. Peck, "the American citizen can follow the activities of the New York and Chicago stock exchanges. . . . And on July 4, 1900, at seven in the morning (midday in Paris), the American president, from his executive office in Washington, will unfurl by means of an electric switch the largest American flag ever made by our glorious ancestors atop the highest monument in France, the Eiffel Tower, which has been placed at the disposal of the United States gov-ernment by special decree of the cabinet ministers."[20]

On the ground floor of the Grand Palais, the United States was allowed five rooms to display its art. Although it included more than two hundred painters and nearly four hundred works, the exhibition seemed merely a repe-tition of the Exposition Universelle of 1889. Alexander Harrison and Francis Davis Millet both served on the awards jury, but the greatest honors went to Sargent and Whistler, just as had been the case eleven years before. "They per-mitted themselves to imagine, and with some pride, the rich and vigorous school of which France was the mother and continues to be the nursemaid," Léonce Bénédite, the French commissioner of fine arts, said of the American delegation. He noted perceptively that the "most interesting phenomenon" was "undoubtedly the process of emancipation" and the "attempts at indepen-dence" motivating the American artists.[21]

But Edward Steichen had not left his home town of Milwaukee for Paris just to visit the American pavilion. As a twenty-year-old, he arrived with far more romantic notions. "I had heard the story of Rodin's *Balzac,* how it had been refused by the art committee," he later recalled in an interview. "I had seen a reproduction of it in a Milwaukee newspaper. I thought it was great. I made up my mind I was going to meet that man."[22] The sculpture, Steichen recalled in his autobiography, "was not just the statue of a man; it was the very embodiment of a tribute to genius."[23] That "stirred up [his] interest": he ven-tured to Paris, "where artists of Rodin's stature lived and worked."[24]

Shortly thereafter, Steichen was introduced to Rodin. In person, he found the sculptor "a stocky man, with a massive head, almost like a bull's,"[25] and asked for permission to photograph him. "For a whole year I went out there every Saturday afternoon and studied him as he met people, as he walked around in his studio in which there was hardly any room for anybody. . . . There was a big marble statue of Victor Hugo, which wasn't finished at that

The photographer Edward Steichen arrived in Paris in 1900 to meet Rodin. By placing
the French sculptor in front of his *Victor Hugo* and his *Thinker* for this photograph,
Steichen succeeded in evoking the mystery of creative genius.

time. There was also a black bronze figure, *The Thinker.* There was no getting
the two statues in the same picture with Rodin. . . . It took me a whole year
before I found out how I could combine those two things. But I did. And it
became one of my best-known photographs. . . . That was undoubtedly the
image that launched me in the photographic world."[26]

Steichen portrayed the sculptor between his statues *Victor Hugo* and *The
Thinker,* reenacting the "homage to genius" that Rodin had himself offered.
The controversy surrounding Rodin's *Balzac* had started twenty years earlier,
when Emile Zola launched a campaign to erect a monument to the writer, who
had died in 1850. "Balzac is alone, without chapel, devotees, without neighbor-
ing ambitions to promote or defend him. . . . O Paris, have you considered
this?" Zola denounced the injustice and neglect shown toward Balzac, in com-
parison to the tribute duly paid to other French writers: Molière, the genius of
the theater; Voltaire, the embodiment of reason and of spirit; Victor Hugo;
Alexandre Dumas; and all the rest—all celebrated as geniuses. But what about
Balzac, "literary prince of unrivaled stature, the soul behind the modern
novel?"[27] Zola prevailed; in 1891, as president of the Société des Gens de Let-
tres, he organized a contest, which Rodin won.

Seven years later, the statue of Balzac was unveiled at the 1898 Paris Salon. Breaking with the tradition of representing the great men of France in a classical and didactic manner, Rodin honored the author of *La Comédie humaine* with a symbolic, outsized, and magisterial sculpture portraying him in a simple robe, his creative potency manifest in an exaggerated, erect phallus. The Société des Gens de Lettres rejected the statue, and the general public railed against the "hoax." Others rushed to the artist's defense. "Rodin is the greatest artist of our time," proclaimed the critic Aurélien Scholl.[28] A collection was taken up to acquire the work; a Belgian patron offered to buy it. Rodin himself explained the reasoning behind his work. "[A] statue in a public place is supposed to represent a great man on a theatrical scale, capable of inspiring admiration in future generations! Such reasoning is absurd. The *Balzac* I needed to show is . . . truly heroic, tireless . . . a genius who in his tiny room was putting together piece by piece an entire society . . . seething with passion."[29] Later, drained by the polemics concerning his work, Rodin decided to put it aside and wait for a few years before dealing with it again. "For now I don't want to think about it anymore, and hope that no one speaks to me about it."[30] Such was the cultural history that Steichen had unknowingly stepped into.

The French sculptor and the young American photographer soon became close friends. Steichen possessed exceptional energy and charisma. How else at such a tender age could he have succeeded in breaking into the rarefied inner circle of great French artists? "I am keenly grateful for your encouragement," he wrote Rodin in slightly awkward French, "and I appreciate it all the more coming from you, for whom I have long felt such great admiration of you, the greatest master of the time."[31] Steichen spent a few months at the Académie Julian in a class taught by Jean-Paul Laurens, but this training was of little use to him. "The kind of work that was admired there was cold, lifeless, slick, smoothly finished academic drawing: I was not interested."[32]

Still, Steichen submitted two of his paintings to the Salon de la Société Nationale des Beaux-Arts in 1901 (one of which was accepted), and in 1902 he entered again, submitting several paintings and charcoal drawings and a group of ten photographs. The jury accepted his painting *Portrait en Blanc,* six charcoal portraits, and all ten of his photographs, including one of Rodin. The *New York Herald* underscored the extraordinary nature of his achievement. "For the first time in the history of paintings and exhibition, photography has been received as exhibits at the annual Salon. They were submitted by Mr. Edward Steichen, a young New Yorker, and are regarded as a great triumph."[33] But a triumph for whom? And over what? For the photographers over the painters? For the Americans over the Europeans? Without thought to the answer, Stieglitz joined the chorus of exultation. "Mr. Steichen," he wrote in

Camera Work, "broke down the immemorial barriers of the recognized Salon of the World, the Champ de Mars in Paris, and has been the first photographer whose prints were admitted to an art exhibition of any importance."[34] It was, indeed, the first time since 1856 that a photograph had been accepted for exhibition at the Paris Salon.

At the same time, Steichen was attracting acclaim of his own in the United States; fourteen of his photographs were included in the National Arts Club's *American Pictorial Photography* show.[35] When he returned from Paris in August 1902, ensconced in an aura of triumph, Steichen naturally sought out Stieglitz, who had recently resigned from *Camera Notes* and was busy launching a new magazine, *Camera Work.* In the first issue, Stieglitz introduced an international list of contributors from England, Germany, France, Norway, and Japan, including the well-known critics Charles Caffin (British), Sadakichi Hartmann (Japanese-German), and J. Nilsen Laurvik (Norwegian).

With its refined graphics and format—the photograph plates were hand-glued on carefully chosen colored boards—*Camera Work* looked like no other magazine in the United States. Steichen designed the cover and advised Stieglitz on the typography; each article opened with an impressive Gothic capital letter. It presented contributions by Maurice Maeterlinck and the Belgian Symbolists, photographs by Pictorialists from Europe and the United States, examples of Japanese printing techniques, and reproductions of works by the Pre-Raphaelites, the Italian Renaissance master Botticelli, and such Modernist painters as Matisse and Picasso, among others. The magazine spanned the entire world of aesthetics, resonating with the unity of a refined sensibility. *Camera Work,* in short, was more than a journal; it was as if a chunk of Europe had dropped into the heart of Manhattan, administered by a group of radical photographers strictly insulated from the local culture.

Sadakichi Hartmann's first article, merely by referring to the Japanese model, seemed to sound the death knell of an entire era: "artistic photographers," he declared, applying "Japanese principles," such as the search for a "inherent ideas of harmony," were responsible for the novelty introduced in the world of interior decoration. "People will learn to see that a room need not be overcrowded like a museum to make an artistic impression, that the true elegance lies in simplicity, and that a wall fitted out in green and gray burlap, with a few etchings or photographs, after Botticelli or other old masters, in dark frame is as beautiful and more dignified than yards of imitation gobelins or repoussé leather tapestry hung from ceiling to floor with paintings in heavy golden frames."[36]

During *Camera Work*'s first four years, Stieglitz benefited considerably from the presence of Steichen, who had decided to open a portrait studio in

American photographers initiated the transatlantic exchange of Modernism. Thanks to Stieglitz's gallery, works of Rodin, Matisse, Picasso, and Cézanne penetrated the American market. Here, from left to right: Frank Eugene, Alfred Stieglitz, Heinrich Kühn, Edward Steichen.

New York. But despite his success in photographing New York society, Steichen longed to go back to Paris. "I have many memories of you dear Master," he wrote to Rodin, "and of your goodness for me but above all the influence of your great art and your noble character still help and encourage me."[37]

He continued to work as a facilitator, tirelessly promoting Rodin's genius and locating clients, patrons, and commissions for him. "I have just finished doing portraits of a number of prominent people," Steichen wrote to his "dear master," "including among others J. Pierpont Morgan, the man of millions who was very friendly to me. I hope to interest him in your work and to get you some big commissions for our new sculpture museum."[38] In Steichen, Rodin knew that he had found not only his best portraitist, but a tireless defender. "I am so pleased," the photographer wrote him, "to see how your work is appreciated here in America. You too will be surprised. I hope that this will develop in more material form and that we will have lots of your beautiful creations in this country before long. It is always those with the most money who have the least understanding of art."[39]

Steichen made this portrait of J. P. Morgan, the railroad
and steel magnate, at the moment he became president of the
Metropolitan Museum of Art in New York.

 Like Stieglitz, Steichen was ill at ease with the commercial crassness of his
native land. Yet through their photographs, both continued to render their
impressions of New York, capturing its inhabitants and spaces. They often
responded to each other's work, appearing, indeed, at times to be working in
unison. *Camera Work* published Stieglitz's photograph *The Flatiron* in 1903;
Steichen's *Flatiron Building* appeared in 1905.

Eleven

Voyagers to the Land of Wild Beasts

"I WISH YOU COULD have a few weeks here alone; just a rest. I'm getting more and more fond and appreciative of Paris; it certainly has more resources in spite of its natives than one can find anywhere else; not that I have been doing anything particular but somehow a feeling of intimacy with the place seems to take hold of me."[1]

Upon his return to France, Steichen moved to a region already celebrated by Corot, purchasing a spacious house in the little provincial village of Voulangis. Just an hour by train from Paris and a few miles from Crécy-en-Brie (known as "the Briarde Venice"), Voulangis could easily have become another artists' colony like Pont-Aven, Barbizon, or Giverny. The hotel facing Steichen's house hosted those passing through, and his garden provided an ideal oasis for endless discussions. Over the course of several summers, it inspired the likes of John Marin, Arthur Carles and Mercedes de Cordoba, Katharine Rhoades, Agnes Ernst, Kathleen Bruce (a student of Rodin's), the dancer Isadora Duncan, the Stieglitz family, and the Romanian-born sculptor Constantin Brancusi. Steichen's presence turned the sleepy town of Voulangis into a unique and informal artists' haven.

The cultural bustle that characterized Paris during those years impressed Steichen even more on his second trip. Since the Impressionists' inclusion in the 1900 Exposition Universelle, interest in their paintings had gradually begun to spread to the general public. Despite Jean-Léon Gérôme's desperate attempt to keep the president of the Republic, Emile Loubet, from entering the room where the Impressionists' works were displayed ("Do not go in, Monsieur le Président, for it would bring dishonor to France"), enthusiasm for their art only increased. In 1903, the Salon d'Automne was launched both to pay homage to the outcast masters of the previous decades and to promote the new avant-garde. That year, it celebrated the oeuvre of Paul Gauguin, while Camille

Pissarro, "the humble and colossal Pissarro," as Cézanne had called him, who died seven months later, was equally grieved by his fellow artists.

Opening its doors on October 18, 1905, the third Salon d'Automne with its 1,636 works by living painters strikingly brought forth "a tidal wave of new artists." "The Salon is fortunate to bring together the young energies that the Salon des Indépendants could not foresee," noted the art historian Elie Faure. "We have to have the openness and the courage to embrace this wholly new language," he wrote.[2] This "wholly new language" was that of Vlaminck, Derain, Vuillard, and Matisse—the "Fauves" ("wild beasts"), as they came to be known. At the fifth Salon d'Automne in 1907, Cézanne, who had died the preceding October, was saluted with a magnificent memorial retrospective. Although he believed that he had "probably come too early," from then on, because of his commitment to painting and professional asceticism, he came to epitomize, for most of the younger artists, the great master par excellence. In fact, in his painting *Homage to Cézanne,* Maurice Denis depicted a Cézanne still life surrounded by a group of the Aixois painter's admirers and followers: Odilon Redon, Paul Sérusier, Edouard Vuillard, Pierre Bonnard, Ambroise Vollard, André Mellerio, and Denis himself.

Most young foreigners who flocked to Paris around that time could identify with Max Weber's first reactions upon his arrival in September 1905: "Paris in those years was a veritable melting-pot in the history of art. They were years of renewal that took on the nature of a spiritual and aesthetic revival. Large and important retrospectives of paintings by Gauguin and Cézanne were held in the Petit Palais in 1906 and 1907 and a large exhibition of drawings by Rodin and paintings by van Gogh followed in the same galleries. In the year before, the Durand-Ruel galleries, rue Laffitte: exceptionally large and important exhibition of Cézanne and Renoir. . . . Ambroise Vollard, informal, unpretentious boutique . . . the most important pictures unhung, some even unframed and scattered around the store: Cézanne, Rouault, Rousseau . . . when Cubism was in its embryonic state Kahnweiler Gallery . . . Louvre, Luxembourg, Guimet, Trocadéro . . . the annual Salon d'Automne and Salon des Indépendants fanned the flames of revolt, and were the storm centers, in the art circles of Paris. . . . There was not a café . . . where the art of the primitives and new paths opened up by the masters . . . were not discussed and argued over with passion and verity. . . . Cézanne and his colleagues and their offspring, Vuillard, Bonnard, Matisse, Braque, Derain, and a few others, were officially regarded as outcasts; but as the years rolled on, Cézanne's spirit and concept reigned supreme. Young aspiring painters from all over the world sat for hours at a time, analyzing Cézanne's color construction and design, his alluring

archaic type of beauty and austerity, which rehabilitated and enriched the art and the intrinsic meaning of painting then, and for all time."[3]

The transatlantic dialogue between Steichen and Stieglitz reached a new threshold when Steichen came into contact with another American microcosm, one that had been established several years earlier in Paris around the Stein family. Leo and Gertrude Stein, brother and sister, then aged twenty-eight and twenty-six, respectively, had briefly visited the city. Just like Steichen, they had been drawn to the French capital by the 1900 Exposition Universelle. For him, the Steins were, so to speak, perfect counterparts of the Stieglitzes. From the same generation and German-Jewish origins, both families had made their fortunes during the Civil War, then educated their children in Europe— the Stieglitzes in Berlin, the Steins in Vienna and Paris. Both had also been inextricably warped by their families' obsession with higher education, and shared an equal appreciation for Europe's historic traditions and America's unlimited potential.

Without question, the most fascinating member of the Stein family was Leo, a "powerful Jew with a Moses head," as one friend remembered him.[4] Cultivated, independently wealthy, and blessed with encyclopedic knowledge, Leo saw himself as cursed with a "neurotic" inability to either create or act. He spent his adult life visiting the museums of the world and studying, for days on end, their greatest masterpieces until they were "perfectly intelligible"[5] to him, and he thereby became, in the judgment of Alfred Barr, "possibly the most discerning connoisseur of twentieth-century painting in the world."[6] After leaving Oakland, California, and spending his childhood in Vienna, Stein studied at Harvard, and then lived for a while in Baltimore before escorting a cousin on a world trip that included the Philippines, China, and Japan. Leo Stein felt equally at home in London, Boston, Florence, Madrid, Munich, Paris, or New York, enjoying the sense of freedom known only to those of unlimited financial means. Leo's older brother, Michael, managed the family fortune, following the aesthetic passions of the others and generously underwriting them.

One day, early in 1903, Leo, having decided he wanted to study painting, enrolled at the Académie Julian and settled in Paris. Gertrude followed him soon after. The rest of the details are well known: brother and sister set up house together at 27, rue de Fleurus, where seven years later Alice B. Toklas would take Leo's place amidst numerous Picassos, Matisses, and Cézannes. Michael Stein and his wife, Sarah, moved in nearly next door, at 58, rue Madame, and in 1905 would begin their collection of Matisses. Between 1904 and 1910, Leo collected avidly. "It was a queer thing in those days that one could live in Montparnasse and be entirely unaware of what was going on in

the livelier world of Montmartre," he wrote in his memoirs.[7] Thus, "a Columbus setting sail for a world beyond the world,"[8] Leo Stein raised anchor and left Montparnasse to explore other neighborhoods. His first stop, following Bernard Berenson's advice, was Ambroise Vollard's eccentric shop on the rue Laffitte. "We got on nicely," Stein later said about the dealer from La Réunion.[9] He immediately fell for Cézanne, identifying him with the Renaissance painter Andrea Mantegna, whose *Crucifixion*—"a sort of Cézanne precursor with the color running all through it"[10]—had become a personal obsession. At Vollard's gallery, Stein bought his first Cézanne landscape, followed by a number of other works: still lifes, bathing women, landscapes, portraits, in oil and in watercolor. At the Salon d'Automne that October, he saw the works of Cézanne, Renoir, and Toulouse-Lautrec, and more than a dozen by Matisse. "The Autumn Salon was new, and I began there. I went again and again, until things [began] to take shape. I looked again and again at every single picture, just as a botanist might at the flora of an unknown land."[11] He and Gertrude sold some of their Japanese prints to help finance the purchase of more paintings—Cézannes, Matisses, Picassos, Gauguins, van Goghs, and Seurats. Leo was drawn primarily to the most experimental works, such as Cézanne's hieratic *Portrait of Madame Cézanne,* Matisse's defiant *The Woman with the Hat,* and Picasso's radical *Acrobat's Family with a Monkey.* "For a while I was the only person that bought Picasso's pictures. I was the only person anywhere so far as I know who, in those early days, recognized Picasso and Matisse."[12]

In Paris, Leo grew into the first theorist of these new tendencies. "In those early days when everyone laughed, and went to the Steins' for the fun of it, half jestingly giggled and scoffed," Mabel Dodge recalled. "Leo stood patiently night after night wrestling with the inertia of his guests, expounding, teaching, interpreting . . . [praising] the Big Four: Manet, Renoir, Degas, and Cézanne."[13] Even Berenson, "who, at the time, claimed for himself the office of High Protectors of Newness in painting," sneered at Leo for some of his choices.[14] For American students in Paris, Leo's passionate pedagogy catalyzed a new approach. Breaking down traditional barriers, he offered an extraordinary closeness to art within the context of his interpretations, generating from his theories on art much intellectual exchange. One of those students, Max Weber, recalled: "For hours we stood around a large table in the corner of the spacious and well-lighted room, examining portfolios full of drawings by Matisse, Picasso and others, and folios well stocked with superb Japanese prints. This salon was a sort of international clearinghouse of ideas and matters of art, for the young and aspiring artists from all over the world. Lengthy and involved discussion took place, with Leo Stein as moderator and participant.

Leo Stein, at 27, rue de Fleurus, was the first theorist of Post-Impressionism.
Behind him are pictures by Maurice Denis, Cézanne, and Gauguin.

Here one felt free to throw artistic atom-bombs and many cerebral explosions
did take place."[15]

Indeed, a special Friday-night ritual started taking place chez Steins:
invitations were selectively extended for an intimate few to dine with the fam-
ily, followed by after-dinner drinks attended by a wider guest list, on a spon-
sored-only basis: one needed merely to ring the doorbell and mention the
name of a mutual friend. Thus, on the rue de Fleurus, there formed a remark-
able crowd of people—young unexperienced provincial bumpkins and hard-
ened European intellectuals, radical genius outcasts and other fixtures of the
artistic scene, all thrown together in the most unexpected mélange. Here,
amidst dark and austere Renaissance furniture, with walls crammed floor to
ceiling with paintings hung so closely together they nearly touched, the new
generation of American artists—Arthur B. Carles, John Marin, Max Weber,
Marsden Hartley, Alfred Maurer, Abraham Walkowitz, Andrew Dasburg,
Morgan Russell, Arthur Lee, Arthur Dove, Stanton Macdonald-Wright,
Patrick Henry Bruce—could both admire one of the most exceptional art col-
lections of its day and rub shoulders with Matisse, Rodin, Braque, and Picasso,
among many others. Capable of true generosity, according to Dasburg, Leo

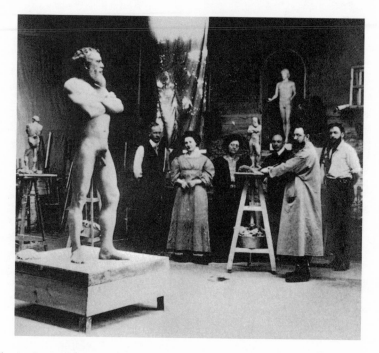

The Académie Matisse, in Montparnasse, was founded by American painters, including
Sarah Stein (left), who was also the first to collect French painting.
Matisse is at the right, his hand on the table.

even "allowed Morgan and me to take a painting by Cézanne to my studio. It
was a long horizontal panel of apples. I studied this painting and copied it
many times while it was in my possession."[16] Mr. Stein knew the value of the
gesture. Some months later, in a letter to Morgan Russell, he added in a post-
script: "In Rome I realized that never did Michelangelo achieve this pure
expression of form in his drawings. I believe that nothing can match Cézanne's
apples."[17]

Coming out of this exceptional atmosphere, it is hardly surprising that
Morgan Russell, Stanton Macdonald-Wright, and Marsden Hartley would go
on to found Synchromism, the first American art movement born in Paris; or
that the same moment saw experiments with Neo-Impressionism and Pointil-
lism by Thomas Hart Benton, who adored the work of Cézanne, and by
Andrew Dasburg, who returned from Europe "inflamed like a newly converted
evangelist" and "talked endlessly" about what he had seen in "experimental
art."[18]

Morgan Russell, though, did not take the most direct path: after studying
Realism with Robert Henri, he dove straight into Impressionism and Post-

Impressionism. No sooner had he begun to admire Monet, "the master of light,"[19] than he realized that the master of Giverny was not alone. "Wait till you get acquainted with Gauguin, Cézanne, and the younger men, Matisse, etc.," he wrote to Dasburg in 1910, adding that "Cézanne's work has helped me discover what was rhythm in color."[20] Russell spent some time with the Futurists, whose work he had discovered at the Bernheim-Jeune Gallery; with the Cubists, at the Delaunay exhibition in 1912, and with Matisse. "Make lines color. . . . Never paint the thing or the subject. . . . Paint the emotion, not illustration."[21] "I would like very much to see more of what's doing in Paris . . . what the searchers are doing," Henri explained to his pupil in May 1910. Russell responded, describing the Matisse studio and citing the master.[22] In 1912, writing in his notebooks about the Synchromist principle of expressing form and space as color, Russell asserted that "color and light must be entirely melted into one and felt as such," and explained the "cubist method," which is "a means of keeping a firm tight grasp on the organization as a whole, the parts being strongly and intimately held together in this whole and never as isolated representational detail."[23] In October 1913, Russell and Macdonald-Wright exhibited their work at the Bernheim-Jeune Gallery. The *New York Press* gleefully entitled its coverage "Synchromist Art Now Assails Eye."[24]

Leo Stein encouraged and judged his protégés, frequently offering brutally harsh critiques, such as this one in a letter to Russell: "If you'll stick to trying to get the immediate expressiveness out of the things that you see you'll probably in the long run get a darn sight more of suggestive significance because you feel its implications than you will by any scattering of attention in the search of a doubling of impressions. The things that you sent over are good but they are the merest beginnings and if you are going to encourage yourself to go off on wild-goose chases of fantasy the result is likely to be unfortunate. Well, I've got other things to do now."[25]

If providing American artists an aesthetic theory was Leo's domain, Michael Stein's was acting as their guide. His favorite pastime consisted of giving them tours through museums and galleries, as well as getting them access to private collections.[26] For artists like Matisse, Cézanne, and Picasso, the Steins represented the daring patrons that the Havemeyers had been for Manet, Degas, and Courbet. But unlike the Havemeyers, who hung their collection in their New York mansion, the Steins' art collections became sites of Parisian pilgrimage. Sarah Stein amassed the largest number of Matisses in the world, promoted the artist's reputation in the United States, and eventually became his student.

The Académie Matisse opened on the rue de Sèvres in January 1908, organized on the initiative of Sarah Stein and a German student, Hans

Purrmann—with about eight other students, including Patrick Henry Bruce, Max Weber, two other Germans, two Hungarians, and a Swede—for classes in painting, drawing, and sculpture.[27] Morgan Russell joined them that spring, after the school moved to a larger space on the Boulevard des Invalides. Demanding highly technical work from his students, Matisse disdained short-cuts and expected them to embrace his rigorous new ideas about painting. "What is critical is to represent the model, not to copy it," Sarah Stein remembered him saying. "Nature inspires the imagination to more than representation. . . . Color must marry form as fact does the drawing."[28] "She is the best expert on my work," Matisse said of her.[29] Stein fervently retained everything Matisse taught, particularly about Cézanne, the "master to us all." Weber also recalled Matisse's insight into the art of Cézanne: "With great modesty and deep inner pride, he showed us his painting of bathers by Cézanne. His silence before it was more evocative and eloquent than words. A spirit of elation and awe pervaded the studio at such times."[30]

When the Steins settled in Paris in 1903, they unintentionally sowed the seeds that would later grow into a genuine and unofficial American art academy in Paris.[31] "The Americans, as I first knew them," wrote Leo Stein, "were not experimenting; they were not even going abroad. Beyond the official salons, they knew nothing and had heard of nothing."[32] Having cornered the best avant-garde art produced in Paris, the Steins made it available to the young Americans, giving them an advantage over their French counterparts. This represented a dramatic change in relation to anything that had come before: with the Steins as cultural catalysts, American artists found themselves suddenly exposed to situations that the French had never experienced.

Some of Picasso's closest friends, including André Salmon and Max Jacob, viewed this slightly exotic group of Americans as totally tasteless. With no little sarcasm Apollinaire, for one, ridiculed a "certain American girl who with her brothers and some parents formed the most unlikely patronage of our times. 'Their naked feet are shod with delphic sandals / They raise their scientific minds to the skies.' The sandals have sometimes done them harm with traitors and lemonade makers. These millionaires want to take the air at an outdoor cafe, and the waiters refuse to serve them, politely making them understand that they do not serve expensive drinks to people in sandals. Incidentally, they don't care, and calmly pursue their aesthetic adventures."[33] "As to the Steins," Mary Cassatt condescendingly proclaimed, "they are Jews and clever, they saw they had no chance unless they could astonish, having not enough money to buy good things so they set up as apostles of Matisse and pose as the only ones who know, and it has succeeded! Amongst the foreign

population in the student quarters and international snobs, it is very amusing but cannot last long."[34]

Leo's theories about Cézanne or Sarah's efforts to establish the Matisse studio notwithstanding, surely what history will longest recall is Gertrude Stein's relationship with Picasso. In the early days, Gertrude presided over the soirées, listening to her brother, only passively involved in the whole artistic enterprise. In the autumn of 1905, however, the Steins met Picasso through his dealer Clovis Sagot and the critic Henri-Pierre Roché. At the age of nineteen, Picasso had come to Paris in 1900—his first trip there—to view the fine-arts exhibition at the Exposition Universelle, which included several of his paintings. Then, after shuttling between Paris and Barcelona, he settled in 1904 in one of Paris's most rundown neighborhoods, in a ramshackle building at 13, rue Ravignan that André Salmon christened the "Bateau-Lavoir" ("Laundry Barge").

In Paris, the "feeling of intimacy with the place" noted by Steichen affected people from all around the world: Gertrude Stein, born in Allegheny, Pennsylvania; Pablo Picasso, born in Málaga, Spain; Constantin Brancusi, born to a shepherd in Hobitza, Romania; Gino Severini, an Italian painter from Cortona in Tuscany; Franz Hessel, a German writer; and other painters, sculptors, and writers, from Holland, Russia, Scandinavia, Germany, the United States, Spain—all voyagers to the land of the Fauves, who found a home in Paris. Out of immediate necessity, they created their own language, a broken, ad hoc, grammatically incorrect, colloquial French. "Only Paris was our country," recalled Hessel, who had been born in Stettin and arrived in Paris sometime around 1906 to spend a few months; he stayed for six years. "It is strange and hard to explain. Paris had become a destiny, a necessity. . . . I knew several painters and the friends of painters, mostly foreigners like myself. As a foreigner, I lived on the margins of life and I loved this city. . . . Sometimes a group of us would get together around a table of French poets, each jabbering away in his way in much-loved French, which we all had in common, but like all the chosen and all the peoples of the Pentecost, in which we understood each other."[35]

An exchange between Gertrude Stein and Picasso provides a good example: "Bonjour, bonjour, bellissima cita questa and molta bella cavallo fait des bois," she wrote on a postcard of Donatello's wooden horse sculpture, in her rather ignorant mixture of pidgin Italian, French, and English.[36] On another card she wrote, "Photograph is beautifuler than the other I have sended to you. This very handsome horse very well showed nicely displayed in a room superb [sic]."[37] On St. Paul's feast day, on a sentimental-looking blue card with the word "Pablo" written on it, she scrawled, "I wish you many happy returns on

your saint day, I little late but still coming. Sincerely [*sic*]."[38] Later, on a repro-
duction of Il Piccio's *Contessa Spini,* she wrote, "She is very pretty, no? What
you do over there? Are you a lonely girl? The merry Catalans are completely
pretty. There is nothing news [*sic*]. Hello to you. Gertrude."[39] Finally, on a card
showing Hans Holbein's *Gattin und der Kinder des Künstlers,* she jotted: "I will
stop by at your house tomorrow friday afternoon for my portrait Gertrude
Stein."[40]

Even if one of them remembered the exact details of the scene, it appears
that soon after their first meeting, Picasso invited Gertrude to sit for her por-
trait. Eighty to ninety times over the course of several months, she trekked to
Montmartre and posed for the painter in his studio in the Bateau-Lavoir. On
Saturdays, Picasso and his girlfriend, Fernande Olivier, would hop over to
Montparnasse for the Steins' soirées, where Picasso first viewed the *Portrait of
Madame Cézanne.* Despite their countless sessions, Picasso seemed afflicted by
Cézanne's well-known inability to complete a picture. After months and
months, he seemed no closer to finishing it. Out of frustration, he painted out
the entire face and went to Gosol, feeling that he'd never make an end, tempted
to give up. But when he came back, with the memory of archaic Iberian sculp-
tures in his head, Picasso quickly took up his brush again and abruptly finished
Stein's portrait: hefty, leaning on her elbow, her face a frozen mask, she sits
expressionless. "Everyone maintains that they aren't alike, but that's not impor-
tant. She'll end up resembling her," Picasso would say.[41] At the same time, with
one artist inspiring the other, Stein was writing *Three Lives.* And in April 1906,
she introduced Picasso to Matisse.

Everyone who met Picasso for the first time was mesmerized by the physi-
cal presence of the Spanish artist, and felt compelled to describe him emphati-
cally. "I used to say that when Picasso had looked at a drawing or a print, I was
surprised that anything was left on the paper, so absorbing was his gaze,"
observed Leo.[42] Echoing these sentiments, Andrew Dasburg recalled: "I met
Picasso at Leo Stein's and of course, by that time, I was really in seventh
heaven. . . . That was the first time that the world of art was open to me, you
see, in comparison to what my experience was at the League, where there was
no revelation. . . . Picasso was young then, as I was too. I only met him briefly,
but I was interested in his personality and he had very dark eyes, he was look-
ing at some drawings that Stein had . . . they were in a folio, but his looking
was so intent. . . . When he looked, he really lifted what he was looking at from
the paper."[43] "I was at Gertrude Stein's yesterday," Marsden Hartley wrote to
Rockwell Kent in 1912 during his first visit to Paris, "looking at her collection
of Picassos and Cézannes. I assure you this man Picasso is a wonder. . . . It was

his water colors, with their new way of expressing color and shape, that inspired me as nothing before."[44]

Max Weber's deep interest in African art and in the work of Henri (Le Douanier) Rousseau provided the only genuine connection between any American painter and Picasso. Weber took sixty-four of Picasso's drawings to New York, exhibiting them at Stieglitz's gallery. "Dear Mr. Picasso," he wrote, "I am very sorry that I did not go to your house, to see you before leaving: but I hope that I will see you soon. My sincere salutations and much, much success. . . . The Congo things at the British Museum are numerous and superb. I hope you see them soon."[45]

In the spring of 1907, six months after finishing his *Portrait of Gertrude Stein,* Picasso threw himself into the most ambitious project he had ever undertaken, a canvas measuring almost 8 feet square, later to be known as *Les Demoiselles d'Avignon.* In the frenetic atmosphere of the Bateau-Lavoir, working in the company of his friends—the writers Guillaume Apollinaire, Max Jacob, and André Salmon; the painters Juan Gris and Henri Rousseau— he passed memorable evenings fueled by vodka, opium, and sex, piling up sketches and preparatory drawings, working throughout the night, in creative bursts and hallucinatory episodes. After he finished the painting in July 1907, Picasso kept it with him for the next ten years, carting it from studio to studio like some secret talisman, revealing it only to close friends and visitors, who frequently remarked on a range of influences, from Ingres's *Turkish Bath* and Cézanne's *Bathers* to Gauguin, Matisse, El Greco, and even the Iberian sculptures and African masks Picasso had recently discovered at the Musée du Trocadéro in Paris.

Working between classical and iconoclastic impulses, he dared to open dialogues between Europe and Africa, the contemporary and the antique. It was as if "someone were drinking gasoline and spitting fire," Braque exclaimed when he saw the painting. Gertrude Stein discovered in it "something painful and beautiful, something of the tormentor and the prisoner both."[46] Wilhelm Uhde was convinced he saw the influences of Egyptian or Assyrian Art. Matisse and Leo Stein ironically scoffed that it showed "the fourth dimension."[47] In his *History of Cubism,* André Salmon speaks of a painting showing "six large female nudes who a friend of the painter had called 'the philosophical bordello,'" and of a group of prostitutes "deprived of nearly all humanity. . . . These are nude equations, white numbers on a black painting."[48] Later, scholars would speak of Eros and Thanatos, describing it as an "exorcist painting."[49]

In the spring of 1908, Gelett Burgess, a young American writer and journalist, came to Paris to write an article about artistic life in Paris. He met every

painter he could—Braque, Derain, Matisse, and Picasso, among others—interviewing them and photographing both the artists and their works. Matisse, who had just finished *The Joy of Life,* exhibited it at the 1906 Salon des Indépendants. Writing about it, Burgess described Matisse as "serious, plaintive, a consciencious experimenter who took the first step into the undiscovered land of the ugly."[50]

For years, Gelett Burgess's description and photographs of *Les Demoiselles d'Avignon* provided the only available testimony about it: "Picasso is a devil. I use the term in the most complimentary sense, for he's young, fresh, olive-skinned, black eyes and black hair, a Spanish type, with an exuberant, superfluous ounce of blood in him. . . . He is the only one in the crowd with a sense of humor; you will surely fall in love with him at first sight, as I did. . . . Picasso is colossal in his audacity. . . . So we gaze at his pyramidal women, his sub-African caricatures, figures with eyes askew, with contorted legs, and things unmentionably worse, and patch together whatever idea we may. . . . But, if Picasso is, in life and art, a devil, he at least has brains and could at one time draw."[51] Most collectors of Picasso's works did not come from France, but instead were American (the Steins, Weber, Walter Pach, Burgess, Paul Burty Haviland, Hamilton E. Field[52]), or Russian (Sergei Shchukin, Ivan Morozov), or German (Kahnweiler, Max Raphael, Uhde), or Czech (Dr. Vincenc Kramar).

In 1909, when Picasso entered his Analytic Cubist period, Gertrude started to "write cubist" and to collect art on her own, while Leo declared his hostility toward Cubism. "When my interest in Cézanne declined, when Matisse was temporarily in eclipse, when Picasso turned to foolishness, I began to withdraw from the Saturday evenings," he wrote.[53] In 1913, Leo Stein left Paris for good, taking with him some of the Cézannes, all the Renoirs, and a few Picasso drawings, and leaving everything else he had avidly collected to his sister, uttering one of his typical prophetic offhand remarks: "You, people in New York, will be soon in the whirlpool of modern art. I, on the other hand, am out of it," he wrote Mabel Weeks. "The present enthusiasm is for cubism of one species or another, and I think cubism whether in paint or ink is tommyrot."[54] Gertrude, in turn, invited Alice B. Toklas to move in with her and came into her own: writing, organizing salons, collecting, cultivating friendships, and leaving behind a written record of the times.[55] Picasso, whose name comes up most frequently in Stein's recollections, never offered an opinion about her work, for the simple reason that he couldn't read English.[56]

Among all the voyagers to the land of Fauves, Gelett Burgess may have come closest to capturing these painters and their secret. Sometimes, to hold on to the general reader, he stuck close to convention, but in the end offered perhaps the most astute insights about their art: "Les Fauves are not so mad,

after all; they are only inexperienced with their method. I had proved, at least, that they were not charlatans. They are in earnest and do stand for a serious revolt. . . . Whether right or wrong, there is, moreover, something so virile, so ecstatic about their work that it justifies Nietzsche's definition of an ascendant or renascent art. For it is the product of a surplus of life and energy, not the degeneracy of stagnant emotions. It is an attempt at expression, rather than satisfaction; it is alive and kicking, not a dead thing, frozen into convention. And, as such it challenges the academicians to show a similar fervor, an equal vitality. It sets one thinking; and anything that does that surely has its place in civilization. . . . Perhaps these Wild Beasts are really the precursors of a Renaissance, beating down a way for us through the wilderness."[57]

Twelve

The Modernists' Transatlantic Shuttle

"CORKING RODIN EXHIBIT no proofs from Goetz."
"Coming end February also bringing Exhibition Matisse drawings"
"Cézanne exhibition sailed Savoie"[1]

Between 1907 and 1913, the Compagnie Française des Câbles Télé-graphiques carried many urgent communications between Steichen and Stieglitz. The frequency of their telegrams increased as the transatlantic shut-tling of the Modernists accelerated and works by Rodin, Matisse, Cézanne, and Picasso started sailing for the first time toward the New World. In January 1908, Rodin's first show in the United States attracted a brand-new public in Stieglitz's gallery—the Little Galleries of the Photo-Secession, at 291 Fifth Avenue (and thus usually called 291)—even if some of *Camera Work*'s sub-scribers, offended by so much nudity, canceled their subscriptions.

Among this new public, Paul Burty Haviland, a young Franco-American student and amateur photographer, offered himself as a potential sponsor. When in April 1908, Stieglitz feared he might have to close his gallery on account of financial difficulties, Haviland forcefully stepped in and signed a new lease on the space in the adjoining building. Rodin's drawings also attracted Agnes Ernst, a young journalist writing for *The Sun:* "It is my first order, my first chance. I'm heart and soul with you," she insisted, when requesting an inter-view. "Do give me a chance."[2] After her marriage to the wealthy banker and col-lector Eugene Meyer in 1910, she would become one of the gallery's principal patrons and organizers.

Steichen's first act was to gather a bunch of the Rodin drawings he had mentioned to Stieglitz and send them to New York. In January 1908, the Little Galleries presented an exhibition of fifty-eight of them: a striking series of female nudes marked by carnality, technical virtuosity, and charged eroticism, subtly reflecting the scope of the sculptor's own sensuality. In the catalogue,

Stieglitz had insisted on warning the public that these were the work of a sculptor and, as such, "they spoke another language than the drawings of the painter . . . one's fingers seem actually to touch marble. They are notes for the clay 'instantanés.' . . . They are done in two minutes, by a mere gallop of the hand over paper. . . . Not even the Japanese have simplified drawing to this illuminating scrawl of four lines, enclosing the whole mystery of the flesh." Mesmerized by the drawings, Stieglitz waxed lyrical over the model's mysteries: "She turns upon herself in a hundred attitudes, turning always upon the central pivot of the sex."[3]

In the *New York Times,* J. Nilsen Laurvik conceded that Rodin's drawings were "of unusual artistic and human interest. . . . As one looks at these amazing records of unabashed observations of an artist, who is also a man, one marvels that this little gallery has not long since been raided by the blind folly that guards our morals. . . . In his work there is a modesty that defies prudishness and a manly outspokenness that confounds the licentious rantings of libertinism. It is also a challenge to the prurient prudery of our puritanism." Then, carried away like his peers by the unbridled vigor of the drawings, he added: "There is a force elemental and unappalling in these simple outlines, that has never before been represented in art. Life has been surprised and stands shivering, breathless and all-absorbed in its passionate, flesh-crushing embrace. In these mad, glad yearnings of man, the female form is like an undulating, writhing, sinuous reptile that will not be denied its prey. . . . It is a hopeful sign of the changing order of things when work such as this can be shown here in New York. No one interested in the development of the modern spirit in art should miss the opportunity of seeing these drawings."[4] Such words fell on deaf ears with William Merritt Chase, who wondered if Rodin was making fun of Stieglitz by sending him "a group of absolutely ridiculous drawings," or if Stieglitz, aware of the whole farce, "was (just) testing the limits of public taste in America."[5]

Undeterred, Stieglitz responded with a long, enthusiastic letter to Rodin. "My dear M. Rodin," he wrote, "I want to thank you for the great pleasure you have given so many Americans in letting us have your drawings for exhibition. Mrs. Simpson will have written you how wonderfully beautiful they look in our little place and how at home they seem. Steichen too will have told you about their success, as I have written to him fully. As for myself, I can only say to have been given the opportunity to live with [them] constantly for four weeks is the greatest spiritual treat I have ever had. It was a delight to see how the best element of New York, social and cultured [*sic*] has approached the work. The American woman especially seeming [*sic*] intuitively to grasp the elemental beauty you feel and express in all things. Kindly accept my sincere

thanks in the name of my associates in the Photo Secession and for Americans generally."[6]

The intimate friendship between Steichen and Rodin deepened over these years. Steichen decided to name his second daughter Kate Rodina. Rodin, meanwhile, continued to ponder the fate of his *Balzac* sculpture: "I've endured a torrent of abuse," he wrote Monet, "like what you once endured when it was thought fashionable to laugh at your invention of opening up space in your landscapes."[7] In October 1908, Rodin made up his mind. "This work at which everyone has laughed," he wrote, "and which everyone took such pains to scorn because they couldn't destroy it, is my life's outcome, the turning point even of my aesthetic."[8] Toward the end of the summer of 1908, Steichen received a letter from Rodin informing him that "he had moved his Balzac out into the open air so that I [Steichen] could photograph it," and suggesting that Steichen work "by moonlight."[9] Inspired, Steichen examined the *Balzac* statue closely, studying it under the variations in light at different times of day. "Been photographing . . . Rodin's *Balzac*," he wrote to Stieglitz, "and I have been doing it *by moonlight*—spent two *whole* nights from sunset to sunrise—it was *great*. It is a commission from himself" (emphasis in original).[10]

Ecstatic with the results, Rodin wrote to him: "It is the Christ in the desert. . . . Your photographs will enable the world to understand my Balzac."[11] "I never met a man," Steichen reported to Stieglitz, "excepting yourself, so hit by a thing as he was by the Balzac's proofs."[12] Later, Rodin confirmed that he considered Steichen "a very great artist and the leading, the greatest photographer of the time."[13] The circle was complete: the nineteen-year-old Steichen had first seen the *Balzac* sculpture in a Milwaukee newspaper and, immediately grasping its significance, decided that he would go to Paris, where there lived "so many geniuses." Steichen had become Rodin's envoy, his messenger, and by his own photo, his dear master's means of bringing Balzac back to life.[14]

A veritable art market was beginning to form around Stieglitz and, as had been the case earlier with Paul Durand-Ruel, the issue of taxes got in the way. The United States taxed imported works of art after Durand-Ruel's Impressionist exhibition of 1886: art could come in and go out only "on bond"; were any works sold, as Steichen explained in an interview, "they would have to go out and then be reimported individually."[15] Steichen, Stieglitz and Haviland sought a solution to the problem. "[W]e have [come] up against the old customs difficulty," Steichen wrote in June 1908. "We can only bring things that have practically no commercial value so that the duty can be paid on them."[16] A little later, Steichen complained that the year's program did not seem as strong as it should be, adding that he thought this was "due to our customs." "I could easily send over some corking stuff otherwise—I will send that and in a

week or two some water colors by John Marin—young American, ask Caffin about them. They are the real article—and being an American there is no duty trouble."[17]

In the recent past, American protectionism had frustrated many artists, including Whistler, Ernest Meissonier, Jean-Léon Gérôme, and Frederic Church. Would it rear its ugly head again? Would it threaten the spread of Modernism at this moment? The only solution that Steichen could envision was to plead before the Federal government that Stieglitz's gallery be classified as an "educational institution,"[18] an idea that pervades his letters during this period. "[A]s far as I can see there is only one way and that is to arrange to get [the works] on bond as an educational institution and dispense them with the public selling—sell privately and have them shipped from Europe after they have been returned." Increasingly optimistic about their prospects, Steichen added, "I can get my hands on an unlimited number of high-quality works— no need to go back to the Rodin operation. I think I can get some Cézanne drawings that you saw, as well as some studies by Maurice Denis. I think if you can get the educational institution idea through it will be just right."[19]

Paul Burty Haviland, who was trained as an attorney, produced a letter citing the relevant government code, as stipulated in Article 717: "Breach of Bond. . . . If any of the articles shall be sold or offered or exposed for sale, transferred, or used in any manner not provided for in the law, duties thereon shall be immediately demanded by the collector at the port of entry. . . . Articles intended for exhibition under paragraph 702 of the Act of July 24, 1897, shall in no case be entered under paragraph 701 of said act. . . . Articles imported under paragraphs 701 and 702 of the tariff shall be subject at any time to examination and inspection by the proper officers of the customs."[20]

In short, nothing had changed since the days of Durand-Ruel. The import tax continued to weigh heavily on the directors of galleries. The bond in question had to be deposited with American customs officials at the moment the works arrived in port, and U.S. Treasury regulations required that the payment be "for an amount equal to double the amount of the estimated duties." Haviland added that he had "found no rulings contrary to any of the above provisions, which could be modified only by an act of Congress."[21] It looked as if the situation was heading toward the kind of diplomatic showdown that had occurred in 1888.

No sooner had Steichen sent Rodin's drawings to Stieglitz than he wrote with news of yet another extraordinary discovery. "I have another cracker-jack exhibition for you that is going to be as fine as the Rodins are. Drawings by Henri Matisse, the most modern of the moderns—his drawings are the same to him and his painting as Rodin's are to his sculpture. . . . His paintings are to

the figure what the Cézannes are to the landscape. Simply great. Some of Matisse's drawings are more finished than Rodin's, more of a study of form than movement—abstract to the limit."[22]

Steichen hand-delivered Matisse's drawings to New York, and in April 1908 Stieglitz showed them at 291. "What mastery in the spacing!" wrote James Huneker in the *New York Sun*. "Matisse's art sends deep roots into Manet and Cézanne! . . . And yet one can also see everywhere the subtle attractions to the Orient."[23] Another newspaper's critic, J. Edgar Chamberlin, insisted, "This French painter is diabolically knowledgeable."[24] Even Bernard Berenson took up his pen to defend the exhibition against attack: "I am convinced that after twenty years of serious research Matisse has finally reached the highest point of the new masters in the visual arts since at least the sixteen last centuries. He is a superb drawer."[25] And in the *New York Times,* Elizabeth Luther Cary compared Matisse to Degas: "Matisse likes to take on the most difficult problems that exist . . . [He is] one of the masters of form, and in his less experimental attempts, a lover of that same geometry on which classical art is based."[26]

As always, Steichen continued to overflow with potential projects for the gallery. He had gotten to know the work of other Americans living in Paris—Arthur B. Carles, John Marin, Jo Davidson, Alfred Maurer, Patrick Henry Bruce, and Max Weber—all very much influenced by the new aesthetics. With them, he founded the Society of Younger American Painters in Paris in February 1908. In April 1909, 291 offered a double show of Maurer's oil paintings and Marin's watercolors, in which one critic recognized a "creative fever born with Cézanne . . . amplified with Matisse."[27] When they returned home to America, all of these artists naturally found their way to 291.

There were no more doddering Academicians to placate, no more juries to face down, no more insults to endure. Weber came back passionate about the work of Le Douanier Rousseau.[28] Arthur Dove unapologetically expressed his affiliation with Cubism.[29] Charles Sheeler, Marsden Hartley, and Abraham Walkowitz offered their own take on Modernism, colored by Fauvism and Cubism. On the walls of 291, their work hung next to Toulouse-Lautrec and Manet lithographs, Rousseau paintings and drawings, Cézanne watercolors, and Picasso watercolors and drawings, as well as art by unschooled children and Japanese prints—all creating an unexpected mélange. As usual, the gallery and the magazine worked hand in hand. After 291 exhibited Picasso's watercolors and drawings in 1911, *Camera Work* published Gertrude Stein's first writings on the Spanish painter. "A continuous series of triumphs," Stieglitz crowed.[30]

"I was ever really fighting for a new spirit in life, that went much deeper than just a fight for photography," wrote Stieglitz. "I did not know in time that I would be broadening the fight, a fight that involved painters, sculptors, liter-

ary people, musicians."[31] His network, now in place, began connecting the artists associated with Paris—French, American, or otherwise—to a New York audience, French artists in Paris to American artists in Paris, sculpture to photography, photography to watercolors, watercolors to literature, the great masters to the unknown, the younger generations to the older ones. Was it possible that the cloisters of the art world had been penetrated surreptitiously via the route of photography? And could this really be accomplished by means of a single magazine and a small independent gallery? Steichen and Stieglitz had succeeded in evading or ignoring local institutions, in order to install a genuinely free artistic space in New York. And they had triumphed where earlier artists—including American painters—exhausted by endless battles with local Academicians, had failed.

In the Stieglitz circle, Haviland contributed both as a critic and a lawyer; Ernst, as a collector and a critic, and the Mexican caricaturist Marius de Zayas—yet another one attracted by Rodin's drawings—provided both drawings and reviews to *Camera Work*. Everything worked by means of friendship and contacts. Gertrude Stein championed first Picasso, then Cézanne. Sarah Stein championed Matisse. Later de Zayas would bring Francis Picabia into the group. Indeed much of the impact of the Stieglitz enterprise came from his collaborators. Selections of work to be shown were made according to principles of taste rather than considerations of profit—in varied and flexible combinations. As Stieglitz and Steichen were joined first by Haviland, and then by Ernst, Weber, and de Zayas, a duo became a trio, then a quartet, culminating in a sextet, all equally at ease with European and American culture. On the New York end worked Hartmann, Caffin, Haviland, Laurvik, Ernst, and Mabel Dodge. On the Parisian end were, in addition to Steichen, Gertrude Stein, Sarah Stein, and Max Weber, who one by one had joined the effort.

"During these winters in New York, I was able to observe the prodigious amount of work that Stieglitz did," Steichen later recalled. "His patience was almost unbelievable. . . . He stood on the floor of the Galleries from ten o'clock in the morning until six or seven o'clock at night. He was always talking, talking, talking, talking; talking in parables, arguing, explaining. He was a philosopher, a preacher, a teacher, and a father-confessor. There was not anything that was not discussed openly and continuously in the Galleries at 291. If the exhibitions at 291 had been shown at any other gallery, they would never have made an iota of the impact that they did at 291. The difference was Stieglitz."[32]

Nonetheless, voices of protest began to be heard from within. During a trip to Paris in 1910, de Zayas found himself less than impressed with what he saw at the Salon d'Automne. "I looked but I did not see," he explained after his visit.[33] On several occasions, de Zayas interviewed Picasso (whose native lan-

guage he shared) for the new but short-lived magazine *291*. In part because of his contact with Picasso, de Zayas had become one of the best observers of what was going on in Paris. Aware of the new tendencies, he was able to appreciate fully some of the developments to which Stieglitz, perhaps because of his age, background, and education, remained impervious. De Zayas, for instance, would attend the sessions of the Puteaux group, which gathered every Sunday in the Paris suburb of Puteaux at the studio of painter Jacques Villon and his brother Raymond Duchamp-Villon. The latter—a doctor, philosopher, and self-taught sculptor—had extended his work into forms common to both sculpture and architecture, creating a sculptural Cubist façade for the collaborative project Maison Cubiste at the 1912 Salon d'Automne, and his powerful Cubist sculpture *Horse* two years later. Duchamp-Villon believed in "rejecting sentimental and literary sculpture," focusing instead on "line, map, volume, life in its balances, cadences, rhythms."[34] The Puteaux Cubists differed from Braque and Picasso, or the Montmartre Cubists, as they were sometimes called. Deeply influenced by science, their art was steeped in scientific and philosophical themes, such as the *section d'or* (golden section) or the "fourth dimension." It was "scientific Cubism" versus "intuitive Cubism," "dissected Cubism" as against "pure Cubism."[35]

By the end of 1910, these artists started meeting regularly on Sunday afternoons: painters Roger de La Fresnaye, Henri Le Fauconnier, Pierre Dumont, Albert Gleizes, Robert Delaunay, Fernand Léger, František Kupka, Jean Crotti, Jean Metzinger, and Francis Picabia; the sculptor Alexander Archipenko; and the writers Guillaume Apollinaire and Georges Ribemont-Dessaignes. A year later, the group also convened on Mondays at Gleizes's studio, then on Tuesdays at the Closerie des Lilas with Paul Fort's group and the Italian Futurists Gino Severini, Filippo Tommaso Marinetti, and Umberto Boccioni. There were frequent celebratory gatherings, such as a dinner that took place on September 12, 1912, at Balzac's house on rue Raynouard or when Gleizes and Metzinger's journal *Du Cubisme* first appeared. In December 1912, at a dinner held in Cézanne's honor, de La Fresnaye delivered an impassioned eulogy. That October, at the Galerie La Boétie, the Puteaux group held an exhibition under the name La Section d'Or—the largest show of Cubist works before World War I—which featured all the major and minor Cubists except Picasso and Braque.[36]

In August 1911, in a letter to Haviland, Stieglitz had once again revealed his powerful prophetic instincts. "In my opinion, the U.S. is undergoing a silent revolution and the big majority of people have no suspicion of it."[37] Several months later, he learned that a big International Exhibition of Modern Art was being organized under the direction of Arthur B. Davies, and believed that it

"naturally focused the people's attention upon '291.' The work that has been going on for years has suddenly assumed a deeper significance to the people at large than was thought possible a year ago. All this is naturally very gratifying to me when I realize with how little money and little actual help all this has been accomplished. . . . During the big show of Post-Impressionism I shall exhibit my own photographs at '291.' It will be a logical thing for me to do. It will be the first show that I have ever given myself at the little place all these years."[38]

"What is all this talk in the papers about the international exhibition that Davies is heading?" Steichen asked Stieglitz in a letter of December 1912. "Is it going to be good or do you need an antidote at '291'? . . . I am certainly in the dark as far as the so-called 'big' exhibition in NY is concerned everybody is asking me about it from Rodin to the newspaper man; and I don't know a damn; feel like a fool not to be able to say yes or not. The Cubists at the Autumn Salon stirred up a tempest; mind you not Picasso but a bunch of mediocrities—most of them just plain damn fools; the result of it looks as if the government was going to turn the Autumn Salon out of the Grand Palais."[39]

It seems particularly ironic that Steichen, one the pioneers of Modernism in the United States, should know nothing about the event soon to be called the "Armory Show" (it was held in New York's 69th Regiment Armory). After returning home from Europe, exasperated by the local scene, Stieglitz had seen himself as an impatient Tannhäuser, dreaming of an America where he could finally "breathe as a free man."[40] Thanks to Steichen, who remained on the divine mountain, he successfully conveyed some of the spirit of Venusberg to the Wartburg. And with this, the "silent revolution" was set in motion.

Part III

From Notre Dame de Paris to the Brooklyn Bridge

1913–1948

The great bridges being built here are as admirable as the most
illustrious cathedrals. The genius who built the Brooklyn Bridge must
take his place next to the man who built Notre Dame de Paris.

—ALBERT GLEIZES

One

"The Man Who Dies Thus Rich Dies Disgraced"; or, Philanthropists of All Kinds

ON NOVEMBER 5, 1895, the steel magnate Andrew Carnegie inaugurated the Carnegie Institute, the museum he created for the city in Pennsylvania where he had made his astonishing fortune: "Not only our own country, but the civilized world will take note of the fact that our Dear Old Smoky Pittsburgh, no longer content to be celebrated only as one of the chief manufacturing centers, has entered upon the path to higher things, and is before long, as we thoroughly believe, also to be noted for her preeminence in the arts and sciences."[1] Several months later, Carnegie established at the new museum an annual exhibition of contemporary painters, with a jury and awards, modeled after the Paris Salons.[2] He had decided that Pittsburgh would become the "cultural capital of America"—or, in the words of a local journalist, "the radiating center of an artistic atmosphere which will permeate the country."[3] Another local critic extended Carnegie's analogy regarding the Paris salons: in France, he noted, the government had succeeded in civilizing its citizenry through museums and art exhibitions; Carnegie's gallery would strive to do likewise for the people of Pittsburgh.[4]

Andrew Carnegie's bold philanthropic gesture would be the first of many. With an endowment of $28 million, the Carnegie Institute would grow into a veritable cultural complex, comprising a public library in addition to the museum and its annual "salon." And the institute was only one beneficiary of Carnegie's largesse. The lion's share of his charitable gifts—$125 million— would be entrusted to the Carnegie Corporation of New York, which as governing body would see to the disbursement of funds nationally: $60 million to subsidize three thousand libraries across the country; $35 million to the Carnegie Institution in Washington, D.C.; $58 million to the Carnegie Foundation for the Advancement of Teaching; $5 million to the Carnegie Relief

Fund (which would finance seventy libraries in New York); and $5 million to help support universities and student financial aid in Carnegie's native Scotland.[5]

The impact of Carnegie's philanthropy in America was vast: by 1913, two years after its creation, the Carnegie Corporation had spent more on education in the United States than the Federal government. Ten years after Carnegie's death in 1919, thanks to these wise investments, his various philanthropies had distributed a sum equal to their founder's original investment, yet their capital remained intact.[6] Carnegie believed that most of the fortune he had amassed in such a brief time should be redistributed for the betterment of widespread culture, both in the United States—where he had lived since the age of thirteen—and in the country of his birth. "I aspire to enlighten my fellow citizens by the joys of the mind, to the things of the spirit, to all that tends to bring into the lives of the toilers of Pittsburgh sweetness and light," he explained. "I hold this the noblest use of wealth."[7] In fact, he regarded such life-improving philanthropy to be not only the noblest use of riches, but the only just one. In what came to be called the Gospel of Wealth, he elaborated his concept of philanthropy, inspired by Calvinist doctrine. "The day is not far distant," he wrote, "when the man who dies leaving behind millions of available wealth, which was free for him to administer during his life, will pass away, 'unwept, unhonored and unsung,' no matter to what use he leaves the dross which he cannot take with him. Of such as these the public verdict will then be 'The man who dies thus rich dies disgraced.' "[8]

While the United States' great industrialists had initiated their relation to culture through fierce individual competition over the acquisition of art and its attendant social status, as a class, they had come to collaborate in unprecedented largesse, building institutions that would bestow prestige on their cities, on their states, and on their nation. And not all were inspired by Calvinist ethics. What clearer sign that a new aristocracy had been validated, together with the new economy they created: the prestige of giving was supplanting the prestige of possessing. Furnishing their cities with cultural institutions and mounting international exhibitions thus became the industrialists' number-one priority. And for the cities themselves, the stakes were not limited to the gifts of private benefactors: intense competition arose for the favors of the Federal government and in particular the Congressional Finance Committee, which itself was beginning to subsidize cultural ventures, if on a much more modest scale.[9]

Between 1885 and 1916, in the South, then along the entire West Coast, Atlanta, Nashville, Omaha, Buffalo, Saint Louis, Seattle, San Francisco, and San Diego all hosted international exhibitions. Majestic edifices created for this

purpose mirrored the architecture of the classical European monuments down to the last detail. But far from being mere imitations, these structures enjoyed the prestige of always being a bit grander in scale than their models, grander in fact than anything that had come before. Hence, Nashville got its Parthenon; San Francisco, its Palace of the Legion of Honor; and Philadelphia, its Place de la Concorde.[10]

America's tycoons, with all the fervor they had applied a short time before to assembling private art collections to boost their personal stature, now embarked upon a building spree, constructing museums, libraries, theaters, concert halls, and universities to enhance the standing of their communities. Under the combined influence of considerable economic abundance, an accelerated urbanization,[11] enormous waves of immigration (until the 1920s), and internal population shifts, this country, so woefully backward in the domain of culture in 1870, would build a network of cultural institutions unique in the world. The arrival of artistic treasures from Europe and Asia tremendously enriched these new institutions, the popular demand for which would be shaped by emerging liberal principles and sensibilities, particularly among the middle class. In Jefferson's America, the typical son or grandson of colonists worked hard, lived ascetically, and devoted no time or money to art; a century later, his grandson—a member of the new middle class—would heed Henry Ford's rejection of that "parsimony" that, he argued, was the "rule of the half-alive mind."[12] "What can be fine about a pinched existence?" would be a question of the new ethic.

Prestige, power, control, self-preservation, paternalism, narcissism, generosity—a varied constellation of motivations animated the new philanthropists. The country's cultural development was driven by a complex procession formed by ambitions both private and public, of feelings both democratic and elitist. "The wealthier classes must seek out and aid the poor," explained George Templeton Strong, a New York philanthropist. His fellow New Yorker Robert Troup, president of the Society for the Relief of the Destitute, agreed, saying that the rich "cannot live without the necessaries provided for them by the labor of the poor; and consequently that the former in assisting the latter, do but pay a debt which is justly their due."[13] Still, the sums that these wealthy men lavished on their philanthropic campaigns, though enormous, usually accounted for a minute fraction of their total worth. William H. Vanderbilt gave away a mere 0.75 percent; J. P. Morgan, 0.5 percent; and John Jacob Astor, 0.33 percent.[14] John D. Rockefeller had decided at a very young age to devote a relatively impressive 6 percent of his income to philanthropy, and the amount of his donations grew at a dizzying pace, in proportion to the development of his massive fortune. "From the beginning, I was trained to work, to save and to

give," he wrote, evoking his Baptist upbringing.[15] Among these new cultural participants were philanthropists of every stripe: mystics like Andrew Carnegie, autocrats like J. P. Morgan, subversives like Albert Barnes, anarchists like Mabel Dodge, despots like Henry Clay Frick, visionaries like John D. Rockefeller, and seekers of heavenly redemption like Andrew Mellon.

By 1879, John D. Rockefeller's Standard Oil Company controlled 90 percent of the U.S. oil industry, an extreme instance of an increasingly common phenomenon. The staggering concentrations of wealth and the enormous monopolies that defined the age of the "robber barons" provoked a wave of harsh legislative correction. Starting in 1890, with the Sherman Anti-Trust Act, followed, in 1914, by the Clayton Antitrust Act and the establishment of the Federal Trade Commission, Congress set out to combat "unfair methods of competition in interstate commerce and unfair or deceptive acts or practices in commerce,"[16] and more generally the perceived evils of the concentration of economic power in the hands of a few. Even the charitable activities of these titans came under scrutiny, and in 1915 the Walsh Commission was established to monitor philanthropic foundations. The Commission warned: "The domination by men in whose hands the final control of a large part of American industry rests is not limited to their employees but is being rapidly extended to control the education and 'social service' of the nation."[17]

Thus, the riches accumulated in the exploitation of industrial materials or cash crops—iron and steel by Carnegie; oil by John D. Rockefeller; copper mining by Guggenheim; tobacco by James Buchanan Duke; railroad tracks and steel by Morgan; coal and steel by Henry Clay Frick—were in part reinvested for the sake of education, culture, and art. Still, William Wilson Corcoran, John D. Rockefeller, Andrew Mellon, J. P. Morgan, and their colleagues remained the most powerful men in the country. On several occasions, they had personally come to the aid of the United States Treasury. Inevitably, the laws of the land were shaped by and for them, even when it came to philanthropy. An exemption of the import tax on foreign works of art, for instance, was due directly to the efforts of Nelson W. Aldrich, the chairman of the National Monetary Commission from 1908 to 1912. Aldrich's accomplishments, prompted by J. P. Morgan, who wanted to bring home his collection of European masterworks from London, led to the formation of the Federal Reserve Board in 1913. Then, in 1917, with the first law granting tax credits for charitable donations, came a supplementary benefit specifically for gifts of artworks for tax purposes: assessment of a particular work would now be calculated based not on its purchase price but on its market value, a provision that permitted many astute collectors to profit handsomely. Each year, thanks to the new tax code, new treasures would become a privilege shared by the commu-

nity. After Louisine Havemeyer's death in 1931, her children donated nearly her entire collection to the Metropolitan Museum of Art, estimated by some to have been worth roughly $3.5 million at the time.[18]

The philanthropic gestures of this powerful plutocracy had long awakened feelings of ambivalence in the general population. In 1829, when the English chemist James Smithson died and bequeathed $500,000 to the United States to build an institution in Washington, D.C., bearing his name, Congressman Chipman decried his offer as an "insult to the American nation." "The native stock in this country, intellectual and physical, . . . needs no foreign aid."[19] Such donations continually inspired a mixture of admiration and resentment on the part of the American people. Perhaps the most emblematic example occurred a century later, with a gift by Andrew Mellon, the Pittsburgh banker who served as Treasury Secretary from 1921 to 1932, when he was appointed ambassador to Great Britain. At the time, the Soviet government was selling off art treasures formerly owned by the czars and housed in the Hermitage Museum, and Mellon expanded his already formidable art collection by acquiring twenty-one paintings from the Hermitage in 1931 for $3,240,000. When he returned to the United States, he was accused of tax fraud and, with a penalty amounting to $2 million, became embroiled in a lengthy trial.[20]

Several months before his death in 1937, Mellon wrote to President Franklin D. Roosevelt: "Over a period of many years, I have been acquiring important and rare paintings and sculpture with the idea that ultimately they would become the property of the people of the United States and be made available to them in a national art gallery—that shall not bear my name—to be maintained in the City of Washington for the purpose of encouraging and developing a study of the fine arts."[21] Mellon's collection was valued at $19 million, and the neoclassical structure that he intended to house it, designed by architect John Russell Pope, would cost $8 million. Frenzied debate ensued. Representative Wright Patman of Texas adamantly opposed Mellon's offer, which, he felt, would set a "bad" precedent. "If we allow Mellon this privilege, Hearst and Morgan will come in next with an offer just as attractive." In Patman's eyes, Mellon accounted for little more than an "untried criminal," and a "lasting memorial in his name," even erected at his own expense, was out of the question. After Patman came Robert La Follette, the liberal senator from Wisconsin, who reminded his colleagues that Mellon's trial for tax fraud remained unresolved. Senator Tom Connally staunchly disagreed: "Suppose we had before us a bill to appropriate $30 million to buy an art collection comparable to that offered by Mr. Mellon?" he asked. As Connally saw it, permitting Mellon to settle his debts using art rather than money had panache; it also offered the American people an inimitable gift worth twenty times the amount he

owed in taxes. On March 24, 1937, Congress passed a resolution accepting Mellon's offer.[22] The philanthropic dynamic by which the ruling elite extended its hegemony would dominate cultural life, and to a great extent social life, in the United States for years to come.[23]

Tocqueville had observed that "benevolent associations anchored American democracy," solidifying the notion that Americans could live in "small homes," all the while aspiring to "the enormous spaces of public monuments."[24] From this idea followed naturally a conviction that significant private collections would eventually belong to the general community. And very early on, from the time of Charles Willson Peale, the American museum, rather than an elitist movement devoted to preserving the past, served primarily as an institution for public education. George B. Goode, a curator at the Smithsonian Institution and its director from 1885 until his death, believed that in its essence, the museum should be as much a community institution as a public library; Great Britain, where museums were already closely tied to public education, provided his model. In his book *Museums of the Future*, Goode drew in grand strokes his vision of the institution, which would offer "a teaching space designed for the educational welfare of the general public."[25] And he launched his appeal for the creation of a network of public museums that would be "apprenticeship centers" forming the taste of the entire nation. The American Association of Museums, founded in 1906, applied Goode's ideas on a national level.

During the first three and a half decades of the twentieth century, more than 110 museums opened their doors.[26] Among these were the Walters Art Gallery in Baltimore, founded in 1904 by William T. Walters, builder of the Atlantic Coast Line Railroad; the John and Mable Ringling Museum of Art, established in 1929 in Sarasota, Florida, by the king of the American circus, who possessed one of the largest collections of Rubens paintings in the United States; the Frick Collection in New York, with exceptional canvases by Fragonard and others, founded by the steel magnate Henry Clay Frick; and the Henry E. Huntington Library and Art Gallery near Los Angeles, created in 1919–22 by the builder of the Southern Pacific Railroad.

The Toledo Museum of Art, founded in Ohio in 1901, was the brainchild of Edward Drummond Libbey, the country's largest glass manufacturer, who had assembled a brilliant collection of paintings by Rembrandt, Holbein, Turner, Constable, Zurburán, Manet, and others. "Someone will always take care of their physical needs, but who will take care of their aesthetic needs?" Libbey asked one day, regarding his fellow citizens.[27] Generosity, intellectual curiosity, and a genuine love of art—all these drove him to bring together one hundred thirty local businessmen, overseen by a fifteen-member board of

trustees from whose ranks Libbey solicited donations, to further his dream of providing Toledo's 130,000 inhabitants an artistic education designed for the masses. In 1908, Libbey donated $105,000 to develop his art museum, and asked the community to come up with an additional $50,000; the sum was raised in three weeks.

Following Libbey's example, other prominent Toledo businessmen bequeathed their art collections to the community. Arthur J. Secor, vice chairman of the Board of Overseers and the museum's second president, voiced the sentiment that had gripped many: "I watch the procession of people, men, women, and children, passing by my house on Sunday, a never-ending file up the street to the Museum, and I turn around and look at my collection of paintings and feel selfish. I am giving them to the Museum tomorrow."[28] And thus the Toledo Museum of Art's collection blossomed, with donations of works from the Italian Renaissance, paintings by French Impressionists, Chinese art, and Dutch still lifes, reflecting the eclectic tastes of its benefactors. Their efforts did not go unappreciated. In 1903, 14,000 visitors crossed the museum's threshold; by 1926, the number of annual visitors had leaped to 150,000.

For years after opening its doors, New York's Metropolitan Museum of Art remained an empty, cavernous warehouse, and was lambasted by the local press for its acquisition politics and the elitism of its projects. Gradually, however, the museum began to transform itself, thanks, above all, to substantial donations. Jacob Rogers, for example, bequeathed to the museum $5 million. But the man most responsible for the Metropolitan's growing fortune was certainly J. P. Morgan, who became president of the museum in 1904 and remained in the post for a decade. By the time he took over, Morgan remained the most powerful financier of his age. In the 1890s, he had almost single-handedly imposed order among the railroad barons, advising them to share the market; he had brought stability to the country's economy by turning it into an international investment bank; he had laid the foundation for monopolies through railroad tariffs; and in 1901 he had founded the United States Steel Corporation, the world's largest trust. Now turning his attention to the Metropolitan, Morgan applied the same management principles that had served him in private enterprise: long-term planning, with well-defined goals, financial acumen, and close supervision of personnel. He disposed of anything he judged mediocre—second-rate or unworthy works, the plaster casts that were cluttering exhibition space. To simplify hanging, he classified works historically. He called in two well-known experts based in London, Caspar Clarke, whom he appointed director, and Roger Fry, whom he hired as curator of paintings; within a few months, however, unable to tolerate Morgan's autocratic manner,

both resigned. Undaunted, Morgan salvaged the situation, turning his sights to the Boston Museum of Fine Arts and recruiting three of its finest: Edward Robinson, Henry W. Kent, and Albert M. Lythgoe. At a time when no formal system existed for training curators in America, Boston had become an incubator for museum professionals, who would pursue their art-history studies at Harvard, followed by an ad hoc training program in Europe. Before long, the Metropolitan had eclipsed the Boston Museum of Fine Arts. And by 1920, with its shrewd acquisitions, its popular weekend public-education system, and an extraordinary, crowd-pleasing collection of Egyptian art, the Metropolitan would become, in terms of both scale and quality, the greatest museum in the Northern Hemisphere.[29]

In the Philadelphia suburb of Merion, an unconventional man, Albert C. Barnes, joined the wave of American philanthropy, in his own peculiar way. This Philadelphia physician, who had made a fortune producing a pharmaceutical product called Argyrol,[30] developed innovative business methods in running his factory: he shortened the workday to six hours, and he organized employee training sessions in which, reflecting his progressive leanings, his workers read from William James, Bertrand Russell, and John Dewey from a special library at their disposal. Based on those readings, he led debates on contemporary painting, mounted art exhibitions for his staff, and encouraged them to purchase artworks. Above all, Barnes, drawn to the relationship between art and education, strongly believed that art was essential to harmonious individual development. Equally progressive in his political attitudes, Barnes fought throughout his lifetime for the rights of black workers, even making them a priority in his mission: in April 1936, during a speech praising Negro spirituals as representing "the most admirable art that America has produced, because they come from the earth and, like the cathedrals, the greatest artistic achievements of the Middle Ages, they are the fruits of a community guided by religion. . . . Their attraction is universal, and they incarnate the soul of the whole people."[31]

And when Barnes decided to build up his own collection, he turned to his old schoolmate William Glackens, giving him carte blanche to buy contemporary art in Europe. Glackens spent $20,000 in Paris, coming home with works by Renoir, Pissarro, and Monet. Beginning in the autumn of 1912, Barnes himself started going to Paris, where he became friends with Leo Stein, and where, in just a few days, he succeeded in making his presence known among the leading Parisian art dealers (including Ambroise Vollard, Paul Durand-Ruel, and Bernheim-Jeune) and some lesser dealers (such as Elie Druet). He acquired a dozen exceptional canvases by Cézanne, Renoir, and Pissarro, for a total of $30,000. With subsequent voyages, his discernment and savvy about the art

world increased. In 1923, he visited Chaim Soutine's studio in "La Ruche" in Montparnasse, and on the spot purchased more than a hundred works. In 1925, he signed a check payable to Paul Durand-Ruel for one million francs, thus acquiring Cézanne's *Card Players;* it was a spectacular addition to a collection that already included some of that master's finest works.

Barnes later became particularly close to two Parisian dealers: Paul Guillaume, who introduced him to African art, and Etienne Bignou, who helped him purchase a large version of Cézanne's *Bathers* before settling in New York. In addition to his terrific prowess as an art collector, Barnes was also a renowned pedagogue: he established the Barnes Foundation—the stated goal of which was to "promote the education and appreciation of the fine arts" among the general public—organized seminars and exhibitions, wrote articles and books on Matisse, Renoir, and Cézanne, and showed strong commitment to the African-American community by bequeathing his art collection to Lincoln University. With this bequest, he deliberately snubbed the stuffy Philadelphia bourgeoisie, whom he loathed.[32]

America is "undergoing a silent revolution," Alfred Stieglitz wrote to Paul Haviland in 1911, and "the big majority of people have no suspicion of it."[33] Stieglitz was right: a "silent revolution" was indeed under way. Yet within the general population, there was little awareness of the vigor, scope, and diversity of the European avant-garde with which American art would soon reckon. In their letters, in their diaries, expatriate American artists issued increasingly urgent warnings back home about what was happening overseas. "I saw the Matisse exhibition of sculpture and drawings," Andrew Dasburg wrote to a friend in March 1912. "There are several portrait heads and a figure that will haunt New York sculptors for some time to come. They will create nothing less than a sensation. Paintings that are not of the usual brand are quite a thing of the past but such a treat New York has never had of sculpture. There will be many a warning to the younger generation from the old and wise advisors to avoid the land of France for such teachings."[34]

In early 1913, an American woman who had recently returned home after several years in Europe opened a salon in her living room on lower Fifth Avenue, steps away from Washington Square. There, one could encounter such writers as Lincoln Steffens, Hutchins Hapgood, John Reed, Carl Van Vechten, and Edwin Arlington Robinson; union organizer William "Big Bill" Haywood; and artists who could have been spotted a few months earlier in Gertrude Stein's Paris apartment—Arthur B. Carles, John Marin, Max Weber, Marsden Hartley, Alfred Maurer, Abraham Walkowitz, Andrew Dasburg, Arthur Lee, Arthur Dove, Stanton Macdonald-Wright, Patrick Henry Bruce, Elie Nadelman. It was the most European circle to be found in all New York.[35] Apart from

Morgan Russell and Marsden Hartley, who remained in Europe until after the First World War, the majority had come home, and now constituted the front line of American Modernism's avant-garde.

A stout, dark-haired woman, Mabel Dodge favored turbans and other exotic attire. Rich, radical, and worldly, she had just spent eight years in Europe—at the sumptuous Villa Curonia in Florence, and in Paris, where she had met the Steins. Before Dodge left, Gertrude wrote a "word portrait" of her that Stieglitz would publish in the June 1913 issue of *Camera Work*. On her return to the United States, Dodge noted that a "new spirit" had swept over New York. "The barriers have fallen," she announced, "and people who did not know each other got in touch with each other. There were new ways of communicating and new forms of communication."[36] Her salon reunited all who opposed the "cold materialism, standardization, and the mechanization of daily life," which, they felt, dominated the modern world. Emma Goldman herself sometimes turned up and, exasperated by the interminable discussion, would rise, condemning "social workers, philanthropists, and dilettante philosophers" for "delaying everything."[37]

A frequent visitor to her salon, John Sloan, had met Mabel Dodge in the offices of a leftist magazine called *The Masses,* before throwing himself into Democratic Party politics. Together with Haywood, Reed, and several others, they organized a politico-artistic demonstration, the Madison Square Garden Pageant, on behalf of a group of textile workers in a New Jersey silk factory who had been on strike for several weeks. "There seems a vague but real relationship between all the real workers of our day," asserted Mabel Dodge. In January 1913, in the *New York Globe*, Hutchins Hapgood commented, "Whether in literature, plastic art, the labor movement . . . we find an instinct to blow up the old forms and traditions, to dynamite the baked and hardened earth so that fresh flowers can grow."[38]

With the help of Sloan and others, Dodge hoped to cultivate a kind of "laboratory of the new world," uniting "anarchists, unionists, poets, artists, journalists, lawyers, suffragettes, killers, psychoanalysts"—anyone wishing to participate in this "great revolution of the spirit."[39] Combining a Communist sensibility with American wealth, Dodge succeeded in introducing a European-style salon in the heart of Greenwich Village. No sooner had she arrived in New York than she became aware of the planning of a huge international art exhibition and became consumed by the idea. "It became, overnight, my own little Revolution," she wrote. "I was going to dynamite New York and nothing would stop me. Well, nothing did."[40]

Two

"A Chilly Wind from the East
Had Blown on Our Artists"

T HE IDEA of an international art show had emerged in December 1911 in a discussion among four men at the recently opened Madison Gallery, run by Clara Davidge, who had only recently penetrated the growing New York art scene. On December 14, after more such discussions, they formed the Association of American Painters and Sculptors, the quintessential artists' society, the successor in a long line of such organizations established to help artists gain a foothold in the United States. Its founders—Walt Kuhn, Jerome Myers, Elmer MacRae, and Henry Fitch Taylor—belonged to a generation of young artists who had not yet achieved great recognition, who did not identify themselves with political issues, as did The Eight, nor were they drawn to what they perceived as the rigidity of the American Academicians in the official art institutions. Instead, feeling "neglected by the official channels," they sought a third way to gain "more dynamic exposure."[1]

No sooner had the Association's platform been announced on January 3, 1912, and reported in the New York dailies, than its members began to quarrel. Barely one month following their election as the group's president and vice president, respectively, J. Alden Weir and the sculptor Gutzon Borglum tendered their resignations and issued a public statement. Weir confessed disappointment after discovering in the press that the Association's members were "openly at war with the Academy of Design,"[2] an organization to which he remained quite devoted. Borglum strongly defended the Academy and denounced the other Association members for "the utter disregard of the common agreement, the arbitrary abuse and misuse of the public confidence," a situation that led him to "repudiate the three or four men who pretend to be the association. The association was formed to help American artists and advance them in their professions. . . . Instead, the American artist has been ignored. He hasn't been given a square deal."[3]

First among the tyrannical "pretenders" Borglum was referring to was Arthur B. Davies, who for several years had been a member of The Eight— mysteriously, since, as a disciple of Odilon Redon, Davies painted Symbolist dreamscapes populated by imaginary creatures, works that were quite out of step with the Realist aesthetic of Sloan, Henri, and The Eight's other members. Following Weir's resignation, Davies was elected to take his place. "How remarkable that a silent, poetic type like Davies turned out to be a dictator at heart," Sloan would later remark with amusement.[4]

The second man implicated by Borglum, Walt Kuhn, was an embittered, mediocre painter who hid neither his strong feelings of nationalism nor his unabashed xenophobia. "The Italians are a mean set of robbers," he wrote in a letter in 1902. "Even the finest countries in Europe doesn't [*sic*] compare with the grandness of our great America."[5] Nor was Kuhn fond of Jews, a sentiment reflected in his description of Jo Davidson, a sculptor in Gertrude Stein's circle: "Regular cringing Jew with an attitude of superior mentality . . . one of those fellows who speaks of 'force,' 'bigness,' and the usual bluff and besides that really he is a bonehead, simply another of the 'naïve,' get-rich-quick matis-settes. I can't bear him."[6]

Kuhn's correspondence during the formation of the Association reveals the rancor and frustration of thwarted professional ambitions. In September 1911, he confided in his wife that "the art atmosphere here is awful, that's my biggest enemy." Two months later, during a group show at the Madison Gallery that included some of his works, he reported more optimistically that he had "the feeling that things are 'on the way' at last. [Fuhr] is sure raving jealous of me and is not clever enough to hide it." But it was not long before Kuhn saw "nothing new at the gallery, very slim attendance. . . . I suppose you're disappointed that H[uneker]'s article [in the *New York Times*] has not come out yet." Several days after that, despair: "Don't worry about my being downcast. I'm naturally demoralized by all the recent happenings. It will take a month to fully realize about where we stand."[7]

It was in the dismal context of his failing career that Kuhn took up the reins of the Association and started to organize its international show together with Davies. Barely a year later, writing from Paris and energized by the exhibition he was helping to mount, he seems to have metamorphosed. "This trip has made me over as an artist. Davies and I work like two well-oiled cogs . . . it's a wonderful thing to see the absolute confidence he puts in me. Today he gave me another thousand dollars to put in the bank. . . . Our show is going to be fully as good as the one in Cologne. . . . Instead of being depressed by seeing so much great stuff, I feel great, and have mental material to last several years. . . . Davies agrees with me that America is the new soil and the game is most inter-

esting at home. Paris is a hothouse where they raise beautiful orchids and other wondrous plants but the rugged old pine grows best in arid climes. . . . The whole bunch of fakers which predominate at home have faded off. . . . This show is going to set things right and they'll all stand out in their true value. . . . This is the first time I have had [to write] since the arrival of Davies. We have practically lived in taxis; we have had absolute success in every direction. . . . Our first statement should appear in Thursday's papers. . . . Press, interviews. . . . Our list of European stuff stupefies everybody. . . . I am in heaven. . . . This show will be the greatest modern show ever given on earth, as far as regards high standard of merit. . . . Davies and I will be the only two men known as authorities in America on modern art, once the show is over. . . . No such thing as this show has ever happened to America before."[8]

If Kuhn had a nose for public relations, Davies proved to be an extremely capable fund-raiser. Within weeks, Davies managed to collect four thousand dollars from his New York friends, roughly half of the show's eventual cost. He also recruited Walter Pach, one of the most refined Americans living in Paris. Erudite, distinguished, and likable, Pach wrote articles, translated, painted, and spoke French, German, and Italian. He had lived in Europe since 1903, and knew most of the modern artists, gallerists, and collectors in Paris. A former student of Robert Henri, he formed, along with Alfred Maurer and Jo Davidson, the old guard of Americans in Paris, benefiting along with them from direct access to the greatest painters of the day. One of his teachers called him "facile with thought and pen, and unusually intelligent."[9] In 1908, Pach published a noted article on Cézanne's work in the United States, and his personal relationship with Matisse was so close that the artist once sent him a drawing he had done in Tangier, accompanied by a note that read in part, "I wish you good luck and want to thank you for your interest in the success of my work."[10]

The fourth figure in this rather unlikely group was John Quinn, a lawyer and art collector of Irish origin on close terms with the New York art critics, some of whom had come from Dublin. He undertook the delicate task of lobbying for reformulation of the taxes levied on foreign artwork imported into the United States.[11] Assuming the role of counsel to the Association, he traveled to Washington, D.C., in 1915. "There is probably not a single American artist of any consequence who approves of the present duties on foreign works of art," he argued.[12] In the end, Quinn emerged victorious, and Kuhn and Davies imported five hundred works of art from overseas, for a total valuation of $200,000.[13]

Pach had followed the wave of grand Post-Impressionist exhibitions in Munich, Cologne, and London—such as the show organized at the Grafton

Gallery by Roger Fry, an elaborate panorama of contemporary French art. This would prove to be of tremendous help for a "home artist" like Kuhn, who lacked this kind of background. Kuhn arrived in Cologne on September 30, 1912, in time to see the end of the international *Kunstausstellung des Sonderbundes Westdeutscher Kunstfreunde und Künstler,* which would serve as the model for the Association's show in New York. From Cologne, he went to the Artz et DeBois Gallery in The Hague, looking for works by Odilon Redon and van Gogh; then to Munich, where he visited the Henrich Thannhäuser Gallery; and to Berlin, and the Hans Goltz Gallery. In early November, Davies caught up with Kuhn and Pach in Paris. The three paid a visit to Brancusi's studio—"That's the kind of man I'm giving the show for," declared Kuhn[14]— and met Picasso, Braque, the Duchamp brothers, and the Steins. They stopped at the Ambroise Vollard Gallery to view works by Cézanne and Gauguin, as well as at the galleries of Elie Druet, Bernheim-Jeune, Henry Kahnweiler, and Durand-Ruel. As their last stop, Kuhn and Davies traveled to London to meet with Roger Fry[15] and to borrow from him a few of the Matisse canvases that were at the Grafton Galleries. On November 21, 1912, after three weeks together in Europe, which Kuhn described as "an orgy of artworks," they returned to New York. The selection was complete.

If avant-garde European art had merely been trickling into a thirsty American culture, Kuhn and Davies burst open the floodgates by hiring Pach and tapping his European network, soliciting loans from local patrons, and alerting New York critics. Thus the International Exhibition of Modern Art, historically known as the Armory Show, emerged from the quirky machinations of an odd group of characters. Everyone in New York sensed that the show would have major impact. Stieglitz and Steichen had predicted it. "There is a growing sense of expectancy about the 'Armory' exhibition," Robert Henri wrote to Walter Pach, "and there is little doubt but that it will make a great stir—and do a great deal of good in a great variety of directions."[16] In a discourse to his students at the Y.W.C.A., the painter Walter Mowbray-Clarke spoke of the event as if referring to a second American Revolution, with the French presenting Matisse as a new Lafayette. The city of New York needed to display, he declared, "really vital art," and could achieve it thanks to foreign help, most notably from France, where "freedom of expression was rampant." It was his wish, he told his students, that "some of their most vigorous minds should come over and help us through their artwork. France has not failed us in our political revolution. Perhaps she would lend a willing hand once more and force home the claims of the particular individual to an unbiased hearing in art matters. . . . Works born of bitter happy years of striving and love and you will

see them soon. Look at them carefully and try to get the message. Let them stimulate you to the same spirit of research."[17]

Others, such as Borglum, concentrated on self-criticism: "What's the matter with American art today? We're timid: Americans haven't any aesthetic courage. . . . But if we bring together a great exposition in which many forms and expressions are recognized, that will bring courage to public collectors and artists alike." "After all," Borglum added, "freedom of thought, freedom of conscience, and freedom of speech must be preserved and safeguarded at any cost."[18] In one of his many public declarations, Arthur B. Davies reiterated the "international character" of the show, which would, he said, bring to New York the "revolutionary character of the artistic activity of today."[19] Some believed that the show, with its imminent arrival of five hundred works by Europeans, would produce adverse effects on the American art scene; on the contrary, the American public would finally have a chance to admire works by these new painters, whom the American academicians referred to as "freaks." "Among the 'freaks' [were] Matisse, who portrays impressions made by objects on his mind rather than on his eye."[20]

Critics in the major newspapers repeatedly invoked all the "-isms" rampant at the time—Cubism, Fauvism, Impressionism, Post-Impressionism, Pointillism, Futurism—and underscored the inferiority complex of American painters as well as the condescension with which the French were using the expression "ripe for America." "But our past is not our present," a more hopeful critic for the *New York Times* wrote.[21] In the *New York American,* Alfred Stieglitz telegraphed a feverish call-to-arms, urging the public to attend the show that would "revitalize art." "The dry bones of a dead art are rattling as they never rattled before. The hopeful bearers of a new art that is intensely alive are doing it. . . . This glorious affair is coming off. . . . Don't miss it." He also counseled against succumbing to the pigeonholing tendencies of the critics: "A word of warning: don't adopt that enemy's impudent device of plastering these emancipated artists with labels. It's dangerous. They detest labels. There's a result—the picture. Take it or leave it."[22]

As they could find no other location in New York sufficiently vast to accommodate a show of such magnitude, Kuhn and Davies approached Colonel Conley, then in charge of the barracks of the 69th National Guard Regiment, located at Lexington Avenue and Twenty-fifth Street. They came to an agreement; the barracks would be rented for five thousand dollars. An overturned, uprooted pine tree, a symbol of a revolt against convention, became the exhibition's official emblem.

The Armory Show opened its doors on February 17, 1913. Approximately

thirteen hundred works, a third of them of European provenance, were on display: paintings by Cézanne, Picasso, Derain, Braque, Gauguin, Redon, Kandinsky, Puvis de Chavannes, Rodin, van Gogh, Henri Rousseau, Rouault, Munch, Duchamp, Picabia, Lehmbruck, Seurat, and Brancusi, as well as works by such old masters as Delacroix and Ingres. Kuhn's resentment, haste, and plain logistics had marked the exhibition's preparation. Little wonder, then, that to the general public, the choice of artworks seemed like an "unreadable chaos," a "discord of strange sounds."[23] The organizers had been intent on showing the connection between wildly different aesthetic movements, and wanted all of modern art's voices to be heard simultaneously—Fauvist, Cubist, Pointillist, Symbolist, Expressionist—but disregarded any method of organization, or a more specific didactic intention.[24]

John Quinn gave the opening address. "The members of this association," he declared to an audience of four thousand invited guests, "have shown you that American artists—young American artists, that is—do not dread, and have no need to dread, the ideas or the culture of Europe. They believe that in the domain of art only the best should rule. . . . This association has had no official, municipal, academic or other public backing. . . . The members have had no axes to grind, no revenges to take. They have been guided by one standard—merit—and they have had the courage of their convictions."[25]

Since the Armory Show occurred during a time of intense debate in American society—a period when calls for a return to conservative values remained ubiquitous—the academicians lost no time in offering up their reactions. "I had the wholly unfashionable idea that portraits should represent their models, seascapes the sea, and landscapes nature," wrote Julian Street, for whom Marcel Duchamp's *Nude Descending a Staircase,* one of the pivotal works on display, represented "an explosion in a tile factory."[26] Others termed Matisse's work "indecent" and "epileptic." The room displaying Cubist works was christened the "Chamber of Horrors."[27] J. Alden Weir, now an elderly gentleman on the verge of assuming the presidency of the National Academy of Design (in 1915), amiably explained that "these French fellows had been doing clever work for years, painting their pretty model over and over again, smoothly. . . . Finally they went to the other extreme." In truth, he felt no passion for "Matisse and his confederates," because he did not find in their work "the sincerity of the early workers."[28] On March 15, the *New York Times* critic Kenyon Cox took up his pen, deploring an event he characterized as "not funny, it is troubling and demoralizing. . . . Cubists and Futurists [*sic*] are making insanity pay."[29]

The rebuttal to this barrage would soon be delivered; the proponents of modernity prepared to take their turn. One critic for the *New York Sun* spoke

of the Armory Show as a "miracle" and a "major event." Others celebrated the end of constraint and convention. And the debate over the direction of American painting grew louder than ever. William J. Glackens, formerly of The Eight and president of the exhibition's American section, bluntly assessed the show's implications: "Everything worthwhile in our art is due to the influence of French art. We have not yet arrived at a national art. The old idea that American art, that a national art, is to become a fact by the reproduction of local subjects, though a few still cling to it, has long since been put into the discard. . . . I am afraid that the American section of this exhibition will seem very tame beside the foreign section. But there is promise of a renaissance in American art, the sign of it everywhere. This show coming at the psychological moment [*sic*] is going to do us an enormous amount of good. . . . It may be that the country, going through the process of building, has not had time for art. It may be that the money-god has been a preponderant influence. . . . It may be that our most energetic men have not had time for art, but inoculate the energy shown elsewhere into our art and I should not be surprised if we led the world."[30]

By the end of the first week, visitors, scandalized but curious, poured into the Armory Show. Increasingly they warmed to the artwork on display. When the show closed its doors, even the disapproving *New York Times* had to concede "Cubists Migrate: Thousands Mourn." "I applaud the incredible success of the show with all my heart," Brancusi wrote to Pach, "and I am happy that the fine arts are beginning to find their place. The credit for having raised them so magnificently goes to you others."[31]

American artists emerged from the Armory Show dispirited and overwhelmed. All that was talked about were European artists and European art. Alongside works by Matisse, Picasso, Duchamp, Picabia, Brancusi, and van Gogh, paintings by Bellows, Frazier, Weir, or Henri paled. The most progressive American painters, such as Weber, Dove, Macdonald-Wright, and Demuth, were not even exhibited. For them, Will Hutchins explained, it was, "depending on your point of view, a meeting with the demon of revolt or with the angel of the resurrection."[32] However, although all of them had works in the exhibition, the members of The Eight would not give ground. Robert Henri toured the show, and, profoundly moved, approached Davies and Pach. "I trust," he said to Pach, "that for every French picture that is sold, you sell an American one." His former student had the presence of mind to reply, "That would not be proportional to their respective merits."[33] Of the 174 paintings sold, a crushing majority came from overseas—a trauma with shades of the Exposition Universelle of 1876.

Commonly considered a pivotal moment in the development of American

modern art, this massive exhibition proved, for many American painters, an unmitigated disaster. Jerome Myers, for one, believed that blame should fall squarely on the shoulders of Davies, who in Myers's eyes had proved himself little else than a traitor. "Thus it was I, an American art patriot, who painted ash cans and the little people around them, took part in inducing to become the head of our association the one artist in America who had little to do with his contemporaries, who had vast influence with the wealthiest women, who painted unicorns and maidens under moonlight. What I did not know was Davies's intense desire to show the modern art of Europe in America. . . . Here was young America innocently advocating a French propaganda."[34]

Andrew Dasburg, who exhibited a plaster sculpture and three paintings at the Armory Show, also resented the exhibition's seemingly anti-American preconceptions: "The members of the Association," he said, "seemed to be prejudiced against anything that smacks of American post-impressionism and seem to have started a campaign of elimination which began by scattering our work all over the place instead of showing it as a group—but this may have been done without any intention behind it. Yet Kuhn said that he thought that some of these men thought themselves 'too important and that they were going to show them they were not.' After a prejudiced statement like that, by one of the officials, one might be forgiven for questioning some of their unexplainable moves. It seems to me that if they were going to let me send one of my things, they might have asked me if I cared. . . . I can understand why Borglum got so sore at them."[35]

The organizers of the Armory Show had chosen to juxtapose the American and European art of the time. The question was whether or not this juxtaposition was truly obligatory—and whether or not it should have been staged, in the heart of Manhattan, under circumstances so utterly merciless to the American artists. The Armory Show's setting ultimately revealed the American artist's preoccupation at the time with economic and social status rather than aesthetic value. Walt Kuhn, a painter struggling in his own country, had used Walter Pach, an expatriate painter, to gain access to the enormous variety of Post-Impressionist works in Europe, which he then assimilated in a manner superficial at best. Given the results, it was ironic to say the least that he himself had said of his quick trips to Europe—where, acting like an impresario of rubbish, he had first seen these works—that they had "made [him] over as an artist."[36]

Looking back, art historian Meyer Schapiro wrote that the Armory Show "marks a point of acceleration" in the spread of Modernism in the United States, and it also offered to the public "a lesson of internationalism. . . . Since the awareness of modernity as the advancing historical present was forced

upon the spectator by the art of Spaniards, Frenchmen, Russians, Germans, Englishmen, and Americans, of whom many were working in Paris, away from their native lands, this concept of time was universalized; the moment belonged to the whole world; Europe and America were now united in a common cultural destiny, and people here were experiencing the same modern art that surmounted local traditions."[37] But while the Armory Show did point the way toward the future, introducing America to the new international aesthetic, American artists would for years deplore its effects. "The Armory Show," wrote Jerome Myers, "had left our critics in a daze. The weathervane had turned and a chilly wind from the East had blown on our artists. Reputations began to tumble, incomes to dwindle. Galleries began to bloom with foreign flowers. The era of modern [sic] had set in. . . . While the French dealers had the world as their market, here in New York we had only what the French left over for us; but at last we could join in the negro's hymn, that we were 'All God's Chillun'."[38] For some of these, buffeted by this "chilly wind from the East," such as Henri, safe harbor would be in the American West. They would anchor their art in the territories of Native Americans. It would be some time before the effects of the Armory Show on the creation of a specifically American art became tangible. For nearly three decades, American artists would wander through a wilderness of confusion and division, in which two vigorous currents of American painters flowed side by side: the Realists, innocent of the slightest trace of overseas influence, and the Modernists, fiercely molded by European models.

Three

"Santa Fe as a Hope"

"How curious," John Sloan confided to his wife, "that a once-eminent figure like Robert Henri could so quickly lose his standing among his peers and his authority. . . . Overnight he became a conservative."[1] Indeed, following the cataclysm of the Armory Show and the full-scale arrival of European Modernism in New York, the Realist painters saw themselves as definitively ousted. Some of them abandoned the decidedly hostile New York scene and, aiming to preserve their individual integrity and that of their work, to protect their identity as American painters, they headed west to Taos and Santa Fe, a region that artists before them had already explored over the previous decades.

In 1835, landscapist Thomas Cole had described his unexpected fascination with the West. "I am an American discovering America," he wrote. "I like the position and I like the results. . . . A sturdier kind of realism, a something that shall approach the solidity of the landscape itself and for the American the reality of his own America as Landscape."[2] In 1866, Worthington Whittredge, accompanying Major General Alfred Atmore Pope on an inspection tour of the Western Territories, including Colorado and New Mexico, realized the uniqueness of the Western landscape. "We are looking and hoping for something distinctive in the Art of our country, something which shall receive a new tinge from our peculiar form of Government; from our position on the globe; or something peculiar to our people, to distinguish it from the art of other nations."[3] In 1885, Birge Harrison, a veteran of Pont-Aven, recognizing the beauty of the region, exulted: "Everything here is flashing, scintillating, iridescent with color. Each adobe, each stray figure frames itself into a brilliant little genre painting."[4] New Mexico would come to represent for generations of American artists, encouraged by a highly supportive local population, a free republic for painters, a refuge from the vagaries of the metropolitan culture, smack in the middle of the United States.

Paris, 1895: At the Académie Julian, Joseph Henry Sharp had described the "pictoral possibilities afforded by the Indians in Taos," urging his fellow art stu-

dents to go see for themselves. Ernest Blumenschein, a painter from Dayton, Ohio, who had also trained as a violinist, and Bert Phillips, from New York State, were intrigued by the idea of Taos and followed Sharp's advice. Three years later, a broken wheel on their horse-drawn wagon caused them to stay in Taos for a time. (Blumenschein remained for several months before returning to illustration assignments in New York; Phillips fell in love and remained there for the rest of his life.) "No artist had ever recorded the New Mexico I was now seeing," Blumenschein remembered. "I was receiving, under rather painful circumstances, the first unforgettable inspiration of my life. . . . I realized that I was getting my own impressions from nature, seeing it for the first time with my own eyes, uninfluenced by the art of any man."[5]

Blumenschein and Phillips then learned about the city's tragic cultural history. Native Americans had lived in the area since the twelfth century—the Tiwa tribe founded the pueblo around 1480—before their life was disrupted by the arrival of Spanish settlers in 1542. Relations between the two groups grew increasingly volatile, culminating in a violent revolt in 1680. When New Mexico achieved statehood in 1912, 98 percent of its inhabitants were Mexican and Native American, with the city of Taos home to no more than fifty individuals of European origin, or "Anglos," as they were called.

The two painters reveled in the region's dramatic beauty: the little village of two hundred inhabitants with its red-mud walls; the mesas rising up 7,000 feet above sea level; the three mountain ranges—the Sangre de Cristo, the Picuris Range, and the Nacimiento—towering over the Rio Grande, which had split into a gorge across the valley. "[N]ever shall I forget my first powerful impressions," Blumenschein wrote in 1926. "The great naked anatomy of a majestic landscape once tortured, now calm; the fitness of adobe houses to the tawny surroundings, the vastness and overwhelming beauty of the skies; terrible drama of stormed peace of night, all in beauty of color, vigorous form, ever-changing light."[6] And in a letter to a friend, he exclaimed, "I am wildly enthusiastic over my surroundings. I live in a little adobe town built up by a tiny stream which cuts through the desert and looses itself in the painted canyon of the Rio Grande. Everything about me is inspiring me to work. . . . Being a good ballplayer, I was enabled to get close to the young Sioux. . . . I found them better disciplined than the average white boy."[7] Life in Taos remained undisturbed by modern technology: no electricity, no running water, with the first phone line only recently installed at Taos Junction some thirty miles west of the Pueblo; and Spanish continued as the only language spoken. Blumenschein quickly grew enthralled with what D. H. Lawrence would later call the "peculiar 'otherness' of Taos."[8]

As the first American painters to settle in Taos as an art colony, Blumen-

schein and Phillips, soon joined by Sharp, Eanger Irving Couse, W. Herbert Dunton, and Oscar Berninghaus—the future founders of the Taos Society of Artists—all came to feel "like the group of Barbizon painters and writers,"[9] as Phillips had put it in September 1899. Phillips, fascinated by the Pueblo Indians in particular, instantly decided to devote his life to painting them. The M. O'Brien & Son Gallery in Chicago soon provided him with the necessary support to do so, agreeing to "take two 'Indian heads' (portraits) each month, as well as anything he could paint" for a whole year,[10] thus marking the very first documented patronage of a Taos artist. A later arrival, Walter Ufer, a gun engraver's son, had left his native Kentucky for Munich, Dresden, Paris, Rome, and North Africa. Upon his return to the United States, he settled in Chicago, where the city's former mayor, Carter H. Harrison, subsidized his first journey to New Mexico. Indiana-born Victor Higgins, the most experimental of the Taos Society of Artists group, had spent four years at the Académie de la Grande-Chaumière in Paris, then moved to Munich and, after that, Chicago. Unlike the other members of the Taos group, he had never tried his hand at illustration before becoming a painter. "The West is composite, and it fascinates me," Higgins wrote. "In the West are forests as luxurious as the F[ôret] de Fontainebleau, desert lands as alluring as the Sahara and mountains most mysterious. An architecture as homogenous as the structures of Palestine and the northern coast of Africa and people as old as the people of history, with customs and costumes as ancient as their traditions. . . . Nearly all that the world has, the West has in nature, fused in its own eternal self."[11]

In 1899, St. Louis artist Oscar Berninghaus, having been commissioned to paint the landscape of the "Chili Line" running along the Denver and Rio Grande Western Railroad, found himself "infected with the Taos germ," and decided to spend a few months in Taos regularly each year.[12] Born in Saginaw, Michigan, to a family of carpenters and cabinet-makers, Eanger Irving Couse had, like the others, understood that he could never succeed in any artistic career without the French experience, and spent ten years in France, five in Paris, painting in Bouguereau's studio at the Académie Julian, before a stint at the artists' colony at Etaples. He found favor in the Paris salons. "He paints easily and touches the popular picture buying taste," his friend Robert Henri wrote at the time.[13] In fact, in capturing the sensibility of local peasant life, Couse showed an amazing knack for the French genre painting of the time— so much so that, after the 1889 Exposition Universelle, the American critic William Armstrong complained that American painters had lost all sense of national identity, asserting that "not only [are] French ideas dominant," but that the best things painted in Paris by his fellow citizens were, "for all critical purpose, French pictures."[14] Couse's shift toward American themes, and espe-

cially Native American ones, started as early as 1891, when he considered the works he would submit to the 1893 Columbian Exposition in Chicago. "I want it to be strictly American, and perhaps of Indians,"[15] he stated. In this respect, *The Captive,* which he initially exhibited in the 1892 Paris Salon (held by the Société des Artistes Français), represents his very first attempt to show Native Americans in a guise that challenged their stereotypical image as aggressors. He chose to depict a moment of serenity in the aftermath of the 1847 Whitman Massacre, with Cayuse chief Five Crows peacefully looking down at young Lorinda Bewley, after her kidnapping by the Cayuse tribe. Ten years later, after visiting Taos for the first time, Couse decided to move there permanently and devote his life to painting the customs and legends of the Native American Indians.

Things would take longer for Blumenschein: in the ten years after the "broken wheel" episode, he shuttled between New York and Paris, eventually spending every summer in Taos from 1910 on before settling there decisively in 1919. Throughout, though, he doubted his abilities as a fine-art painter, fearing that without adequate European training, his career would never progress beyond that of an illustrator. However, he knew all too well that an American art could only develop in a place like Taos. In 1900, while still in Paris, he wrote to his friend Butler: "Am working in school and happy with my painting, and study of the grand pictures in the Louvre. I hope I'll not have to return to illustration, and will make an effort to borrow money if necessary, in order to get to Taos where living is cheap and inspiration in every hand [*sic*]. If I can only keep up my painting and study (which is possible in Taos) I may eventually do something in the picture line. . . . You must go to Taos with me old man."[16]

In 1900, William Haskell Simpson, the advertising agent for the Atchison, Topeka & Santa Fe Railway Company, decided to use art as the centerpiece for his national campaign promoting the romance of the "Santa Fe Southwest." In the following years, he worked closely with the Taos artists and actively participated in their creative process, advising them first to sketch, then to paint the most appropriate subjects.[17] In time, Simpson amassed a corporate art collection of more than six hundred paintings, and created the famous *Santa Fe Railway Calendar,* annually distributing three hundred thousand of them to schools, homes, and offices throughout the country. With his help, such paintings as Couse's *Moki's Snake Dance—A Prayer for Rain,* 1904, and *Pueblo Indians' Eagle Dance,* 1922, Ufer's *Taos Girls,* 1916, Higgins's *Tales of Ancient Taos,* 1917, and Blumenschein's *Evening at Pueblo of Taos,* 1919, would come to represent unknown territories and Native American customs in numerous American households—just as paintings by the Hudson River School artists had helped Americans discover the marvels of exotic and primitive landscapes four

decades earlier, albeit by less aggressively commercial means. Couse had already granted the American Colortype Company "exclusive rights to reproduce his paintings for the next five years" in the American Colortype Calendar.[18] As the vision of Taos and Santa Fe soon spread across the country, it beckoned to more and more artists. In 1908, popular journalist Charles F. Lummis wrote: "Any man who is really an artist will find the Southwest . . . a region where the ingenuity, the imagination, and the love of God . . . are visible at every turn. . . . It is high time for the artists to come upon the Southwest."[19]

On July 19, 1915, Blumenschein, Phillips, Berninghaus, Sharp, Couse, and Dunton founded the Taos Society of Artists. Immediately afterward, they organized their first exhibition at the magnificent Palace of the Governors in Santa Fe. "Out of the West will come a distinctive phase of our national art," announced Edgar L. Hewett, the local archaeology school director, in his welcoming speech.[20] Blumenschein declared some years later: "With our European education, our own natural talents, and the great benefit our overculturation received from the healthy vigor of the Indian's art—his pottery, blankets, jewelry, music, superb dances—there is no doubt that this art group and the equally famous one of Santa Fe, will be serious and honorable factors in the development of New Mexico."[21] The discovery of their country's natural beauty and especially the revelation of Native American culture, long rooted in craftsmanship and deeply respectful of artists—a culture that offered numerous inexpensive, picturesque models—had been crucial in the artists' decision to settle in New Mexico. But these elements were not enough to give rise to a full-fledged artists' colony or a strong local market for the work produced. It was left to a handful of industrialists to make the difference. Exploiting the region's business opportunities, they began to channel their business initiatives westward, establishing along the way a patronage system for the Taos and Santa Fe painters.

Alternative venues first opened up for the Taos Society of Artists when the painters decided to organize traveling exhibitions around the country. In 1917, their show visited New York, Boston, Chicago, St. Louis, Des Moines, Denver, Santa Fe, Los Angeles, Pasadena, and Salt Lake City. "It would be difficult to find a person in the whole country making any pretension to being posted in art matters who has not heard of Taos and the 'Taos Artists,'"[22] wrote Bert Phillips. Their fame grew steadily as they showed their works in juried exhibitions, in which some of them received important awards. In 1916, Ufer won the Martin B. Cahn Prize at the Art Institute of Chicago for *Solemn Pledge—Taos Indians;* in 1921, he won the First Altman Prize at the National Academy of Design for *Hunger,* then the third prize at the Carnegie International in Pittsburgh, as well as another at the Venice Biennale. By the late 1920s, Ufer was

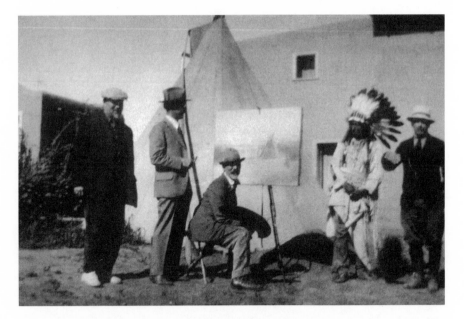

In Taos, New Mexico, in front of Joseph Sharp's studio, decorated with a tepee, are some of the founders of the Taos colony, standing around Soaring Eagle, the Indian model. From left to right: Bert Phillips, Sharp, Ernest Blumenschein, Eanger Irving Couse

making nearly fifty thousand dollars annually, more than John Singer Sargent had ever earned in a year. In 1925, Martin Hennings was awarded the Walter Lippincott Prize at the Pennsylvania Academy of the Fine Arts for *Announcements;* and in 1929, Blumenschein won the Henry Ward Ranger Prize from the National Academy of Design for *The Burro*. Later, however, as Modernism became popular with American exhibition juries, the more conservative Taos artists had to turn to commercial galleries and private patrons for support.

In the meantime, midwestern cities such as Cincinnati, Saint Louis, and Chicago were also acting as patrons, commissioning or buying for their local museums. As early as 1894, the Cincinnati Art Museum had purchased *Harvest Dance* by Joseph H. Sharp. Later, Joseph H. Gest, the institution's director, supported Sharp's career even more directly, providing him with painting materials and numerous commissions. In Saint Louis, the Anheuser-Busch Brewing Company commissioned a number of posters and brochures from Berninghaus for its advertising campaigns, and helped the Saint Louis Art Museum acquire many of his paintings. In Chicago, the mayor himself, Carter Harrison, formed a coalition, asking local bankers and industrialists for help promoting art citywide by selecting and purchasing works to be exhibited in public spaces. In 1914, he created the Commission for the Encouragement of

Local Art, from which Ufer benefited before their relationship soured (due to the patron's imperiousness and the artist's wounded pride), whereas for Higgins the city's coalition remained a steady benefactor for years.

Surprisingly, the Taos artists also received support from other states. In 1917, after the Missouri State Capitol building in Jefferson City had been completed, a Decoration Committee was established to select art for the Capitol dome. Dr. John Pickard, an art history professor at the University of Missouri who was named president of the committee, visited several state capitols and reported being "tired of looking at ceilings filled with female figures in floating draperies where one has to read a plaque on the wall to learn what it is all about."[23] Berninghaus, Couse, Dunton, Higgins, Phillips, Blumenschein, and Ufer were selected, each contributing to the collective work with murals and lunettes representing historic or quotidian scenes from the Southwest. *Osage Hunters, Trail to the Happy Hunting Ground, Couteau's Treaty with the Osages, Boone's Lick Spring—Sons of Daniel Boone Making Salt, Trader at Fort Carondelet*—these were among the group's first collective public commissions, and would remain the most important testimony of their political views.

Only Blumenschein and Ufer used their art to make social commentary, but their efforts to counter negative stereotypes did not often succeed in educating the general public or changing government policy. In 1887, the Dawes Act had pressured Indians to assimilate by making individual land grants in exchange for abandoning tribal domains. Blumenschein often railed against the Bureau of Indian Affairs, arguing that traditional customs and arts should be encouraged, to preserve "Indians that are still real and themselves (not the unhealthy, scrofulous specimens that Uncle Sam feeds, but self-supporting, clear-minded people who still have the same customs)."[24] In the *Albuquerque Evening Herald,* he publicly criticized the Federal officials who were gradually trying to "wean away [the Indian] from his dress, his dance, his blanket and his pottery." Sometimes, Blumenschein went so far as to get involved with highly controversial issues, such as the attitudes toward assimilation and the wearing of traditional versus modern dress in the pueblo. He did so in 1920 with the painting *Star Road and White Star,* where he handled the sensitive issue of the Native American Church and its use of peyote by younger members of the Taos pueblo.

Soon support also flowed from the region's local government. At the urging of Santa Fe's mayor, Arthur Seligmann, Dr. Edgar L. Hewett, by then director of the Museum of New Mexico, opened its galleries to all artists working in the state, requiring them only "to change their paintings about every two months";[25] he also launched *El Palacio,* the official journal of the New Mexico Museum and Archeological Society, in 1913, with the mission of reviewing and

Mabel Dodge Luhan, the anarchist patroness from New York, and her husband, Tony Luhan, of the Pueblo Indian tribe, pose in the desert of New Mexico for the painter Andrew Dasburg, on their way to a Snake Dance ceremony.

commenting on the exhibitions. Thus, the Taos artists received from their adopted state the rarest of privileges: the assurance of both an exhibition space and critical attention—exactly what others like Robert Henri and his group had fought for not so long ago in New York City.

Robert Henri arrived in New Mexico in 1916, with the second wave of artists heeding the call of the West. Very quickly, he understood that, on many levels, this new territory represented the perfect remedy for the situation he had tirelessly denounced. "There is a place in America—and this place is Santa Fe—where an artist can feel he is in a place which invites," wrote the charismatic former leader of The Eight. "The painters are all happy. . . . And here painters are treated with that welcome and respect that is supposed to exist only in certain places in Europe."[26] On his return to New York, Henri, who had been Hewett's guest, thanked him for his hospitality, and reiterated his dreams of a new artistic frontier in fervent, nearly mystical terms: "I count on the West for fresh and modern and very American ideas, and above all on everyone in Santa Fe, for since I have been there I have looked on Santa Fe as a hope."[27] Sloan realized that he had found a "place where the artist was embraced as an important part of the community"[28] and by 1920 had purchased a house in Taos. Subsequently, Henri invited several of his fellow artists to visit Santa Fe, notably John Sloan, George Bellows, and Randall Davey.

During this same period, someone who could hardly be accused of fleeing the Modernists—Mabel Dodge—also came to Taos. Following her involvement with the Armory Show in 1913 and an affair with radical activist and journalist John Reed, Dodge had married the sculptor Maurice Sterne, who urged her to join him in Santa Fe in the winter of 1917. With all her worldly experience and exposure to socialites, she yearned for a more authentic, more profound existence. Having thrived in Florence, Paris, and New York, the Buffalo heiress unexpectedly established a permanent connection to Taos and the Pueblo Indians with their six-hundred-year-old community, in which artistic and religious elements were fully and harmoniously integrated. They offered, Dodge believed, a model of permanence and stability, and among them she would find her true home, a place that gave her, in her own words, a feeling of complete spiritual fulfillment. Like most women of her social status, she had been given the epitome of a traditional education, and had been groomed to fill the woman's traditional role, to charm and marry well—expectations she found stifling, both intellectually and emotionally. In Taos, she discovered everything she had been searching for in her European travels: its lack of emphasis on material wealth, its dedication to communal values, its profound respect for nature.

In envisioning Taos as a breeding ground for a new American culture, she became a major exponent of the primitivist doctrines that attracted so many lost intellectuals in the 1920s. "For the first time in my life, I heard the voice of the One coming from the Many,"[29] she wrote after witnessing a Pueblo dance in 1917. Some months later, Dodge sent Maurice Sterne back to New York, while she immersed herself in the "total" experience of Taos by getting involved with a Pueblo Indian named Antonio Luhan, who became her fourth husband in 1923. A tall, handsome man, Tony Luhan invited her on long walks in the countryside, showing her Indian villages and introducing her to his tribal rituals. Ultimately, she saw in Luhan her spiritual guide, whose companionship and love offered her a unique opportunity for healing and redemption. "It was the Indian life I was entering, very slowly, a step at a time," she said. "I had heard, of course, of the Golden Age, and of the Elysian Fields, but they had only been words to me. Now I found out what they meant."[30]

In 1921, following the passage by Congress of a law that would take control of sixty thousand acres of land away from Native Americans, Dodge threw herself into social and political activism. She helped Tony Luhan organize the Pueblo tribes to protect their land and launched the first national campaign to protect the rights of Native Americans. She got in touch with John Sloan's wife, who in turn contacted her New York friends working at the leftist magazine *The Masses*. Alice Henderson wrote an article on the subject for *The New Republic*, Elizabeth Sheplet Sargent wrote others for *The Nation* and *The World*,

Georgia O'Keeffe (left) meets Maud Dale, wife of the art collector Chester Dale, at an opening. Dale was one of the great patrons of the time, giving his collection to the National Gallery of Art in Washington, D.C.

and Mary Austin did the same for *The Forum*. Dodge testified before several Congressional hearings on the issue and lectured about it in New York. She lobbied the progressive Senator Robert ("Fighting Bob") LaFollette, and succeeded in persuading D. H. Lawrence to express his outrage in a letter to the *New York Times*.

In Taos, Mabel Dodge re-created the atmosphere of her New York salon, but the talk centered on a new vocabulary, with terms she had coined such as "global spiritualism," "sensitivity," "sensuality"—a mystical amalgam of European aesthetics, a revolt against reactionary morality, and her own notions of Native American culture. Photographers Ansel Adams and Paul Strand, painters Georgia O'Keeffe, John Marin, Andrew Dasburg, and Marsden Hartley, and writers D. H. Lawrence and Willa Cather, among others, all visited at Dodge's invitation.

A whole mythology of the Pueblo began to take form in the American imagination, with the support of other personalities such as the anthropologist Jaime de Angulo, a French friend of the Luhans who brought Carl Jung to Taos (Jung never met them, though, since Dodge was in New York at the time). "The white American must preserve the Indian," de Angulo wrote, "not as a matter of justice or even brotherly charity, but in order to save his own neck."[31]

His letter echoed Dodge's beliefs concerning the grave importance of primitive cultures to all civilizations; furthermore, he felt that American Indian traditions could offer a new and significant outlook on Anglo-European culture. In *Man and His Symbols,* Jung later mentions the Pueblo Indians as guarding a meaning in their life that the white man has irreparably lost. "It is the role of religious symbols to give a meaning to the life of man. The Pueblo Indians believe that they are the sons of father Sun, and this belief endows their life with a perspective (and a goal) that goes far beyond their limited existence. It gives them ample space for the unfolding of personality and permits them a full life as complete persons."[32]

Georgia O'Keeffe spent most summers after 1929 in New Mexico, painting in Santa Fe, Taos, and the nearby village of Abiquiu, and became, in the eyes of the general public, New Mexico's most prestigious artist. This young woman, perhaps the country's leading woman painter, built her career from Texas to New York and from New York to New Mexico unabashedly. For the old prophet of European Modernism, Alfred Stieglitz, she played the role of model, muse, wife, and mother, but, fiercely independent, she left the East Coast definitively in 1949 to settle in Abiquiu, where she died at the age of ninety-eight. All in all, her spare, almost reductive desert scenes represent another essential step away from Europe toward the birth of an entirely American art. At the same time, her career offered American feminism one of its first and greatest role models. "If you ever go to New Mexico," she wrote, "you will itch to return for the rest of your life."[33] O'Keeffe became a fervent supporter of the Southwest, and some of her most spectacular early works of art were produced in Taos—visions of the desert environment, filtered through Modernism's form-reducing prism, such as her painting *Black Cross with Stars,* which echoed Modernist photographer Paul Strand's *Ranchos Church.*

Mabel Dodge Luhan was joined by Elizabeth Harwood, Helene Wurlitzer, and Millicent Rogers, and a community of women patrons decided to settle in New Mexico,[34] impelled mostly by a personal quest for spirituality, poetry, and beauty as Dodge had before them. Rogers, a Standard Oil heiress, had traveled the world but found her home in Taos, as Dodge had. "In Rome, Paris, and on the East Coast," she declared, "I saw many beautiful things, but nothing made more of an impression on me than an Indian camp."[35] Her house reflected her improbable trajectory with an unimaginably eclectic collection of Native American artifacts, Navajo rugs, and Hispanic furniture all mixed with art and furniture collections she had assembled while living in New York and in Sankt Anton, in the Austrian Tyrol (with Schiaparelli designs, Biedermaier furniture, and Art Nouveau objects).

In the early 1920s, in the wake of Georgia O'Keeffe and Andrew Dasburg,

the Modernists formed the third wave of painters to join the Taos art colony, following in the footsteps of Dodge. Marsden Hartley, who first came to New Mexico in 1918 and visited again several times after that, sent Stieglitz enthusiastic letters about the area: "The country is very beautiful and also difficult," he wrote. "It needs a Courbet with a Renoir eye. . . . A sculptural country. Here you can't say that the light shines on things, but that the things are in the light. That's why it's a place of forms, in which the problem of light appears altogether different."[36] Later, Hartley came to the same conclusion as many others regarding New Mexico's deep political importance in asserting an American art: "I have heard before of the hospitality of the people of Santa Fe toward artists," he confided, "and this is certainly a proof of it. It is so seldom that the artist is considered in the scheme of things, that it sounds almost like [a] miracle. That is the attitude in Europe, even in the uttermost parts; the artist is looked upon as something worth having and holding, and he is respected for his talents and his devotion to an idea, which I am sorry to say in our country is not felt as well as I hope it will be in the not far future. Artists are useful citizens, despite the tendency among laymen such as merchants and other money-makers to count them as idlers. History has proven long since what fine citizens they were, or we should not know about men like Michelangelo and his like."[37]

Other Modernist artists arrived in Santa Fe, among them Fremont Ellis, W. R. Mruk, Will Shuster, Josef Bakos, and Willard Nash, who in October 1921 formed a group they called Los Cincos Pintores, based on the conviction that "art [is] universal," singing "to the peasant as well as the connoisseur," and with the firm goal to "reach out to the factory, the mine and the hospital as well as the gallery."[38] Three years later, they organized an impressive exhibition of their work in Los Angeles. "An organization rather unique in American art history, and one that may yield considerable influence on the art development of the southwest," noted a journalist in *El Palacio*, "has just been formed by five young painters."[39]

Unavoidable conflicts arose between the Realists and Modernists in Taos. Members of the Taos Society of Artists, which had included Henri and his friends, sided with the Realists. In January 1923, some members of the Taos Society of Artists refused to admit some Santa Fe Modernists, such as Bakos and William Henderson, who had been nominated for membership. In response, Blumenschein, Higgins, and Ufer, along with a group of Santa Fe artists—Frank Applegate, Bakos, Gustave Baumann, Henderson, and B. J. O. Nordfeldt—immediately formed a new organization to promote Modernist tendencies, calling it the New Mexico Painters. The Taos Society of Artists dissolved altogether after four years. Later, Andrew Dasburg, another Modernist,

would speak about "much resistance" faced from Taos painters—Couse and Sharp in particular—during his attempt to spread the word about Cubism.[40] John Marin's watercolors, he added, offered a "poet's way" of rendering the New Mexican landscape, a way that was "more New Mexico in character than any one particular subject" and that avoided "literal transcriptions."[41]

Unlike England and France, which had spawned schools of pastoral painting depicting nymphs and fairies frolicking in fresh ponds, America had yet to discover its own pastoral tradition. In this distant corner of the American West, a generation of local artists could unveil or invent a mythological past. "Notice, please, the desire for 'fresh' material," wrote Blumenschein. "We were ennuied with the hackneyed subject matter of thousands of painters; windmills in a Dutch landscape; Brittany peasants with sabots, French roads lined with Normandy poplars; lady in negligee reclining on a sumptuous divan; lady gazing in mirror; lady powdering her nose; etc. etc. We felt the need of a stimulating subject. This, and the nature of youth, brought us to the West."[42] In Taos these painters discovered an Arcadia of the sort that Greuze could never have even imagined.[43] But the painters' commitment to New Mexican culture reached much deeper than their appreciation of the new Arcadia and its wealth of new inspiration.

Interest in Native Americans themselves was starting to grow, with details of their lives and beliefs emerging, thanks to painstaking anthropological research. "There is in the mind of every member of the Taos Art colony the knowledge that here is the oldest of American civilizations. The manners and customs and style of architecture are the same today that they were before Christ was born," wrote one critic,[44] hailing a culture that was both authentically American and as old as Europe's. In 1924, the *Dallas Morning Sun* devoted an entire article to an exhibition of New Mexico painters. "We in Texas glow with warranted pride that these men, who have set up their easel in the still primitive sections of the southwest, are preserving for generations yet unborn the only really typical American life left to us—that is of its earliest people, the Indians, who antedated the coming of Coronado. This society is doing for the Indians what the great masters of early European art did for the people's country and customs of their times."[45] In the Southwestern deserts and mountains, the New Mexico artists had originally sought to escape the conditions and concerns of illustrators, those second-class citizens of the republic of art. Working alongside the Indians provided them with much more than the solidarity of an artists' community, a new set of themes for their art, or a real market for their art. Above all, they found a measure of status that for so long their own society had not been able to grant them.

New York, Cultural Capital
of the World

"I'M NOT GOING TO NEW YORK," wrote Marcel Duchamp in April 1915, "I'm leaving Paris."[1] He had avoided conscription into the French army "because of physical incapacity"—he had a heart murmur.[2] His brothers Raymond and Jacques, however, having been "deemed ready and able," were mobilized on August 11, 1914, along with most young men of their generation. Informed opinion held that the war would not last more than six months. An antimilitarist, Marcel had awaited his draft notice while vacationing with his parents at a house they rented in Yport, working on a large slab of glass and drawing *Cemetery of the Eight Uniforms or Liveries*. He met several times that summer with Walter Pach, who was busy organizing three exhibitions of contemporary French art with John Quinn's financial support. It was Raymond Duchamp who had originally agreed to help Pach, but by then Marcel's brother had already left for the front to serve as an auxiliary military doctor. During the course of the exhibitions, Quinn himself acquired two of the five works that Marcel had shown, *The Chess Game* and *Apropos of Little Sister*.[3]

This was by no means an easy time for Marcel Duchamp. Raymond's wife, Yvonne, had begun to insinuate that her young brother-in-law's exemption from military duty was a sign of weakness. And in Paris, people spat in the faces of the men who had not gone to fight. Secretly, Duchamp began to organize his departure for New York. "I have told no one about this plan," he wrote Pach on April 2, 1915. "Thus I ask you to reply to me about the subject on a separate sheet, so that my brothers learn nothing before my resolution is complete."[4] A few days later, he again wrote Pach of his difficulties. "I have asked you to keep this secret from my brothers, because I know that my leaving will be very hard on them. So too for my father and my mother. . . . I will probably leave on May 22 or May 29."[5] The most critical issue was arranging for an occupation in New York: he wanted to find work as a librarian. It was a job he had held in Paris but above all he wanted to be considered a "professional artist" rather

than the celebrity he had become in the aftermath of the Armory Show two years before, where *Nude Descending a Staircase* had caused such a scandal.

The young man who embarked for New York on June 6, 1915, aboard the SS *Rochambeau,* calmly puffing his pipe, looked somewhat austere, his clean-shaven, impassive face an enigmatic mask. He had left France once before, in 1912, when he spent two months in Munich around the Blaue Reiter group, before visiting museums in Vienna, Prague, Leipzig, Dresden, Cologne, and Berlin. Duchamp had hurriedly prepared his clandestine trip to New York but he did not fail to bring with him his very French sensibility, his refined aesthetics, and rarefied obsessions.

Born in Blainville, Normandy, Marcel was the youngest son in a family of artists and had only just been discovered in his own country. His oldest brother, Gaston, known as Jacques Villon, was an engraver and painter; the more famous middle brother, Raymond, who called himself Duchamp-Villon, was a sculptor as well as a physician; and his sister, Suzanne, painted landscapes. Marcel learned much from his brothers but went about his art with considerable independence. In February 1912, after *Nude Descending a Staircase* had been rejected by the Salon des Indépendants in Paris, he set off "to put painting once again at the service of the mind,"[6] pursuing artistic experiments he called "playful physics,"[7] evident in such works as *Two Nudes: One Strong and One Swift* and *The King and Queen Surrounded by Swift Nudes.* This spirit of independence inspired the poet Guillame Apollinaire to praise Marcel's talents very early on. After attending a reading in Puteaux of a play, *La Légende Rouge, synthèse d'idées révolutionnaires,* by P.-N. Roinard, Apollinaire took up the case of the youngest Duchamp. "The reading," wrote Apollinaire, "took place the day before yesterday amid interesting pictorial essays by Jacques Villon and sculptures by Duchamp-Villon. All that was missing were paintings by the youngest [son] of this family of Normandy artists, Marcel Duchamp, who is also to my mind the one in whom the family's talents are both most evident and most novel. He has become a librarian in Sainte-Geneviève and shelves books."[8]

But just who was this young artist at the moment when he embarked for New York? His temperament seemed as wide-ranging as his gifts. Duchamp was "more interested in ideas than in visual products."[9] He illustrated the poems of Jules Laforgue, including "Again to This Star"—but "less for the poems than for their titles,"[10] as he put it. He experimented with movement and perspective, reading the works of the chronophotograph theorists Eadweard Muybridge, Etienne-Jules Marey, and Albert Londe, who sought ways of giving expression to "solidified movement" and whose motto was "reduce, reduce, reduce."[11] He liked to provoke and had no patience for either the "ordi-

nary habits of thinking" or the "platitudes of the café and the studio."[12] In the fall of 1911, Duchamp went to the Théâtre Antoine with the Picabias to see the rollicking production of Raymond Roussel's *Impressions d'Afrique*,[13] and was amazed by the poetry of such lines as "the letters of white on the bands of the old billiard ball," transformed into "the letters of white on the bands of the old plunderer."

Duchamp decided then and there that Roussel had "shown him the path art must take: intellectual expression rather than animal expression."[14] And so it was the painter also became a linguist following in the footsteps of Jules Romains and Apollinaire, throwing himself into the *Logical Grammar* of Jean-Pierre Brisset, who studied language by means of an incredible network of puns; and thus was born an idiosyncratic wit, who played with Alfred Jarry and Raymond Roussel at inventing a spontaneous new approach to humor, one that began by using words as "verbal cells in their pure denominative capacity" before turning to "the anarchic development of these cells when confronted with certain catalysts," and finally to "tearing the connective tissue that held them all together."[15] He was a theorist who criticized the Italian Futurists Gino Severini, Filippo Tommaso Marinetti, and Umberto Boccioni for what he called their "impressionism of the mechanical world." Like Metzinger, Duchamp placed art in a context of non-Euclidian geometry; like Picabia, he "conceived of an art that worked by a different scale." And he was an intellectual who believed that "as a painter it was much better to be influenced by a writer than by another painter"; he was a scientist, a member of the Puteaux group, fascinated by mathematics and pure abstraction in the manner of Balzac's *Search for the Absolute.* A pundit, a poet, a dandy, an aesthete, a populist, an artist—Marcel Duchamp left a Europe at war, taking as luggage his talents and his *bric-à-brac* of passions: Lautréamont, Apollinaire, Roussel, Brisset, chess, and the Vermot almanac.[16]

In the months following the Armory Show, the New York art scene underwent rapid and profound transformation. New collectors appeared, increasingly lively debate about modern art emerged in the press, and above all, new exhibition spaces cropped up all around the city, among them French dealer Stéphane Bourgeois's gallery at 668 Fifth Avenue, Charles Daniel's gallery at 2 West Forty-seventh Street, and the Modern Gallery at 500 Fifth Avenue. By 1917, thirty-four galleries had mounted some two hundred and fifty exhibitions of works by artists labeled either "modern" or "progressive."[17] Traditional exhibition venues—such as M. Knoedler & Company, or Montross—changed utterly, surrendering to the advancing Modernists as well.

The general public was starting to discover a new generation of young artists, such as Arthur Dove, John Marin, and Marsden Hartley. Indeed, the

most fundamental change the Armory Show produced was a steadily growing market for American paintings. Artists no longer needed to go to Europe to gain recognition; increasingly they were finding an attentive public, informed critics, and enlightened collectors right at home, a shift that undoubtedly resulted both from the Armory Show and the decline of the European market. New patrons emerged with tastes directly informed by the Armory Show— Mary Quinn Sullivan, Katherine S. Dreier, Walter Arensberg, John Quinn, A. E. Gallatin, Duncan Phillips, the Stettheimer sisters—who began to read about and buy contemporary American art, build networks, and open salons. They differed greatly from earlier waves of patrons: rather than robber barons or magnates, these collectors were often independent professionals—lawyers, artists, intellectuals—as well as the wealthy heirs of prominent families.

Such dynamism naturally stimulated local production of art. In 1914, the National Arts Club mounted an exhibition of two hundred works—with not a single canvas painted by a non-American. In the exhibition's catalogue, J. Nilson Laurvik embraced the notion of the "experimental nature of modern art."[18] Nevertheless, Laurvik's approval could not prevent Andrew Dasburg's series of abstract compositions, entitled *Portraits of Mabel Dodge,* from causing a minor scandal. Dasburg had been a regular at Laurvik's salon, but reactions to his work at that exhibition swayed the National Arts Club from mounting a similar show the following year.

The already well established gallery 291 grew more daring in its offerings after the arrival of Francis Picabia and Marius de Zayas. In 1914, the gallery mounted an exhibition of Brancusi sculptures. The following year, despite some discouragement from Alfred Stieglitz, de Zayas, Picabia, and Agnes Ernst Meyer founded the short-lived magazine *291;* their intention was to mingle European and American elements, to mix literature, art, illustration, and drawings: calligraphy by Apollinaire, graphic compositions by de Zayas, poems by Stieglitz, writings by Max Jacob, Agnes Meyer, Katharine Rhoades, and Alberto Savinio, watercolors by Marin and Braque, sketches by Picasso and Walkowitz, African masks, children's drawings. Thus, the United States had just acquired a periodical in every way equal in sophistication to Apollinaire's *Soirées de Paris.*[19] And there were memorable gatherings of contributors, such as Agnes Meyer's legendary picnics.[20]

Five months after arriving in New York, Marcel Duchamp found work as a librarian. His way seemed paved—welcomed by Walter Pach, put up by Walter and Louise Arensberg in their West Side apartment, invited by the lawyer and collector John Quinn to urbane dinners in exchange for French lessons.[21] Walter Arensberg soon proved Duchamp's most important contact. An amateur poet, an exegete of the works of Dante and Shakespeare, and thanks to his wife

a man of great wealth, Arensberg had already begun collecting art when he met Marcel, but "Duchamp was the spark plug that ignited him," as one of Arensberg's friends put it.[22] For three years, a group of artists and collectors orbited around the Arensbergs' salon, which, besides the Arenbergs, the Picabias, and Duchamp, most often included Sophie Treadwell, Arthur Cravan, Beatrice Wood, Mina Loy, Henri-Pierre Roché, and Arensberg's Harvard classmate Dr. Ernest Southard.[23]

The Arensbergs' salon had little or nothing in common with the Steins'. There was no hierarchy of "those who knew and those who owned," no old hands offering to instruct young Americans in matters of "taste." The Arensbergs sheltered Duchamp in exchange for his artworks, and their invited guests took part in free-flowing and wide-ranging debates about science, sex, art, alcohol, and language—virtually nothing was out of bounds. "Here summer is just like winter," Marcel wrote to Louise Arensberg during her brief absence from New York during the summer of 1917. "We drink a little. I got drunk a few times. . . . Apart from that I hardly work at all—I have a few lessons. We go to bed earlier. (3 instead of 5 [a.m.].) . . . My studio was painted white. It's very nice."[24]

A shared love of verbal sparring often pitted Marcel Duchamp and Walter Arensberg in amicable competition. Both passionate philologists, enamored of arcana and enigmas, they rewrote dictionary definitions and played chess games by mail. The aim of these contests was to circumvent "ordinary rules" of language, and they invented new phonetics, morphology, and syntax, through an "unflinching reasoning based on the rigid use of varying stereotypes and semantic confusions."[25] Duchamp himself knew no English when he arrived in New York, but he exploited his linguistic handicap to extreme effect. In fact, he achieved a peculiar virtuosity out of his limitations, making the space between languages a language unto itself, and using the resulting strange hybrid tongue as a way to enhance his native secretiveness. Duchamp's love of subversion led to his exploration of the readymade, Dada sculptures—he would sign and exhibit banal, ready-made objects, such as snow shovels or bottle racks. Presented unchanged as works of art, these works represented a shift in context from the utilitarian to the aesthetic. Duchamp had coined the term in a letter to his sister, in which he described his first two readymades, *Bicycle Wheel* and *Bottle Rack* (both 1913), fashioned from objects he had bought at the Bazar de l'Hôtel de Ville. Later, in his "assisted" readymades, he would combine found objects, making three-dimensional collages. Thus, such works as *Apolinère Enameled, Comb,* and *With Hidden Noise* were born. "The essential danger," Duchamp later explained, "lay in achieving a new kind of taste. . . . Taste is habit."[26]

When the painter Jean Crotti arrived in New York in October 1915,

Duchamp organized an enormous celebration with help from the Arensbergs and Duchamp's new American friends Alfred Stieglitz, Man Ray, Max Weber, Louise Norton, and Joseph Stella.[27] Another memorable event was the "Duchamp Festival," a party held by the sisters Ettie and Florine Stettheimer—both painters—on July 28, 1917, celebrating Marcel's thirtieth birthday. An exhibition at the Society of Independent Artists in April 1917 permitted Duchamp for the first time to take part in an event outside the "Arensberg cult." Put in charge of hanging works for the entire show, he decided to arrange them in alphabetical order of the artists' last names, and employed a lottery system to select the first letter—an eccentric method he defended as most democratic. As for his own work, he contributed a ready-made: an upside-down urinal which he called *Fountain* (signing it "R. Mutt, 1917," appropriating the name of a bathroom-equipment manufacturer). When the exhibition's organizers grumbled that he had plagiarized a simple plumbing appliance, Duchamp famously replied, "That is absurd. The only works of art America has produced are her plumbing and her bridges."[28] When his *Fountain* was "suppressed," he and Arensberg promptly resigned from the exhibition committee.

Aided and abetted by Man Ray, Francis Picabia, and John Covert, Duchamp continually pressed the limits of provocation. Before an elite gathering of New Yorkers, he insisted that the poet-boxer Arthur Cravan stand up and deliver a lecture; Cravan, though dead drunk, obliged. The satiric newspapers raved about the incident. As numerous articles about him began appearing in the press, Duchamp's name became increasingly familiar among the general public. He certainly had a gift for the attention-grabbing remark, but Duchamp's rhetorical way had been paved by Picabia who, upon his arrival for the Armory Show, told journalists that "[y]our New York is a cubist city, the futurist city." Picabia's pronouncement circulated widely, as did his comments about the city's "stupendous skyscrapers" and "marvelous subways."[29] The United States, he predicted, was "destined to become the first modernist country," a place where the American "spirit in its novelty and vigor fills each of its citizens with hope." In New York, he declared, "art and life fall into each other's arms with a marvelous and thunderous energy, like long-lost brothers."[30]

Of course, American artists reveled in such sentiments. Two years later, European artists, apparently summoned by Picabia's rhapsodic comments, launched another offensive on New York. Duchamp and Picabia arrived in June 1915, with Crotti and his wife, Yvonne, and Albert Gleizes and his wife, Juliette Roche, following in October. By November 1915, the *Literary Digest* was trumpeting "The European Art Invasion"[31] in response to the arrival of two pacifists and two war-weary veterans. In fact, these four had simply sought

refuge in New York from the tumult of the war in Europe, yet the American press saw them as the vanguard of modernity, the first European artists who would make America "the center of the art world." "For the first time," the *Literary Digest* announced, "Europe seeks America in matters of art."[32] Frederick James Gregg ratified this view in *Vanity Fair,* proclaiming New York's emergence as the "world's new art center."[33]

The newcomers were quick to see the wisdom in corroborating this interpretation. "For the first time," Albert Gleizes said in an interview, "it was American art that was attracting Europe. . . . The European artists are clamoring on your banks seeking the vital energy that all living art demands. . . . New York inspires me in an amazing way. . . . The great bridges they have built here are as admirable as the most famous cathedrals. The genius who built the Brooklyn Bridge should take his place alongside the one who built Notre Dame."[34]

By the time Gleizes made these remarks, in October 1915, celebrating New York's dynamism, the city's real-estate market had already been booming for forty years. In 1906, lower Manhattan boasted eighteen skyscrapers, the quintessential monuments of urban modernity. When the Equitable Building's imposing towers started rising up over Broadway in 1914, some were alarmed to realize that the city's development was barreling forth without any organized plan. The brainchild of General Coleman Du Pont of Delaware, who had made his fortune in gunpowder, the forty-story Equitable project was considered sheer folly by his detractors, who fought its completion tooth and nail. It was, one critic said, "like piling forty structures one on top of the other in one isolated part of the city . . . simply in order to build the biggest office building in the world."[35] Enormous, increasingly elaborate, and largely unregulated, these structures continued what French artists suspected: that modernity was emerging in America at a far faster pace than in Europe—and that inevitably artists would be swept along with it.

Picabia and his wife left New York after a year[36] and settled in Barcelona, where he started the magazine *391.*[37] The following year they moved to Zurich, where Picabia met Tristan Tzara, and then finally they returned to Paris. "The Picabias sailed ten days ago," a saddened Alfred Stieglitz wrote to Paul Haviland when they left New York. "I like both of them as much as ever."[38] Duchamp left for Buenos Aires on August 24, 1918. On the other side of the Atlantic, at the Cabaret Voltaire in Zurich, Tzara, Walter Serner, Jean Arp, Marcel Janco, Hugo Ball, and Richard Huelsenbeck, among others, were formulating the theoretical and linguistic bases for a sort of internationale of provocateurs, an all-out assault on tradition. Drawing on the experiments of Picabia and Duchamp in Paris in 1912; Picabia and de Zayas in New York in

1913–15; Duchamp, Arensberg, Picabia, Man Ray, and others in New York in 1915–18; André Breton and Jacques Vaché in Nantes in 1916; Arp and Max Ernst in Cologne in 1919–20; and Huelsenbeck and George Grosz in Berlin in 1918–20, the spirit of Dadaism was born.

In New York, radical institutions such as the Ferrer Center (sometimes called the Modern School) focused on advancing the cause of artistic freedom and modern art. A quasi-anarchist organization that sprang up in the wake of the execution of Spanish radical Francisco Ferrer, it offered classes by such notable figures as Robert Henri and Emma Goldman, Bayard Boyesen (a prominent political writer and activist during the textile workers' strike in Patterson, New Jersey in 1913) and the Austrian gallerist Carl Zigrosser, who was a fervent Nietzschean convinced that "avant-garde art and radical politics were part of the same revolutionary process."[39] Several years later, Zigrosser opened the influential Weyhe Gallery in New York. Across the Hudson River, a bookseller named John Cotton Dana turned the local Newark Museum into one of the country's most progressive avant-garde art centers. Beginning in 1913, galvanizing local clubs and schools, he fostered an ever-growing demand for exhibitions, classes, and seminars, which celebrated the work of even such advanced artists as Max Weber and Picasso.[40]

The People's Art Guild, an organization of artists and art lovers founded in 1915—its motto was "Place Art in Populous Districts"—lasted for three years under the leadership of John Weichsel.[41] In 1916, the Bronx House, located between 172nd Street and Washington Avenue, exhibited canvases by Marsden Hartley, John Marin, Charles Sheeler, and Stanton Macdonald-Wright, while the Y.M.H.A. Building on 165th Street just north of Harlem hosted a show of works by Thomas Hart Benton, John Sloan, Charles Demuth, Abraham Walkowitz, and Oscar Bluemner. Back in Manhattan, these artists' paintings could be seen in such marginal venues as the Café Monopol, the Levitt Restaurant, the Hudson Guild in Chelsea, the Parish House of the Church of the Ascension, and the Community Center school on Seventieth Street. Wherever and whenever an inexpensive and friendly space could be found, an exhibition would follow, whether in a restaurant, a store, or public schools. Even the *Jewish Daily Forum* and the Ladies Waistmakers' Union would offer their space in 1917 to present exhibitions. Modernism was turning up on every street corner, even if it had not yet captured the hallowed halls of American art.[42]

American painters of the Stein generation, those first spotted and championed by Stieglitz—Dove, Hartley, Marin, Demuth, Weber, Walkowitz, Bruce, Macdonald-Wright—had been nurtured by the Fauves and Cubists, inspired by Le Douanier Rousseau and Cézanne. Some of them had studied with

Matisse and visited the studios of Picasso and Brancusi, and several had proposed new aesthetic languages, such as Synchromism, Orphism, and Simultanéism. In New York, they found themselves working alongside Europeans—Gleizes, Duchamp, Picabia—trained under the same conditions, and with whom they shared the same set of references. By 1915, the war in Europe had scattered French artists and had crippled the French art market, virtually forcing Steichen to operate from Sharon, Connecticut, and Stieglitz to show American artists almost exclusively. On July 1, 1917, he closed his gallery, after a last show devoted to works by Georgia O'Keeffe. But three years later, others—notably Katherine Dreier—would fill the void he left.

In Europe, all illusions evaporated. Artists became soldiers, and the war, which was supposed to have lasted a single summer, dragged on endlessly. Paris itself had been threatened by the German advance, a turn of events that deeply shocked the American artists living there. Andrew Dasburg, after attending the Armory Show, returned to Paris for a few months in the early days of the war, where he witnessed the devastation: "One went, after the Battle of the Marne, and visited the battlefields . . . and also there was a group of newspapermen including John Reed at the time. The shock of the bombardment in Grasse, you know is something that possessed one's mind. One day when I was in the gare St. Lazare, I noticed that the schedule of the train stops was out in the direction of Grasse, and the last stop was a place called Cézanne. So, I mentioned it to Reed and Dunn who was with the *NY Times* at the time. He said, 'why don't we go out there, to see what I can see?' I even have some photographs. I had a camera with me. We visited the battlefield—it was autumn and the trees were dense yellow then. What impressed me among the debris of all sorts on the battlefield was where the camps had been, there was straw and covers of German helmets and pieces of uniform lying around. All through the fields the fleur de lys had come up and it was perfectly beautiful. And seeing a man patching a hole in a stone wall surrounding an estate, you thought, 'Here it is all passing already.' It all seemed so very unreal—the reality."[43]

Frozen in isolationist pacifism, the United States debated for three years before declaring war on Germany in April 1917; the first American troops did not arrive in France until that June. By the time the war ended and the Armistice was signed on November 11, 1918, Europe had lost ten million young men, with another twenty million wounded. Henri Barbusse and other writers struggled to record the unspeakable horror.[44] Most painters had been drafted and left Paris, with the exception of the Spaniards, whose country remained neutral. On Saturday, July 15, 1916, Gertrude Stein received a telegram: "My dear Gertrude Tomorrow (sunday) an opening at Poiret's come around 3:30. This letter will serve as your invitation. All Best Picasso [*sic*]."

The exhibition *Modern Art in France,* organized by the poet and art critic André Salmon and supported by the art patron Paul Poiret and open from July 16 to July 31, 1916, was the first art show since war had been declared, and the first time Picasso's *Les Demoiselles d'Avignon* was shown in public. Apollinaire chaired a literary event on July 21, and used the occasion to reassure the audience that the avant-garde arts and letters in France, Italy, and Spain were "free of 'Boches' [Germans]." The luminaries who attended such literary and musical gatherings included Eric Satie, Darius Milhaud, Georges Auric, and Igor Stravinsky.[45]

Posted at a military hospital in Saint-Germain-en-Laye, Duchamp-Villon could return to Puteaux from time to time. But left on his own—with Jacques at the front, his own wife and sister serving as military nurses, and Marcel in America—he could manage to participate in only one artistic event, the *National Exhibition of Artists Killed, Wounded, Taken Prisoner or in the Army.* Despite everything he had seen and experienced in the war, and perhaps to some degree because of it, Duchamp-Villon rediscovered his "taste for . . . work," as he wrote to Walter Pach in October 1915. "I saw everything worth seeing, took stock of all the forms of life at war, was able to appreciate the effects of its infernal genius. . . . Whether in the idea of death, ever-present in the rumble of artillery and shriek of shells . . . or of life seething in great potent masses. . . . Synthetic thought continues to make great progress here. . . . La Fresnaye is somewhere up North, Léger in the East. . . . Villon has suffered grievously for two months. . . . And you, and Marcel, and Gleizes, and Picabia, and all the others? What are you up to? Tell me what's happening over there, exhibitions, etc. . . . What are you talking about? Intrigues, scandals? . . . What about the expatriate crowd? Do they get along better than they did in Paris?"[46]

A year later, having been transferred to Châlons-sur-Marne, Duchamp-Villon contracted typhoid fever and never fully recovered his health. Working obsessively between bouts of fever, he managed to work on a sculpture of his physician, *Professor Gosset;* rewrite his will; carve chess pieces; and write a burlesque comedy. "The one thing I long for is to return to work with my wax and my plaster," he wrote to his sister in May 1918. "Nothing else matters anymore." On October 7, he died in the military hospital at Cannes, a month before Apollinaire and two days before the Armistice was signed. In Argentina, Marcel learned of the news of his brother's death and immediately returned to Paris. In the course of World War I, the Duchamp family had, for the glory of France, lost one of its most brilliant sons, while another departed for America with no support apart from his creative genius. If the fate of the Duchamp family has any meaning as an allegory of France's, it was the Great War that

decisively reshuffled the deck in favor of the New World at the expense of the Old.

The 1919 Salon d'Automne gave the impression that artistic innovation had ended. The Louvre reopened to the public, with the general consensus that "France's greatest strength is her past."[47] In a country overwhelmed by grief and loss, a "dithyrambic worship of things past pervaded the cultural atmosphere," this classicism seeming to offer the best kind of solace and support.[48] As if unable to resist this harking back to the days of Ingres, Chardin, and Poussin, many artists in Paris, including Picasso, Gris, Delaunay, La Fresnaye, Gleizes, Matisse, Metzinger, and Severini, all began painting mothers and children. A young French writer named Maurice Sachs, who knew many of these painters, kept a journal of those years. In the entry dated July 14, 1919, he marks what seems like the beginning of a new age with tragic optimism: "The world is ageless now, or if it has any age that age is twenty. The heat was tremendous but you only realized that when there were no more soldiers to watch marching past. Cries of joy rose like steam over the drunken crowd and followed after the troops. . . . It took me two hours to get from the avenue of the Grande-Armée to the rue de la Faisanderie. You felt as if the streets would never be empty again, and that from dawn to dawn, from one end of Paris to the other, for years on end, there would be this joyous, shimmering, warm, enthusiastic world. I cannot describe it. Nothing like it will ever be seen again. For there will be no more war."[49]

When peace finally returned, Europeans were dumbfounded to discover that New York had become a major artistic center, and that rather than being hurt by the war, the art market had prospered, but in a place far from the front lines. In the years that followed, little by little the United States would be seen in a different light, like a new country, one in full flower, in striking contrast to Europe, which was in postwar reconstruction. In 1924, the poet Louis Aragon, talking with Elizabeth Eyre, exclaimed, "Ah America, the country of skyscrapers and cowboys, railroad accidents and cocktail shakers." "No, no, no," replied the American woman, "that's an old fashioned Frenchman's idea of America, America." "Excuse me," he went on, "I got that idea from Americans who live in Paris, we invented the legend of America, and now it's the American's turn at believing it."[50] Fernand Léger returned enchanted from his first transatlantic voyage. "The United States is not a country," he sang out, "it's a whole world," stating that New York and Moscow had become international hubs, leaving Paris in the role of mere "observer."[51] His canvases would depict the spectacle of Broadway, its shifting, its tempo, the glare of its lights—all building toward the invention of his new system "color apart, drawing apart," a mechanized utopia in vibrant colors and the pure geometric forms of modern machines. Respond-

ing to a question from the magazine *transition* in 1928, Gertrude Stein affirmed that America had become "the mother of the twentieth century civilization . . . and not just Europe's spiritual daughter."[52]

In 1920, Marcel Duchamp returned to New York and got involved with Katherine Dreier and her Société Anonyme, Inc., as well as projects with Hartley, Stella, Covert, Ray, Elsa von Freytag-Loringhoven.[53] While he continued to make his readymades, in 1919 he produced a mustachioed Mona Lisa, *L.H.O.O.Q.*,[54] and sometime later proposed that a Rembrandt painting be used as an ironing board. At the same time, he continued to work on *The Large Glass* (the formal title of which is *The Bride Stripped Bare by Her Bachelors, Even*). "Marcel wanted to insist upon this philosophic truth," said Katherine Dreier, "that matters of the spirit can never be possessed. The moment you think you've done it, they disappear like smoke."[55]

Becoming a true center for aesthetic experimentation, New York City had at last begun to take modernity to its heart, and the romance would never end. Braque had been wounded by a shell, Duchamp-Villon and Apollinaire were dead, Villon and others profoundly traumatized or reduced to silence. And Marcel Duchamp—the "most eccentric and the most inexplicable human being who ever came" to the city which, according to some, had become the "cultural capital of the world"—was on the way to becoming, for many generations, the true father of American art.[56]

Five

Abby, Lilly, Mary, and the Others: The Women Take Charge

"WOMEN WHO USUALLY see Fifth Avenue through the polished windows of their limousines and touring cars strode steadily side by side with pale-faced thin bodies of girls from the sweltering sweatshops of the East Side. All along Fifth Avenue, from Washington Square, where the parade formed, to Fifty-seventh Street, where it disbanded, thousands of men and women of New York blocked every cross street on the line of march. Women doctors, women lawyers, women architects, women artists, actresses, and sculptors, women waitresses, domestics, a huge division of industrial workers, women of the seven suffrage states in the union . . . all marched with an intensity and purpose that astonished the crowds that lined the streets."[1]

With startling ferocity, protesters for women's suffrage burst onto the streets of New York, as though abruptly summoned by some Pied Piper. In fact, the battle lines had been drawn for some time, not on the New York streets, but in factories and ateliers, in parlors, boardrooms, and bedrooms across town, where people of every class and occupation contemplated the role of women in American public life. The Fifth Avenue women's suffrage march, which took place in February 1912—a year before the Armory Show—would prove a turning point in the drama of the status of American women.

A harbinger of this spectacular demonstration on the streets of New York had come seventy years earlier with the Seneca Falls Convention. On July 19, 1848, Elizabeth Cady Stanton, a judge's daughter, addressed an overflowing audience in a humble church in upstate New York: "Woman alone can understand the height, the depth, the length and the breadth of her degradation."[2] The speakers that day, mostly of Puritan heritage with a profound belief in the egalitarian and democratic promise of American life, railed with moral indignation against what they perceived to be the systematic oppression of women in the United States. Twenty years later, the movement enjoyed one of its early victories—at least a symbolic one—when a clandestine election was held in a

small community in southern New Jersey. On Election Day in 1868 in the town of Vineland, Margaret Pryor in her Quaker bonnet spoke out with a vigor and defiance that belied her eighty-four years: "I feel so much stronger for having voted," she declared.[3] Her historic act would remain illegal, however, until 1920, when the Nineteenth Amendment to the Constitution finally extended the franchise to the other half of the adult population throughout the United States.

The vote was not the only right at stake for women at this time; the feminists also fought for greater equality in the professional arena. Sara Tyson Hallowell, for one, would be the first clear victim of the conservative tradition in Chicago's art world. In 1892, Augustus G. Bullock, chairman of the Chicago Columbian Exposition's commission on fine arts, wrote in a letter to a colleague, "I have had an interview today with Miss Hallowell who came from Chicago to see me . . . She has the strong endorsement of almost everyone East and West whose name might be expected to lend weight to her petition; not only of leading artists American and foreign but of presidents of Art Museums, like Mr. [Henry G.] Marquand of New York and Mr. [Martin] Brimmer of Boston. She also has the endorsement of the Chicago committee. I gave her full hearing and told her that all the papers she left with me would be laid before our committee at its October meeting."[4] When Hallowell applied in 1890 for the position of director of fine arts for the fair, she was far and away the most qualified candidate, having organized a number of international exhibitions during the course of the 1880s.

She also enjoyed high patronage: a wealthy member of the Exhibition Committee, Bertha Honoré Palmer, the wife of hotel-owner Potter Palmer, lobbied to make Hallowell director of the exhibition and encouraged several newspapers, including the *New York Times* and the *Chicago Independent News,* to do likewise. As the selection date approached, Mrs. Palmer spared none of her social and political connections, corresponding on Hallowell's behalf with Chauncey Depew, the influential New York State cultural commissioner.[5] It was Palmer's sacred mission "to prevent a gross injustice to a charming woman . . . who should not be shut out from any emoluments and distinctions which lie before her . . . simply because she is a woman," but her effort would finally prove fruitless. Despite the considerable professional strides made by women in the nineteenth century as well as the deep admiration Hallowell had justly earned, for both her administrative skill and her sense of aesthetics, from artists, patrons, and other professionals, it was as yet inconceivable for a woman to serve as America's standard-bearer to challenge Europe's cultural hegemony. Still gripped by national insecurity, the fair's fine-arts selection committee deemed that a woman, no matter how competent, would never be

taken seriously in such a significant and symbolic role.[6] Thus, a man was chosen instead.

Until the twentieth century, the domain of cultural patronage remained almost exclusively the domain of an elite group of upper-class men who built their art collections to cultivate social status and to connect themselves to a European legacy of refinement. And even as, superficially, high culture was at last becoming more accessible to the masses, the audiences for art exhibitions, concerts, and opera performances continued to be predominantly middle- or upper-class white men of European descent.[7] The years 1890–1920 saw some change with the rise of women's clubs established to support art and art appreciation throughout the United States, in ways that often defied social conventions. By the turn of the century, women became more and more visible as both collectors and connoisseurs. At the same time, they appeared to be growing in wealth and influence; indeed, since wives tended to survive their husbands, and new property laws were favorable to them, women controlled a greater share of the nation's wealth.[8]

Before long, the flourishing ranks of educated or self-educated women assuming important positions in the art world inspired a good deal of anxiety that their power would become overwhelming, and that they would take over American culture. In 1912, one journalist warned that a monopoly of women was forming in the arts—in education, literature, music, the visual arts, even in the church and theater. Many such jeremiads followed. Some commentators were particularly apprehensive about women being "fully in possession of formal education," occupying most teaching posts, and rapidly invading "our elementary schools." Numerous critics went a step further, protesting that American culture itself was being "feminized."[9]

Women's positions on the boards or committees that ushered in modern art engendered a reciprocity of support and recognition between the institutions championing modern art and those championing women's rights. Some of the most ardent supporters of modern art were also suffragettes, and even those who eschewed political causes in favor of aesthetic ones (e.g., Isabella Stewart Gardner) furthered the public recognition of women in positions of aesthetic, cultural, and managerial power. Clara Davidge, an interior decorator, contacted well-to-do clients and friends, including Gertrude Vanderbilt Whitney and Florence Blumenthal, when soliciting financial support for the Armory Show. Women painters from Mary Cassatt to Marguerite Zorach and Marie Laurencin, were encouraged by other women to exhibit their work. And many female patrons and collectors lent paintings to the Armory Show: Sarah Stein lent a pair of Matisses; Sara Choate Sears, her Cézanne; other Modernist paintings came from Gertrude Vanderbilt Whitney, Katherine Dreier, and

Among the first American collectors of the French painters was Louisine Havemeyer,
seen here with her husband, the sugar baron Henry O. Havemeyer.

Emily Crance Chadbourne.[10] Perhaps not surprisingly, it was women in the art
world—with everything to gain—rather than men, who assumed the greatest
risks with modern art, offering chances to the young, innovative artists and
gambling on the unknown. These mavericks increasingly repudiated conven-
tion, in terms of both their roles as women and their aesthetic taste.

Mary Cassatt's career as an artist, an art dealer, an appraiser, and an inter-
mediary between France and the United States had prefigured that of others
who would depart from the standard of the bourgeois American woman who
studied art in Paris. Born into a wealthy Chicago family, she was among the
first to act as a liaison between the worlds of French art and American collec-
tors. Beginning in 1877, Cassatt advised her friend Louisine Havemeyer to take
risks and purchase works by such artists as Cézanne and Degas. Somewhat par-
adoxically, Cassatt and Havemeyer, both staunch feminists, nevertheless uti-
lized their talents and skills to support the careers of men.[11]

Louisine Havemeyer's husband, sugar baron Henry O. Havemeyer, began
by collecting mainly Dutch Old Master paintings—a respectable hobby for a
nineteenth-century American gentleman—and kept a famous room of Rem-
brandts in their home. She persisted in her preference for French Impression-

ism and, little by little, her husband came around to her side and began acquiring such artists as Degas and Monet, as well as a series of erotic Courbets. A traditional wife, albeit with titillating tastes, Mrs. Havemeyer found further outlets for her progressive beliefs later in life. After her husband's death in 1907, she became an impassioned suffragette. A talented speaker, she read her entertaining speeches with an unusual visual aid—a dazzling, battery-powered model of the *Mayflower* lit up by thirty-three small light bulbs that blinked as she hailed the bright future that awaited once women were granted the vote. Her enthusiasm and escalating militancy even landed her in prison for her participation in a demonstration during which an effigy of President Wilson was burned in front of the White House.[12]

Isabella Stewart was born in 1840, the only surviving daughter of a wealthy New York steel magnate. Groomed to be a society lady, she married Jack Gardner, a wealthy Boston Brahmin, but in time she too stepped out of the conformist role. One remarkable anecdote has Gardner taking a lion from the Boston zoo for a walk in the zoo's lobby, grasping onto his mane instead of a leash.[13] The motto emblazoned on her stationery and over the gate of her home said it all: "C'est mon plaisir." She opened Fenway Court—the legendary Italianate villa built for her as both a residence and a museum—to the public on New Year's Day, 1903. William James applauded the "aesthetic perfection" of this private museum, and the "extraordinary and wonderful moral influence" it had on her guests. Henry Adams called Fenway Court a "tour de force." Enthralled, journalists praised Gardner for her impressive collection and the environment in which it was shown, calling it one of the "real triumphs of museum-making."[14] The first woman to defy successfully the limitations that had thwarted Hallowell's career only two decades earlier, Isabella Stewart Gardner defied definition as well. And while her daring iconoclasm mesmerized her society peers, her rejection of social role-playing fairly terrified them as well.[15]

An art patron and talented artist herself, Alice Pike Barney studied in Paris under Carolus-Duran, who had also taught John Singer Sargent. She married millionaire Albert Clifford Barney, but even while fulfilling her social obligations and wifely duties, she never stopped painting. In 1898, Mrs. Barney traveled again to Paris, this time studying under Whistler and exhibiting her work. Her pastel drawings were praised by some as superior to those of such admired figures as Mary Cassatt and Cecelia Beaux, and an early portrait depicting her daughter Natalie was shown at the Paris Salon[16] in 1889 and again in 1897, and at London's Royal Academy exhibition three years later. For the next twenty-five years, she continued showing her works at both public and commercial galleries in Washington, D.C., New York, and Paris, while also designing cos-

Gertrude Vanderbilt Whitney in her studio in Macdougal Alley, New York City, ca. 1919

tumes and creating sets for theater productions.[17] A Paris art journal described her as an American artist "as dynamic as she was eccentric, who later became a dramaturge, theater director, philanthropist, political leader, and, in a word, an animator gifted with a great power of seduction and influence."[18] After her husband's death in 1902, she decided to found Studio House, a "meeting place for wit, wisdom, genius and talent," according to a 1910 society magazine. Members of the diplomatic corps, actress Sarah Bernhardt, dancer Ruth St. Denis, Alice Roosevelt Longworth, and many other notables were frequent guests.[19]

In 1907, Clara Davidge became the only New York dealer to handle American art exclusively at that time. She operated her Madison Gallery on a non-profit basis: rather than producing income, her primary goal was to offer talented, innovative, little-known artists the opportunity to show and sell their work. In this way, she hoped to alter what she perceived as two serious problems in the New York art market: the domination of European art, and the

scarcity of exhibition space for young creators.[20] In three years, the gallery held thirty-four exhibitions, introducing such young artists as George Bellows, Walt Kuhn, and Elmer MacRae in their first shows. Her circle in New York included Willa Cather, Richard Waterson Gilder, Edwin Arlington Robinson, Cecilia Beaux, William Glackens, Ernest Lawson, Everett Shinn, and Maxfield Parrish. Davidge's father, Henry Codman Potter, an Episcopal minister, had always "challenged upper-class attitudes about woman's role in society"; with five daughters and at least two close female assistants, he believed that "women could and should work outside the home."[21] The Puritan ethic that allowed women to be heard in public in Quaker-style meetings, such as the Seneca Falls Convention, also inspired Davidge's success as a businesswoman and art expert. Her social and business skills would prove invaluable to the Armory Show, earning her a place in the annals of the avant-garde. She collected at least $4,100 for the exhibition, and for her fund-raising efforts, the Association of American Painters and Sculptors named her honorary treasurer, printing donation forms marked with her name and position.[22]

Georgia O'Keeffe never studied in Europe. Her achievements as an artist were heralded in galleries like Alfred Stieglitz's 291, where Europeans in New York encountered the best of American modernism. Born in 1887, O'Keeffe hailed from the Midwest. She first visited New Mexico in 1917, and returned there often to paint, especially after 1929. Unabashedly feminine in a masculine field, as Steiglitz's wife and muse she influenced his taste, guiding this venerable prophet of European Modernism toward a deeper and keener appreciation of what was irreducibly American as she pursued her work among the Pueblo Indians between Taos and Santa Fe.

Gertrude Vanderbilt Whitney offers perhaps the most emblematic example of all, assuming a multiplicity of newly available roles in art at the turn of the century. The daughter of railroad magnate Cornelius Vanderbilt, she married Harry Payne Whitney, and reinvented herself as an artist, studying with Rodin in Paris and becoming an accomplished sculptor. Raised with a commitment to philanthropy, she also became a tireless patron of the arts, supporting American artists studying in Paris and purchasing American works for her collection. "Dear Mr. Russell," she wrote to Morgan Russell, one of her beneficiaries, "It is now some years since I have been paying you a monthly allowance that you might study Art unhampered in Paris. I now feel sure that your progress had been so good, that you will be able and proud to stand on your own feet and make a living independently of me. Therefore I propose to discontinue this allowance from January 1, 1916, and in doing so, I want you to feel that you have my best wishes and sympathy for your success in all that you undertake. It will always be a pleasure to me to hear from you how you are get-

ting on. Yours sincerely, Gertrude V. Whitney. The last payment will therefore be on Dec. 1, 1915."[23]

Whitney's first acquisition was made in 1908, when she purchased four of the seven works sold at the exhibition mounted by The Eight that year. In 1914, she created the Whitney Studio, an exhibition space for contemporary American artists adjacent to her own Greenwich Village studio. The following year, she helped found the Friends of Young Artists, to underwrite the needs of American artists rejected by established galleries. As a patron of the Society of Independent Artists, founded in 1916, Mrs. Whitney continued to support American artists of all backgrounds. Between 1918 and 1930, she devoted her energies first to the Whitney Studio Club and then the Whitney Studio Galleries, both of which showed American art exclusively.[24]

In 1929, Whitney took stock of her collection, which now consisted of more than six hundred works of contemporary art and had far outgrown the space she had to show it. It was time, she decided, to establish a permanent home for it. She considered two alternatives: either to donate her collection to an existing institution, or to build her own museum. Whitney decided to give her works to the Metropolitan Museum of Art. She had her assistant Juliana Force contact the museum's director, Edward Robinson, offering her entire collection and revealing, in addition, Whitney's eagerness to construct and endow a new wing. Whitney's generous offer was flatly refused. In a discussion between Whitney and Force over lunch following the flabbergasting phone call to Robinson, the Whitney Museum was born, with Whitney proposing Force as the museum's director. When Force protested, pleading inexperience, Whitney insisted: "Either you're the director, or we won't do it." In discussing their venture, neither woman considered contacting administrators of existing museums; they consulted only artists. "So when the museum was born it was not the ward of committees. Its guardians were two ladies of singularly complementary qualities."[25] The rejection of modern and American art by New York's dominant cultural institution inspired a slew of collections specializing in modern art. And it was these notable collections—assembled by women— that formed the basis of the great museums that followed, from the Whitney to the Modern to the Guggenheim, unlike the museums of the last century, which were founded by men.

At the Whitney's opening ceremony on November 18, 1931, Gertrude wore mourning attire (her husband had died of pneumonia barely a year earlier), a "black velvet and chiffon dress, matching hat, jet beads, and a bouquet of purple orchids at her wrist." She stood "taller than Al Smith and Otto Kahn in their dark suits, almost as tall as Representative Bacon, very erect in his cutaway." President Hoover sent a letter, which was publicly read: "I profoundly

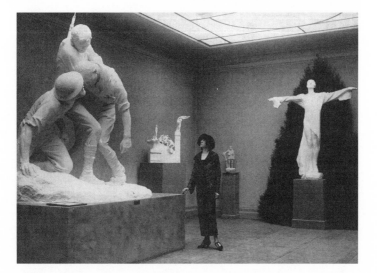

Gertrude Vanderbilt Whitney with her sculpture *Impressions of the War* at an exhibition
of her sculpture at the Whitney Studio, 1919

regret," it said, "that the pressure of imperative public duties prevents my
accepting your kind invitation to speak at the opening of the Whitney
Museum of American Art. It is an enterprise which makes a strong appeal to
my own interest and I am sure that this permanent, pioneer museum devoted
exclusively to American paintings and sculpture will appeal to the country as a
benefaction of nation-wide interest. It is a promising step toward placing
American art in the position of importance and dignity which its excellence
and individuality merit. It should quicken our national sense of beauty and
increase America's pride in her own culture. Please accept for yourself my
heartiest congratulations on the consummation of your plans and the appreci-
ation which I know every American must feel for so notable a contribution to
the nation."[26]

"For twenty-five years," Gertrude Vanderbilt Whitney responded, "I have
been intensely interested in American art. I have collected during these years
the work of American Artists because I believe them worthwhile and because I
have believed in our national creative talent. Now I am making this collection
the nucleus of a museum devoted exclusively to American art—a museum
which will grow and increase in importance as we ourselves grow."[27] Stuart
Davis later stated: "The Whitney Museum in its early days had played a unique
role in giving the American artist . . . public importance . . . there was no
other center where he was given any importance. . . . It not only gave him a

place to show his work but also sees a great deal in tangible support, in buying paintings and giving money to live on. . . . Nobody else did it."[28]

In the struggle to establish an American art, women had evolved from passive roles to active ones. From wives and muses they had first grown to assume intermediary functions in the art world, working as associates, volunteers, writers, patrons, or publicists, exemplified by Gertrude Stein, Mabel Dodge Luhan, and Agnes Ernst Meyer. Soon such secondary functions proved too confining. Indeed, American women would be the movers and shakers in the contemporary art world, carrying the banner of the Modernists or Realists, championing the causes and artists others would not. There would be artist-patrons such as Gertrude Vanderbilt Whitney, who founded the Whitney Museum of American Art; Katherine Dreier, who created the Société Anonyme; the visionaries Abby Aldrich Rockefeller, Lilly Bliss, and Mary Quinn Sullivan, who founded the Museum of Modern Art; and later still, Peggy Guggenheim. Out of the efforts of these women, three of New York City's great museums were born. The historic Armory Show had followed the marches for suffrage, a chronology of events that created a triumphant connection between Modernism and feminism. Henceforth, America's greatest art institutions would be the works of women.

The "Greatest Modern Museum in the World"[1]

"MISS BLISS AND I feel great hesitation about making first exhibition only American," Abby Rockefeller cabled to Alfred Barr. "We suggest joint French-American with possibility following artists: Ryder Homer Prendergast Davis Eakins Cézanne Seurat Gauguin Daumier Renoir."[2] The date was August 20, 1929. Three days later, Rockefeller tried again to convince Barr with her sound reasoning: "Our first idea of a standing exhibition of the French artists Cézanne Seurat Gauguin Van Gogh would be my first choice. I feel this because I believe that the modern movement was started by these men, and I believe it is chronologically appropriate, but if the rest of the committee wishes to have an American exhibition, I believe that it would be much more of a challenge to the public to exhibit pictures of the living American artists. . . . It would seem to me a little bit flat to start with a purely American exhibit of the older men. On this subject another thought disturbs me. If we select for instance ten living American artists for our first exhibition, we are going to antagonize from the beginning the friends and admirers of all the others, whereas if we start out with a French exhibition, we may have a chance to establish ourselves before we have to plunge into the obvious difficulties of an American exhibition. My thought would be that we start with an exhibition of the best French, and at the same time announce the several exhibitions that are to follow of American painting and sculpture as well as French and others."[3]

Right from the start, the Museum of Modern Art's young director had to negotiate the often conflicting expectations of very different institutional constituencies: its three women founders; its board of trustees; and its president, Conger Goodyear. All grappled with the same pressing questions concerning the presentation of American art in a modern museum, the place of European culture, the proper balance of the Old World and the New, the status of contemporary American art; these essential issues would dominate Barr's fourteen-year tenure as director. Abby Rockefeller's telegram was composed barely a

month after Barr's first meeting with her, and only three months before the museum's opening. Soon after his appointment, Barr formulated a vision that, despite major obstacles, he would steadfastly refuse to abandon. "A new art museum," as his first draft expressed it, must be a "multi-departmental museum, including architecture, design, photography, and film."[4] Insisting on a global vision, Barr rejected the notion that art ought to be confined to categories of nationality. As a model, he often referred to Charles Rufus Morey, one of his professors at Princeton, who taught a seminar on early Christian and medieval primitive art, and focused on the interrelationships among all the cultural artifacts of the period, regardless of their provenance—painting, sculpture, architecture, illuminated manuscripts, ivory carvings—and even regarded folklore and theology as relevant to his analysis.

No one was better versed in European art than Alfred Barr. With his friend Jere Abbot, he had gone to Europe in 1927 and spent an entire year traveling through England, Holland, Germany, Russia, Poland, Czechoslovakia, Austria, France, and Italy. He had admired the "modernity of Dutch architecture," finding it deplorable that "no such thing was possible in American museums," spotted the beauty in typography and book bindings, felt dazzled by his four-day visit to Dessau, where he had spoken with the modern artists teaching at the Bauhaus—Joseph Albers, Herbert Bayer, Lyonel Feininger, Paul Klee, and László Moholy-Nagy. The Bauhaus, he realized, "opened a new world," creating an "interrelation of the arts, crafts, and interplay." H. F. Hartlaub—the director of the Mannheim Kunsthalle, "the most active modern art collection in Europe"—fascinated him. Barr also admired the Weissenhof housing complex in Stuttgart, conceived by Ludwig Mies van der Rohe, with buildings by him, Le Corbusier, Peter Behrens, and a dozen others; he attended exhibitions of the work of Wassily Kandinsky and Max Beckmann; he went to Colmar to see Grünewald's legendary Isenheim Altarpiece. After three months in Germany, which was caught up in the creative ferment of the Weimar Republic, Barr and Abbot spent two months in the Soviet Union, where the Constructivists and Suprematists debated on the relationship of art and propaganda. He met Diego Rivera, Sergei Eisenstein, Vsevolod Meyerhold, El Lissitzsky, Aleksandr Rodchenko, and Sergei Tretiakov in Moscow, where he went to a screening of Eisenstein's films *Battleship Potemkin* and *Ten Days That Shook the World*. He determined to study postwar primitivism, studied the Shchukin and Morozov collections in Leningrad, and visited every church and saw every icon in Novgorod. After this systematic exploration of Europe's new aesthetic movements, Barr dutifully reported his discoveries, writing articles and giving lectures on the utilitarian aesthetic of Communist artists in LEF, the new Russian architecture, or the strange realism of Otto Dix.[5]

America versus Europe—Barr found this dichotomy at once simplistic and incongruous. "I wish to study contemporary European culture and gather materials for a thesis," he had written in "The Machine in Modern Art." "Contemporary art," he continued, "is puzzling and chaotic but it is, to many of us, living and important in itself and as a manifestation of our amazing though none too lucid civilization."[6] Alfred H. Barr, Jr., was the son a Presbyterian minister who had led congregations in Detroit and Baltimore. Tall, stern, erudite, and possessed of rare intellectual rigor, he briefly considered becoming a paleontologist. "I congratulate you on the perfectly splendid student that you have developed in Alfred Barr," Paul Sachs wrote to his Princeton colleague Charles Rufus Morey after Barr's arrival at Harvard for postgraduate work. "I predict . . . he is going to be a scholar of distinction."[7]

Descended, like Alfred Stieglitz and Leo Stein, from German Jews, Sachs had written his thesis on fifteenth- and sixteenth-century Dutch engravings.[8] He had also begun assembling his own collection of drawings, eventually acquiring a Picasso drawing in Paris, and organizing—against the advice of his colleagues—the first exhibition of modern French art at Harvard's Fogg Art Museum, in 1928.[9] Sachs's ideas faithfully reflected those of his own professor, the art historian Charles Eliot Norton, a specialist in American art. Profoundly pessimistic about the state of culture in his own country, Norton had lived in England, where he became friends with local theorists such as John Ruskin, Thomas Carlyle, and John Stuart Mill. "It is our misfortune," Norton wrote in 1865, "to have no body of educated men competent to pass correct judgment, and forming a court of final appeal in matters of learning; not an academy, not an organized body, but a scattered band of men of learning and cultivated critics who would leaven the whole mass of popular ignorance."[10]

Sachs, sharing Norton's views, decided that the United States urgently needed an elite to guide its people toward a new culture, and thus offered Harvard students an innovative course on museums that was based on these principles. Sachs would offer his Museum Course for forty-four consecutive years, becoming the veritable father of the modern American museum. The curriculum was conceived, he explained later, "to implant scholarly standards in future museum workers, to educate their eyes so that they might be helped to see."[11] Sachs's idea was to train "connoisseur-scholars." "A museum worker must first and foremost be," he stated, "a broad, well-trained scholar and a linguist, and then, in due course, a specialist."[12] He foresaw the end of a system in which museum directors went about their work empirically, like impresarios, and initiated in its stead a succession of "arts administrators" who would know how to talk to art patrons.[13] In the same way, the new American museum "should not only be a treasure house, but also an educational system."[14]

Sachs's Museum Course originated in the early part of the century, at the very moment a financial boom was sweeping the American economy. Collectors continued acquiring significant numbers of European artworks, museums sprang up around the country, and the United States developed an art market of unprecedented dynamism. Because of Sachs's training in the business world—he had left the family financial firm of Goldman, Sachs & Company to devote himself to an academic career—he understood better than anyone the importance of finance in managing a private cultural institution. "In every prosperous municipality in the land," he wrote, "in the next ten years the call is likely to come for thoroughly equipped curators and directors. Harvard must maintain its leadership in this new profession, the dignity of which is as yet imperfectly understood."[15]

Barr arrived at precisely the right moment to incarnate Sachs's ideal "guide," the one to lead the American people toward a new culture. But in his attempt to follow Sachs's model, Barr endured numerous conflicts, failing at times, succeeding at others. In the end, having surrounded himself with an effective infantry, a Junior Advisory Committee and the "young Turks" he brought into the museum, he managed to connect the American public with modern art.

At Harvard, Barr had joined a small group of students who would prove to be highly influential. Among them, Lincoln Kirstein—who had published his first novel, *Flesh Is Heir,* before even starting college—would soon found the magazine *Hound and Horn* as a "forum for art and poetry," publishing new essays on photography, music, architecture, and art in general, from such contributors as W. H. Auden, Ezra Pound, T. S. Eliot, and Edward M. M. Warburg. Eddie (as the latter was called) was the youngest son of the banker Felix Warburg, who had assembled an impressive collection of drawings by seventeenth-century Dutch masters in his Fifth Avenue apartment in New York. The younger Warburg did not share his father's tastes in either art or friends, and rarely missed an occasion to air these differences publicly.

On June 17, 1930, the *Boston Transcript* reported: "Despite its obsession with maintaining its prestige, Harvard today finds itself in a sad state compared to other universities around the country, mainly because of a sharp lack of professors and a suffocating excess of authority. The period of stimulating discussion between professors and students appears to be ended forever."[16] Class Day at Harvard was not ordinarily an occasion for polemic, nor for radical discourse; indeed, it was one of the country's most tradition-bound and self-congratulatory commencement ceremonies. Crimson banners flapped noisily against the massive columns of the Widener Memorial Library and Memorial Church, while America's oldest families gathered solemnly in their

finery to observe the faculty march, clad in their vibrant robes, overseeing the graduation exercises of the nation's future elite. The procession left Harvard Yard and wound its way toward Memorial Hall before penetrating Sanders Theater, decorated with stained glass and flanked by statues of philosophers. As per tradition, a dean led the assembled guests and students in a prayer, then turned the proceedings over to the class orators.

It was in this context that young Eddie Warburg, elected by his peers to give the student's Class Day speech, addressed the gathering on that June day. "Two rather embarrassed members of my audience," he later recalled, "were Professor Paul J. Sachs, outstanding member of the Department of Fine Arts at Harvard, and my father, a friend of Sachs'. In the early days of the new Fogg Art Museum they had worked hard together as a fundraising team to develop this institution. They normally hoped that on this day they would be given the opportunity to bask in the warm words of praise that souls waft in the direction of the speaker's platform."[17] Local papers such as the *Boston Transcript* and the *Boston Traveler* trumpeted the news that Warburg had taken to task Harvard's teaching methods ("Harvard Class Day Orator Raps Inefficiency in Teaching"[18]). Neither Kirstein nor Philip Johnson—an architecture student Barr got to know the following year—was fond of Sachs, whom they ironically baptized "Uncle Paul." Along with Warburg and John Walker—a student of Bernard Berenson's—they lent works from the collections of their friends and parents to the Harvard Coop, mounting the first exhibition of the Harvard Society for Contemporary Art, Inc., which some believe provided a model for the founding of the Museum of Modern Art.

When he invited Philip Johnson, Lincoln Kirstein, Eddie Warburg, and others into the museum's inner circle, Barr welcomed their ideas, their critical sensibility, and most of all, their love of provocation. "I just said to Alfred," Johnson later recalled about the exhibition entitled *The Art of the Machine,* " 'Wouldn't it be fun?' and Alfred said, 'It would be fun. Put it on.' Those were days of no bureaucracy. That was cooked up by Alfred and me just by sitting around."[19] In 1932, Barr entrusted Kirstein with mounting the exhibition *Murals by American Painters and Photographers.* Among the numerous works presented, Hugo Gellert's *Us Fellas Gotta Stick Together, Al Capone,* was the most provocative; it depicts three of the crown princes of American capitalism—J. P. Morgan, John D. Rockefeller (the father-in-law of one of the museum's founders), and Henry Ford—barricaded with President Hoover behind enormous sacks of dollars while Al Capone brandished his revolver at them.[20] The year before, Abby Rockefeller had asked her youngest son, Nelson, to sit on the museum's board. Though only twenty-three at the time, he had the delicate responsibility of explaining the mural exhibition to his grandfather and

his grandfather's friends. "Some of the trustees wanted Lincoln fired," remembered Eliza Parkinson, another young member of the museum's Junior Advisory Committee. "Nelson was marvelous; he backed Lincoln completely."[21]

Undoubtedly one of the best-informed men of his day, Barr profited from the constant advice of a network of friends, most of them veteran explorers of European art, who constantly fed him information. "Some astoundingly good pictures here: Manet, Chardin, Rembrandt, Matisse, Gauguin, Léger," Warburg wrote Barr in a letter from Stockholm. "We found Essen particularly progressive," Johnson wrote him in another. "We were thrilled by the sight of the Bauhaus. It is a magnificent building. I regard it as the most beautiful building we have seen of the larger than house variety. Beauty of plan and great strength of design. It has a majesty and simplicity which are unequaled. . . . Getting a much better education than in any architectural school in our country. . . . Klee exhibition in Dessau, Cézanne in Amsterdam, Matisse in Essen."[22]

A month before the opening of the Museum of Modern Art's first exhibition, the *New York Times* ran an editorial regretting that the museum's first show would be devoted to French art. "American artists will feel that they might have been given the earliest chance in an American museum of contemporary art to show what they can do."[23] During all his years at the head of the museum, Barr was the object of repeated attacks by the American Abstract Artists group and by Regionalist painters for what they saw as his European chauvinism. Nevertheless, the museum's first show, *Cézanne, Gauguin, Seurat, Van Gogh,* attracted, during the several weeks of its run in 1929, more than forty-seven thousand people, who came to see the thirty-five paintings by Cézanne, twenty-six by Gauguin, seventeen by Seurat, and twenty-seven by van Gogh, all on loan from the museum's trustees or private collectors in Europe and the United States. A journalist for the *New York Evening World* carped, "Art, in the imagination of the U.S., is a collection of Old Masters brought over from Europe at fabulous expense."[24] In *The Nation,* Lloyd Goodrich—two years before his appointment as the Whitney's chief curator—condemned the French school with virulence: "Seldom has there been such a crying need in the world of art for standards to correct certain popular tendencies. The modern French school, after years of bitter controversy, has conquered this country as it has every other. While there would be little dissent from the opinion that the art of France leads the world today as it has for the past century or more, it is also incontestable that we have carried our admiration for it to an absurd length, accepting almost without question anything which bears the cachet of Paris, exalting certain distinctly second-rate artists far beyond their desserts and in the process neglecting the art of every other country and to a certain extent our own."[25]

For the nation's own, neglected artists, Barr devised an alternative exhibition, *Paintings by Nineteen Living Americans,* which was a disaster, both critically and in terms of public perception. Why, it was asked, had organizers chosen Rockwell Kent, Charles Demuth, John Sloan, Max Weber, and Lyonel Feininger, instead of Robert Henri, George Bellows, and Arthur B. Davies? The directors of the new museum soon discovered that, as a writer for the *Evening Post* put it, "if dead artists are not the only artists, they are decidedly the safer ones to handle."[26] The Junior Advisory Committee entered the fray. "We criticized the trustees for emphasizing Europeans," remembered Eliza Parkinson, "and particularly [the country was] having a Depression and American artists needed help."[27]

Pursuing a democratic approach, Barr deftly negotiated between the wealthy and the professionals, the young and the old, the "noble gentry" financing the museum and the trustees guiding it. "Still another important factor," he wrote, "is the tendency on the part of the public to identify art with painting and sculpture—two fields in which America is not yet, I am afraid, quite the equal of France; but in other fields—film, architecture, and photography, for instance, the United States would seem to be the equal or superior of any other country."[28] By decompartmentalizing his museum, Barr offered an opportunity for American artists who used methods other than painting and sculpture to display their gifts.

Barr clashed with Conger Goodyear in particular over the construction of the museum's new building. Architecture was one of Barr's passions. While traveling in Europe, he had seen and admired much new Dutch and German architecture, and so he enthusiastically supported a proposal by his Harvard friends Philip Johnson and Henry-Russell Hitchcock to mount an architectural exhibition that remains one of the museum's greatest feats to this day: a showcase of the new International Style, featuring the work of Le Corbusier, Ludwig Mies van der Rohe, Walter Gropius, and J. P. Oud. This exhibition would prove to be one of Barr's most militant. A sort of architectural Salon des Refusés, it crystallized his complicity with those European architects against more conventional impulses—those, for instance, represented by members of the traditional New York Architectural League, whom Barr later attacked."[29]

It was the choice of an architect for the new building that set Barr and Goodyear in fierce opposition. "I have talked to Nelson today about Oud and von [sic] der Rohe," Goodyear wrote his young director, "and we have agreed: it would not be wise to suggest that either of them should be associated architects for our building."[30] The following day, Barr's assistant confirmed matters: "Philip Goodwin [the architect who had been selected against Barr's will] came out definitely against any foreign architect as collaborator . . . he will withdraw

if we go on."[31] At the very moment that Barr was meeting with the greatest European architects of the time, such as Oud, Mies, and Le Corbusier, and talking to them about building "his" museum, back in New York Goodyear had simply decided to hire an architect of lesser stature so long as he was American. Barr tried appealing directly to Nelson Rockefeller, to whom he felt closer than he did to Goodyear. "Did you not say that it would be fatal if Goodwin resigned?" he asked Rockefeller.[32] Then Barr contacted Goodwin himself. "I know," he wrote, "that some of our Trustees are strongly nationalistic in feeling. . . . Why should they be prejudiced against foreign architects? Mies. The greatest architecture of our generation. Le Corbusier more original and more brilliant. . . . The Museum, as a patron of modern architecture, cannot afford to run the risk of mediocrity in the design of its new building. It must have the superlative best."[33] In fact, Barr had already secured Mies van der Rohe's formal agreement to collaborate with him.

But Goodyear remained adamant. "TOO LATE TO CONSIDER ANY EURO-PEAN ARCHITECT STOP," he cabled. "GOODWIN USING STONE STOP GREATLY PLEASED WITH PRELIMINARY PLANS STOP NELSON CABLING STOP R FULLY G."[34] "The architecture controversy is too involved to write about," Barr wrote to his secretary a few days later, feeling disillusioned and bitter. "Neither Goodwin nor Nelson have answered a line, but I had a long patriotic cable from Goodwin who says that Stone has not been appointed collaborator, though Nelson telegraphed me that he had. The discrepancy is, I suppose, a matter of terms."[35] Several days later, he admitted to Joseph Hudnut, the architecture dean at Harvard, "I am almost (but not entirely) beaten in my struggle to hire van der Rohe. You are the only one who might help me turn the scales."[36] But the request was of no avail.[36]

This would prove to be Barr's greatest defeat. Within several years, nonetheless, using his contacts in both Europe and the United States, he had scored perhaps a greater victory by rejuvenating architectural instruction in the American schools. "I admire your initiative and your courage in breaking new paths in the tradition of architectural training in America," he wrote to Hudnut. "I wish you the best of luck in your search for a great teacher of design in Europe. . . . I hope you will have a successful trip in every way and that as a result a new era in American architecture may begin."[37]

During the course of his tenure, Barr had turned his museum into a traditional, historic *Kunstmuseum* with an important permanent collection, but by exhibiting the works of contemporary artists he had made it equally a *Kunsthalle*, creating departments of photography, film, design, and architecture as well as a publications department, a library, and, most important of all, a department for traveling exhibitions, with a team of editors and designers pro-

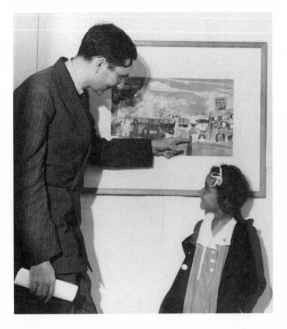

Alfred H. Barr, Jr., director of the Museum of Modern Art, as part of the museum's education program, introduces a little girl to one of the pictures in the exhibition *New Horizons in American Art* in autumn 1936.

ducing highly sophisticated catalogues for shows around the country. Later would come radio programs, such as *Art in America,* as well as a circular called *Art in America News.* Letters poured in from everywhere, many in response to the radio program. "*Art in America* is in pretty fantastic shape," Eddie Warburg wrote to Barr. "Perhaps the only drawback is that everybody gets the feeling that the museum is seen as a necessary Rock of Gibraltar, as far as Art is concerned, and that it has established itself so well, that obviously it must be backed by millions, and therefore there is no need to contribute."[38] Indeed, it almost seemed as if the museum might be a victim of its own success. A lecture series was inaugurated, and crowds poured in.

"On October 17 Gertrude Stein sailed back to the U.S. after 30 years," the *Herald Tribune* announced. "She is aged 60 and she will remain there until November 17. She will give a talk at the MoMA on November 1, 1934. She was congratulated at the Algonquin by Alfred Barr."[39] After only five years of existence, the Museum of Modern Art, with its lecture series and grand historic retrospectives, had become the country's major cultural center. In 1936, two such important shows occupied the museum's four floors. For *Cubism and Abstract Art,* Barr had drawn a "chart of modern art" on the catalogue's cover, visualizing the scope of modern artistic trends, depicting the birth of modern

art from 1890 to 1935. In *Fantastic Art, Dada, Surrealism*, he had included works by Hieronymus Bosch and Arcimboldo as well as drawings by children and the mentally ill.

Reflecting on the museum's organizational structure, Barr identified two distinct types of activity—production and distribution—writing at one point: "Basically, the Museum 'produces' art knowledge, criticism, scholarship, understanding, taste. This is its laboratory or study work. . . . This preparation or 'production' work is the stuff of which the Museum's prestige is made. . . . Once the product is made, the next job is its distribution. An exhibition in the galleries is distribution. Circulation of exhibition catalogs, memberships, publicity, radio, are all distribution."[40] He had managed to maintain a balance between temporary exhibitions, based on the German *Kunstverein* model, and the permanent collection, modeled after those at the Tate Gallery in London and the Musée du Luxembourg in Paris. And he had done it on his own terms. In 1933, in a brochure entitled *Theory and Contents of an Ideal Permanent Collection*, Barr outlined his ideas in Gallic terms: "The Permanent Collection may be thought of graphically as a torpedo moving through time, the blunt end pushes into the advanced field of art by means of the changing exhibitions. The bulk is made of accepted modern art. The tail tapers off into art which has become classical and is ready for the general museum. The torpedo moves forward by acquiring, and retails its length of 70 years by giving to other museums. Its strong and well-proportioned permanent collection gives body to the Museum and supplies a background to any changing exhibitions. . . . A torpedo moving through time, its nose the ever advancing present, its tail the ever receding past of fifty to a hundred years ago. If painting is taken as an example, the bulk of a collection, as indicated in the diagram, would be concentrated in the early years of the 20th century, tapering off into the 19th with a propeller representing 'background' collections."[41]

Seven

"America Without That Damned French Flavor": Modernism in the United States

I N 1921, Duncan Phillips offered the city of Washington, D.C., both his
private home and his art collection; it would become the Phillips Collec-
tion. "It is worthwhile," he proclaimed, "to reverse the usual process of popu-
larizing an art gallery. Instead of the academic grandeur of marble halls and
stairways and miles of chairless spaces, with low standards and popular attrac-
tions to draw the crowds, we plan to try the effect of domestic architecture, or
rooms small or at least livable."[1] One of the first great collections in the United
States to privilege modern art, the Phillips Collection had been constituted in
a highly personal manner, built up through investigations that were at once
painstaking and contradictory. The Armory Show, with all of its confusion and
chaos, had given him a near distaste for van Gogh and Matisse, although later,
at his own pace, he would acquire their canvases as well. In addition to paint-
ings by Cézanne, Matisse, and Bonnard, he had acquired works by the Spanish
masters Goya and Velázquez, as well as some by nineteenth-century French
innovators such as Manet and Daumier and such American modernists as
Dove, Marin, and Hartley.

Progressively, as it seemed less and less important to imitate Europe slav-
ishly, Americans amassed collections that merged contemporary American
paintings with European masters. Very often, the riskiest acquisitions were
influenced by the collectors' wives: Marjorie Phillips was a painter, and Maud
Dale, the wife of Chester Dale, was an art historian. Eclectic but consistent,
the Dales' collection, eventually offered to the National Gallery (of which
Chester Dale was president), included works by former members of The
Eight, such as Henri, Luks, and Bellows; American Impressionists, such as
William Merritt Chase and Mary Cassatt; Manet, Degas, and Renoir; Post-

Impressionists, like Gauguin, Picasso, and Le Douanier Rousseau; and artists such as Modigliani and even Salvador Dalí.[2]

First and foremost, these collecting couples frequented the gallery run by Alfred Stieglitz, whose own work as a photographer had been influenced by Georgia O'Keeffe. O'Keeffe, whom he had met in 1916, spoke proudly about the "Great American Thing,"[3] urging the new generation to remain in the United States and to champion American art: "I knew that at that time— before WWI—almost any one of those great minds would have been living in Europe if it had been possible for them. They did not want to live in New York. How was the Great American Thing going to happen?"[4] Similarly, Thomas Eakins, from 1914 on, had encouraged artists to stay in America: "If America is to produce great painters, and if young art students wish to assume a place in the history of the art of their country, their first desire should be to remain in America to peer deeper into the heart of American life."[5] Starting in 1923, Stieglitz would commit himself deliberately to the art of "America without that damned French flavor."[6]

The change in Stieglitz's tastes became quite apparent in 1925, when he opened the Intimate Gallery, at 489 Park Avenue, which he intended to devote exclusively to American artists. Of course, many of them, such as Dove, Hartley, and Marin, were veterans of 291 and had been comrades of Steichen's in Paris. Photographs by Paul Strand and Stieglitz reflected the gallery's American identity, as did paintings by O'Keeffe and Oscar Bluemner. None of these artists had been directly influenced by Europe, even if their pastel-colored canvases, abstract representations of the American landscape—and more specifically the American West—sometimes resembled the work of the Symbolists.

Modernism, inseparable from the forceful rise of American industry, profoundly established itself throughout the country in a variety of disciplines in full expansion, such as design (often called the "applied arts"), which entered American homes on a daily basis. Furthermore, the glorification of the machine, which had been emblematic of the European avant-garde—as in the works of Marcel Duchamp, Fernand Léger, and the Italian Futurists—was taken up again in the United States with an energy and daring that largely overtook the European positions. In 1927, for example, the *Machine-Age Exposition* would mark a decisive step in the establishment of Modernism. The show, organized in a banal office on Fifty-seventh Street by Jane Heap, co-editor of *The Little Review,* and a selection committee, brought together works by such artists as Alexander Archipenko, Charles Demuth, Marcel Duchamp, Hugh Ferris, Louis Lozowick, Jean Lurçat, Elie Nadelman, Man Ray and Charles Sheeler. Eschewing a hierarchical organization, the show presented an iconoclastic selection of works from the United States, Austria, Belgium,

France, Germany, Poland, and Russia: art objects (photographs and paintings) shown with utilitarian objects (radios, fans, guns, car engines, light bulbs). For the first time, "the hero was not the decorator but the engineer" and the "dynamic beauty of the machine." The same theme was expressed on the cover of the catalogue, a painting commissioned from Fernand Léger, an abstract design evoking the wheels of a machine. The artists represented in the *Machine-Age Exposition*—former students of Matisse; those who had known Picasso and Rousseau; those who admired Braque and Derain; New York painters influenced by Duchamp, Picabia, and Gleizes; and those who had been converted to Modernism by Stieglitz's gallery and by the Armory Show— all participated equally, together making up a new generation. With this event, they attested to the development of a new aesthetic. After having integrated the lessons of the most innovative European masters, they pushed on and proposed an American version of Modernism.[7]

From now on, America itself would be the central theme of their work: brightly colored fragments of cityscapes, skyscrapers, bridges, and amusement parks for Joseph Stella; street scenes and graphic language in a synthesis of Cubism and Matisse's colors for Stuart Davis and Patrick Henry Bruce; industrial forms inspired by Fernand Léger for Gerald Murphy; everyday objects rendered in a Cubist manner for Max Weber; a geometric abstraction that would later be called Precisionism for Charles Demuth, Charles Sheeler, Preston Dickinson, Ralston Crawford, and Niles Spencer; technological objects or mechanical abstractions rendered in Duchampian fashion for Morton Livingston Schamberg, Man Ray, and John Covert.

Little by little, those returning from Paris would be criticized for a style too imitative of French artists: "American artists who sought to continue the discoveries of Paris were denounced as un-American."[8] Thus Noguchi—who lived in France from 1927 to 1929—was severely accused on his return to the United States of being nothing more than a "copyist of Brancusi,"[9] with whom he had worked while he was in Paris. Stieglitz would also reproach Hartley for being too seduced by France: "You have really made no practical contact in Europe and you are really without contact in your own country,"[10] he would hear. As for Calder, who divided his time between Paris and New York from 1926 to 1933, he was one of the rare Americans of this generation to profit from his Parisian experience, forging a style that was very personal, even revolutionary, in abandoning painting for sculpture made of steel wire.

In fact, conscious that they bore something new, these artists felt liberated from European influence. When Stuart Davis returned to Paris in 1929, he felt able to "denounce the discouraging rumor that there were young modern painters in Paris whose work surpassed by far that of their American equiva-

lents. . . . The work that is being done in New York is every bit as good as the best over there."[11] Two other Henri students, Edward Hopper and Guy Pène du Bois, whose everyday scenes, painted in a Realist manner, showed an America often in despair, agreed with Davis. "If an apprenticeship to a master has been necessary," declared Hopper, "I think we have served it. Any further relation of such a character can only mean humiliation to us. After all we are not French and never can be and any attempt to be so, is to deny our inheritance and to try to impose upon ourselves a character that can be nothing but a veneer upon the surface."[12] At the same time, the return to classicism—which had overtaken Paris at the end of World War I and was holding back abstraction and Modernism there—hardly affected the United States.[13] But something was different, something essential: the construction of a true American art, free from European influence, was under way.

As far back as 1927, in Hartford, Connecticut, A. Everett Austin, Jr.—"Chick" as he was known to most—had tackled the destiny of the Wadsworth Athenaeum, which defined itself as the "oldest public museum in the United States."[14] In just a few years, he committed himself to an ambitious transformation that would affect every aspect of the museum—the building's architecture, its permanent collection, its temporary exhibitions, its function, the taste of the local public, and the definition of art. He explained in the local newspaper, "It is the duty of a museum to show, by means of loan exhibitions, the manifestations of the art which is living, and which is being produced around us, the very moment almost, that we are observing it. So also it is the duty, nay the passionate interest of the intellectual mind to observe all these manifestations. Whether to like them or dislike them is another matter, but to see them is all important."[15] With his vision and his determination, as well as conviction, imagination, fantasy, and erudition, Austin succeeded in his mission—to enrich the Wadsworth so that it would become for Hartford both a Metropolitan Museum of Art and a Museum of Modern Art.

Austin understood that this city in central Connecticut, which until then had prided itself on simply being "the insurance capital of the world,"[16] possessed considerable, latent financial resources. He knew that, with a bit of skill, he could use his trustees' goodwill to make Hartford one of the country's most exciting centers for Modernism. Two years before Alfred H. Barr, this Harvard-educated twenty-seven-year-old, who had traveled in Europe and mastered four foreign languages, became a museum director and gave his imagination free rein, explaining on occasion that "visitors have, in reality, a right to find excitement in a museum as well as in a movie theatre."[17] He had the mad "goal of making the Athenaeum a cultural center so alluring that it would draw even Europeans to Hartford."[18] Certainly, he succeeded on the night of February 8,

1934, with the simultaneous premier of Virgil Thomson and Gertrude Stein's opera *Four Saints in Three Acts* and the opening of a Picasso exhibition unique in America.[19]

To a new building constructed in the International Style and important acquisitions—from Tintoretto to Pietro da Cosimo—Austin would add a unique schedule of exhibitions, the likes of which had never before been seen in the United States. In addition to presenting Dalí and the Surrealists in an exhibition entitled *Newer Super-Realism*[20] and the first American museum exhibition devoted solely to Picasso, he revealed his progressive attitude by integrating the great masters of traditional European art with contemporary art, as in the exhibition *Landscape Painting* in December 1930, where Sassetti's *Procession of the Magi* was shrewdly juxtaposed with paintings by Mondrian and Hopper.[21] He alternated classical exhibitions with enormous range and depth, such as *French Art of the Eighteenth Century* and *Italian Painting from the Sei- and Settecento* with others revealing the marvels of contemporary art, such as *Modern Mexican Art, Modern German Art,* and *Selected Contemporary French Paintings;*[22] he opened museum space to photography, to music—in a program he called "Friends and Enemies of Modern Music"[23]—to cinema, to architecture, to dance, to opera. This impressive series of achievements revealed, little by little, his Modernist ambitions.

"It must not be forgotten that the battle over modern art was won in Europe many years ago," he wrote in an article in 1929. "The ideas expressed in the paintings are not new—they only appear new to us because we have had so little opportunity to become acquainted with them and because of the unfortunate newspaper publicity which has accompanied the exposures of such paintings as the *Nude Descending a Staircase.* . . . We are very inclined to make fun of the things that we do not understand or are not familiar with, as part of what psychologists term a protective mechanism. . . . One of the most stimulating things about art is that intelligently studied it helps people in thinking for themselves and in developing their powers of selection."[24] Alongside such personalities as Lincoln Kirstein, Philip Johnson, James Thrall Soby, Eddie Warburg, and others, Chick Austin accomplished in Hartford one of the most exceptional advances in European Modernism, in an environment that, until then, had remained rather provincial and conservative.

Another figure to help the Modernist cause was Earl Horter, an important Philadelphia collector, whose enthusiasm played an important role in getting the public to embrace contemporary art. A successful advertising artist and printmaker, Horter, one in a handful of American collectors, had a passion for European Modernism, in particular Analytic Cubism. In all, his collection combined masterpieces of modern art—paintings and collages by Braque,

Brancusi sculptures, Picasso's *Portrait of Daniel-Henry Kahnweiler,* Duchamp's *Nude Descending a Staircase,* works by John Marin, Charles Sheeler, Joseph Stella[25]—with his other passions, African and Native American art and artifacts. His devotion to the local painters in Philadelphia, notably Arthur B. Carles, whose paintings figured prominently in his collection, had a strong impact on the advance of Modernism, and on the young American artists in his community.

While Alfred Barr was struggling in vain to enlist a European architect to design the Museum of Modern Art, new museums were emerging in municipalities around the country. This second generation of American museums, which featured modern architecture (rather than neoclassical), would be consecrated to collections that did not limit themselves to past masters but welcomed modern and contemporary painters. Between 1933 and 1942, more than fifty such institutions for modern art opened their doors, adding to the first wave of construction in cities as varied as Des Moines, West Palm Beach, Hartford, Colorado Springs, and Dallas. The underlying conception of the American museum, run like a private business with an enthusiastic staff, normally involved retaining the egalitarian spirit Tocqueville had noted in those "benevolent institutions" that "anchored American democracy."[26] Yet how each museum was managed varied from city to city—either it could be entirely private, as was the case with Kansas City, or a combination of public and private, as was the case in Cleveland, or entirely public, as was the case in Detroit.

At the beginning of the 1930s, a lively dialogue began over what role the museum should play; among those to offer his thoughts was the theater designer Lee Simonson, who noted that museums in America had been viewed, until then, as "warehouses for the protection of art objects," and that their directors had never thought about either their organization or their social function. He therefore proposed that the time had come to invent "popular presentations using a modern technology"[27] and argued that, "unless they are structurally reconceived, the really formative moments in the development of American taste will be . . . when increasing hordes of . . . travelers stand for the first time under the columns of the Parthenon, or see the roseate temple, der ell Bahari, across the Nile at Luxor."[28] A transformation in American museums would begin during these years, turning what had been a "heterogeneous educational warehouse" into "an engine designed to generate culture rather than simply preserve it."[29]

John Cotton Dana, the director of the Newark Museum, was a true missionary in this regard. In his book *The Museum as Patron,* he denounced museums "constructed to imitate Europe, and which perhaps might bring prestige to the host cities and attract tourists, but did nothing for students." Dana pro-

posed in their stead an institution designed to serve the community, and where programs and activities would be determined by local needs: "vibrant education centers for a dynamic community" that would "fit in above all with the work of local artists." In Dana's view it was unfortunate that "most American museums attempted to erase all trace of local art."[30] In fact, Dana was the first museum director to mount a full retrospective of the work of Max Weber, in 1913.

H. L. Mencken called Chicago "the only genuine civilized city in the New World."[31] It was here that the Armory Show went after its New York run. Oddly—though perhaps symbolically—the director of the Chicago Art Institute, William M. R. French, had been in California for the entirety of the Armory Show. "I shall save myself a great deal of mental wear and tear," he wrote to Sara Hallowell. He argued mysteriously, "We are about to bring the best part, meaning the worst part, of the Post-Impressionist show here."[32] In 1912, there were only ten art galleries in Chicago. One of them, directed by W. Scott Thurber and designed by Frank Lloyd Wright, offered Chicago's first exhibition of the work of Arthur Dove, soon after its appearance in Stieglitz's New York gallery. It featured his powerfully architectural works, inspired by Matisse, Cézanne, and the Fauves in general. Only one of Dove's paintings, *Based on Leaf Forms and Spaces,* was bought, by Arthur Jerome Eddy, a worldly Chicago lawyer whose full-length portrait had been painted by Whistler in 1894 and who wrote the first important book on Cubism in the United States, *Cubists and Post-Impressionism* (1914). "The keynote of the modern movement in art is expression of self," Eddy wrote, "the representation of one's inner self as distinguished from the representation of the outer world."[33] Eddy attempted to convince his friends to share his passion for Kandinsky, whose work he vigorously defended in *The Image of the Spiritual in Art.*

Despite the Dove exhibition's disappointing sales, Chicago's critics immediately grasped the show's importance in inaugurating a new era. "Mr. Dove brings to Chicago the message of the autumn salon," wrote Harriet Monroe. "Modern minds, he thinks, are reaching out toward an art of pure color and form dissociated from 'representation.'"[34] "Dove's groping was what Les Fauves are doing in Paris, in London, in America," wrote George Cram Cook in the *Chicago Evening Post*'s Friday Literary Review. "This is the real creative impulse of our century."[35] In the years to follow, Chicago would benefit from a confluence of happy circumstances: literary and aesthetic currents would merge in the city, transforming it forever.

These conditions gave rise to the emergence of several interesting publications. *The Dial,* a literary magazine edited by Francis Fisher Browne, the owner of Browne's bookstore, was succeeded by the radical, interdisciplinary journal

The Little Review, founded by Margaret Anderson and Floyd Dell in 1913. Young and militant, Anderson wanted her publication to integrate all the current trends in poetry, literature, theater, the visual arts, and progressive politics in general; and she would publish—in several cases, for the first time in the United States—pieces by Joyce, Cocteau, Eliot, and Pound, among others. Anderson would become a charismatic leader among Chicago's most innovative thinkers. "Our culture—or what little we have of such a thing—is clogged by masses of dead people who have no conscious inner life," she explained.[36] Some time later, in an article entitled "Art and Anarchism," she resumed her argument. "An anarchist is a person who realizes the gulf that lies between government and life; an artist is a person who realizes the gulf that lies between life and love."[37] The magazine's co-founder, Dell, interpreted the significance of the Armory Show by comparing it to a bomb that "exploded . . . within the minds of everybody who could be said to have minds. For Americans it could not be merely an aesthetic experience, it was an emotional experience. . . . It brought not one gospel, it brought half a dozen at least and from these one could choose what one needed."[38]

The battle over Modernism in Chicago was waged in the press as well, fueled by two critics, Eleanor Jewett and Clarence J. Bulliet. Jewett, a rather conventional woman, raged against Modernism in the *Chicago Tribune,* throwing her support behind Josephine Hancock Logan's moralistic book *Sanity in Art.* Bulliet, who wrote for the *Chicago Evening Post,* invented a supplement for the daily called *Tuesday Art Supplement,* subtitled *The Magazine of the Art World.* In the first issue, Bulliet loudly proclaimed Chicago as "the art center of America."[39] Later, in his book *Apples and Madonnas,* which went through several printings, Bulliet favorably compared Cézanne's work to Raphael's.[40] Between 1920 and 1928, three groups of artists emerged in Chicago: one, the Cor Ardens, formed in the late summer of 1921 by Raymond Jonson and Rudoph Weisenborn; the No-Jury Society, founded under the inspiration of John Sloan and based on the motto of the Salon des Refusés, "No jury, no prize"; and the Neo-Arlimusc group, which proposed "an informal meeting place for all artistic workers." A series of exhibits, lectures, and even several Cubist balls took place in 1923 and 1924.[41]

Others, too, left their imprint on Chicago's artistic community. In 1930, Katharine Kuh, five years after returning to Chicago, opened one of the country's most active galleries, welcoming European emigrés such as Ludwig Mies van der Rohe, László Moholy-Nagy, and Gyorgy Kepeš. Rue Winterbotham Carpenter and Alice Roullier revamped the Arts Club of Chicago during the 1920s, making it somewhat similar to Stieglitz's 291, exhibiting works by Rodin, Braque, Picasso, and Nadelman. But the advent of Modernism in "the

only genuine civilized city in the New World" was not without its setbacks. For example, after Arthur J. Eddy's death, his collection of Cubist paintings was sold and dispersed, lost to the city of Chicago. In 1921, the Art Institute possessed only two twentieth-century European works. Four years later, however, thanks to donations and bequests, it would become one of the country's richest museums in modern paintings. Frederick Clay Bartlett, an active and visionary collector who believed that the museum's highest and greatest purpose was "the education of taste" rather than the "transmission of history,"[42] gave his entire collection to the Art Institute. He had personally supervised the framing and hanging of "his" paintings, stressing his theory that these works most revealed their beauty "when framed in simple well-proportioned moldings in a tone of white" rather than in "ornate molding of the various Louis."[43] At the Century of Progress Exposition in Chicago in 1933–34, it was clear that Modernism had arrived at the Art Institute. "There has never been in the history of the country so rapid an advance of taste in so short a time. We can begin to be proud of ourselves,"[44] wrote Forbes Watson in the *Literary Digest* in 1934.

The Broadmoor Art Academy in Colorado Springs was founded in 1919 by Mr. and Mrs. Spencer Penrose in their own home, at 30 West Dale. Penrose, an industrialist, had built the city hall and the road system around Colorado Springs, and now offered his wife, Julia, the opportunity to realize her lifelong dream: establish a painting school and a community center for music, theater, and dance. This institution was yet another example of the powerful effect that women had on Modernist advances during this period. The Broadmoor Academy would metamorphose with the arrival in 1930 of Betty Sage Care, an avant-gardist from New York and a former member of Mabel Dodge Luhan's circle, who had just been elected head of the school's board of trustees. She decided to appoint a new director, Boardman Robinson, an experimental painter who had studied in Paris under Gérôme but whose tastes tended toward Whistler and Manet. In Paris he had married Sally Whitney, and frequented the salon of Frederick Keppel, Sr., with his superb collection of prints by artists from Rembrandt to Whistler.

Robinson was also a man of radical political beliefs who, in his capacity as a magazine illustrator, had followed John Reed to Russia during the revolution there. To the Broadmoor, isolated in the Rocky Mountains, he invited all manner of American Modernist artists, including Willard Nash, one of the Taos "Cincos Pintores." In 1929, Nash exhibited his Cubist-inspired watercolor series *Dancing Indians,* which had influenced Andrew Dasburg during one of Dasburg's first trips to New Mexico. In an interview, Diego Rivera later argued that "the watercolor by Mr. Nash, although it is affiliated to the French school,

is . . . proof that the American personality in art does exist and can express itself in spite of the School of the artist."[45] On January 5, 1935, the new Colorado Springs Fine Arts Center was inaugurated in impressive fashion: for some, the city was becoming a "Boston of the West."[46] Still, during the inaugural ceremony, attended by Martha Graham, some members from the community balked at the scene before them. A local doctor, standing in front of a Brancusi sculpture, wondered aloud whether "it was supposed to represent a bird or a suppository."[47]

An artists' group also emerged in Texas, one that managed to combine local themes with Modernist aesthetics—the Dallas Nine. Among its members, Alexander Hogue, who had studied with Blumenschein, modeled himself on Whistler, and despised Regionalist painters with their mediocre scenes of wildflowers or, as in the work of Frank Reaugh, cowboys. Hogue harangued American painters, paradoxically urging them to free themselves from European convention while simultaneously advising them to study Cézanne. "To be outstanding, their art should be indigenous," he argued. "The American artist in general will come of age when he has the stamina to blaze his own trails through the part of his country in which he lives."[48] French painters painted the world they found around them; local artists should paint the Texas landscape, which offered, according to Hogue, more than the "pretty stagey things around Taos."[49]

While Hogue's paintings were hanging at the Allied Arts Exhibition in Dallas in March 1933, John William Rogers of the *Dallas Times Herald* urged the city's citizens to go look at these works, "all created by men and women you see about every day." "To those who call Dallas home," Rogers went on, "this exhibition has a significance that a collection of the finest masters in the Louvre would have, because here we find the living art . . . born of our lives and our environment." "The modern dominates the traditional so strongly that the effect is startling," a journalist from the *Dallas Morning News* chimed in.[50] Hogue beamed with pride; several of his paintings had been bought by the Musée du Jeu de Paume in Paris. Another member of the Dallas Nine, Jerry Bywaters, who had studied with John Sloan, combined abstraction and local color in his impressive canvases, such as *Procession of the Saints;* while Otis Dozier, who had been converted to Modernism after reading *The Dial*—the local literary magazine—evoked the local black population, as in *Deep Arm (Black People)* or his sculpture *Negro Head,* 1935. Thus bit by bit, the tools derived from Modernism constructed an artistic language that allowed expression of the American reality.

Modernism arrived in California in 1915, the date of the Panama-Pacific International Exposition, where the Divisionists and Post-Impressionists

would be discovered simultaneously. Stanton Macdonald-Wright, landing in California in 1920 after a trip to Paris, announced Modernism's presence on the West Coast. "Today, knowledge travels fast . . . Thus modern painting is not the isolated effort of a few men but another story added to the always growing edifice of art."[51] In 1922, the architect Frank Lloyd Wright's son organized the exhibition *Painting of American Modernists* at the Museum of Science, History and Art in Exposition Park in Los Angeles. In 1921, the Arensbergs left New York to settle in Los Angeles, despite their relative dislike for the city, which they found at once "provincial, superficial," and corrupted by "bad taste or advertising." "I am ashamed to live in a town where they do not react to some such God given opportunity,"[52] wrote Louise Arensberg to one of her friends in the early 1930s, criticizing the lack of discernment on the part of the galleries and potential patrons.

In 1929, in a letter to Sonia Delaunay, the founder of the U.C.L.A. art faculty, Annita Delano, told her that "the architectural clubs and the painters and sculptors, are all debating about the modern trend." If she deplored a certain sluggishness, she nevertheless sensed an imminent awakening: "They are so slow," she wrote, but "the great raw country—so new, so provincial in some ways—but waking up."[53] Noting as well a significant recognition of architecture and design, she declared: "In architecture, here in LA, there are a few leaders. Quite a number of buildings by Frank Lloyd Wright and some by his son. There are two men, RM Schindler and Richard Neutra, who represent tendencies similar to Le Corbusier and Gropius. So, you see, we have a miniature group pounding at the conservatives."[54]

In fact, following New York's example, Los Angeles attracted numerous European artists fleeing the rise of Nazism in the 1930s. German culture, as well as British and Russian—with the emigration of such notable figures as Thomas Mann, Bertolt Brecht, Aldous Huxley, Igor Stravinsky—marked the West Coast more profoundly than it did New York, which remained stubbornly under French influence. Art dealer Galka Scheyer, a key figure of this new California trend, exhibited works by three European Modernists—Kandinsky, Jawlensky, and Paul Klee—together with several by Lyonel Feininger, and created for them a group she named the Blue Four. In the winter of 1927, she presented in her Oakland gallery another show of European Modernists, including Fernand Léger. Later, California's singular cultural character found itself even more enriched, thanks to the contributions of Mexican painters arriving from the south. Soon, in San Francisco, one would be able to admire murals by the likes of Diego Rivera, José Clemente Orozco, and David Alfaro Siqueiros, who would serve as veritable models for the W.P.A. programs.

In Taos and Santa Fe, other American painters returning from Europe,

such as Andrew Dasburg, Marsden Hartley, and John Marin, developed their own Modernist enclaves across the country—more often than not with the support of avant-garde women. For better or for worse, the Modernist sensibility had found its way into certain museums and regions. Converting the public was often a different matter. "I have been trying to explain some of Hartley's pictures to the elite of Buffalo," a frustrated Dasburg wrote in a letter, "and believe me it is like trying to convert a Methodist into a Buddhist."[55]

Albert Barnes of Philadelphia, who had made his fortune in pharmaceutical products, was one of the most impressive collectors of the time. In the suburb of Merion, he assembled an extraordinary collection that defied local aesthetic inclinations. It included works by Tintoretto, Rembrandt, and El Greco; English Gothic furniture; superb canvases by Cézanne, van Gogh, Picasso, and Seurat; and a mural created by Matisse especially for him, *Dance,* 1931–33. In 1920, Katherine Dreier started her Société Anonyme with help from Marcel Duchamp and Man Ray, and despite a tiny operating budget, she spread the word about Modernist works. Klee, Miró, Léger, and Kandinsky all received their first solo exhibitions in the United States thanks to Dreier's efforts. "What was needed," explained Duchamp, "was to bring over paintings that permitted a confrontation of values . . . A comprehensive state of mind regarding contemporary art . . . It is from their efforts that the resolutely modern attitude of today's America will emerge in matters of art."[56] Both Duchamp and Man Ray left the United States in 1921, but Dreier perpetuated their Modernist cause single-handedly, creating a museum devoted to avant-garde art from both Europe and America. "I feel that we are doing the work which the Metropolitan Museum ought to be doing," she stated bluntly.

The most revealing testimony to the difficulties Modernism faced while gaining acceptance in the United States, however, involved a lawsuit brought by Brancusi against American customs officials, who in 1927 had refused to let his sculpture *Bird in Space* enter the country duty-free, maintaining that it could not truly be defined as a work of art. Edward Steichen, who had invited Brancusi to exhibit at 291, was called upon as "importer of the product" to testify at the hearing. Judge Waite interrogated Steichen. "What makes you call the sculpture a 'bird'? Does it resemble a bird for you?" "It does not literally resemble a bird," Steichen replied, "but I feel it to be a bird, and the artist defines it as a bird." The judge insisted, "Is the artist's simply calling it a 'bird' enough to make it a bird?" "Yes, Your Honor," came the affirmative reply. Judge Waite pressed on: "If you spotted the sculpture in the street, would you call it a bird?" Steichen responded with silence. Another judge, named Young, intervened. "If you were to come upon the object in the forest, would you photograph it?" "No, Your Honor," Steichen responded. The progress of the ques-

tion did not bode well, but when the verdict was announced on November 26, 1928, Judge Waite acknowledged that a "so-called modern school of art" had developed, and moreover that its object represented more than simply imitating natural objects. Whether or not one was sympathetic to avant-garde ideas or the schools that promoted them, added the judge, their existence and their influence remained undeniable facts that the courts must recognize and take into account.[57]

Alfred Barr's efforts to create in New York a new kind of museum, and the sudden outcropping of museums around the country, fed the same movement: the spread of Modernism in the United States. But another national movement arose in parallel, becoming stronger with the increasing economic crisis—that of a Regionalist American art. On December 15, 1935, a statement appeared in *Art in America News,* under the heading "Contemporary American Art": "There is growing demand for a distinctive note of Americanism in art. Twenty-one years since the Armory Show's epoch-making event. Artists are recording on canvas the daily drama of American life; every aspect of the American life is respected. . . . Public Works of Art Project inaugurated by the government in December 1933 and continued until April 34 brought life and art together in a very practical way throughout the country. . . . It was a democratic art movement that recognized the artist as a useful citizen and his work as a valuable asset to the state."[58] Faced with Modernist works influenced by European art, some artists would respond with work anchored in the American experience. The question was whether or not two such very different movements, at once antagonistic and complementary, could co-exist on American soil.

Eight

"Warning: Men at Work"

I will fall in love with a Salem tree
And a rawhide quirt from Santa Cruz,
I will get me a bottle of Boston sea
And a blue-gum nigger to sing me blues.
I am tired of loving a foreign muse.[1]

AROUND THE 1920S, writers, poets, and painters were singing America's beauty. After World War I, the United States enjoyed enormous prosperity, followed by years of reactionary nativism, during which conservatism, the "Red Scare"—fear of Communist revolutionaries—and a distrust of immigrants spread throughout the country. A new attitude toward immigration surfaced, along with the successive passage of three highly restrictive laws: the Immigration Act of 1917; the Emergency Immigration Act of 1921, which established quotas; and a more restrictive quota law in 1924, the Johnson-Reed Immigration Act, which made permanent a national quota system, based on national origins for the American people. This last legislation set a permanent limitation on the number of new immigrants entering the country after 1929, in order to preserve the "magic" proportion of the United States's population as of 1920, mirroring the harmony of its original cultural blend.

It was, in a sense, a return to America's roots. Distinctly local aesthetics were evolving, with new and different subjects discovered in each individual state. *In the American Grain,* a collection of essays by William Carlos Williams, sat on nightstands in millions of households. His character Boone, who crossed the state of Kentucky, declared his passion for the landscape and its inhabitants. "In the woods," wrote Williams, "[Boone] always preferred the company of an Indian to that of his own son; these men, the Indians, treated him with the greatest respect. . . . In all his soul, he had decided to devote his body and goods to this soil of the New World he adored, and that he believed to be, in every way, the cherished land of his heart."[2]

Robert Henri had exhorted his students to paint what they perceived around them. But after the Armory Show, a "chilly wind from the East" had chased the urban Realists toward the West, the Midwest, and the South. "No American art," declared one of those Realists, Thomas Hart Benton, "could be produced by an artist if he doesn't live in an American way, if he doesn't behave as an American, and if he does not find in America his reason to live."[3] With such guides as Henri and Benton, a new path opened up, a local school that embraced rural and regional scenes. Edward Hopper, Charles Burchfield, Ben Shahn, Thomas Benton, Grant Wood, John Steuart Curry, Reginald Marsh, Raphael Soyer, Katherine Schmidt, and Isabel Bishop were among those who took stock of the local reality and their American countrymen. "Several years ago," a 1934 *Time* article explained, "a number of great American artists satisfied themselves by turning to France and copying their academic canvases, usually provoking either anger or confusion on the part of the public. These days," the article continued, "most high-quality American painters find inspiration in their native country, and discover themes as interesting as they were beautiful, on the Kansas farms, in the Iowa wheat fields, or in the Manhattan slums."[4]

American folk art became fashionable among some American middle-class collectors. A certain patriotism—a particular chauvinism associated, at times, with an anti-Modernist sentiment—would engender nostalgia during those years, and a return to Americana. By the mid-1920s, Electra Havemeyer Webb, the third child of Harry and Louisine Havemeyer, had amassed a substantial collection of folk-art objects, and with them decided to establish a museum. Henry Francis du Pont had assembled Early American furniture and objects. Elie Nadelman, a Polish-born sculptor who had emigrated to the United States from Paris in 1914, preferred popular art objects. Abby Aldrich Rockefeller began collecting folk art and art naïf, including paintings, etchings, embroidery, and basketry. In 1930, Holger Cahill organized an American folk art exhibition at the Newark Museum. Some collectors of such work, including Abby Rockefeller, Elie Nadelman, Charles Sheeler, and Joseph Hirschhorn, managed to reconcile their passion for Modernism with one for folk art, an interest that was encouraged by Edith Halpert, who opened her American Folk Art Gallery in 1931.[5] Even the Arensbergs became interested in American Colonial furniture. But while the prevailing economic prosperity and industrial development that made much of this production possible seemed likely to endure indefinitely, it all came to a halt with the stock-market crash on October 28, 1929, a shock that closed half the country's banks and left vast numbers of Americans without employment.

When Franklin Delano Roosevelt took office on March 4, 1933, thirteen million people were unemployed, and one to two million of these were itiner-

ant workers, squatting in makeshift shantytowns on the perimeters of large
cities. Since the crash, the economy had remained at a standstill, 42 percent
of the country's banks were still insolvent, and unemployment was at its all-
time peak. Little wonder that the Republican incumbent, Herbert Hoover,
had lost in a landslide to his Democratic challenger. The only surprise was
that the Democrat was Roosevelt. This governor of New York State seemed,
from the start, an unlikely liberal. A scion of American nobility, a distant
cousin of Teddy Roosevelt, the twenty-sixth president, with his background of
privilege—complete with childhood photographs portraying him as Little
Lord Fauntleroy—should have augured conservatism. Yet, as president, his
social policies consistently favored the invisible, those on the margins of Amer-
ica's population: minority groups, the destitute, the elderly, the unemployed.
In an unprecedented and still unequaled wave of sound welfare legislation,
Roosevelt instituted national social security and farm relief, gave bargaining
power to union organizers through the Wagner Act, and established a program
that provided work for thousands of artists, writers, and theater professionals
during the ten years following its founding: the W.P.A.

"I pledge to you, I pledge to myself, a new deal for the American people,"
Roosevelt had declared upon being nominated as the Democratic presidential
candidate. In ten years, the federal government would spend nine billion dol-
lars on its New Deal programs, employing some eight million Americans—a
quarter of its active population. The first measures were implemented in
1933–35, under the auspices of the Federal Emergency Relief Organization.
After 1935, its name became the Works Progress Administration, and after 1939,
the Work Projects Administration; it is usually referred to simply as the W.P.A.

Some of the opportunities that the W.P.A. made possible for artists came
into existence thanks to George Biddle,[6] a socially conscious young man from
a prominent Philadelphia family. A classmate of Franklin's at Groton and Har-
vard, his family, like the Roosevelts, enjoyed a long, prestigious tradition of
service in the United States government, his ancestors having served in cabi-
nets and advised presidents since George Washington. Biddle entered law
school after Harvard, but suffered a nervous breakdown and only managed to
recover from his depression through painting. "This craving and curiosity for
life," he exclaimed, "was retarded and almost, perhaps, completely frustrated
by thirteen years spent in a New England boarding school, college, and law
school!"[7] Although he eventually completed his studies and passed the bar,
Biddle would never return to the law. But he did maintain a faithful corre-
spondence with Franklin, the friend of his youth.

On May 2, 1932, Biddle wrote to Roosevelt praising Diego Rivera and José
Clemente Orozco: "The Mexican artists have produced the greatest national

school of mural painting since the Italian Renaissance. Diego Rivera tells me that it was only possible because Obregon [the president of Mexico] allowed Mexican artists to work at plumber's wages in order to express on the walls of the government the social ideals of the Mexican revolution." Biddle linked the Mexican program with Roosevelt's commitment to social change. "The younger artists of America are conscious, as they never have been, of the social revolution that our country and civilization are going through [with the Depression], and they would be very eager to express these ideals in a permanent art form, if they were given the government's cooperation. They would be contributing to and expressing in living monuments the social ideals that you are struggling to achieve. And I am convinced that our mural art, with a little impetus, can soon result, for the first time in our history, in a vital national expression."[8]

In 1933, inspired by the grandiose promise of American cultural greatness, and heeding Biddle's observation and advice, Roosevelt instituted the Public Works of Art Project (P.W.A.P.), headed by Harry L. Hopkins, who had come along with Roosevelt from his New York State administration. It was followed by the W.P.A.'s Federal Art Project, which allocated public money for the arts for the first time in American history. The program would emerge as one of the greatest triumphs of the W.P.A., with, at its peak, five thousand artists employed by the federal government. Initially, the program merely hired artists, without any clear mission. "This is a relief measure," said Juliana Force, New York City's regional chairman during the early stages of the project. "We are interested in knowing only one thing about any artist—is he in need of employment?"[9] But charges of aesthetic favoritism abounded, and the public remained suspicious of special funding for artists as opposed to, say, carpenters and masons.

In 1935, Hopkins invited Holger Cahill, an expert on American art, to Washington, D.C. He wanted to discuss the role of the American artist in the W.P.A. Cahill, who had advised Abby Rockefeller on her folk art collection, had also substituted for Alfred Barr at the Museum of Modern Art during his year-long sabbatical in 1932–33, organizing two interesting shows there: *Folkloric American Art: The Art of the Man on the Street in the United States, 1750–1900* and *The American Sources of Art;* the latter exhibition explored recent discoveries from Aztec, Mayan, and Incan digs. In Washington, Cahill roundly and publicly criticized the Federal Art Project, condemning its efforts as mediocre. More should be done, he urged, in educating the American public about the art their tax money was supporting. Art needed to be taken out of the cities and into the country; away from the studios and into the public schools; research should be done on the history of American folk crafts—

otherwise, an American art would never exist. At the same time, he frowned upon the charges of favoritism in the program, arguing that it must be style-blind.[10] Cahill's bluntness and spontaneity had an unforeseen effect; he was soon appointed head of the very program he criticized.

As head of the W.P.A. from 1935 to 1942, Cahill was something of a mystery. *Time* magazine praised him as a "ruddy little man who knows the history of American art more intimately than anyone else and who uses refined horse sense in his designs on the country and its people." The article stated that he was "born in St. Paul, Minnesota, in 1893," and was named "Edgar Holger Cahill ([his] first name was dropped but survives as 'Eddie')."[11] In fact, according to his own autobiography and a report published in the *Archives of American Art Journal* in 1991, Holger Cahill was from "a small valley near the Arctic Circle in Iceland," his given name was Sveinn Kristjan Bjarnarson, and he was six years older than he claimed—born in 1887.[12] His family emigrated to Canada in 1889, and Cahill subsequently left home and wandered across the United States before arriving in New York in the fall of 1913, just missing the Armory Show by a few months. Accounts of Cahill's life are plagued with misinformation, making it difficult to separate truth from myth. His autobiography presents a clear but subjective view of his life, while interviews and the accounts of friends contradict it. To artists, he appeared to be a jovial man with a well-groomed head of white hair, a small mustache, and elegant manners, and he was a hard worker who had just completed a book on American art with Alfred Barr in 1933. His wife, Dorothy Miller, a leading Modernist scholar, would be the Museum of Modern Art's first trained curator. But it is at once ironic and fitting that this immigrant with a dubious pedigree would become the preeminent celebrant and promoter of American art, the one to give it a proper place and history in American culture.

As director of the W.P.A. for most of its existence, Cahill maintained that "the fundamental aim of the project [is] quite simple." It proceeded, he said, "from a concept of art [which was] not as the possession of the few, but a free impulse which should have a large and natural place in our society. Art should not be a luxury for the few. It should belong to the whole people. In the greatest periods of art it has belonged to the people. It is my hope and belief that if these art projects continue we can give art back to the people—that we can produce a genuine, democratic people's art."[13] Cahill's plan was to revitalize American folk art traditions through research into the native crafts of each region, breaking up what he called the "big city monopoly" on art. "Bring art to the highways and byways of America, especially to underprivileged sections such as Alabama, Mississippi, and the Dakotas and other such sections," he

said in an internal memo of 1936 under the heading "What We Would Like to Do." Cahill's mission was nothing other than to educate the entire American population about American art. He established community art centers in the business districts of communities, often in failed banks. The centers had gallery as well as studio and workshop space, and "once opened, [should] relate [their] exhibitions and teaching directly to what everybody knows within the community—not what everybody ought to know. High hatting is taboo."[14] By September 5, 1938, some 150 community centers had been established throughout the United States, attracting 4 million people to public art programs—as many as visited the Modern and the Met combined in those same years; the W.P.A. had produced 42,406 paintings to decorate 13,458 public institutions, and had completed 1,150 murals in that five-year period. True to Biddle's predictions, the most popular projects of the W.P.A. were these nearly twelve hundred public murals, veritable embodiments of democratic art.[15]

Thomas Hart Benton, the realist from Neosho, Missouri, became America's favorite muralist. *Time* magazine featured Benton in its January 11, 1937, issue with a cover story entitled "Legislators' Lounge." It describes the progress of "some of the most important murals in the U.S. within the classically Italianate chamber of the State Capitol building," where "a small, dark, wiry man [is] painting furiously, while the walls around him slowly blossom with mule skinners, Mormons, dancing Negroes and Mississippi boatmen."[16] Benton's virile ("crude" and "muscular"[17]) style garnered accolades, while his subjects— steelworkers, shipbuilders, farmers—epitomized the new celebration of national themes. The prodigal son of American painting had come home.

Since, at the same time, Modernism was gradually penetrating such remote centers of the country as Colorado Springs, Taos, and Dallas, clashes between Realist and Modernist American painters inevitably erupted. In January 1935, for example, a much-publicized debate took place in Dallas, Texas, between Thomas Hart Benton (a Realist), and Stuart Davis (a Modernist). "I, too, think that great art will come out of the Middle West, but certainly not on the basis of Benton's presumptions," Davis argued. "It will come from artists who perceive their environment not in isolation but in relation to the whole." Benton had come to Dallas sponsored by a W.P.A. program headed by John S. Ankeny. The city had received strong support under the New Deal. The new director of the Dallas Museum of Fine Arts, Lloyd Rollins, a friend of Ansel Adams, had received his training at Harvard's Fogg Art Museum, and had served as the P.W.A.P. director for the New York metropolitan region. Rollins was determined to raise the level of visibility for local artists at any cost: "I want to establish something outstanding here in the Southwest," he said on his

arrival. In the debate with Davis, Benton declared, "In spite of all cultivated whoopings to the contrary, art cannot be imported. It has to grow. Keep your plant and water it."[18]

Arguing for "direct representation" over "introspective abstraction," "direct perception of things" over "intellectual conceptions," Benton had preached a form of aesthetic protectionism with strong Midwestern populist resources. He greatly praised Don Brown, a native Texas artist who thought that "American art and American life will inevitably be richer in self-understanding." Brown, in turn, remained the strongest supporter of Benton in Texas. "The chief good I can foresee from Benton's activity down here," he said, "is that his ideas will serve as a powerful antidote to that kind of provincialism which had Middle-Western artists painting diluted examples of French Impressionism thirty years after it was a dead issue in France."[19] Another artist championed by Benton during his Texas sojourn was John Breckinridge Martin, a local octogenarian artist who privileged folk expression. But Benton had a hard time with younger Texan Modernists such as Alexander Hogue, who rejected "those three Musketeers of the Middle West"—i.e., Benton, Wood, and Craven; Jerry Bywaters, who despised the "superficial nature" of Benton and his approach; and Harry Carnohan, who refused Benton's "stiff and wooden style," which to him was symptomatic of a "corn-belt school," too insular and sensitive to criticism.[20]

In San Francisco, Diego Rivera adorned the historic walls of the San Francisco Art Institute with political scenes from Mexican-American local history, while in Colorado Springs, Andrew Dasburg and Ward Lockwood were frescoing the walls of the Colorado Springs Fine Art Center in 1936 with soignée scenes inspired by popular American theater, from *The Girl of the Golden West* to *Uncle Tom's Cabin*. Although the W.P.A. typically favored Social Realism, some abstract murals were also executed under the program, the most notable examples being Arshile Gorky's 1,530-square-foot masterpiece *Aviation* at Newark Airport, or the unusual collaboration in a Williamsburg, Brooklyn, housing project among young artists Willem de Kooning, Byron Browne, and Albert Swinden. Enthusiastically reviewing the transformation of the New York City public school buildings by W.P.A. painters and decorative artists, City Commissioner Alberto C. Bonnaschi decreed that "murals be installed in every new building when it is erected."[21]

In addition to being an ambitious planner, Cahill struck everyone as a gifted public speaker. In numerous addresses made in New York and Washington, D.C., he introduced his socially radical ideas about democratic art to the public, in generous, commonsense terms. Using economic and biological metaphors instead of the mystical rhetoric that had often been used to describe

the artist's struggle, Cahill proclaimed the figure of the "artist-laborer" who could be helped, like any other victim of economic hardship, through shrewd government intervention. "It is true that there has been very little private demand for American art in the past few years," he said in a speech to collectors at the Metropolitan Museum of Art, which had declined Gertrude Vanderbilt Whitney and Juliana Force's offer of an American art collection in 1930. "But that does not mean that everybody is already oversupplied with American art. Very few people in this country own art. Yet the potential audience is extremely wide. . . . A far wider demand for works of art has developed on the part of schools, libraries, and other public institutions, than the W.P.A. Federal Art Project has been able to meet."[22] Cahill's rhetoric of economic tribulations and government intervention made the mysterious and European business of art production seem like an American story of hard times. His program had stirred huge American popular cultural production. Cahill had re-created the artist's image, eradicating the then-prevalent myth of the European-trained bohemian and replacing it with that of the American workingman.

The W.P.A. magic produced many success stories for American artists whose careers engaged the popular media: Ruth Fish, a rural W.P.A. official, discovered the wood carvings of a young Taos resident named Patrociño Barela and brought them to the attention of Vernon Hunter, her boss, director of the Federal Art Project in New Mexico. Young Barela—a great talent whom some compared with Brancusi—became a W.P.A. employee a month later, in December 1935. "I never went to school," he said. "My daddy he sent me to water goats in the hills. I go here, there, nine years, dig potatoes, coal mines, work in W.P.A."[23] Barela made eighty dollars a month—the average W.P.A. wage—and eventually showed his art in Santa Fe, earning a mention in the local newspaper. In September 1936, Cahill, eager to present a show of his "five thousand godchildren," organized at the Museum of Modern Art an exhibition called *New Horizons in American Art.* The exhibition put a national spotlight on more than 171 artists from around the country, with more than four hundred works of art created in 1935–36—including more work from young Barela than any other artist.[24] *Time* magazine declared the twenty-eight-year-old the "discovery of the year."[25]

Jackson Pollock came to New York from Cody, Wyoming, at the age of eighteen, began working for the W.P.A. five years later, and remained on the W.P.A. payroll from 1935 to 1942, becoming another of the program's favorite sons. Holger Cahill, in an interview during the 1960s, proudly recalled an "interesting anecdote about Jackson Pollock: Pollock was a student of Thomas Benton's. For a year or two he worked on the Projects doing paintings like Benton's 'brown, soupy things.' Burgoyne Diller went to see Pollock, who had

stopped coming to work and he saw 'a lot of throwing around paint.' Diller asked Pollock why he hadn't been coming and Pollock replied, 'You wouldn't want these things anyhow. Nobody wants these things of mine.' Diller picked up a few and said, 'Bring these to the project' and they were accepted. From that time on, Pollock went on to develop his style working at twenty-four dollars a week within the W.P.A."[26] In fact, Pollock wasn't doing his mature dripped and thrown paintings until 1945–47; but so numerous were actual W.P.A. success stories that apocryphal ones came to feed the mythology.

Cahill was particularly proud of the 103 regional art centers where classes and exhibitions were regularly held. He liked to recount the story of Nan Sheets, a director of one of the W.P.A. art centers in Oklahoma, who had written a letter to Tom Parker, one of his assistants: "We don't like these things," she complained, referring to an abstract art exhibition she was about to show. "Within six months," Cahill recalled, "she had changed her mind. Ms. Sheets was demanding the kind of art that she had protested against six months before!"[27] Was there really an irate Ms. Sheets? Possibly, but not necessarily. Like the spurious Pollock story, this tale about educating the American public may have grown out of his pride as well as his desire to trace the acceptance of abstraction to the W.P.A. years. The testimony of artists from the Harlem Community Art Center provides a more reliable lasting tribute to the W.P.A. legacy. Already a hotbed of literary and intellectual activity in the 1920s, Harlem gained a generation of painters and photographers when its art center opened. Roy DeCarava, Romare Bearden, and others would confirm Jacob Lawrence's view that, without the W.P.A., "I would never have become an artist. It was a turning point for me."[28]

All in all, the flowering of American art during the W.P.A. years represented the peak of activity for Social Realist painters such as Benton and Rivera. Although the program was created to support Realist art, the farsightedness of Cahill changed its course, fostering a respectful recognition of every artist who was a contributing member of American culture, whatever his or her aesthetic inclination. In fact, without the unbiased program of autonomy, support, and public education implemented by Biddle and Cahill, young W.P.A. artists such as Ad Reinhardt, Jacob Lawrence, Stuart Davis, Jackson Pollock, and Willem de Kooning might never have been encouraged to develop their respective styles. "From 1933 to 1941," stated one early critic, "was undoubtedly the most productive art period that America has seen."[29] History would agree. In 1943, President Roosevelt asked that the W.P.A. be "given its honorable discharge." It had served its purpose during the Depression, but the turn of the decade saw the world preparing to go to war.

When Holger Cahill died in 1960, letters to his widow, Dorothy Miller,

demonstrated the level of affection and admiration he had inspired in "his" artists, and those of the next generation. "As a beneficiary of Holger's activity," Joseph Hirsch wrote, "I can't forgo the sad privilege of writing you, who provided young me with a boost (a century ago). The pride you must feel at the healthful influence that non-conformist Cahill exerted in our contemporary art world will not only outlive your present sorrow but will grow with time."[30] A young Southern artist, Jasper Johns, who was only nine years old when the W.P.A. program began, wrote, "I just learned . . . of Mr. Cahill's death. I hope that my deepest sympathy may be of some small comfort to you now."[31] Even today, it is not rare to hear nostalgic reminiscences of Cahill's legacy, and of that mythical era when the Federal government supported artists and when, throughout the country, the phenomenon of artists creating art for public buildings would be noted by the wonderfully matter-of-fact sign "Warning: Men at Work."

Nine

The *Demoiselles* Sail
to the United States

O N SATURDAY, AUGUST 31, 1929, Conger Goodyear, president of
the Museum of Modern Art, visited the home of the collector Jacques
Doucet at 33, rue Saint-James in Neuilly, the chic Parisian suburb.[1] He had
gone there to solicit the loan of van Gogh's painting *Irises* for the museum's
inaugural exhibition two months later. Doucet agreed. Their visit together
would play a major role in the museum's future, a development that neither
would have ever foreseen.

Goodyear was invited to look around. He found himself especially dazzled
by the extreme sophistication of the place. Since Doucet had moved, just a year
earlier, into his "studio"—as he would always refer to it—he had utterly
devoted himself to its meticulous, elegant décor. The staircase that led to the
first floor was itself a gem. Conceived by the sculptor Joseph Csáky, it followed
a design Doucet himself had provided. "Steps in enamel under glass, silver,
bordered by a banister of wrought iron that began in the form of a large pea-
cock at rest; on the first landing a parrot decorated the continuation of the
banister, in which here and there were plaques of black glass engraved with ani-
mal motifs. As you reached the hall on the first floor, facing the corridor lead-
ing from the studio and through the Oriental room, hung, in a place of honor
that instantly drew your attention, *Les Demoiselles d'Avignon,* encased in the
wall and surrounded by a metallic frame made by [Pierre] Legrain."[2] The
immense canvas—nearly eight feet square—appeared as a fresco more than a
painting. Facing it, double doors by Lalique led through the Oriental room
and into the studio. "When the door was open," remembered another visitor
to Doucet's home, "*Les Demoiselles d'Avignon* could be seen through the room
of exotic objects . . . and constituted the endpoint of all perspective."[3]

Three days after his visit, in a note to Doucet, Goodyear expressed his
"great pleasure" at having viewed his "paintings and other splendid works of
art. I will long remember the arrangement of the modern portion of your

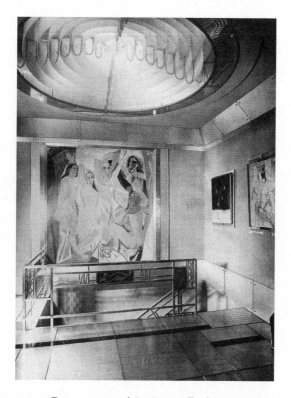

In his Neuilly apartment, Doucet presented *Les Demoiselles d'Avignon* in a spectacular manner;
he had it encased in the wall, and commissioned Pierre Legrain to create
a special metallic frame for the painting.

house. . . . I hope that one day we will have the pleasure of seeing you in America. Perhaps you will organize an exhibition for us, one that will show as never before the possibility of beauty and modernity being in harmony." That same day, Goodyear also sent a note to César de Hauke, who worked at the Seligmann Gallery in New York and had introduced him to Doucet. "That is by far the most interesting collection that I have seen in Europe and it was a handsome gesture on Doucet's part to lend us the van Gogh for our exhibit."[4] By inviting Doucet to the United States, and proposing that he organize an exhibition in New York, Goodyear revealed how deeply moved he had been by all he had just discovered.

By the early 1920s, word had spread that some exceptional collections could be found in Paris. Soon after Doucet moved into his Neuilly villa in 1928, travelers rushed over to see it. Jeshvanroo Holkar, a young Indian maharajah, wrote to him, stunned, before returning to India to take power: "Dear M.

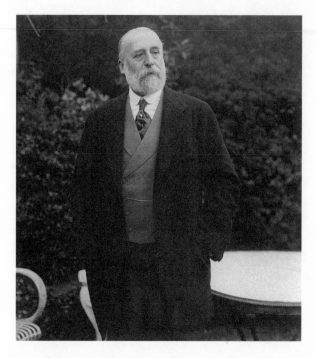

Jacques Doucet, the couturier who was one of the great collectors of his time, bought
Les Demoiselles d'Avignon in 1924 on the urging of his young art adviser, André Breton.

Doucet, I cannot leave Europe and return to my own country without telling
you how delicious those too-short moments I was able to spend in your com-
pany and among all your beautiful things were. I hope that you will not think
that I exaggerate if I tell you very simply that my two-hour visit to your home
counts among the best I spent in Paris and in France, and therefore in Europe.
Those memories are precious and I will forever guard them jealously. Your
advice and thoughts were also no less precious to me."[5]

Doucet was seventy-six when Goodyear made his visit. Stately, haughty,
and refined, he always dressed impeccably and had a carefully groomed white
beard. This man of taste, called a "genius with material," had supported the
career of the decorative artist Pierre Legrain, helping make him the century's
most successful bookbinder. He had also commissioned carpet designs from
Jean Lurçat, furniture from the architect and designer Eileen Gray, and a foun-
tain sculpture from artist Henri Laurens. Doucet's *maison de couture* on the rue
de la Paix boasted an exclusive clientele, and very early on the self-taught,
erudite gentleman began collecting art. Little by little, he had assembled
four innovative collections, selling off his "old-fashioned things"—an art and
archaeology library, which he donated to the University of Paris in 1912, and

Pablo Picasso in his studio at 5 *bis*, rue Schoelcher, in front of *Les Demoiselles d'Avignon*

eighteenth- and nineteenth-century furniture and paintings—and replacing them with "fresher works": prints, objects, and furniture from the Far East; the most beautifully bound and brilliant collection of modern French literature then in existence; an assortment of Art Deco objects; another one of primitive African and Pacific items; and one of the world's most exceptional private collections of Impressionist, Post-Impressionist, and contemporary art, including paintings by Degas, Manet, Monet, Seurat, van Gogh, Cézanne, Gauguin, Henri Rousseau, Matisse, Picasso, Braque, and Derain, and sculptures by Brancusi and Ossip Zadkine.[6]

Like Abby Rockefeller and others before her, Doucet surrounded himself with a team of young advisors and art experts. He first called on André Suarès for advice, but found him, as early as 1916, too "oriented toward the past," and brushed him aside for a young medical student who also happened to be a subversive poet—and who, thanks to Paul Valéry's intervention on his behalf with Gaston Gallimard, had obtained an administrative post at the *Nouvelle Revue Française,* correcting the proofs for Marcel Proust's novel *A la recherche du temps perdu.* The young poet was André Breton. Along with Tristan Tzara, Louis Aragon, Philippe Soupault, Paul Eluard, and Pierre Drieu la Rochelle, Breton had tried, amid the jeering and hissing, to draw public attention to the

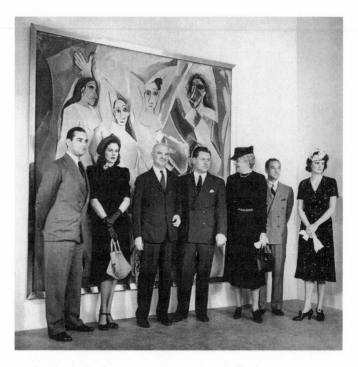

Ten years after the death of Jacques Doucet, *Les Demoiselles d'Avignon,* meant to go to a
French museum, was bought by the Museum of Modern Art in New York. When it arrived
there, the museum's Board of Trustees posed proudly in front of the canvas, which would
become the core of the permanent collection: (left to right) John Hay Whitney,
Mrs. W. T. Emmet, A. Conger Goodyear, Nelson A. Rockefeller,
Mrs. John Sheppard, Edsel Ford, and Mrs. John Parkinson, Jr.

Dada movement from 1919 on before abandoning it. In 1921—when Breton
was twenty-four—Doucet offered him a position as his "artistic adviser and
librarian."[7] For 60,000 francs a year, Breton would keep Doucet apprised of
the intellectual activity of the time, while offering his own views on the con-
temporary cultural climate as well.[8] Ultimately, Doucet dissociated himself
from Suarès, turning his attention to the youngest, most controversial mem-
bers of the future, such as Breton. In so doing, he deliberately shut the door on
the past and its "old-fashioned things," embracing the twentieth century and
its most subversive creations.

André Breton had worked with Jacques Doucet for less than a year before
he mentioned Picasso to his employer. The "minuscule pieces" that Doucet had
been collecting, Breton suggested, should be abandoned for larger works: "You
know that I slightly despise," Breton wrote Doucet, "especially as regards your
future home, the fact that you have not yet bought one of Picasso's master-
works (I mean one whose historic importance is absolutely undeniable, such as

for example the *Demoiselles d'Avignon,* which marked the beginning of Cubism and which it would be painful to see leave France)."⁹ Two years later, Breton persevered. "I don't believe that we finished with Picasso and yet the work still seems today to be the touchstone for a collection." "It's what emerges in Picasso," Breton insisted further, "on which depends the character of what follows, passionate or not, rich or poor." Admitting the "extreme difficulty" of selecting specific artworks, Breton asserted that for him, only one "certitude" remained—that of choosing *Les Demoiselles d'Avignon,* "because it is a work leading directly into Picasso's laboratory, and because it is the heart of the drama, the center of all the conflicts that Picasso gave birth to and which will go on forever, I believe. Here is a work that is more than simply a painting. It is the theater of everything that has happened in the last fifty years, the wall on which Rimbaud, Lautréamont, Jarry, Apollinaire, and all those whom we still love have appeared before. If it disappears it will take with it the greatest part of our secret."¹⁰

At the insistence of his very young, very brash adviser, Doucet finally purchased the painting. In January 1924, Doucet capitulated, offering 25,000 francs for *Les Demoiselles d'Avignon.* Picasso resented what he considered a disappointing sum, but Breton intervened, explaining that Doucet had already bequeathed his entire collection to the Louvre. "I am the only collector," Doucet would say, "whose influence can convince the Louvre to accept avant-garde painting."¹¹ And consequently, Picasso acquiesced. On April 16, Doucet took possession of the work. "The Germans are arriving in France," he had written to Suarès a few weeks earlier, "buying up everything for sale. I was polite but maintained my position firmly. How too stupid to let everything go. Actually there are two or three slightly scandalous things—too advanced for them. . . . I bought them; and in two years I will be proved right. A large Picasso, *Les Demoiselles d'Avignon,* a large Matisse, a fishbowl with red fish, and Seurat's drawing for *Circus.* With that I am set and can bide my time; they won't have them for America."¹² Doucet, extremely possessive, jealously protected his collections and resolutely refused to see his works depart definitively from French territory. Grasping this fact, Breton had shrewdly used it to push him into buying Picasso's masterpiece. At the year's end, Breton congratulated Doucet on his decision: "Picasso is the only authentic genius of our time, and an artist such as never before seen, except perhaps in antiquity."¹³

Yet scarcely ten days later, Breton was still trying to conquer Doucet's lingering uncertainty about *Les Demoiselles:* "I understand that you want to have in writing some final assurance about the place this painting deserves to have in the entirety of modern artistic history," he wrote. "Without [Picasso], as I have told you many times, there is, to my mind, no way of representing today the

state of our civilization in this particular angle of view. . . . I cannot help but see in *Les Demoiselles d'Avignon* the most important event of the beginning of the twentieth century. Here is the painting that deserves to be paraded through the streets of our city the way that Cimabue's *Virgin* once was. . . . It seems impossible not to talk in mystical terms about it. The question of beauty only arises afterward, and still must be handled with great care. . . . My belief is that we are dealing here with a sacred icon."[14]

Finally convinced, Doucet set about constructing his Studio in Neuilly in a loving, painstaking manner, like some precious jewelry box in which he would guard his treasure. After he moved into the new house in 1928, art lovers from all over sought to visit him. Two months before Goodyear's arrival, Doucet received Jules Guiffrey, a paintings curator from the Louvre with whom he was well acquainted, accompanied by Jean Marquet de Vasselot, a curator from the Louvre's department of decorative arts. The pair once again reminded Doucet of his intention to "bequeath his collections" to the Louvre, a promise that, since 1921, had inspired polite but tense negotiations between Doucet and the French bureaucrats. Georges Salle, for example, an adjunct curator at the Louvre, had been asked by Doucet to draw up a list of Far Eastern objects that might eventually find their home in the museum. Such bequests were one thing, but as to modern painting's entering the Louvre, that remained something different altogether, especially since the Musée du Luxembourg, rather than the Louvre, was officially charged with exhibiting contemporary art. The curatorial committee of France's national museums, those responsible for determining acquisitions and donations, consisted mainly of archaeologists; when the question of accepting a donation arose, they had authority over its approval or veto.[15] At a meeting on February 26, 1926, for example, the committee voted to allocate funds for the purchase of "two heads in the Hittite style" and *The Camp of St. Omer* by Swebach, called Fontaine; to accept the gift of a sketch by David; and to conclude that "negotiations to arrange for the purchase of a statue of Elisa Bonaparte by Canova would not be pursued."[16] But such offerings were a far cry from the Cubist painters, from the Dada spirit, and from the subversive leanings of a seventy-three-year-old collector under André Breton's influence.

Doucet had not been particularly optimistic about his ability to sway the bureaucrats who dictated the national museums' taste, or to introduce, despite it all, the "fresher works" he had recently acquired. "For the last sixty years in France," he had complained in 1917 to René-Jean, the curator of his library, "the world of modern art has always been ten or twenty years behind. . . . I expect a strong reaction against modern painting and must say as well that among the avant-garde there is no one to take the lead, apart from foreigners

such as Picasso."[17] Nonetheless, in a series of three meetings—in 1921, 1924, and 1925—with the intervention of Guiffrey, he decided to bequeath to the French State Henri Rousseau's *The Snake Charmer* and Seurat's *Circus,* asking in exchange for a "formal promise of acceptance" from the National Museums' Art Council.[18]

These arrangements were made at the time of the famous Kahnweiler auctions. Daniel-Henry Kahnweiler, a dealer of German nationality, had renounced Paris in 1914 for Rome and Berne, leaving behind a collection of 1,500 contemporary artworks that were sequestered by the French government, in accordance with Article 297 of the Treaty of Versailles; then the government legally liquidated them, as it did all the property of German subjects. Paul Léon, director of the Beaux-Arts, neglected to notify the government of potential preemptive offers from the French museums; excluded from the auction, the museums thus lost an exceptional opportunity to replenish their holdings. Restocking the national collections became all the more difficult with the concurrent disappearance of a number of distinguished Parisian modern art dealers: works from the Kahnweiler collection, for the most part, left French soil.

It was three years before his purchase of *Les Demoiselles d'Avignon,* and Doucet knew perfectly well that the work would not appeal to France's curators. Undoubtedly, for this reason, Jean Marquet de Vasselot, a normally open-minded and receptive figure, did not even bother to inform the committee of Doucet's intention to donate the painting to the Louvre. On a slip of paper dated June 15, 1929 he jotted down, "M. Guiffrey and I went to visit M. Doucet, who offered to donate after his death a panel of ? ? [*sic*] by Picasso and the old woman by Cézanne for the Louvre and the Luxembourg. I will write to him." In any case, this information never appeared in the minutes of the consulting committees convened after that date. Might Marquet de Vasselot, finding the proposal unacceptable, have omitted mentioning the offer? Or perhaps had the committee's secretary, shocked by such a notion, preferred to remain silent? At the time, then, Doucet already understood that the Louvre would refuse his donation of the Picasso. In his memoirs, dealer René Gimpel recalled that: "[Painter Jacques] Mauny . . . went to Doucet and saw his new modern installation. . . . He was very impressed with it. Doucet's collection also dazzled him. No one knows how to choose the way he does. He is donating a Douanier Rousseau to the Louvre. Best of all, the Louvre refused his Picasso. No official at the Louvre or the Luxeumbourg wants to hear about Picasso. He is held in contempt."[19]

Nevertheless, by the end of the summer of 1929, a parade of French officials had gone to pay Doucet their respects: Raymond Koechlin, president of the National Museums' Art Council; François-Poncet, undersecretary of state

for the fine arts; and Henri Verne, director of the National Museums. Despite their fawning, which included offering him the medal designated for the museums' greatest benefactors, Doucet could not shake his innate distrust of their sanctioned, stuffy views. In fact, a strange ballet had taken place on the rue Saint-James in Neuilly that summer of 1929. Two worlds intersected, each wooing the collector in its way: the energetic, forward-thinking Americans, who had found a treasure they dreamed of acquiring, and the blasé, fearful, backward-looking French, who would realize only too late what they had lost. Doucet died abruptly two months after Goodyear's visit; he had had barely enough time to bequeath his literary library to the University of Paris. His widow would handle his other possessions.

Goodyear once again had the opportunity to meet with French officials in 1932, when Alfred Barr was organizing *Three Centuries of American Art* in Paris at the Jeu de Paume. "Of course," Barr wrote to Goodyear, "I do not think the French intend to slight American art by suggesting this pre-season date. But it appears so to some outsiders. The way to increase the prestige of American painting in France (and thus in America, Cahill did a difficult job very well), is to be frankly nationalistic, that is, to avoid sending coals to Newcastle, i.e., to avoid sending competent imitations of French paintings by Americans and to concentrate on what will seem authentically American to the French. Of course it is very hard to judge what will really interest the French, for French taste, I am convinced, is just as chaotic as ours, and considerably worse in many respects. To take as examples the French museum men, whom I think you have met: Guiffrey, will be far more interested in Homer than in Sargent (Manet vulgarized). Or Blakelock (Theodore Rousseau sentimentalized). George Duthuit will study, I think, a Hopper or Sheeler or Marin, but will pass by Henri, Kuhn or Bellows; George Henri Rivière will think Stuart Davis a rather feeble Dufy and Lurçat. But I am confident that he will like Peter Blume, Georgia O'Keeffe and Burchfield. Of course we must be sure to prove to the French that the American can paint."[20]

Four years later, Barr had nearly abandoned the project. "I had to write 47 official letters and make 11 official calls, in order to borrow 4 watercolors from the Louvre," he wrote Joseph Hudnut. "Mrs. Rockefeller has just been fêted by the French as a result of Mr R's having spent $3 million in restoration of French public monuments. . . . The French are experts at using the prestige of Paris in order to get as much as possible gratis from the philistine nations who want to exhibit in the world's art capital."[21] Matters seemed to improve only slightly when the French government offered 100,000 francs to underwrite the exhibition. "These 100,000 francs would prove in a more concrete form the interest of the French government," an exasperated Barr wrote to Eustache de

Lorey in July 1936. "It is perhaps not relevant to recall in this contingency that the Museum has, in the past years, spent many thousands of dollars in bringing to America French works of art." Barr went on to mention exhibitions of Cézanne, Gauguin, Seurat, van Gogh, Corot, Daumier, Matisse, Toulouse-Lautrec, Redon.[22] In the end, André Dezarrois, suddenly shifting to a more congenial tone, wrote back to Alfred Barr in September: "Let all your friends know that I would be very happy to welcome you to the Jeu de Paume next spring and that I will do everything possible to ensure the success of our exhibition. . . . I approve . . . your program for film. Making it happen will nonetheless present difficulties that I hope you can overcome. In any event, do not forget that the museum is not immense and that its walls are not elastic."[23]

Still, the setbacks were not yet behind them. This time, Goodyear, personally offended, took up his pen and wrote to Eustache de Lorey: "I am disappointed. I am coming reluctantly to the conclusion that the exhibition is not really wanted by the French authorities . . . the best course for us to take . . . is to withdraw from any further consideration."[24] Goodyear's strong style had its effect. Under rather desperate circumstances, *Three Centuries of American Art* finally opened two years later, late in the spring of 1938, a time of year that was definitely not the high season for art. "Messieurs, the art of America!" broadcast Goodyear in a long-winded, pompous, and overly optimistic article.[25] "Quantities of pictures by second-rate artists crowd the room," wrote the journalist for *Gringoire*. "American art is of comparatively recent date,"[26] declared his colleague from *Paris-Midi.* The *New York Times* sustained this tone, informing its overseas readers of the bad news: "Contemporary art in the U.S. establishes the impression of an art created by intelligent, hard-working people, completely lacking in a profound artistic sensitivity. They produce an art which is radically artificial—just as artificial silk or wool are artificial products."[27] Trying to save face, Conger Goodyear told Walt Kuhn with some bitterness that "the reception given to the exhibition was not altogether flattering, but I am sure it was worthwhile."[28]

Six years after Doucet's death, an associate at Jacques Seligmann's gallery visited the collector's widow. Barr requested a rendezvous with Madame Doucet soon afterward, and in the summer of 1935, during a visit to Paris to borrow works for his *Cubism and Abstract Art* exhibition the following year, he took a detour to Neuilly. Stopping by at 33, rue Saint-James, he noted once again how Doucet had encased the painting in the wall of the staircase in his home. Since 1931, Barr had been imagining a Picasso exhibition, and in his earliest notes, had marked *Les Demoiselles d'Avignon* with three stars, characterizing it as a major work. Madame Doucet refused to lend it. Despite her rebuff, Barr provided a reproduction of the painting in the exhibition catalogue, along

with this description: "*Les Demoiselles d'Avignon,* on which Picasso had begun work in 1906 and finished in 1907, is often called the first Cubist painting. The figures on the left-hand side were done first and still recall the sturdy nudes, sculptural and classical, which in 1906 had given way to the delicate and sentimental figures of the 'pink' period. But the angularity of the figures on the right, with their grotesque expressions and concave profile and their fixed expressions belong to the most primitive phase of the Negro period."[29]

By September 1937, Madame Doucet, weary of haggling with the Louvre, decided to sell five Picassos, including *Les Demoiselles d'Avignon,* to the Seligmann Gallery in New York, which paid 150,000 francs for the painting. *Les Demoiselles* left France aboard the ocean liner *Normandie,* departing from Le Havre on October 9, 1937. The first viewing of the painting took place at the Seligmann Gallery during the exhibition "*Twenty Years in the Evolution of Picasso, 1903–1923,*" where it was welcomed with nearly universal praise from the local press. On November 9, during a meeting, the Museum of Modern Art's curators decided that to inaugurate the new building, the museum would acquire "as many paintings of the first order as possible." Barr advised the purchase of "the most important painting of the twentieth century."[30] Two days later, the trustees unanimously approved his suggestion. Financial negotiations would take another two years, and to buy *Les Demoiselles,* the museum would have to sell a small Degas, a donation by Lilly Bliss.

On May 10, 1939, the Museum of Modern Art's new building, designed by Goodwin and Stone, was inaugurated with the exhibition *Art in Our Time.* Catalogue entry number 157 presented a reproduction of *Les Demoiselles d'Avignon,* which, Barr wrote, "is one of the rare paintings in the history of modern art about which one can justly say that it defined the era. . . . It is a work of transition, in which one can see Picasso's ideas appearing directly before us. . . . It is however not for its historic importance that the museum decided to acquire this extraordinary work of art, but for the vehement dynamism of its composition. *Les Demoiselles d'Avignon* remains one of Picasso's most formidable achievements. There are few works of art in which the arrogance of genius presents itself with such power."[31]

The city of Paris, with its unequaled effervescence in the early part of the century, had provided Picasso with the aesthetic climate that allowed the conception and creation of this canvas; but some thirty years later, it was New York that ultimately embraced the work. The painting had been spotted, evaluated, and acquired by American collectors, just as others—the Havemeyers, for example—had earlier bought the most beautiful Manets. In the Museum of Modern Art, Americans alone possessed a single institution with both aesthetic and financial expertise. On May 10, 1939, the museum's entire board proudly

posed for a photograph in front of *Les Demoiselles d'Avignon*. Conger Goodyear looks like a general reviewing his troops, while the elegant and ladylike Mrs. W. T. Emmet appears slightly comical, with her prim smile, standing directly in front of this mélange of drunken sailors, Ingres's *Turkish Bath*, African and Iberian art, and these ladies of the evening, these *demoiselles* who populate Picasso's "philosophical bordello."

The culture that had since its Puritan founding pledged to battle the debauchery, excess, and depravity of Catholic Europe, this country had procured for itself a twentieth-century mistress from the bordello of Avignon, created in a Parisian slum by a penniless Spaniard. Around this one painting, the Museum of Modern Art would build much of its collection of modern European art, about which Leo Castelli, who arrived in New York in 1941, would later say: "The permanent collection put together by Alfred Barr was an encyclopedia of European art, such as no museum in Europe would be able to offer. It brought together Russian Futurists, German Expressionists, and French Surrealists in a manner that was exceptional."[32] Castelli was a cosmopolitan art lover. Born in Trieste, he had studied in Vienna and Budapest, had lived in Bucharest, Paris, and London, and knew all of Europe's museums. But that day, did he not assert that, because of the Museum of Modern Art, New York had become the capital of the European art world?

Ten

"The Rush Toward the West"[1]: Europeans to the New World

"ARTISTS AND SYMPATHIZERS of non-figurative art. Paris: 209 members. The rest of the world: 207 members. All things change: Italy knew the greatness of the Renaissance, Montmartre the glory of the Fauves; now Paris is bound up in the present movement. We sincerely hope she will keep this position and prerogative."[2]

In 1934, the magazine *Abstraction-Création: Art non-figuratif* in Paris published these telling figures of their association's "members and friends" at home and abroad compiled three years earlier, comprising a census of non-figurative artists from around the world. In effect, as the magazine's editors themselves stated, "these statistics spoke for themselves." "It is also curious to see," they added, "how the number of those interested in the movement has increased in America."[3] During its five years of existence, the association, which was dedicated to the "promotion of non-figurative art" in an artists' collective, published and displayed works by artists such as Piet Mondrian, Wassily Kandinsky, and Jean Arp.[4] For the moment, they portrayed the change as natural, expressing not a hint of worry or concern.

European artists did worry, and for good reason: after Duchamp, Picabia, Gleizes, and other artists who had been living in Paris left for the United States, many for New York, whose art scene offered an increasingly stronger attraction, especially in contrast to that of Paris, where apathy toward abstract art from both the galleries and the public, from 1936 onward, engendered resentment and disillusion. The German art scene would soon suffer the effects of the Nazi ideology which, with its concept of *entartete Kunst* (degenerate art), expelled anything "modern" from its midst.

Henri Matisse visited the United States several times during the 1930s. His son Pierre had moved to New York at the end of 1924 and began working at a gallery, trying hard not to be "simply his father's son" but also to sell "first-class paintings."[5] In 1930, the elder Matisse came to New York in March and visited

Chicago, Los Angeles, and San Francisco on his way to board a boat to Tahiti. Then, he came back in September to serve on the award jury of the Carnegie Institute's *International Exhibition of Paintings* in Pittsburgh, after which he went to Philadelphia and met Albert Barnes, who commissioned the artist to paint an immense mural—a triptych—for the central gallery of his museum in Merion, just outside the city. "One can learn here as well as anywhere," Matisse said in an interview with the *New York Evening Post.* "And maybe even better. Nearly all modern art is here in the United States, or at least most of the good modern works, and at the Metropolitan you find the whole history of art."[6]

From then on, collectors, artists, and patrons increasingly recognized his talent. In 1931, the Museum of Modern Art mounted a Matisse retrospective, the first of its kind at the museum; Pierre Matisse organized a number of events around his father's latest works; and in 1938 Nelson Rockefeller commissioned him to paint the large overmantel in his New York apartment.[7] In 1933, after returning from overseeing the installation of his mural in Philadelphia, Matisse realized that a new era was dawning for art; in the New World, the old European conventions were crumbling. "When you see the United States of America, you will understand that, one day, they will have painters," Matisse enthusiastically told André Masson. "Because it is not possible, in a country of such dazzling, visual spectacles that they would not have painters, one day."[8]

Others followed suit. Like Matisse, Fernand Léger and Jean Hélion— haunted by the effects of the First World War—were deeply impressed by their visits to the United States. Léger—a short, stocky, mustachioed man with rough hands who resembled the workers he portrayed—had been active in Paris in the A.E.A.R.,[9] before going to America in 1931, 1935–36, and 1938–39, and moving there in 1940 for the duration of the war. In 1938, with the young Dutch-born painter Willem de Kooning and Byron Browne as his assistants,[10] Léger worked on the beginning phase of a mural for the W.P.A. A retrospective of his work was exhibited at New York's Museum of Modern Art in 1935 and later at the Art Institute of Chicago. Nelson Rockefeller commissioned Léger to do a decorative panel for his apartment, and the collector Albert E. Gallatin bought fifteen of his best works. While in New York, Léger influenced a number of American artists working in post-Cubist abstraction and produced radically new work, shaped by America's industrial culture. *The Great Julie,* 1945, provides an example; it is a portrait of a massive-looking, sculptural woman, a sort of anti–Mona Lisa. When Léger first arrived, he viewed America with some misgivings and doubts about its culture. "America has great writers," he noted in 1935, "but it has no painters."[11] He would change his mind. "America isn't a country, it's an entire world," he wrote several years later. "There are no limits there. One is confronted with endless reserves of strength. There is

incredible vitality here, constant activity . . . I am struck by the intensity of the contrasts and the activity."[12] "An American culture based upon what is best in Europe is being born," he added. "This spiritual alliance that must and will endure is a guiding lamp, a rallying point upon which French eyes are focused."[13] Echoing Matisse, he went on to say that young painters in America are working "with such intensity that it is impossible that this people, who have the best teachers and most beautiful art collections, will not one day succeed at expressing themselves in original ways."[14]

Hélion spent a few months in the United States in 1932 and 1933 before making extended visits to New York and Virginia. "Here," Hélion wrote a friend of his, French author Raymond Queneau, "one talks of the war in Europe as if it were some distant recess; the war means nothing here; it's good to know that." Hélion, one of the founders of the Abstraction-Création group in 1931—along with Jean Arp, Auguste Herbin, Albert Gleizes, and several others—had apparently left the Old World definitively behind; European artists seemed to him like the poor insect in Kafka's story "Metamorphosis": passive, inept, impotent. "Good God but are we a sad bunch, we sons of these wretched little countries, artists waving around our talents like insects on their backs waving their legs, trying to turn over, to get back on their feet and remember where we were all going before the whole world went crazy. Being a foreigner today is a lucky thing. . . . I can hear the horns of the boats on the Hudson River. Some of them are leaving for France, but I have no desire to leave. I can't say I'm happy, but at least I'm not suffering. I am somewhat free; I am hidden within my own portable shadow."[15] Hélion spoke of the United States as if it were a scale, a frame, a workplace. "From far away, France seems to me more tragically than ever pushed into the sea, and so weak in terms of its exterior politics that I want to drown myself in tears. . . . I am working, working a great deal, especially at getting myself ready."[16] Hélion's labors bore fruit: in the space of three years he had had three separate exhibitions in New York and one at the Art Institute of Chicago, all of them favorably received. But World War II caught up with Hélion in 1940 in his studio in Rockbridge Baths, Virginia. "Now we are at war with this lunatic Hitler. For ten days we have had our ears glued to the radio. As of August 24, I have placed myself at the disposition of the French consulate in Philadelphia, who told me to submit my military papers and wait for orders. I've done this. I have no idea what they will be but I'm ready to do my duty, whatever that duty is."[17] Hélion was mobilized several days later, returned to France and joined the army, and was soon captured by the Germans.

Other European artists, such as Hans Hofmann and Josef Albers, decided to settle permanently in the United States. Born in Weissenberg, Bavaria, Hof-

mann spent ten years in Paris, where he studied at two of the private art academies and met such artists as Picasso, Matisse, and Léger. In 1930, he was invited to teach at the University of California at Berkeley, and again the following year, and in 1932 he settled in New York and never left. He taught at the Art Students League for a year, and then, in 1933, he opened the Hans Hofmann School of Fine Arts. It was, as the brochure advertised, "a school of modern art" in Greenwich Village. Offering the American painter both training in the European tradition and a method for becoming the finest type of modern artist, the school's brochure—presented entirely in lower-case type—sounded prophetic: "there is generally speaking a growing interest through the world in contemporary art, which has its nucleus in paris. new york today is also commanding international attention in activities concerning art, as proved by the series of brilliant exhibitions presented the winter of 1935–1936 at the moma: léger, van gogh, cubism, abstract art . . . there is much talent in america, as indeed there is everywhere. the whole question for the young artist is not to follow the prevailing ideas in art, but to absorb them to their full potentialities in order to have a clear point of departure from which, in future, to develop new directions. the forming of these . . . will be a true expression of american culture. to do this through work and struggle with the ideas representing our times. this is the modern artist."[18]

When a student who had just arrived at Black Mountain College in North Carolina asked Josef Albers what he was going to teach him, the master responded, "To open your eyes." A legendary pedagogue, Albers, whether teaching at Black Mountain College, at Yale, or at other universities, mesmerized his students. Like him, an extraordinary number of the European expatriate artists conferred their knowledge upon their American artist colleagues and many art students during the 1930s. These Americans gained a new dimension of experience—apart from exhibitions, as sophisticated as they were—of the European painters in the United States: direct contact, through teaching, by these Europeans now physically on American soil. John Andrew Rice, who founded Black Mountain College in 1933, had decided to invent a radically new educational system, in which teaching and the practice of art would become the focal point of education. Albers transplanted to the United States his introductory course from the Bauhaus, which rejected the imitation of pre-existing works in favor of observation, discovery, and the appropriation of materials.[19] This approach, which had proved so effective for artists overseas, served to anchor the students' art in the concrete world while it also effected a fundamental reversal in methodology and relationships to Europe's examples. Black Mountain no longer exists—it closed its doors in 1957—but remains an American legend. There, an extraordinary array of American artists, among

them the country's greatest, would be born.[20] Albers's departure for the United States prefigured a migration of a great number of Bauhaus teachers to American universities.

In 1938, French painter Amédée Ozenfant—co-founder, in 1924, with Fernand Léger, of the Académie Moderne in Léger's own studio, where they had welcomed so many American students[21]—was invited to teach at the University of Washington in Seattle, then in 1939 opened the Ozenfant School of Fine Arts in New York. The Académie had brought together on its teaching staff such artists as Marie Laurencin and Alexandra Exter.[22] As for Lyonel Feininger, this American artist who had just spent five decades in Europe and shared experiences with the Cubists in Paris and the Brücke and Blaue Reiter groups in Berlin and Munich, and had taught at the Bauhaus in Weimar and Dessau, returned to the United States in 1937 to teach at Mills College in Oakland, California; he stayed there for one term and then settled in New York, where he remained until his death in 1956.

From the late 1930s into the 1940s, dealers, collectors, critics, and artists domestic and foreign intermingled and intersected.[23] Galleries opened by Europeans accelerated artistic fusion. Pierre Matisse's gallery on Fifty-seventh Street gradually attracted a growing clientele; he sold several Maillol bronzes and some of the finest of his father's paintings. Then he shrewdly decided to adapt to circumstances. He began exhibiting work by other European artists, such as Miró (whose career in America owed everything to Matisse), Dubuffet, Giacometti, and Dufy, and was largely responsible for the extent of their influence on young artists. Matisse's clients represented a new breed of collector: Duncan Phillips, James Thrall Soby (a curator at the Wadsworth Atheneum, and director of painting and sculpture at the Museum of Modern Art, and whom Matisse called "Mr. Modernism"), Walter P. Chrysler, Jr., and Joseph Pulitzer, Jr. Matisse became the conduit to an education in the European and American avant-garde, helping guide the direction of public opinion.[24]

Having arrived in New York in 1924, Pierre Matisse opened his gallery in 1931, although it did not really take off until he moved to the Fuller Building in 1934. All was not easy at first: the rejection of French art by young American artists, which had begun after the Armory Show, continued. "We are slightly— or greatly—victims of a fierce campaign for American modern art and naturally one reaction will be that French art will fall under attack," he wrote his family in 1931, several months after the opening of the Whitney Museum. "The art pages in the newspapers are filled with announcements of exhibitions of American art but our exhibitions barely get a mention. This campaign has not at all affected the exhibition of Papa's work at the modern museum, and the number of visitors during the first week exceeds the number of those who

went to the Corot-Daumier show."[25] Nonetheless, in 1932, business at his gallery was disastrous. But he persisted, and throughout the 1930s and '40s, he offered Americans the premium work by his father and by Joan Miró, with whom he had signed an exclusive contract for three-quarters of that artist's output, the rest going to his Paris dealer, Pierre Loeb, who ran Galerie Pierre, one of the most dynamic and innovative galleries in Paris.[26] Pierre Matisse, in addition, took on several other artists from galerie Pierre. In turn, he showed Balthus, Alberto Giacometti, Roberto Matta, Wilfredo Lam, and Jean Dubuffet. "In the future world," Pierre Matisse wrote, "America, full of dynamism and vitality, must play a role of premiere importance."[27]

In the 1930s, two of the most perspicacious German dealers, Curt Valentin and Karl Nierendorf, also took on the New York scene, establishing galleries in Manhattan committed to presenting modern art from Europe to the American public—Galerie Nierendorf in 1936, and Buchholz Gallery, Curt Valentin in 1937. Other spaces showing contemporary European art around the same time were the galleries run by Julien Levy and Marie Harriman, and later, Sidney Janis. Following the artists and dealers, magazine editors also decided to go to the United States. Eugène Jolas, for instance, with the help of James Johnson Sweeney,[28] reestablished the magazine *transition,* which he had founded in Paris in 1927.[29] In 1935, under Sweeney, its new editor-in-chief, the revamped magazine not only sported a fresh elegance, with covers by Kandinsky, Duchamp, Miró, and Léger, but featured new sections: articles on music ("The Ear"), painting and sculpture ("The Eye"), cinema, and architecture, together with "Inter-Racial Documents" and poetry—outlining, with his choice of European artists, the tastes of the Museum of Modern Art (where Sweeney would begin working as a curator in 1941).

By 1937, Parisian artists had much greater representation on the American scene than in Paris. The Abstraction-Création group had been dissolved in 1936. One year later, the magazine *Plastique* emerged, founded by Jean Arp, Sophie Taeuber-Arp, and César Domela, trying to bring a bit of formalism to the presentation of abstract art. The only trilingual publication (in German, English, and French) published in Paris, *Plastique*—"Devoted to the Study and Appreciation of Abstract Art, Paris–New York"—was financed by two American painters and collectors, Albert E. Gallatin and his cousin George L. K. Morris.[30] Suprematism, Constructivism, the situation of abstract artists in the United States, Surrealism—such were some of the themes of the magazine, which treated aesthetic problems without any national specificity. "Politics and the economic crisis stifle cultural life in Europe and plunge artists into misery,"[31] Sophie Taeuber-Arp wrote to Gallatin when requesting financial support for the magazine.

In New York, even before Alfred Barr and the opening of the extraordinary Museum of Modern Art in 1929, certain individuals had started to organize museum projects of their own, and initiated a regular exchange of American and European art. Then, in the 1930s and 1940s, numerous artists, collectors, patrons, and gallery directors, who had been in contact with American painters during that period, put the finishing touches on the process that others had established before them. Certainly, one of the pioneers of this movement had been Katherine Dreier who, by founding the Société Anonyme, Inc., with Marcel Duchamp and Man Ray in 1920, had led the way. She created the first American museum in the United States exclusively dedicated to the presentation and promotion of abstract art—a permanent demonstration of a so-called modern expression of art. Born into a German immigrant family in New York, Dreier possessed a political vision, a relentless willfulness that nurtured this venture, which would last five years in two rooms on the top floor of a brownstone house on East Forty-seventh Street, facing the Ritz-Carlton Hotel.

During the first year of the Société Anonyme, she secured the support of eighty patrons, including Walter Arensberg, Marsden Hartley, critics Henry McBride and Christian Brinton, the Stettheimer sisters, and art dealers Stéphane Bourgeois, Charles Daniel, and Mitchell Kennerley. Given her very personal approach, Dreier understood that the United States lacked a comprehensive audience. She organized conferences—including one in 1921 entitled "What Is Dadaism?"—and built up an art library of artists' manifestos, exhibition catalogues, books, and periodicals on European modern art, among which could be found, notably, *Valori Plastici, Der Sturm*, and *Der Dada* (Berlin, 1919–20). Like Stieglitz, who, for his gallery 291, worked in collaboration with Steichen, she joined forces with such European artists as Duchamp, then Kandinsky (who became the Société's honorary vice president in 1923), presenting at the same time numerous American artists. She was the first to show in the United States the works of Archipenko, Klee, Kandinsky, Léger, Joseph Stella, Campendonk. She had strong ideas that she implemented with activism and vigor, with an "appetite of domination," some would say. Fundamentally, she believed that only the creators themselves were capable of organizing and presenting their works and those of their colleagues. "The historians" she wrote in 1923, "are very valuable in making many things clear, but through their historic attitude of mind, they are often blocked from recognizing the seed from which the tree will grow. Their function in life is a totally different one from that of the creative artist, and it is our duty as reasonable thinking people not to confuse these two distinct functions."[32]

Despite a rapid and progressive loss of patrons supporting the Société Anonyme—which forced her to close the small gallery—Dreier set the course,

supplying the necessary funds herself to organize exhibitions in schools, muse-ums, clubs, and commercial galleries in Detroit, Baltimore, Washington, D.C. (featuring her own collection and art lent by galleries, private collectors, and the artists themselves). By 1925, the collection of the Société Anonyme included more than two hundred works, and the many exhibitions she organ-ized would present the same international blend. In 1926, she organized for the Brooklyn Museum an exhibition of postwar international art conceived as a follow-up to the 1913 Armory Show and, on the advice of her "experts" Duchamp, Léger, and Kurt Schwitters, she traveled to Paris, Hannover, Vienna, Weimar, and Venice[33] and also solicited loans from Stieglitz's collection in New York. Her *International Exhibition of Modern Art* represented an intel-ligent selection of more than three hundred works by some one hundred artists from thirty different countries. This unique tour de force displayed side by side, on a grand scale and for the first time in the United States, European and American artists belonging to all the twentieth-century avant-garde move-ments. Cubists, Expressionists, Dada artists, de Stijl artists, and Constructivists mingled with American Modernists from Stieglitz's stable and Marcel Duchamp from the Société Anonyme, along with American "independents" such as Stuart Davis, Preston Dickinson, and William Zorach. If, as an answer to the Armory Show, this event did not quite inspire the animated controversy expected, it nevertheless succeeded, by importing an enormous number of art-works, in developing surprising collections of European art on American soil.

After publishing the short-lived revue *Brochure Quarterly* (1926–27)[34] Dreier decided to take a break from the activities of the Société Anonyme and travel in Europe. Two years later, during a fallow period in her life, the director of the New School for Social Research in New York, invited her to inaugurate its new premises. She accepted, proposing another colossal exhibition,[35] and then undertook a series of conferences, "Art of the Future," during the aca-demic year 1931–32. Her last seminar, a true hymn to electricity—"the great unknown force"[36]—was followed by a gala symposium whose participants included Georgia O'Keeffe, Alfred Stieglitz, and Eleanor Roosevelt. Affirming America as the nation of the future, thanks to its "power, vitality," and its capacity to leave its past behind, Dreier resumed her role of activist to bring artists together.

Katherine Dreier followed in the footsteps of Gertrude Stein and Alfred Stieglitz, whose cultural and social origins she shared. Leo Stein had left the scene by moving to Florence; Stieglitz abandoned his interests in European art soon after he married O'Keeffe in 1924; Dreier picked up the torch where they had left off. In addition, her relationship with Marcel Duchamp allowed her to give him—thanks to the Société Anonyme—an opportunity to further

develop the work of the Puteaux group in the United States.[37] The majority of the artists who had shown in the 1912 Section d'Or exhibition and the 1920 and 1925 exhibitions showed their work in New York a few years later. And a bit of the spirit animating the Duchamp brothers would be felt along the East and Hudson Rivers. Katherine Dreier helped bring together the various experiences of these European go-betweens, arranging unprecedented occasions of direct dialogue between contemporary artists from the United States and Europe.

Also among these go-betweens was the well-born collector Albert Eugene Gallatin—the great-grandson of the Secretary of the Treasury under Presidents Jefferson and Madison—a talented painter and critic, recognized especially for his essays on Aubrey Beardsley, James McNeill Whistler, and Charles Demuth. Following numerous trips to Europe, he linked himself to the French painter Jacques Mauny, then in the 1930s to Jean Hélion, who became successive advisers for his collection. Thus, he followed the "team model" of Stieglitz–Steichen and Dreier–Duchamp, in which a patron who was also an artist added his clout through a close association with a fellow artist. In 1927, Gallatin founded, in a building of New York University's Washington Square campus, the Gallery of Living Art, one of the first American spaces entirely devoted to modern art.[38] He knew that, to stimulate the emergence of an American school, emulating Europe would be essential: the most urgent need was to present the best of contemporary European art, rigorously selected; the Americans would take it from there.

For Gallatin, collecting meant "to write art history," to bring together the precursors and the young recruits, with the freedom that only private patronage could permit. "The director has not favored any particular group in forming the collection," he wrote, "aside from the American section." This critical attitude, he explained, necessitated "the discrimination and courage of the individual collector." To this end, he amused himself by comparing his achievements to those of the Medicis, as well as to those of such European collectors as Alphonse Kann, the viscomte of Noailles, Jacques Doucet, Shchoukin, Helene Kröller-Müller, and such Americans as the Havemeyers, Barnes, Quinn, and Arensberg. The Gallery of Living Art, he explained in a detailed catalogue, had a strongly didactic ambition and would allow the masses to study "the many phases of the newer influences at work in progressive twentieth century [sic]," in a space that was neither a private collection, nor a commercial gallery, but a museum open to the public, with a permanent collection.[39]

In contrast to the European museum model, Gallatin insisted that his gallery be dedicated to "living" art.[40] "This appears to be the most satisfactory name," he insisted, "even when we realize that the paintings by Old Masters at

the National Gallery, London, are alive, and that the pictures, recently painted, at the Luxembourg Museum, Paris, are not."[41] Gallatin expressed his surprise that no other museum had been founded on this principle in the United States, "the most modern of all countries."

The creation of the Museum of Modern Art galvanized a number of local artists into expressing their feelings of exclusion and resentment. Alfred Barr's exhibition *Cubism and Abstract Art* presented there in 1936 worsened matters; many felt that their work had been ignored. Most of all, they decried Alfred Barr's "family tree" diagram of modern art, in which he showed a marked preference for Surrealism over Cubism.[42] In reaction to Barr's omission of contemporary American abstraction, the American Abstract Artists group was formed in the fall of 1936 and soon numbered more than fifty. Some of its members picketed MoMA. "How can the Museum of Modern Art be Modern?" asked one of its leaflets, which was distributed in front of the museum after the protest. "Let's look at the facts. The museum is supposed to exhibit the art of our era. Art of whose era? Sargent, Homer, Lafarge and Harnett? Picasso, Braque, Léger, and Mondrian? What era? If it's that of the descendants of Sargent and Homer, then where are the descendants of Picasso and Mondrian? Where is American Abstract Art? Shouldn't the concept of modernity include the Avant-Garde?"[43] The declaration's impact was all the greater given that it was signed not only by Americans involved in post-Cubist geometry, but also by European immigrants such as Lásló Moholy-Nagy and Josef Albers.

Meanwhile the Whitney Museum, exclusively devoted to American art, continued to welcome the modern in every manifestation, from the descendant of Sayer to the most avant-garde. In 1935, the curators of *Abstract Painting in America* attempted to map the evolution of abstraction from the Armory Show to the 1930s. Influenced by most European abstract trends of the time, the works of artists such as Charles Demuth, Charles Sheeler, Stuart Davis, John Ferren, Burgoyne Diller, the early Arshile Gorky, and George L. K. Morris were gathered in a noted show. Another European painter who became a curator, German-born Hilla Rebay,[44] had studied in Munich and Paris before arriving in New York. When the Museum of Non-Objective Painting was founded in 1930—later it would become the Solomon Guggenheim Museum—she became its advisory curator, with collections of European art—ranging from Kandinsky, Delaunay, Léger, Braque, and Mondrian—including these abstract American painters.

World War I had already forced a number of European artists to flee to New York. Hitler's rise to power in January 1933, the signing of the German-Soviet Pact in September 1939, and the invasion of France by German troops in May of 1940, created a second wave of artistic immigrants. Within three

In New York, in 1945, emigrés gather at the home of the dealer Pierre Matisse. Left to right (back row), Roberto Matta, Yves Tanguy, Aimé Césaire, Henry Seyrig, André Breton, Denis de Rougemont, Nicolas Calas, Marcel Duchamp, Sam Francis; (front row) Eliza Breton, Suzy Césaire, Sonia Sekula, Jackie Matisse, Patricia Matta, Teeny Duchamp, Eva Calas.

decades, a new demographic order, perhaps the most extraordinary in the entire history of art, would forever change New York. Among the new arrivals from France were Roberto Matta (Chilean), Nicolas Calas (Greek), Max Ernst (German), Piet Mondrian (Dutch), Victor Brauner (Romanian), and Salvador Dali (Spanish). Finally, in 1941, came André Breton and André Masson, with the idea of joining Marcel Duchamp.[45] "It was in America that things came into focus for me," Masson later wrote. "That is where I went the farthest, where I matured."[46] They all went to the Museum of Modern Art to discover (or rediscover) Picasso's *Guernica* and *Les Demoiselles d'Avignon*,[47] Meret Oppenheim's *Object*—the famous fur-covered cup and saucer—and the drooping clocks in Salvador Dali's *The Persistence of Memory*. They returned stunned by both the museum's art and its architecture. "What was extraordinary was the modern side, the accessible side," recalled actress Dolorès Vanetti, a friend of Duchamp and Breton. "There was this museum, this garden in the heart of the city and this modern architecture. It was like no other museum we knew. Modern art, contemporary art, was recognized here; that was the difference."[48]

The war brought about many fortuitous meetings between émigrés and

Marcel Duchamp participates, with Alfred H. Barr, Jr., and the dealer Sidney Janis, in the jury
that chose Max Ernst's painting *The Temptation of Saint Anthony* for the Loew-Lewin prize,
organized by the writer-director Albert Lewin for the movie *The Private Affairs of Bel-Ami*
(1946). He wanted to feature the work of a contemporary painter in Technicolor.

those simply passing through New York: Masson and Claude Lévi-Strauss
scoured the antiques stores on Third Avenue together, looking for artifacts
from the South Pacific.[49] At Dolorès Vanetti's home, Duchamp met French
author Jean-Paul Sartre, who was then a special envoy of the Paris newspaper
Le Figaro. Sartre composed a *cadavre exquis*[50] that delighted the painter: "Lau-
rent Pichat virant, coup hardi, bat Empis/Lors, Empis, chavirant, couard dit:
'Bah! Tant pis!' " All of the new arrivals expressed their surprise at what con-
fronted them in this original, highly visual country. "American museums strike
the European visitor as being paradoxical," wrote Lévi-Strauss. "They were
assembled in a shorter amount of time than our museums, but that fact, rather
than making them lag behind, seems from many points of view to have helped
them surpass us . . . America has made a virtue of necessity."[51] In 1945, after
years of deprivation in Paris, Sartre also arrived in New York. Wearing shoes
with cardboard soles, he was put up at the Plaza Hotel. The city, he wrote later,
seemed to "sparkle"—all of the stores had electric lights. He arrived on a snowy

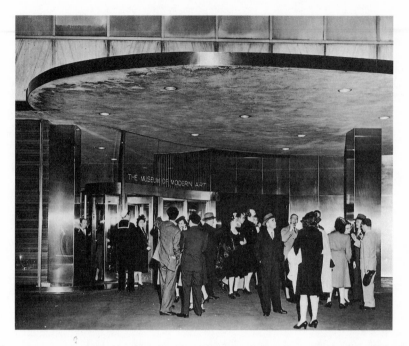

The entrance to the Museum of Modern Art, May 1944, during the opening of the exhibition *Art in Progress,* celebrating the fifteenth anniversary of the museum

night and happened to come across people emerging from a formal ball in tuxedos, diamonds, and furs. "It was exactly like finding peace. These people were completely unaware of the war."[52] Then there were the lectures—Dali's "Surrealism Today"; Calas's "The Fate of Jocasta and the Destiny of Painting" and "Surrealism, Painting, and Iconoclasm"; Mondrian's "A New Realism." "MoMA is doing all it can, as I have been fortunate to see," Calas wrote Alfred Barr in January 1941. "The major difficulty artists and writers are confronted with when coming to America and want to earn a living is to get in touch with the intellectual public."[53]

Foreign artists reconfigured the map of New York. They met up at the restaurant Larée on Fifty-sixth Street, for what they called "banquets"; the price was a dollar a head. Surrealists Breton, Ernst, Tanguy, Calas, Masson, Matta, Swiss painter Kurt Seligmann, and English painter Leonora Carrington (until 1941), usually went there, joined by various Americans, including composer John Cage, sculptor David Hare, Arshile Gorky, and Joseph Cornell. The evenings nearly always ended in boisterous marathon discussions. "André Breton didn't join in these conversations," recalled Vanetti. "He didn't speak a word of English and regally ignored the whole thing. He viewed America as an abomination, and wanted nothing to do with it. He was really on his own in

this." Apart from his friendship with art historian Meyer Schapiro and several others, Breton did keep his distance from America, and was thus exceptional in the émigré community. When he launched his magazine *VVV* in June 1942, he remarked, unsurprisingly, that he found "no curiosity in anything that was not immediately commercial, and no thinking about the written work."[54] In 1942, Duchamp returned to the United States, and was at once infused with new life to discover so many new artists there. European art in New York had come to occupy an unimaginable proportion of the art world there; and the dynamism of available space, and the intelligence with which museums presented its panoramic progress from Puvis de Chavannes to Mondrian, offered the local public a privilege available in no other country in the world.

A last European impulse would arrive with the energy of painter Roberto Matta, who played a considerable role. Thanks to him—and Breton—the younger generation of American artists would meet some of the Parisian Surrealists, who were their near contemporaries, and a few of them worked together. Arriving in 1939 on the same boat as Tanguy, this South American abstract painter would soon personify the latest trends from Europe. Affable and charismatic, speaking perfect, fluent English, he sought gregarious situations and loved the battle of ideas. His own work came to show a highly unusual synthesis of the various groups: he introduced and pitted against each other abstract and Surrealist artists, Americans and Europeans.

In the winter of 1941–42, Matta invited a few of his new American friends—Gerome Kamrowski, William Baziotes, and Robert Motherwell—to share his work sessions with him (Jackson Pollock went once). The group created poems and drawings together, employing the automatist technique. "These artists . . . were full of vitality," Matta later recalled. "But in some funny way they were painting from color reproductions instead of painting about themselves. You know what I mean? Actually they had a fantastic experience to [sic] America. . . . And this automatic technique of the Surrealists (which means to show the functioning of the mind) fit them like a glove. They were very professional. They knew a great deal! As a matter of fact, they knew even more than we Surrealists knew about art history. Their studios were covered with reproductions of pictures pasted to the walls, while in our case there was not so much reference to these things."[55] Thanks to Matta's influence, American artists, conscious of their maturity and of their newborn originality, started feeling the imminence of their autonomy. "They wanted to transform art, while the Surrealists wanted to change life,"[56] Robert Motherwell once explained of the Americans.

Peggy Guggenheim offered yet another opportunity for European and American artists to cross paths. She came to New York in 1941 with her soon-

to-be husband Max Ernst. Two years later, assisted by the Austrian-born archi-
tect Frederick Kiesler, who had spent much of his life in Vienna, she founded
an extraordinary gallery, Art of This Century.[57] Art of This Century consisted
of a Cubist and an abstract gallery, a Realist gallery, and a film gallery—one of
them with walls of pliant, undulating canvas. Guggenheim asked André Bre-
ton to help complete her art collection. In 1942, he and Marcel Duchamp
organized a memorable exhibition called *First Papers of Surrealism* in a rented
mansion on Madison Avenue. Pierre Matisse's *Artists in Exile* show that same
year, *European Artists in the United States* at the Whitney, and James Johnson
Sweeney's *Eleven Europeans in America* show at the Museum of Modern Art in
1946 solidified European influence.

After the war, most European artists returned home. "Surrealist invention
ended with the period of exile, around 1945," explained Masson in 1959. "It was
then that American painting gathered momentum, taking up both automatism
and the purely instinctive painterly gesture. . . . The Americans, unhampered
by tradition, were more prepared than others to be receptive to this technique.
Pollock carried it to extremes that I myself could not envision."[58]

Finale

The Heroic Dance
of Jackson Pollock[1]

S TELLA ROBINSON MCCLURE, LeRoy McCoy Pollock, and their five
sons—Charles, Jay, Frank, Sandford (Sande), and Jackson—confronted
by the most severe economic jolts to hit the American West since the beginning
of the century, left Iowa. They had decided, like thousands of other farmers
there, to abandon their farm and to search for a sunny plot of land where they
could establish a new homestead. Jackson, their youngest son, born in Cody,
Wyoming, in 1912, was only ten months old when they departed by train for
California, crossing some 5,000 miles and eight different states. "Roy" Pollock,
though a competent dairy farmer, could not adjust to the crude ways and
means of the local market. When the United States entered World War I in
1917, demand for cotton skyrocketed, generating the formation of bigger farms
and bankrupting small dairy farmers. The Pollock family farm was put up for
auction in the spring of 1917. Over the course of the next seven years the fam-
ily wandered—to Chico, California; Janesville, California; Orland, California;
Phoenix, Arizona; Carr Ranch, California; Riverside, California. Pollock's
father, despite intermittently trying his hand at different lines of work, often
ended up unemployed. He became active in the American branch of Interna-
tional Workers of the World, supported the Bolshevik Revolution in Russia,
and followed world affairs by reading the leftist periodical *The Nation* faith-
fully. As for Stella Pollock, her son Frank conveyed her rare combination of
qualities when he described her strength, saying she "never seemed to worry
about the next day, whether we'd make it. My god! She'd drive a team and
spring wagon to town for supplies, buying hundred-pound sacks of flour. She
knew one flour from another, where it came from, which was good and which
wasn't. . . . She didn't only do housework and cook. She did everything on the
farm but work in the fields. . . . She milked cows and when Dad went off with
the produce she milked more than normally."[2]

Jackson Pollock grew up in the West, shaped by its elemental concerns and

precariousness. After school, he would go off rabbit hunting with his brothers, a pistol slung over his shoulder, or head to the local bars. In Phoenix, on Saturdays, groups of Apache Indians would appear in the courtyard of their farm to buy the melons Jackson's father had not been able to sell at market. When they returned from town, Charles and Jay spoke of meeting peaceful tribes such as the Pima and Maricopa, who sold snakeskins and wore handmade silver-and-turquoise jewelry. One day in 1920, when Jackson was eight years old, a small group of Indians appeared in front of the Pollock house in Janesville. Members of the Wadatkut ("grain eaters") tribe, related to the Paiutes of the North, had come to take part in the annual Bear Dance ritual. Their tribe all but annihilated, the few surviving Wadatkut subsisted culturally on mere vestiges of their legends and their language; soon, even these fragments would disappear.[3] During the family's year-and-a-half stay in Janesville, California, a tiny city of two hundred inhabitants at the foot of the Sierra Nevada, the Pollock boys would experience both the realities of Indian culture and the memories of the Gold Rush. In fact, the Diamond Mountain Inn—the Janesville hotel run by the Pollocks—had been the last stagecoach stop of gold prospectors and diamond miners for half a century.

Jackson and his brothers frequently attended rituals at the Wadatkut funeral sites, located just a few miles from their home. Singing and dancing in unison, members of the tribe moved in increasingly tighter circles around whoever was wearing the bearskin, as they uttered a slow, magical incantation.[4] The Pollock boys became even more closely attached to native traditions when Stella grew too ill to look after the children, and Nora Jack, a woman from the tribe, took her place. She told them legends about her people, describing their respect for the powers of nature, a respect tied to an animism that stretched back to the dawn of human history.[5]

Following such an unstable childhood, Pollock's adolescence revealed itself as only slightly less chaotic. Within three years, they would move from Janesville to Orland, from Orland to Phoenix, Arizona, then to Riverside and Los Angeles. At the same time, Roy Pollock deserted the family for three years, only occasionally dropping by. At the age of sixteen, following in his older brother Charles's footsteps, Jackson attended the Manual Arts High School in Los Angeles. Occasionally expelled because of "insolence and rebellion," he then dropped out of school altogether. Strong, stocky, muscular, with his intense gaze, he struck all who encountered him with his combination of virility and vulnerability.

At the age of eighteen, he went to New York to live with his older brothers Charles and Frank, then started classes at the Art Students League with

Thomas Hart Benton. It was September 1930, at a time of a comprehensive return to American themes in art—a cause that Benton, of course, championed. Before World War I, Benton had studied in Paris—to inure himself, he insisted, to the "ecstatic mist" of French bohemianism. He railed against Paris, he railed against Chicago and even against New York, declaring that he had found his truth while traveling in search of his roots, somewhere between Virginia, Kansas, and Missouri. Benton used this conversion experience to reinvent himself as the American painter par excellence, a reactionary anti-Modernist who would lead the crusade against European art: "Down there in Virginia I was thrown among boys who had never been subjected to any aesthetic virus. . . . I was released from the tyranny of the prewar soul which everybody so assiduously cultivated in the world of art and which was making such a precious field of obscurities. I proclaimed heresies around New York, talked on the importance of subject matter, then under rigid taboos among the aesthetic elite, and ridiculed the painters of jumping cubes, of cockeyed tables, blue bowls, and bananas, who read cosmic meanings into their effusions. In a little while, I set out painting American histories in defiance of all the conventions of our art world."[6]

Through his fervent evangelism, Benton single-handedly inaugurated a new era that would affirm the primacy of American art. He inoculated his students with anti-Modernist venom and urged them to break the ties that had bound them to Paris for so many years. The Depression and the W.P.A. would deepen the rupture with Europe by keeping artists on American soil; few had the money to travel abroad. Such were the conditions of Jackson Pollock's first true art education.

Along with his Regionalist "Benton period," Pollock combined numerous artistic influences thanks in part to his friend Reuben Kadish, who had put him in contact with the Mexican muralists. Pollock worked with José Clemente Orozco and, in particular, with the Communist painter David Alfaro Siqueiros, who was producing epic frescoes in New York. While depicting the proletarian victims of American capitalism with pre-Columbian imagery, and echoing both Renaissance fresco painters and the Spanish Realists, Pollock managed to offset Benton's influence.

From 1935 to 1942, Pollock, like so many others, was on the government payroll, participating in the W.P.A.'s Federal Art Project. He lived in New York, earning a dollar and a half an hour for cleaning the statue of Peter Cooper in Union Square,[7] hauling his paintings or sculptures into federal offices to pick up his weekly paycheck, working as a janitor at the City & Country School (one of Greenwich Village's most progressive, where his brother Charles taught

drawing),[8] and pushing the limits of alcohol abuse, which, between detox and bouts of depression, would force him into a three-month stay at the Bloomingdale Asylum, a psychiatric hospital in White Plains.

Nearly every summer, the three Pollock brothers in New York would drive a used car cross-country to visit their mother in California, occasionally dreaming of reaching Mexico. For American painters, art's magnetic poles, which for decades had been located in East Coast cities and in Europe, had shifted West—even if the best formal education for young regional artists was still to be found in New York's art schools. From his trips West, and from visits to the Museum of Natural History in New York, Pollock absorbed the themes and colors of the Tomahawk. By the beginning of 1936—Pollock was then twenty-four—some more established figures in the art world started taking note of his gifts. Burgoyne Diller, the painter who supervised the mural division of the W.P.A., began referring to Pollock as "a great hope for American painting."[9]

Nonetheless, the consensus remained that America had miles and miles to go. "In the late thirties," as later recalled by Lee Krasner (who married Pollock in 1945), "there was a feeling that American art could never achieve the status, could never become the aesthetic equal of French art. . . . Absolutely no one thought American painting could rival French painting, then or ever."[10] Pollock had come to Manhattan in September 1930—only months after Alfred Barr's arrival—where he discovered Picasso and the primitive art that so profoundly influenced his work. In May 1939, Barr organized the *Art in Our Time* exhibition at the Museum of Modern Art around the acquisition of *Les Demoiselles d'Avignon*. Several days later, *Guernica* went on display uptown, at the Valentin Gallery. In the fall of that same year, Barr gave Picasso his first significant New York retrospective, *Picasso: Forty Years of His Art.* Bypassing intermediary phases, bypassing the transition from Post-Impressionism to Fauvism or Cubism, Pollock got dragged straight into the fully formed Picasso engine.[11]

Little by little, as Pollock moved into New York's European circles, his career accelerated. In 1939, he met John Graham, a Russian painter and theorist who had had his essay "Primitive Art and Picasso" published in *Magazine of Art* in 1937, and who later invited him to join some European and American painters in an exhibition at the McMillen Gallery in January 1942.[12] In autumn 1941, after invitations to participate in the show had been arranged, he had met Lee Krasner, one of Hans Hofmann's students, the daughter of Ukrainian Jewish immigrants. Then came Peggy Guggenheim, who, on the advice of James Johnson Sweeney, Mondrian, and Marcel Duchamp, offered to show Pollock's work in her gallery and to subsidize him, picking up where the government left off. She also commissioned a big panel for her Manhattan home, *Mural,* which was completed on a single night, New Year's Eve 1943, and delivered the fol-

lowing day, on a sort of dare.[13] Last but not least there appeared critic Clement Greenberg. The decisive meeting took place during Pollock's first solo exhibition, in November 1943. "The most powerful painter in contemporary America," Greenberg wrote in October 1947, "and the only one who promises to be a major one is Jackson Pollock. . . . Why? Because the feeling his art contains is radically American."[14]

So read the official biography of Pollock written to corroborate the standard telling of the American art epic. "Jackson broke the ice," as Willem de Kooning would later put it,[15] recounting the rise of American painters on the international scene in the years just following World War II, according to the needs of an American history that was to be written alongside Pollock's. Everything about his life has been chronicled: his psychological problems, his alcoholism, his embodying the myth of an America triumphant, or self-destructive. He has been seen as a virile, paint-flinging cowboy; as a fragile, tormented drunk; as a savage, crazed genius of staggering, raw talent coming from nowhere. He has been seen as the last European Modernist, and much has been said about his relationship to a Modernist aesthetic; he has been called the "first Existentialist painter" and the last of the "great classical" artists. Despite the brevity of his career—which ended with his brutally dying, drunk, in a car crash in August 1956—myths about him have given rise to an enormous body of literature.

Certainly, he produced his best works in a single shot, as with *Mural,* in 1943, or later, *Summertime* and *Lavender Mist,* in 1948, before collapsing once again. Between 1944, when he painted *Gothic* on an easel, and 1947, when he laid the canvas on his studio floor, Pollock, as though burning all bridges, committed himself to a potent expression of his emotions with prodigious speed. He revolutionized his approach. With the canvas on the floor, his body hunched over it, he dipped his brush into a can of paint and, leaning on one leg, circled the painting in a slow and steady motion, throwing the paint with a rhythmic movement of his forearm, dancing around his art. "My painting does not come from the easel. I hardly ever stretch my canvas before painting. I prefer to tack the stretched canvas on the hard wall or the floor. I need the resistance of a hard surface. On the floor I am more at ease. I feel nearer, more part of the painting, since this way I can walk around it, work from the four sides and literally be in the painting. This is akin to the method of the Indian sand painters of the West."[16] Certainly, the artists associated with him—Mark Rothko, Willem de Kooning, Robert Motherwell, Arshile Gorky, William Baziotes, and Barnett Newman, among others—took advantage more slowly of the new conditions emerging for American artists.

In fact, Jackson Pollock's rise situates itself in the very particular context of

1930s America: after the uncertainty of an unprecedented economic crisis, the Federal government put in place its first and only political program of public support for artists, an initiative hinted at by nothing in the country's history. As for the Pollock family, hit hard by the crisis, they would profoundly engage themselves in the political combats of the period, and would demonstrate their exemplary solidarity when confronting the struggles of "Jack," their youngest member. "Jack has been having a very difficult time with himself," Sande wrote to Charles in June 1937. "This past year has been a succession of periods of emotional instability for him, which is usually expressed by a complete loss of responsibility, both to himself and to us. . . . So without giving the impression that I am trying to be a wet nurse to Jack, honestly I would be fearful of the results if he were left alone with no one to keep him in check. There is no cause for alarm, he simply must be watched and guided intelligently. You will understand the necessity of keeping this strictly confidental."[17]

Charles, Jay, Frank, and Sande—Jackson's brothers in Detroit, in Los Angeles, and in New York—never stopped concealing Jackson's material and psychological needs, safeguarding his well-being among themselves, elevating their brother's "state" to that of a "family secret" (reluctant even to inform their own wives of his troubles), taking care to send their mother whatever economic support they could to protect her from the most somber aspects of her youngest son's condition. "I feel I must tell you of the serious problems we have now and have had these past 5 years. The subject is Jack," Sande wrote again four years later. "To mention some of the symptoms will give you an idea of the nature of the problem: irresponsibility, depressive mania (Dad), overintensity and alcohol are some of the more obvious ones. Self-destruction, too."[18] Educated in the arts, the Pollock brothers found it possible, thanks to the Federal government's new politics, to accomplish a "useful" professional activity in their country's development, one that also conferred social status on the artist. In this respect, they assumed that Jack would find a structure in the W.P.A. program favorable to developing his talent.

"On the credit side we have his Art," Sande continued, "which if he allows to grow, will, I am convinced, come to great importance. As I have inferred in other letters he has thrown off the yoke of Benton completely and is doing work which is creative in the most genuine sense of the word. Here again although I 'feel' its meaning and implications, I am not qualified to present it in terms of words."[19] Their influence included existential support. The Pollock brothers were Jack's first guides in art. Charles had studied at the Otis Art Institute in Los Angeles; Jack trailed him there. Charles had followed Benton to New York; Jack arrived soon thereafter. Charles, Sande, and Frank had joined the ranks of the W.P.A.; Jack would also participate in the program. Selflessly,

patiently, his brothers guided and advised him, sometimes giving in to him despite their own hardships and without the hope of any reciprocity whatsoever. The Pollock brothers would commit themselves without ever counting on their baby brother for anything back. "It has taken much of our energy," Sande conceded after years of support, attributing to him the aura of an artist prodigy who did not fear disrobing his rivals, no matter how prestigious. Sande continued: "His thinking is, I think, related to that of men like Beckmann, Orozco and Picasso. We are sure that if he is able to hold himself together, his work will become of real significance. His painting is abstract, intense, evocative in quality. . . . It is hard work, laden with anxiety, discouragement, but satisfaction."[20]

Attentive readings, pointed critiques: step by step, the Pollock boys guided Jack's education, allowing him to orient himself according to the various aesthetic trends that traversed 1930s America and, according to their respective opinions, with a nondogmatic vision. Sande, for example, never stopped trying to convince Charles that Jack should not limit himself to Regionalist painters such as Benton. "I am, admittedly, a pretty small fart to be blabbing my mouth about a man like Benton, but I have observed, in the recent issues of *Life,* his drawings and captions of the Michigan Communists and Fascists. . . . If these drawings are to be taken seriously the man is artistically bankrupt and [his] captions prove him to be politically rotten."[21]

A few years later, despite setbacks in his own artistic experiences and looking for work, Sande again lavished Jack with extravagant praise: "I have not done much painting. Jack however is doing very good work. After years of trying to work along lines completely unsympathetic to his nature, he has finally dropped the Benton nonsense and is coming out with a honest, creative art. . . . The whole idea of a Missouri Venetian, both in idea and paint, seemed phony. One had a feeling he should rush up and hold the pretty girls on the canvases."[22]

Through Frank, Jack had met Reuben Kadish, who introduced him to an entirely different world. The son of a Lithuanian Jew—member of the BUND, a revolutionary illegal organization—who had emigrated to the United States in 1910, Kadish too was a strong believer in Marxist theory. He, Sande, and Jack all studied with Siqueiros, coming into contact with one of the most politically committed painters of the time. The mural painter, whose technique approached that of a mason, commanded a new status that led to enthusiastic public recognition. "The fresco is a radical transformation of the painting technics," Siqueiros explained in one of his public speeches in Los Angeles around the time when Pollock met him, linking the process to antique methods. "The Egyptians, the Greeks, the Romans, the Italian Primitives and the

American Indians used principally the so-called 'fresco' to decorate their buildings. We, modern Mexican painters revive and promote this process."[23]

The Mexican muralists presented Pollock with a revolutionary perspective situating the mural painter as rooted in ancient tradition, long preceding that of modern Europe. The Mexican Revolution would propel them to target their actions in cities in California, then in other cities in the United States. "NEW YORK WILL BE OUR FIRST INTERNATIONAL FIELD OF ACTION (THE STARTING SIGNAL FOR A NEW AND BIG ERA WHICH IS MOVING ON IN THE VISUAL ARTS). . . . Therefore, we have given ourselves this town as a target, neglecting the old London and the bohemian Paris. . . . We uniquely represent the forward thinkers. Afterward, others will join our ranks. Others will come from Argentina, Brazil, Bolivia, Mexico, California, from all the U.S. territory. And some Europeans will join us."[24]

"To be on the Project," "to be off the Project," "to get back on the Project," "to be still off the Project," "to get a wall"—such was one of the leitmotifs in the correspondence between American artists during the decade 1933–43, the years of the Works Progress Administration. Galvanized by the model of the Mexican muralists, the Pollock brothers committed themselves one after the other to the W.P.A.'s Federal Art Project. "I was glad to hear that you have decided to get on the Project and get a wall," Sande wrote to Charles in September 1938. "You would be a good deal happier painting. It seems to me that it would be wise to get the painting you have here placed with some Dealer like Loenthal . . . that might sell. . . . I have done a wall . . . the living room in the Nurses residence, on Welfare Island . . . I chose a subject which I am certain would be of interest to my audience . . . Namely Frontier Nursing, a service that is carried on by a group of social conscience women in the hill country of Kentucky . . . more about the poverty-stricken people of the back country."[25]

Sande and others, who had known the freedom of Mexican experience, rebelled at times against the American program, which they found excessively rigid and bureaucratic. Siqueiros remained a constant influence: in February 1936, he came to New York for the first American Artists Congress, and then a few months later started an experimental workshop where he would push his research on the possibilities in painting even further. In the end, the Federal government, by offering artists a gigantic blank canvas—its innumerable schools, post offices, airports, universities, libraries, and other public buildings—where they could apply their talent, opened up for them a number of possibilities for sharing and emulation. And Jackson Pollock found there at the same time his first professional harbor and an opportunity to see his art alongside that of his peers. He was twenty-three when he began his employment on

the Federal Art Project in August 1935, and worked successively in the divisions of sculpture, mural, and easel painting.

In New York, Jack would fully experience the "Barr decade"—that is, he would be able to consult the "encyclopedia of European art" that Paul Sachs's graduate student was in the process of amassing at the Museum of Modern Art. The city offered an abundance of possibilities: one could go to admire *Les Demoiselles d'Avignon,* which the museum's Board had just acquired; *Guernica,* which had just been completed, at the Valentin Gallery; or the incredible series of *Constellations,* twenty-three works created by Miró in 1945 that inspired an incredible fascination in the contemporary public. "The large Picasso show was a fine one. For imagination and creative painting, he is hard to equal,"[26] Sande wrote to Charles. Enriched by the action of numerous actors in the art world, both American and European, who collectively were responsible for assembling the art treasures now on display in its institutions, the city created a public. New York had become a different city, rich in innovation.

As American artist Harry Jackson recalls, Pollock integrated the European tradition with his early training: "Jack . . . talked my goddam ear off one long night, drinking beer in the kitchen. [He] brought out *Cahiers d'Art* and analyzed Tintoretto in great detail, explaining the composition of this and that; what he was doing was bringing me pure Tom Benton: Venetian Renaissance to Tom Benton. Tom to Jack, Jack to Harry. Then he analyzed Braque, Picasso, Juan Gris, and Matisse, but he wasn't that crazy about Matisse. He talked especially about composition that one night, and Lee came down several times to say, 'Jackson, come on to bed—you're going to be so tired and you've got this and that to do,' something like that. But we went on until dawn with Jack describing Tintoretto and weaving a spell: 'See, it goes back over there, and then over here, and it never goes off the canvas.' "[27]

After the war, most of the European emigrés who had come to the United States—notably many of the Surrealists, who had so profoundly influenced American artists—went home. "The refugees were around during the war," remembered Philip Pavia. "They were 'the artists'; we all looked up to them . . . with that started the nucleus. Then the refugees slowly disappeared. They went back to Europe. Then we were on our own."[28] The great question for the group who were first called the Irascibles, then the Abstract Expressionists, centered on European tradition and its impact. "Some of the Abstract Expressionists wanted to shatter Europe," explained Robert Motherwell, "others wanted to continue Europe." Pollock used to boast, "I never went to Europe. The idea of an isolated American painting, so popular in this country during the thirties, seems absurd to me."[29]

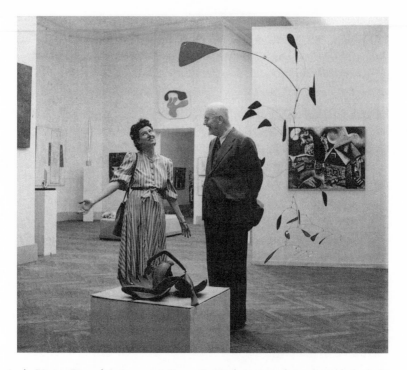

At the Venice *Biennale* in June 1948, Peggy Guggenheim introduces six works by Jackson
Pollock to Europe. Here, in front of a Calder mobile, she talks with the art historian
Lionello Venturi.

In June 1948, after a six-year suspension caused by the war, the Venice
Biennale was reinitiated. From June to September 1948, in preparation for the
Biennale's twenty-fourth exhibition, the directors culled art from fourteen
countries. "Here, as well as in all the countries in Europe," explained the Bien-
nale's general secretary Rodolfo Pallucchini in his opening speech, "the contrast
between figurative art and abstract art is becoming more and more violent,
even dramatic. . . . To complete the inventory of contemporary art move-
ments, we are exhibiting the collection of Peggy Guggenheim of New York,
rich in all the directions painting has taken, from Cubism to Surrealism."[30] In
fact, it was only due to the fact that the Greek delegation had pulled out for
political reasons that an empty space was offered to Peggy Guggenheim (who
had returned to live permanently in Europe) and her collection.

Alfred Frankfurter, director of the Biennale's American pavilion, striving
to be "democratic," decided to present every painting trend since 1920 and
showed seventy-six artists in all, among them such old standbys as Thomas
Hart Benton, Grant Wood, Ben Shahn, and Charles Burchfield; a few Realists,
including John Sloan and George Bellows; American Impressionist Maurice

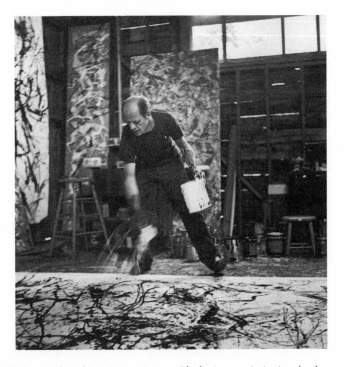

Jackson Pollock at work on his painting *Autumn Rhythm* in 1950, imitating the dance of Navajo sand painting, captured on film by photographer Hans Namuth

Prendergast; independents such as Walt Kuhn; Modernists Charles Demuth, Stuart Davis, Marsden Hartley, Joseph Stella, Abraham Walkowitz, Max Weber, John Marin, Arthur Dove, and Georgia O'Keeffe. Almost lost in this wildly varied crowd were three younger artists: William Baziotes, Arshile Gorky, and Mark Rothko.

But, after problems with transportation and customs, the American pavilion could not be installed until July 25, a full month after the Biennale's official opening. So it was that Peggy Guggenheim's collection came to represent the United States of America. Thirteen American painters—among them, Alexander Calder, Robert Motherwell, Rothko, Baziotes, Gorky, Clyfford Still, and Pollock—rubbed shoulders with fifty-four Europeans—the three Duchamp brothers, Jean Arp, Picabia, Aleksander Archipenko, Brancusi, Yves Tanguy, Max Ernst, Wassily Kandinsky, Marc Chagall, Hélion, Picasso, Mondrian, Henry Moore, Paul Klee, Léger, El Lissitzky, René Magritte, and Kasimir Malevich. Peggy Guggenheim showed these works mixed together, the European works alongside the American ones, rendering them all more intelligible. She had brought six paintings by Pollock—*Eyes in the Heat,* 1946, *The Moon-*

Woman, 1942, *Two,* 1943–45, *Circumcision,* 1945, *Drawing,* 1942, and *Don Quixote*—and for many it was these that would make Guggenheim's collection "the real event" of the Biennale. For, from among her offerings, as one critic, Enzo Di Martino, would later recall, "We discovered Pollock's enormous canvases, the most violently new of all the painters, whom Peggy had met in his uncle's cabinet-making shop."[31]

In the years that followed, until Pollock's death in 1956, he would behave in an increasingly arrogant, abusive way—seemingly endless stormy brawls and drunken depressions, while the brooding artist would be hailed by *Life* magazine and the *New York Times* as America's greatest artist, a greatness widely, if sometimes grudgingly, acknowledged by countless peers. The composer Morton Feldman wrote, "The day Jackson Pollock died I called a certain man I knew—a very great painter—and told him the news. After a long pause he said, in a voice so low it was barely a whisper, 'That son of a bitch—he did it.' I understood. With this supreme gesture Pollock had wrapped up an era and walked away with it."[32] Passionate, explosive, childlike, contradictory—such was the image of Jackson Pollock working on *Autumn Rhythm* captured by photographer Hans Namuth in 1950. Frozen in a blur of graceful movements as he poured paint onto his gigantic canvas on his studio floor, the painter's singular act of creation was bared, and his rhythmic gestures would conceal the full weight of the four preceding generations of artists, collectors, curators, museum directors, gallerists, critics, and professors that had built, carried, and sustained this work and paved the way for this inevitable advent of an American art. This myth fascinated the Americans: there was no longer any doubt that Pollock was their first real master. The painter's heroic dance around his canvas became the consummate allegory for Americans, fulfilling Matisse's prophecy—"One day, they will have painters"—and exorcising centuries of European domination. Like Prometheus, Pollock had just passed on the artistic torch.

Epilogue

1998: A Voyage to Taos

T O C O M P L E T E T H I S S T U D Y , and to understand the establishment of artist colonies in the American West, I traveled throughout the United States in the summer of 1998 on a final working trip. The year 1998 seemed to mark a turning point in the American art world. The opening of the Guggenheim Museum in Bilbao, an event that Tom Krens had planned for so long, was awaited with trepidation by a number of Europeans. Frank Gehry's audacious, monumental "ship" design transformed the city, spurring development in the surrounding vicinities. "The end of the millennium" preoccupied all of New York's museums. Following the suggestion of its president, Leonard Lauder, the Whitney was preparing to pronounce the twentieth century as—using Henry Luce's famous phrase—"the American Century." The curators at the Modern decided to put their entire permanent collection on display in *MoMA 2000,* a three-tiered exhibition intended to stimulate new reflection.

At the same time, Leo Castelli, while he continued actively at age ninety-one to seek out the most interesting shows in town, quietly planned the closing of his SoHo gallery and the opening of a new one closer to his home on Seventy-ninth Street. In the summer of 1998, Jasper Johns sold his apartment in New York and moved to Connecticut. After a tour of his beautiful barn, which towers over a lake, we sat before his new painting, *Halloween,* and spoke for hours on end, returning frequently to Duchamp, Cézanne, and Picasso.

I knew I had to go to Taos. I wanted to retrace the steps of Andrew Dasburg and Marsden Hartley, who, following sojourns in Concarneau and Pont-Aven and rendezvous at the Steins' salon in Paris, had moved to New Mexico. In addition, many of my New York friends had deep attachments there. Bill Katz encouraged me to take the trip, offering me names, numbers, addresses. "I spoke to Agnes Martin about you," he told me. "She's expecting to hear from you. But don't call before four in the afternoon." I called Agnes Martin. During her 1993 retrospective at the Whitney, I had been struck by the aesthetic mastery and originality of this stunning artist, who in SoHo in the 1950s had befriended Ellsworth Kelly, Delphine Seyrig, and Jack Youngerman.

Martin's studio adjoins an unfinished house that looks like the Facteur Cheval factory, with its strange mixture of adobe walls, iron rods, and pebbly cement. A large, solid woman of eighty-six with big, powerful hands, blue eyes, short hair, and wrinkles, she spoke happily about her retirement home, El Plaza del Retiro, which liberates her from practical concerns. She drives proudly a white Mercedes convertible, a present from Arnie Glimcher, her gallery director. She speaks sparingly and with great thoughtfulness. "Things have to be done slowly, by very small steps. . . . For twenty years I destroyed all my work. . . . I am for a complete control of emotions, that's how you get happiness."[1]

By then I had been in Taos for a week, staying in the apartment of the Harwood Foundation, a spacious place with a strange, turpentine-like odor. The former home of the Harwood family, this adobe house, encircled by tall scarlet and pink peonies, seemed at once spartan and colorful, filled with colonial Spanish furniture, primitive Mexican carvings, and sculptures by Patrociño Barela, with an entire round room devoted to Martin's canvases. Assisted by local art historians Liz Cunningham and David L. Witt, who deluged me with books and files, I studied the works of Blumenschein, Berninghaus, Ufer, Dunton, Couse, and others. The art produced by this first generation of artists in New Mexico represented a middle way between picturesque Romanticism and old-fashioned Realism, but without, I felt, any reconception of either. Nonetheless, within the limited space of Taos, defined by three cultures, their accomplishments changed the country's social dynamic with the Native American population. Later, the Taos colony stood for everything American art in the twentieth century had to offer: landscape painters influenced by the Hudson River School, followed by folk artists and Regionalists, then by Realists such as Henri, Sloan, and Lawson, and after them by Modernists O'Keeffe, Marin, Hartley, Dove, and Dasburg, followed in turn by local artists such as Barela, whose powerful sculptures were discovered by the men of the W.P.A.; and finally, the more recent generations, practitioners of Minimalist and Conceptual art.

We needed to get back to Albuquerque. Bill arrived a half-hour late. To the right, clouds formed horizontal lines in the sky: fleecy white, light blue, orange, pink. To the left, blue-black storm clouds were erupting over the Sangre de Cristo, making the mountain chain look like a vast gray monster. We drove on, passing the Santo Domingo Pueblo and the Santa Clara Pueblo, fleeing the storm with a kind of urgency. There were the mountains, the desert, the Native Americans, the Hispanics, the Anglos. I wanted to take everything in. Passing the Sangre de Cristo mountains, the canyon of the Rio Grande, looking like an open wound in nature, the sensuality of the San Francisco de Asis church in

Ranchos; the howling coyotes in the desert near Carson, the summer storms over the Sandia Mountains, the serenity of the Pueblo Indians making their Dreamcatchers, I was still trying to understand.

The idea of this book had originated a decade earlier, in the years that I spent at the Cultural Services of the French Embassy in the United States. A specialist of the French intellectual scene, I found myself unexpectedly pulled into the world of the American visual arts, which grabbed me strongly. Was it because after just two weeks in the United States I had met Leo Castelli, who right away decided that he "intended to complete my training in American art," as he put it? Was it because my job immersed me in this country's art world, leading me, for instance, to open the Paris 1889 Universal Exhibition at the Pennsylvania Academy of the Fine Arts in Philadelphia, the Matisse retrospective at the Museum of Modern Art, the Fauves exhibition in San Francisco, the Seurat show at the Metropolitan Museum? During these numerous travels, I discovered America's impressive museums and collections and I learned how to interact with a whole new world, a system widely different from the one I knew in France. As I grew interested in the uniqueness of the American system, I started to look at it with the eyes of a cultural anthropologist, in the position of a "participant observer," interviewing everyone around me to try to grasp one or another of the elements which had built this particular world. After these four years of diplomatic assignments were completed, I decided to devote my full attention to studying this system. I returned to my role as a cultural historian, once again plunging into archival research both in the United States and in France. Specifically, I wanted to understand the process which changed the working conditions of painters in the United States and helped them gain legitimacy after World War II.

For a long time, linked with corruption, indulgence, and monarchy, art had remained suspect in a rural American society. Later, American art suffered neglect from the ruling elite, who acquired European treasures to assert its prestige and expand its power. As feelings of inferiority receded and the country developed, the necessity of looking to Europe diminished: America moved swiftly from rural to urban, always stunning, whether in its desire to copy Europe or to ignore it; or in the scarcity of its cultural institutions, then by their shining presence. Yet paradox and tension remained—those who had arrived with the first settlers, who founded a society both democratic and egalitarian, yet arrogant and brutal; and those who emerged as the country progressed, suspended between financial goals and moral imperatives, between individual success and the general good, between the might of its industry and the power of its religion.

American painters were searching for an art that was their own, desperately

trying to free themselves from Europe. Had my trip to New Mexico helped me understand them? I wondered. What I discovered there was entirely different from what I had expected. The Taos Society of Artists or the Cinco Pintores group did not create any aesthetic revolution. But it was in meeting with Agnes Martin that I knew I had accomplished my quest. In her studio covered in a fine layer of dust, she sorted slowly through her paintings, asking for my reactions to each and every one. Behind their economy of color and form lay a mastery as impressive as a silent opera, the blues, pinks, yellows, and whites melting into silence. They seemed to me like one of those Indian blankets, patiently woven by Pueblo women beside their sacred lake, the Great Blue Lake, a thousand years ago.

Acknowledgments

The idea of this book imposed itself in steps: first, in October 1989, when, after arriving in New York, I started to discover the world of American museums and their fabulous French art collections; then, during my years spent working in the French Embassy's cultural services, during which we tried systematically to function in harmony with both French and American institutions, seemingly so dissimilar; and finally, in the summer of 1995, when, thanks to a writer's grant from the Rockefeller Foundation in Bellagio, the definitive project for this work was born.

I would never have imagined undertaking this research in the French and American art world if I had not had the chance to be introduced to it by some of the milieu's greatest actors, who unfortunately have since disappeared, such as Dominique Bozo, Leo Castelli, and Dominique de Ménil who, with Agnes Gund and Daniel Shapiro allowed me to observe from inside, confiding in me their observations, thoughts, and plans.

John Young and the Florence Gould Foundation helped me work in New York under optimum conditions. At the Rockefeller Foundation, thanks to Alberta Arthurs, Pascuale Pesce, Nilüfer Göle, and Mohammed Arkoun, I was able to put in place the book's earliest stages. Thanks to Yves Mabin, the director of the Bureau du Livre, at the Foreign Affairs Ministry in Paris, I was able to travel, making trips that were indispensable to a strong knowledge of the territory.

At the Museum of Modern Art in New York, Rona Roob, Jennifer Russell, Michelle Elligot, Jennifer Bott, and Mikki Carpenter provided me constantly with material and advice, in the most generous way. At the Metropolitan Museum of Art, in New York, I received from William S. Lieberman, Nan Rosenthal, Gary Tinterow, and H. Barbara Weinberg support, feedback, keen critiques, and most astute comments throughout innumerable lively and enriching discussions. At the National Academy of Design, Annette Blaugrund, who had played a major role in introducing me to both the 1889 Exposition Universelle and to the major art museums in the country, followed up by reading entire parts of this manuscript; and to David Dearinger for his helpful suggestions. At the Whitney Museum of American Art, Leonard Lauder, Fiona Donovan, and Beth Rudin deWoody helped deepen my understanding

of Gertrude Vanderbilt Whitney and her fantastic legacy. At the Guggenheim Foundation, in Venice, both Tom Krens and Philip Rylands provided encouragement and insight for the last part of the book. At the Pollock-Krasner Foundation, House and Study Center, in East Hampton, New York, Helen Hamilton appeared as a magical presence and provided me unexpectedly with the most appropriate fellowship, which enabled me to further my understanding of Pollock's trajectory and to benefit from her generous academic advice. In the Archives of the Harwood Foundation, in Taos, my research was driven by Robert Ellis, David L. Witt, and Elizabeth Cunningham, alongside innumerable discussions and parties. Dean Carlton Rochell helped me gain access to the Tamiment Library, Bobst Library, at New York University; Jane Clarke opened for me the doors of the Archives of the City & Country School, in New York.

At the Service de Documentation and the Bibliothèque of the Musée d'Orsay, in Paris, I received almost daily support thanks to Bernadette Buiret, Dominique Lobstein, Quentin Bajac, Emmanuelle Héran, and Edouard Papet. At the Archives of the Musée Rodin, in Paris, Hélène Pinet welcomed me with efficiency and generosity. Hélène Seckel, Anne Baldassari, and Sylvie Fresnault became my key contacts at the Archives Picasso at the Musée National Picasso, Paris. And Yveline Cantarel-Besson helped me understand the arcanes of the French Museums committees before I consulted the Archives des Musées Nationuax, Musée du Louvre, Paris. Olivier Corpet was a constant source of information at the Institut des Mémoires de l'Edition Contemporaine, Paris. As for Caroline Godfroy Durand-Ruel, she generously granted me access to her great-grandfather's archives, Archives Durand-Ruel, Paris. As for Yves Peyré, both his erudition and wit contributed to a fascinating time of research at the Archives of the Bibliothèque Littéraire Jacques Doucet, Paris. At the Musée d'Art Américain in Giverny, Maureen Lefèbvre, Bud Korngold, and Derrick Cartwright gave me commentaries and help. Armelle Sentilhes, conservateur général du Patrimoine, opened for me the Duchamp files at the Archives Départementales de Basse-Normandie, in Rouen.

Numerous personal friends have been essential during the long and intense process of researching and writing. I would especially like to thank Omero Antonutti, Harley Baldwin, David Braunschvicg, Marie-Claude de Brunhoff, Ken Burns, Jerome Charyn, Vera Di Maio, James T. Dyke, Gail and Stefan Edlis, Elisabeth de Farcy, Norina Ferrini, Jérôme Godefroy, Tina and Massimo Guzzetti, Pamelo Johananoff, Lucien R. Karhausen, Bill Katz, Julian Lethbridge, Barnet Liberman, Susan Lorence, Bernard Rigaud, T. Conley Rollins, Lee Siegel, Giovanni Simonnetti, Dominique Schneider, Sarah Taggart, Dolorès Vanetti, Karen Kennerly, and Sondra Myers.

My assistants and collaborators, both in New York and Paris, Larissa Bailiff, Anne Dressen, Jennifer Donnelly, Kristen Gresh, Etienne Hellman, Ewa Jaskiewicz, Judith Lévy, Ava Liberman, Frank-Adrien Papon, Maika Pollack, Antoine Schweitzer, Terry Taffer, Amy Wilpizeski, and Anya Zalenskaia, persevered with passion and commitment through the ups and downs of this adventure.

Invaluable comments were generously and pertinently bestowed by experts and specialists who informed my work with their expertise: among them, my thanks go out to Jacques Andréani, Dore Ashton, Avis Berman, Riva Castleman, Anne Distel, Kathleen A. Foster, Martin Friedman, Alan Henrikson, Virginia Couse Leavitt, Jean-Claude Lebensztejn, Herman Leibovics, Frédéric Morvan, James Moore, Earl Stroh, Jennifer Tobias, Justin Vaisse, Maurice Vaisse, Robert R. White, and John Wilmerding. John Patrick Diggins is responsible for my overall education in American history, Paul Berman for improving my comprehension of Puritanism in the United States, and Kathleen D. McCarthy for introducing me to a women's culture. I thank all of them here.

Henri Loyrette agreed to reread and comment on the manuscript, as did Frédéric Baleine du Laurens and Emmanuelle Héran. Anne-Elisabeth Crédeville intervened at the critical moment, bringing along her culture, her talent, and her patience. Finally, Christian Bachmann, who is no longer with us, had, as so often before, listened, criticized, and translated my earliest sketches. This book is dedicated to him.

For the American edition, Morton L. Janklow took action at decisive moments, contributing his impressive knowledge of the art scene and conferring his definitive authority on matters as essential as the book's title. Tina Bennett was the indispensable and generous transatlantic presence. I was also graced with the professional competence of Svetlana Katz, and, at Knopf, of Ben Moser, Robin Reardon, Kevin Bourke, Kathy Zuckerman, Jason Zuzga, and especially of George Andreou, my editor, for his impressively refined editing skills. As for Laurie Hurwitz-Attias, who, aside from providing the American voice, helped with the translating, editing, and researching, both in terms of the language and of her expertise in the subject: her unfailing presence simply made it possible for the American edition to come to life. This book is about cultural weavers, those rare ambassadors who carried the spirit of Modernism overseas. The people I thank on these three pages belong to this same group.

Notes

The following abbreviations are used: AAA (Archives of American Art, Smithsonian Institution); *AAAJ (Archives of American Art Journal)*; Stieglitz Papers (Alfred Stieglitz Papers, Beinecke Rare Book and Manuscript Library, Yale University).

Part I

The Argonauts and the Golden Fleece: 1855–1889

Ouverture

Paris, 1867: Bumpkins in a Ballroom

1. *L'Exposition Universelle de 1867 illustrée*, t. I, III. "Le Cortège impérial" et IV. "La fête du 1ᵉʳ juillet," p. 291.

2. See "Exposition Universelle de 1867," in *Modern Art in Paris 1855–1900*, and Rimmel, *Souvenirs de l'Exposition Universelle*, pp. 16, 17, 18.

3. Rimmel, *Souvenirs de l'Exposition Universelle*, p. 161.

4. *L'Exposition Universelle illustrée*, t. I, IV. "La fête du 1ᵉʳ juillet," p. 292.

5. Exceptionally, in 1855 the Salon and the Exposition Universelle had been held together; in 1867, things were back to normal and the events were separate.

6. Fink, *American Art in the Nineteenth-Century Paris Salons*, p. 88.

7. In 1874, a critic dubbed this group the "Hudson River School."

8. For a description of this painting, see p. 14 of this book.

9. Kelly, *Frederic Edwin Church*.

10. Quoted in Chesneau, *Les nations rivales dans l'art*, p. 161.

11. Leslie, *Report on the Fine Arts*, p. 15.

12. *New York Daily Tribune*, January 23, 1867.

13. *L'Exposition Universelle de 1867 illustrée*, t. I, IV. "La fête du 1ᵉʳ juillet," p. 298.

14. Troyen, "Innocents Abroad," pp. 3–29; see also H. Barbara Weinberg, "L'attrait de Paris," in *Un nouveau monde: chefs d'oeuvre de la peinture américaine, 1760–1910*, (Paris: Editions de la Réunion des Musées Nationaux, 1984), pp. 16–32, and Patricia Mainardi: *Arts and Politics of the Second Empire: the Universal Expositions of 1855 and 1867* (New Haven and London: Yale University Press, 1987).

15. Conway, "The Great Show at Paris," p. 248.

16. Jarves, "Art Thoughts," pp. 297–99.

17. Rimmel, *Souvenirs de l'Exposition Universelle*, pp. 321–24.

18. *L'Exposition Universelle de 1867 illustrée*, vol. 1, Sixième livraison, p. 86.

19. *L'Exposition Universelle de 1867 illustreé*, t. II. "L'Exposition américaine," p. 194.

20. Ibid.

21. Rimmel, *Souvenirs de l'Exposition Universelle*, p. 335. The surface area of the United States was 3 million square miles—almost 1 billion acres.

22. Ibid.

Chapter One

"O, That We Had Cathedrals in America"

1. Baur, "Worthington Whittredge," p. 21.
2. Friedrich Lessing's nephew.
3. Blaugrund, *The Tenth Street Studio Building.*
4. Baur, "Worthington Whittredge," p. 42.
5. This painting was also notable for being part of the American "disappointment" at the 1867 Exposition Universelle.
6. *Letters and Papers of Copley and Pelham, 1739–1776,* pp. 65–66.
7. Tocqueville, *De la démocratie,* p. 73.
8. *Letters and Papers of Copley and Pelham,* p. 64.
9. McCoubrey, *American Art 1700–1960,* p. 14.
10. Neal, *Wandering Recollections,* p. 35.
11. For more on this subject, see Hughes, *American Visions,* pp. 81–93.
12. *Morse: Letters and Journals,* vol. 1, p. 132; quoted in Harris, *Artist in American Society,* p. 82.
13. Clark, quoted in Ken Burns, *Lewis and Clark: The Journey of the Corps of Discovery* (New York: Alfred A. Knopf, 1998).
14. Thomas Cole, *Essay on American Scenery,* May 1835; reprint, *The American Monthly Magazine,* n.s., 7 (January 1836), p. 97.
15. Tocqueville, *De la démocratie,* p. 55.
16. Beecher, *Norwood; or, Village Life in New England,* p. 231.
17. Ibid., "Puritanism," in *Lectures and Orations,* p. 34.
18. Ibid., p. 32.
19. Here, and elsewhere in this chapter, I have relied heavily upon the Neal Harris's remarkable *The Artist in American Society.*
20. Hawthorne, *Passages from the English Notebooks,* vol. 2, p. 133.
21. Osgood, *The Literary World* 9 (September 27, 1851), p. 252.
22. See David S. Reynolds, *Beneath the American Renaissance: The Subversive Imagination in the Age of Emerson and Melville* (Cambridge, Mass.: Harvard University Press, 1988).
23. Baur, "Worthington Whittredge," p. 61.
24. Emerson, "Self Reliance," in *Essays and Lectures,* p. 135.
25. Emerson, "Nature," in *Essays and Lectures,* p. 313.
26. Emerson, "On Art," in *Essays and Lectures,* p. 315.
27. Henry David Thoreau, *Walden* (New York: Modern Library, 1937), p. 125.
28. *The Illustrated Magazine of Art,* May 1854.
29. Nathaniel Hawthorne, *Passages from the French and Italian Notebooks,* p. 26.
30. Ibid., p. 38.
31. *The Crayon* (1858).
32. *The Knickerbocker,* 42 (July 1853), p. 93.
33. *Illustrated Magazine of Art,* op. cit.
34. Bauer, "Worthington Whittredge."
35. George Inness, "A Painter on Painting," *Harper's New Monthly Magazine* 56 (February 1878), pp. 456–61.
36. See Avery, *Church's Great Picture.*
37. Troyen, "Innocents Abroad," p. 5.

Chapter Two

A Generation of Pioneers

1. *The Crayon,* January 10, 1855, p. 29.

2. Jervis McEntee, *Diary,* February 13, 1878.

3. *American Monthly Magazine,* 1874.

4. Between 1850 and 1858, they went from forty thousand to five hundred thousand dollars. These statistics are drawn from *Report of the Secretary of the Treasury* (see Harris, *The Artist in American Society,* p. 254).

5. See Digby Baltzell, *Puritan Boston and Quaker Philadelphia: Two Protestant Ethics and the Spirit of Class Authority and Leadership* (New York: Free Press, 1979).

6. Samuel F. B. Morse, quoted in Burrows, *Gotham,* pp. 468–69.

7. Ibid., p. 467.

8. *The Knickerbocker* (November 1848). See Hudson River School catalogue, p. 54.

9. *The Crayon* (March 1858).

10. Philip Hove, quoted in Burrows, *Gotham,* p. 472.

11. Bermingham, *American Painters in the Barbizon Mood,* p. 37.

12. Ibid.

13. Also advised by Hunt in Boston were Henry C. Angell, Peter C. Brooks, Alexander Cochrane, H. P. Kidder, and Henry Sayles; see Fink, *American Art,* p. 93.

14. See Gibson Dane, "A Biographical and Critical Study of William Morris Hunt," Yale University Ph.D. diss., 1949.

15. Ibid.

16. Thomas Harton Benton, *Tom Benton's America: An Artist in America* (New York: Robert M. McBride & Company, 1937), p. 12.

17. Ibid., p. 26.

18. McEntee, *Diary,* op. cit., May 21, 1873.

19. Neal, "American Painters and Painting," in McCoubrey, *American Art,* p. 125.

20. Emerson, "The American Scholar," in *Essays and Lectures,* p. 59.

21. Emerson, "Thoughts on Art."

22. Henry David Thoreau, *Walden* (New York: Modern Library, 1937), p. 22.

23. Jarves, "The Art Idea," pp. 132–36.

Chapter Three

"The Magnificent Ghosts of Genius"

1. A contemporary of Peale, quoted in Dickson, *Observations on American Art,* p. 18.

2. Daunou, quoted in Marès: *L'Institut de France,* p. 21.

3. See *Ingres raconté par lui-même et par ses amis.*

4. Geneviève Bresc, *Mémoires du Louvre* (Paris: Gallimard, Découvertes, 1989), p. 82.

5. See Pomian, "Francs et Gaulois."

6. Hawthorne, *Passages from the French and Italian Notebooks,* pp. 20–21.

7. Wallace and Andrews, *Sixty Years' Memories of Art and Artists* (Woburn, Mass.: The News Print, 1900), p. 20.

8. For more on the system of art criticism, see Gamboni, *La Plume et le pinceau.*

9. Charles Baudelaire, "Salon de 1845," in *Critique d'art* (Paris: Gallimard, 1992), p. 11.

10. Baudelaire, "Salon de 1846," in *Critique d'art,* pp. 129–30.

11. Baudelaire, "Exposition Universelle de 1855," in *Critique d'art,* p. 242.

12. Ibid., p. 243.

13. Ibid., p. 251.

14. David, quoted in Michel, *Géricault,* p. 35.

15. Michelet, quoted in Michel, *Géricault,* p. 89

16. Baudelaire, "Salon de 1845," op. cit. p. 15.

17. Bourdieu, *Homo Academicus.*

18. Moulin, *Le Marché de la peinture en France,* pp. 29–31; and Moulin, *L'Artiste, l'institution, le marché.*

19. Albert Boïme: "Les Hommes d'affaires et les arts en France au XIX° siècle," in *Actes de la Recherche en Sciences Sociales,* 28 (June 1979), pp. 55–75.

20. See *Les Schneider, Le Creusot.*

21. For a more complete listing of these patron-entrepreneurs, see two very interesting studies: Lobstein, *Au temps de l'Impressionnisme,* and Boïme, "Les Hommes d'affaires et les arts en France au 19ième siècle," op. cit.

Chapter Four

"Greeks of Our Time"

1. Kenyon Cox, letter dated October 26, 1879, in Morgan, *An American Art Student in Paris,* p. 179.

2. Letter of Andrew Dasburg, Archives of American Art, Smithsonian Institution, New York, Dasburg files.

3. Morgan, *An American Art Student in Paris,* p. 8

4. Jarves, "The Art Idea," p. 560.

5. Vasari, *Lives of the Artists,* pp. 87–88.

6. Valenciennes, quoted in Pomarède and de Wallens, *Corot: la mémoire du paysage,* p. 35.

7. Marie-Catherine Sahut and Régis Michel, *David, l'art et le politique* (Paris: Gallimard, Découvertes, 1988), p. 21.

8. Fumaroli, *L'Etat culturel,* p. 407–9.

9. William Morris Hunt, *Talks on Art,* compiled by Helen Mary Knowlton, vol. 1 (Boston: Houghton, Mifflin, 1883), p. 93.

10. Hunt, quoted in Smith, *Barbizon Days,* p. 16.

11. See Chapter 2, pp. 27–28.

12. de Nieuwerkerke, quoted in Bermingham, *American Painters in the Barbizon Mood.*

13. Bermingham, *American Painters,* p. 73.

14. Cassatt, quoted in Hale, *Mary Cassatt,* p. 25.

15. Dorothy Young, *Life and Letters,* p. 81.

16. Ibid., pp. 19–50.

17. Milner, *Studios of Paris,* p. 30.

18. Henry Siddons Mowbray, "Autobiography," reprint, *Le Voyage de Paris: les Américains dans les écoles d'art, 1868–1918* (Paris: Réunion des Musées Nationaux, 1990), pp. 30–31.

19. Henry Ward Beecher, *Star Papers: or, Experiences of Art and Nature* (New York, 1855), p. 57.

20. George S. Hillard, *Six Months in Italy* (Boston, 1854), pp. 13–14.

21. David Sellin, *Americans in Brittany and Normandy: 1860–1910*, (Phoenix: Phoenix Art Museum, 1982).

22. Cox, letter dated October 26, 1877, in Morgan, *An American Art Student in Paris*, p. 8.

23. Dorothy Young, *Life and Letters*, October 4, 1874, pp. 49–50.

Chapter Five

The American Colony: Pont-Aven

1. Bridgman letter in Jacobs, *Good and Simple Life*.
2. Butler letter dated July 3, 1885, in Jacobs, *Good and Simple Life*.
3. Jacques Cambry, quoted in the excellent visual guide by Quéinec, *Pont-Aven*.
4. A tidal flood in an estuary.
5. For historical details, see Quéinec, *Pont-Aven*.
6. Dorothy Young, *Life and Letters*, August 30, 1874, p. 44.
7. Henry Bacon, 1881, quoted in Jacobs, *Good and Simple Life*.
8. Filiger, quoted in Terrasse, *Pont-Aven*, p. 144.
9. Dorothy Young, *Life and Letters*, August 3 and 30, 1874, p. 44.
10. Bermingham, *American Art in the Barbizon Mood*, p. 77.
11. Gauguin, letter dated June 27, 1886, in Cachin, *Paul Gauguin*, p. 33.
12. Letter from Gauguin to his wife, dated July 19, 1887, archives of the Musée de Pont-Aven.
13. Antoine Terrasse, *Pont-Aven, l' Ecole buissonnière* (Paris: Gallimard, Découvertes, 1992), p. 64.
14. Letter from Signac written in the summer of 1891, in Rewald, *Histoire du Post-impressionnisme*, vol. 1, p. 283.

Chapter Six

Brouhaha, Hue and Cry, and Fisticuffs

1. Rewald, *Histoire de l'Impressionnisme*.
2. Courbet, in *Le Courrier du Dimanche*, December 25, 1861.
3. Courbet, quoted in Georgel, *Courbet*, p. 65.
4. Notably in texts by T. J. Clark, including *Une Image du peuple* and *The Painting of Modern Life: Paris in the Art of Manet and His Followers* (New York: Knopf, 1985); and by Linda Nochlin, especially "Courbet's Real Allegory," in *Courbet Reconsidered* (New York: Brooklyn Museum, and New Haven: Yale University Press, 1988), pp. 17–42; and Michaël Fried, *Le Réalisme de Gustave Courbet*. See also the catalogue for the exhibition *Courbet 1819–1877* (Paris: Grand Palais, RMN, 1977).
5. The phrase is from Nochlin, "Courbet's Real Allegory."
6. The studio Courbet opened was in the same tradition as the Académie Suisse and the Boudin studio.
7. Courbet, letter of March 10, 1862, in Petra ten-Doesschate Chu, ed., *Correspondance de Courbet* (Paris: Flammarion, 1996), p. 185.
8. Jullien, *Fantin-Latour et ses amitiés*, pp. 6–8.
9. For more on the subject of the Salon des Refusés, see Lobstein, "Salons-salons, du

un au multiple." Also, see Danield Wildenstein, editor, "Le Salon des Refusés 1863," catalogue and documents in *La Gazette des Beaux-Arts,* September 1965.

10. de Chennevières, *Souvenirs,* p. 96.

11. Viollet-le-Duc, "Réponse à M. Vitet."

12. Ibid.

13. Delacroix, quoted in Rewald, *Histoire de l'Impressionnisme,* p. 24.

14. Lecoq de Boisbaudran, quoted in Duranty, *La Nouvelle Peinture,* pp. 7–8.

15. La Farge, quoted in Rewald, *Histoire de l'Impressionnisme,* pp. 23, 33.

16. Bazille, *Correspondance,* p. 78, letter dated January 27, 1864.

17. Ibid., p. 53, letter to his father, dated June 3, 1863.

18. Ibid., p. 108, letter to his mother, dated May 5, 1864.

19. Ibid., p. 137, letter to his mother, dated April 1867.

20. Ibid., p. 174, letter to his father, dated May 2, 1869.

21. Ibid., p. 119, letter to his father, dated April 9, 1869.

22. See the work of, among others, Loyrette and Tinterow, *Origins of Impressionism,* which contains a chronology of the years 1859 to 1870; Rewald, *Histoire de l'Impressionnisme;* Dominique Lobstein, *Au temps de l'Impressionnisme;* and Venturi, *Archives de l'Impressionnisme.*

23. All this is admirably demonstrated by Loyrette and Tinterow, op. cit. In the Salon of 1859, critics were in agreement on having seen "the end of an age without engendering a new cycle." They detected empty technical virtuosity: "Everybody knows how to paint" (Zacharie Astruc); "Everybody has talent" (Perrier); "There are incontestable signs that the work is superior" (Faucheux); "Practical expertise has greatly increased of late" (Chesneau). They observed a shift in traditional views: "The genres are overlapping with each other" (A. J. Du Pays). The critics also noted the reconfiguration of ancient forms; the grand format was no longer the province exclusively of History, itself moribund as a genre: "Instead of giving it some new colors, Jean-Léon Gérôme's laborious reconstitutions destroy them" (Baudelaire, II, 1985–87, pp. 639–41).

24. Castagnary, *Salons (1857–1870).*

25. Ibid.

26. Courbet, quoted in Georgel, *Courbet,* p. 109.

Chapter Seven

Masters and Disciples: "Rembrandt, Rubens, Gérôme"

1. Albert Boïme, in his very thorough book, *The Academy and French Painting in the Nineteenth Century* (Phaidon, 1971), criticized "the conception of the Academy des Beaux-Arts as a static and moribund institution," a conception that he notes is "historically unjustified." He denies the value and the reconstructions a posteriori. For Boïme, the Academy, an institution threatened from all sides by a series of various transformations, was unable to adapt or to change, and transformed into an even more rigid institution.

2. Shinn, "Art Study in the Imperial School of Paris."

3. Eakins, letter of April 1869, in Letters 1867–1869, Archives of American Art, roll 640, frames 1553–4.

4. Brush, quoted in Bowditch, *George deForest Brush's Recollections of a Joyous Painter,* p. 10; also quoted in Weinberg, *American Pupils of Jean-Léon Gérôme,* p. 23.

5. Dorothy Young, *Life and Letters,* May 1874, p. 37.

6. Ibid., March 21, 1875, p. 71.

7. Ibid., August 30, 1874, p. 47.

8. Eakins, letter dated April holidays 1869, *Letters 1867–69,* Archives of American Art, Eakins Papers, 1432–1565.

9. Dorothy Young, *Life and Letters,* March 30, 1874, p. 33.

10. Eakins, April Fool's Day 1869, *Letters 1867–1869,* Archives of American Art, Eakins Papers.

11. Shinn, "Art Study in the Imperial School at Paris," p. 68.

12. Eakins, p. 549.

13. Dorothy Young, *Life and Letters,* March 21, 1875, p. 71.

14. Benson, "Jean-Léon Gérôme," p. 582.

15. See Ackerman, *Jean-Léon Gérôme,* and Weinberg, *American Pupils of Jean-Léon Gérôme,* p. 71.

16. Ibid.

17. Dorothy Young, *Life and Letters,* June 13, 1874, p. 45.

18. See Milner, *Studios of Paris,* p. 23.

19. Mumford, *Brown Decades,* p. 205.

20. Boïme, *Thomas Couture and the Eclectic Vision,* pp. 442–556; and Couture, *Thomas Couture (1815–1879).*

21. Boïme, *Thomas Couture,* p. 557.

22. Gleyre, quoted in Rewald, *Histoire de l'Impressionnisme,* p. 60.

23. Gleyre, quoted in Charles Cément: *Etude biographique et critique avec le catalogue raisonné de l'oeuvre du maître* (Paris: Librairie Académique, Didier et Cie, Librairies Editeurs, 1878).

24. Moore, quoted in Milner, *Studios of Paris,* p. 22.

25. Bastien-Lepage, quoted in Milner, *Studios of Paris,* p. 30.

26. Moore, quoted in Milner, *Studios of Paris,* p. 17.

27. Georges Rochegrosse, *L'Académie Julian,* November 1909.

28. See Rewald, *Histoire du Postimpressionnisme,* vol. 1, pp. 260–98.

29. See Fehrer, *Julian Academy.*

30. R. Dupont, "L'Art en France et en Amérique," *L'Académie Julian,* March 1907.

31. For more on the relationship between Bridgman and Gérôme, see Fink, *American Art,* pp. 165–70.

32. Dorothy Young, *Life and Letters,* August 8, 1874, pp. 44–45; January 1875, p. 65; April 20, 1875, p. 74.

33. Morgan, *An American Art Student in Paris,* letters dated December 18, 1877, p. 49, and June 3, 1879, pp. 160–1.

Chapter Eight

"The Art Sensation of the Year"

1. The United States has no analogous positions; these French titles can be roughly translated as follows: "Director of the Beaux-Arts"; "Undersecretary of the Beaux-Arts"; "Beaux-Arts Minister."

2. See White and White, *Canvases and Carriers.*

3. Vaisse, *La Troisième République et les peintres,* p. 62.

4. See Mainardi, *The End of the Salon.*

5. See Vaisse, *La Troisième République et les peintres,* particularly p. 117: "The separation of the artists from the State had been accomplished, but the enduring, free, and great exhibits that they had hoped for did not happen." More globally, his book provides a very thorough and balanced analysis of the entire period, in contrast to the more Manichean

interpretation of events, which are mostly hindsight reconstructions. For example, he views separately and in very subtle fashion the aesthetic, institutional, and economic power structures (p. 95 ff.).

6. Eugène Viollet-le-Duc, "L'Enseignement des Arts: il y a quelque chose à faire," in *La Gazette des Beaux-Arts*, vol. 12 (1862), p. 397. Reprinted in *A propos des l'enseignement des arts du dessin*, preface by Bruno Foucart (Paris: Ecole Nationale Supérieure des Beaux-Arts, 1984), p. 109. Also see Pacquement, "L'Ecole des Beaux-Arts, à l'aune de l'art contemporain," pp. 60–71.

7. Duranty, *La Nouvelle Peinture*, pp. 19, 38; reprinted, *The New Painting: Impressionism 1874–1886*, exhibition catalogue (Washington, D.C.: National Gallery; San Francisco: De Young Museum, 1986), p. 477.

8. In the magazine *Le Charivari*, on April 25, 1874, the critic Louis Leroy, reviewing the first independent painters exhibition, commented on Monet's painting *Impression, soleil levant:* "What does this canvas represent? Look in the booklet: 'Impression, Soleil Levant.' Impression, definitely. I was also thinking: 'because I'm impressed.' There must really be some impression in all that."

9. See Robert Jensen, *Marketing Modernism in Fin-de-siècle Europe* (Princeton, N.J.: Princeton University Press, 1994).

10. Père ("Father") was an affectionate form of address used for older men in rural areas.

11. Venturi, *Archives de l'Impressionnisme*, vol. 2: *Mémoires de Paul Durand-Ruel*, p. 34.

12. Ibid., p. 210.

13. Ibid., p. 192.

14. See Rewald, *Histoire de l'Impressionnisme*, p. 297.

15. Letter to Durand-Ruel, summer 1884 (undated), in Loyrette, *Aux Origines de l'Impressionnisme*, pp. 145–146.

16. Venturi, *Archives de l'Impressionnisme*, p. 311, letter dated April 26, 1886.

17. Ibid., p. 315, letter dated June 22, 1886.

18. *The Home Journal*, April 14, 1886.

19. *The Nation*, April 15, 1886.

20. *The Critic*, April 17, 1886.

21. *New York Mail and Express*, April 10, 1886.

22. *The Telegram*, April 9, 1886.

23. *The Churchman*, June 12, 1886.

24. *The Home Journal*, May 26, 1886.

25. *The Sun*, April 11, 1886.

26. *The Critic*, April 17, 1886.

27. Ibid.

28. *New York Times*, April 10, 1886.

29. *The Post*, April 10, 1886.

30. *The Sun*, April 11, 1886.

31. The *New York Mail and Express*, April 21, 1886. For all these quotes from the American press, I had the good fortune to consult the Durand-Ruel archives, opened to me by Caroline Godfroy Durand-Ruel on June 17, 1998.

32. Durand-Ruel, *Memoirs*, in Venturi, *Archives de l'Impressionnisme*, pp. 214–220.

33. Dorothy Young, *Life and Letters*, p. 168.

34. Venturi, *Archives de l'Impressionnisme*, p. 312.

35. Duret's observation is cited in Jensen, *Marketing Modernism*, op cit., p. 18.

36. For a fuller discussion, see Boïme, "Les Hommes d'affaires . . . ," pp. 55–75.

Chapter Nine

With or Without His Sting: Whistler the Butterfly

1. Along with Manet and Baudelaire, Fantin-Latour followed Delacroix's funeral procession, all the way to the Père Lachaise cemetery. But the ceremony was poorly attended and lacked emotion. Fantin-Latour therefore resolved to celebrate the master's life in his own way, in protest against the lack of official homage at these ceremonies. See "Fantin-Latour, groupes et portraits d'artistes et d'hommes de lettres," *Les Arts,* no. 5, May, 1906.

2. Duranty, "Ceux qui seront les peintres," p. 13.

3. " 'A nos débuts, Fantin, Whistler et moi,' expliquait joliment Degas, 'nous étions sur la même voie, la route de Hollande.' " See *Whistler 1834–1903,* exhibition catalogue (Paris: Réunion des Musées Nationaux, 1995).

4. Thorp, *Whistler on Art,* letter dated January 26, 1849, pp. 1–3.

5. Baudelaire, "Peintres et aquafortistes," p. 400.

6. See *Whistler 1834–1903,* op. cit.

7. Thorp, *Whistler on Art,* p. 11, letter to George Lucas, dated June 26, 1862.

8. Letter from Fantin-Latour to Whistler, dated May 15, 1863, Glasgow University Library, Whistler Collections, F. 12.

9. Desnoyers, quoted in Duret, *Whistler et son oeuvre,* p. 16.

10. Castagnary, *Salons (1857–1870),* vol. 1, p. 179.

11. Chesneau, *Les nations rivales dans l'art,* p. 161.

12. Thorp, *Whistler on Art,* p. 22, letter from Whistler to Fantin-Latour, January 23, 1864.

13. Ibid., p. 22, letter from Whistler to Fantin-Latour, dated January 23, 1864.

14. Ibid., p. 102, letter from Whistler to Walter Dowdeswell, dated April 1886.

15. About Whistler's *Nocturne in Black and Gold,* Ruskin had declared: "I did not expect to have to listen to a faker asking 200 guineas so that he could throw a can of paint at the public's face" (*Fors Clavigera,* July 2, 1877).

16. Thorp, *Whistler on Art,* p. 102, letter to Walter Dowdeswell, April 1886.

17. Théodore Duret, *Whistler et son oeuvre.*

18. Whistler, *Ten O'Clock,* p. 35.

19. *The Queen.*

20. *The Times.*

21. Cablegram in *New York Tribune.*

22. *Pall Mall Gazette,* February 21, 1885.

23. *The World,* November 17, 1888.

24. Henri de Régnier, *Nos Recontress* (Mercure de France, 1931), p. 210.

25. The phrase belongs to Henry Houssaye, used in "Le Salon de 1882," *La Revue des Deux Mondes,* Paris, June 15, 1882.

26. Clarence Cook, "Two Picture Exhibitions," *The Art Amateur,* vol. 10, January 1884, p. 28.

27. *New York Adviser,* May 22, 1886.

28. *The Sun,* April 11, 1886.

29. Letter to the *New York Tribune,* dated October 12, 1885.

30. Letter to Edward Kennedy, dated February 11, 1894, Library of Congress, Whistler-Kennedy Correspondence.

31. Merrill, *With Kindest Regards.*

32. *Pall Mall Gazette,* May 1867.

33. Lesur, *Correspondance de Claude Debussy,* p. 106, letter to the Belgian violinist Eugène Ysaÿe, dated September 22, 1894. The title Debussy chose was borrowed from Whistler (Archives Myriam Chimènes, Paris). When Debussy wrote to Ysaÿe in 1894, he was planning the work as a set of three pieces for solo violin and orchestra, with Ysaÿe to be the soloist; but by the time he completed the *Nocturnes* in 1899, the scoring was for orchestra with no solo violin, but with a female choir added in the third piece.

34. Letter dated October 29, 1891. See MacDonald and Newton, "Selling of Whistler's *Mother.*"

35. Ibid., letter dated November 27, 1891.

36. Ibid., letter dated November 27, 1891.

37. Ibid., p. 107.

38. Ibid., pp. 97–120.

39. Letter to his wife, dated February 1, 1892, Glasgow University Library, Whistler Collections, Whistler–Mallarmé Correspondence, p. 149.

40. Fragment of a letter probably written in December 1891 to the duke of Marlborough.

41. Bailly-Herzberg, *Correspondance de Pissarro,* p. 160.

42. Smalley, "American Artists Abroad."

43. Thorp, *Whistler on Art,* p. 107, August 21, 1886.

44. Jensen, *Marketing Modernism,* op cit., p. 43.

Chapter Ten

Two "Cosmopolitan and Cultivated" Americans

1. Women weren't admitted to the Ecole des Beaux-Arts until 1897.

2. See Mathews, ed., *Cassatt and Her Circle,* letters dating between November 22 and December 13, 1878.

3. Sainsaulieu, "La Robe et le pinceau."

4. Letter from Alice Kellogg to her parents dated October 25, 1888, AAA, Kellogg Papers. See *Le Voyage de Paris,* p. 29.

5. See White and White, *Canvases and Carriers,* p. 66: "It is clear that women were not recognized as professional painters." See illustration on p. 65.

6. Anonymous letter, 1887, Veronique Wiesinger, "Some General Ideas," in *Le Voyage de Paris,* pp. 13–24.

7. See interview with Mary Cassatt in Segard, *Mary Cassatt.*

8. Ibid., p. 97.

9. Ibid., October, 1872.

10. Letter from Emily Sartain to John Sartain, May 8, 1873.

11. See Mathews, *Cassatt and Her Circle,* letters dating June 1874.

12. Ibid.

13. Segard, *Mary Cassatt,* pp. 7–8.

14. F-C. de Syène [Arsène Houssaye], "Salon de 1879," *L'Artiste,* May 1879, p. 292.

15. Georges Lafenestre, "Les Expositions d'art," *Revue des Deux Mondes,* May–June, 1879, p. 481.

16. See the letter from Robert Cassatt to Alexander Cassatt, dated December 13, 1878.

17. Havemeyer, *Sixteen to Sixty,* pp. 249–251. I would guess that Louisine was nineteen years old rather than sixteen.

18. Ibid.

19. Ibid., p. 206.

20. Ibid, pp. 207–208.

21. Durand-Ruel Archives, Paris.

22. Durand-Ruel Archives, Paris.

23. This sketch of Sargent owes much to the two catalogues: *John Singer Sargent,* edited by Patricia Hills, in particular the essays by Stanley Olson, "On the Question of Sargent's Nationality," Patricia Hills, "The Formation of a Style and a Sensibility," and Albert Boïme, "Sargent in Paris and London: Portrait of the Artist as Dorian Gray"; and *John Singer Sargent,* edited by Elaine Kilmurray and Richard Ormond, with detailed essays by H. Barbara Weinberg, "Sargent and Carolus-Duran," and Mark Simpson, "Sargent and his Critics."

24. See Kilmurray and Ormond, *John Singer Sargent,* p. 34.

25. Fairbrother, *John Singer Sargent.*

26. Letter from Dr. Fitzwilliam Sargent to George Bemis, April 23, 1874, G. Bemis Papers, Massachusetts Historical Society.

27. John Singer Sargent to Mrs. Mary T. Austen, Florence, April 25, 1874, in Charteris, *John Sargent,* p. 19.

28. In Florence, Sargent studied at the Accademia delle Belle Arte with three Americans: Edwin White, Walter Launt Palmer, and Frank Fowler.

29. Letter to Heath Wilson, dated May 23, 1874. See Weinberg, "Sargent and Carolus-Duran," in Kilmurray and Ormond, *John Singer Sargent,* p. 7.

30. Will H. Low, "The Primrose Way," typescript.

31. Fairbrother, *John Singer Sargent,* p. 12.

32. Will H. Low, *A Painter's Progress,* pp. 185–188.

33. Will H. Low, *A Chronicle of Friendships,* pp. 12–13.

34. Letter to Heath Wilson, June 12, 1874. Cited by Weinberg, "Sargent and Carolus-Duran," in Kilmurray and Ormond, *John Singer Sargent.*

35. Edwin H. Blashfield, "John Singer Sargent, Recollections," *North American Review* 221 (June 1925). Cited by Weinberg, "Sargent and Carolus-Duran," in Kilmurray and Ormond, *John Singer Sargent.*

36. The senior Sargent may not have known that another American, Edgar Melville Ward, had received a third-class medal in ornamental design three years earlier.

37. See Weinberg, "Sargent and Carolus-Duran," in Kilmurray and Ormond, *John Singer Sargent,* note 26.

38. Blashfield, "Recollections," op cit.; letter dated August 15, 1879.

39. Montezuma/Montague Marks, "My Note Book," *The Art Amateur* 9, no. 4 (September 1883), p. 69.

40. *American Architect and Building News* 15, no. 443 (1884), p. 296.

41. "The Salon, from an Englishman's Point of View," *Art Journal* (London) 44, no. 7, p. 218.

42. See Boïme, "Sargent in Paris," in Hills, *John Singer Sargent,* p. 75.

43. Louis de Fourcaud, "Le Salon de 1884," *Gazette des Beaux-Arts,* pp. 477–484. Also see Trevor J. Fairbrother, "The Shock of John Singer Sargent's Madame Gautreau," *Arts Magazine* 55 (January 1994).

44. Henry James, "John Singer Sargent," in *Picture and Text,* p. 683.

45. "A skillful painter but not an artist," Degas once said of Sargent to Louisine Havemeyer. See Havemeyer, *Sixteen to Sixty,* p. 243.

46. Boïme, "Sargent in Paris," in Hills, *John Singer Sargent,* p. 82. I don't agree with the "psychologizing" of this article. Sargent, "lacking a secure authentic culture . . . found himself most at ease among an elite which had international connections" (p. 105).

47. "John Singer Sargent, An Educated Cosmopolitan," *The Art Amateur,* 1888: "From an old, respectable and wealthy Philadelphia family . . . his social position is of the best."

48. Thorp, *Whistler on Art,* pp. 121–23.

Chapter Eleven

Getting In: Legions of Honor, Honorable Mentions, and Third-Class Medals

1. Harry Siddons Mowbray, *Autobiography,* in *Le Voyage de Paris,* p. 30.

2. *The American Register,* May 3, 1879, p. 4.

3. Dorothy Young, *Life and Letters,* April 15, 1877, p. 123. Weir's position is all the more interesting given that four years later, having returned to New York, he wrote to Cassatt about buying a work by Manet. In 1881, on the recommendation of William Merritt Chase, he advised the collector Erwin Davis to acquire *Child, Sword,* and *Woman with Parrot.* He would also be one of the founding members of the group "The Ten," before being called "an American Impressionist" by American critics.

4. See Karen Zukowski's excellent biography of Harrison in Blaugrund, *Paris 1889,* pp. 160–164.

5. James Whistler and Mary Cassatt would prove to be among the rare ones to venture among the marginal painters.

6. These numbers are provided by Fink, *American Art in the Nineteenth Century Paris Salons.*

7. Ibid., p. 210.

8. Maurice du Seigneur, *L'Art et les artistes au Salon de 1880* (Paris: P. Ollendorff, 1880), p. 94.

9. *The Nation,* April 15, 1886.

10. See Blaugrund, "Behind the Scenes," pp. 20–21.

11. *Scribner's Monthly,* December 18, 1889.

12. The catalogue of the 1875 Salon included an extract from James Fenimore Cooper's *Naval History of the United States:* "A division of the English fleet pursued the American frigate *Constitution,* which was cleverly saled and managed to escape following a chase that lasted for sixty hours. The next month, it took revenge by taking possession of the English frigate Guerrière, from the same fleet."

13. In the exhibition, the following text accompanied the painting: "The little boat *Mayflower* left the coast of Holland and disappeared into the fog, carrying to the unknown beaches of the New World the first band of 'Puritan' souls, proud and innocent, risking any danger in pursuit of religious freedom. But because the boat was small, many had to remain behind. Thus husbands were separated from their wives, fathers from their children, lovers from lovers. A young girl appeared on the dunes and, distraught, held out her arms to the ship that was disappearing into the distance."

14. In all, according to experts, less than 10 percent of historical paintings produced by Americans and exhibited in the Salon during these years referred to U.S. themes. See Fink, *American Art,* particularly the chapter "Themes and Imagery," and pp. 161–62.

15. Bénédite, *Le Musée du Luxembourg,* pp. 94–95. See also Bénédite, *Le Musée du Luxembourg, les peintures.*

16. *Scribner's Monthly,* December 18, 1880, p. 173.

17. See Vaisse, *La Troisième République et les peintres,* pp. 130–46.

18. See Jacobs, *Good and Simple Life,* p. 61.

19. Henry Bacon, "Glimpses of Parisian Art," *Scribner's Monthly* 18 (December 1880), pp. 169–70.

20. Bacon, "Glimpses of Parisian Art," *Scribner's Monthly* 21 (March 1881), p. 737.

21. Low, *A Painter's Progress,* p. 144.

22. Letter to J. Alden Weir, March 10, 1878, in Mathews, *Cassatt and Her Circle.*

Chapter Twelve

Success: A New School "Nurtured by Us"

1. Venturi, *Archives de l'Impressionnisme,* vol. 2, p. 214.

2. Cahn: "Faire vrai, laisser dire."

3. See Mainardi, *End of the Salon.*

4. "Guide du Salon de 1883," p. 351.

5. Ibid., p. 326.

6. Henry Houssaye, *Revue des Deux Mondes,* June 1, 1883, pp. 596–97.

7. Chesneau, *Salon 1883,* p. 277.

8. Houssaye, *Revue des Deux Mondes,* op. cit.

9. "Extreme resistance of the French classical tradition . . . had a true capacity for adaptation and negotiation, just enough to maintain the appearance of modernity while mainting its superiority as official cultural elitism" (Mainardi, *End of the Salon,* pp. 131–33).

10. "Guide du Salon de 1883," op. cit., p. 14.

11. Ibid., p. 69.

12. Ibid., p. 6.

13. Eugène Véron, *Dictionnaire Véron* (Paris: Poitiers, 1883), p. 18.

14. Ibid., p. 100.

15. "Guide du Salon de 1883," op.cit., p. 22.

16. Edward Strahan, "L'Art en Amérique," in *Salon 1883, Exposition annuelle de la Société des Artistes Français, annuaire illustré des Beaux-Arts et catalogue illustré de l'Exposition Nationale,* ed., F. G. Dumas (Paris: Baschet, 1883).

17. Venturi, *Archives de l'Impressionnisme,* vol. 2, pp. 214–215.

18. Schalk, quoted in Albert Boïme, "The Chocolate Venus, 'Tainted' Pork, the Wine Blight, and the Tariff: Franco-American Stew at the Fair," in Blaugrund, *Paris 1889,* p. 79.

19. Ibid., p. 80.

20. This recurring debate between France and the United States is reminiscent of the one that took place in the fall of 1993, at the moment when the GATT (General Agreement on Trades and Tarifs) was being signed, about the "cultural exception," or earlier, in 1946, following the signing of the Blum-Byrnes Accord. See Annie Cohen-Solal, "Coal Miners and Dinosaurs: American Media and France," in *Media Studies Journal,* special issue, *Global Views on U.S. Media,* The Freedom Forum Media Studies Center (New York: Columbia University Press, October 1995).

21. Boïme, "Chocolate Venus," in Blaugrund, *Paris 1889,* p. 82.

22. Arthur, quoted in ibid.

23. Royal Cortissoz, *Art and Common Sense* (New York, 1913), p. 212.

24. Church, quoted in "Our Artistic Show in Paris," *New York Herald,* March 8, 1889, p. 1, cited in Blaugrund, "Behind the Scenes," p. 19.

25. Sheldon, *Recent Ideals of American Art,* pp. 32–34; and Durand-Gréville, "La Peinture aux Etats-Unis," p. 67, quoted by Boïme in Blaugrund, "Behind the Scenes," p. 81.

26. Cortissoz, *Life of Whitelaw Reid,* pp. 138–59.

27. L. Verax, *De l'envaissement de l'Ecole des Beaux Arts par les étrangers* (Paris: Librairie des Imprimeries Réunies, 1886).

28. Lobstein, "Salon-salons," p. 5.

29. The silver medals were awarded to Boggs, Bridgman, Chase, Davis, Dewing, Dolph, Donoho, Gay, Lowell Birge Harrison, Howe, Knight, Mac-Ewan, Mosler, and Reinhart.

30. The honorable mentions went to Brandegee, Breck, Bristol, Brown, Goerge Bernard Butler, Denman, Dow, Gross, Haas, Hayden, Henry, Koehler, McEntee, Nicoll, Parton, Thériat, Truesdell, Turner, Vedder, Walden, Weir, and Whittredge.

31. Bronze medals were awarded to Beckwith, Bell, Blashfield, Blum, Howard Russel Butler, Coffin, Cox, Dana, Delachaux, Dodge, Farny, Forbes, Fowler, Gardner, Gifford, Gutherz, Hart, Hassam, Inness, Johnson, Jones, Klumpke, Minor, Moore, Peters, Richards, Simmons, Story, Thayer, Thompson, Ulrich, and Vonnoh.

32. François Thiébault-Sisson, "Les Merveilles de l'Exposition," in Blaugrund, *Paris 1889.*

33. Henry Havard, "Exposition des Beaux-Arts," in F. G. Dumas, ed., *Revue de l'Exposition Universelle,* vol. 2, (Paris: Baschet, 1889), pp. 291–92.

34. M. de Varigny, *Revue des Deux Mondes,* October 15, 1889, p. 837.

35. "American Artists at the Paris Exhibition," *Harper's New Monthly,* September 1889, p. 489.

36. Thiébault-Sisson, "Les Merveilles de l'Exposition," in Blaugrund, *Paris 1889.*

37. Havard, "Exposition des Beaux-Arts," op. cit.

38. M. de Varigny, *Revue des Deux Mondes,* op. cit.

39. Havard, "Exposition des Beaux-Arts," op. cit.

40. Varigny, *Revue des Deux Mondes,* op. cit.

41. Ibid.

42. Alfred Picard, ed., *Exposition Universelle de 1889,* reports of the international jury (Paris: Imprimerie Nationale, 1890), p. 45.

43. Ibid, "Peintures: l'huile, sections étrangères," p. 73.

44. Ibid., p. 72.

Part II

The Return of the Prodigal Sons: 1870–1913

Chapter One

A "Secret Conspiracy" Against Thomas Eakins

1. Foster and Leibold, *Writing About Thomas Eakins,* p. 239, letter from Thomas Eakins to Eduard Coates, dated September 12, 1886.

2. Boston Art Students Association, *The Art Student in Paris,* p. 11. I owe special thanks to Professor Alan Henrickson, who tracked down and found this document for me.

3. Baur, "Worthington Whittredge," pp. 39–40.

4. Letter dated July 19, 1871. See Segard, *Mary Cassatt,* p. 25.

5. See Cooper, *Thomas Eakins, The Rowing Pictures;* Foster, *Thomas Eakins Rediscovered;* Ackerman, "Thomas Eakins and his Parisian Masters Gérôme and Bonnat;" Porter, *Thomas Eakins;* Foster and Leibold, *Writing About Thomas Eakins;* Johns, *Thomas Eakins: The Heroism of Modern Life;* McKinney, *Thomas Eakins;* Danly and Leibold, *Thomas Eakins and the Photograph;* and Wilmerding, *Thomas Eakins and the Heart of American Life.*

6. Eakins, letter to BE dated November 5, 1869, AAA, Eakins Papers.

7. Letter from Gérôme to Thomas Eakins dated May 10, 1873, in Goodrich, *Thomas Eakins,* pp. 113–14.

8. Cooper, *Thomas Eakins,* p. 14, n. 3.

9. Goodrich, *Thomas Eakins,* pp. 116, 164.

10. Ibid., pp. 121–22.

11. Of course, Gérôme guaranteed his students acceptance to the Salon; this was done in part through the intermediary of his father-in-law, the art dealer Goupil.

12. Cooper, *Thomas Eakins,* p. 85.

13. *The Nation,* vol. 18, 1874, p. 172; see also Ackerman, *Thomas Eakins,* pp. 24, 253.

14. Foster and Leibold, *Writing About Thomas Eakins,* p. 61. Eakins wrote this in French with impeccable spelling: "le plus beau morceau de peinture que j'aie vu de ma vie."

15. Ibid.

16. See Susan N. Carter, "Art Journal," in Goodrich, *Thomas Eakins,* p. 136.

17. Ibid.

18. Ibid.

19. Goodrich, *Thomas Eakins;* S. G. W. Benjamin, *Art in America.*

20. Ibid.

21. Goodrich, *Thomas Eakins,* p. 212. The Society of American Artists had accepted *The Gross Clinic* for its annual exhibition, which traveled to Philadelphia. However, the directors of the Pennsylvania Academy decided to avoid Eakins' painting when it was on exhibit.

22. Ibid., pp. 280–81.

23. Ibid., p. 294.

24. Ibid., p. 281, letter to the board of directors of the Pennsylvania Academy of Fine Arts dated April 8, 1885.

25. Ibid., pp. 282–83, anonymous letter addressed to James Claghorn, president of the academy, April 11, 1882, and signed "R. S." Pennsylvania Academy of Fine Arts archives.

26. Ibid., p. 285, Thomas Eakins, letter to the Arts Students League, 1887.

27. Ibid.

28. Ibid.

29. Foster and Leibold, *Writing About Thomas Eakins,* p. 215, letter to Edward Hornor Coates, dated February 15, 1886.

30. Ibid.

31. Ibid., p. 237, letter to Edward Hornor Coates, dated September 11, 1886.

32. Cooper, *Thomas Eakins,* pp. 70, 78.

33. Goodrich, *Thomas Eakins,* p. 289, letter from H. C. Cresson to the *Philadelphia Evening Item,* February 22, 1886.

34. Ibid., letter from Eakins to Coates, dated September 12, 1886.

35. Foster and Leibold, *Writing About Thomas Eakins,* p. 79, letter from Eakins to Coates, dated February 15, 1886.

36. Ibid., p. 220, document dated March 10, 1886.

37. Ibid., p. 79, letter from Eakins to Emily Sartain, dated March 25, 1886, in Pennsylvania Academy of Fine Arts archives.

Chapter Two

"We Will Help to Fertilize the Art Soil of America"

1. Dorothy Young, *Life and Letters,* May 1, 1877, p. 123; May 12, 1877, p. 125; and June 7, 1877, p. 127.

2. Ibid., letter from Wyatt Eaton to Weir, dated June 5, 1877.

3. Ibid., letter to his brother, dated May 1877.

4. Letter from Weir to his brother, dated July 20, 1877, AAA, Weir Papers.

5. Dorothy Young, *Life and Letters*, p. 139: *The Art Journal*, spring 1877.

6. Ibid., p. 138: *New York Times*, spring 1877.

7. Ibid., p. 139: Clarence Cook, *New York Tribune*, March 1878.

8. Ibid., p. 142.

9. Ibid., p. 142, letter dated July 1878.

10. Ibid., p. 143, letter dated August 21, 1878.

11. Ibid., p. 143, letter dated July 1878.

12. Ibid., p. 142: *The Art Amateur*.

13. Ibid., p. 140.

14. Ibid., p. 141: The critic is Clarence Cook.

15. Ibid., p. 148.

16. Ibid., p. 167: Weir's remarks appeared in *The Critic*, 1885.

17. Ibid., p. 167.

18. Ibid., p. 164.

19. This whole category of painter, dismissed by French critics at the time, have been since then called *peintres pompiers*.

20. Dorothy Young, *Life and Letters*, May 1, 1887, p. 124.

21. Ibid., letters dated 1884–1890, pp. 163–73.

22. Ibid., Summer 1880, p. 145.

23. Ibid.

24. Ibid.

25. See *The Graphic*, January 11, 1883, p. 39, and May 23, 1896, p. 632; *Magazine of Art*, vol. 19, p. 163.

26. Bastien-Lepage, quoted in "The Monthly Record of American Art," *Magazine of American Art*, no. 6, December 1883.

27. Dorothy Young, *Life and Letters*, p. 144.

28. Ibid., letter from John Twachtman, dated January 2, 1885.

29. Ibid., pp. 159–60.

30. *Rosa Bonheur 1822–1899*, p. 73.

31. Dorothy Young, *Life and Letters*, Summer 1880, p. 170.

32. Ibid., p. 142.

33. Letter, J. Alden Weir to John Weir from Paris, dated July 20, 1877, AAA, Weir Papers.

34. Gombrich and Eribon, *Ce que l'image nous dit*, pp. 69–70.

Chapter Three

Between Pale Lilac and Yellow: The "Monet Gang"

1. "A crowd of new radicals . . . the Monet gang back from Europe . . . who wants anything pale lilac and yellow" (diaries of J. C. Beckwith, April 20, 1890, AAA, Beckwith Papers).

2. June 24, 1888.

3. Letter from Paul Monet to Gustave Geoffroy dated October 7, 1890.

4. Letter dated April 3, 1891.

5. Letter dated June 1891.

6. Fuller, *Claude Monet*, p. 3.

7. Georges Clémenceau, "Révolution de Cathédrales," *La Justice,* 20 Mai 1895, p. 114.

8. Levine, *Monet and His Critics.*

9. William H. Gerdts, *Monet's Giverny: An Impressionist Colony* (New York: Abbeville Press, 1993), and William H. Gerdts et al., *Lasting Impressions: American Painters in France, 1865–1915,* exhibition catalogue (Giverny: Musée Américain, 1992); and Hilman and Nutting, "Lilla Cabot Perry," and "Reminiscences of Claude Monet," *American Magazine of Art,* vol. 18 (March 1927) pp. 119–125.

10. Gerdts, *Monet's Giverny,* op. cit., p. 223. MacMonnies created *The Ship of State,* an enormous sculpture that was placed at the entrance to the Hall of Honor at the Chicago World's Fair in 1893. Mary would share with Mary Cassatt the mural—fifty-seven feet high—for the Pavilion of the Woman, Mary MacMonnies doing *Primitive Woman* and Mary Cassatt *Modern Woman.*

11. See Weitzenhoffer in Rewald, *Aspects of Monet,* p. 86, n. 40.

12. Dorothy Young, *Life and Letters,* May 1892, p. 190.

13. Theodore Robinson, "Claude Monet," *The Century Magazine,* vol. 44 (September 1892).

14. Levine, *Monet and His Critics,* p. 157.

15. Hillman and Nutting, "Reminiscences of Claude Monet From 1889 to 1909," *American Magazine of Art,* vol. 18 (May 1927), pp. 119–25.

16. Hamlin, *Roadside Meetings,* pp. 30–31.

17. Letter from Meteyard to Richard Hovey, April 20, 1890, in Kilmer, *Thomas Buford Meteyard.*

18. "Monthly Record of American Art," *Magazine of Art,* May 1891, vol. 14 (May 1891); and Hiesinger, *Impressionism in America,* p. 97.

19. Hiesinger, *Impressionism in America,* p. 97.

20. Ibid., p. 98.

21. Bridgman, *L'anarchie dans l'art* (Paris: Société Française d'Éditions d'Art, 1898), pp. 8, 72, 222.

22. Dorothy Young, *Life and Letters,* Spring 1892, p. 177.

23. Ibid., p. 177.

24. Ibid., p. 175.

25. Ibid., p. 178.

26. Ibid.

27. See these excellent works: Weinberg, *American Impressionists and Realists;* Novak, "L'Impressionnisme américain, sources et réflexions"; Gerdts, *American Impressionism;* Neff, *American Painters in the Age of Impressionism;* Hiesinger, *Impressionism in America.*

28. Dorothy Young, *Life and Letters,* January 1891, pp. 175–76.

29. See pages 46–53 of this book.

30. "Talks with Artists: Mr. Childe Hassam on Painting Street Scenes," *Art Amateur* 27 (October 1892), p. 116.

31. The painting came back to France a year later, when the dealer who bought it sold it to Alfred Chauchard, head of the Magasins du Louvre, for 800,000 francs—a profit of 200,000 francs; see Paul Hayes Tucker, *Monet in the '90s: The Series Paintings* (Boston: Museum of Fine Arts; New Haven and London: Yale University Press, 1989), pp. 56, 103.

32. De Chenclos, "Les Yankees chez eux," p. 1842.

33. Durand-Gréville, "La peinture aux Etats-Unis," p. 69.

34. The American collector was probably Erwin Davis, according to a conversation by

the author with Charlie Moffatt in Paris, June 27, 1997. In Havemeyer, *Sixteen to Sixty,* Louisine Havemeyer tells readers that she too was interested in buying Manet's masterpiece. "Long afterward the Louvre bought Manet's *Olympia,* which had I been a little more persistent they would have lost."

35. *Rétrospective Manet, 1832–1883,* exhibition catalogue (Paris: Réunion des Musées Nationaux, 1993), pp. 174–83.

36. For this letter (in the original French), see Distel, "Il y a cent ans, ils ont donné *l'Olympia.*"

37. Among those who gave money for the cause were Braquemond, Caillebotte, Sargent, Duret, Durand-Ruel, Puvis de Chavannes, Pissarro, and Rodin.

38. Hiesinger, *Impressionism in America.*

39. See Anne Distel, "Le legs Caillebotte," in Distel, *Gustave Caillebotte.*

40. Gerdts, *American Painters in France, 1865–1915,* p. 68.

41. Hiesinger, *Impressionism in America,* p. 26, Caroll Beckwith's diary, April 20, 1890.

Chapter Four

Chicago, 1893

1. "The Gilded Age," "the Brown Decades," and "the Mauve Decade" refer to the three last decades of the nineteenth century in America, and have been the object of revisionist views since the 1930s. Lewis Mumford in particular offered a useful reevaluation of the period, one in which he emphasized the importance of the arts in the Gilded Age. This is also the argument in Harris, "The Gilded Age Reconsidered Once Again" and "The Quest for Unity"; see also Weinberg, "Late Nineteenth-Century American Painting: Cosmopolitan Concerns and Critical Controversies."

2. Harris, *Cultural Excursions,* p. 62.

3. John G. Cawelti, "America on Display: The World's Fairs of 1876, 1893, 1933," in Frederic Cople Jaher, ed., *The Age of Industrialism in America* (New York: The Free Press, 1968), p. 325.

4. Ibid.

5. Harris, *Cultural Excursions,* p. 85.

6. The expressions are Neil Harris's, *Cultural Excursions,* p. 15.

7. Again according to Harris, an entirely new American historiography emerged, one that saw the abandonment of the "late chauvinism" that had dominated until then. "But how were Whistler, Sargent, Cassatt and the others able to gain such a following in Europe?" There was greater acceptance of transatlantic methods of teaching, vocabulary, techniques, and artistic ideals.

8. Low, *A Painter's Progress,* p. 251.

9. There have been differing interpretations of the World's Columbian Exposition, which has been the focus of a number of pointed questions. From a purely architectural perspective, the fair was the crowning achievement of Daniel H. Burnham; and there has been much debate on the "Burnham versus Louis Sullivan" question: the former's work was based on European and historical sources and the latter's on Naturalist and American sources. Did the Fair "set the American modernist movement back a half-century," as was the argued during the 1920s and 1930s? And so on. See Draper, "The White City and Its Interpreters," pp. ix–xix.

10. Findling, "World's Columbian Exposition."

11. *New York Herald,* February 3, 1893, p. 9.

12. *Brooklyn Daily Eagle,* February 26, 1893, p. 5.

13. Ibid. For more on this debate between "French options" and "real American art," see Carr, "Prejudice and Pride."

14. Monroe, "Chicago Letter."

15. *Gazette des Beaux-Arts,* September 1, 1893, p. 455.

16. Rober Ballu, "Report of the First Commissioner of the Beaux-Arts on his Mission to Chicago," addressed to the minister of fine arts, and dated July 6, 1893. Musée d'Orsay Archives.

17. Beer, *The Mauve Decade,* p. 43 (with a quotation from William Walton, *World's Columbian Exhibition: Art and Architecture, 1893*).

18. See Ballu, "Report to the First Commissioner," op cit.

19. Hallowell was influenced in this by the critic Hamlin Garland and his defense of Impressionism, the first ever written in English. He spoke of the international nature of the phenomenon—Russian, Norwegien, Swedish, Danish, and American, all artists touched by the vitality of the movement of "bluish shadow."

20. See Mario Mangone, "Il 'nuovo orologio' della White City."

21. See Loyrette, "Chicago, une image française."

22. Pierre Bourdieu, in Faure, *L'Amérique des Français,* 1990.

23. Mumford, *The Brown Decades,* pp. 208–9.

24. Quoted in Carr, "Prejudice and Pride," p. 100.

25. Monroe's statements appeared in the *Chicago Herald,* June 15, 1893.

26. John La Farge, "The American Academy at Rome," *Scribner's Magazine* 28 (August 1900), p. 254, quoted in Carr, "Prejudice and Pride."

27. George Hoar, "To editors of *The Critic* in response to their request to explain the bill to create a national Art Commission," *The Critic* 12 (April 14, 1888), p. 182.

28. Brooke Adams, *International Review* (August 1880), reprinted in *The Boston Daily Evening Transcript,* June 26, 1880, p. 2.

Chapter Five

The Great Wave of Collections in America

1. Josephson, *The Robber Barons,* pp. 342, 344.

2. S. N. Behrman, *Duveen* (London: Hamish Hamilton, 1952), p. 18.

3. Weitzenhoffer, *The Havermeyers,* p. 86.

4. Ibid., p. 85.

5. Ibid., p. 86.

6. Ibid, p. 92, n.19.

7. Ibid., pp. 86–87.

8. $550, cited in Weitzenhoffer, "Impressionist Progress in America," p. 85.

9. Second only to the collection of the French opera singer Jean-Baptiste Faure, as cited in Distel, "Les Collectionneurs des Impressionnistes: amateurs et marchands."

10. Havemeyer, *Sixteen to Sixty,* p. 252.

11. Ibid., p. 258.

12. Ibid., pp. 229–31.

13. Ibid., p. 218.

14. Ibid., p. 219.

15. Ibid., p. 238.

16. It was there that Louisine Havemeyer saw *The Grand Canal, Venice* (*Blue Venice*) in 1875, which the American critics had generally celebrated. Ibid., p. 226.

17. See White and White, "Sociology of Career Support," and Furet-Robert, "The Fluctuating Dollar Prices for Impressionist Paintings, 1860–1960s," in Barbara Ehrlich White, ed., *Impressionism in Perspective,* pp. 76–78.

18. Weitzenhoffer, *The Havemeyers,* and Tinterow, *Splendid Legacy.*

19. See Ehrlich White, *Impressionism in Perspective,* op.cit.

20. Tinterow, in Frelinghuysen, *Splendid Legacy,* pp. 51–52.

21. On the deacquisition of entire collections of French academic art in favor of the Impressionists, see also Zafran: *French Salon Paintings from Southern Collections.*

22. See McCarthy, *Women's Culture,* pp. 28–32.

23. See Beer, *The Mauve Decade.*

24. Durand-Ruel Archives, Paris.

Chapter Six

From the "Blue Shadow School" to "The Ten"

1. "[T]he Monet gang back from Europe [who] want anything pale lilac and yellow." From the diaries of J. Carroll Beckwith, dated April 20, 1890, cited in Hiesinger, *Impressionism in America,* pp. 22, 60–61.

2. *Commercial Advertiser,* January 14, 1898, p. 1.

3. *New York Daily Tribune,* January 10, 1898, p. 10.

4. *New York Herald,* January 11, 1898, p. 7.

5. This phrase was used by an unidentified member of The Ten, and appeared in the *New York Herald* on January 9, 1898, p. 7.

6. Tomkins, *Merchants and Masterpieces:* p. 80 ff.; *Art Interchange* 34, no. 4 (April 1895), p. 114; and Hiesinger, *Impressionism in America,* p. 31.

7. Robinson's diaries, March 1, 1894, and November 20, 1894, Frick Museum Art Reference Library. See also Hiesinger, *Impressionism in America,* p. 29.

8. Robinson's diary, dated May 5, 1895, Frick Museum Art Reference Library.

9. *New York Daily Tribune,* May 28, 1897, p. 7.

10. Barse is quoted in *The Sun,* January 1898, p. 2.

11. Cox's comments were printed in the *Commercial Adviser,* January 19, 1898, p. 1.

12. Unidentified member of the society quoted in the *Commercial Adviser,* January 10, 1898, p. 1.

13. *Commercial Adviser,* January 8, 1898, p. 1.

14. Dorothy Young, *Life and Letters,* Spring 1898, p. 199.

15. Hiesinger, *Impressionism in America,* pp. 153–54.

16. Dorothy Young, *Life and Letters,* Spring 1898, p. 199.

17. *New York Times,* April 8, 1899.

18. *New York Times,* April 2, 1902.

19. *New York Times* [n.d.] 1901.

20. *New York Times,* December 1898 and January 1899.

21. Dorothy Young, *Life and Letters,* 1898, p. 234.

22. Ibid., October 1901, pp. 203, 205.

23. Ibid., May 6, 1902, p. 209.

24. Ibid., p. 209.

25. Ibid., pp. 207–8 (Brown), 211 (Wood), 218 (Collins).

Chapter Seven

The Revenge of Thomas Eakins

1. Quoted in Porter, *Thomas Eakins,* p. 22.

2. Letter dated Friday, January 13, 1888, AAA.

3. Robert Henri, *Pilgrims to Paris, Travels and Tribulations,* Oct. to Dec. 1888, AAA, Henri Papers.

4. Ibid.

5. Ibid., September 27, 1888.

6. Ibid.

7. Robert Henri, "Diary in Paris, France," April 8, 1889, AAA, Henri Papers.

8. Henri "Diary", op. cit., April, 1, 1889.

9. Ibid., April 1, 1889.

10. Ibid, March 17, 1889.

11. Henri, *Pilgrims.*

12. Ibid.

13. Henri, "Diary," February 28, 1889.

14. Ibid., March 28, 1889.

15. Ibid. February 1, 1889.

16. Ibid, May 24, 1889.

17. Ibid, March 8, 1889.

18. Ibid, March 2, 1889.

19. See Dewey F. Mosby, *Henry Ossawa Tanner,* exhibition catalogue (Philadelphia Museum of Art, 1990; New York: Rizzoli, 1991).

20. Henri, "Diary," op. cit., April 5, 1889.

21. Ibid., March 24, 1889.

22. Ibid., May 22, 1889.

23. Ibid., March 21 and May 26, 1889.

24. See Loughery, *John Sloan, Painter and Rebel,* p. 43.

25. Ibid, p. 25.

26. Ibid., pp. 25–26.

27. Robert Henri, "Insurgency in Art," *The Literary Digest,* 15 (August 23, 1910), p. 814.

28. Forbes Watson, "Robert Henri," *Arts* 16 (September 1929).

Chapter Eight

"Come Take a Ride Underground"

1. See Dominque Rouillard, "L'Amérique n'a pas de monuments," in Hubert Damisch and Jean-Louis Cohen, eds., *Américanisme et modernité: l'Idéal américain dans l'architecture* (Paris: Flammarion, 1993), p. 59.

2. For more on the Sherwood Building see Davis, " 'Our United Happy Family.' "

3. Letter from Robert Henri to John Sloan, June 15, 1901, in Perlman, ed., *Revolutionaries of Realism,* p. 53.

4. *New York Sun,* May 15, 1907.

5. To read more about the relationship between The Eight and New York, see Zurier, Snyder, and Mecklenburg, *Metropolitan Lives.* For Warhol's comment, see caption, p. 152.

6. J. Carroll Beckwith, "Does One Learn More of the Abstract Elements of Beauty from Antique Drawing than from the Nude," *American Student of Art,* April 1, 1906,

p. 10. For more on the relationship between academic teaching and Robert Henri's techniques, see Helen Goodman, "Robert Henri, Teacher," in *Art Magazine,* September 1978, pp. 158–60.

7. Pène du Bois, *Artists Say the Silliest Things,* p. 73.

8. AAA, Stuart Davis Papers.

9. *New York Evening Sun,* April 2, 1902.

10. Quoted in James Spencer Dickerson, "Has America an American Art?" *World Today* 13 (December 1907), p. 1234; also see Perlman, *Revolutionaries of Realism,* p. 114.

11. See Bolger, "William Macbeth and George A. Hearn: Collecting American Art, 1905–1910." See also Tomkins, *Merchants and Masterpieces.*

12. Quoted in Loughery, *John Sloan,* p. 112.

13. *New York Evening Post,* February 24, 1900.

14. Arthur Hoeber, "A Most Lugubrious Show at the National Arts Club," *New York Globe and Commercial Advertiser,* January 21, 1904.

15. James Gibbons Huneker, *New York Sun,* December 23, 1907.

Chapter Nine

Ashcan School vs. Academy

1. *New York Times,* March 1907.

2. Schwartz, *Shock of Modernism.*

3. Besides the academies and their annual shows, there were several clubs such as the Colonial Club, the National Arts Club, and the Lotos Club that offered exhibition space consisting of two or three galleries.

4. *New York Times,* March 1907.

5. "Eight Independent Painters to Give an Exhibition of Their Own Next Winter," in the *New York Sun,* May 15, 1907.

6. Charles deKay, "Artists at Their Little Games. The Academy Would Be Better Served by Live Outside Opposition Than Squabbles Started by Discontented Juryman," *New York Times,* March 17, 1907.

7. Among the rejected were three of Henri's group: Davies, Lawson, and Myers. In 1906 the Society of American Artists—which had long ceased to be an innovative force— requested to be folded back into National Academy of Design. The two organizations were fused and admission to them was increasingly difficult.

8. *New York Sun,* April 17, 1907.

9. *New York Tribune,* May 15, 1907.

10. *New York Herald,* May 15, 1907.

11. *New York World,* February 2, 1908; *New York Herald,* May 15, 1907.

12. William Macbeth, *Art Notes,* AAA.

13. Perlman, *Immortal Eight,* pp. 151–73.

14. See Sloan's diaries, in Loughery, *John Sloan.* The Eight were dubbed the "Ashcan School" much later.

15. *New York Sun,* April 7, 1910.

16. Roberts, "The Younger American Painters."

17. Ibid.

18. *The Sun,* February 9, 1908.

19. Cited in Zurier, *Metropolitan Lives,* op cit., pp. 182–87; see also Robert Henri, "The Pennsylvania Academy," *New York Sun,* February 5, 1910; "Auditors Held by Henri Two

Hours," *Ohio State Journal,* January 27, 1911; Doezema and Kelly, *Painting of George Bellows,* pp. 89–121; and Doezema, *George Bellows and Urban America.*

20. *The Sun,* March 21, 1907.

21. After 1908, following the success of the show, the National Academy included The Eight in its annual exhibition.

22. Goodman, "Robert Henri."

23. The book reached thirty printings.

24. Henri, *The Art Spirit,* p. 226.

25. Ibid., pp. 188–89.

26. Ibid., p. 131–32.

27. Ibid., pp. 149, 187–88, letter from New Mexico. For more on The Eight, see Homer, "The Exhibition of the Eight," and Perlman, "Prophet of the New."

28. Upton Sinclair, quoted in Kelly, "Roll Back the Years."

29. See Allan Antliff, "Carl Zigrosser and the Modern School: Nietzsche, Art and Anarchism," in *AAAJ,* vol. 34, no. 4 (1994).

30. See St. John, *John Sloan,* p. 570.

31. James Huneker, *The Sun,* February 9, 1908.

32. Guy Pène du Bois, "Great Modern Art Display Here April 1," *New York American,* March 17, 1910.

Chapter Ten

The Photographers Step In

1. Letter from Alfred Stieglitz to Sadakichi Hartmann, December 22, 1911, in Greenough and Hamilton, eds., *Alfred Stieglitz: Photographs and Writings.*

2. *Tannhauser,* Act II, scene 4.

3. Stieglitz's father, Ephraim, called "Edward," was born in Kassel, Hesse, and emigrated to America in 1849. See Whelan, *Alfred Stieglitz.*

4. Norman, *Alfred Stieglitz: An American Seer,* p. 35, letter from Stieglitz to Norman.

5. Homer, *Alfred Stieglitz and the Photo-Secession,* p. 17.

6. Quoted in M. Humphries, "Triumphs in Amateur Photography: Alfred Stieglitz," *Godey's Magazine,* January 1898, p. 588.

7. Homer, *Stieglitz and the Photo-Secession,* p. 25.

8. Interview with Stieglitz, in Lyons, *Photographers on Photography,* p. 119.

9. Dorothy Norman, "From the Writings and Conversations of Alfred Stieglitz," *Twice a Year,* no. 1 (Fall–Winter 1938), p. 98.

10. Ibid., p. 119.

11. *Camera Notes,* July 1, 1897, p. 3.

12. Lyons, *Photographers on Photography,* p. 120.

13. Letter from A. Horsley Hinton to Alfred Stieglitz, December 7, 1898, quoted in Homer, *Stieglitz and the Photo-Secession,* p. 35.

14. In fact, Holland Day and Stieglitz were in fierce competition with each other, and Stieglitz had even tried to prevent the exhibition from taking place.

15. Steichen, *A Life in Photography.*

16. Linel, "Art et photographie."

17. Stieglitz, "Pictorial Photography."

18. Steichen, "The American School."

19. Picard, "Technical and Administrative Reports."

20. Ibid.

21. Bénédite, "Introduction," on the fine arts, quoted in Steichen, *A Life in Photography*. On Steichen's visit to the Exposition Universelle, see also Niven, *Steichen: A Biography*, pp. 76–80.

22. Paul Cummings, interview with Edward Steichen, June 5, 1970, AAA.

23. Niven, *Steichen*, p. 48.

24. See *1898: Le Balzac de Rodin* (Paris: Musée Rodin, 1998); and Pinet, *Les Photographes de Rodin*.

25. Steichen *A Life in Photography*.

26. Cummings, Steichen interview, op cit., p. 7.

27. Emile Zola, "Une statue de Balzac," *Le Figaro*, December 6, 1880, quoted in Musée Rodin, *Le Balzac de Rodin*, pp. 17–18.

28. Aurèlien Scholl, "Courrier de Paris," in *L'Echo de Paris*, May 20, 1989.

29. Rodin, quoted in Elsen, *In Rodin's Studio*, p. 183.

30. Rodin, quoted in Chincholle, "L'incident Rodin-Balzac."

31. "J'ai été très sensible aux encouragements que vous m'avez donnés, et je les apprécie d'autant plus venant de vous pour qui je professais depuis longtemps une si haute admiration de vous, le plus grande [*sic*] maître du temps" (letter from Edward Steichen to August Rodin, 1901, *Rodin Archives*, Musée Rodin, Paris).

32. Steichen, *A Life in Photography*.

33. *New York Herald*, March 30, 1902.

34. Alfred Stieglitz, "The 'Champs de Mars' Salon and Photography," *Camera Work*, vol. 6, no. 1 (July 1902), p. 50.

35. Alfred Stieglitz, "Four Happenings," in *Twice a Year*, no. 8–9, 1942, p. 117.

36. Sadakichi Hartmann, "The Influence of Artistic Photography on Interior Decoration," *Camera Work* 2, 1903, p. 119 ff.

37. "Je garde bien des souvenirs cher Maître de vous et de votre bonté pour moi mais par-dessus tout l'influence de votre grand art et votre noble personalité m'aident et m'encouragent toujours" (Edward Steichen to Auguste Rodin, New York, 1903, Rodin Archives, Musée Rodin, Paris).

38. "Je viens de faire des portraits de bien des personnes prominentes entre autres M. Pierpont Morgan l'homme des millions qui a était [*sic*] très aimable pour moi. J'ai l'esperance de l'interresser [*sic*] en vos oeuvres de vous procurer quelque grand commissions [*sic*], pour notre nouveaux [*sic*] musée de sculpture" (ibid.).

39. "Je me réjouis beaucoup de voir come [*sic*] votre travail est apprécié ici en Amérique. Vous même serez surprise [*sic*]. J'espère que cela se développera dans une forme plus materiel et que nous aurons beaucoup de vos belles créations dans ce pays avant peu. C'est toujours les gens avec le plus d'argent qui ont le moindre compréhension d'art" (ibid.).

Chapter Eleven

Voyagers to the Land of Wild Beasts

1. Letter from Steichen to Stieglitz, January 1908, Collection of American Literature (Alfred Stieglitz Papers, Mss 85, box 46, folder 1091: 1900–1903), Beinecke Rare Book and Manuscript Library, Yale University (hereafter cited as Steiglitz Papers).

2. Elie Faure, introduction to *Salon d'Automne*, exhibition catalogue (Paris, 1905), pp. 12–15.

3. Max Weber, "The Matisse Class," AAA, Weber Papers.

4. Henri-Pierre Roché, quoted in Reliquet and Reliquet, *Henri-Pierre Roché, l'enchanteur-collectionneur,* p. 55.

5. Leo Stein, *Appreciation: Painting, Poetry & Prose,* p. 143.

6. Winneapple, *Sister, Brother,* p. 2.

7. Leo Stein, *Appreciation,* p. 156.

8. Ibid., p. 157.

9. Ibid., p. 155.

10. Ibid., p. 155.

11. Ibid., p. 157.

12. Ibid., p. 188.

13. Luhan, *Intimate Memories,* vol. 2, pp. 321–22.

14. Berenson, *Sketch for a Self-Portrait.*

15. Weber, "The Matisse Class."

16. Dasburg, quoted in Levin, *Synchromism and American Color Abstraction, 1900–1925,* p. 33.

17. June 26, 1910, AAA, Russell Papers.

18. Dasburg, quoted in Levin, *Synchromism,* p. 33.

19. Levin, *Synchromism,* p. 12, Russell to Dasburg, August 1908.

20. Ibid., p. 33, Russell to Dasburg, October 27, 1910.

21. Ibid., p. 14, Russell to Dasburg.

22. Robert Henri, letter dated May 12, 1916, AAA, Henri Papers.

23. Levin, *Synchromism,* p. 16, Russell's notebooks, dated November 5, 1912.

24. *New York Press,* March 7, 1914.

25. New York, November 24 [n.d.], AAA, Morgan Russell Papers.

26. See John Rewald, *Cézanne and America,* p. 60.

27. See Elderfield, *Henri Matisse: A Retrospective,* pp. 137, 180 (Chronology).

28. Sarah Stein, "Notes," in Matisse, *Ecrits et Propos sur l'Art,* pp. 64–73.

29. Sarah Stein, "Four Americans in Paris," p. 270.

30. Weber, "The Matisse Class," pp. 59–56.

31. For more on the Stein family, see Seckel, "27 rue de Fleurus, 58 rue Madame, les Steins à Paris," "Autour de Cézanne," and "L'Académie Matisse," pp. 278–333; Winneapple, *Sister-Brother: Gertrude and Leo Stein;* Sarah Stein, "Four Americans in Paris"; Rewald, "The Steins and Their Circle."

32. Weber, "The Matisse Class," op. cit., p. 157.

33. Apollinaire, *Chroniques d'art,* p. 42.

34. Letter from Mary Cassatt to Adolphe Borie, July 27, 1910, Archives of the Philadelphia Museum of Art, quoted in Rewald, *Cézanne in America,* op cit., p. 85.

35. Roché, *Romance parisienne: Les papiers d'un disparu,* pp. 24–25, 30.

36. Rough translation: "Hello, hello, extremely beautiful this city and very beautiful horse made of woods."

37. "Cette photographe est plus jolie que l'autre que je vous a envoyer. C'est très beau cette chevel est très bien placée dans une salle superbe" [sic]. Dated August 1, 1910. Paduaa, sala della Ragione. Archives Picasso Musée National Picasso, Paris.

38. "Je vous souhaite beaucoup de répétition joyeuse de votre fête, je suis un peu tard mais j'arrive tout de même. Sincèrement à vous." Dated July 18, 1909. Archives Picasso, Musée National Picasso, Paris.

39. "Elle est très jolie n'est ce pas. Quescé que vous fait la bas. Etes vous seule. Les joyeux catalans sont tout à fait joli. Il n'y a rien de neufs. Bonjour à vous. Gertrude." Dated August 1, 1911, Fiesole. Picasso Archives, Musée National Picasso, Paris.

40. "Je passerai chez vous demain vendredi après-midi pour mon portrait. Gertrude Stein." March 1906. Archives Picasso, Musée National Picasso, Paris.

41. Gertrude Stein, *The Autobiography of Alice B. Toklas.*

42. Ibid.

43. Interview with Andrew Dasburg, AAA, Dasburg Papers.

44. September 22, 1912, AAA, Dasburg Papers.

45. "Cher Mr. Picasso, Je regret beaucoup que jeu ne suis pas alle chez vous, pour vous voir avant partir: mais j'espere que je vous verez bientot. Mes sincères salutations et beaucoup beaucoup du success [*sic*]. [. . .] Des choses Congo au Museum British sont numereous et superb. J'espere que vous leur verez bientot [*sic*]," December 28, 1908, Archives, Musée National Picasso, Paris.

46. Gertrude Stein, *Autobiography of Alice B. Toklas.*

47. Letter from Matisse to Kahnweiler, June 12, 1912, in *Les Demoiselles,* op cit.

48. Salmon, "Histoire anecdotique du cubisme."

49. There is most notably the exhibition organized around *Les Demoiselles d'Avignon,* with the enormous and passionate work done by Hélène Seckel, William Rubin, Alfred Barr, Leo Steinberg, and Yves-Alain Bois, to name but a few.

50. Burgess, "The Wild Men of Paris," p. 404.

51. Ibid., pp. 407–8.

52. Letter from Hamilton E. Field to Pablo Picasso, care of Frank Burty Haviland, dated July 31, 1910, Musée d'Orsay.

53. Leo Stein, *Appreciation,* p. 201.

54. Letter from Leo Stein to Mabel Weeks, February 4, 1913, in Edmund Fuller, ed., *A Journey into the Self* (New York: Crown Publishers, 1950), p. 48.

55. See "Testimony Against Gertrude Stein," in *transition,* pamphlet no. 1 (The Hague, February 1935), a supplement to *transition* 23 (Paris, 1934–35), p. 3. Among the authors are Braque, Matisse, André Salmon, and Tzara, Eugène, and Maria Jolas.

56. See Leo Stein, *Appreciation,* p. 190.

57. Burgess, "Wild Men of Paris," p. 414.

Chapter Twelve

The Modernists' Transatlantic Shuttle

1. Compagnie française des cables télégraphiques, January and February 1908, and January 24, 1911, Stieglitz Papers, 1900–1903.

2. Quoted in Lyons, *Photographers on Photography,* p. 126.

3. Stieglitz, "The Rodin Drawings at the Photo-Secession Galleries," *Camera Work* 22 (1908), p. 402.

4. From the *New York Times,* reprinted in *Camera Work* 22 (1908), p. 403.

5. Anecdote reported by Georgia O'Keeffe, in *Georgia O'Keeffe: A Portrait by Alfred Stieglitz* (New York: Metropolitan Museum of Art, 1978).

6. Letter from Alfred Stieglitz to Auguste Rodin, New York, January 17, 1908, written on paper with Photo-Secession letterhead (Archives Rodin, Musée Rodin, Paris). Charlotte Simpson was Rodin's primary patron in the United States; see Niven, *Steichen: A Biography,* pp. 171, 285.

7. August Rodin to Claude Monet, *Correspondance de Rodin,* vol. 1 (Paris: Musée Rodin).

8. Rodin's comment appeared in *Le Matin,* July 13, 1908.

9. Steichen, *A Life in Photography*.

10. Letter from Steichen to Stieglitz, Stieglitz Papers, September–October 1908.

11. Steichen, *A Life in Photography*. For more about this, see Pinet's detailed article "Il est là, toujours, comme un fantome," pp. 195–204.

12. Letter from Steichen to Stieglitz, November 1908. Stieglitz Papers.

13. Rodin, quoted in George Besson, "Pictorial Photography: A Series of Interviews," *Camera Work* 24 (October 1908), p. 14.

14. Some even talked of photography as Rodin's "Pygmalion's dream." See Albert Elsen, *In Rodin's Studio,* p. 30.

15. Paul Cummings interview with Edward Steichen, June 5, 1970, AAA, p. 12.

16. Stieglitz Papers.

17. Ibid.

18. Ibid.

19. Ibid.

20. Letter from Paul B. Haviland to Alfred Stieglitz, November 2, 1908, Stieglitz Papers.

21. Ibid.

22. Letter from Steichen to Stieglitz, January 1908, Stieglitz Papers.

23. *New York Sun,* April 1908.

24. *New York Evening Mail,* April 1908.

25. Berenson's was responding to a negative review of the show in *The Nation,* October 29, 1908; the reply appeared in the November 12 issue.

26. *New York Times,* April 1908.

27. Charles Caffin, *Camera Work,* July 27, 1909, p. 42. Also see *Paris–New York, 1908–1968* (Paris: Centre Georges Pompidou and Gallimard, 1991), p. 33.

28. Sandra Leonard, *Henri Rousseau and Weber* (New York: Richard Feigen, 1970), p. 42.

29. Ibid., p. 360.

30. Stieglitz wrote this to his fellow photographer Child Bayley following the gallery's third Matisse exhibition in 1912. See Norman, *Alfred Stieglitz.*

31. Lyons, *Photographers on Photography,* p. 120.

32. Steichen, *A Life in Photography*.

33. M. de Zayas, "The New Art in Paris," *Camera Work* 34–35 (April–July, 1911).

34. Duchamp-Villon, quoted in *La Dépêche de Rouen* (newspaper), October 10, 1911.

35. Braque and Picasso invented Cubism. "Analytical Cubism," Braque and Picasso's first phase, involved analyzing several different views of the same object, in a "scientific" attempt to present all the possible facets of the object. The later phase, "Synthetic Cubism," involved a synthesis, where the "courb" [curve] will give a more simplified approach. The Puteaux group followed Braque and Picasso's discoveries, slightly switching the concepts.

36. *Duchamp-Villon,* exhibition catalogue (Paris and Rouen: Centre George Pompidou and the Musée des Beaux Arts, 1999). See *La Section d'or, 1912, 1920, 1925,* under the direction of Cecile Debray and François Lucbert (Paris: Editions Cercle d'art, 2000).

37. Letter from Alfred Stieglitz to Paul Burty Haviland, Lucerne, Grand Hôtel National, August 6, 1911, in Paul Burty Haviland Collection, Musée d'Orsay, Paris.

38. Letter to Ward Muir, January 30, 1913, quoted in Greenough and Hamilton, *Alfred Stieglitz,* p. 196.

39. Stieglitz Papers.

40. "French Artists Spur On American Art," *New York Times,* October 24, 1915, part IV, p. 2.

Part III

From Notre Dame de Paris to the Brooklyn Bridge: 1813–1948

Chapter One

"He Who Dies Thus Rich Dies Disgraced"

1. Andrew Carnegie's speech can be found in Neal, *Wise Extravagance,* p. 12.

2. Ibid., p. 17. Carnegie's words were spoken at the opening of the first international exhibition in November 1898.

3. William Nimick Frew in ibid., p. 17.

4. *Pittsburgh Dispatch,* November 5, 1895, in ibid., p. 33.

5. See James Mackay, *Little Boss: A Life of Andrew Carnegie* (Edinburgh and London: Mainstream Publishing, 1997).

6. Ibid., p. 270.

7. Carnegie, "Best Use of Wealth."

8. Carnegie, *The Gospel of Wealth and Other Timely Essays.* The essay "Wealth" was reprinted in *North American Review,* June and December, 1889.

9. See Neil Harris, "Great American Fairs and American Cities," in Harris, *Cultural Excursions,* pp. 111–32.

10. These exhibitions, besides being eligible for federal funding, attracted overall more than 200 million Americans and created a representation of the general public that was often particularly racist. See works by Neil Harris, as well as the findings of James Gilbert ("World's Fairs as Historical Events") and Lisa Rubens ("Representing the Nation") in *Fair Representations: World's Fairs and the Modern World* (Amsterdam: VU University Press, 1994).

11. Chicago's population was 1,100,000 in 1890 had reached 2 million by 1900; by 1960 it had hit 7 million. Figures quoted in Damisch, ed., *Americanisme et modernité,* p. 21.

12. Ford, quoted in Tarkington, *The Magnificent Ambersons.*

13. Robert Troup was the president of the Society for the Relief of the Destitute.

14. DiMaggio, "Cultural Entrepreneurship in Nineteenth-Century Boston."

15. Rockefeller, quoted in Fosdick, *History of the Rockefeller Foundation,* p. 4.

16. Federal Trade Commission Act.

17. Whitaker, *The Philanthropoids,* p. 101.

18. Tinterow, *A Splendid Legacy,* p. 52.

19. Whitaker, *The Philanthropoids,* p. 40.

20. Quoted in Kopper, *America's National Gallery of Art,* p. 76.

21. Ibid., p. 114.

22. Ibid., pp. 122–23.

23. For an analysis of the role of urban elites, see Jaher, *The Urban Establishment,* pp. 244–74.

24. Tocqueville, *De la démocratie.*

25. See Caroline Cussatlegras, "La Mission éducative des musées américains et son évolution," master's thesis (Paris: Centre de Recherches d'Histoire Nord-Américain, Université Paris 1, May 1995).

26. Jaher, *Urban Establishment,* pp. 244–74.

27. Ibid., p. 13.

28. *Toledo Treasures,* p. 15.

29. See Tomkins, *Merchants and Masterpieces,* as well as Jean Strouse, *Morgan, American Financier* (New York: Random House, 1999).

30. Argyrol was widely used to treat eye inflammations, particularly in newborns.

31. See Richard J. Wattenmaker, "Le Docteur Barnes et sa fondation," in *De Cézanne à Picasso,* p. 22.

32. See Wattenmaker, "Le Docteur Barnes," op. cit., and Anne Distel, "Le Docteur Barnes est à Paris," in *De Cézanne à Picasso.*

33. Letter from Stieglitz to Paul Burty Haviland, written at the Grand Hôtel National, Lucerne, August 6, 1911, in Paul Burty Haviland Collection, Musée d'Orsay, Paris.

34. Andrew Dasburg to Grace Johnson, March 14, 1912, AAA, Dasburg Papers.

35. For more on this crowd, see Rosenstone, *Romantic Revolutionary;* Mary Jo Buhle, Paul Buhle, and Dan Georgakas, *Encyclopaedia of the American Left* (Urbana and Chicago: University of Illinois Press, 1992), pp. 275–76, 283–84; Sean Wilentz, "Low Life, High Art," *The New Republic* 207 (September 28, 1992); and Zurier, *Art for the Masses.*

36. Mabel Dodge, *Movers and Shakers* (New York: Harcourt Brace Jovanovich, 1936), pp. 83 ff.

37. Letter from Andrew Dasburg to Grace Mott Johnson, February 6, 1914, AAA, Dasburg Papers.

38. Hutchins Hapgood, *New York Globe,* January 27, 1913.

39. Dodge, *Movers and Shakers,* op. cit., pp. 83 ff.

40. Ibid., p. 67.

Chapter Two

"A Chilly Wind from the East Had Blown on Our Artists"

1. Loughery, *John Sloan,* p. 187.

2. Dorothy Young, *Life and Letters,* January 1912, p. 238.

3. *New York Times,* February 7, 1912.

4. Loughery, *John Sloan,* p. 189.

5. AAA, Walt Kuhn Papers.

6. Ibid., November 29, 1911.

7. Ibid., December 6 and 9, 1911.

8. Ibid., postcards from Kuhn to his wife dated November 16, December 13, and December 14, 1912.

9. See *Discovering Modernism: Selections from the Walter Pach Papers* (Washington: Smithsonian Museum [n.d.]).

10. Note from Matisse to Pach, Tangiers, December 6, 1912, AAA, Walter Pach Papers.

11. Between 1790 and 1894 there was a 10- to 30-percent tax on the importation from overseas of art considered a "luxury product." Between 1894 and 1897, the tax disappeared altogether, only to reappear at a level of 20 percent between 1897 and 1909. After 1909, and theoretically until 1915 (according to a "twenty-year clause"), the level was 15 percent. From that point onward, until the present day, the tax disappeared. See Report of Tariff Commission, 1882, H.M. 47-2, v. 2, 3, number 6, as well as *Gazette des Beaux Arts,* April 1946, pp. 225–52, and 47 n.

12. Quinn, quoted in the *Evening Sun,* January 13, 1915.

13. For more on Quinn, see Reid, *The Man from New York.*

14. See AAA, Nikifora Pach Papers.

15. Roger Fry had briefly worked as paintings curator at the Metropolitan Museum, at

J. P. Morgan's behest, and was one of the most prolific and influential critics of his day. Fry had studied at Cambridge with Sydney Colvin where, in opposition to the Ruskinian tradition, he developed a formalist theory of art, explored in his articles in *The Athenaeum*. See Green, *Art Made Modern*.

16. Robert Henri to Walter Pach, New York, January 31, 1913, AAA, Walter Pach Papers.

17. Mombray-Clark, in an article from an unspecified newspaper, AAA, Kuhn Papers.

18. Borglum, quoted in the *New York Evening Post,* December 31, 1912.

19. Davies, *New York American,* January 3, 1913.

20. *New York American,* January 3, 1913.

21. *New York Times,* January 5, 1913.

22. *New York American,* January 25, 1913.

23. See Meyer Schapiro, "The Introduction of Modern European Art in the United States: The Armory Show" (1913), in *Theory and Philosophy of Art: Style, Artist, and Society* (New York: Braziller, 1994), p. 390.

24. For Walter Pach, though, "the work was not only in radical rupture with the past, it also constituted a subversive remise en cause like that which had up until now been conceived and recognized ("For and Against," AAA, Walter Pach Papers).

25. Brown, *The Story of the Armory Show,* pp. 43–44.

26. Julian Street, *Everybody's Magazine.*

27. *New York Evening Post,* February 22, 1913.

28. Dorothy Young, *Life and Letters,* pp. 248–50.

29. *New York Times,* March 10, 1913.

30. Interview with William J. Glackens, "The American Section," *Art and Decoration,* March 1913.

31. Letter from Brancusi to Pach, Paris, March 13, 1913, in AAA, Walter Pach Papers.

32. *The Trend,* March 1914, p. 1963.

33. Perlman, *The Immortal Eight,* p. 207.

34. Myers, *Artist in Manhattan.*

35. AAA, Andrew Dasburg Papers.

36. December 6 and December 9, 1911, Walter Kuhn Papers, AAA.

37. Meyer Schapiro, "The Introduction of Modern Art in America: The Armory Show" (1915), in *Modern Art, 19th and 20th Centuries: Selected Papers* (New York: George Braziller, 1978), pp. 137, 139–40.

38. Myers, *Artist in Manhattan.*

Chapter Three

Santa Fe as a Hope

1. Quoted in Loughery, *John Sloan,* p. 189.

2. From Thomas Cole, *America as Landscape* (1835), p. 340. See also Thomas Cole, *Essay on Scenery,* 1835.

3. Baur, "Worthington Whittredge," *Autobiography,* p. 40.

4. Birge Harrison, *Harper's* 1885, in Eldredge, *Art in New Mexico.*

5. Blumenschein, quoted in William T. Henning, Jr., *E. L. Blumenschein Retrospective.*

6. Ernest L. Blumenschein, "Origin of the Taos Art Colony," *El Palacio* 20, no. 10 (May 15, 1926), pp. 190–92, in AAA, Taos Society of Artists Papers.

7. Letter from Blumenschein to Ellis Parker Butler, part of a collection of fifty-six letters written between 1899 and 1931, AAA, Blumenschein Family Papers, courtesy Elizabeth Cunningham.

8. Keith Sagar, *D. H. Lawrence and New Mexico* (Salt Lake City: Gibbs M. Smith, 1982).

9. Returning to Paris only confirmed Blumenschein's passion for the American West: "I've had my fill of Paris and its bad air. If I'd live here a year, I'd think I'd lose all the native refinement I ever possessed. . . . Here the atmosphere would cause a lily to droop her head and die of shame. There is no choice of thoughts, no standard of life (at least in the Latin Quarter). Everything that's natural is to be listened to, consequently vulgar ideas are as common as better ones. . . . The question of money, and the great desire to get to Taos and settle—settle to work—are great factors" (Blumenschein Family papers, AAA, courtesy Elizabeth Cunningham). See Schimmel and White, *Bert Geer Phillips and the Taos Art Colony;* and White, *The Taos Art Colony and the Taos Society of Artists, 1911–1927,* pp. 65–83; see also Bert Phillips to Blumenschein.

10. See Schimmel and White, *Bert Geer Phillips and the Taos Art Colony,* p. 89.

11. Higgins, interview by Bickerstaff: "Pioneer Artists of Taos," *American Artist,* January 1978, p. 58.

12. Gordon Sanders, *Oscar Berninghaus, Taos, New Mexico: Master Painter of American Indians and the Frontier West* (Taos: Taos Heritage Publishing Co., 1985), p. 8.

13. Henri to [recipient unknown], October 19, 1889, Robert Henri Correspondence, Beinecke Library, Yale University, quoted in Virginia Couse Leavitt, *Eanger Irving Couse: Image Maker for America* (Albuquerque: Albuquerque Museum Foundation, 1991), p. 9.

14. Armstrong, "Fine Art at the Paris Exhibition," *Portfolio,* 20, 1889, p. 173, quoted in ibid., p. 12.

15. Ibid.

16. Letter from Ernest L. Blumenschein to Ellis Parker Butler, Paris, January 16, 1900, Blumenschein Family papers, AAA, courtesy Elizabeth Cunningham.

17. Among all the artists, the most eager to collaborate with Simpson was Couse, who almost always obliged his patron's suggestions, and was almost ready to accept a lower fee, an attitude that contrasted markedly with Blumenschein's intransigence respecting both fees and subjects.

18. Porter, *Taos Artists,* p. 25.

19. Lummis, "The Artist's Paradise," *Out West,* September 29, 1908, p. 81, cited in Porter, *Taos Artists,* p. 24.

20. Hewett maintained warm relations with Couse, who shared his boundless admiration for the local culture. One day Hewett gave him a tile decorated by one of the Pueblo artisans. "Work of this type can be just as important as any other," Couse wrote. "It is a great mistake many people make when they believe 'high' art is only on canvas. Some of these motives here give rare evidence, not only of themselves, but also of their race, through the simple decoration of a piece of pottery or in the make of the pottery itself. Plainly their work is not a mere convention, does not aim at being a 'design' or 'work of art.' . . . I was . . . glad to hear that you were doing good work with your classes. . . . Things are very interesting here. The new museum is a wonder with the influence of Dr. Hewett and the excellent men about him. . . . Most museums are glum and morose temples looking homesick for the skies and association of [illegible]. The museum here looks as though it were a precious [illegible] of the Santa Fe sky and the Santa Fe mountain. It has its own complexion. It seems warmly at home as if it had always been here. Without any need of the treasures of art which are to go and into it if a treasure of art in itself. Art

of this time and this place of these people and related to all the past. Santa Fe can become a rare spot in all the world" (Couse to Hewett, September 24, 1917, AAA, Taos Society of Artists Papers.

21. Blumenschein, "Origin of the Taos Art Colony."

22. Phillips, quoted in Couse Leavitt, *Eanger Irving Couse*, p. 37.

23. Pickard, quoted in Caroline Pickard Culbert, "The Missouri State Capitol and the Taos Group," typed manuscript, Kit Carson Foundation Archives, Taos, cited in Porter, *Taos Artists*, p. 2.

24. Blumenschein, quoted in James Moore, "Ernest Blumenschein's Long Journey with Star Road," *American Art*, Fall 1995, p. 18. This brilliant text is the most revealing interpretation of the Taos painters' political involvement.

25. Porter, *Taos Artists*, p. 249

26. Letter from Robert Henri to Dr. Edgar L. Hewett, written on a train in Kansas, November 29, 1917, AAA, Robert Henri Papers.

27. Robert Henri to Edgar L. Hewett, New York, December 20, 1920, AAA, Taos Society of Artists Papers.

28. Helen Goodman, "Robert Henri, the Teacher," Ph.D. diss. (New York: NYU, 1975), p. 105.

29. Rudnick, *Mabel Dodge Luhan*, p. 177.

30. Luhan, *Intimate Memories*, vol. 4, *Edge of Taos Desert*, p. 177.

31. De Angelo, quoted in Rudnick, *Mabel Dodge Luhan*, p 185.

32. Carl G. Jung, *Man and His Symbols* (New York: Dell, 1968), p. 76.

33. Georgia O'Keeffe, "My World Is Different," *Newsweek*, October 10, 1960, p. 101.

34. Elizabeth Cunningham, notes from lecture "Leading Ladies of Taos," June 1998, Taos, N.M.

35. Ibid.

36. Marsden Hartley to Alfred Stieglitz, 1918; see Eldredge, *Art in New Mexico*, p. 154.

37. Letter from Marsden Hartley to Edgar L. Hewitt, on "The Taos Society of Artists" letterhead, s.d., AAA, Taos Society of Artists Papers.

38. *The Santa Fe New Mexican*, Emil Bisttram Papers, R581–840.

39. *El Palacio*, November 1, 1924.

40. Andrew Dasburg, oral interview, AAA, Dasburg Papers.

41. Ibid.

42. Blumenschein, "Origin of the Taos Art Colony," op. cit.

43. Each new painter who arrived in New Mexico could not resist making comparisons between its colonies and those in Normandy and Brittany, where so many of them had spent time painting young women in traditional costumes. In Taos and Santa Fe, they were working with Pueblo Indians, whom they paid 25 cents an hour, "which is more than twice as much as the Indians can make in other other work," as Couse noted. Dasburg had painted at Concarneau during the summer of 1909, and had been unenthusiastic about the experience. He recalled with fondness his time in Paris—visiting the Steins' salon, discovering Matisse, studying Cézanne's still lifes—but felt a profound aversion for painting the rural French countryside. He wrote to his friend Grace Johnson on September 5, 1909: "When tired with the noise of sabots, dirt and dirty peasants with bad smells for which Concarneau has not a small reputation we appreciate this refuge more than a little. . . . Concarneau is not the kind of place that we like best. It is a town many times larger than Woodstock—NY—one could almost call it a city without the simplest modern improvements; of course this does not hold good in the hotles [*sic*] and summer houses of the wealthy. To my mind, it is not the place for a landscape painter as the country is very monotonous being cut up into small fields with earth walls and high edges around most of

them; of course one can always find interesting bits to paint and one becomes friendly after a while with the mutilated old tree trunks. . . . The town has and is still full of painters all thinking they are painting the life of the people here and what a lot of senti-mental pretty pictures they do turn out! The buildings in which the market is held looks more like a painting academy than a market." Dasburg concludes this list of complaints with the observation that he hasn't worked as well as he would have liked in Concarneau, where "nearly everyone wears sabots and the women always wear headresses which are always as clean as they can be; one wonders if they put a new one on every day and who their laundress can be. The little children are dressed exactly like the older people, so that the little girls look like little grandmamas. They mind the babies during the days as most of the women work in the usine during the summer and the men are out in the boats fish-ing. . . .You ought to be glad," he concludes, "you are not a baby in Concarneau!" (AAA, Dasburg Papers). It seems clear that the American painters, as Blumenshein had said, were now looking for "new subjects." Dasburg arrived in Taos seven years after his stay in Con-carneau. On June 2, 1916, he described to Grace Johnson what it was like to go on a trail ride on a horse named Dick. "[R]iding today seemed like a dream in Arcadian fields. Stopped in town to make a call, but finding no one at home we wandered in the direction of the Pueblo, on the road that is hedged in with wild plum trees and roses in bloom that pour above one's head on both sides of the way. The fields are still filled with the color of wild peas and a taller lavender flower that grows like a larkspur. Some cactus is out, mostly the yellow variety, though I did see some pink magenta kind, further up the mountain. . . . Beyond the Pueblo, I followed a road that headed to the large cleft in the mountain, which divides it like the river operating the two Pueblos. This led into a trail among the larger trees and along the track, which it follows when [?] finally it becomes like everything else and you must pick it out at your whim. I was in this way, until an Indian coming down the mountains found me and commanded that I go back from forbidden territory—Vamoose—as he put it. Possibly I was getting in the vicinity of one of their shrines. . . . I found in one place a circular arrangement of stones that looked as if it were built for cere-monial purposes. Or he may have thought I was looking for the deposits of gold that are known to be theirs. Coming back, I left the path entirely and picked up my way down among the Piñones with all the valley before me hung like a map in space."

44. Quoted in Eldredge, *Art in New Mexico*, p. 67.

45. Ibid., p. 51, *Dallas Morning Sun,* December 7, 1924.

Chapter Four

New York, Cultural Capital of the World

1. Marcel Duchamp to Walter Pach, April 27, 1915, in Tomkins, *Duchamp: A Biogra-phy,* p. 141.

2. Under "detail of services and various moves," one can read: "declared unfit for serv-ice number 2, on September 1, 1909; maintained unfit in January 6, 1915 and on March 27, 12917" but, "as to the AD/DEP 3153 bulletin of June 23, 1955, private medical elements have been blurred" (regimental register of class 1907 for Duchamp, Henri, Robert, Marcel, côte 1 R 3222, Directions des Archives Départementales de Rouen, Seine Maritime).

3. Tomkins, *Duchamp,* pp. 137–40.

4. Ibid., Marcel Duchamp to Walter Pach, April 24, 1915.

5. Ibid., Marcel Duchamp to Walter Pach, April 2, 1915.

6. James Johnson Sweeney, "Eleven Europeans in America," *Museum of Modern Art Bulletin,* 1946, p. 20.

7. Sanouillet, *Duchamp du signe,* p. 171.

8. Apollinaire, *Chroniques d'art* (Paris: Gallimard, Folio edition, 1960), entry for May 19, 1914.

9. Sanouillet, *Duchamp du signe,* p. 170.

10. Ibid., p. 171.

11. Dagognet, *Etienne-Jules Marey.*

12. Sanouillet, *Duchamp du signe,* p. 173.

13. "It was more than simply a success; there was an outcry. People thought me crazy . . . and complaints were sent to the director." Roussel, *Comment j'ai écrit certains de mes livres,* pp. 10, 30.

14. See Michel Sanouillet, "M. D., Criticavit," in Sanouillet, *Duchamp du signe,* p. 174.

15. See Breton, *Anthologie de l'humour noir;* and Sanouillet, *Duchamp du signe,* p. 28.

16. The Vermot almanac was a traditional French publication founded in the 1880s, which gathered riddles, puns, weather forecasts, recipes, and proverbs, among others. See Sanouillet, pp. 170–74.

17. Zilczer, "The World's New Art Center," pp. 2–7.

18. See AAA, Dasburg Papers.

19. *291,* nos. 1–12 (March 1915–February 1916), in the Haviland Archives, Musée d'Orsay, Paris.

20. Photos of Agnes Ernst Meyer's picnics, 1913–14, are in the Haviland Archives, Musée d'Orsay, Paris.

21. Tomkins, *Duchamp: A Biography,* pp. 143, 147.

22. Ibid., p. 146.

23. Reliquet and Reliquet, *Henry-Pierre Roché, l'enchanteur collectionneur.*

24. Duchamp to Louise Arensberg, August 24, 1917, in Arensberg Archives, Philadelphia Museum of Art, quoted in Tomkins, *Duchamp,* pp. 197–98.

25. Sanouillet, *Etant donné,* pp. 21–34.

26. Ibid., interview with Sweeney, p. 181.

27. Tomkins, *Duchamp,* p. 150.

28. From "The Richard Mutt Case," the unsigned lead editorial in *The Blind Man,* no. 2 (May 1917), edited and published by Duchamp, Henri-Pierre Roché, and Beatrice Wood on the occasion of the *Independent Exhibition,* quoted in Tomkins, *Duchamp,* p. 185.

29. Francis Picabia, "How New York Looks to Me," *New York American,* March 30, 1913.

30. Ibid.

31. "The European Art Invasion," *Literary Digest,* November 27, 1915, pp. 1223–25.

32. Ibid.

33. Frederick J. Gregg "The World's New Art Center," *Vanity Fair,* January 1915, p. 31.

34. "French Artists Spur on American Art," *New York Tribune,* October 24, 1915, part 4, p. 2.

35. Quoted in Thomas a. P. van Leeuwen, "Le Gratte-ciel, ou le mythe de la croissance naturalle," in Damisch, ed., *Américanisme et modernité,* pp. 78, 82.

36. Although he had declared that "New York is the place to be," Picabia, an independent Dadaist, needed the European context to develop his own experimentations.

37. The name of the magazine was chosen as a nod to Stieglitz, De Zayas, Meyer, and Picabia's *291.*

38. Stieglitz to Haviland, July 5, 1916, in the Haviland Archives, Musée d'Orsay, Paris.

39. Zigrosser, *My Own Shall Come to Me,* p. 82. For more on Zigrosser, see Antliff, "Carl Zigrosser and the Modern School: Nietzsche, Art and Anarchism," pp. 16–23.

40. Rudi Blesh, *Modern Art USA: Men, Rebellion, and Conquest 1900–1956* (New York: Alfred A. Knopf, 1956), pp. 80–81.

41. AAA, John Weichsel Papers.

42. AAA, People's Art Guild Papers.

43. Andrew Dasburg interview, AAA, Dasburg Papers.

44. Dagen, *Le Silence des peintres: les artistes face à la grande guerre.*

45. Silver, *Esprit de Corps.*

46. Letter from Raymond Duchamp-Villon to Walter Pach, October 17, 1915, AAA, Walter Pach Papers.

47. Silver, *Esprit de Corps,* pp. 228, 271.

48. Hans Haron, in Silver, *Esprit de Corps,* pp. 270, 456.

49. Sachs, *Journal d'un jeune bourgeois,* pp. 17, 18.

50. Louis Aragon, discussion with Elizabeth Eyre, published in *Town and Country,* 1924.

51. Léger, *Mes Voyages,* p. 23

52. *transition,* 1928.

53. Davidson, "The European Art Invasion."

54. An acronym for the French colloquial expression "Elle a chaud au cul," meaning something like "She's a red-hot tomato" or "She's a hot dish" or "She's a hot number."

55. Katherine Dreier to H. P. Roché, Sept. 24, 1946, Katherine Dreier Papers, Beinecke Library, Yale University, quoted in Religict, op. cit., p. 88.

56. From a letter from Robert Allerton Parker to Sophie Treadwell dated October 4, 1968, cited in Sanouillet, *Etant donné Marcel Duchamp,* p. 76.

Chapter Five

Abby, Lilly, Mary, and the Others: The Women Take Charge

1. *Baltimore American,* April 15, 1912.

2. Gattey, *Bloomer Girls,* see also Chapters 4 and 5.

3. Flexner, *Century of Struggle.*

4. Bullock to Ellsworth, 30 Sept 1890, in Ellsworth Papers, Special Collections, Chicago Public Library.

5. Carr, "Prejudice and Pride," p. 66.

6. Ibid.

7. McCarthy, "Patronage of the Arts."

8. Ibid., *Women's Culture,* p. 112.

9. Ibid., p. 150.

10. Ibid., p. 185.

11. For her part, Lilla Cabot Perry managed to become close to Monet and introduced him to Bostonian society. With her knowledge of the Japanese art world, she became the most brilliant ambassador of Impressionism in the United States.

12. McCarthy, *Women's Culture,* p. 142.

13. Ibid., p. 161.

14. Ibid., p. 171.

15. Ibid., p. 159.

16. Nancy Cusick, "Alice Pike Barney," review of *Alice Pike Barney,* by Jean L. Kling, *Women Artist's Newspaper,* p. 13.

17. Ibid., p. 16.

18. Cusick, "Alice Pike Barney."

19. Cusick, "Alice Pike Barney," p. 13.

20. Christine I. Oaklander, "Clara Davidge's Madison Art Gallery: Sowing the Seed for the Armory Show," *Archives of American Art Journal* 36, no. 3–4 (1996), p. 21.

21. Ibid., p. 22.

22. Ibid., p. 439.

23. Letter from Gertrude Vanderbilt Whitney to Morgan Russell, dated Sept. 19, 1915, AAA, Morgan Russell Papers.

24. Maxwell L. Anderson, foreword to Haskell, *The American Century,* p. 8.

25. Friedman, *Gertrude Vanderbilt Whitney,* p. 525.

26. Ibid., p. 558.

27. Ibid., p. 559.

28. Ibid., Stuart Davis interview by Hermon More and John I.H. Baur, September 29, 1953.

Chapter Six

The "Greatest Modern Museum in the World"

1. Early Museum History Files, MoMA Archives.

2. Abby Rockefeller to Alfred H. Barr, August 20, 1929, in Early Museum History Files, MoMA Archives.

3. Ibid., August 23, 1929.

4. Roob, "Alfred H. Barr, Jr.," pp. 1–9.

5. Alfred H. Barr Papers, Early Museum History Files, MoMA Archives.

6. Roob, "Alfred H. Barr, Jr.," p. 12.

7. Ibid., p. 7, letter from Paul Sachs to Charles Rufus Morey, June 12, 1925.

8. Sachs, *Modern Prints & Drawings.*

9. See Cohen, "Paul J. Sachs and the Acceptance of Modern Art by an American Elite," Chapter 2, "The Jewish Quota Debate," pp. 28–29.

10. Charles Eliot Norton, *The Nation,* July 13, 1865.

11. Sachs, "Tales of an Epoch," p. 169.

12. Ibid., p. 169.

13. Sachs, "Tales of an Epoch," p. 169.

14. Ibid., pp. 150–73.

15. Ibid., p. 424.

16. "Harvard 30 Celebrates Class Day," *Boston Transcript,* June 17, 1930.

17. Edward M. M. Warburg, oral history, Early Museum History, MoMA Archives.

18. *Boston Traveler,* Tuesday, June 17, 1930.

19. Philip Johnson, oral history, Early Museum History, MoMA Archives.

20. Lynes, *Good Old Modern,* p. 99.

21. Eliza Parkinson, oral history, MoMA Archives.

22. Early Museum History Files, MoMA Archives.

23. *New York Times,* September 9, 1929.

24. *New York Evening World,* MoMA Archives.

25. Lloyd Goodrich, "A Museum of Modern Art," *The Nation,* December 4, 1929, p. 665.

26. *Evening Post,* February 21, 1930.

27. Parkinson, oral history, Early Museum History, MoMA Archives.

28. Alfred H. Barr, Jr., "Re: Bulletin on What the Museum Has Done in the Field of American Art," Memorandum to Miss [Dorothy C] Miller, October 10, 1940, in Alfred Barr Papers, p. 96, MoMA Archives.

29. "Bulletin on What the Museum Has Done in the Field of American Art," Memorandum to Miss Miller, October 10, 1940, in Alfred Barr Papers, MoMA Archives.

30. A. Conger Goodyear to Alfred H. Barr, June 17, 1936, MoMA Archives.

31. Tom Mabrey to Alfred H. Barr, June 18, 1936, MoMA Archives.

32. Alfred H. Barr to Nelson Rockefeller, July 7, 1936, MoMA Archives.

33. Alfred H. Barr to Philip Goodwin, July 6, 1936, MoMA Archives.

34. Goodyear's reference is to Edward Durell Stone, Goodwin's assistant. Conger Goodyear to Alfred Barr, July 7, 1936. MoMA Archives.

35. Alfred H. Barr to Knoedler, August 1, 1936, MoMA Archives.

36. Alfred H. Barr to Joseph Hudnut, August 26, 1936, MoMA Archives.

37. Alfred H. Barr to Joseph Hudnut, August 9, 1936, MoMA Archives.

38. Eddie Warburg to Alfred Barr, April 18, 1933, Early Museum History, MoMA Archives.

39. *New York Herald Tribune,* October 25, 1934.

40. Alfred H. Barr quoted in Christoph Grunenberg, "The Politics of Presentation: The Museum of Modern Art, New York," in *Art Apart: Art Institutions and Ideology across England and North America* (New York: Manchester University Press, 1994), p. 197.

41. Ibid.

Chapter Seven

"America Without That Damned French Flavor": Modernism in the United States

1. *The Eye of Duncan Phillips: From Renoir to Rothko* (New Haven: Yale University Press, 1999).

2. See "The Middle Years, Chester Dale," in Kopper, *America's National Gallery of Art,* pp. 237–49. Maud Dale was the driving force behind their collection, and after her death, Chester Dale became obsessed with Salvador Dalí.

3. Quoted in Corn, *The Great American Thing,* p. 1.

4. Ibid.

5. Ibid.

6. Ibid., p. 3.

7. See Johnson, *American Modern,* pp. 8–38.

8. Stuart Davis, cited in Wilkin, "Becoming a Modern Artist, 1920," p. 54.

9. Henry McBride, art critic of the *New York Sun,* quoted in Turner, *Americans in Paris,* p. 174.

10. Stieglitz to Hartley, cited in Turner, *Americans in Paris,* p. 176.

11. Stuart Davis, "Self-Interview," *Creative Art,* September 1932, p. 211.

12. Elderfield, *The Museum of Modern Art at Mid-Century.*

13. Dasburg and Maurer both returned to more conventional work, for instance.

14. Gaddis, *Magician,* p. 66.

15. *Hartford Times,* January 25, 1928, cited in Gaddis, *Magician,* p. 85.

16. Gaddis, *Magician,* p. 76.

17. Ibid., p. 161.

18. Ibid., p. 204.

19. Ibid., p. 205.

20. Ibid., p. 155–61

21. Ibid., pp. 143–46.

22. Ibid., pp. 140, 130–31.

23. Ibid., p. 184.

24. Ibid., p. 131, *Hartford Times*, Nov. 30, 1929.

25. See Innis Howe Shoemaker, with Christa Clarke and William Wierzbvowski, *Mad for Modernism: Earl Horter and His Collection* (Philadelphia Museum of Art, 1999).

26. Tocqueville, *De la démocratie*, p. 69.

27. Neil Harris, "Museum, Merchandising, and Popular Taste," in Harris, *Cultural Excursions*, p. 74.

28. Ibid., p 75.

29. Fox, *Engines of Culture;* see also Harris, *Cultural Excursions*, p. 108.

30. John Cotton Dana, "Creative Art," *Creative Art*, no. 75 (March 1929).

31. Mencken, *A Book of Prefaces.*

32. Letter from William M. R. French to Sarah Hallowell, March 18, 1913.

33. Eddy, *Cubists and Post-Impressionism*, p. 112.

34. Harriet Monroe, *Chicago Tribune*, March 17, 1912.

35. George Cram Cook, *Chicago Evening Post*, Friday Literary Review, March 29, 1912.

36. Margaret Anderson, "To the Innermost," *The Little Review*, no. 7 (October 1914).

37. Ibid., "Art and Anarchism," *The Little Review* (March 1916).

38. Dell, *Homecoming*, p. 238.

39. Clarence J. Bulliet, "Chicago as the Art Center of America," *Chicago Evening Post*, Oct. 7, 1924.

40. Ibid., *Apples and Madonnas.*

41. See Paul Kruty, "Declarations of Independents: Chicago's Alternative Art Groups of the 1920s," in Prince, *The Old Guard and the Avant Garde*, pp. 77–93.

42. Prince, *Old Guard and Avant-Garde*, p. 222.

43. Ibid., p. 222.

44. Forbes Watson, "Another Great Art Exhibit for World's Fair," *Literary Digest*, August 4, 1934.

45. Interview with Diego Rivera, *San Francisco Daily News*, May 6, 1931.

46. See *Pike's Peak Vision: The Broadmoor Art Academy, 1919–1945* (Colorado Springs: Colorado Springs Fine Arts Center, 1989), pp. 65 and 68.

47. Ibid., p. 70.

48. Alexander Hogue, *Southwest Review*, January 14, 1929, pp. 256–61.

49. Ibid.

50. John William Rogers, *Dallas Times Herald*, March 26, 1933; *Dallas Morning News*, March 1933.

51. Stanton Macdonald-Wright, quoted in a brochure for the exhibition *Painting of American Modernists*, AAA, Stanton Macdonald-Wright Papers. Cited in Paul Karlstrom, ed., *On the Edge of America: California Modernist Art, 1900–1950* (Berkeley: University of California, 1996), p. 8.

52. Louise Arensberg, *Turning the Tide*, p. 14.

53. Delano to Delaunay, March 11, 1929, AAA, Annita Delano Papers.

54. Ibid.

55. Letter from Andrew Dasburg to Grace Johnson, February 17, 1914. AAA, Dasburg Papers.

56. Duchamp, in an interview by James Johnson Sweeney, in the *Bulletin of the Museum of Modern Art*, p. 182.

57. *Brancusi contre États-Unis, un procès historique.*

58. Sarah Newmeyer, Early Museum History, MoMA Archives.

Chapter Eight

"Warning: Men at Work"

1. Stephen Vincent Benet, "American Blues," in Kammen, *Mystic Chords,* p. 322.

2. William Carlos Williams, "The Discovery of Kentucky," in Williams, *In the American Grain,* p. 139.

3. Larkin, *Art and Life in America,* p. 416.

4. *Time,* December 24, 1934.

5. See Kammen, *Mystic Chords of Memory.*

6. See *Pike's Peak Vision: The Broadmoor Art Academy, 1919–1945* (Colorado Springs: Colorado Springs Fine Arts Center, 1989).

7. Ibid., p. 157.

8. Edward B. Rowen, "Will Plumbers' Wages Turn the Trick?" *American Magazine of Art,* vol. 27 (February 1934), p. 80.

9. *Time,* December 25, 1933, p. 19.

10. See Wendy Jeffers, "Holger Cahill and American Art," *Archives of American Art Journal,* 31, no. 4 (1991), pp. 2–11.

11. "In the Business District," *Time,* September 25, 1938, p. 5.

12. *AAAJ,* 1991.

13. AAA, Holger Cahill Papers.

14. Ibid.

15. Transcript of Holger Cahill interview, April 12 and April 15, 1960, AAA, Holger Cahill Papers.

16. "Legislator's Lounge," *Time,* January 11, 1937, p. 41.

17. Ibid.

18. Stewart, *Lone Star Regionalism.*

19. *Dallas Morning News,* January 1935.

20. Stewart, *Loan Star Regionalism.*

21. "Endorsements of the Federal Art Project in the Works Progress Administration by Leading Organizations and Authorities in Educational and Art Fields," AAA, WPA Files.

22. AAA.

23. Gonzales and Witt, *Spirit Ascendant.*

24. Ibid., p. 36.

25. *Time,* December 24, 1934.

26. Transcript of Holger Cahill interview, April 12 and April 15, 1960, AAA, Holger Cahill Papers.

27. Ibid.

28. Lawrence quoted in Leuchtenburg, *The FDR Years,* p. 261.

29. Forbes Watson, "Opportunities in the Arts," AAA, Watson Papers.

30. Letter from Hirsch to D. Cahill, July 12, 1960, AAA, Holger Cahill Papers.

31. Letter from Jasper Johns to Dorothy Cahill, North Carolina, July 17, 1960, AAA, Holger Cahill Papers.

Chapter Nine

The *Demoiselles* Sail to the United States

1. Goodyear was accompanied by César M. de Hauke, a dealer from the Seligmann Gallery in New York.

2. Seckel and Cousins, "Chronologie," in *Les Demoiselles d'Avignon,* vol. 1.

3. Ibid., testimony of Madame Morissonin.

4. Ibid., p. 599, Goodyear to Doucet, September 3, 1929.

5. Jeshvanhroo Holkar to Jacques Doucet, with letterhead reading "Château Holkar, Saint Germain en Laye" and dated October 22, 1929, quoted in de Croisset, *Voyages aux fêtes de Kapurthala,* privately printed by Rose Adler after Doucet's death. See document DV 17, Bibliothèque Littéraire Jacques Doucet, Paris.

6. Quoted in *La Bibliothèque littéraire Jacques Doucet,* brochure (Paris: Doucet Littérature, 1996), p. 8.

7. For more on the relations between Doucet and Breton, see Yves Peyré, "L'Absolu d'une rencontre," in *Cahiers de la Bibliothèque Littéraire Jacques Doucet,* no. 1, pp. 92–96.

8. Breton, *Oeuvres complètes.*

9. Seckel and Cousins, "Chronologie," André Breton to Jacques Doucet, December 3, 1921.

10. Ibid., André Breton to Jacques Doucet, November 6, 1923.

11. Ibid., p. 580; see also Jacques Doucet, pp. 297–8.

12. Ibid., Doucet to André Suarès, March 9, 1924.

13. Ibid., André Breton to Jacques Doucet, December 2, 1924.

14. Ibid., André Breton to Jacques Doucet, December 12, 1924.

15. I thank Yveline Cantarel-Besson, former curator at the Archives des Musées Nationaux, Louvre Museum, for her help in providing information about this subject.

16. Procès Verbal du Comité Consultative du Musée du Louvre, February 11, 1926, Archives of the French National Museum.

17. Seckel and Cousins, "Chronologie," p. 580, Jacques Doucet to René-Jean, March 6, 1917.

18. This agreement was ratified on July 6, 1925. See Seckel and Cousins, "Chronologie," p. 596.

19. René Gimpel, *Journal d'un collectionneur marchand de tableaux* (Paris: Calmann-Lévy, 1963), p. 384.

20. Alfred H. Barr to A. Conger Goodyear, November 21, 1932, Early Museum History, MoMA Archives.

21. Alfred H. Barr to Joseph Hudnut, July 19, 1936, Early Museum History, MoMA Archives.

22. Alfred H. Barr to Eustache de Lorey, July 19, 1936, Early Museum History, MoMA Archives.

23. André Dezarrois to Alfred H. Barr, September 17, 1936, Early Museum History, MoMA Archives.

24. A. Conger Goodyear to Eustache de Lorey, December 11, 1936, Early Museum History, MoMA Archives.

25. *New York Times Magazine,* May 22, 1938.

26. Both quoted in the *New York Herald Tribune,* July 7, 1938.

27. *New York Times,* July 31, 1938.

28. A. Conger Goodyear to Walt Kuhn, October 19, 1939, AAA, Walt Kuhn Papers.

29. "Cubism and Abstract Art" catalogue, March 2 through April 19, 1936.

30. Seckel and Cousins, "Chronologie," p. 614

31. Ibid., p. 618.

32. From an interview with Claude Berri, Nov. 5, 1995 and based upon meetings between me and Leo Castelli.

Chapter Ten

"The Rush Toward the West": Europeans to the New World

1. "Kandinsky-Albers, une correspondance des années trentes," p. 93.

2. "Abstraction création: art non figuratif."

3. Ibid.

4. Other artists whose works were shown there included Theo van Doesburg, Kurt Seligmann, Max Bill, Kurt Schwitters, Georges Vantongerloo, and Albert Gleizes. Among the Americans, they would present the work of Katherine Dreier, Alexander Calder, Carl Holty, Frederick Kann, Arshile Gorky, William Einstein (Stieglitz's nephew), and Florence Henri.

5. Russell, *Matisse,* p. 51.

6. L. Sherwin, "For Art, Matisse Says Remain in New York, Don't Go to Paris," *New York Evening Post,* September 22, 1930.

7. For a detailed analysis of the reception of Matisse's work in the United States, of his influence on the generation of young American painters, in contrast to Picasso in particular, or the influence of others, such as Alfred Barr, on his work, see de Chassey, *La violence décorative.*

8. *Matisse, Ecrits et propos,* p. 109.

9. Stands for the Association for Revolutionary Artists and Writers.

10. He would do the second project together with Stuart Davis.

11. Quoted in *Fernand Léger,* exhibition catalog.

12. Rey, "Ainsi parlait Cendrars de son copain Léger,"p. 436.

13. "Paris–New York, New York–Paris, 1941," Léger, *Mes voyages,* pp. 55–56.

14. Interview in *Les Lettres Françaises,* April 12, 1946.

15. Hélion, *Lettres d'Amérique,* p. 22, letter dated November 20, 1936.

16. Ibid., pp. 20–22.

17. Ibid., p. 152, letter dated September 3, 1939.

18. Hans Hofmann, January 21, 1938, Early Museum History, MoMA Archives.

19. This notion of appropriating materials, fundamental to the Bauhaus creators, had not yet been fully assimilated by the American public. In 1938, the Museum of Modern Art organized a comprehensive exhibition entitled *Bauhaus 1919–1928.* "Let it then remain a legend," Kandinsky wrote to Josef Albers (in a letter dated April 28, 1938, cited in "Kandinsky-Albers, Une correspondance des années trentes," p 105). Kandinsky had never entirely approved of this exhibition. As for the failure of the New Bauhaus in Chicago, it was caused by the "personal" interpretations of the movement by its director, László Moholy-Nagy, the "dissident" Bauhaus artist from Dessau, who focused on the use of the machine. "Since the tendency to 'return to craftsmanship' is hardly dealt with, the importance given to the 'machine' becomes excessive and rather misleading" (Kandinsky to Albers, in a letter dated January 5, 1939, in ibid., p. 126). See also Findeli, *Le Bauhaus de Chicago.*

20. He was the grandson of a German immigrant who had made his fortune in the steel industry. Theodore Drier, although schooled in engineering, decided to devote himself to teaching mathematics and physics. At Black Mountain College, he taught physics and used his family connections to help further the institution.

21. Einstein and Florence Henri had both frequented the Académie Moderne in Paris. In 1923, Othon Friesz asked Fernand Léger and Marie Laurencin to participate in teaching there; it had been under his direction since 1913. Two years later he was replaced by Amédée Ozenfant, whose students were from diverse origins, including Scandanavia, Germany, Russia, Romania, and Poland.

22. Lassalle, *Fernand Léger,* pp. 137–139.

23. For the influence of Europeans on the Americans in the forties, see Castelman and Davenport, *Art of the Forties.*

24. *Portrait of Pierre, the Child with the Red Hat,* film by Gero von Boehm, Z.D.F., 1995.

25. Russell, *Matisse: Father and Son,* p. 83.

26. The other quarter came back to Pierre Loeb, who had as early as 1926 defended the Catalan painter. On May 2, 1934, despite the fact that the arrangement had been virtually concluded, PM wrote to Pierre Loeb: "But we must not forget that although Miró is widely known, very few of his followers dare to buy his pictures. I have to see my way through before I can engage in a contract of this sort. Miró's reputation in the United States is based on a certain sensationalism, as a result of the picture you sold to Monsieur Gallatin [*The Dog Barking at the Moon,* 1926], and it will require great efforts on my part to combat the public's views." Russell, *Matisse,* p 114.

27. Ibid., p. 256.

28. James Johnson Sweeney knew the European artistic scene perfectly. An alumnus of Georgetown University (1922), he had studied for two years at Cambridge in England (1922–24), where he met Roger Fry; then spent a year at the Sorbonne (1925), and a year in Sienna (1926). From 1941 to 1948, he was at the Museum of Modern Art, where he organized exhibitions of Miró, Calder, Klee, Mondrian, Moore, and Stuart Davis. Named Director of the Painting and Sculpture Departments at MoMA in 1945, he stepped down in 1946.

29. See McMillan, *Transition. Transition* was the most important magazine for American expatriates in Paris. Its creator, Eugène Jolas, intended to expose Americans to the European literary avant-garde—for instance, Dadaism, Expressionism, and Surrealism—by publishing English-language texts by such writers as Joyce, Stein, and Beckett. Like Drier, Jolas had also understood the importance of German artists.

30. A. E. Gallatin had asked Jean Hélion to reflect upon the conception of a magazine that would promote modernism in the United States. The French painter accomplished the preparatory work necessary to publish four issues of the review, which was to be entitled *Plastique,* and sent all his preliminary research to Gallatin; Gallatin abandoned the project for financial reasons. See the important study by Arnauld Pierre, in *Künstlerischer Austausch / Artistic Exchange, Akten des XXVIII Internationalen Kongress für Künstgeschichte,* Berlin, July 1992, pp. 333–348, Akademie Verlag.

31. Ibid., pp. 333–48, Sophie Taeuber-Arp to Gallatin, in a letter dated February 12, 1935.

32. Dreier, *Western Art and the New Era,* p. 89. See also Herbert, Apter, and Kenney, *The Société Anonyme and the Dreier Bequest at Yale University, a Catalogue Raisonné.*

33. To meet Braque, Arp, Ernst, Kakadzè, Mondrian, Léger, Puni, Pevsner, Schwitters, Gropius, Kandinsky, Klee, Moholy-Nagy, Lissitsky, and Gabo.

34. In 1926 and 1927, where nevertheless she would deal with important issues, such as the political and artistic situtation in Russia, or artistic education in the United States.

35. This "Special Exhibition" opened its doors on January 1, 1931, and presented seventy works by thirty-seven artists, originating from ten different countries, all produced after 1924. Kandinsky and Mondrian, alongside Gorky and Graham, were its two stars. Duchamp selected paintings from the studios of Crotti, Suzanne Duchamp, Ernst, Mon-

drian, Picabia, Villon, and Jean Violler, and then added works by Adriaan Lubbers, Miró, G. Papazoff, Man Ray, Stella, and Campendonk.

36. There, she realized her dream of making an alliance between music and painting, projecting Duchamp's *Anemic Cinema* and part of Lotte Reinigers's *Prince Achmed*; and showing Archipenko's *Archipentura,* a three-dimensional painting in which louvered sections rotated under electric power. Thomas Willfred offered a demonstration of his Clavilux, an electric color-organ that produced color patterns synchronized with music.

37. See above, II, 12, last paragraph.

38. Remember also in 1928, the Society for Contemporary Art at Harvard, and then, in 1929, the creation of the Museum of Modern Art.

39. In addition to Gallatin's text, which is dated 1933, and was further developed in 1940, texts by Hélion and James Johnson Sweeney were also found there.

40. *Gallery of Living Art. A.E. Gallatin collection, 100, Washington Square East, N.Y.,* exhibition catalogue. Director: A. E. Gallatin.

41. "And the Metropolitan Museum of Art, New York," he added in the edition of 1940.

42. Barr, *Defining Modern Art,* p. 92. See also Alfred Barr, *Cubism and Abstract Art,* exhibition catalogue, 1936.

43. Barr, *Defining Modern Art,* p. 27.

44. Lukach, *Hilla Rebay: In Search of the Spirit in Art.*

45. See Gold, *Crossroads Marseille.*

46. Sawin, *André Masson in America,* p. 4.

47. *Les Demoiselles d'Avignon* had never been exhibited publicly in France; it had gone straight from Picasso's studio to Jacques Doucet's before sailing to New York.

48. Author, interview with Vanetti, January 27, 1996.

49. Lévi-Strauss was teaching at the New School for Social Research at the time; see Annie Cohen-Solal: "Lévi-Strauss in America," *Partisan Review* 67 (Spring 2000), p. 252.

50. "*Cadavre exquis,*" literally "exquisite corpse," was a Surrealist game, in which artists and writers would invent sentences that sounded alike but had utterly different meanings.

51. Lévi-Strauss, "New York pré et post-figuratif," in *Le regard éloigné.* Translated by Joachim Neugroschel, *The View from Afar* (Chicago: University of Chicago Press, 1992); see also *Critique,* January 1999, a special issue devoted to Lévi-Strauss.

52. For more information about Sartre's travels to the U.S. in 1945–1946, see Annie Cohen-Solal, *Sartre* (New York: Pantheon, 1987), pp. 223–244, 269–279.

53. Letter from Nicolas Calas to Alfred H. Barr, Early Museum History, MoMA Archives.

54. Vanetti interview op. cit.; author interview with Claude Lévi-Strauss, September 3, 1989. See also Levi-Strauss, "New York pré and post-figuratif."

55. Sidney Simon, "An interview with Peter Busa and Matta" (in Minneapolis, December 1966), in Giovanna Ferrari, *Entretiens morphologiques, notebook no. 1, 1936–1944* (Paris, Sistan Limited, 1987), p. 249.

56. Martica Sawin, "Duchamp aux USA," in *La Planète affolée,* catalogue of exhibition *The Crazy Planet,* Marseille, April 12–June 30, 1986, pp. 250–51.

57. Rylands, "Peggy Guggenheim and Art of this Century," pp. 9–13; see also Rylands, "Peggy Guggenheim"; Guggenheim, *Confessions of an Art Addict*; Guggenheim, *Art of This Century*; Prandin, "Peggy Guggenheim"; P. B. Vail, *Peggy Guggenheim: A Celebration* (New York: Guggenheim Museum, 1999).

58. Sawin, *André Masson in America 1941–1945.*

Finale

The Heroic Dance of Jackson Pollock

1. So much has been written about Jackson Pollock that adding to the body of work on this complex man sometimes seems gratuitous. Everything about his life has been chronicled. I note here the major works guiding my discussion: Steven Naifeh and Gregory White Smith, *Jackson Pollock: An American Saga* (New York: Clarkson N. Potter, 1989); Jeffrey Potter, *To a Violent Grave: An Oral Biography of Jackson Pollock* (New York: G. P. Putnam, 1985); and MoMA, *Jackson Pollock: A Retrospective* (New York: Museum of Modern Art, 1998).

2. Potter, *To a Violent Grave,* p. 20.

3. Ibid., p. 83.

4. Ibid., pp. 84–85.

5. Ibid., p. 85.

6. Benton, *Tom Benton's America,* p. 45.

7. AAA, WPA Papers.

8. Courtesy Jane Clark, City & Country School Archives, New York.

9. Naifeh and Smith, *Jackson Pollock,* p. 283.

10. Lee Krasner, quoted in Naifeh and Smith, *Pollock,* p. 341.

11. See Kirk Varnedoe's interesting analysis in "Comet: Jackson Pollock's Life and Work," in MoMA, *Jackson Pollock,* p. 34.

12. John Graham, "Primitive Art and Picasso," *Magazine of Art,* April 1937, pp. 236–39. On the McMillin show, see Ashton, *The New York School,* p. 122. For more on the relationship between Pollock and Graham, see Elizabeth Langhorne, "The Magus and the Alchemist," *American Art Magazine,* Fall 1998, pp. 47–67.

13. See Naifeh and Smith, *Jackson Pollock,* pp. 466–68.

14. Clement Greenberg, "The Present Prospects of American Painting and Sculpture," *Horizon,* October 1947, and Greenberg, "The Best?" and Greenberg, "Is Any Good Art Painted in the U.S.?," *Time,* December 1947.

15. Ashton, *New York School,* p. 152.

16. Pollock, interview in *Arts and Architecture,* 1944, pp. 14 ff.

17. Letter from Sande to Charles Pollock, July 1937, Pollock-Krasner House and Study Center, East Hampton, Long Island.

18. Sande to Charles, July 1941, Pollock-Krasner House and Study Center, East Hampton, Long Island.

19. Ibid.

20. Ibid.

21. Letter from Sande to Charles Pollock, July 1937, Pollock-Krasner House and Study Center, East Hampton, Long Island.

22. Letter from Sande to Charles Pollock, May 1940, Pollock-Krasner House and Study Center, East Hampton, Long Island.

23. "Hacía la revolución técnica de la pintura es decir: hacía el vehículo de la plástica dialéctica subversia de la revolución communista." Getty Institute, Research Library, Special Collections and Visual Ressources, Los Angeles, Siqueiros Papers.

24. Ibid. The other part of the speech read: "Such is the necessity imposed by the modernity of our mechanical technics and the dynamism of our methodology. Its mechanical potential is fitted to our needs. Its immense moving human crowds are calling us to arms. Its cosmopolitanism is a true tool for our internationalism.

25. Letter from Sande to Charles Pollock, September 1938, Pollock-Krasner House and Study Center, East Hampton, Long Island.

26. Letter from Sande to Charles Pollock, May 1940, Pollock-Krasner House and Study Center, East Hampton, Long Island.

27. Potter, *To a Violent Grave,* pp. 150–51.

28. Emil de Antonio and Mitch Tuchman, *Painters Painting: A Candid History of the Modern Art Scene 1940–1970* (New York: Abbeville Press, 1984), p. 39.

29. Ibid., p. 44.

30. *Catalogo,* p. xvi; Rylands and di Martino, *Flying the Flag for Art;* Bandera, *Il carteggio Longhi-Pallucchini.*

31. di Martino, *La Biennale di Venezia.*

32. B. H. Friedman, ed. *Give My Regards to Eighth Street: Collected Writings of Morton Feldman* (Cambridge: Exact Change, 2000), p. 118.

Epilogue

1998: A Trip to Taos

1. Author interview with Agnes Martin, Taos, June 29, 1998.

Bibliography

Aaron, Daniel, ed. *America in Crisis: Fourteen Crucial Episodes in American History.* New York: Alfred A. Knopf, 1952.

Abbott, Berenice. *New York in the Thirties.* New York: Dover Publications, 1939.

"Abstraction création—art non figuratif." *Les Tendances nouvelles,* no. 4 (1935).

Ackerman, Gérald M. *Jean-Léon Gérôme.* Courbevoie: ACR Editions, 1986.

———. "Thomas Eakins and his Parisian Masters Gérôme and Bonnat." *Gazette des Beaux Arts,* vol. 129 (April 1969).

Adams, Philip Rys. *Walt Kuhn, Painter: His Life and Work.* Columbus: Ohio State University Press, 1978.

Alexander, Charles C. *Here the Country Lies: Nationalism and the Arts in Twentieth Century America.* Bloomington: Indiana University Press, 1980.

American Art of Our Century. Exhibition catalog. New York: Whitney Museum of American Art and Frederick Praeger, 1961.

Americans in Brittany and Normandy 1860–1910. Exhibition catalog. Phoenix: Phoenix Art Museum, 1982.

Andréani, Jacques. *L'Amérique et nous.* Paris: Odile Jacob, 2001.

Antliff, Allan. "Carl Zigrosser and the Modern School: Nietzsche, Art and Anarchism." *Archives of American Art Journal,* vol. 34, no. 4 (1994).

Antonowa, Irina, and Merkert Jörn, eds. *Berlin-Moskau 1900–1950.* Munich: Prestel, 1995.

Apollinaire, Guillaume. *Chroniques d'Art (1902–1918).* Paris: Gallimard, 1960.

The Armory Show, International Exhibition of Modern Art, 1913. Vol. 1: *Catalogs;* vol. 2: *Pamphlets;* vol. 3: *Contemporary Documents.* New York: Arno Press, 1972.

"Artists of the Rockies and the Golden West." Colorado Springs: *The Western Collector's Choice,* vol. 11, no. 1 (Winter 1884).

Ashton, Dore. *The New York School: A Cultural Reckoning.* Berkeley: University of California Press, 1972.

———. "The Unknown Shore." *Atlantic Monthly* (September 1962).

Avery, Kevin J. *Church's Great Picture: "The Heart of the Andes."* New York: Metropolitan Museum of Art, 1993.

Bacon, Henry. "Glimpses of Parisian Art." *Scribner's Monthly,* no. 21 (March 1881).

Bailly-Herzberg, Janine, ed. *Correspondance de Camille Pissarro, 1865–1885,* vol. 1. Paris: Presses Universitaires de France, 1980.

Baker, Paul R. *Stanny! The Gilded Life of Stanford White.* New York: Free Press, 1989.

Balfe, Judith H., and Margaret Jan Wyszominski, eds. *Art, Ideology and Politics.* New York: Praeger, 1985.

Bandera, Maria Cristina. *Il Carteggio Longhi-Pallucchini, le prime Biennale del dopoguerra, 1948–1956.* Venice: Charta, 1999.

Barr, Alfred H., Jr. *Defining Modern Art—Selected Writings of Alfred H. Barr, Jr.* New York: Harry N. Abrams, 1986.

Barr, Margaret Scolari. "Our Campaigns: Alfred H. Barr, Jr., and the Museum of Modern Art: A Biographical Chronicle of the Years 1930–1944." *The New Criterion* (Summer 1987): pp. 23–74.

Baudelaire, Charles. "Peintres et aquafortistes" (1862), in *Critique d'art.* Paris: Gallimard, 1992.

Bauquier, Georges. *Fernand Léger, vivre dans le vrai.* Paris: Adrien Maeght, 1987.

Baur, John I., ed. "The Autobiography of Worthington Whittredge, 1820–1910." *Brooklyn Museum Journal* (1942).

Bazille, Frédéric. *Correspondance de Frédéric Bazille,* ed. Didier Vatuone. Montpellier: Presses du Languedoc and Musée Fabre, 1992.

Bazin, Germain. *The Museum Age,* trans. Jane van Nuis Cahill. New York: Universe Books, 1967.

Becker, Howard S. "Art as a Collective Action." *American Sociological Review,* no. 39 (December 1974): pp. 767–76.

———. *Art Worlds.* Berkeley and Los Angeles: University of California Press, 1982.

Beecher, Henry Ward. *Lectures and Orations* (1913), reedited by Newell Dwight Hillis. New York: AMS Press, 1970.

———. *Norwood, or Village Life in New England.* New York: Charles Scribner, 1868.

Beer, Thomas. *The Mauve Decade.* New York: Alfred A. Knopf, 1926.

Bénédite, Léonce. *Le Musée du Luxembourg.* Catalogue raisonné des écoles contemporaines. Paris: Imprimeries Réunies, undated.

———. *Le Musée du Luxembourg, les peintures,* ed. H. Laurens. Paris: Librairie Renouard, 1912.

———. "Introduction," *Exposition Universelle Internationale de 1900 à Paris.* Paris: Imprimerie Nationale, 1900.

Benjamin, S. G. W. *Art in America: A Critical and Historical Sketch.* New York: Garland, 1976. Reprint of c. 1879 edition.

Benjamin, Walter. "Paris, the Capital of the Nineteenth Century" (1935), in *The Arcades Project,* trans. Howard Eiland and Kevin McLaughlin. Cambridge, Mass.: Belknap Press, 1999.

Benson, Eugene. "Jean-Léon Gérôme." *The Galaxy,* no. 1 (August 1866).

Benton, Thomas Hart. *Tom Benton's America, An Artist in America.* New York: Robert M. McBride, 1937.

Berenson, Bernard. *Sketch for a Self-Portrait.* New York: Pantheon, 1949.

Berman, Avis. *Rebels on Eighth Street: Juliana Force and the Whitney Museum of American Art.* New York: Atheneum, 1990.

Bermingham, Peter. *American Painters in the Barbizon Mood.* Washington: Smithsonian Institution, 1975.

Bernheim, Cathy. *Picabia.* Paris: Editions du Félin, 1995.

La Bibliothèque littéraire Jacques Doucet. Brochure. Paris: Doucet Littérature, 1996.

Biddle, Flora Miller. *The Whitney Women and the Museum They Made.* New York: Arcade, 1999.

Blaugrund, Annette. "Behind the Scenes, the Organization of the American Paintings," in *Paris 1889. American Artists at the Universal Exposition.* Exhibition catalog. Pennsylvania Academy of the Fine Arts, Philadelphia. New York: Harry N. Abrams, 1989.

———. *The Tenth Street Studio Building: Artist-Entrepreneurs from the Hudson River School to the American Impressionists.* Exhibition catalog. Southampton, N.Y.: Parrish Art Museum, 1997.

Blumay, Carl, and Edwards Henry. *The Dark Side of Power: The Real Armand Hammer.* New York: Simon and Schuster, 1992.

Body-Gendrot, Sophie, and Martin Schain. *National and Local Development of Immigration Policy in the United States and France: A Comparative Study.* New York: New York University Press, 1992.

Boïme, Albert. *The Academy and French Painting in the Nineteenth Century.* London: Phaidon, 1971.

———. "Les hommes d'affaires et les arts en France au XIX° siècle." *Actes de la Recherche en Sciences Sociales,* no. 28 (June 1979).

———. *Thomas Couture and the Eclectic Vision.* New Haven and London: Yale University Press, 1980.

Bois, Yves-Alain. *Matisse and Picasso.* Paris: Flammarion, 1999.

Bolger, Doreen. "William Macbeth and George A. Hearn: Collecting American Art, 1905–1910." *Archives of American Art Journal,* vol. 15, no. 2 (1975).

Bolger, Doreen, Barbara H. Weinberg, and David Park Curry. *American Impressionism and Realism: The Painting of Modern Life, 1885–1915.* Exhibition catalog. New York: Metropolitan Museum of Art and Harry N. Abrams, 1994.

Boston Art Students' Association. *The Art Student in Paris.* 1887. (Boston Public Library, Fine Arts Department, Boston Reserve Closet).

Bourdieu, Pierre. *Homo Academicus.* Paris: Editions de Minuit, 1995.

Bourdieu, Pierre, et Alain Darbel. *L'amour de l'art: les musées et leur public.* Paris: Editions de Minuit, 1966.

Bowditch, Nancy Douglas. *George deForest Brush: Recollections of a Joyous Painter.* Peterborough, N.H.: Noone House, 1970.

Brancusi contre Etats-Unis, un procès historique, Foreword by Margit Rowel. Paris: Adam Biro, 1995.

Braque, Georges, Henri Matisse, André Salmon, Tristan Tzara, Eugène and Maria Jolas, et al. "Testimony Against Gertrude Stein." *Transition pamphlet* no. 1, supplement to *Transition,* vol. 23 (February 1935).

Braun, Emily, and Thomas Branchick. *Thomas Hart Benton: The America Today Murals.* Exhibition catalog. Williamstown, Mass.: Williamstown College Museum of Art, 1985.

Breton, André. *Anthologie de l'humour noir.* Paris: Sagittaire, 1940.

———. *Oeuvres complètes,* vols. 1, 2, 3, ed. Marguerite Bonnet. Paris: Gallimard, 1988, 1992, 1999.

Bridgman, Frederick. *L'Anarchie dans l'art.* Paris: Société Française d'Éditions d'Art, 1898.

Brown, Milton W. *American Painting from the Armory Show to the Depression.* Princeton: Princeton University Press, 1955.

———. *The Story of the Armory Show.* New York: Joseph H. Hirshhorn Foundation, 1963.

Bucco, Martin. *Main Street: The Revolt of Carol Kennicott.* New York: Twayne, 1993.

Bulliet, Clarence J. *Apples and Madonnas.* New York: Covici, Friede, 1927.

Bürger, Peter. *Theory of the Avant-Garde,* trans. Michael Shaw. Minneapolis: University of Minnesota Press, 1984.

Burgess, Gelett. "The Wild Men of Paris." *The Architectural Record,* vol. 27 (January–June 1910).

Burns, Sarah. *Inventing the Modern Artist: Art and Culture in Gilded America.* New Haven and London: Yale University Press, 1997.

Burrows, Edwin G., and Mike Wallace. *Gotham: A History of New York City to 1898.* London: Oxford University Press, 1998.

Cachin, Françoise. *Manet: "J'ai fait ce que j'ai vu."* Paris: Gallimard, 1994.

———. *Manet 1832–1883.* Exhibition catalog. Paris: Réunion des Musées Nationaux, 1983.

———. *Paul Gauguin, "ce malgré moi de sauvage."* Paris: Gallimard, 1993.

Caffin, Charles. "Prints by Edward J. Steichen of Rodin's Balzac." *Camera Work* (July 28, 1909).

Cahiers de la bibliothèque littéraire Jacques Doucet, no. 1. Paris: Doucet Littérature (1997).

Cahill, Holger, and Alfred H. Barr, Jr., eds. *Art in America in Modern Times.* New York: Reynal and Hitchcock, 1934.

Cahn, Isabelle. "Faire vrai, laisser dire." Exhibition brochure for "Manet, Monet, la gare Saint Lazare." *Le Petit Journal des Grandes Expositions,* no. 296 (February–May 1998).

Camfield, William. *Picabia.* Munich: Prestel, 1993.

Carnegie, Andrew. "The Best Use of Wealth," in *Miscellanous Writings of Andrew Carnegie,* ed. Burton J. Hendrick. Freeport, N.Y.: Books for Libraries Press, 1933.

———. *The Gospel of Wealth and Other Timely Essays* (1933), ed. Edward C. Kirkland. Cambridge, Mass.: Belknap Press of Harvard University Press, 1962.

Carr, Carolyn Kinder. "Prejudice and Pride," in *Revising the White City: American Art and the 1893 World's Fair.* Exhibition catalog. Washington: National Museum of American Art and National Portrait Gallery, Smithsonian Institution, 1993, pp. 63–123.

Cartwright, Derrick R. *L'Amérique et les Modernes, 1900–1950.* Exhibition catalog. Giverny: Musée d'Art Américain, 2000.

Castagnary, Jules-Antoine. *Salons (1857–1870).* Paris: Charpentier-Fasquelle, 1892.

Castelman, Riva, and Guy Davenport. *Art of the Forties.* Exhibition catalog. New York: Museum of Modern Art, 1991.

Catalogo. XXIV Biennale di Venezia. Venice: Edizioni Serenissima, 1948.

Cauman, Samuel. *The Living Museum: Experiences of an Art Historian and Museum Director, Alexander Dorner.* New York: New York University Press, 1958.

Chadwick, Whitney. *Women, Art, and Society.* London: Thames and Hudson, 1990.

Chapon, François. *Jacques Doucet.* Paris: J. C. Lattès, 1984.

Charbonnier, Georges. *Le monologue du peintre.* Paris: Juilliard, 1960.

Charteris, Evan Edward. *John Sargent.* New York: Charles Scribner's Sons, 1927.

Chase, Mary Ellen. *Abby Aldrich Rockefeller.* New York: Macmillan, 1950.

Chassey, Eric de. *La violence décorative: Matisse dans l'art américain.* Paris: Editions Jacqueline Chambon, 1998.

"La Chauve-Souris et le Papillon." Correspondence Montesquiou-Whistler. Glasgow: University of Glasgow, 1990.

Chave, Anna C. *Mark Rothko: Subjects in Abstraction.* New Haven: Yale University Press, 1989.

Chenclos, Albert de. "Les Yankees chez eux." *Le Correspondant* (1842).

Chennevières, Philippe de. *Souvenirs d'un directeur des Beaux-Arts, L'Artiste, 1883–1889,* vol. 2. Paris: Athéna, 1979.

Chernow, Ron. *The Warburgs.* New York: Random House, 1993.

Chesneau, Ernest. *Les nations rivales dans l'art.* Paris: Librairie Académique Didier, 1868.

———. *Salon 1883.* Exposition annuelle de la Société des Artistes Français, Annuaire Illustré des Beaux-Arts et Catalogue Illustré de l'Exposition Nationale, ed. F. G. Dumas. Paris: Baschet, 1883.

Chickering, Reverend John W. "The Reciprocal Influence of Piety and Taste." *The Christian Keepsake and Missionary Annual* (1839).

Chincholle, Charles. "L'incident Rodin-Balzac." *Le Figaro* (May 17, 1898).

Clark, Eliot. *History of the National Academy of Design.* New York: Columbia University Press, 1954.

Clark, T. J. "In Defense of Abstract Expressionism. *October,* no. 69 (Summer 1994).

———. *Une image du peuple, Gustave Courbet et la Révolution de 48.* Paris: Art Editions, 1991.

Cohen, Norman Stuart. "Paul J. Sachs and the Acceptance of Modern Art by an American Elite." Ph.D. diss. Cambridge, Mass.: Harvard University, 1989. Harvard Archives, HU 92.

Cohen-Solal, Annie. "Coal Miners and Dinosaurs: American Medias and France." *Media Studies Journal* (October 1995).

Coleman, Laurence Vail. *Museum Buildings,* vol. 1: *A Planning Study.* Washington: American Association of Museums, 1950.

———. *The Museum in America: A Critical Study.* Vol. 3. Washington: American Association of Museums, 1939.

La Collection Havemeyer. Quand l'Amérique découvrait l'Impressionnisme. Exhibition catalog. Paris: Réunion des Musées Nationaux, 1997.

Conway, M. D. "The Great Show at Paris." *Harper's New Monthly Magazine,* vol. 35 (July 1867).

Coombes, Annie E. "Museums and the Formation of National and Cultural Identities." *Oxford Art Journal,* vol. 11, no. 2 (1988): pp. 57–68.

Cooper, Helen A. *Thomas Eakins: The Rowing Pictures.* New Haven: Yale University Press, 1996.

Corn, Wanda M. *The Great American Thing: Modern Art and National Identity, 1915–1935.* Berkeley: University of California Press, 1999.

Correspondance de Gustave Courbet, ed. Petra ten Doesschate Chu. Paris: Flammarion, 1996.

Correspondance Mallarmé–Whistler, ed. C. P. Barbier. Paris: A. G. Nizet, 1964.

Cortissoz, Royal. *The Life of Whitelaw Reid,* vol. 2: *Politics, Diplomacy.* New York: Charles Scribner's Sons, 1921.

Courbet 1819–1877. Exhibition catalog. Paris: Galeries nationales du Grand Palais and Réunion des Musées Nationaux, 1977.

Couse Leavitt, Virginia. *E. I. Couse: Imagemaker for America.* Albuquerque: Albuquerque Museum Foundation, 1991.

Couture, Thomas. *Thomas Couture (1815–1879): Sa vie, son oeuvre, son caractère, ses idées, sa méthode, par lui-même et par son petit-fils.* Paris: Le Garrec, 1932.

Cowles, Virginia. *1913: An End and a Beginning.* New York: Harper & Row, 1967.

Cox, Annette. *Art-as-Politics: The Abstract Expressionist Avant-Garde and Society.* Ann Arbor, Mich.: U.M.I. Research Press, 1977.

Crane, Diana. *The Transformation of the Avant-Garde: The New York Art World 1940–1985.* Chicago: University of Chicago Press, 1987.

Croisset, Francis de. *Voyages. Aux fêtes de Kapurthala.* Paris: Kra, 1929.

Cubism and Abstract Art. Exhibition catalog. New York: Museum of Modern Art, 1936.

Cunningham, Elizabeth. *Pikes Peak Vision: The Broadmoor Art Academy, 1919–1945.* Colorado Springs: Fine Arts Center, 1989.

Dagen, Philippe. *Le silence des peintres: les artistes face à la grande guerre.* Paris: Fayard, 1996.

Dagognet, François. *Etienne-Jules Marey.* Paris: Hazan, 1987.

Damisch, Hubert, ed. *Américanisme et modernité.* Paris: EHESS, Flammarion, 1993.

Dana, John Cotton. "The Museum as Art Patron." *Creative Art,* vol. 4, no. 3 (March 1929), pp. xxiii–xxvi.

Danes, Gibson A. "A Biographical and Critical Study of William Morris Hunt 1824–1879." Ph.D. diss. New Haven: Yale University, 1949.

Danly, Susan, and Cheryl Leibold. *Eakins and the Photograph.* Chicago: Smithsonian Institution Press, 1994.

Davidson, Abraham A. "The European Art Invasion," in *Making Mischief: Dada Invades New York.* Exhibition catalog. New York: Whitney Museum of American Art and Harry N. Abrams, 1996, pp. 223–27.

Davis, John. "Our United Happy Family, Artists in the Sherwood Building, 1880–1900" (1845). *Archives of American Art Journal,* vol. 36, nos. 3–4 (1998).

De Antonio, Emil, and Mitch Tuchman. *Painters Painting: A Candid History of the Modern Art Scene 1940–1970.* New York: Abbeville Press, 1984.

De Cezanne à Matisse. Les chefs d'oeuvres de la Fondation Barnes. Exhibition catalog. Paris: Musée d'Orsay, Gallimard Electa, and Réunion des Musées Nationaux, 1993.

De Kooning, Elaine. *The Spirit of Abstract Expressionism.* New York: George Braziller, 1994.

Dell, Floyd. *Homecoming, an Autobiography.* Port Washington, N.Y.: Kennikat Press, 1933.

Delouche, Denise, ed. *Artistes étrangers à Pont-Aven, Concarneau et autres lieux de Bretagne.* Rennes: Presses Universitaires de Rennes, 1989.

Les Demoiselles d'Avignon. Exhibition catalog. Paris: Musée National Picasso and Réunion des Musées Nationaux, 1988.

Dickson, Harold Edward, ed. *Observations on American Art: Selections from the Writings of John Neal 1793–1876.* State College, Pa.: Pennsylvania State College, 1943.

Diggins, John Patrick. *The Proud Decades: America in War and Peace, 1941–1960.* New York: W. W. Norton, 1989.

DiMaggio, Paul J. "Cultural Entrepreneurship in Nineteenth-Century Boston," in *Non-profit Enterprise in the Arts, Studies in Mission and Constraint.* New York and Oxford: Oxford University Press, 1986.

DiMaggio, Paul J., ed. *Non-Profit Enterprise in the Arts: Studies in Mission and Constraint.* New York and Oxford: Oxford University Press, 1986.

Di Martino, Enzo. *La Biennale di Venezia.* Milan: Mondadori, 1995.

Distel, Anne. *Les Collectionneurs des Impressionnistes: amateurs et marchands.* Paris: Bibliothèque des Arts, 1989.

———. "Gustave Caillebotte, peintre, mécène et collectionneur," in *Gustave Caillebotte 1848–1894.* Exhibition catalog. Paris: Galeries nationales du Grand Palais and Réunion des Musées Nationaux, 1994.

———. "Il y a cent ans, ils ont donné *l'Olympia.*" *Le Journal du Musée d'Orsay 1848–1914,* no. 4. Paris: Réunion des Musées Nationaux, 1992, pp. 44–48.

Doezema, Marianne. *George Bellows and Urban America.* New Haven and London: Yale University Press, 1992.

Doezema, Marianne, and Frank Kelly. *The Painting of George Bellows.* New York: Harry N. Abrams, 1992.

Dorner, Alexander. *The Living Museum.* New York: New York University Press, 1958.

Doss, Erika. *Benton, Pollock, and the Politics of Modernism.* Chicago: University of Chicago Press, 1995.

Douglas, Ann. *The Feminization of American Culture.* New York: Alfred A. Knopf, 1977.

Draper, Joan E. "The White City and Its Interpreters: Historians, Critics, and the Chicago World's Columbian Exposition of 1893," in Daniel H. Burnham, *The Final Official Report of the Director of Works of the World's Columbian Exposition.* Reprint. New York and London: Garland Publishing, 1989.

Dreier, Katherine. *Western Art and the New Era: An Introduction to Modern Art.* New York: Brentano's, 1923.

Dubin, Steven C. *Displays of Power: Memory and Amnesia in the American Museum.* New York: New York University Press, 1999.

Duchamp-Villon. Exhibition catalog. Paris: Réunion des Musées Nationaux, 1998.

Duncan, Carol. *Civilizing Rituals: Inside Public Art Museums.* New York and London: Routledge, 1995.

Dunlap, William. *History of the Rise and Progress of the Arts of Design in the United States,* vol. 2 (1834). Boston: Frank W. Bayley and E. Goodspeed, 1918.

Durand-Gréville, E. "La peinture aux Etats-Unis." *La Gazette des Beaux-Arts,* no. 36 (1887).

Duranty, Louis-Edmond. "Ceux qui seront les peintres." *Almanach parisien pour 1867.* Paris: 1867.

————. *La Nouvelle Peinture, A propos du groupe d'artistes qui expose dans les galeries Durand-Ruel.* Paris: Edmond Dentu, 1876.

Duret, Théodore. *Histoire de James McNeill Whistler et son oeuvre.* Paris: H. Floury, 1904.

Du Seigneur, Maurice. *L'art et les artistes au Salon de 1880.* Paris: P. Ollendorff, 1880.

Eddy, Arthur Jerome. *Cubists and Post-Impressionism.* Chicago: A. C. MacClurg, 1914.

Eden, Robert. *The New Deal and Its Legacy, Critique and Reappraisal.* New York: Greenwood Press, 1989.

Edgerton, Giles. "Is America Selling Her Birthright in Art for a Mess of Pottage?" *The Craftsman,* vol. 11 (March 1907).

Eisler, Benita. *O'Keeffe & Stieglitz: An American Romance.* New York: Penguin Books, 1991.

Elderfield, John, ed. *Continuity and Change: The Museum of Modern Art at Mid Century.* New York: Museum of Modern Art and Harry N. Abrams, 1995.

Eldredge, Charles, Julie Schimmel, and William H. Truettner. *Art in New Mexico 1900–1945: Paths to Taos and Santa Fe.* Exhibition catalog. New York: Abbeville Press, 1987.

Elsen, Albert. *In Rodin's Studio: A Photographic Record of Sculpture in the Making.* Ithaca: Cornell University Press; Oxford: Phaïdon, 1980.

Emerson, Ralph Waldo. *Essays and Lectures.* Washington: Library of America, 1983.

————. "Thoughts on Art." *The Dial,* vol. 1, no. 3 (January 1841).

Engelhard, Georgia. "Alfred Stieglitz, Master Photographer." *American Photography,* no. 39 (April 1945).

Etant donné Marcel Duchamp. Paris: Association pour les Etudes de Marcel Duchamp et Editions Liard (Premier Semestre, 1999).

Exposition Universelle de 1867 illustrée, vol. 1, ed. M. Fr. Ducuing. Paris: Imprimerie Impériale, 1867.

Exposition Universelle Internationale de 1900 à Paris, introduction by Léonce Bénédite. Paris: Imprimerie Nationale, 1900.

Fairbrother, Trevor. *John Singer Sargent.* New York: Harry N. Abrams, 1994.

Faure, Christine, and Tom Bishop. *L'Amérique des Français.* Paris: Editions François Bourin, 1992.

Fehrer, Catherine. *The Julian Academy: Paris 1868–1939.* New York: Shepherd Gallery, 1989.

Fermi, Laura. *Illustrious Immigrants: The Intellectual Migration from Europe, 1930–1942.* Chicago: University of Chicago Press, 1968.

Fernand Léger 1911–1924: The Rhythm of Modern Life, ed. Dorothy Kosinski. Exhibition catalog. Munich and New York: Prestel, 1994.

Fernand Léger. Exhibition catalog. Paris: Centre Georges Pompidou and Réunion des Musées Nationaux, 1997.

Fernand Léger. Exhibition catalog. New York: Museum of Modern Art, 1998.

Ferrier, Jean-Louis, ed. *L'Aventure de l'Art au XXe Siècle.* Paris: Hachette, Editions du Chêne, 1988.

Findeli, Alain. *Le Bauhaus de Chicago: l'oeuvre pédagogique de László Moholy-Nagy.* Quebec: Septentrion; Paris: Kinchieck, 1985.

Findling, John E. "The World's Columbian Exposition," in *Chicago's Great World's Fairs.* Manchester and New York: Manchester University Press, 1994.

Fink, Loïs Marie. *American Art in the Nineteenth Century Paris Salons.* New York: Cambridge University Press, 1990.

Flanner, Janet. *Paris c'était hier: Chroniques d'une Américaine à Paris.* Paris: Mazarine, 1981.

Fleming, Donald, and Bernard Bailyn, eds. *The Intellectual Migration, Europe and America, 1930–1960.* Cambridge, Mass.: Harvard University Press, 1969.

Flexner, Abraham, with Esther S. Bailey. *Funds and Foundations: Their Policies Past and Present.* New York: Harper & Brothers, 1952.

Flexner, Eleanor. *Century of Stuggle: The Woman's Rights Movement in the United States.* London and Cambridge, Mass.: Belknap Press of Harvard University Press, 1994.

Fosdick, Raymond B. *John D. Rockefeller, Jr.: A Portrait.* New York: Harper & Brothers, 1956.

———. *The Story of the Rockefeller Foundation.* New Brunswick, N.J., and London: Transaction, 1989.

Foster, Kathleen A. *Thomas Eakins Rediscovered.* New Haven: Yale University Press, 1997.

Foster, Kathleen A., and Cheryl Leibold. *Writing about Thomas Eakins.* Philadelphia: University of Pennsylvania Press, 1989.

Four Americans in Paris: The Collections of Gertrude Stein and Her Family. Exhibition catalog. New York: Museum of Modern Art, 1970.

Fox, Daniel M. *Engines of Culture: Philanthropy and Art Museum.* London: Transaction, 1995.

Frank, Elizabeth. *Jackson Pollock.* New York: Abbeville Press, 1983.

Frederick Kiesler, Artiste-Architecte. Exhibition catalog. Paris: Centre Georges Pompidou, 1996.

Frelinghuysen, Alice Cooney, ed. *Splendid Legacy: The Havemeyer Collection.* Exhibition catalog. New York: Metropolitan Museum of Art, 1993.

"French Artists Spur on American Art." *New York Tribune,* 24 Oct. 1915.

Fried, Michaël. *Le réalisme de Gustave Courbet.* Paris: Gallimard, 1993.

Friedman, B. H. *Gertrude Vanderbilt Whitney: A Biography.* New York: Doubleday, 1978.

Friedman, Martin, Bartlett Hayes, and Charles Millard. *Charles Sheeler.* Exhibition catalog. Washington: Smithsonian Institution, 1968.

Fuller, William H. *Claude Monet.* New York: Gillis Bros., 1891.

Fumaroli, Marc. *L'etat culturel: essai sur une religion moderne.* Paris: Editions de Fallois, 1992.

Fusell, Paul. *The Great War and Modern Memory.* London: Oxford University Press, 1975.

Gaddis, Eugene. *Magician of the Modern: Chick Austin and the Transformation of the Arts in America.* New York: Alfred A. Knopf, 2000.

Gagnon, François-Marie. "The Work and Its Grip," in *Jackson Pollock: Questions.* Montréal: Ministère des Affaires Culturelles, Musée d'Art Contemporain, 1979.

Gamboni, Dario: *La plume et le pinceau: Odilon Redon et la littérature.* Paris: Editions de Minuit, 1989.

Gattey, Charles Neilson. *The Bloomer Girls.* London: Femina Books, 1967.

Gauguin et l'Ecole de Pont-Aven. Exhibition catalog. Pont-Aven: Musée de Pont-Aven, 1997.

Gay, Peter. *Weimar Culture: The Outsider as Insider.* New York: Harper & Row, 1968.

Georgel, Pierre. *Courbet, le poème de la nature.* Paris: Gallimard, 1995.

Gerdts, William H. *American Impressionism.* New York: Harry N. Abrams, 1984.

———. *American Painters in France (1865–1915).* Evanston, Ill.: Daniel J. Terra Foundation, 1992.

Glackens, Ira. *William Glackens and the Eight: The Artists Who Freed American Art.* (Revised edition of *William Glackens and the Ashcan Group: The Emergence of Realism in American Art.* New York: Crown Publishers, 1957.) New York: Horizon Press, 1983.

Golan, Romy. *Modernity and Nostalgia: Art and Politics in France Between the Wars.* New Haven and London: Yale University Press, 1995.

Gold, Mary Jane. *Crossroads Marseille, Nineteen Hundred and Forty.* Garden City, N.Y.: Doubleday, 1980.

Goldman, Emma. *Living My Life.* Salt Lake City, Utah: Peregrine Smith Book/Gibbs M. Smith, 1931.

Goldthwaite, Richard. *Private Wealth in Renaissance Florence.* Princeton, N.J.: Princeton University Press, 1968.

Gombrich, Ernst, and Didier Eribon. *Ce que l'image nous dit*. Paris: Editions Adam Biro, 1991.

Gonzales, Edward, and David L. Witt. *Spirit Ascendant: The Art and Life of Patrociño Barela*. Santa Fe: Red Crane Books, 1996.

Goodman, Helen. "Robert Henri, Teacher." Ph.D. diss. New York: New York University, 1975.

Goodrich, Lloyd. *Thomas Eakins*. Cambridge, Mass.: Harvard University Press, 1982.

Grant, Susan. *Paris: A Guide to Archival Sources for American Art History*. Washington: Archives of American Art, Smithsonian Institution, 1997.

Green, Christopher, ed. *Art Made Modern: Roger Fry's Vision of Art*. London: Courtauld Gallery, 1999.

Green, Nicholas. "Dealing in Temperaments: Economic Transformation of the Artistic Field in France During the Second Half of the Nineteenth Century." *Art History*, vol. 10, no. 1 (March 1987), pp. 59–78.

Greenberg, Clement. *Art and Culture: Critical Essays*. Boston: Beacon Press, 1961.

———. "The Best?" *Time* (December 1947).

———. *The Collected Essays and Criticism: Arrogant Purpose, 1945–1949*, ed. John O'Brian. Chicago: The University of Chicago Press, 1986.

———. *The Collected Essays and Criticism: Perceptions and Judgments, 1939–1944*, ed. John O'Brian. Chicago: University of Chicago Press, 1986.

Greenough, Horatio. "Remarks on American Art" (1843), in John W. McCoubrey, *American Art: 1700–1960. Sources and Documents*. Englewood Cliffs, N.J.: Prentice Hall, 1965.

Greenough, Sarah. *Modern Art and America: Alfred Stieglitz and His New York Galleries*. Boston: Bulfinch Press, 2001.

Greenough, Sarah, and Juan Hamilton, eds. *Alfred Stieglitz: Photographs and Writings*. Exhibition catalog. New York: Callaway, 1983.

Grenn, Martin. *New York, 1913: The Armory Show and the Patterson Strike Pageant*. New York: Charles Scribner's Sons, 1988.

Grunden, Robert M. *American Salons: Encounters with European Modernism 1885–1917*. New York: Oxford University Press, 1993.

Guggenheim, Peggy. *Art of This Century: Objects, Drawings, Photographs, Paintings, Sculptures and Collages, 1912–1942*. New York: Art of This Century, 1942.

———. *Confessions of an Art Addict*. New York: Macmillan, 1960.

Guilbaut, Serge. *How New York Stole the Idea of Modern Art: Abstract Expressionism, Freedom, and the Cold War*. Chicago: University of Chicago Press, 1983.

Guilbaut, Serge, ed. *Reconstructing Modernism: Art in New York, Paris, and Montreal 1945–1964*. Cambridge, Mass.: MIT Press, 1990.

Guilds Committee for Federal Writers' Publications. *The W.P.A. Guide to New York City*. New York: Pantheon, 1982.

Hale, Edward Everett. *Public Amusement for Poor and Rich*. Boston: Phillips, Sampson, 1857.

Hale, Nancy. *Mary Cassatt: A Biography*. New York: Doubleday, 1975.

Hamilton, Ian. *Writers in Hollywood 1915–1951*. New York: Harper and Row, 1990.

Hamlin, Garland. *Roadside Meetings*. New York: Macmillan, 1930.

Hamovitch, Mitzi Berger, ed. *The Hound and Horn Letters*. Athens, Ga.: University of Georgia Press, 1982.

Harris, Neil. *The Artist in American Society: The Formative Years, 1790–1860*. Chicago: University of Chicago Press, 1982.

———. *Cultural Excursions: Marketing Appetites and Cultural Tastes in Modern America*. Chicago and London: University of Chicago Press, 1990.

———. "The Gilded Age Reconsidered Once Again" and "The Quest for Unity." *Archives of American Art Journal*, vol. 23, no. 4 (1983), pp. 8–18.

Harrison, Helen, ed. *Such Desperate Joy: Imagining Jackson Pollock.* New York: Thunder's Mouth Press, 2000.

Haskell, Barbara. *The American Century, Art and Culture, 1900–1950.* New York: Whitney Museum of American Art in association with W. W. Norton, 1999.

Havemeyer, Louisine. *Sixteen to Sixty: Memoirs of a Collector.* New York: Ursus Press, 1993.

Hawthorne, Nathaniel. *The Hawthorne Treasury: Complete Novels and Selected Tales.* New York: Modern Library, 1999.

———. *Passages from the English Notebooks and Our Old Home.* In *The Works of Nathaniel Hawthorne.* 2 vols. Boston: Standard Library, 1871.

———. *Passages from the French and Italian Notebooks.* Boston: Houghton Mifflin, 1883.

Hélion, Jean. *Lettres d'Amérique, Correspondance avec Raymond Queneau, 1934–1967.* Paris: I.M.E.C. Editions, 1996.

———. *A perte de vue.* Paris: I.M.E.C. Editions, 1996.

Henning, William T., ed. *E. L. Blumenschein Retrospective.* Colorado Springs: Fine Arts Center, 1978.

Henri, Robert. *The Art Spirit,* ed. Margery Ryerson with an Introduction by Forbes Watson. New York: Harper & Row, 1923.

Herbert, Robert L., Eleanor S. Apter, and Elise K. Kenney. *The Société Anonyme and the Dreier Bequest at Yale University: A Catalogue Raisonné.* New Haven, Westford, and London: Yale University Art Gallery, Yale University Press, 1984.

Hermant, Jacques. "L'art à l'Exposition de Chicago." *Gazette des Beaux-Arts* (September 1893).

Hiesinger, Ulrich W. *Impressionism in America: The Ten American Painters.* Munich: Prestel, 1991.

Hills, Patricia, et al. *John Singer Sargent.* New York: Whitney Museum of American Art, 1986. Exhibition catalog.

Hilman, Carolyn, and Oliver Jean Nutting. "Lilla Cabot Perry, Painter and Poet" and "Reminiscences of Claude Monet from 1889 to 1909." *American Magazine of Art,* vol. 18 (March 1927), pp. 119–25.

Hindry, Ann. *Claude Berri rencontre/meets Leo Castelli.* Paris: Renn, 1990.

Hofmann, Hans. "January 21, 1938." New York: Museum of Modern Art Archives, "Early Museum History," box 12/24.

Hogrefe, Jeffrey. *O'Keeffe: The Life of an American Legend.* New York: Bantam Books, 1992.

Hollingsworth, Harold N., and William F. Holmes, eds. *Essays on the New Deal.* Austin: University of Texas Press, 1969.

Homer, William Innes. *Alfred Stieglitz and the American Avant-Garde.* Boston: New York Graphic Society, 1977.

———. *Alfred Stieglitz and the Photo-Secession.* Boston: Little Brown, 1983.

———. "The Exhibition of the Eight: Its History and Its Significance." *The American Art Journal,* vol. 1 (Spring 1969).

Horizon (October 1947).

Horowitz, Helen Lefkowitz. *Culture and the City: Cultural Philanthropy in Chicago from the 1880s to 1917.* Lexington: University Press of Kentucky, 1989.

House, John. "Time Cycles in Monet." *Art in America* (October 1992), pp. 126–35.

Howe, Irving. *A Margin of Hope.* New York: Harcourt Brace Jovanovich, 1982.

Hudson, Kenneth. *Museums of Influence.* London: Cambridge University Press, 1987.

Hughes, H. Stuart. *Between Commitment and Disillusion.* Middletown, Conn.: Wesleyan University Press, 1987.

Hughes, Robert. *American Visions: The Epic History of Art in America.* New York: Alfred A. Knopf, 1997.

Huth, Hans. "Impressionism Comes to America." *Gazette des Beaux-Arts,* vol. 29, no. 6 (April 1946), pp. 225–52.

Hynes, Samuel. *A War Imagined: The First World War and English Culture.* New York: Atheneum, 1991.

Ingres raconté par lui-même et par ses amis. Genève: Editions Pierre Cailler, 1948.

Interview with Jackson Pollock. *Arts and Architecture* (February 1944), pp. 14–15.

Jackson Pollock. Exhibition catalog. New York: Museum of Modern Art, 1967.

Jackson Pollock. Exhibition catalog. Paris: Centre Georges Pompidou, 1982.

Jackson Pollock: A Retrospective. Exhibition catalog. New York: Museum of Modern Art, 1998.

Jacobs, Michael. *The Good and Simple Life: Artist Colonies in Europe and America.* Oxford: Phaidon, 1985.

Jaher, Frederic Cople. *The Urban Establishment: Upper Strata in Boston.* Urbana, Chicago, and London: University of Illinois Press, 1982.

James, Henry. *Complete Stories 1898–1910.* Washington: Library of America, 1983.

———. *Picture and Text.* New York: Harper and Bros., 1893.

Janis, Sidney. *Abstract and Surrealist Art in America.* New York: Reynal and Hitchock, 1944.

———. "European Artists Come to New York." *Decision 2,* nos. 5–6 (Nov.–Dec. 1941).

Jarves, James Jackson. "The Art Idea" (1864), in John W. McCoubrey, *American Art 1700–1960, Sources and Documents.* Englewood Cliffs, N.J.: Prentice Hall, 1965.

———. "Art Thoughts" (1869), in John W. McCoubrey, *American Art 1700–1960, Sources and Documents.* Englewood Cliffs, N.J.: Prentice Hall, 1965.

———. "The Quest for Unity." *Archives of American Art Journal,* vol. 23, no. 4 (1983).

Jay, Martin. *Downcast Eyes: The Denigration of Vision in XXth Century French Thought.* Berkeley: University of California Press, 1993.

———. *Force Fields.* New York: Routledge, 1993.

Jewell, Edward Alden. *Have We an American Art?* New York and Toronto: Longmans, Green, 1939.

Johns, Elizabeth. *Thomas Eakins: The Heroism of Modern Life.* Princeton: Princeton University Press, 1983.

Johnson, Stewart J. *American Modern, 1925–1940: Design for a New Age.* Exhibition catalog. New York: The Metropolitan Museum of Art and Harry N. Abrams, 2000.

Josephson, Matthew: *The Robber Barons: The Great American Capitalists, 1861–1901* (1934). Reissued. London: Eyre & Spotiswoode, 1962.

Jullien, Adolphe. *Fantin-Latour et ses amitiés.* Paris: L. Laveur, 1909.

Kammen, Michael G. *The Mystic Chords of Memory: The Transformation of Tradition in American Culture 1870–1990,* vol. 3: *1915–1945.* New York: Alfred A. Knopf, 1991.

"Kandinsky–Albers, Une correspondance des années trente." *Les Cahiers du Musée National d'Art Moderne.* Special Issue/Archives. Paris: Editions du Centre Pompidou, 1998.

Karlstrom, Paul J., ed. *On the Edge of America: California Modernist Art, 1900–1950.* Berkeley and Los Angeles: University of California Press, 1996.

Karlstrom, Paul J., and Susan Ehrlich. *Turning the Tide: Early Los Angeles Modernists, 1920–1956.* Exhibition catalog. Santa Barbara: Santa Barbara Museum of Art, 1990.

Karmel, Pepe. "Pollock at Work: The Films and Photographs of Hans Namuth," in Kirk Varnedoe et al., *Jackson Pollock.* New York: Museum of Modern Art, 1998.

Kaspi, André. *Les Américains: Les Etats-Unis de 1607 à nos jours,* vol. 1: *Naissance et essor des Etats-Unis, 1607–1945;* vol. 2: *Les Etats-Unis de 1945 à nos jours.* Paris: Editions du Seuil, 1986.

Kelly, Franklin. *Frederick Edwin Church.* Exhibition catalog. Washington: National Gallery of Art, Smithsonian Institution Press, 1989.

Kelly, Harry. "Roll Back the Years: Odyssey of a Libertarian." Manuscript in John Nicholas Beffel papers, Tamiment Library, Bobst Library, New York University.

Kert, Bernice. *Abby Aldrich Rockefeller.* New York: Random House, 1993.

Kilmer, Nicholas. *Thomas Buford Meteyard.* New York: Berry-Hill Galleries, 1989.

Kilmurray, Elaine, and Richard Ormond, eds. *John Singer Sargent.* Boston: Museum of Fine Arts, 1999. Exhibition catalog.

Kirstein, Lincoln. *Flesh Is Heir: An Historical Romance* (1932). Reedited. New York: Brewer, Warren and Putnam, 1975.

Kootz, Samuel. *New Frontiers in American Painting.* New York: Hastings House, 1943.

Kopper, Philip. *America's National Gallery of Art: A Gift to the Nation.* New York: Harry N. Abrams, 1991.

Krauss, Rosalind. *The Optical Unconscious.* Cambridge, Mass.: MIT Press, 1993.

Krohn, Claus-Dieter. *Intellectuals in Exile: Refugee Scholars and the New School for Social Research.* Amherst: University of Massachusetts Press, 1993.

Künstlerischer Austausch/Artistic Exchange: Akten des XXVIII Internationalen Kongress für Kunstgeschichte. Berlin: Akademie Verlag (July 1992).

Lacambre, Geneviève. "Whistler, de l'incompréhension à la gloire." Exhibition brochure. Paris: Musée d'Orsay. *Le Petit Journal des Grandes Expositions* (February–April 1995).

Lacorne, Denis. *La crise de l'identité américaine, du melting-pot au multiculturalisme.* Paris: Fayard, 1997.

Lader, Melvin P. *Arshile Gorky.* New York: Abbeville Press, 1985.

Lanchner, Carolyn. *Fernand Léger.* Exhibition catalog. New York: Museum of Modern Art, 1998.

Lane, John R., and Susan C. Larsen, eds. *Abstract Painting and Sculpture in America, 1927–1944.* New York: Harry N. Abrams, 1983.

Langhorne, Elizabeth. "The Magus and the Alchemist." *American Art Magazine* (Fall 1998).

Larkin, Oliver W. *Art and Life in America.* New York: Rinehart, 1957.

Lassalle, Hélène. *Fernand Léger.* Paris: Flammarion, 1997.

Lavin, Irving, ed. *Three "Essays on Style" by Erwin Panofsky.* Cambridge, Mass.: MIT Press, 1995.

Lawrence, D. H. *The Plumed Serpent.* New York: Vintage Books, 1959.

Lears, Jackson. *No Place of Grace: Antimodernism and the Transformation of American Culture (1880–1920).* New York: Pantheon Books, 1981.

Lebensztejn, Jean-Claude. "De Kooning." *Critique* (June–July 1984).

———. "Eight Interviews/Statements." *Art in America,* special Matisse issue (July–August 1975).

Leeds, Valerie Ann. *My People: The Portraits of Robert Henri.* Seattle: University of Washington Press, Orlando Museum of Art, 1994.

Léger, Fernand. "Paris–New York, New York–Paris" (1941), in *Mes voyages.* Paris: L'Ecole des Lettres, 1997.

———. Interview in *Les Lettres Françaises* (April 12, 1946).

Leja, Michael. *Reframing Abstract Expressionism: Subjectivity and Painting in the 1940's.* New Haven: Yale University Press, 1993.

Leslie, Frank. *Report on the Fine Arts.* Washington: Government Printing Office, 1868.

Lesur, François, ed. *Correspondance de Claude Debussy.* Paris: Hermann, 1993.

Letters and Papers of John Singleton Copley and Henry Pelham, 1739–1776. New York: Kennedy Graphics, Da Capo Press, 1970.

Leuchtenburg, William E. *The FDR Years: On Roosevelt and His Legacy.* New York: Columbia University Press, 1995.

———. *Franklin D. Roosevelt and the New Deal, 1932–1940.* New York: Harper & Row, 1963.

Lévi-Strauss, Claude. "New York pré- et post-figuratif," in *Un regard éloigné.* Paris: Plon, 1988, pp. 345–56.

Levin, Gail. *Synchromism and American Color Abstraction, 1900–1925.* New York: Whitney Museum of American Art and George Braziller, 1978.

Levine, Lawrence W. *Highbrow/Lowbrow: The Emergence of Cultural Hierarchy in America.* Cambridge, Mass.: Harvard University Press, 1988.

Levine, Steven Z. *Monet and His Critics.* London and New York: Garland Press, 1976.

Lévy, Julian. *Memoirs of an Art Gallery.* New York: G. P. Putnam's Sons, 1977.

———. *Portrait of an Art Gallery.* Cambridge, Mass.: MIT Press, 1998.

Lieberman, William S. *Jackson Pollock: The Last Sketchbook. Facsimile of Pollock Sketchbook.* New York: Johnson Reprint Corporation, Harcourt Brace Jovanovitch, 1982.

Linel, H. P. "Art et Photographie." *Le Figaro,* November 12, 1901, p. 3.

Lippmann, Walter. *A Preface to Politics.* New York: Macmillan, 1933.

Lisle, Laurie. *Portrait of an Artist: A Biography of Georgia O'Keeffe.* Albuquerque: University of New Mexico Press, 1986.

Lobstein, Dominique. *Au temps de l'Impressionnisme.* Paris: Gallimard and Réunion des Musées Nationaux, 1993.

———. "Salon–Salons, du un au multiple." In *Peintures françaises de la collection Monsted.* Aarhus: Aarhus Kunstmuseum, 1998.

Louchheim, Katie, ed. *The Making of the New Deal: The Insiders Speak.* Cambridge, Mass.: Harvard University Press, 1983.

Loughery, John. *John Sloan, Painter and Rebel.* New York: Henry Holt, 1995.

Low, Will Hicok. *A Chronicle of Friendships, 1873–1900.* New York: Charles Scribner's Sons, 1908.

———. *A Painter's Progress, Being a Partial Survey Along the Pathway of Art in America and Europe.* New York: Charles Scribner's Sons, 1910.

Lowe, Sue Davidson. *Stieglitz.* New York: Farrar Straus Giroux, 1983.

Loyrette, Henri. "Chicago, une image française," in *Chicago, naissance d'une Métropole, 1872–1922.* Paris: Réunion des Musées Nationaux; Munich: Prestel, 1987, pp. 120–35.

———. *Degas.* Paris: Fayard, 1990.

Loyrette, Henri, and Gary Tinterow. *Aux Origines de l'Impressionnisme: 1859–1869.* Paris: Réunion des Musées Nationaux, 1994.

Luhan, Mabel Dodge. *Intimate Memories,* vol. 2: *European Experiences.* New York: Harcourt Brace, 1935.

———. *Intimate Memories,* vol. 4: *Edge of Taos Desert (An Escape to Reality).* New York: Harcourt Brace, 1937.

Lukach, Joan M. *Hilla Rebay: In Search of the Spirit in Art.* New York: George Braziller, 1983.

Lynes, Russell. *Good Old Modern: The Museum of Modern Art.* New York: Atheneum, 1973.

———. *The Taste Makers.* New York: Harper & Brothers, 1954.

Lyons, Nathan, ed. *Photographers on Photography: A Critical Anthology.* Englewood Cliffs, N.J.: Prentice Hall, 1966.

MacDonald, Margaret F., and Joy Newton. "The Selling of Whistler's Mother." *American Legion of Honour Magazine,* vol. 69, no. 2 (1978).

Mackay, James. *Little Boss: A Life of Andrew Carnegie.* Edinburgh and London: Mainstream Publishing, 1997.

Mainardi, Patricia. *The End of the Salon: Art and State in the Early Third Republic.* New York: Cambridge University Press, 1993.

Mallarmé, Stéphane. *Correspondance complète 1862–1871.* Paris: Gallimard, 1995.

Manet, 1832–1883. Exhibition catalog. Paris: Galeries Nationales du Grand Palais and Réunion des Musées Nationaux, 1993.

Mangone, Mario. "Il 'nuovo orologio' della White City," in A. Baculo, S. Gallo, and

M. Mangone, *Le Grandi Esposizioni del Mondo 1851–1900, dall'edificio città alla città di edifici dal Crystal Palace alla White City*. Naples: Ligori Editore, 1988.

Marès, Antoine. *L'Institut de France, le parlement des savants*. Paris: Gallimard, 1995.

Marquis, Alice Goldfarb. *Alfred H. Barr, Jr., Missionary for the Modern*. Chicago: Contemporary Books, 1989.

Masson, André. *Anatomie de mon univers*. New York: Curt Valentin, 1943.

———. *La mémoire du monde*. Geneva: Skira, 1954.

Mathews, Nancy Mowll. *Cassatt and Her Circle: Selected Letters*. New York: Abbeville Press, 1984.

Matisse, Henri. *Ecrits et propos sur l'art*. Paris: Hermann, 1972.

May, Henry F. *The End of American Innocence (A Study of the First Years of Our Own Time: 1912–1917)*. New York: Alfred A. Knopf, 1959.

McCarthy, Kathleen D. "Patronage of the Arts," in *Encyclopedia of the United States in the Twentieth Century*, vol. 4, ed. Stanley I. Kutler. New York: Macmillan Library Reference, 1996.

———. *Women's Culture, American Philanthropy and Art 1830–1930*. Chicago and London: University of Chicago Press, 1991.

McCoubrey, John W. *American Art 1700–1960: Sources and Documents*. Englewood Cliffs, N.J.: Prentice-Hall, 1965.

———. *American Tradition in Painting*. New York: George Braziller, 1963.

McKinney, Roland. *Thomas Eakins*. New York: Crown Books, 1992.

McMillan, Douglas. *Transition, the History of a Literary Era: 1927–1938*. New York: George Braziller, 1975.

Mencken, Henry Louis. *A Book of Prefaces*. New York: Alfred A. Knopf, 1918.

Merrill, Linda. *The Peacock Room: A Cultural Biography*. New Haven: Yale University Press, 1998.

Merrill, Linda, ed. *With Kindest Regards: The Correspondence of Charles Lane Freer and James McNeill Whistler, 1890–1903*. Washington, D.C.: Freer Gallery, 1986.

Michel, Régis. *Géricault, l'invention du réel*. Paris: Gallimard, 1992.

Milner, John. *The Studios of Paris, the Capital of Art in the Late Nineteenth Century*. New Haven and London: Yale University Press, 1988.

Modern Art in Paris 1855–1900. Reprint. London: Garland Publishing, 1981.

Monroe, Lucy. "Chicago Letter." *The Critic*, vol. 22, no. 588 (May 27, 1893), p. 351.

"The Monthly Record of American Art." *Magazine of American Art*, no. 6 (December 1883).

Mooradian, Karlen. *Arshile Gorky Adoian*. Chicago: Gilgamesh Press, 1978.

Morgan, H. Wayne, ed. *An American Art Student in Paris: The Letters of Kenyon Cox, 1877–1882*. Kent, Ohio, and London: Kent State University Press, 1986.

———. *An Artist of the American Renaissance: The Letters of Kenyon Cox, 1883–1919*. Kent, Ohio: Kent State University Press, 1995.

Morris, Lloyd R. *Incredible New York: High Life and Low Life of the Last Hundred Years*. New York: Random House, 1951.

Morse, Samuel F. B.: His Letters and Journals, ed. Edward Lind Morse. Boston and New York: Houghton Mifflin, 1914.

Mosby, Dewey F. *Henry Ossawa Tanner*. Exhibition catalog. Philadelphia: Philadelphia Museum of Art, 1990; New York: Rizzoli, 1991.

Moulin, Raymonde. *L'artiste, l'institution, le marché*. Paris: Flammarion, 1992.

———. *Le marché de la peinture en France*. Paris: Editions de Minuit, 1967.

Mulkay, Michael, and Elizabeth Chaplin. "Aesthetics and the Artistic Career: A Study of Anomy in Fine-Art Painting." *The Sociological Quarterly*, vol. 23 (Winter 1982).

Mumford, Lewis. *The Brown Decades: A Study of the Arts in America 1865–1895.* New York: Harcourt Brace Jovanovich, 1931.

Myers, Jerome. *Artist in Manhattan.* New York: American Artists Group, 1940.

Naifeh, Steven, and Gregory White Smith. *Jackson Pollock: An American Saga.* New York: Clarkson N. Potter, 1989.

Naumann, Francis M. *New York Dada 1915–1923.* New York: Harry N. Abrams, 1994.

Neal, John. "American Painters and Painting" (1829), in John W. McCoubrey, *American Art 1700–1960, Sources and Documents.* Englewood Cliffs, N.J.: Prentice Hall, 1965.

———. *Observations on American Art: Selections from the Writings of John Neal (1793–1876),* ed. Harold Edward Dickson. Philadelphia: Pennsylvania State College, 1943.

———. *Wandering Recollections of a Somewhat Busy Life.* Boston, 1869.

Neal, Kenneth. *A Wise Extravagance: The Founding of the Carnegie International Exhibitions, 1895–1901.* Pittsburgh: University of Pittsburgh Press, 1996.

Neff, Linda. *American Painters in the Age of Impressionism.* Exhibition catalog. Houston: Museum of Fine Arts, 1994.

Nelson, Mary Carol. *The Legendary Artists of Taos.* New York: Watson-Guptill Publications, 1980.

New Criterion. Special Alfred H. Barr, Jr., Issue (Summer 1987).

Newman, Barnett. *Selected Writings and Interviews,* ed. John P. O'Neill. New York: Alfred A. Knopf, 1990.

Niven, Penelope. *Steichen.* New York: Clarkson N. Potter, 1997.

Nochlin, Linda. *Impressionists and Post-Impressionists. Sources and Documents.* Englewood Cliffs, N.J.: Prentice Hall, 1966.

———. "The Painter of Modern Life: Paris in the Art of Manet and His Followers" and "Courbet's Real Allegory: Rereading the Painter's Studio," in *Courbet Reconsidered.* Exhibition catalog. New York and New Haven: Brooklyn Museum and Yale University Press, 1988. pp. 17–42.

Noël, Bernard, ed. *Marseille–New York, 1900–1945.* Marseille: André Dimanche, 1985.

Nord, Philip G. *Impressionism and Politics: Art and Democracy in the Nineteenth Century.* London and New York: Routledge, 2000.

Norman, Dorothy. *Alfred Stieglitz: An American Seer.* New York: Random House, 1973.

Novack, Barbara. "L'impressionnisme américain, sources et réflexions," in *Les impressionnistes américains.* Washington: Smithsonian Institution, 1982.

Oaklander, Christine I. "Clara Davidge's Madison Art Gallery: Sowing the Seed for the Armory Show." *Archives of American Art Journal,* vol. 36, nos. 3–4 (1996).

Ockman, Joan. *Architecture Culture 1943–1968: A Documentary Anthology.* New York: Rizzoli, 1993.

O'Connor, Francis V. *Federal Support for the Visual Arts: The New Deal and Now.* Greenwich, Conn.: New York Graphic Society, 1969.

Pach, Walter. *The Art Museum in America.* New York: Pantheon Books, 1948.

Pacquement, Alfred. "L'Ecole des Beaux-Arts, à l'aune de l'art contemporain." *Le Débat, "Situations de l'art contemporain,"* no. 98 (Jan.–Feb. 1998).

Panofsky, Erwin. *Meaning in the Visual Arts.* Garden City, N.Y.: Doubleday, 1955.

Paris 1900: The "American School" at the Universal Exposition, ed. Diane P. Fisher. New Brunswick, N.J., and London: Montclair Art Museum and Rutgers University Press, 1999.

Paris–New York: 1908–1968. Exhibition catalog. Paris: Centre Pompidou and Gallimard, 1991.

Paris Post War: Art and Existentialism: 1945–1955. Exhibition catalog. London: Tate Gallery Publications, 1993.

Paz, Octavio. *Marcel Duchamp: Appearance Stripped Bare.* New York: Viking Press, 1978.

Peggy Guggenheim: A Celebration. Exhibition catalog. New York: Guggenheim Museum, 1999.

Pène du Bois, Guy. *Artists Say the Silliest Things.* New York: Dueil, Sloan and Pearce, 1940.

―――. "Great Modern Art Display Here April 1." *New York American* (March 17, 1910).

Perlman, Bernard B. *The Immortal Eight (American Painting from Eakins to the Armory Show, 1870–1913).* Westport, Conn.: North Light, 1979.

―――. "Prophet of the New." *Art News* (Summer 1984).

―――. *Robert Henri, His Life and Art.* New York: Dover Publications, 1991.

Perlman, Bernard B., ed. *Revolutionaries of Realism: The Letters of John Sloan and Robert Henri.* Princeton, N.J.: Princeton University Press, 1997.

Pinet, Hélène. "Il est là, toujours comme un fantome." *1898, Le Balzac de Rodin.* Exhibition catalog. Paris: Musée Rodin, 1998.

―――. *Les photographes de Rodin.* Exhibition catalog. Paris: Musée Rodin, 1986.

Pleynet, Marcelin. *Robert Motherwell.* Paris: Papierski, 1989.

―――. *Rothko et la France.* Paris: l'Epure, 1999.

Poggioli, Renato. *Theory of the Avant-Garde.* Cambridge, Mass.: Harvard University Press, 1968.

Pointon, Marcia, ed. *Art Apart: Artifacts, Institutions, and Ideology Across England and North America.* Manchester: Manchester University Press, 1994.

Polcari, Stephen. *Abstract Expressionism and the Modern Experience.* Cambridge, Mass.: Cambridge University Press, 1991.

Polizzotti, Mark. *Revolution of the Mind: The Life of André Breton.* New York: Farrar Straus Giroux, 1995.

Pomarède, Vincent, and Gérard de Wallons. *Corot, la mémoire du paysage.* Paris: Gallimard, 1996.

Pomian, Krysztof. "Francs et Gaulois," in *Lieux de mémoire,* ed. Pierre Nora. Paris: Gallimard, 1986.

Porter, Dean A., Teresa Hayes Ebie, and Suzan Campbell. *Taos Artists and Their Patrons: 1898–1950.* Notre Dame: Snite Museum of Art/University of Notre Dame Press, 1999.

Porter, Fairfield. *Thomas Eakins.* New York: George Braziller, 1959.

Post-Impressionism: Cross-Currents in European and American Painting, 1880–1906. Exhibition catalog. Washington, D.C.: National Gallery of Art, 1980.

Potter, Jeffrey. *To a Violent Grave: An Oral Biography of Jackson Pollock.* New York: Pushcart Press, 1985.

Prandin, Ivo. "Peggy Guggenheim," in *Profili Veneziani del Novecento.* Venice: Supernova, 1999.

Prince, Sue Ann, ed. *The Old Guard and the Avant-Garde: Modernism in Chicago, 1910–1940.* Chicago: University of Chicago Press, 1990.

Quéinec, Bertrand. *Pont-Aven, cité des peintres.* Rennes: Editions Ouest France, 1988.

Rapport sur l'Exposition Universelle de 1855 présenté à l'Empereur par S. A. I. le Prince Napoléon, Président de la commission. Paris: Imprimerie Impériale, 1857.

Reff, Theodore. "Le Papillon et le Vieux Boeuf," in *From Realism to Symbolism: Whistler and His World.* Exhibition catalog. Philadelphia: Philadelphia Museum of Art, 1971.

Reid, B. L. *The Man from New York: John Quinn and His Friends.* New York: Oxford University Press, 1968.

Reliquet, Scarlett, and Philippe Reliquet. *Henri-Pierre Roché, l'enchanteur collectionneur.* Paris: Ramsay, 1999.

Rewald, John. *Histoire de l'impressionnisme.* Paris: Albin Michel, 1986.

―――. *Histoire du postimpressionnisme.* Paris: Albin Michel, 1961.

————. "The Steins and Their Circle," in *Cézanne and America, Dealers, Collectors, Artists and Critics, 1891–1921.* London: Thames and Hudson, 1989, pp. 53–86.

Rewald, John, and Frances Weitzenhoffer. *Aspects of Monet: A Symposium of the Artist's Life and Times.* New York: Abrams, 1984.

Rey, Henry-François. "Ainsi parlait Condrars de son copain Léger." Interview in *Arts Spectacles,* quoted in *L'aventure de l'art au XXe siècle,* under the direction of Jean-Louis Ferrier. Paris: Hachette-Chene.

Rimmel, Eugène. *Souvenirs de l'Exposition Universelle.* Paris: Edmond Dentu, 1868.

Roberts, Mary Fanton (alias Giles Edgerton). "The Younger American Painters: Are They Creating a National Art?" *Craftsman,* vol. 13 (February 1908).

Roché, Henri-Pierre. *Romance parisienne: Les papiers d'un disparu* (1920). Paris: Maren Sell, 1990.

Roob, Rona. "Alfred H. Barr, Jr.: A Chronicle of the Years 1902–1929." *The New Criterion* (Summer 1987).

Rosa Bonheur 1822–1899. Exhibition catalog. Bordeaux: Musée des Beaux Arts de Bordeaux and William Blake, 1997.

Rose, Barbara. *American Art Since 1900.* New York: Praeger, 1975.

————. *Readings in American Art, 1900–1975.* New York: Praeger, 1975.

Rose, Bernice. *Jackson Pollock: Works on Paper.* Exhibition catalog. New York: Museum of Modern Art and Drawing Society, 1966.

Rosenberg, Emily S. *Spreading the American Dream: American Economic and Cultural Expansion, 1890–1945.* New York: Hill and Wang, 1982.

Rosenberg, Harold. *The Tradition of the New.* New York: Horizon Press, 1959.

Rosenstone, Robert A. *Romantic Revolutionary: A Biography of John Reed.* New York: Alfred A. Knopf, 1975.

Rosenthal, Nan. *The Jackson Pollock Sketchbooks in the Metropolitan Museum of Art.* Exhibition catalog. New York: Metropolitan Museum of Art, 1997.

Roussel, Raymond. *Comment j'ai écrit certains de mes livres.* Paris: Gallimard, 1979.

Rubin, William, and Carolyn Lanchner. *André Masson.* Exhibition catalog. New York: Museum of Modern Art, 1976.

Rudnick, Lois Palken. *Mabel Dodge Luhan: New Women, New Worlds.* Albuquerque: University of New Mexico Press, 1984.

Russell, John. *Matisse: Father & Son.* New York: Harry N. Abrams, 1999.

————. *The Meanings of Modern Art.* New York: Harper and Row, 1981.

Rylands, Philip. "Peggy Guggenheim," in *Spazialismo, Arte Astratta, Vicenza 1950–1960.* Venice: Il Cardo, 1996.

————. "Peggy Guggenheim and 'Art of This Century.'" New York: Stony Brook Foundation and Guggenheim Museum, 1997.

Rylands, Philip, and Enzo di Martino. *Flying the Flag for Art: The United States and the Venice Biennale, 1895–1991.* Richmond, Va.: Wyldbore and Wolferstan, 1993.

Saarinen, Aline. *The Proud Possessors.* New York: Random House, 1958.

Sachs, Maurice. *Journal d'un jeune bourgeois à l'époque de la prospérité.* Paris: Gallimard.

Sachs, Paul J. *Modern Prints & Drawings: A Guide to a Better Understanding of Modern Draughtsmanship.* New York: Alfred A. Knopf, 1954.

————. "Tales of an Epoch." Unpublished memoir. Cambridge, Mass.: Fogg Museum Archives, Harvard University, 1956.

Sainsaulieu, Marie-Caroline. "La robe et le pinceau," in *Les femmes impressionnistes: Mary Cassatt, Eva Gonzalès, Berthe Morisot.* Exhibition catalog. Paris: Musée Marmottan, 1993.

Salmon, André. "Histoire anecdotique du cubisme," in *La jeune peinture française.* Paris: Société des Trentes, 1912.

Sandler, Irving. *The Triumph of American Painting: A History of Abstract Expressionism.* New York: Harper and Row, 1986.

Sandler, Irving, and Amy Newman, eds. *Defining Modern Art: Selected Writings of Alfred H. Barr, Jr.* New York: Harry N. Abrams, 1986.

Sanouillet, Michel. *Etant donné Marcel Duchamp.* Paris: Association pour les Etudes de Marcel Duchamp and Editions Liard. Premier Semestre, several issues, 1999.

Sanouillet, Michel, ed. *Duchamp du signe.* Paris: Flammarion, 1994.

Sawin, Martica. *André Masson in America, 1941–1945.* New York: Zabriskie Gallery, 1996.

———. *Surrealism in Exile and the Beginning of the New York School.* Cambridge, Mass.: MIT Press, 1995.

Schaffner, Ingrid, and Lisa Jacobs, eds. *Julien Levy: Portrait of an Art Gallery.* Cambridge: Mass.: MIT Press, 1998.

Schapiro, Meyer. *Theory and Philosophy of Art: Style, Artist, and Society.* New York: Braziller, 1994.

Schimmel, Julie, and Robert R. White. *Bert Geer Phillips and the Taos Art Colony.* Albuquerque: University of New Mexico Press, 1994.

Les Schneider, Le Creusot: une famille, une entreprise, une ville (1836–1960). Exhibition catalog. Paris: Fayard and Réunion des Musées Nationaux, 1995.

Schwartz, Constance. *The Shock of Modernism in America: The Eight Artists of the Armory Show.* Exhibition catalog. Roslyn Harbor, N.Y.: Nassau County Museum of Fine Art, 1984.

Seckel, Hélène. "27 rue de Fleurus, 58 rue Madame, les Stein à Paris," "Autour de Cézanne," and "L'Académie Matisse," in *Paris–New York 1908–1968.* Exhibition catalog. Paris: Centre Georges Pompidou and Gallimard, 1991.

Seckel, Hélène, and Judith Cousins. "Eléments pour une chronologie de l'histoire des 'Demoiselles d'Avignon.'" *Les Demoiselles d'Avignon: guide de l'exposition,* vol. 1. Paris: Musée Picasso, 1998.

Segard, Achille. *Mary Cassatt, un peintre des enfants et des mères.* Paris: Ollendorff, 1913.

Sellin, David. *Americans in Brittany and Normandy 1860–1910.* Exhibition catalog. Phoenix: Phoenix Art Museum, 1982.

Sellin, David, ed. *Peintres américains en Bretagne 1864–1914.* Exhibition catalog. Pont-Aven: Musée de Pont-Aven, 1995.

Shapiro, Theda. *Painters and Politics: The European Avant-garde and Society, 1900–1925.* New York: Elsevier, 1976.

Sheldon, George William. *Recent Ideals of American Art.* New York: Garland, 1977. Reprint of 1888 edition.

Sherman, Claire Richter, and Adele M. Holcomb, eds. *Women as Interpreters of the Visual Arts, 1820–1979.* Westport, Conn.: Greenwood Press, 1981.

Sherman, Lila. *Art Museums of America: A Guide to Collections in the United States and Canada.* New York: William Morrow, 1980.

Shinn, Earl. "Art Study in the Imperial School of Paris." *The Nation* (April–July 1869).

Shulman, Holly Cowan. *The Voice of America: Propaganda and Democracy 1941–1945.* Madison: University of Wisconsin Press, 1990.

Silver, Kenneth E. *Esprit de Corps: The Art of the Parisian Avant-Garde and the First World War, 1914–1925.* London: Thames and Hudson, 1989.

Smalley, George. "American Artists Abroad." *Munsey's Magazine,* vol. 27 (April 1862).

Smith, Charles Sprague. *Barbizon Days: Millet, Corot, Rousseau, Barye.* New York: A. Wessels, 1903.

Sollers, Philippe. "De Kooning, vite." in *La guerre du goût.* Paris: Gallimard, 1996.

————. *Le Paradis de Cézanne.* Paris: Gallimard, 1995.

Sollers, Philippe, and Alain Kirili. *Rodin: Les dessins érotiques.* Paris: Gallimard, 1987.

Spaeth, Eloise. *American Art Museums: An Introduction to Looking.* New York: McGraw-Hill, 1969.

Spender, Matthew. *From a High Place: A Life of Arshile Gorky.* New York: Alfred A. Knopf, 1999.

Spurling, Hilary. *The Unknown Matisse.* New York: Alfred A. Knopf, 1999.

Steffensen-Bruce, Ingrid A. *Marble Palaces, Temples of Art: Art Museums, Architecture, and American Culture, 1890–1930.* Lewisburg, Pa.: Bucknell University Press, 1998.

Steichen, Edward. "The American School." *The Photogram,* vol. 8 (January 1901).

————. *A Life in Photography.* New York and London: Museum of Modern Art and W. H. Allen, 1963.

Stein, Gertrude. *Autobiographie d'Alice B. Toklas.* Paris: Gallimard, 1973.

Stein, Leo. *Appreciation: Painting, Poetry and Prose.* Lincoln and London: University of Nebraska Press, 1996.

————. *A Journey into the Self,* ed. Edmund Fuller. New York: Crown, 1950.

Stein, Sarah. "Four Americans in Paris: The Collection of Gertrude Stein and Her Family," in Barbara Pollack, *The Collectors: Dr. Claribel and Miss Etta Cone.* New York: Bobbs-Merrill, 1962, p. 270.

————. "Notes," in Henri Matisse, *Ecrits et propos sur l'art.* Paris: Hermann, 1972.

Steinberg, Leo. *Other Criteria: Confrontations with Twentieth Century Art.* Oxford: Oxford University Press, 1972.

Stewart, Rich. *Lone Star Regionalism: The Dallas Nine and Their Circle, 1928–1945.* Austin: Dallas Museum of Art and Texas Monthly Press, 1985.

Stieglitz, Alfred. "Pictorial Photography." *Scribner's* (November 1899).

St. John, Bruce. *John Sloan.* New York: Praeger, 1971.

————. *John Sloan's New York Scene: From the Diaries, Notes and Correspondence, 1906–1913.* New York: Harper & Row, 1965.

Strouse, Jean. *Morgan, American Financier.* New York: Random House, 1999.

"Sweeney, James Johnson." *The Bulletin of The Museum of Modern Art,* vol. 13, nos. 4–5 (1946).

Taft, Robert. *Artists and Illustrators of the Old West: 1850–1900.* New York: Charles Scribner's Sons, 1953.

Tarkington, Booth. *The Magnificent Ambersons.* New York: Grosset and Dunlap, 1918.

Tashjian, Dickran. *A Boatland of Madmen: Surrealism and the American Avant-Garde, 1920–1950.* New York: Thames and Hudson, 1995.

Terrasse, Antoine. *Pont-Aven: l'ecole buissonnière.* Paris: Gallimard, 1992.

Thersiquel, Michel. *Mémoire de Pont-Aven, 1860–1940.* Pont-Aven: Société de Peinture de Pont-Aven.

Thorp, Nigel, ed. *Whistler on Art: Selected Letters and Writings, 1849–1903.* Glasgow: Fyfield Books, Centre for Whistler Studies, Glasgow University Library, 1994.

Tinterow, Gary. In *Splendid Legacy: The Havemeyer Collection.* Exhibition catalog edited by Alice Cooney Frelinghuysen. New York: Metropolitan Museum of Art, 1993.

Tocqueville, Alexis de. *De la démocratie en Amérique* (1835). Paris: Gallimard, 1986.

Toledo Treasures: Selections from the Toledo Museum of Art. Exhibition catalog. New York: Hudson Hills Press, 1995.

Tomkins, Calvin. *The Bride and the Bachelors.* New York: Viking Press, 1968.

————. *Merchants and Masterpieces: The Story of the Metropolitan Museum of Art.* New York: E. P. Dutton, 1970.

———. *Duchamp: A Biography.* New York: Henry Holt, 1996.

Troyen, Carol. "Innocents Abroad: American Painters at the 1867 Exposition Universelle, Paris." *The American Art Journal,* vol. 16, no. 4 (Autumn 1984).

Turner, Elizabeth Hutton. *Americans in Paris (1921–1931).* Washington: Counterpoint, 1996.

Vaisse, Pierre. *La Troisième République et les peintres.* Paris: Flammarion, 1995.

Varnedoe, Kirk. "Comet: Jackson Pollock's Life and Work," in *Jackson Pollock.* Exhibition catalog. New York: Museum of Modern Art, 1998.

Vasari, Giorgio. *Lives of the Artists,* vol. 2. London: Penguin Books, 1986.

Vayssière, Bruno. *Reconstruction de la construction.* Paris: Picard, 1988.

Venturi, Lionello. *Archives de l'impressionnisme,* vol. 2: *Mémoires de Paul Durand-Ruel.* Paris: Durand Ruel, 1939.

Verax, L. *De l'énvahissement de l'Ecole des Beaux Arts par les étrangers.* Paris: Librairie des Imprimeries Réunies, 1886.

Viollet-le-Duc, Eugène. "Réponse à M. Vitet à propos de l'enseignement des arts et du dessin." *La Gazette des Beaux-Arts,* vol. 12 (1862). Reprint with a foreword by Bruno Foucart. Paris: Ecole Nationale Supérieure des Beaux Arts, 1984, pp. 103–45.

Le voyage de Paris: les américains dans les écoles d'art, 1868–1918. Château de Blérancourt, Musée National de la Coopération Franco-Américaine. Paris: Réunion des Musées Nationaux, 1990.

Waldman, Diane. *Arshile Gorky (1904–1948): A Retrospective.* Exhibition catalog. New York: Guggenheim Museum, 1981.

Wallach, Alan. *Exhibiting Contradiction: Essays on the Art Museum in the United States.* Amherst: University of Massachusetts Press, 1998.

Wallock, Leonard. *New York: Culture Capital of the World.* New York: Rizzoli, 1988.

Warnod, André. " 'Amerique ce n'est pas un pays, c'est un monde' dit Fernand Léger." *Arts,* no. 49 (Jan. 4, 1946), p. 1.

Watkin, David. *The Rise of Architectural History.* Chicago: University of Chicago Press, 1983.

Weber, Eugen. *The Hollow Years.* New York: W. W. Norton, 1994.

Weber, Nicholas Fox. *Patron Saints: Six Rebels Who Opened America to a New Art, 1928–1943.* New York: Alfred A. Knopf, 1992.

Webster, Jean. *Daddy Long-Legs.* New York: Samuel French, 1922.

Weil, Patrick. "Politiques d'immigration de la France et des Etats-Unis à la veille de la Seconde Guerre mondiale." *Cahiers de la Shoah.* Paris: Université de Paris I and Liana Lévi, 1995.

Weinberg, Helen Barbara. *American Impressionists and Realists, the Painters of Modern Life: 1885–1915.* New York: Metropolitan Museum of Art and Harry N. Abrams, 1994.

———. *The American Pupils of Jean-Léon Gérôme.* Fort Worth: Amon Carter Museum of Western Art, 1984.

———. "Late Nineteenth-Century American Painting: Cosmopolitan Concerns and Critical Controversies" and "The Quest for Unity." *Archives of American Art Journal,* vol. 23, no. 4 (1983), pp. 19–26.

———. *The Lure of Paris.* New York: Abbeville Press, 1993.

Weinberg, Steve. *Armand Hammer: The Untold Story.* Boston: Little, Brown, 1989.

Weitzenhoffer, Frances. *The Havemeyers: Impressionism Comes to America.* New York: Harry N. Abrams, 1986.

Weld, Jacqueline Bograd. *Peggy: The Wayward Guggenheim.* New York: E. P. Dutton, 1986.

Wharton, Edith. *The Reff.* New York: D. Appleton, 1927.

Whelan, Richard. *Alfred Stieglitz.* New York: Little, Brown, 1995.

Whistler, James Abbott McNeill. *The Gentle Art of Making Enemies.* London: Heinemann, 1890.

———. *Ten O'Clock,* trans. Stéphane Mallarmé. Paris: L'Echoppe, 1992.

Whistler Papers, ed. Liana DeGirolami Cheney, and Marks. Lowell, Mass.: Whistler House Museum, 1986.

Whitaker, Ben. *The Philanthropoids: Foundations and Society.* New York: William Morrow, 1974.

White, Barbara Ehrlich, ed. *Impressionism in Perspective.* Englewood Cliffs, N.J.: Prentice Hall, 1965.

White, H. C., and C. A. White. *Canvases and Carriers: Institutional Changes in the French Painting World.* New York: John Wiley and Sons, 1965.

———. "The Sociology of Career Support by the Dealer and by the Group Show." *Impressionism in Perspective,* ed. Barbara Ehrlich White. Englewood Cliffs, N.J.: Prentice Hall, 1965.

White, Robert R. *The Taos Art Colony and the Taos Society of Artists, 1911–1927.* Albuquerque: University of New Mexico Press, 1994.

White, Robert R., ed. *The Taos Society of Artists.* Albuquerque: University of New Mexico Press, 1983.

Whitman, Walt. *Leaves of Grass.* Washington, D.C.: Library of America, 1985.

Wightman Fox, Richard, and T. J. Jackson Lears, eds. *The Power of Culture.* Chicago: University of Chicago Press, 1993.

Wildenstein, Daniel. "Le Salon des Refusés 1863. Catalogue et documents." *La Gazette des Beaux-Arts* (September 1965).

Wilentz, Sean. "Low Life, High Art." *The New Republic,* vol. 207 (September 28, 1992).

Wilkin, Karen. "Becoming a Modern Artist, 1920," in *Stuart Davis, American Painter.* Exhibition catalog. New York: Metropolitan Museum of Art and Harry N. Abrams, 1991.

Williams, William Carlos. *In the American Grain.* New York: Albert and Charles Boni, 1925.

Wilmerding, John. *Thomas Eakins and the Heart of American Life.* Exhibition catalog. Washington: Smithsonian Institution Press, 1993.

Wilson, Richard Guy. "Charles F. McKim and the Development of the American Renaissance (1876–1917): A Study of Architecture and Culture." Ph.D. diss.: University of Michigan, 1972.

Winneapple, Brenda. *Sister Brother: Gertrude and Leo Stein.* New York: G. P. Putnam's Sons, 1996.

Witt, David L. "In or Out of the Mainstream? The Lost Artists of Taos." *Ayer y Hoy* (Autumn 1998).

The W.P.A. Guide to California. New York: Pantheon Books, 1984.

Young, Dorothy Weir. *The Life and Letters of Julian Alden Weir.* New Haven: Yale University Press, 1960.

Young, Mahonri Sharp. *American Realists: Homer to Hopper.* New York: Watson-Guptill Publications, 1977.

Zafran, Eric M. *French Salon Paintings from Southern Collections.* Exhibition catalog. Atlanta, Ga.: High Museum of Art, 1983.

Zakian, Michael, and Katherine Plake Hough. *Transforming the Western Image in 20th Century American Art.* Palm Springs, Calif.: Palm Springs Desert Museum, 1992.

Zigrosser, Carl. *My Own Shall Come to Me.* Philadelphia: Casa Laura, 1971.

Zilczer, Judith. "The World's New Art Center Modern Art Exhibition in New York City 1913–1918." *Journal of Archives of American Art,* vol. 14, no. 3 (1974).

Zolberg, Vera L. *Constructing a Sociology of the Arts.* New York: Cambridge University Press, 1990.

Zurier, Rebecca. *Art for the Masses: A Radical Magazine and Its Graphics, 1911–1917.* Philadelphia: Temple University Press, 1988.

———. "Picturing the City: New York in the Press and the Art of the Ashcan School, 1890–1917." Ph.D. diss. New Haven: Yale University, 1988; Ann Arbor, Mich.: U.M. Dissertation Services, 1996.

Zurier, Rebecca, Robert W. Snyder, and Virginia M. Mecklenburg. *Metropolitan Lives: The Ashcan Artists and Their New York.* Exhibition catalog. Washington, D.C.: National Museum of American Art and W. W. Norton, 1995.

Archives Consulted

Archives of the Boston Public Library, Fine Arts Department
Archives of the City & Country School, New York
Archives of the Guggenheim Foundation, Venice
Archives of the Harwood Foundation, Taos, New Mexico
Archives of the Krasner-Pollock Foundation, House and Study Center, East Hampton, New York
Columbia University, Butler Library
 Oral History program: Holger Cahill, Paul Sachs
Getty Research Institute for the History of Art and the Humanities, Los Angeles, California, Research Library, Special Collections & Visual Resources:
 The Clement Greenberg Papers
 The Harold Rosenberg Papers
 The David Alfaro Siqueiros Papers, 1920–1991
Harvard University, Cambridge, Massachussets, Fogg Art Museum:
 Paul Sachs Papers
 Edward M. M. Warburg Papers
Robert Henri Archives, courtesy Janet LeClair
The Museum of Modern Art Archives, New York:
 Alfred H. Barr, Jr., Personal Papers
 Early Museum History
 Museum Matters
 Oral History: Leo Castelli, Philip Johnson, Eliza Bliss Parkinson Cobb, Edward M. Warburg
New York University Bobst Library, Tamiment Institute Library
 Ferrer School Papers
 Rand School Papers
Smithsonian Institute, the New York Regional Center, Archives of American Art:
 Jozef and Teresa Bakos Papers
 William and Ethel Baziotes Papers
 Thomas Hart Benton Papers
 Emil Bisttram Papers
 Holger Cahill Papers
 Andrew Dasburg and Grace Mott Johnson Papers
 Arthur B. Davies, Exhibition of Paintings
 Thomas Eakins Papers
 Albert Gallatin Scrapbook
 Marsden Hartley Papers
 Robert Henri Papers
 Kraushaar Gallery Papers
 Walt Kuhn Family Papers
 Ward Lockwood Papers
 George Luks Papers

Macbeth Gallery Papers
Macdowell Club Exhibitions Papers
New Deal and the Arts Project File
Walter Pach Papers
Guy Pène du Bois Papers
Jackson Pollock Papers
John Quinn Ledgers
Mary Fanton Roberts Papers
Morgan Russell Papers
Everett Shinn Papers
John Sloan Papers
Taos Society of Artists Papers
Forbes Watson Papers
John Weichsel Papers
J. Alden Weir Papers
Whitney Museum of American Art
Yale University, New Haven, Connecticut, Beinecke Rare Book and Manuscript Library:
Robert Henri Papers
Gertrude Stein and Alice B. Toklas Papers
Alfred Stieglitz/Georgia O'Keeffe Papers

Archives de la Bibliothèque Littéraire Jacques Doucet, Paris
Archives Départementales de Basse-Normandie, Rouen
Archives des Musées Nationaux, Musée du Louvre, Paris
Archives du Musée Rodin, Paris
Archives Durand-Ruel, Paris
Archives of the Daniel Terra Foundation, Musée d'Art Américain, Giverny
Archives Picasso, Musée National Picasso, Paris
Institut des Mémoires de l'Edition Contemporaine, Paris: Archives Jean Hélion
Service de Documentation et Bibliothèque du Musée d'Orsay, Paris: Fonds Paul Burty-Haviland

Index

note: *italicized* page numbers refer to illustrations

Illustration Credits

A Note About the Author

Annie Cohen-Solal was born in Algeria and has received a Ph.D. in French literature from the Sorbonne. She has taught at New York University and the Universities of Berlin, Jerusalem, and Paris XIII, and she writes frequently about French intellectuals and cultural policy for a variety of publications. Having served as the Cultural Counselor at the French embassy in the United States from 1989 to 1993, she is currently a Professor at the Ecole des Hautes Etudes en Sciences Sociales in Paris, where she teaches a seminar in American art and has produced the series *Painters for the New World* for France-Culture. The French edition of *Painting American* was awarded the Prix Bernier by the Académie des Beaux Arts. Cohen-Solal's acclaimed *Sartre: A Life* was an international best-seller translated into sixteen languages. She lives in Paris and New York.

A Note on the Type

This book was set in Adobe Garamond. Designed for the Adobe Corporation by Robert Slimbach, the fonts are based on types first cut by Claude Garamond (c. 1480–1561). Garamond was a pupil of Geoffroy Tory and is believed to have followed the Venetian models, although he introduced a number of important differences, and it is to him that we owe the letter we now know as "old style." He gave to his letters a certain elegance and feeling of movement that won their creator an immediate reputation and the patronage of Francis I of France.

Composed by North Market Street Graphics, Lancaster, Pennsylvania
Printed and bound by Quebecor Printing, Fairfield, Pennsylvania
Designed by Ralph Fowler